D1256629

The Faustian Bargain

The Faustian Bargain

The Art World in Nazi Germany

Jonathan Petropoulos

OXFORD
UNIVERSITY PRESS

2000

OXFORD
UNIVERSITY PRESS

Oxford New York
Athens Auckland Bangkok Bogotá Buenos Aires Calcutta
Cape Town Chennai Dar es Salaam Delhi Florence Hong Kong Istanbul
Karachi Kuala Lumpur Madrid Melbourne Mexico City Mumbai
Nairobi Paris São Paulo Singapore Taipei Tokyo Toronto Warsaw

and associated companies in
Berlin Ibadan

Copyright © 2000 by Jonathan Petropoulos

Published by Oxford University Press, Inc.
198 Madison Avenue, New York, New York 10016

Oxford is a registered trademark of Oxford University Press

Library of Congress Cataloging-in-Publication Data
Petropoulos, Jonathan.
The Faustian bargain : the art world
in Nazi Germany / by Jonathan Petropoulos.
p. cm. Includes bibliographical references and index.
ISBN 0-19-512964-4
1. National socialism and art.
2. Art and state—Germany—History—20th century.
3. Germany—Cultural policy—History—20th century.
4. Art treasures in war—Germany.
5. Nazis—Germany—Art collections.
6. Art—Germany—Biography. I. Title
N6868.5.N37P4823 2000
709'.43'09043—dc21 99-33372

1 3 5 7 9 8 6 4 2

Printed in the United States of America
on acid-free paper

*Don't forget the little criminals so that they don't change sides
at the last minute and pretend that nothing happened.*

—circular of the White Rose resistance group

*We do not have the right to judge,
but we have the duty to accuse.*

—Hildegard Knef and Ernst Wilhelm Borchert,
The Murderers Are Among Us

For Kimberly

Contents

Acknowledgments

In researching and writing this book, I have relied upon the assistance of friends and colleagues in innumerable ways. In an attempt to make some sense of the crucial yet diverse support, I would like to thank the following individuals.

I am very grateful to my colleagues at Loyola College, who have offered not just intellectual stimulation, but friendship and camaraderie. I will miss them very much as I move on to a new position at Claremont McKenna College. Joanne Dabney, the administrator of the History Department deserves special recognition for her tireless efforts. I would also thank Deans David Roswell and John Hollwitz, who have provided me with the resources needed to conduct research in Europe. I owe a debt of gratitude to the Loyola Center for the Humanities for several summer grants and a junior faculty sabbatical. The German Academic Exchange Service awarded me two fellowships, which permitted valuable research trips to Germany. The Holocaust Educational Foundation and its president, Theodore Zev Weiss, also provided much needed financial assistance.

I would convey special thanks to friends who took the time to read the manuscript. James Van Dyke, Paul Jaskot, Scott Denham, Günter Bischof, Chris Jackson, Rebecca Boehling, Ines Schlenker, Stephan Lindner, Marion Deshmukh, and Geoffrey Giles read all or part of the book. I take responsibility for all of its shortcomings, but there would have been many more without their assistance. Similarly, the opportunity to present my findings at lectures and symposia elicited very useful feedback. In this respect, I would thank the following for their suggestions: O. K. Werckmeister, Peter Hayes, Eugen Blume, Dieter Schmidt, Wolfgang Wittrock, Keith Holz, Sabine Eckmann, Christoph Zuschlag, John Czaplicka, Jan Tabor, and Rosl Merdinger. I would also thank

several senior scholars for continuing to offer wise counsel. I truly appreciate the assistance of Charles Maier, Richard Hunt, Peter Paret, Vernon Lidtke, and Philip Eliasoph.

A number of individuals are also studying the looting of art prior to and during World War II, and they have offered me invaluable advice and encouragement over the years. I would recognize Elizabeth Simpson and Konstantin Akinsha, my partners in The Documentation Project, as well as Lynn Nicholas, Willi Korte, Marc Masurovsky, Hector Feliciano, Gerald Aalders, Oliver Rathkolb, Sarah Jackson, Constance Lowenthal, Thomas Buomberger, Cynthia Salzman, Patricia Kennedy Grimsted, Anja Heuss, Wolfgang Eichwede, Ulrike Hartung, Walter Robinson, William Honan, Ulrich Bischoff, Gert Kerschbaumer, and Anne Webber.

Certain individuals were invaluable because of their help with the research. At times, they shared valuable documents that they possessed. This was the case with Oliver Rathkolb mentioned above, who copied an important file on Kajetan Mühlmann; Bernard Taper also sent me copies of his interrogations of Mühlmann; Jody Bresnahan, who let me use papers belonging to her father who had served in the Office of Strategic Services; Josephine Gabler, who sent me material pertaining to Arno Breker and Georg Kolbe; and Andrea Schmidt, who shared with me her research on Klaus Graf von Baudissin. Sylvia Hochfield and Milton Esterow also put files in the *ARTnews* office at my disposal. Michael Dobbs at the *Washington Post* and Walter Robinson at the *Boston Globe* also shared useful information with me. Steve Rogers at the Department of Justice's Office of Special Investigation sent me materials concerning war crimes inquiries. I would also thank my dear friends Timothy and Mary Louise Ryback, who escorted me on trips in and around Salzburg as we searched for houses and graves of figures in the book.

There were also a number of professionals who made my work in their institutions very productive. I would thank Timothy Benson and colleagues at Rifkind Center in Los Angeles; Valérie Dahan and Sarah Halperyn of the Centre Documentation Juive Contemporaine; A. J. van der Leeuw, formerly of the State Institute for War Documentation in Amsterdam; Anette Meiburg and Dr. Blumberg at the Bundesarchiv in Berlin-Lichterfelde; Dr. Michael Kurtz, Greg Bradsher, and David Van Tassel at the National Archives in Washington/College Park; Stephen Mize of the National Gallery in Washington, DC; Dr. Cornelia Syre, Dr. Carla Schulz-Hoffmann and their colleagues at the Bavarian State

Painting Collections in Munich; Gode Krämer at the Art Collection of Augsburg; Roswitha Juffinger at the Residenzgalerie Salzburg; Professor Norbert Frei and his coworkers at the Institute for Contemporary History in Munich; F. Luykant at the Germanisches Nationalmuseum in Nuremberg; Fraulein Götze at the Central Archives of the Berlin State Museums; Dr. Bliss at the Secret State Archive of the Prussian Cultural Heritage Foundation; and Andrea Hackel at the Austrian State Archive.

This project was also advanced as a result of individuals who shared their knowledge of the figures in this study. In this respect, I would thank Dr. Bruno Lohse, Peter Griebert, Annemarie Fiebich-Ripke, Dr. Wilhelm Höttl, Hilde Ziegler Mühlmann, Marianne Feilchenfeldt, Gabriele Seibt, Julius Böhler, Simon Wiesenthal, and Professor S. L. Faison.

There are individuals who do not fit into any of the above mentioned categories. I would thank my friends and frequent hosts in Germany, Karl and Irmgard Zinsmeister, and Stephan and Sigrid Lindner as well as my research assistant in Baltimore, Melanie Desmedt.

I would also express tremendous gratitude to my agent Agnes Krup who offered wisdom and encouragement as I put this book into its final form. I look forward to a long and harmonious partnership. I have similar sentiments with respect to Peter Ginna, who has been a wise and sensitive editor. He made the revision process flow smoothly and improved the book immensely. Many thanks also to Catherine Clements, for her careful work copyediting the manuscript, and to Helen Mules, who oversaw the production process.

Finally, I would thank my wife, Kimberly, who often traveled with me and made the research excursions all the more enjoyable, but who also endured my absences and held down the fort. She has been unwavering in her support throughout this project and has been a true partner.

Abbreviations and Acronyms

AdR	Archiv der Republik (Archive of the Republic in the Austrian State Archive, Vienna)
ALIU	Art Looting Investigation Unit (United States)
AVA	Allgemeines Verwaltungsarchiv (of the Austrian State Archive, Vienna)
BA	Bundesarchiv (Federal Archives of Germany)
BAL	Bundesarchiv Lichterfelde (German Federal Archives in Berlin-Lichterfelde)
BDC	Berlin Document Center
BHSA	Bayerisches Hauptstaatsarchiv (Bavarian Main State Archives, Munich)
BMfU	Bundesministerium für Unterricht (Federal Ministry for Education, Austria)
BSdI	Bayerischer Staatsministerium des Innern (Bavarian State Ministry of the Interior)
BSMF	Bayerischer Staatsministerium der Finanzen (Bavarian State Ministry of Finance)
BSUK	Bayerischer Staatsministerium für Unterricht und Kultus (Bavarian State Education Ministry)
BSGS	Bayerische Staatsgemäldesammlungen (Bavarian State Painting Collections, Munich)
BSM/ZA	Berliner Staatlichen Museen/Zentralarchiv (Berlin State Museums/Central Archive)
CDJC	Centre Documentation Juive Contemporaine (Documentation Center for Contemporary Jewry, Paris)
CIC	Counter Intelligence Corps (United States)
CIR	Consolidated Interrogation Report
DAF	Deutsche Arbeitsfront (German Labor Front)

DBFU	Der Beauftragte für Überwachung (Commissar for Supervision)—Alfred Rosenberg
DIR	Detailed Interrogation Report
DÖW	Dokumentationszentrum des Österreichischen Widerstandes (Documentation Center of the Austrian Resistance, Vienna)
DT	*Deutsche Tageszeitung*
DWZ	*Deutsche Wochen-Zeitung*
ERR	Einsatzstab Reichsleiter Rosenberg (Special Staff of Reichsleiter Rosenberg)
FOIA	Freedom of Information Act
ffr.	French franc
GBI	General Bauinspektor, Berlin (General Building Inspector, Berlin)—Albert Speer
Gestapo	Geheimes Staatspolizei (Secret State Police)
GDK	*Grosse Deutsche Kunstausstellung* (*Great German Art Exhibition*)
GSAPK	Geheime Staatsarchiv Preussischer Kulturbesitz (Secret State Archives of the Prussian Cultural Foundation, Berlin)
IfZG	Institut für Zeitgeschichte (Institute for Contemporary History, Munich)
KfdK	Kampfbund für Deutsche Kultur (Combat League for German Culture)
KiDR	*Kunst im Dritten/Deutschen Reich (Art in the Third/German Reich)*
KPA	Kulturpolitisches Archiv (Cultural-Political Archive of the DBFU)
MFA and A	Monuments, Fine Arts and Archives (within Supreme Headquarters, Allied Expeditionary Force)
NA	National Archives, Washington, DC, and College Park, MD.
NGA	National Gallery of Art, Washington, DC
NS	Nationalsozialistisches (National Socialist)
NSDAP	Nationalsozialistische Deutsche Arbeiter-Partei (NS German Workers' Party)
NS-KG	Nationalsozialistische-Kulturgemeinde (NS Cultural Community)
OFD	Oberfinanzdirektion (Main Finance Office, Munich)

ÖIfZG-BA Österreichisches Institut für Zeitgeschichte-Bildarchiv
(Austrian Institute for Contemporary History-Picture
Archive, Vienna)

OSS Office of Strategic Services (United States)

ÖSA Österreichisches Staatsarchiv (Austrian State Archive,
Vienna)

RFM Reichsfinanzministerium

RIOD Rijksinstituut voor Oorlogsdocumentatie (Netherlands
State Institute for War Documentation, Amsterdam)

RkdbK Reichskammer der bildenden Künste (Reich Chamber
for the Visual Arts)

RM Reichsmark

RMdI Reichsministerium des Innern (Reich Ministry of the
Interior)

RMVP Reichsministerium für Volksaufklärung und Propaganda
(Reich Ministry for Public Enlightenment and Propa-
ganda)

RMWEV Reichsministerium für Wissenschaft, Erziehung und
Volksbildung (Reich Ministry for Science, Education, and
Public Instruction)

RSHA Reichssicherheitshauptamt (Reich Security Main Office)

SA Sturmabteilung (Storm Division)

SD Sicherheitsdienst (Security Service)

Sf Swiss franc

SS Schutzstaffel (Protection Staff)

SV-B Süddeutscher Verlag-Bilderdienst (Süddeutscher Press-
Picture Service, Munich)

VB *Völkischer Beobachter*

Vugesta Vermögens Umzugsgut von der Gestapo (Property
Removed by the Gestapo)

The Faustian Bargain

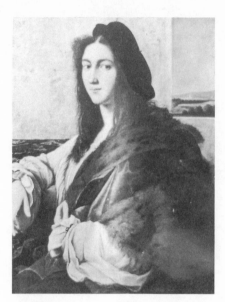

Raphael, Portrait of a Gentleman, *from the Czartoriski family collection. Painting is still missing today (NA).*

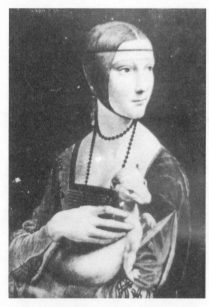

Leonardo da Vinci, Lady with an Ermine *(also known as* Portrait of Cecilia Gallerani*), from the Czartoriski family collection (NA).*

Introduction

Imagine the thoughts that passed through the mind of Kajetan Mühlmann in June 1941 as he sat in the first-class compartment of the Reichsbahn train carrying him from Cracow to Berlin. Next to him, wrapped tightly in protective packaging, were three paintings: Raphael's *Portrait of a Gentleman*, Leonardo da Vinci's *Lady with an Ermine*, and Rembrandt's *Landscape with the Good Samaritan*. They were three of the most prized artworks in Poland—taken from the Czartoryski family's collection—and they were in his personal care.

Mühlmann, it would seem, had very mixed emotions as he watched the Polish countryside pass outside the window. On the one hand, he was a Nazi, a German nationalist, and took great satisfaction in the notion that these masterpieces, these examples of "Aryan" superiority, were returning *heim ins Reich* ("home to the Reich"). Mühlmann later testified about the excitement he felt merely transporting these masterpieces and the prospect of reporting their arrival in Berlin to Reichsmarschall Hermann Göring, his patron and protector, undoubtedly

enhanced this sentiment. Göring was then at the height of his power and had undeniable presence. To be summoned by the Reichsmarschall to his grandiose Carinhall estate was a heady experience that helped bolster Mühlmann's ego and made him feel a part of the Nazi elite. Yet this excitement and self-satisfaction was tempered by a certain frustration and dread. This was now the second trip to hand over these paintings: after the first delivery to Berlin, when Göring had stored the works in the Kaiser Friedrich Museum, General Governor Hans Frank, another of his superiors, had responded by ordering them returned to Cracow, and Mühlmann had complied.[1] He recounted later that he hated being caught in a struggle between rapacious Nazi leaders and feared that it might not only undermine his career, but jeopardize his life. This scholar, who had earned his doctorate by writing a dissertation on baroque fountains in his native Salzburg, also knew at some level that he was violating fundamental ethical precepts, although he remonstrated after the war, "we were art historians; what did we know about international law, the Geneva Convention and such." He added defensively, "we carried out our project in Poland with absolute humanity."[2] Mühlmann was close friends with several high-ranking SS leaders who played prominent roles in the persecution of Jews and other subject peoples and was actually well aware of the Germans' policies. Feeling powerful and a part of a historical process, yet at that same time complicit in grave deeds beyond his control, Kajetan Mühlmann expressed his ambivalence about his undertaking in Poland by jumping at the opportunity to transfer his operations to the less brutal occupation administration in the Netherlands.

These conflicting thoughts and emotions were common to nearly all of the experts who implemented the Nazi leaders' art policies. The scene above was not unique. When museum director Ernst Buchner entered a chateau in the south of France and encountered the multi-paneled Ghent altarpiece by the Van Eyck brothers, he, too, later testified in 1945 to a flood of mixed emotions.[3] An expert in early modern northern European painting, he had a profound appreciation of this altar, one of the greatest artworks of its kind. Yet despite his belief that the altar belonged to Germany and should be repatriated, there was the stark reality that he was escorted by an armed detachment and that the work was being taken by force. Both Mühlmann and Buchner found ways to assuage these pangs of guilt. They rationalized their behavior on the grounds that they were safeguarding cultural property, following orders, and taking what was rightfully Germany's. It is these varying

emotions, this psychic drama, that makes the history of the Nazi art experts so compelling.

The "art world" is a somewhat vague term that encompasses a host of professions, ranging from dealers to museum officials and from academics to practicing artists. Additionally, this term conjures up varied and at times conflicting associations. On the one hand, it is characterized by a certain mystery—a place where personal connections are paramount and clandestine transactions not infrequent. Conversely, it is populated by erudite and polished professionals, members of a glamorous international elite who have mastered vast stores of arcane knowledge.[4] It is important to emphasize at the outset that the subjects of this book qualify as intellectuals. Most had the benefit of formal education, were cognizant of contemporary political and cultural trends, and possessed a veneer of sophistication. This is the history of skilled and successful individuals who collaborated with the Nazi leaders and helped implement a nefarious cultural program.

While it is naïve and without historic foundation to expect members of the intelligentsia to behave in a more scrupulous and humane fashion than those who do not lead the life of the mind, there has nonetheless been a persistent expectation that they will do so. This was especially the case in the nineteenth century, when those who were educated were imagined to have greater insight and a more highly developed social conscience.[5] This expectation was also shared by the U.S. intelligence agents in the Office of Strategic Services (OSS)— many of them academics—who hatched a plan during the war to contact intellectuals as part of the invasion of Germany. The OSS agents believed that German intellectuals, along with labor and church leaders, would be most inclined to join the anti-Nazi resistance as soon as it became feasible.[6] The OSS agents were sorely mistaken, and as we have subsequently discovered, those in the learned professions were often among the first to be co-opted, not to mention frequently supportive of the Nazi regime right until the end.[7] Even later, in the German Democratic Republic, with the lessons of National Socialism all too clear, the professoriate was overrepresented among Stasi (the East German secret police) informers: Timothy Garton Ash cites the statistic that "one in every six professors and one in ten university employees had worked for or in some way cooperated with the secret police under the old regime."[8] In both dictatorships, the Third Reich and the former East Germany, one cannot help but ask, why was this the case and what were they thinking?

Part of the project of this book is to understand the various motivations that induced talented and respected professionals in the art world to become accomplices of the Nazi leaders—in most cases, to become art plunderers. This is admittedly a daunting project. Because it deals with the complexities of human nature, motivation is at some fundamental level inexplicable. Scholars will never get it entirely right. But this limitation does not mean that one should give up trying. Motivation lies at the core of most history and is central to the drama; as with others who have tackled the subject (such as Michael Kater and his study of musicians in the Third Reich), I proceed knowing that certain critics will be dissatisfied with the conclusions.[9] I have not attempted to construct a system to categorize the subjects. While this has been tried in a cursory way at least once before, it seems best to appreciate the uniqueness of the subjects depicted here and leave this project to sociologists or those in other disciplines.[10] Some common traits—patterns in gender and class, perhaps even a "syndrome"—emerge in the course of this study. But it is essential to appreciate that the subjects treated here were individuals who acted for their own reasons.

It is also not my intention to demonize either these figures or the Nazi leaders. Timothy Garton Ash made a relevant observation about Stasi informers: "If only I had met, on this search, a single clearly evil person. But they were all just weak, shaped by circumstance, self-deceiving; human, all too human. Yet the sum of all their actions was a great evil."[11] This formulation offers a satisfying balance. On the one hand, the subjects, like most people, fell somewhere in the gray area of behavior. On the other, their story has an important ethical component inextricably linked with the more systematic persecution of the period.

The phrase "Faustian bargain" is often used in an imprecise manner to describe any immoral or amoral act that leads to self-advancement. One sees this, for example, in a *Newsweek* article about Swiss bankers serving the Nazis in return for greater profits.[12] In fact, since its inception in the sixteenth century, the story of Faust and his pact with Mephistopheles entailed more than self-interest. He made his deal with the devil in return for greatness and in pursuit of a lofty ideal (in many versions, for knowledge).[13] The figures in this study were not simply corrupt or self-promoting. They were at or near the top of their respective fields and held ambitions for even loftier accomplishment. They collaborated with the Nazi leaders, whom they often recognized as brutal and vainglorious, because they perceived opportunities in terms of their own work. They were not concerned with mere survival, but pur-

sued a vision of greatness that would ultimately yield fame and a kind of immortality. Additionally, they themselves would have been familiar with the Faustian myth. It was a well-known trope at this time for those who were culturally literate (Oswald Spengler, in *Decline of the West*, even talked about the twentieth century as the "Faustian era").[14] One finds cases like Albert Speer, who remarked in his memoirs, "For the commission to do a great building, I would have sold my soul like Faust. Now I had found my Mephistopheles. He seemed no less engaging than Goethe's."[15] The Faustian metaphor, then, is useful not only because of its expressiveness, but also because it was central to the culture discussed in this book. Nonetheless, the metaphor should not be viewed as a procrustean bed where all are trimmed to fit. It is meant as a kind of shorthand for the ethical compromises that occurred and not as an all-encompassing explanation for these highly complex histories.

These figures in the art world had the opportunity for a Faustian bargain because the Nazi leaders themselves cared so much about culture—the visual arts in particular. This book is intended to complement my earlier study, *Art as Politics in the Third Reich* (1996), which documented the leaders' involvement in arts administration and their passion for collecting paintings and sculpture. The Nazi leaders devoted an inordinate amount of time to cultural matters. Indeed, culture and propaganda may indeed have been "the war that Hitler won."[16] Their control of the arts was an important element of their totalitarian system. Similarly, their commitment to amassing both private and state art collections stands as a remarkable aspect of their rule. Never before, with the possible exception of Napoleon and his cohorts, had an entire leadership corps been responsible for the acquisition of so much art. Through purchase and plunder (the Third Reich was a "kleptocracy"), their harvest amounted to hundreds of thousands of pieces.[17]

The Nazi leaders could not have dominated the artistic sphere or have amassed such collections without the assistance of figures in the art world. It was a joint project. The leaders provided the political leverage and the operating capital, and the subordinates offered their skill and expertise. This collaboration occurred in all branches of the art world, hence the organization of this study. It is divided according to various professions that collectively comprise the art world: museum directors and curators, art dealers, art critics, art historians, and artists themselves. One could have added the profession of conservationists, which was a burgeoning field at a time when military actions increasingly threatened civilian areas. But the history of the conservation

experts, because of the nature of their employment, is subsumed within other categories, especially that of museum personnel. One could have also included architects, a group usually included in the German term *"bildende Künstler"* (visual artist); but such individuals often had little to do with actual artworks, and there is already a substantial literature devoted to their activities in the Third Reich. This book is intended as a contribution to the history of professions in modern Germany. While there have been studies on a range of occupations—from doctors and lawyers to engineers and scientists—there has been no comprehensive work on the professions that comprised the art world.[18] It is important to note that these professions are so interrelated that boundaries often are blurred. It is not uncommon to find museum directors who were art historians or critics who took over galleries. Placing individuals in specific categories sometimes proved difficult, but I have situated them in a manner reflecting their primary area of activity and the core of their professional identity.

While scholars of the Third Reich have long been aware that the Nazi leaders relied upon technocrats to implement their ideologically determined policies—including coordinating the deportations by rail and designing the gas chambers—this study shows how individuals in the cultural realm were also co-opted.[19] It is striking how the Nazi leaders elicited the cooperation of not just ideological zealots, but also many who were ostensibly apolitical. One finds a situation in the art world that is analogous to the findings of Christopher Browning and Daniel Goldhagen, who have both shown that "ordinary" people participated in the murder of Jews and other victims of the Holocaust. Of course, one must tread carefully when making comparisons between mass murderers and art looters; the distinction is profound and must be preserved. But, as I argued in *Art as Politics*, the two projects were interlinked, part of a continuum. With respect to the cultural sphere, one sees a progression from persecution in the professional realm (dismissing Jewish and left-wing employees) to the expropriation of Jewish property (part of the efforts to dehumanize the victims) to the spoliation of cultural property of neighboring countries and, in certain cases (especially in the East), outright destruction. In short, the Nazi leaders' cultural policies were inextricably bound up with their racial and geopolitical agendas. The collusion of figures in the art world certainly involved the creation of propaganda and the legitimation of the Nazi leaders's cultural ambitions (as was the case, for example, with philosopher Martin Heidegger).[20] Yet the subjects of this book went a step fur-

ther because they were deeply implicated in the regime's criminal programs. And while the figures in the art world discussed here must be regarded as second rank when viewed with respect to the entirety of the political and social structure of the Third Reich, they were not merely reactive to the policies and programs of the Nazi state. They often conceived initiatives and then presented these plans to the leaders for approval. Alternatively, they induced the Nazi elite to amend orders. One of the themes in this study concerns the manner in which the experts influenced the Nazi regime's aesthetic policies. These figures exercised considerable power with regards to art, and they frequently had official positions—often made up on the spot and involving titles like "commissar" or "delegate"—which denoted this influence.

The first of the five main figures, Dr. Ernst Buchner, served during the Nazi era as the General Director of the Bavarian State Painting Collections. This post, where he oversaw a network of fifteen museums, constituted one of the most important in all of Europe. A knowledgeable and well-respected expert on premodern German art, Buchner evolved into a politicized accomplice of the Nazi leaders in the initiative to amass huge collections.

The second chapter, on art dealers, focuses on Karl Haberstock, arguably the most successful dealer during the Third Reich. Haberstock's greatest coup was earning the confidence of Hitler and convincing the dictator to appoint one of his friends, Hans Posse, as the director of the Führermuseum in 1939. This led to special opportunities during the war. Haberstock was exonerated by a denazification court in 1949 and reestablished his business in Munich. He and his wife, who often assisted him in the gallery, left their collection to the city of Augsburg, his place of birth.

The third chapter is dedicated to art critics, who served as important mediators between the regime and the public during the Third Reich because they communicated ideological precepts manifest in contemporary art. The most important critic in Nazi Germany was Robert Scholz, who wrote for the Party newspaper, *Der Völkische Beobachter*, and, as of 1937, edited the flashy official Nazi art journal, *Kunst im Deutschen Reich (KiDR)*. Scholz served as the art expert for Nazi ideologue Alfred Rosenberg, and this drew him into the plunder of France as his chief established a notorious agency. In the 1960s, Scholz revived his career as a leading art critic in radical right-wing German publications.

Art historians, although usually concerned with works from previous epochs, were closely bound up in the cultural program of the Nazi

regime; that relationship is discussed in chapter 4. Kajetan Mühlmann serves as an apt example there because he was arguably the single most prolific plunderer in the twentieth century. An Austrian who once worked for the Salzburg festival, Mühlmann led plundering commandos in Poland and the Netherlands. Mühlmann was truly chameleonlike, and toward the end of the war, he relocated to his native region in the Austrian Alps and appeared to join the resistance. In the 1950s, he lived out his life on the idyllic Lake Ammersee outside Munich, reportedly generating income by selling artworks that he had hidden during the war.

The final chapter is devoted to artists, in particular Arno Breker. Breker was simultaneously representative of those who chose to collaborate with the Nazi leaders and exceptional because of his stature within the Third Reich. Breker produced monumental sculptures that have become closely identified with the regime, and indeed, he was one of the most celebrated artists in Nazi Germany. Breker's Faustian bargain included changing the style of his art. His work shifted from a variant of naturalism, where he was strongly influenced by August Rodin, to a monumental and characteristically fascist idiom.[21] Until his death in 1991, he was never able to acknowledge that he had compromised his art or helped sustain the Nazi regime. Like many other figures in this study, Breker's later years were characterized not only by rehabilitation, but also denial.

Within each chapter, three or four ancillary figures are discussed in order to show that the representative figures were not unique. Joining Buchner in the chapter on museum directors, for example, are Hans Posse, who made his Faustian bargain by accepting the directorship of the Führermuseum for the opportunity to build the greatest museum of all time, and Otto Kümmel, who headed the Berlin museums and led a wartime effort to reclaim works removed from Germany during the past four centuries. Although these figures receive shorter treatment, their stories are significant and often quite extraordinary. Prince Philipp of Hessen, the son-in-law of the king of Italy who served as a liaison between Hitler and Mussolini while procuring art for the Nazi elite, offers another example of a remarkable life that merits closer examination. There were a number of factors that mitigated against an intensive exploration of each of the art experts discussed in the book: one was access to extant documentation. It is often extremely difficult to research these second-rank figures. The data protection laws of Germany, Austria, and France, among other countries, limit the release of information for those not considered to possess "world historical

stature." In Germany, the archival law states that one must normally wait until thirty years after the death of the subject to gain access to personal files. Even then, it is not always possible to see documents, and institutions still reject requests to work with files on the grounds of data protection.

The prosapographical (comparative biographical) approach, as adopted in studies of the courts in ancient Rome or in imperial Germany, is usually pursued when the subjects have had some fundamental connection with one another.[22] This is the case with the subjects in this book. The art world tended to be close-knit to begin with, and it was not unusual to have mentors, academic advisers, or clients in common. Frank McDonald, in a well-researched popular novel on the art world, appreciated this, writing, "They're all connected, the people in the trade, the dealers, international rings, politicians, the people who run the legal side, even the police. Business is business."[23] Yet those in the art world who served the Nazi leaders had even more extensive contact with one another than is customary. Robert Scholz, to take just one example, wrote about Arno Breker and attended the latter's openings; he saw Haberstock as part of a commission to sell off the purged modern art; and he worked with Ernst Buchner in the storage of plunder of the Einsatzstab Reichsleiter Rosenberg (Special Staff of Reichsleiter Rosenberg, or ERR) in the Neuschwanstein castle at war's end. In other words, Scholz encountered nearly all of the figures discussed in this book. This was frequently the case for those who were art plunderers. Because the looting was directed by a limited number of subleaders administering agencies that were ordered to cooperate with one another and because the experts who comprised the staff moved throughout the Reich and the occupied lands in order to carry out their various projects, there was significant contact between them. Even more remarkable is their interaction in the postwar period. As will become evident from the individual histories, these figures continued to have contact with one another after 1945. They were often incarcerated together pending interrogations (or more rarely, during trials) and this deepened the ties between them. Whatever the reasons—and this would include common histories, a shared interest in art, a similar worldview, the same quest for profit, and an equal need for protection from investigators—many of these figures kept in touch after the war. This interaction was both professional and social, and as a result, one can talk about a clandestine postwar network of former Nazi art experts who operated primarily in Bavaria and Austria.

This study underscores the extent to which individuals who participated in the criminal programs of the Nazi regime were able to rehabilitate their careers after 1945. This continuity from the Third Reich to the Federal Republic has been recognized in a wide range of other fields extending from medicine and law to academia and the opera[24]; most famously, the U.S. government engaged Nazi rocket scientists as part of the cold war space race.[25] But these histories have been known for some time. The art world is one of the last areas where misconceptions have endured. This is perhaps partly due to a reluctance to implicate certain cultural figures in the crimes of the Nazis. Frank Whitford, for example, has written of the myths that continue to surround certain modernists:

> The admittedly more ambiguous sympathies of some of the other heroes of German modernism have been kept under wraps more successfully. Architect Mies van der Rohe, for example, director of the Bauhaus when it was closed by storm troopers as a hotbed of "cultural bolshevism" in 1933, signed an open letter in the *Völkischer Beobachter* less than a year later, urging that Hitler be given absolute power. Among his co-signatories were [Emil] Nolde, the painter Erich Heckel, and the sculptor Ernst Barlach. In 1937 Mies went to work with Speer on the interiors of the German pavilion at the 1937 Paris Universal Exhibition. . . . The fascist or nationalist leanings of leading modernist heroes such as Mies, Nolde, and Barlach make it clear that the conventional picture of art in Nazi Germany is much more complicated than it might seem.[26]

Just as the myths of the modernist heroes have recently been exploded, the impression that cultural figures were removed from politics during the Third Reich has gradually been amended. Were those involved with the arts embroiled in politics more than members of most other professions? One is reminded of the remark made by the character Wilhelm Furtwängler in Ronald Harwood's play, *Taking Sides*: "only tyrannies understand the power of art." The Nazi leaders possessed a totalistic ideology in which their cultural policies were inextricably linked with their other goals, and they appreciated how culture could be manipulated so as to secure the support of the German people.

Within the cultural realm, then, what started out as compromise and collaboration on the part of a few individuals became a widespread phenomenon. For those who remained in Germany, so many were co-opted that one can talk of trends that applied to entire professions. In

short, prosapography becomes social history and, in the process, shows us one of the most insidious aspects of Nazi Germany: that the regime co-opted "ordinary" people—or alternatively, individuals induced themselves—to support the Nazi policies and participate in criminal acts. This brings us back to the knotty and even paradoxical metaphor of Faust. He was, like the figures in this book, exceptional in many respects as he pursued knowledge and power. But Faust's story also speaks to humans more generally. He shows that ambitions leave us vulnerable and that we often make unfortunate decisions in the face of a greater power. It is in this spirit—knowing that these art experts made unique choices, but ones that many others, perhaps even we ourselves, might have made—that we examine their pacts with the devil.

Art Museum Directors

The history of art museum directors in Germany is an illustrious one, as royal collections were transformed into public ones in the nineteenth and early twentieth century under the guidance of a number of talented and committed experts. Indeed, it has often been rendered as a kind of hagiography: a succession of great men, from Wilhelm von Bode (1845–1929) and Alfred Lichtwark (1852–1914) to Hugo Tschudi (1851–1911) and Ludwig Justi (1876–1957).[1] These complimentary portrayals are not entirely unjustified: museum directors often combined public service with stellar scholarship. But this history cannot be written as a story of uninterrupted progress and triumph. Because these individuals oversaw significant portions of Germany's cultural patrimony and occupied such highly visible positions, they were subject to extreme political pressures. Scholars including Peter Paret, Christopher With, and Robin Lenman have documented the tribulations and sometimes compromised behavior of museum officials during the Wilhelmine period.[2]

The profession, of course, suffered even more intrusive political interference during the Third Reich. Those museum directors who

endured the early purges of the Third Reich were pressured to conform to National Socialist ideological dictates to an extent that not only compromised the ethical principles traditionally associated with humanistic enterprises, but made them complicit in the crimes of the regime. The Nazi administration provoked an unprecedented series of crises and so devastated this once august group that the postwar recovery and reconstruction process could not be—or at least was not—carried out without the involvement of tainted members.

Museum directors, while possessing considerable erudition and even international renown, comprised one of the most nazified professions in Germany. An inspection of directors' dossiers from the Reich Chamber for the Visual Arts files housed in the former Berlin Document Center reveals a frequency of Party membership that rivals those of physicians, one of the most highly nazified professions (Michael Kater estimates that 44.8 percent of doctors in the Third Reich "followed the Nazi Party").[3] One should note that below the level of director, museum staff remained more professional and were not as highly nazified. The Berlin State Museums, for example, had fifty-eight staff members in 1943 who were curators, conservators, or scholarly associates; of these, ten were members of the National Socialist German Workers' Party (Nationalsozialistische Deutsche Arbeiter-Partei, or NSDAP), or about one-and-a-half times the national average of 10 percent.[4] Like physicians, museum directors—as the case of Ernst Buchner demonstrates—facilitated and even occasionally initiated significant components of the National Socialist ideological program of *Gleichschaltung* ("coordination, which really meant the elimination or nazification of the social and political institutions"), racially based persecution, and military conquest.[5] Of course, there are limitations to this comparison: doctors were involved in the killing operations far more directly. But the purging of Jews from museum staffs, the expropriation of Jews' artistic property, and the rapacious forays into neighboring lands must be seen as related to the genocidal program.

Similarly, a number of museum experts espoused a mixture of hateful anti-Semitism and Teutonic arrogance that characterized many perpetrators of the Holocaust. Certain subfields in particular attracted Nazi ideologues. Archeology (*Früh- und Vorgeschichte*, literally, early and prehistory), for example, became so nazified that one postwar administrator lamented in a letter to Bavarian Prime Minister Franz Meyers that a "Professor Wagner is the only pre-historian in Bavaria left over from the war."[6] Besides Wagner, the Bavarian administrator thought, archeol-

ogists were either so politically tainted so as to preclude rehabilitation or they were dead. Others in the museum field, such as Ernst Buchner, the director of the Bavarian State Painting Collections (Bayerischen Staatsgemäldesammlungen, or BSGS) from 1933 to 1945 and then from 1953 to 1957, did not adhere to a zealously Nazi outlook. However, his complicity in the oppressive policies of the regime is a central theme in this chapter.

Another concern is the postwar rehabilitation of many museum officials who committed criminal acts in the service of the regime. As with many fields, two explanations can be offered. The first was a perception of necessity: millions of artworks had been displaced during the war and the physical state of German museums was disastrous. Even with the assistance of Allies' Monuments, Fine Arts, and Archives (MFA and A) officers, trained professionals were at a premium, and many compromised German museum directors began to resurrect their reputations by cooperating with the Allies in their postwar reconstruction efforts. The second reason was a general antipathy on the part of Germans for postwar justice. Norbert Frei has documented in his recent study on the Germans' engagement with their own Nazi past:

> In autumn 1949, immediately after the opening of the Bundestag, all parties began efforts to end, even in part to reverse, the political cleansing [of Nazis] that had been implemented by the Allies since 1945. . . . Above all, this entailed lifting sentences and [pursuing] integration measures to the benefit of an army of millions of former Party members, who almost without exception regained their previous social, occupational, and civil—if not political—status that they had lost in the course of denazification, internment, or similar "political" penalties. By the middle of the 1950s, almost no one continued to fear that their Nazi past would be exposed by state or legal authorities.[7]

In other words, unless fired and prosecuted by Allied authorities prior to 1949, those responsible for criminal acts normally went free and resumed their lives.[8] And during the occupation the Allies were, with reason, almost exclusively concerned with murderers. The failure of postwar justice and denazification is not a new story, but what has not been recognized is that so highly regarded a profession as museum administration featured such criminal behavior and that there was such tremendous continuity between the Third Reich and the Federal Republic.

It should be underscored that not all museum directors in the post-war period had been complicit in the crimes of the National Socialist regime. But this is because many either emigrated or pursued a course of "inner emigration" after 1933. Many chose one of these options out of necessity: the 7 April 1933 Law for the Restoration of the Professional Civil Service, which provided for the firing of individuals who were Jewish or politically "unreliable," was invoked to dismiss museum directors, as well as numerous professors at art academies.[9] Across the Reich, twenty-seven museum directors and numerous art academy professors were removed from their offices.[10] The former included Gustav Hartlaub in Mannheim, Ludwig Justi in Berlin, Gustav Pauli and Max Sauerlandt in Hamburg (the directors of the Kunsthalle and Art and Crafts Museum, respectively), Carl Georg Heise in Lübeck, Karl With in Cologne, Karl Ernst Osthaus in Hagen, Julius Baum in Ulm, Alois Schardt in Berlin, and Emil Waldmann in Bremen.[11] Others attempted to work with the new regime and endured a little longer: Georg Swarzenski continued on in Frankfurt through 1934 and Eberhard Hanfstaengl remained at the Berlin Nationalgalerie until 1937. For those museum directors who were not National Socialists and who tried to resist from within, the challenges were often overwhelming. Between intrusive politicians and aggressive local organizations, such as the Combat League for German Culture (Kampfbund für deutsche Kultur), the pressures could be, and often were, tremendous.[12]

But the fact remains that the museum officials always had the option of resigning (and the choice of remaining in Germany or leaving). It is true that emigration, even before 1939, was not easy: museum professionals were tied to language and national culture more so than artists or musicians, and they often specialized in German art, which had less appeal abroad than in their native country.[13] But these educated men had options and were not forced down the path of criminality. Eberhard Hanfstaengl, for example, even at the late date of 1937, when forced out as director of the Nationalgalerie in Berlin, went to work as an editor for the Bruckmann publishing house in Munich.[14]

Ernst Buchner was raised in Munich, arguably the artistic center of Germany after 1871. As Peter Gay wrote of Walter Gropius, "he had *Kultur* in his bones."[15] Born on 20 March 1892 as the son of an academic painter, Georg Buchner (a representative of the conservative though

flourishing "old Munich school" and then a member of the more progressive Munich Secession), the future director of the Bavarian State Painting Collections was constantly surrounded by artists and members of the related professions.[16] His father was quite successful, with paintings in the Munich Glaspalast, the municipal museum devoted to contemporary art. His mother was the sister of sculptor Josef Flossmann, who was sufficiently famous to have a street named after him in the Munich suburb of Pasing where Buchner grew up.[17] Buchner was raised in an environment populated by artistically inclined individuals, and this also seemingly affected his brother Georg, who became a successful architect and professor at the Munich Arts and Crafts School.[18]

Buchner was raised with a high regard for artistic accomplishment. From the time of his youth he was brought up with an awareness of the prestige and power possessed by museum directors, and he admitted in later accounts that he had long dreamed of holding the preeminent post in his native Bavaria. It was extremely common for members of the artistic professions to come from backgrounds where they had been exposed to the arts early in their lives. While one commonly finds that writers with bourgeois roots, like the Mann brothers or Franz Kafka, rebelled against parents who worked in the commercial or mercantile sphere, those who entered into the arts administration typically stemmed from backgrounds where their parents were already familiar with this world.[19]

Buchner was educated to revere high culture and to believe in German superiority in this regard. Such ideas were not uncommon, especially in Bavaria, where conservative forces were among the strongest in the nation. These views were perhaps best reflected by the transplanted Munich citizen Thomas Mann in his wartime reflections on the relationship between culture and nationality, including "Thoughts in the War" (1914) and *Reflections of an Unpolitical Man* (1918): German *Kultur*, with its depth, profundity, and engagement with spiritual matters, towered over rational French *Zivilisation*, let alone the English with their empiricist obsessions. Ernst Buchner shared such views with Mann prior to the latter's evolution into a liberal democrat and critic of fascism during the Weimar Republic.[20] As OSS officer Theodore Rousseau noted after an extensive interrogation of his prisoner at Altaussee, Austria, in 1945: "Any conversation with [Buchner] on his own subject, German painting, reveals at once his fixed belief in a Greater Germany—whether the Führer be Frederick the Great, William II, or Hitler."[21]

Such nationalistic sentiments were inculcated at an early age in a traditional education of a *Volksschule* (1902–9), followed by three years at the Theresien Gymnasium (1909–12). Buchner went on to the Ludwig Maximilian University in Munich, but abandoned his studies when war erupted in 1914. He volunteered for the Seventh Bavarian Field Artillery and spent four years at the front. He demonstrated remarkable courage in the field, meriting the Iron Crosses (both first and second class), the Bavarian Military Service Award with Honors, and the War Service Cross.[22] By the end of the war, he had been promoted to first lieutenant and commanded a battery. These experiences during his youth were formative and arguably explain later behavior. Historian Neil Gregor, discussing managers at Daimler Benz, has commented on this link between conservatism in Wilhelmine Germany and National Socialism: "Although many were by no means Nazis, they shared the nationalist attitudes of their class and generation and had been socialized in an authoritarian political culture which facilitated their compliance."[23] Buchner himself was to claim after the war, "I felt and acted nationalistically and as a patriot, not as a National Socialist or Party member."[24]

When Buchner returned from the front in 1919, he resumed his studies in art history at the university in Munich, with an interlude in Berlin, and developed his professional persona. He became a student of the famed art historian Heinrich Wölfflin (1864–1945), who wrote, among other landmark works, *The Principles of Art History*, which offered a systematic approach to the analysis of paintings.[25] Buchner was not as theoretical as his mentor, but exhibited an aptitude for connoisseurship and developed a remarkable knowledge of Bavarian painting. Buchner was also perhaps influenced by the political views of his *Doktorvater*: Wölfflin was a conservative nationalist who later joined the pro-Nazi Combat League for German Culture in 1929 and evinced sympathy for Hitler's cultural program.[26] But Buchner's relationship with Wölfflin predated the Nazis' rise to power and the two focused more on scholarship, even if there was talk of artistic "instincts" found in the "blood" of certain people, and other ideas not incompatible with National Socialism.[27] Buchner was very hardworking and needed only three years to complete his dissertation, titled "Jan Polack: The City Painter of Munich."[28] Focusing on a local figure proved a shrewd decision not just because of the availability of sources, but because he widened his circle of contacts and developed an area of expertise that would have direct application in finding a job. Buchner's scholarly

method here, where he examined virtually all of Polack's works and subjected them to careful formalist analysis, laid the foundation for his later reputation as the preeminent authority on early Bavarian painting.

As was often the case in the fine arts administration in Germany, those seeking to make their career relied upon the patronage of senior members of the profession. Accordingly, Buchner remained close to home at the start of his career, as he utilized the connections that his father and he had made over the years. His links to Wölfflin, who possessed considerable influence, were also helpful: Buchner's longtime assistant in both Cologne and Munich, Dr. Ernst Holzinger (1901–?), as well as Dr. Karl Feuchtmayr (1893–1961), who left the BSGS to succeed Buchner at the Wallraf-Richartz Museum in Cologne in 1933, all shared the same supervisor.[29] A more important and lasting supporter, however, was the Generaldirektor of the BSGS, Dr. Friedrich Dörnhöffer (1865–1934). Dörnhöffer thought highly of Buchner, as his recommendation of Buchner for a curatorial position in 1926 attests: "Dr. Buchner is a museum man of the very first rank. . . . He combines to a very rare degree all the qualities of intellect and character that constitute a museum expert: an unusually receptive artistic talent, a passionate devotion to the researching and investigation of individual artworks, a strong sense for quality, an astonishing memory, a love for organizational work, [and] practicality."[30] Dörnhöffer's concern for his protégé later extended to encouraging Buchner in 1933 to become a Nazi Party member, thinking that this step would aid his career.[31]

With Dörnhöffer's help, Buchner rose through the ranks of the Bavarian State Painting Collections, beginning with an unpaid internship in 1921. From 1922 to 1928, Buchner occupied junior staff positions at various Munich museums. He began as a technical assistant in the graphic arts collection and then moved over to the Residenzmuseum. By 1923 he had become an assistant curator, and by 1926, with the help of the recommendation quoted above, he was promoted to the position of curator at the BSGS.[32] Another major break came in 1928 when, at the age of thirty-six, he was offered the directorship of the Wallraf-Richartz Museum in Cologne by Lord Mayor Konrad Adenauer. The museum, arguably the finest in Rhineland-Westphalia, was a perfect stepping-stone for an ambitious young museum official with eyes set upon the first-tier positions in Berlin, Munich, and Dresden. Buchner spent four years in Cologne, staging well-received exhibitions, including the 1928 retrospective of Wilhelm Leibl, and developing a reputation as a scholar. In addition to his position as director, he edited

the *Wallraf-Richartz Jahrbuch*, which, although founded only in 1924, was rapidly growing into a distinguished journal.

For curators and museum directors in Germany during the first half of the century, advancement within the profession depended upon not only patronage but scholarly productivity. These two elements determined most appointments in what was a highly competitive profession, so scholarship could not be ignored. One need only look at the other top museum administrators to see that they had carved out areas of expertise: Otto Kümmel of the Berlin State Museums was a leading figure in the study of Asian art, and Hans Posse in Dresden published numerous studies on Dutch masters and Renaissance art. Ernst Buchner built on his knowledge of Bavarian art to become a respected authority on the broader field of Northern Renaissance and German Baroque painting, which featured masters such as Grünewald, the Cranachs, and Dürer. He subsequently published a number of studies, including *The German Portrait in the Late-Gothic and Early Dürer Period, Historical and Battle Pictures of the German Renaissance, Concerning the Work of Hans Holbein the Elder*, and *Martin Schongauer as Painter*.[33] Buchner was frequently consulted by other curators concerning this field. His stature as a scholar was later confirmed in 1941 when he was inducted into the Bavarian Academy of Scholarship and in 1942 when Hitler elevated him to professor at the Ludwig Maximilian University in Munich. His specialization in German art not only reflected his nationalist orientation, but was also a calculated decision that would position him well for the post he coveted most: director of the museums of his native Munich. Bavaria housed more examples of the German old masters than any other region in the country, thanks to the long tradition of Wittelsbach patronage.

Buchner realized his longtime ambition to become director of the Bavarian State Paintings Collections in July 1932. This post was regarded as the second most important in Germany, just behind the head of the Berlin network of museums. Thus, the forty-one-year-old Buchner, after a successful interview with the Bavarian Education Minister, Franz Goldenberger, and "highly confidential" discussions with Konrad Adenauer in Cologne (who let him out of his contract), succeeded his friend, the venerable Geheimrat (Privy Counsel) Dr. Friedrich Dörnhöffer, who had held the post since 1914.[34] Because of Buchner's contractual obligations, he did not begin in Munich until 1 March 1933.[35] Still, he had realized his ambition to oversee the collections of what were then fifteen institutions (the number has now more

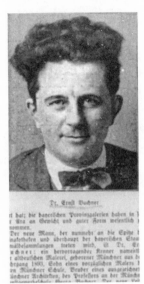

*Ernst Buchner, at age 40, upon appointment as
General Director of the Bavarian State Paint-
ing Collections, 26 February 1933 (BHSA).*

than doubled), including the Alte and Neue Pinakotheken, the Neue
Staatsgalerie, provincial museums in Aschaffenburg, Augsburg, Bam-
berg, Burghausen, Ingolstadt, Landshut, Schleisheim, Speyer, and
Würzburg, and the castles at Ansbach, Bayreuth, and Neuschwanstein
(Füssen).[36] These various museums housed some 10,500 pictures.[37]
Despite the worsening economic crisis, which cut into budgetary allo-
cations and made acquisitions increasingly difficult, it was a dream job
for an ambitious young museum administrator. Buchner oversaw a tal-
ented curatorial staff and started with the considerable salary of RM
14,000 per year (RM 2.5=$1); by comparison, his colleague Ernst
Holzinger, a curator, earned RM 4,800 in 1933.[38]

 With the National Socialist seizure of power in January 1933, Buch-
ner faced the prospect of losing his new job. The 7 April 1933 Law for
the Restoration of the Professional Civil Service sanctioned the wide-
ranging purges, especially of Jews and socialists, and many non-Party
members perceived a threat. While Buchner was not vulnerable
because of ethnicity or a left-wing past, it was abundantly clear that top
positions, such as his directorship, would be evaluated in terms of the
current political climate. Buchner joined the Nazi Party on 1 May
1933—one of approximately a million *Märzgefallenen* (March violets)

who entered the Party that spring—and he viewed the affiliation as a career move.[39] It should be stressed that Party membership was not necessary to retain one's museum position. Many of Buchner's colleagues kept their posts without joining.[40] But Buchner felt vulnerable. He had been attacked in a 28 March article in the Nazi Party paper, *Der Völkische Beobachter,* for "his relation to Jews," and letters between him and a colleague, the curator August Levy Mayer, were found when the police searched the latter's home in March 1933.[41] Buchner therefore perhaps thought that he needed protection from similar attacks in the future. After the war, Buchner reflected that many museum directors perceived challenges on the part of "opportunists hungry for jobs and unleashed by kitsch painters."[42] He was apparently not a very demonstrative Nazi: he refrained from using the *Heil Hitler* greeting, refused to wear the Party pin on his lapel, and occasionally elicited substandard evaluations from Party functionaries.[43] One evaluator even suggested that Buchner intentionally avoided interviews and contact with the Party representatives.[44] While it is difficult to gauge the degree to which Buchner initially embraced National Socialism, his behavior suggests that he qualified as what Martin Broszat, in his study of German elite of the period, called a "pre-National Socialist." That is, Buchner stood among the national conservatives who embraced many of the Nazis' objectives of revising the Treaty of Versailles and reorganizing the country, without supporting their "boundless racial and geopolitical goals."[45]

Buchner, despite having certain reservations about the Nazi Party, complied with most official policies. His three children, for example, all joined either the Hitler Youth or the Association for Young Girls (Bund deutscher Mädel) before membership became compulsory.[46] In the professional sphere, Buchner carried out his administrative functions in line with the new regulations specified by the Nazi regime. In one recommendation supporting a subordinate's promotion, he wrote to the Bavarian Education Ministry, "Dr. Busch is of Aryan extraction and his orientation is national."[47] Granted, Buchner had limited autonomy and his decisions concerning personnel were vetted by the Bavarian Education Ministry. But Buchner, like most Germans, did not buck the system. When one of his employees, the restorer Franz Xaver Durneder, was turned down for promotion because he was not a member of the Party, Buchner communicated the decision to Durneder, and there is no evidence of any argument or appeal.[48]

Buchner was fortunate that he did not have to contend with the purges that arose from the Law for a Restoration of the Professional

Civil Service. There was only one individual in the employ of the BSGS to whom the law appeared to have some application—the Jewish curator, Professor August Levy Mayer, who specialized in Spanish Old Masters—and he was evidently already on his way out because he had been caught dealing art on the side (behavior which to this day constitutes grounds for dismissal among museum staff).[49] Levy Mayer and Buchner had a cordial relationship, but Buchner never came to the defense of Professor Levy Mayer. Then again, the curator's situation was hopeless both because of the art dealing and his Jewishness. It is therefore not surprising that Buchner chose not to intervene here. What is more remarkable is that the BSGS in 1933 had no other Jewish or left-wing employees, a fact that speaks to the conservative orientation of the institution.

Buchner generally played according to the rules as they were presented to him by the Nazi regime, and this meant that he at times became a cog in the propaganda machinery. In mid-October 1933, for example, as Hitler laid the foundation stone for the House of German Art, Buchner oversaw the work of artists and artisans as they turned the city into "a sea of banners, floral decorations, pine branches, [and] red cloth. . . white-blue Bavarian flags were expressly prohibited."[50] And prior to the opening of the House of German Art in 1937, he succumbed to political pressure and provided space in the Neue Pinakothek for the work of living, officially approved artists. Buchner evidently did not welcome these annual shows. As he noted in 1945, "the temple of art became the annual art fair. . . the great masterpieces of Schwind, Feuerbach, Böcklin, among others, were stuck in a corner each year in order to make room for modern works that were mostly mediocre."[51] But neither did he do much to protest these shows either, as he waited patiently until the House of German Art was completed in 1937 when he could "reclaim" the exhibition space.[52]

The files of the Bavarian State Painting Collections also record the loans made by Buchner and his colleagues to other institutions and groups that staged exhibitions. The BSGS, for example, lent art in support of the 1935 show *Blood and Soil*, organized by the local chapter of the National Socialist Cultural Community (NS-Kulturgemeinde, or NS-KG), and for *Volk and Family*, which was arranged by the Schutzstaffel (SS) Race and Settlement Main Office, which appeared in the Hamburg Kunsthalle.[53] In general, Buchner did not appear overly enthusiastic about crudely political shows (he turned down Robert Scholz, the subject of chapter 3, who requested works for *Sea Travel and Art*).[54] But throughout the 1930s, he proved compliant with

respect to requests made by those who embraced the Nazi line. There were even instances with regard to exhibitions when he himself appeared rather "brown." In 1935, for example, Buchner voiced "the strongest objections" to the idea of sending German Romantic art on a tour of the United States, noting that, "America is one of the lands that shelters many enemies of Germany, who persecute with hate all that is German."[55] In sum, despite his occasional discomfort with Nazi policies and practices, it is not surprising that a 1940 evaluation of Buchner by Party functionaries "raised no political objections."[56]

Buchner took great pride in his professional reputation, and there were instances when official policies conflicted with his duties as a custodian of these collections. He claimed after the war that he could not bring himself to purchase "Nazi art" that was exhibited in the official shows, and indeed, he resisted pressure to add such works to the BSGS collection.[57] Buchner also maintained that he was censored by the Bavarian Education Ministry for criticizing officially sponsored art shown at the Munich Kunstverein (he used the word "banal").[58] Additionally, he continued to promote premodern German art, even when this provoked controversy. The best example of this was the 1938 exhibition, *Albrecht Altdorfer and His Circle*, which commemorated the 400th anniversary of the death of the artist.[59] Because of the religious nature of the art, Hitler, Minister President Siebert, and Gauleiter (Party District Leader) Adolf Wagner all refused to visit the exhibition, and Buchner was accused of turning the gallery into a "Catholic platform."[60] Although he had been promised a subvention of RM 45,000 for the exhibition, Buchner received only RM 15,000. Yet because of positive public and critical reception, revenues came to RM 96,000 (against costs of RM 92,000).[61] The difficulties associated with staging exhibitions in Nazi Germany eventually became moot for Buchner: with the advent of war in 1939, the Alte and Neue Pinakotheken closed their doors to the public and the artworks were sent to the provinces for safekeeping. Although restoration work continued in the museums' workshops through 1944, there were no wartime exhibitions to organize.[62]

Yet prior to this point, Buchner became embroiled in a more vivid and important conflict concerning the purging of the so-called "degenerate" works from the state collections. This program began in the summer of 1937, but had roots earlier in the decade. In 1935, Buchner had resisted the efforts of Bernhard Rust and other officials in Berlin to sell works by Manet, Van Gogh, and others that had been acquired largely by legendary museum director Hugo von Tschudi before World War I.[63]

Later, in July 1937, Adolf Ziegler, the president of the Reich Chamber for the Visual Arts, led a commission that toured museums and selected works to be removed. Ziegler wielded orders from Propaganda Minister Joseph Goebbels, and later from Hitler, and himself occupied an important post where he had the ability to issue fines of up to RM 100,000 to members of the Reich Chamber of Culture who failed to obey regulations.[64]

Buchner did not recognize the right of the Ziegler commission to seize artworks from public galleries. He considered such actions to be an unlawful incursion into an independent (or quasi-independent) sphere, and accordingly, he defended most of the works in his care with great tenacity. Buchner, like Eberhard Hanfstaengl at the Nationalgalerie, refused to meet Ziegler and the commission; he was absent when they appeared at the Neue Staatsgalerie on 9 July 1937 to undertake their "cleansing" action and then even stood up to Hitler directly in a face-to-face meeting that took place shortly thereafter.[65] Hitler made certain concessions in this meeting, promising that all affected museums would be compensated for their losses after the seized works had been sold abroad. OSS officer Theodore Rousseau noted that Buchner "was one of the very few German museum directors who succeeded in holding on to their collections of 'degenerate' art."[66] While this is not completely true—108 works from the BSGS were taken, including paintings by Franz Marc and Emil Nolde—Buchner did resist this sort of encroachment and also ultimately obtained at least RM 100,000 and certain traditional works as compensation for the Bavarian State Painting Collections.[67]

Buchner's record with respect to modernist art is a mixed one— arguably the best that could be expected of a museum official who endured until the end of the Third Reich. There were certainly cases where his sentiments were laudable: he fought to keep works by the German-Jewish Impressionist Max Liebermann in the galleries; he defended the art of Edvard Munch, citing Goebbels's letter of praise on the artist's seventieth birthday in 1933; he defended a number of younger Bavarian artists whose work was proscribed; and he vehemently opposed proposals to destroy the purged art, though he was unable to prevent works from being burned in the furnaces of the Berlin Nationalgalerie in 1936 or at Berlin's Main Fire Station in 1939 (only the latter contained works from the Bavarian collections).[68] But Buchner's record with regard to modern art is not entirely unambiguous. Buchner, for example, wrote to Emil Nolde in 1935 declining the

artist's request for a show, and he noted two years later in an August 1937 letter to Professor Lösche that he had never bought or even wanted to buy art created by Emil Nolde (and signed this letter "*Heil Hitler!*").[69] Ernst Buchner, like a number of Nazis with "moderate" aesthetic views, admired much modern art, including the French Impressionists and Van Gogh but also extending to the more abstract work of Franz Marc.[70] Yet he evinced little sympathy for many other Expressionists (especially those often viewed as more "primitive") or for the exponents of the New Objectivity (who, like George Grosz, were often politically engaged in support of the left).

While Buchner demonstrated certain scruples with respect to the "degenerate" art to be confiscated from the collections under his purview, the same cannot be said about his behavior regarding Jewish-owned artworks that were seized by the Gestapo in the wake of *Kristallnacht* (Night of Broken Glass) in November 1938. Just as 1938 marked a turning point in the broader history of the regime—in terms of not only cultural matters, but also foreign policy and the persecution of the Jews—it was also a critical juncture in Buchner's own personal evolution. By this time, he was on frequently familiar terms with the top Nazi leaders. His meeting with Hitler about the "degenerate art" was the first of many, as the Führer frequently consulted with Buchner on artistic matters while amassing a collection for a great museum he planned at Linz. Yet it is difficult to explain Buchner's behavior, which, as will be seen, became gradually more immoral with greater proximity to those with power. His motivation for collaborating with the Nazi leaders reflected a combination of rationalization and indoctrination, a very complex process that entailed an inner struggle.

Ernst Buchner undoubtedly believed that he was safeguarding the artworks that came under his care. He later portrayed himself as a protector of art with respect to both confiscated works and those endangered by aerial bombardment. There was certainly an element of the classic rationalization: "If I don't take these paintings, somebody else is going to do it; and it is better that they are in the hands of an expert who will care for them." He was also faced with the dilemma, what else could be done that would be more credible? Buchner was hardly in a position to countermand the orders of Hitler, Himmler, and the other Nazi leaders. And other German museums were also adding to their collections by way of works seized from Jews. In many respects, his ethical principles were compromised once he had decided to work with the Nazis. Yet he saw himself as a moderate in the arts administration—

someone who mitigated the destructiveness of the regime's policies.

Buchner, however, did not act solely due to these considerations or rationalizations; he also internalized many of the beliefs that formed the basis of Nazi policies. From an early point in the Third Reich, he exhibited a willingness to administer confiscated art. In December 1933 he wrote the Bavarian Education Ministry, expressing the desire to acquire a bronze sculpture that belonged to, in his words, the "known pacifist and women's rights activist Anita Augspurg," who was now in exile (with the collection in custody of the Bavarian Political Police).[71] Buchner also gradually evinced less sympathy for Jews. After the difficulties he experienced as a result of his relationship with Professor Levy Mayer, he exhibited a reluctance to assist old friends or acquaintances who came under attack. By the late 1930s, he had become involved with the artworks taken from local Jews by the Gestapo—first as a response to emigration, then as part of the more extensive Aryanization measures. "Aryanization" was the Nazi term for the transfer of Jewish property to gentiles as a means of ridding the economy of Jewish influence, and the regime developed the idea as an organized program: in 1938, Jews were required to report all wealth and register businesses; they were prohibited from functioning as business managers, then finally pressured to cede their assets or sell them for a fraction of the true value.[72] Individuals lost their collections in this manner, and many Jewish galleries, like the renowned Bernheimer firm in Munich, were taken over by Aryan trustees. As the confiscated works mounted up, Buchner cooperated with the Gestapo by making rooms available in the Bavarian National Museum.

Yet Buchner did far more than store the works. Utilizing his contacts within the Gestapo, he began to purchase the prized pieces for his own collections. Although Führermuseum director Hans Posse had first choice of the confiscated works, Buchner was next in line when it came to the Munich loot.[73] In one instance, he inspected seized artworks in the galleries of the Kameradschaft Münchener Künstler (the new name for the Aryanized Bernheimer firm), and bought three works for RM 37,500, including Spitzweg's *That is Thy World*, a work that came from the Bernheimers' stock.[74] Later, during the war, Buchner visited another exhibition of confiscated Jewish art at the Baer Gallery in the Kaulbach Strasse.[75] Between 1939 and 1944, Buchner bought at least twenty-eight works that had been taken from Jews, including paintings by Delacroix and Trübner.[76] He made payments to the Gestapo via the Bank der Deutschen Arbeit and spent at a minimum RM 253,610.[77]

*Painting by Alois Erdtelt confiscated from
Jewish resident of Munich, Hugo Marx, and
purchased by Buchner for the Bavarian State
Painting Collections, June 1940 (BHSA).*

These works were kept separate from the other objects in the collection
and were never exhibited publicly. Because this sort of transaction was
unprecedented, it was not even entirely clear if the sales were legal.[78] In
spring 1943, Gauleiter Paul Giesler suggested that the money paid by
the BSGS for the confiscated Jewish art be returned by the Gestapo to
the State Painting Collections and that the works be considered "Reich
property" that was on loan.[79] It is evident that this did not occur. Buch-
ner up through April 1944 was still adding to collections under his con-
trol by purchasing "artworks out of non-Aryan property."[80] And the fact
remains that when Buchner signed off on such purchases, he had few
illusions about the enterprise. He cleared all transactions with Gauleiter
Adolf Wagner and even sent reports about which second-rank works
were suitable for leaders' offices.[81]

Beyond his dealings with the Gestapo and the local Gauleiter, Buch-
ner took the initiative and tried to induce Jews to sell their artworks to
him at bargain prices, lest they be seized. Buchner later argued that this
was humane in that it kept the police away from the owners. He also
maintained that he was under pressure to report Jewish collections to
the authorities, and that in the case of the Jewish doctor and art histo-
rian Dr. August Goldschmidt, who entrusted his art to Friedrich Dörn-

höffer, Buchner kept silent, which "easily could have cost me my position."[82] But Dörnhöffer was Buchner's mentor, and his silence in this case was arguably more out of loyalty to this important supporter—who would have come under attack for shielding a Jew—rather than a concern for Goldschmidt. Other episodes also cast doubt on Buchner's concern for Jewish victims. He reportedly visited one Jewish couple, Hugo and Else Marx, who lived on the Franz-Josef Strasse, and expressed an interest in the art they owned. Else Marx, who along with her son filed a claim for lost works after the war, told how, "one day at the end of 1938 or the beginning of 1939 the director of the Bavarian State Gallery appeared at the residence of a member of the Jewish faith Hugo Marx. . . . He forced the persecuted one under the threat of considerable disadvantages to sell against his will the following three pictures to the State Gallery (by Gustave Courbet, Alois Erdtelt, Eduard Schleich)."[83] Buchner purchased the artworks on behalf of the state collection for RM 5,000, RM 1,200, and RM 1,200 respectively—well below market-value (the Courbet, for example, was worth approximately RM 15,000).[84] Buchner derived a particular advantage by buying directly from the owner because Hitler and the other top political leaders had first choice of the works taken by the Gestapo. By approaching the actual owners, Buchner circumvented this pecking order.

While Buchner may have maintained that he was saving works by keeping them in a public collection, the truth was not nearly as straightforward: his sales sometimes appeared as forced because he raised the specter of the Gestapo's involvement; he did not pay market prices for the works; and he never did anything for the sellers aside from relieve them of their property; that is, there is no evidence that he attempted to help them emigrate or even retain the remainder of their property. In short, Buchner played an important role in the seizure of Jewish collections and the Aryanization of Jewish art dealerships in Munich. In terms of the latter, which included the Kunsthandlung Helbing on the Wagmüllerstrasse, the Kameradschaft Münchner Künstler, the Heinemann Galerie, and the Fleischmann Galerie, he had good relations with their new non-Jewish "trustees."[85]

As a result of such acquisition tactics, the collections under Buchner's purview grew at an unprecedented rate between 1938 to 1944. The BSGS collections swelled from about 10,500 to 12,000 paintings during his tenure.[86] Of course, he was not alone among museum directors in taking advantage of the dislocated Jewish property, the prolific booty flowing from the conquered lands, and the favorable rates of

exchange in the occupied lands. The Folkwang Museum in Essen, for example, spent 6.9 million francs in Paris alone and museum officials in the Rhineland also expanded their collections via purchases in France.[87] While Buchner evidently did not embark on purchasing trips abroad like many other directors, he knew most of the major dealers who worked in the occupied Western territories and bought works acquired there from them. This included purchases from many figures featured in chapter 2: Göring's agent Walter Andreas Hofer in Berlin; Linz dealers Karl Haberstock of Berlin, the Brüschwiller brothers in Munich, Maria Almas Dietrich in Munich, Hildebrand Gurlitt in Hamburg, and Eduard Plietzsch of the Dienststelle Mühlmann (the looting organization in the Netherlands); as well as Theodor Fischer, a Swiss dealer who auctioned off the "degenerate" art and traded for art plundered by Nazis from French Jews.[88] Buchner himself rarely traveled to the occupied West, but let these dealers represent him. In the case of Haberstock, the two would sometimes resort to communication via shortwave radio (the *Reichssender*) as Buchner made decisions on purchases in Paris.[89] While this was a rather unusual procedure for German museum directors, Buchner was clearly an important customer for German dealers. Quite typically, he worked more with compatriots who would travel to the occupied lands rather than with foreign agents. These German dealers sometimes acknowledged their lucrative business relationship by making "gifts" to the BSGS, such as Haberstock's presentation of Max Klinger's painting *On the Beach* in 1943 (which still occupies a prominent place in the Neue Pinakothek), and his gift of a rare volume to the museum's library.[90]

The problematic nature of much of this commerce should be stressed. In one document, Buchner discussed utilizing the revenue from the sale of "degenerate" art and noted that the BSGS had bought a Madonna with angel by the Master of the Aachener Altar from Baron von Pöllnitz (who worked with Haberstock in France) for RM 100,000, and two paintings by Ferdinand Waldmüller for RM 30,000, the latter two having been confiscated from the Viennese Bloch-Bauer collection and sold by the Aryanization trustees, the Deutsche Allgemeine Treuhand-AG.[91] Furthermore, because foreign currency was in short supply, Buchner was in regular contact with Nazi leaders in Berlin: he was ordered in December 1938 to get Reich Minister Rust's approval for all acquisitions requiring foreign funds.[92]

Buchner was able to purchase in quantity from these dealers because he was successful in obtaining funds from both the Reich and provincial

administrations. This was never an easy task, and he made repeated pleas so as to keep up with the institutions of other major cities. As he noted in one appeal to the Bavarian State Education Ministry (Bayerische Staatsministerium für Unterricht und Kultus, or BSUK) for more funds, "the extraordinarily modest allocation for purchases of RM 48,000 cannot [permit the BSGS] to enter seriously into competition with the museums from Cologne, Frankfurt a. M., Bonn, Essen, etc. As the responsible head of the famous galleries of 'the city of art,' it is difficult for me to have to see how the collections of the mentioned cities at this time have a budget for new acquisitions at their disposal that is more than ten times ours."[93] He met partial success with his requests early on in the war. In 1942, for example, the Bavarian Education Ministry allocated him RM 250,000 for new acquisitions.[94] The following year he requested RM 500,000 aside from the normal budget (*ausserplanmässig*), and he compared this sum to grants given to the Frankfurt Municipal Museums (RM 2.5 million to obtain a private arts and crafts collection), to the Wallraf-Richartz Museum (RM 3.5 million for the Carstanjensche painting collection which included works by Rembrandt, Hals, and others), to Vienna and Berlin (RM 1 million each), and to the Germanisches Nationalmuseum in Nuremberg (RM 500,000 for new acquisitions).[95] Reich Finance Minister Schwerin von Krosigk ultimately granted the BSGS RM 350,000 in 1943 and raised this sum to RM 450,000 in 1944.[96] But Buchner was never entirely satisfied with the financial support provided to his institutions, especially in light of the fact that Munich had been declared one of the five "Hitler cities," specifically, "the city of German art."[97]

As a result of budgetary allocations that he considered inadequate, and because foreign currency proved difficult to procure, Buchner entered into a number of trades during the war; these had a discernible impact on the nature of the collections under his supervision.[98] After the war, Bavarian authorities and the experts they engaged were very critical of these exchanges, viewing them as financially ill-advised and ideologically biased.[99] Indeed, Buchner was required to offer justifications for his deals on several occasions after 1945. It is more generous to say that Buchner's love for premodern German art got the best of him, as he made disadvantageous trades for such works. In this respect, he shared with Hitler the notion that German art of past epochs was underappreciated and undervalued and that greater recognition would come with time.[100] Therefore, Buchner gave up at least 112 pictures in exchanges; most notably a portrait of Bindo Altoviti by Raphael (now

in the National Gallery of Art in Washington, D.C.) that King Ludwig of Bavaria had acquired at great cost (20,000 ducats in Florence), which Buchner traded for a work that he thought was by Matthias Grünewald, *Portrait of a Holy Man*, although other experts disputed the attribution.[101] In this trade for a work by one of the venerated German Old Masters, Buchner also deaccessioned Gerard Dou's *Market Criers* (now in the Boymans-van Beuningen Museum in Rotterdam) and Rubens's *Maria with Child*. In another trade in 1940, where he came to terms with Karl Haberstock in Berlin, he exchanged works by Renoir (*St. Marks in Venice*), Monet (*Cliffs of St. Adresse*), Menzel (*The Contribution*), and three Dutch works for Hans Thoma's *Girl Feeding Chicken*.[102] And in one of many deals with Eduard Plietzsch, Buchner traded a landscape by Jan van Goyen and a work attributed to Adam Elsheimer in exchange for a predella by Wolf Huber and Johann Jakob Zeiler's *Study for a Church Ceiling* (neither of which are exhibited today).[103]

Many of Buchner's exchanges and sales—and only a few are noted above—were made without consulting the curator of the Wittelsbacher Provincial Foundation (Landesstiftung), and this constituted a violation of procedure.[104] A representative of the foundation complained after the war that they "had not been kept informed [of exchanges and sales] between 1933 and 1945 and that "the collection of Dutch paintings was hard hit" (at least seventy-four Dutch works were deaccessioned).[105] Buchner, then, behaved in a rather autocratic way, but he had Hitler's personal support to this. The two met in early 1941 to discuss "museum questions," and the dictator expressed complete confidence in the director. An ancillary idea that both agreed upon was that the Bavarian State Painting Collections would sell certain works to the Führermuseum in Linz and then use the revenue to purchase works that would fill holes in the two Pinakothek collections. Hitler asked Buchner for more specific suggestions, and the director offered a painting from Rubens's workshop that had been in the Aschaffenburg filial gallery (after thirty years in a depot). Hitler paid RM 200,000 and Buchner used the revenue to buy works by Van Ruisdael, Rottmann, Kalckreuth, and Zick.[106] OSS investigators found at least eighteen other works in the Linz collection that came from the BSGS and indicated that there were probably more.[107] The deaccessioning of works to the Führermuseum, like the trades, were means of creating opportunities to bolster the Bavarian collections, but they were not uncontroversial in terms of either method or result. These exchanges speak more to a poor job of directing a museum

than to any criminal behavior, but they are important because they grew out of an increasingly nazified worldview.

Buchner was instrumental in shaping the venerable collections in his care according to Nazi precepts, and the legacy of his actions is still apparent today. It should be stressed that foreign currency was at a premium and that trades were therefore a common acquisition tactic. But trades, by definition, entail cutting into the permanent collection. Buchner was sufficiently professional to realize that a great encyclopedic museum (that is, the entire collection of the BSGS), needed examples from all the important phases and schools in the history of art, and he tried to prevent any one area from being gutted completely. He turned down a request to trade French modern works for a Bellini, noting explicitly that he intended to preserve this part of the collection, and he rebuffed Karl Haberstock's approach to trade for paintings by Max Liebermann.[108] Yet, as noted above, Buchner's love of German art was too strong, and he made poor decisions. One need only see the letters in the files of the BSGS; they document the postwar efforts by Eberhard Hanfstaengl (1886–1973), Buchner's successor as director, attempting to nullify or reverse certain trades. In 1950, he was pressuring Karl Haberstock to return a Renoir and a Degas, which had been exchanged for another work by Hans Thoma (*The Bible Lesson*), and Generaldirektor Hanfstaengl's tone was one approaching desperation.[109] He was not able to undo Buchner's work, and even today, many curators in the BSGS view Buchner's trades as unmitigated disasters. Very few paintings Buchner acquired by trade, one curator noted, still hang on the walls today. Another BSGS curator, Konrad Renger, who is an expert in Flemish Old Masters noted with wit, "Berlin lost artworks due to the war; Munich lost them due to the director."[110]

The trend toward unbridled arrogance continued as the war progressed and led to an increased disregard for both museological convention and international law. For Buchner, the nadir came with the peak of the Germans' expansion in the summer of 1942 when he led an expedition into unoccupied France in search of the famed Ghent altarpiece, the Van Eyck brothers' elaborate work, *The Mystic Lamb*. This twelve-paneled depiction of Christ surrounded by prophets, martyrs, and knights was one of the first oil paintings, and ranks, in the words of art historian Colin Eisler, "among the very greatest works of art in Northern Europe from the fifteenth century."[111] The mayor of Ghent had taken the altar from St. Bavo's Cathedral and entrusted it to the French in May 1940 as he and other compatriots feared a repeat of the Schlieffen

plan, a German invasion of the West through Belgium. The French authorities evacuated the altar from Paris to Pau in the unoccupied region as part of their own safeguarding measures, which included moving most of the Louvre's contents to châteaus in the south. The altar remained in a local museum in Pau until 1942, when Buchner received orders from the Reich Chancellery in June 1942 to remove the multipaneled altar and transport it to Germany.

During postwar interrogations, Buchner remarked that the order came by complete surprise and that he had never discussed the subject with authorities. But this claim seems rather disingenuous considering Buchner's area of expertise (he knew this work exceedingly well, including its provenance) and the fact that this piece had great political significance: four panels had been repatriated to the Belgians in the Treaty of Versailles as compensation for the destruction of cultural treasures by the Germans in World War I (two from the Kaiser-Friedrich Museum in Berlin and two from the Alte Pinakothek in Munich), and the altar had emerged as a focal point of the revanchist art policy of the Nazis.[112] Buchner also maintained that the order he received from the Reich Chancellery "specifically stated that the altarpiece was not being confiscated by the German Reich, but was being put out of danger from air attacks so that it could eventually be restored to its legal owners."[113] While Buchner's experience at the front in World War I had exposed him to the ravages of war, and he perhaps genuinely feared the destruction of art that he loved, there were actually no military operations or air raids in this region at the time. Buchner later confessed to OSS interrogators "in an unguarded moment" that the altar was destined for the Kaiser Friedrich Museum in Berlin (now the Bode Museum).[114] It is also significant that the panels were first stored with more than 21,000 artworks plundered from French Jews by the Einsatzstab Reichsleiter Rosenberg (ERR), at Schloss Neuschwanstein, which was part of Buchner's bailiwick.[115] In the summer of 1944, he helped transfer the altar to the salt mine at Altaussee, where Hitler safeguarded the works destined for the Führermuseum, among other treasures.[116] Throughout the entire undertaking, Buchner was sworn to strict secrecy, which is arguably also an indication that it was not an entirely legal maneuver.[117]

Buchner's sojourn to Pau remains a remarkable, if still murky, episode in his career. On the exculpatory side, one finds that Buchner's museum would not have been the beneficiary of the "transfer" and that the enterprise was apparently sanctioned by the French authorities. Vichy Prime Minister Pierre Laval approved an order on 3 August 1942 assenting to the removal, and the Vichy militia escorted Buchner and his associates

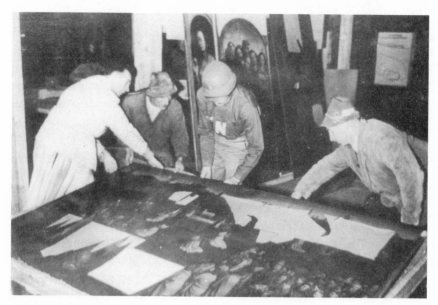

A panel of the Van Eyck altar with protective coverings over fragile areas—measures taken by Buchner and his staff, 1945 (NA).

to the demarcation line as the altar made its way back to Germany via Bordeaux, Tours, Dijon, and Belfort.[118] Buchner was accompanied by the chief restorer of the Bavarian Museums, Professor Reinhard Lischka, and they used the professional transport firm that they normally engaged, the Spedition Wetsch (Wetsch had also carted off the purged modern art from the BSGS in 1937).[119] Additionally, Buchner's actions might be justified on the grounds that Himmler and the SS were hatching plans to seize the altar. An art historian and expert on the Van Eycks by the name of Dr. Martin Konrad had been charged with securing the treasure in June 1941, and the SS very well may have succeeded if not for the efforts of the head of the Wehrmacht's Art Protection (Kunstschutz) office, Franz Graf von Wolff-Metternich (1893–1978), who managed the astonishing feat of preventing Himmler's agents from crossing over the demarcation line into the unoccupied zone. The leaders of the Security Service (SD) in France were confident they could pull off a secret raid with Dr. Konrad but decided that this was inappropriate considering the renown of the altar.[120] The role of the SS in the removal of the altar remains uncertain. According to some postwar reports, Buchner was escorted by an SS commando,

but this seems not to have been the case, and the files in the Bavarian State Painting Collections contain letters where he thanks a Wehrmacht captain named Wilhelm Abert and his cohorts in a motor pool for their assistance.[121] What was less ambiguous was that the Germans were claiming ownership of the masterpiece. Additionally, it was obvious that Laval had no authority to sign over Belgian property entrusted to the French for purposes of safekeeping.

In the end, one must recognize that the Reich was planning to seize the altar as its own, and Buchner knew it. As he wrote his counterpart in the capital, Otto Kümmel of the Berlin State Museums, who was not only director of the Berlin State Museums but also special commissar for Securing Foreign Museums and German Cultural Objects: "with you I enthusiastically greet the fact that finally the screaming injustice of the Versailles Treaty, in which top works of European art that were paid for with good German royal currency (*Königtalern*) were robbed from us, and that they will again be restituted."[122] While Buchner may have been acting out of principle and because of orders from above, he himself benefited from the enterprise: after the altar was removed to Germany Hitler awarded Buchner a special honorarium of RM 30,000 (officially justified as compensation for evaluating potential purchases).[123]

The seizure of the Ghent Altar was followed by a similar incident approximately one month later, in late August 1942, when Buchner led an expedition to Leuven to confiscate four panels of Dirk Bouts's triptych *The Last Supper*.[124] This work, like the Van Eyck brothers' altar, had also been awarded to the Belgians in the Treaty of Versailles as stipulated in Article 247. Two of the four panels had been in the Alte Pinakothek until 1920, and this perhaps induced Buchner to take the lead in pushing for its "repatriation."[125] On 7 July 1942, he wrote to Walter Hanssen at the Führerhaus in Munich,

> Through the dictated peace of Versailles, not only the panels of the Ghent Altar of Hubert and Jan van Eyck, but also four panels of the Leuven *Last Supper Altar* of Dirk Bouts were carried off to Belgium without justifiable legal title. The panels are among the most exquisite in old Netherlands painting. The panels are currently housed in the Church of Peter in Leuven and are in great danger from air attack. In consideration of the reparations and the screaming injustice of the Versailles Treaty, nothing stands in the way of an immediate return of the panels. Permit me the suggestion that the four panels be returned to Germany.[126]

Hitler approved Buchner's request to pursue the Bouts altar and the actual seizure took place on 28 August.[127] The trips to Pau and Leuven, although comparable in many respects (including Buchner's repetition of the phrase "screaming injustice of the Versailles Treaty"), should be viewed as separate. What distinguished Buchner's involvement in the seizure of the Bouts altar was his role as instigator. Quite possibly, his experience with the Van Eyck work emboldened Buchner to propose another such "restitution." In his own words (in another letter to Küm-mel), Buchner concluded, "I have consequently suggested that the *Last Supper Altar* of Dirk Bouts . . . also be returned."[128] With the Bouts altar, it was Buchner who approached the Reich Chancellery and initiated the seizure (he and his colleagues at the BSGS had even identified it as a target for "repatriation" as early as June 1940 in a letter to the Bavarian Education Ministry).[129] This was not a case of being ordered to carry out an unpleasant project, but of initiating one.

By the midpoint of the war Ernst Buchner had become part of the regime's plundering bureaucracy. This development, it should be stressed, was gradual: he had helped with the expropriation of Jewish property in 1938 to 1939; he had attended meetings convened by Joseph Goebbels in 1940 to discuss plans to "repatriate" artworks of "German origin"; and finally, he personally led looting commandos.[130] While his most egregious behavior occurred in 1942, the critical point of his transformation took place earlier. Buchner had evidently partici-pated in the Germans' campaign against France and the Low Countries in May 1940, although again, it is not clear in what capacity. In a 15 June 1940 letter to art historian Heinz Braune in which he sounded very determined to "repatriate" German art from the South Tyrol and Sweden, among other European lands, Buchner described how he had just returned from "leading an interesting commando in Northern France and Paris."[131] In this letter, Buchner does not elaborate on his mis-sion, and there are no other extant documents that shed light on his role in this phase of the war. Slightly later, in a letter to the Bavarian Educa-tion Ministry in October 1940, which was marked "Confidential!" (*Ver-traulich!*) and titled "Secured Artworks From Jewish Property in Paris," Buchner discussed the plundering in France. He noted that "a series of German museum officials from Berlin and Vienna. . . had been ordered to Paris" and complained of being excluded. He reasoned, "a just distri-bution of the artworks in question appears possible only when it takes place under an elevated central authority with the guidance and partic-ipation of representatives of the great German art collections."[132]

In this letter, he counted Hans Posse as an ally and claimed that both Dresden and Munich were being shut out in the division of the art. Buchner went so far as to request a specific work out of the *"Pariser Judenbesitz"* (Parisian Jewish property) that he thought especially important for "Bavarian art history": Matthias Gerung's *The Trojan War*, which had once been in Schloss Neuburg on the Danube. Buchner's pleas to the Bavarian Education Ministry led Minister Adolf Wagner to write letters to Reich Education Minister Rust and to Reich Foreign Minister Ribbentrop, where he requested that Buchner be involved in the evaluation of the confiscated Jewish art in Paris.[133] While Buchner never received the assignment in Paris that he sought, he did what he could to secure plundered art for the Bavarian museums, and this included overseeing a report documenting all the paintings that the French had removed from Munich since 1800.[134] This list, which was similar to those compiled by museum directors all over the Reich, was to serve as a basis for German claims against France when a peace treaty was negotiated.

It is also evident that during the war Buchner was increasingly involved with the dealers and experts who facilitated the expansion of the Nazi leaders' art collections. Buchner's relationship with this circle was again characterized by a certain ambivalence. On the one hand, he welcomed the contact because it enabled him to acquire prized works for his own galleries. On the other hand, these dealers and agents were often woefully unprofessional. Buchner, for example, was known to become "exasperated" with the Munich vendor Maria Almas Dietrich, who brought him "so many second-rate and fake pictures."[135] One episode, which culminated with Dietrich being "put out of his office," has become so well-known as to qualify as apocryphal.[136] The tale was originally told by Buchner himself and had two obvious purposes: to make him appear more knowledgeable about art than Dietrich and her clique (which in fact he was) and to distance himself from them (a more dubious endeavor). In fact, Buchner got on quite well with Dietrich, to the point where she donated a picture by the Scottish painter John Lewis Brown to the Bavarian State Painting Gallery in 1941 "as an expression of thanks for art historical information."[137] Concerning Hitler's photographer and artistic adviser, Heinrich Hoffmann, Buchner again exhibited ambivalence. While he thought the photographer to be an amateur and refused to write articles for Hoffmann's propagandistic but high-profile art journal, *Kunst dem Volk*, he nevertheless had numerous dealings with him.[138] Even after the war, Buchner stood by

Hoffmann in the latter's quest to effect the return of part of his art collection. From 1954 through 1956, Buchner endorsed many of the claims of the photographer and wrote letters of support to the Bavarian State Education Ministry—although the BSGS was also a beneficiary and received several dozen works from the photographer's collection, including paintings by Pieter Brueghel the Younger and Carl Spitzweg.[139] Buchner's views about the art dealers and advisers who served Hitler were more positive than he would later admit, and his interactions with them far more self-interested.

Buchner actually assumed a semiofficial position within the agency that Hitler created to amass a collection for the Führermuseum in Linz. Initially, he sold works to Hitler that were being deaccessioned by the BSGS.[140] In 1943, he became a member of a commission that made selections from among the works submitted for the museum. Serving along with two other curators and Bormann's adjutant, Helmut von Hummel, Buchner passed judgment on the works sent in by the dealers. The commission usually gathered at the Führer Building on the Arcisstrasse in Munich to review the works, although Buchner also evaluated works in his Alte Pinakothek office and submitted written reports to the Reich Chancellery.[141] Most often, he assessed the authenticity and condition of the objects and left the determination of the price to the dealers. Yet he was called upon to appraise works of dubious provenance, such as 250 works from the Schloss collection that had been acquired for the Führermuseum after a notorious liquidation action was undertaken by French Commissar for Jewish Affairs Louis Darquier de Pellepoix and the Vichy government.[142] (Buchner also consulted for Himmler and other SS leaders as they collected art.)[143]

For his services, Buchner was paid handsomely: his customary fee was RM 500 per consultation, and Hitler awarded him more on special occasions, such as the Führer honorarium that coincided with the "return" of the Ghent Altar.[144] There were other awards from Hitler, too, including the War Service Cross that Hitler signed personally and had bestowed by Munich Gauleiter Paul Giesler.[145] Buchner also contributed to the Linz Project (the Führermuseum) by alerting Martin Bormann's office about works on the market that might be suitable (for example, he passed on information about work by Franz von Stuck offered in Prague) and by serving on the commission that made recommendations about the use of the Altaussee salt mine as a storage facility. In December 1943, he joined in the inspection of the mine and declared it suitable for housing artworks.[146] At war's end, it contained

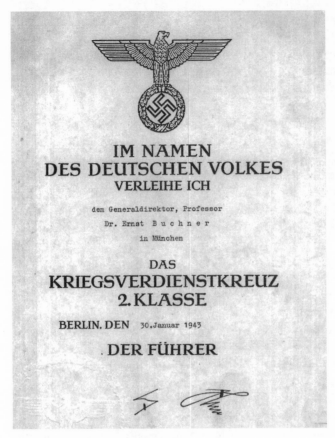

A certificate signed by Hitler awarding Ernst Buchner the Iron Cross, 30 January 1943 (NA).

6,577 paintings, 137 sculptures, and 484 cases with various other art objects, making it one of the most important repositories in the Reich.[147] Buchner's oversight of both the Neuschwanstein and Altaussee repositories made him one of the key figures in the safeguarding of the Nazis' loot.

Buchner was aware both of the provenance of the artworks and the stakes of the jurisdictional battle that emerged as a result of the competing plans for the depots. Regarding the former, he sent a top secret memo to Martin Bormann on 30 January 1941 that had the subheading "Re: The safeguarding of the artworks confiscated in Paris from Jewish collections."[148] In this communication, Buchner suggested storing the plunder in the castle at Dachau, noting that there were no military or

industrial facilities located nearby. As an alternative, he mentioned Schloss Neuschwanstein, which he thought even safer from aerial attack. The decision to utilize Neuschwanstein was made shortly thereafter, as noted in a 15 April 1941 letter from Posse to Bormann that reported Buchner's role in the matter.[149] Approximately 2,000 works from the BSGS, including most of the masterpieces, were stored with the French loot in the castle, and two members of Buchner's staff were stationed there to watch them.[150] To Buchner's credit, he took personal care of the artworks he was responsible for moving. He accompanied each of the seventeen transports that left Munich in the middle of the night, and the BSGS collection suffered virtually no losses during the war.[151] Indeed, Buchner showed both foresight and even courage in evacuating collections at an early point in time. The first transports left the city in September 1939, and though Hitler had given orders in September 1938 about safeguarding museum objects, such actions were sometimes construed as defeatist and could therefore be dangerous to one's career.[152] Buchner also managed to stay clear of the vitriolic exchanges among Reich and Party officials precipitated by competing safeguarding plans, although he was often very emotional about the bombing (for example, he repeatedly used the phrase "barbaric terror attacks" in letters to Haberstock, and his son was seriously injured in the March 1943 bombing attacks on Munich).[153] Later in the 1950s, when he had successfully reestablished his career, he emphasized and modified this aspect of his wartime activities to his advantage. When he retired from museum administration, one local Munich paper lauded him as "The Savior of the Alte Pinakothek."[154]

Buchner proved very shrewd, if somewhat self-interested, when safeguarding the artworks during the war. While he helped shelter some two hundred private collections in addition to those belonging to the state (thereby helping out friends like Haberstock), he wavered when the General Governor of Poland, Hans Frank, asked for assistance.[155] Frank, who supervised Kajetan Mühlmann and his commandos in one of the most extensive plundering campaigns of World War II, attempted to stash a number of the Polish paintings in the depot of the Bavarian State Painting Collections, but Buchner, who met with Frank's wife on 17 March 1945, refused to touch these plundered works.[156] This decision, while arguably related to the Germans' military fortunes—booty often appears alluring with victory and dangerous when defeat is imminent—also shows that he differentiated among plundered art: while he had justified the seizures of the Ghent and Bouts altars on the grounds

The Alte Pinakothek after its destruction,
1948 (BSGS).

of an unfair treaty, Frank's unvarnished thievery defied rationalization. Buchner also exhibited an aptitude for self-preservation by avoiding involvement in the conflict surrounding the plans to blow up the Altaussee salt mine repository. Gauleiter Adolf Eigruber, supported by elements within the SS, conceived a plan to prevent the works from falling into the hands of the Allies. Nearly all others involved in the storage of the Nazis' collections and loot told dramatic stories about the final days of the war.[157] Buchner was notably quiet at war's end amidst the struggles to control the repositories. In fact, Buchner kept such a low profile that it is not possible to say with certainty where he was in April and May 1945.

Ernst Buchner was arrested on 18 June 1945 by the Americans and initially held at the Police Headquarters in Munich, where he was interrogated at length by the OSS.[158] Buchner cooperated fully with the Americans, in particular with OSS officer Theodore Rousseau, who later became a curator at the Metropolitan Museum of Art. The results of these conversations yielded the second *Detailed Interrogation Report of the Art Looting Investigation Unit.* This and the related reports on individuals, along with the synthetic *Consolidated Interrogation Reports,* have become the most important sources on the art world during the Third

Reich. Buchner clearly made a good impression on the Americans. In 1957 Rousseau noted, "Among the many slimy and crooked people that I interrogated, Buchner stood out as rather honest and straightforward in his attitude. Nothing that he told us turned out to be a falsehood— an unusual case in this group."[159] It should be noted that Buchner was a charming and charismatic individual; acquaintances even recall how he loved to entertain with his guitar.[160] And because Buchner cared about most kinds of art and hoped to save his career, he made himself useful to the art administration in the new Federal Republic of Germany. Buchner volunteered as a consultant and lent his services in the recovery of works that had been stolen or had disappeared in combat.[161]

Despite his cooperation, Ernst Buchner was removed from office in May 1945.[162] As a Party member who had served the regime, he was required to undergo denazification proceedings if he wanted to resume his career as a civil servant. The way denazification policy worked, Buchner was assumed guilty prior to a hearing. But pending the outcome of the legal proceedings, he was placed in a sort of limbo and paid a nominal salary (*Wartegeld*) so that he could get by. Denazification was carried out by local boards according to the Law for the Liberation from National Socialism and Militarism of 5 March 1946 and was required for all Party members who wished to continue their careers (one could refuse to appear, but this would hamper future employment, especially as a civil servant). The denazification boards collected evidence about the subject; typically a prosecutor and a defense attorney presented statements from witnesses that were either accusatory or exculpatory. The board then rendered a verdict, placing the individual in one of five categories: (1) major offender; (2) offenders; (3) lesser offenders; (4) fellow travelers; and (5) those exonerated. While the process was initially overseen by each of the occupying powers in their respective zones, the Federal Republic assumed responsibility in September 1949. Henceforth, only those placed in category one or two faced further prosecution or impediments with regard to employment. Ultimately, 98 percent of those who went through denazification were placed in the categories "fellow travelers" or "exonerated."[163]

Ernst Buchner was tried by a board in Munich in 1948. The court found evidence that attested to ambivalent behavior: while he had been in the service of the regime (the *Führerhonorar* of RM 30,000 was noted), he also supposedly "up until the end stood in the closest confidence of clear opponents of the National Socialists."[164] Buchner was also credited for criticizing certain ideological exhibitions, such as the show

Blood and Soil in 1935, and for eliciting attacks from Nazi extremists (the 1933 article in the *Völkischer Beobachter* was noted).[165] Due to a variety of factors, including Buchner's mixed record, incomplete documentation (for example, the full extent of his involvement of the removal of the Van Eyck and Bouts altars was not known), his impressive testimony, and a reluctance to view noncapital offenses as serious crimes, the board ruled that he was a fellow traveler (*Mitläufer*). And as noted above, this permitted his rehabilitation. Indeed, Buchner immediately applied for reinstatement to his former position.[166] The Bavarian Kultusministerium weighed various opinions, including that of the rector of the Ludwig-Maximilian University in Munich, where Buchner had an honorary appointment. The rector could see no reason to end Buchner's career in the arts administration and noted that his expertise was not in question.[167]

Buchner's appeal was successful. However, because his job had already been filled by Eberhard Hanfstaengl, he received the title "Director of the BSGS Slated for Reappointment (zur Wiederverwendung)", which meant that he retained his former rank but not the actual position. Buchner requested either a corresponding position within the jurisdiction of the Bavarian Education Ministry or placement in *Wartestand* (provisional retirement with the possibility of returning). Some within the Bavarian Education Ministry suggested that Buchner either head the Dörner Institute (dedicated to restoration work), take over the Haus der Kunst in Munich, or assume the deputy director position at the Germanisches Nationalmuseum in Nuremberg.[168] There was also discussion of giving Buchner a university appointment. Ultimately, Buchner received a subvention from the state to research and write until a suitable post opened up for him.[169]

Buchner's success in salvaging his reputation—both officially and in the public sphere—found clearest expression in his reappointment as the director of the Bavarian State Painting Collections on 1 April 1953. He held this post for over four years until his retirement at age sixty-five in September 1957. This step in the rehabilitation process proved much more controversial than his earlier return to state service. Edgar Hanfstaengl, a Christian Social Union (CSU) member active in the formation of cultural policy, and a relation of the retiring director, for example, opposed Buchner's reappointment. He noted in a letter to the Bavarian Education Minister Josef Schwalber that Buchner had a tarnished reputation both nationally and internationally not only because of his former Party membership, but because he had "extensively iden-

tified with the policies of the Third Reich."[170] Hanfstaengl also listed other widespread criticisms, most notably, that Buchner engaged in disadvantageous trades where he had deaccessioned important works, that he was too old to oversee the extensive project of reconstruction, that he had little regard for contemporary art, and that he, like all other museum directors, had done no more than his duty in saving the collections during the war.

The local press was divided yet restrained about Buchner's reappointment. On the one hand, the conservative *Münchener Merkur* argued that Buchner should succeed Hanfstaengl. The Social Democratic Party (SPD)-oriented *Süddeutsche Zeitung*, on the other, published an editorial expressing disappointment that a younger person "allied with modernity" was not selected.[171] One journalist, Susanne Carwin, launched the most hard-hitting attack in a radio broadcast on the Bayerishe Rundfunk: she focused on Buchner's seizure of the Ghent and Bouts altars and the RM 30,000 honorarium in a critique so withering that it elicited a response from Buchner's allies; one week later Erhard Göpel, an art critic (discussed in chapter 3) who bought works in the

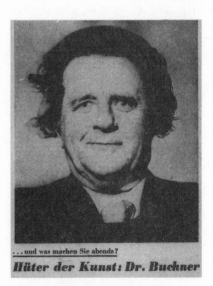

... und was machen Sie abends?

Hüter der Kunst: Dr. Buchner

Press clipping from Die Welt *of Ernst Buchner upon his reinstatement as active General Director, 23 June 1953. Caption reads, ". . . And what do you do in the evening? Protector of Art: Dr. Buchner" (BHSA).*

occupied Netherlands for the Führermuseum, spoke in defense of Buchner.[172] In the end, neither Carwin's criticisms nor those of others derailed Buchner's appointment, and he was confirmed by the Bavarian Landtag, the Prime Minister's Council, and the Education Ministry.

The question remains: why was Buchner reappointed to this high-profile position in the Federal Republic's arts administration? First, his timing was propitious because Buchner stood on the sidelines as the Director Slated for Reappointment at a time when Eberhard Hanf-staengl had surpassed the pension age of sixty-five (this had occurred in 1950 and he was, effectively, working on borrowed time). Some argued that financial considerations were a factor: Buchner was going to receive a pension and it was better to have him work for the money.[173] Others were impressed with Buchner's commitment to rebuild the bombed-out museums. In 1949, he had been a cofounder of the Association for the Friends of the Alte Pinakothek, which proved effective at raising funds for the museum's reconstruction.[174] Buchner also attracted sup-porters because he opposed Hanfstaengl's program of exhibiting the paintings from the BSGS in foreign cities. Hanfstaengl reasoned that with no viable local venue, it was appropriate to show the works abroad, and there were exhibitions of masterpieces of the Pinakothek in Brussels, Amsterdam, Paris, London, and Bern. He planned a similar show in the United States as an expression of gratitude for the support given in the difficult postwar years, but this provoked controversy and the Bavarian Parliament passed a resolution prohibiting the exhibition (the issue arose in the wake of the controversial exhibition of 202 Ger-man masterpieces from the U.S. arts depots, which even the American arts officers had protested).[175] The reappointment of Ernst Buchner, then, represented support for continuity and tradition, as well as an overriding concern for restoring local cultural institutions.

Ernst Buchner's second tenure was relatively successful as he was able to take credit for a number of positive developments. Granted, with all the baggage that he carried from the past, Buchner was no longer an unburdened *Wunderkind*. The Bavarian Education Ministry reflected the commonly held reservations about Buchner by creating a system of more stringent checks on the director's authority. Minister Josef Schwalber, for example, created a commission to oversee the pur-chase and sale of artworks in the collection, and he himself appointed the members (who then reported to the parliament).[176] This limitation, which Buchner publicly supported (he noted that his predecessors Tschudi and Dörnhöffer had answered to a committee of experts), was

intended to deflect criticisms about Buchner's earlier trades. Despite this arrangement, which drew attention to earlier difficulties, Buchner's rehabilitation proceeded apace. For instance, he was confirmed by the University of Munich faculty senate as an honorary professor.[177] He led the popular movement to rebuild Leo von Klenze's Alte Pinakothek in accordance with its traditional architectural style (in contrast to West Berlin, for example, where the Dahlem museums incorporated much more modern architecture).[178] He then organized the celebrations in June 1957 when the Alte and Neue Pinakotheken were reopened in festivities featuring Federal President Theodor Heuss.[179] In the meantime, Buchner had reordered the state galleries, and this involved establishing

Buchner escorting German President Theodor Heuss (center) and Bavarian Minister President Wilhelm Hoegner (left) through the Alte Pinakothek, 7 June 1957. The latter presented Buchner with an award, thanking him for his service on behalf of the Bavarian government (BSGS).

new facilities, such as the Schackgalerie. He was therefore able to over-see the BSGS at a critical time of development and to take much of the credit for the resuscitation of Bavaria's great museums.

Like many other directors in the Federal Republic, Buchner also endeavored to reach out to the once proscribed modern artists and repair the damage done during the Third Reich. In March 1953, just after resuming the general directorship, he announced, "The first exhi-bition that I have planned for the near future will be dedicated to Edvard Munch and Die Brücke. The people who see me exclusively as a prime exponent of premodern German painting hardly know how much types like Marc and Beckmann were interested in old German masters, and how much they learned from them."[180] Buchner at least took steps to recover the lost modernist heritage, even if he lacked a natural affinity for it.[181] As one critic noted, Buchner had "connections to modern art that were not the most congenial, as he, for example, wanted to regard Leo Samberger as the greatest German painter among the moderns"[182] (Samberger was a fin-de-siècle painter from Munich greatly influenced by Franz von Lenbach).

Even with Buchner's struggle to change his ways, rumors about his tarnished past persisted. These had blown up again in 1956 in what was termed a scandal when the *Süddeutsche Zeitung* published incriminating wartime documents and journalist Susanne Carwin reemerged to pen an article in the journal *Frankfurter Hefte* that focused on the Van Eyck and Bouts altars, as well as the collections confiscated from Bavarian Jews.[183] After the ensuing exchanges, which included Buchner's response in the January 1957 issue of the periodical and four letters of support, the Bavarian Education Ministry issued a statement that Buch-ner's contract would not be extended beyond the retirement age of sixty-five, which he reached in 1957.[184] The Bavarian government, in a decision of the prime minister's council, extended his tenure a few months beyond his birthday in March so that he could preside at the reopening of the Pinakothek. Yet because of the mounting political pressure, even this became difficult to arrange, and he was kept on for the last three months as a temporary employee (*Angestellte*) rather than as a permanent civil servant (*Beamter*).[185]

Despite his almost being forced out, Buchner upon his retirement in 1957 was widely celebrated as a hero for his work in safeguarding Bavar-ian art collections. He was even awarded the Bavarian Service Medal (*Verdienstorden*) in 1959.[186] The Alte Pinakothek also received two paint-ings as bequests in his honor: Georg and Otto Schäfer from Schweinfurt

donated Orazio Gentileschi's *Two Women Before the Mirror*, which was placed in the Titian Room of the museum; and the Munich art dealer Julius Böhler (who had a long history of business with Buchner, Hitler, and other Nazi leaders) gave Moyses van Uyttenbroeck's *Shepherd's Scene*, which was placed in the Elsheimer Cabinet.[187]

Buchner retired as gracefully as possible. He announced that he would pursue his scholarship on the history of old Bavarian painting, the work, he noted "that I began already as a student."[188] This yielded the 1960 study *Painting of the Late Gothic: Masterpieces of the Alte Pinakothek in Munich*.[189] Occasionally he wrote an introduction for an exhibition catalog, as he did for a show of German and Austrian art from 1780 to 1850.[190] But for the most part, Ernst Buchner maintained a low profile and pursued his scholarship. He died on 3 June 1962, while working toward the completion of a five-volume series on old Bavarian panel painting. His scholarly papers were considerable, and in addition, he compiled an important library of some 6,000 volumes and a unique photo archive depicting artworks. It is interesting that, according to Buchner, he used most of the RM 30,000 honorarium given to him by Hitler after the Van Eyck and Bouts "expeditions" to build these collections.[191] Part of the agreement he had arranged after the war and prior to his reappointment in 1953 was that in exchange for financial support from the Bavarian government Buchner would turn over his scholarly production to the state.[192] He did not prove entirely reliable in this respect. Before his death, he sold his photo archive to Dr. Georg Schäfer in Schweinfurt—an act that infuriated his successor and long-time supporter Dr. Kurt Martin. What he did not sell to Dr. Schäfer in Schweinfurt ended up in the library of the Central Institute for Art History in Munich, where there is, even today, a Buchner Archive.

Neither the American nor German authorities who evaluated Ernst Buchner's career during the Third Reich grasped the real significance of his behavior. The Americans came closest to recognizing the import of Buchner's actions. In July 1945, Theodore Rousseau wrote,

No amount of passive resistance could counterbalance the moral effect of his official allegiance. Buchner, one of the countless "white" Germans, prominent men in their communities who, in spite of an inner dislike for Nazism and a realization of its evils, nevertheless agreed to act as its representatives, through a mixture of personal ambition and fear of consequences of standing aside. These men bear a heavy responsibility to the mass of their com-

patriots, for they provided the fanatics and criminals with the necessary cloak of respectability. . . . It is recommended (a) that Buchner be kept under house arrest at the disposition of the Monuments, Fine Arts and Archives authorities, Third U.S. Army for consultation, and (b) that he be placed on the list of those officials who are to be prohibited permanently from holding any position in a newly constituted German fine arts administration.[193]

It is remarkable that Buchner was not only allowed to return to his profession, but to reclaim one of its most important posts. There was, of course, the matter of personality. Buchner was unusually intelligent and accomplished and could be very charming. He also had long-standing relationships with influential people in a variety of spheres, including government, business, and high society. Equally important was the Germans' strong desire to rebuild their country and, more specifically, its cultural edifices. Buchner carefully associated himself both with the preservation of German cultural treasures and with the reconstruction of Munich's great museums.

Germany, of course, needed to construct not just new buildings, but a new national identity. Buchner's case illustrates the importance of culture to that effort.[194] Most Germans believed that they lived in the land of not only Goethe and Schiller, but also of Grünewald and Dürer. Buchner and others benefited from the widespread desire to restore to Germany, and specifically to Munich, an image as a cultural center. As noted in the *Süddeutsche Zeitung* in a 1953 article, "whoever came to Munich from Illinois or Iserlohn [a small city in the Ruhr region] in the decades before the last war had three items on their agenda: the German Museum, the Pinakothek, and the Hofbräuhaus."[195] Buchner headed one of the most public and famous of German institutions—the centerpiece of the city that called itself the "city of art."[196] It was much preferable to highlight this epithet rather than the more notorious appellation, "capital of the Nazi movement." It was so important to reclaim this artistic legacy that the director of the Bavarian Provincial Office for the Care of Monuments, Professor Dr. Georg Lill, noted with respect to Buchner, "As I communicated to American art officers years ago, Buchner belongs among those art historians who cannot easily be dispensed with in the cultural construction of Germany since we do not possess an overabundance of leading personalities with practical experience in this region."[197]

In short, the impulse toward reconstruction—this wish to rebuild the museums and celebrate the art within them—induced officials to ignore the findings of the Americans and support Buchner's rehabilitation. And Buchner was not unique. Other colleagues who were *Mitläufer*, or "fellow travelers," retained their positions, such as the restorer Hermann Lohe, who became the chief restorer of the BSGS in 1959.[198] This pervasive ambition to reclaim a position as a cultural center elicited Gordon Craig's observation, "Munich's astonishing rise from the ashes after 1945, so that by the 1960s it was the richest, fastest growing, most culturally ambitious city in the Federal Republic, drawing 1.7 million foreign tourists a year . . . was accompanied by a remarkable amnesia about the past."[199]

This inclination to turn a blind eye to complicity in Nazi criminal endeavors of course extended beyond the art world, but the case of Ernst Buchner follows a typical pattern of collaboration during the Third Reich and rehabilitation after the war for many within his profession. Buchner's counterpart in Vienna, Dr. Friedrich Dworschak (1890–1974), head of the Kunsthistorisches Museum from 1938 to 1945, was involved in a range of initiatives involving plundered art and served on the staff of the Führermuseum (in charge of the coin collection). After the war, Dworschak was made a court counsel (Hofrat) in 1960 and publicly celebrated by Austrian President Adolf Schärf.[200] Even Buchner's successor as BSGS director, Kurt Martin, who assumed the post in the later 1950s, had aspects of his career that are questionable: one U.S. intelligence report listed him as a "personal expert" for Ambassador Otto Abetz in Paris during the war and noted that he had acquired works in the occupied lands in his capacity as director of the Karlsruhe Kunsthalle.[201] After the war, it was difficult to find experienced art personnel who had not been complicit in the official *Kunstpolitik*. Buchner, then, was not unique in using history in a selective manner in the search to forge both a personal and collective identity that would help him work through a difficult National Socialist past.

There were many others who worked in the museum world during the Third Reich who confronted difficult choices. This chapter focuses on directors, in part because as heads of their institutions they had more contact with the Nazi leaders and, arguably, were more conscious of the

political and ethical ramifications of their behavior. The directors of the top museums in the Reich—institutions not only in Munich, but also Berlin, Dresden, Vienna, Essen, and a number of other cities—all made accommodations with the Nazi leaders. Like Buchner, they began their collaboration with the regime by implementing the prejudicial personnel policies that applied to all branches of the civil service, and by the early 1940s they, too, attempted to enlarge the collections in their care by way of the persecution of Jews and the conquest of foreign lands. Ernst Buchner was by no means a unique figure.

There is a compelling argument that Hans Posse, the director of the Führermuseum, conforms to the paradigm of the Faustian bargain more than any other figure treated in this volume. Posse would likely have replaced Ernst Buchner as the main figure in this chapter had he not died in late 1942. (As a result of which he never experienced the last phases of the Third Reich, denazification, and rehabilitation, all of which are major topics in this study.) A protégé of Wilhelm von Bode and gifted scholar who was recognized early on for his abilities, Posse was appointed director of the famed Dresden Gemäldegalerie in 1910 at the age of thirty-one. This titan of the museum world seemed to have maintained his integrity and resisted the pressure tactics of the National Socialists up until 1939: he was even forced into semiretirement in 1938 when antimodernist activists, supported by the local Gauleiter, Martin Mutschmann, attacked him for his earlier acquisitions (pictures by Dix, Klee, and Kandinsky, among others, as well as the Jewish Impressionist Max Liebermann).[202] Had he fully retired or died then, he would be considered representative of the best of the German intelligentsia. But Posse entered into one of the most quintessentially Faustian of bargains to occur during the Third Reich. He was approached by Hitler personally and presented with the opportunity to create the greatest museum of all time in exchange for his efforts and loyalty.[203] Posse did not need the money and his career was already a tremendously distinguished one.[204] But he simply could not resist the temptation to utilize the dictator's resources and shape a remarkable assemblage of objects.

Posse, like his successor Hermann Voss (1884–1969), worked assiduously to build the Linz Project collection. Together, they incurred bills of over RM 100 million and acquired some 8,000 paintings (as compared to the 3,000 housed today in the National Gallery in Washington or the 5,000 in Amsterdam's Rijksmuseum).[205] Despite all these purchases, Posse could have no illusions about his project. At the outset he was charged with cataloguing the plundered art taken from Vienna's

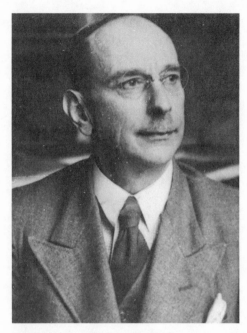

Hans Posse, General Director of the Dresden State Painting Gallery and Führermuseum, 1939 (BA).

Jews, which by January 1939 numbered in the thousands and was valued, according to Himmler, at between RM 60 and 70 million (one Nazi bureaucrat estimated in 1939 that "70 percent of the art in private hands was in the hands of non-Aryans," a statement that is difficult to corroborate).[206] Shortly thereafter, Posse was making selections from seized works in the *Altreich*, followed by systematic and bald expropriations from collections in Poland and the other conquered countries.[207] As one scholar noted, "Posse had to quickly ascertain that some art objects came from Jewish property and were only available because they had either been confiscated or come on the market due to political regulations. He had no qualms when it came to the confiscation of Jewish property."[208] When it came to prized artworks, Posse was a ruthless competitor. He not only defended the so-called Prerogative (*Vorbehalt*) of the Führer, but recommended that limitations be imposed on certain markets (for example, the Netherlands) in order to thwart competitors. (Hitler realized that with his vast financial resources he would be best served by an open market and rejected the suggestion.)[209] In short, Posse worked like a man possessed. He traveled incessantly and

viewed thousands of artworks in the process. His pace did not slow noticeably even when he contracted cancer of the mouth.

Hitler was clearly impressed with Posse's efforts. In May 1940, he arranged for Posse to be appointed a professor, one of the highest honors that could be accorded in Germany. Hitler also made time in his schedule for the museum director. The Linz Project was one of the dictator's favorite undertakings, as shown by letters from Bormann to Posse: one, for example, noted that a travel report "had overjoyed the Führer" and that Posse's description of the "trash of the Netherlands greatly amused him."[210] There are also reports that Hitler evinced a true respect for Posse. He generally accepted the director's suggestions, with the exception of those concerning nineteenth-century German art. Posse did not value these works to the same degree as Hitler and often bought them with reluctance. Albert Speer recounted one episode where Hitler tried to convince Posse of the merits of Hans Grützner's work: "Objective and incorruptible, [Posse] turned down many of these expensive acquisitions. 'Scarcely useful,' or 'Not in keeping with the stature of the gallery, as I conceive it.' As was so often the case when Hitler was dealing with a specialist, he accepted the criticisms without demur."[211] While Speer's assessment of Posse's scruples is questionable, there is no doubt that the dictator and director were in agreement about how to create the Führermuseum. Hitler's high regard for Posse found expression upon the latter's death in December 1942 when the dictator ordered a state funeral. The *Staatsakt* took place in the Marble Room of the Zwinger palace in Dresden, and Joseph Goebbels delivered the eulogy.[212]

Despite the recognition brought by a state funeral, it was not fame that Hans Posse sought. In fact, he was so content to amass the Führer's collection in an unobtrusive, businesslike way that many scholars claimed incorrectly that the Linz Project was top secret. And as noted above, Posse also did not seek financial gain from the enterprise. When he died, he possessed an "artistic estate" (*künstlerischer Nachlass*), which included two wooden Madonnas from the fifteenth and sixteenth centuries and a number of unremarkable paintings. His widow sold these works, some furniture, his scholarly library and his diary, which recorded his professional activities on behalf of Hitler, for RM 75,000—an amount that provided her with a modest income.[213] Posse dreamed that his exertions on Hitler's behalf would yield something more permanent and unique: the greatest art collection in the world. Contemporary observers also recognized this ambition. As stated in a December

1942 obituary in the *Frankfurter Zeitung*, "What Posse created here will in future times be an object of general admiration." The article continued, "May the name of the man live on inseparable from his works."[214] These passages suggest Faustian quest for immortality. Of course, Posse ultimately failed. It is instructive that the OSS agents recommended in 1945 that the entire Linz Project that he set up be considered a "criminal organization"—the same status accorded to the SS at Nuremberg.[215]

While Hans Posse had a uniquely close relationship with Hitler, other prominent museum directors were also prepared to lend their services to the regime. Professor Dr. Otto Kümmel (1874–1952), head of the Berlin State Museums from 1933 to 1945, provides another striking case of an illustrious museum administrator who implemented the Nazis' policies. Unlike Posse, Kümmel was a convinced Nazi— although he joined the Party only in May 1933 when it could in no way jeopardize his career. Kümmel wore his Party badge with pride, and a 1937 evaluation noted that "[Kümmel] is an original Nazi (*Ur-Nazi*), old Party member, and enjoys everywhere the greatest respect and trust!"[216] Douglas Cooper of the British intelligence service noted after the war that Kümmel had exhibited no difficulty in implementing the Nazi cultural policies and that he had "fired all non-Nazis he could and replaced them by Nazis."[217] Kümmel's political beliefs, however, did not negate the fact that he was one of the top experts in the field of Asian art. From his start at the Museum für Kunst und Gewerbe in Hamburg through his work under Wilhelm von Bode in Berlin, he built impressive Asian collections in the decades before and after World War I. Even in the 1960s, he was described as "a scholar of world renown."[218]

Kümmel is perhaps now best remembered for working with Joseph Goebbels and the Propaganda Ministry to organize the "repatriation" of German artworks upon the advent of war in 1939. Given the title "Special Commissar for Securing Foreign Museums and German Cultural Objects," Kümmel oversaw a group of experts that compiled a list of artworks of German origin (or that had been removed from German collections since 1500) located abroad. Their findings were assembled into the now notorious Kümmel report. The three volume, five-hundred-plus-page document was the Nazis' wish list for art in foreign lands, and it established Kümmel as a leader among museum officials in the plundering campaign.[219] Although Kümmel was ultimately pushed aside by others in the looting bureaucracy, his support for the Nazi program was important because he provided both technical assistance and a kind of intellectual legitimation.

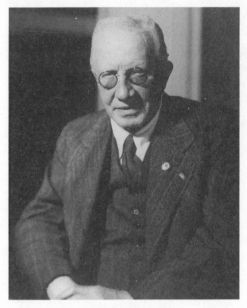

Otto Kümmel, General Director of the Berlin State Museums, 1940 (BA).

Otto Kümmel, like all figures in this study, had moments when he acted laudably, episodes that induce one to place him in the gray area between innocence and criminality. Most notably, he displayed courage at the end of the war as he struggled to safeguard the Berlin collections. He visited the depot in the Flakturm Zoo on 22 April when the fighting was at its most intense. On 28 April, after emerging from a bunker at the Dahlem museum complex (he had been forced underground for a few days because of the shelling), he immediately sought out a German speaking Red Army officer and subsequently, during the next couple of weeks, worked tirelessly to safeguard the works in the various depots.[220] Kümmel later cooperated with the Allies' MFA & A units in Berlin and penned from memory the twenty-seven-page "Report Concerning the Berlin State Museums Measures to Protect Against War Damage."[221] Kümmel appreciated the value of artworks, which explains his concern for them before, during, and after the war. Unlike many of his peers, however, his career came to an end in 1945: Otto Kümmel was sacked as director by the Soviets on 17 May and lived a quiet life until his death in 1952.[222]

The case of Otto Kümmel raises an issue about the Faustian para-
digm: was there really a bargain or breach of ethics if one was a true
believer? Certainly not all the figures in this study made identical sacri-
fices in terms of their own principles and values. But most realized their
responsibility for wrongdoing, even if it came after the fact, with defeat,
and this indicates an awareness that a moral compromise occurred. It is
perhaps more difficult to reckon with individuals who expressed no
regrets and who continued to defend their behavior. Such is the case, for
example, with Klaus Graf (Count) von Baudissin, the notoriously anti-
modernist director of the Folkwang Museum in Essen, who in July 1936
was the first in Germany to purge his museum of modern art (Wassily
Kandinsky's painting *Improvisation 28* of 1912, which Baudissin placed
in "protective custody," then sold a few days later to the Ferdinand
Möller Gallery in Berlin for RM 9,000), and who attracted attention for
his remark that the most beautiful object ever created was the
Stahlhelm (or steel helmet of the armed forces, often viewed as a sym-
bol of militarism and illiberal politics).[223] The Folkwang Museum,
because it housed such a remarkable collection of modern art, lost more
works to the Nazi government's purges than any other German
museum.

Early in his career Baudissin expressed sympathy for modernism, but
he gradually moved to the more conservative and intolerant wing of the
Party.[224] Already by 1933 he conceived and organized one of the first
exhibitions of shame (*Schandausstellungen*): works by George Grosz,
Otto Dix, and Max Beckmann, among others, were displayed in an
ignominious manner in *The Spirit of November: Art in the Service of
Decay*, which caused an uproar when it appeared in Stuttgart.[225] Baud-
issin's unilateral decision in the autumn 1935 to have all names that
sounded Jewish stricken from the Folkwang's membership rolls also
stunned many observers.[226] Furthermore, around this time he joined the
SS (his brother-in-law was Himmler's adjutant Karl Wolff) and later
served in a Death's Head regiment during the war.[227] The Death's Head
branch of the SS was responsible for operating the concentration and
death camps, although Baudissin appears to have been deployed in pris-
oner of war (POW) camps and done mostly administrative work.[228]
Himmler on several occasions placed art experts in regular SS forma-
tions: Karl Diebitsch, for example, who was the artistic adviser to the
Reichsführer-SS, was assigned to duty in the Eleventh SS-Totenkopf-
standarte and then led the SS-Standarte Germania.[229]

Like Buchner, Posse, and Kümmel, Baudissin was a scholar. His work

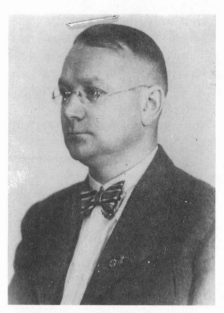

Count Klaus von Baudissin, Director of the
Folkwang Museum in Essen (BDC).

did not approach theirs in terms of its importance to the field of art history, but with a doctorate and numerous publications to his name, he was not without some ability.[230] Baudissin was engaged by Reich Education Minister Rust in July 1937 to oversee museum policy and played a leading role in the purging of modern art from state collections. He joined Ziegler's commission, which visited museums and selected the works to be removed and even advocated extending the purge of private collections—a position that did not find acceptance, primarily for legal reasons.[231] His radicalism also found expression in the meeting of museum directors that he and Rust convened in late November 1937 in the Pergamon Museum: Baudissin's colleague Walter Hansen (see chapter 3) delivered an address in which he argued that degeneration was so pervasive in European cultural history that it even extended to pictures by "the painter of the ghetto, Rembrandt," as well as to works by Matthias Grünewald, which lacked heroism.[232] Ernst Buchner was one of eight museum directors to leave the meeting in protest of Baudissin, Hansen, and company. Baudissin's response to this protest (which was also related to the general program to purge modern works from museums) was to accuse the directors of "acts of indiscipline."[233] Baudissin

was a central figure in the implementation of the Nazis' *Kunstpolitik* and became associated with the most radically antimodernist and anti-Semitic circles (even Bruno Lohse, who later served as one of Göring's agents and a cataloger of the ERR plunder in Paris turned down a chance to work with Baudissin in Essen in 1936 because he considered him too extreme).[234] Yet as far as the records reveal, Baudissin was not involved in the plundering program. His wartime history is nonetheless remarkable as he was a member of an SS Death's Head regiment and offers another striking example of the nexus of culture and barbarism.

When Baudissin emerged from postwar incarceration—a Soviet POW camp in 1947 and the internment camp Neuengamme at the end of 1948—he set about defending and justifying his actions.[235] Baudissin believed that he had behaved honorably during the Third Reich and had been treated unfairly both then and in the present. He devoted his remaining years to rehabilitating his reputation, or as one scholar noted, "to minimizing his role in the National Socialist state and thereby portraying himself as an actual opponent or even victim of the regime."[236] On 20 July 1949, he filed suit against the city of Essen for releasing him from his post at the museum.[237] He wished to return to the Folkwang Museum, but his successor, his former assistant Dr. Heinz Köhn, who had become acting director in 1937 when Baudissin had gone to work for Reich Minister Rust, held the post and continued to do so until 1962.[238] The city responded that Baudissin had been released because his initial appointment had been due to political reasons. Although he won several legal victories—a local court in Gelsenkirchen found that he had "sufficient training as a museum director" and he was exonerated (or placed in Group V) after a lengthy denazification trial—Baudissin was not able to salvage his reputation.[239]

Baudissin had too much information to refute. There were the findings of the American officers who set about to restore the arts administration in postwar Germany: even prior to the end of the war, Harvard scholar and Fogg Museum director Paul Sachs, in consultation with expatriate director Georg Swarzenski, described Baudissin in a list of German art personnel as "poor knowledge; unscrupulous Nazi, disagreeable personality, no professional reputation."[240] The initial postwar accounts of Baudissin also hindered his rehabilitation. Paul Ortwin Rave (1893–1962), a curator at the Nationalgalerie in Berlin, included a very negative portrayal in his pathbreaking study *Art Dictatorship in the Third Reich* (*Kunstdiktatur im Dritten Reich*). Baudissin accused Rave of "murdering his reputation" (*Rufmord*) and made legal threats to both the

author and the publisher.[241] They avoided litigation with an under-
standing that if there was a second edition, Rave would revise the study
in light of Baudissin's annotations. But the book was published again
only after Rave's death and the changes were never made. Baudissin
actually distributed his "corrections" to a circle of individuals who had
been part of the art world during the Third Reich.[242] Despite his legal
success and his energetic efforts to cast a different light on his role in
the National Socialist cultural administration, Baudissin failed to revive
his career. He lived out his life a frustrated man—still writing exculpa-
tory notes to Paul Rave, who detested him and responded reluctantly—
and died unrepentant in 1961 at the age of seventy.[243]

There were other professionals within the field of museology besides
directors who faced similar dilemmas: curators, conservationists, and
administrators were all forced either to serve Nazi masters or leave their
posts. Many compromises occurred in these related professions because
the Nazi leaders needed and valued the contributions of non-Nazis.
When it came to acquiring and safeguarding artworks, the leaders were
quite practical. They generally wanted the best people in their service,
and politics, if not irrelevant, were a secondary concern, as Hitler's rela-
tionship with Hans Posse suggests. Similarly, Posse's successor, Hermann
Voss, was in Lynn Nicholas' words, "a known anti-Nazi, who had been
passed over for the more prestigious directorship of the Kaiser Friedrich
Museum 'for cosmopolitan and democratic tendencies, and friendship
with many Jewish colleagues.'"[244] As a result of this need for experts, the
Nazis recruited decent and principled people who were sincere in their
desire to safeguard the artworks and to minimize the destruction. Paul
Rave, for example, mentioned earlier as a curator at the Nationalgalerie
during the Third Reich (and therefore partially complicit in the purge
of modern art, as well as a contributor to the official magazine *Kunst im
Deutschen Reich*), was extremely conscientious in his work to protect
Berlin's artistic treasures.[245] At war's end, he accompanied artworks to
the Merkers mine and stayed until the arrival of the Red Army.[246]
Another honorable figure was Franz Graf Wolff-Metternich, who
headed the Wehrmacht's Art Protection (Kunstschutz) unit from just
before the outbreak of war until 1942, when he was forcibly retired
after repeatedly protesting the confiscations by the ERR and the com-
mandeering of works by Göring and other Nazi leaders.[247]

The portraits of the more laudable figures, like Rave and Wolff-Metternich, and of those who were more responsible for the Nazis' cultural policies all need to be rendered in shades of grey. After the war, Hans Posse's widow was not wholly without reason in still professing to be "proud of his accomplishments."[248] Posse, like many others in the museum world, appreciated the artworks in his care and wanted them preserved for humanity. Museum professionals worked with the National Socialist regime for a variety of reasons. Some thought that they could exert a moderating influence on the Nazi policies. Others were true believers for whom little ethical compromise was required. Still others did not think much about the issues at stake and sought only to continue on in their jobs.

Regardless of the motivation, one can clearly discern certain consequences that resulted from the collaboration of museum directors and curators. Exhibitions were a form of propaganda for the regime, and they articulated the ideological tenets of nationalism, ethnocentrism, racism, and conformity (*Gleichschaltung*). Nearly all museums articulated these messages. When, for example, the Ulm Stadtmuseum deaccessioned most of the pieces in its Moderne Galerie, it was effectively transformed into a *Heimatmuseum*, or a museum of German folk art. It therefore communicated a new message to visitors, one that stressed Nazi themes (for example, the so-called "blood and soil" notions about Aryans rootedness in the German earth) and affirmed a positive stance in relation to the regime.[249] The individuals administering museums were remarkably important to the Nazi leaders because they helped communicate ideas fundamental to the regime. What started as fairly straightforward propaganda, however, evolved into an elaborate and multidimensional program. The careers of Buchner, Posse, Kümmel, and Baudissin have shown that many directors were not merely compliant, but also even instigated some of the Nazis' activities. They became partners in this ideological aesthetic program from beginning to end.

Art Dealers

The world of art dealers has long been charac-
terized by secrecy. It has been a business where knowledge means both
power and profit. As a result, a great deal of activity in this area was
concealed in the Third Reich and especially during World War II, when
the business had such high political and financial stakes.

Art dealer Karl Haberstock appreciated this quality of his trade. Early
in the war, he wrote to the Reich Ministry of Finance concerning regu-
lations about the import of artworks from the occupied western lands,
bemoaning the new procedures for securing export licenses: "German
buyers are very much interested in purchasing paintings and works of
art, most of which are in the hands of private persons who do not wish
to publicize such sales; not with any intent to evade French law but sim-
ply out of consideration of their official standing in public life."[1] True to
form, Haberstock was not entirely forthright about the reasons for the
sellers' wish for anonymity—most wanted to avoid being identified as
collaborators—but he was correct about the wish for secrecy. Due not
only to politics, but also to taxes, export restrictions, and a variety of

other concerns, it was not uncommon during the Third Reich, nor is it today, to arrange clandestine cash sales and trades of artworks. And within the circumscribed art world, where the real players knew one another and where there was relatively little litigation prior to 1945 (thereby reducing the need for contracts and written agreements), many deals were made with only a handshake. This makes it exceedingly difficult to write a comprehensive history of the profession.

Although there were attempts in many German lands to professionalize the art-dealing business dating back to the nineteenth century, most practitioners made their way by means of an almost premodern business culture. Professionalization came primarily in the form of the Union of German Art and Antiques Dealers (Bund Deutscher Kunst- & Antiquitätenhändler), although smaller associations also existed and competed with the union. Its purpose was to grant legitimacy to dues-paying members, represent common interests with respect to the government and other external entities, and foster a sense of solidarity among the dealers. In fact, it was fairly impotent and had no authority to regulate the trade, despite the guildlike quality of the profession.

Art dealers had varying mind-sets and catered to vastly different clienteles. Art historian Robert Jensen, in his study of the art market in fin-de-siècle Europe, distinguished between entrepreneurial dealers and those he termed "ideological," that is, who claimed "to be dedicated not merely to making money, but to be an advocate for a particular kind of art, held above all others in the name of its 'authenticity.'"[2] Any generalization about art dealers, however, has many exceptions. One can nonetheless identify common features, beginning with, as noted above, that the art trade was rather premodern in character. Family businesses were very common and one often began a career by way of a kind of apprenticeship. Peter Watson has noted, "the descendants of the Brame, Bernheim, and Wildenstein families are still active in the art business today."[3] Additionally, successful dealers typically had a certain polish: besides connoisseurship, a knowledge of foreign languages was important. Much of this training occurred on the job. If not born into an art-dealing family, one often entered a firm at a very junior level, which entailed considerable mundane labor and paying one's dues. During the Third Reich, it was very common to find knowledgeable and cosmopolitan dealers who had never attended a university.

Despite the limitations to the professionalization of the art-dealing business, the Nazi leaders still sought control of it almost from the outset. With the creation of the Reich Chamber of Culture and the subor-

dinate arts-specific chambers in September 1933, the Union of German Art and Antiques Dealers was subsumed into the Reich Chamber for the Visual Arts. The union initially retained a semiautonomous identity in that it continued to exist and had a chairman, Adolf Weinmüller (1887–1958), a well-known Munich dealer. But the organization experienced the pressures of *Gleichschaltung* (coordination) from the beginning. For example, members were obliged to make an annual "contribution" of 12 RM (plus an additional 6 RM per employee) to the Adolf Hitler Fund of the German Economy.[4] The revenue was then directed to Hitler, who used it as a discretionary fund. Weinmüller was supportive of the Nazi regime and facilitated this effort at coordination. In October 1934, he sent a circular to all members ordering them to refrain from going outside the association to Party authorities in their attempts at self-advancement, or alternatively, denunciation. Weinmüller demanded that such actions occur through the dealers' union; to do otherwise, he contended, was pointless and displayed a general lack of discipline.[5] Weinmüller also endeavored to make his association the preeminent one in the country and evinced a competitive outlook with respect to other organizations. He noted that when certain dealers were approached about joining his association, they sometimes resisted and argued that they already belonged to one of the smaller rivals, such as the Combat Community of Aryan Art Dealers in Berlin.[6] Of course, these feuds between professional organizations proved rather pointless, as the Reich Chamber for the Visual Arts dominated them all and made any independence impossible. The union was ultimately dissolved in 1935.

The art trade in Germany, as in many other parts of the world, had long featured a considerable Jewish presence. This obviously changed during the Third Reich, although it did so gradually. Jews were initially permitted to join the Reich Chamber of Culture, and many did so in order to continue their business. It was not until 1935, when the Nazi government increased racial persecution (with the Nuremberg Laws, for example), that Hans Hinkel undertook the "de-Jewification" (*Entjudung*) of the Reich Chamber of Culture, and concerted efforts were made to force Jews out of the profession. In that year, the first of a series of measures concerning the commerce of artworks, the Auction Law, was passed, prohibiting Jews from owning auction houses.[7] Further government initiatives, including Hans Hinkels's decree of 21 January 1937 concerning the *Entjudung* of the art and antique trade and the more general De-Jewification Measures of 26 April 1938 continued this process.[8]

Collectively, they led to the Aryanization of a number of establishments, including that of Hugo Helbing, which one Nazi official in 1940 acknowledged had been "the leading auction house in Munich."[9] Not surprisingly, considering the importance of personal connections in the Nazi hierarchy, the Helbing auction house was taken over by Adolf Weinmüller, the former head of the dealers' union. The above-mentioned Nazi official remarked on Weinmüller's friendship with an official in the local police headquarters (Polizeipräsidium) and noted, "Through the exclusion of Jews, Weinmüller had the possibility to continue under optimal conditions the tradition of Munich as the city of great art auctions, where he was virtually without competition."[10]

Yet it is important to stress that there was a period at the outset of the Third Reich when certain Jewish dealers remained in business and attempted to weather the storm. There were clearly customers who were still willing to patronize their establishments. And even after the Aryanizations, Jews continued to work in the profession, using Christian colleagues to cover for them. The Nazi official who penned the complaint about Weinmüller noted that the dealer continued to employ Jews as experts up through *Kristallnacht* in November 1938 and listed four individuals by name, including the "book Jew" (*Bücherjude*) Heinrich Hirsch.[11] Jewish dealers, despite the spate of laws and decrees that limited their room to maneuver, continued their businesses to a remarkable extent up through 1938. This is borne out by the massive scale of the confiscations that occurred after November 1938, when the pace of the Aryanizations picked up dramatically.[12] The persistence of Jewish dealers up until *Kristallnacht* also speaks to the fact that many erroneously believed that there was a place for them in Nazi Germany.

German Jewish art dealers found it very difficult to emigrate and retain their assets. Even before 1938 when Adolf Eichmann pioneered the "Viennese model" of "one-stop" preparation for emigration—an arrangement in the Aryanized Schwarzenberg villa in Vienna where he denuded the departing Jews of virtually all their wealth and property before allowing them to leave the Reich—German officials had become deft at this kind of confiscation. In 1933, they passed laws whereby those emigrating were permitted to take only RM 200 with them, and this sum was down to RM 10 by 1938.[13] As one scholar noted, "for most, emigration meant starting from scratch, and this under extremely difficult conditions."[14] Nonetheless, most German Jewish dealers did decide to leave Germany, despite the costs. Many revived their careers

in their new homelands, favoring centers of the art market such as Paris, London, and New York. During the war, for example, Harvard Museum director Paul Sachs assisted the OSS by providing a (far from complete) list of seventeen German dealers in New York, including Jacob Goldschmidt, Friedrich Seligmann, and Justin Thannhauser.[15] In 1939 and early 1940, a number of Jewish dealers in Western Europe, including Paul Rosenberg in France, followed suit and also left the Continent in order to continue their businesses.[16]

In addition to ethnically persecuted dealers, there were those who suffered what one might label repression. Above all, these were the supporters of modern art, often dealers whose careers and identities were closely entwined with Expressionism and other avant-garde movements. Ferdinand Möller, for example, remained committed to artists of Die Brücke to the extent to which it was possible. Throughout the 1930s, Karl Nierendorf would utilize his home for exhibitions and invite selected "guests," as he did for a show of Franz Marc's work. Nierendorf also had a branch in New York and sometimes helped out artists whose work was proscribed by staging shows abroad, as he did with painter Xaver Fuhr in 1938.[17] And Günther Franke in Munich retained his Nolde watercolors, "which he would pull from under the table for visitors he could trust."[18] Somewhat ironically, more than a half dozen of these dealers who supported modernism worked with the Nazi regime to help sell off "degenerate" works in state collections; but they rightly feared that works that were not exported would be destroyed.

The "liquidation" of modern works from state collections in many cases marked the beginning of business relationships between the dealers and the Nazi leaders. Only a select number of dealers received commissions between 1937 and 1941 to dispose of the purged artworks from state collections: the decision was made by Goebbels and the Propaganda Ministry, although Bernhard Rust and the Reich Education Ministry also played a role. Goebbels and his associates engaged some of the most renowned firms for the task of selling modernist art abroad in exchange for foreign currency and desirable traditional art, and this included Ferdinand Möller (Berlin); Karl Buchholz (Berlin); Wolfgang Gurlitt (Berlin); Karl Haberstock (Berlin); Hildebrand Gurlitt (Hamburg); Bernhard Böhmer (Güstrow in Mecklenburg); Galerie Valentin (Stuttgart); Harold Halvorson (Oslo); and Galerie Z. R. (Paris).[19] These were chosen not only because they had reputations and came to mind, but because they had the international contacts and were best suited for

this business. Karl Haberstock, for example, wrote to his niece in 1944 to congratulate her on her master's thesis in art history and noted that "the men whom you cite, for example [Otto] Benesch [a professor at Harvard University] and [Wilhelm Reinhold] Valentiner [an illustrious art historian], I personally know very well. They now live abroad. Valentiner has often been very useful to me in America."[20]

While some of these dealers were recruited or retained by the regime, in many cases they initiated contact with Nazi officials because they hoped to enrich themselves through the sale of modern art in German museums. Goebbels, Ziegler, and their cohorts removed over 17,000 artworks from state collections, and at the outset the potential for sales appeared enormous. Of course, certain dealers sincerely believed that they were saving modern art by exporting it; the book burnings of 1933 constituted an unforgettable alert, and a few may have known about the clandestine burning of works from the Littmann collection in the Berlin National Gallery in 1936. But the overriding factor was undoubtedly profit.[21] The dealers wrote to the Propaganda Ministry and offered their services. It is interesting to see how they kowtowed to the Nazi leaders. They were prepared to accept almost all conditions, including secrecy. As one observer noted of the dealers who helped with the disposal, "Participation on the disposal commission must naturally be on a voluntary basis. Also, the appearance of private business on the part of the art dealers must be avoided so as to prevent damaging propaganda abroad against Germany."[22] In other words, they were to avoid any appearance of self-interest or impropriety in order to protect the reputation of both Germany and the Nazi leaders. The dealers also frequently used Nazi parlance, as if to curry favor. It is striking to find that Bernhard Böhmer, who was Ernst Barlach's friend and the trustee of his estate, wrote to the Propaganda Ministry about *Verfallskunst* (art of decay), and the like.[23]

The dealers of "degenerate" art sold in tremendous volume, but they did not reap the profits that they had initially envisioned. They took a standard commission of 10 to 25 percent on each work, but the purge of the German museums led to a glut in the market for modern works.[24] As the bottom fell out, the dealers concluded sales and trades that today seem unbelievable: Kirchner's *Hanging* for $10, Schlemmer's *Winter Landscape* for $30, and an Otto Dix *Self-Portrait* for $40.[25] They still reaped profits, if only due to the scale of the business. For certain dealers, the real payoff, however, came in the form of improved relations with the Nazi leaders. Through their involvement in the disposal of

purged modern works, they became known to Hitler, Göring, Goebbels, Himmler, Ribbentrop, Schirach, and others, who amassed sizeable collections. This familiarity enabled them to make huge sums during the war.

The European centers of the wartime art market were in France and the Low Countries, more specifically, in Paris, Amsterdam, Rotterdam, and to a lesser extent Brussels. The German dealers arrived soon after the fighting had ended and bought at a prodigious rate from the start. They began in the Netherlands, which was the first Western country to capitulate. Hans Posse wrote regular reports to Bormann about the Dutch market: in one, from January 1941, he noted that "up to the end of 1940, paintings were exported from Holland to Germany amounting to 8 million gulden" and calculated that he had personally sold Hitler and Göring works totaling 3 million gulden (divided about evenly), thereby comprising 37.5 percent of the total.[26] Despite the booming market in the West, German dealers were often frustrated by what they perceived as a shortage of works. Posse noted, "the main Dutch art collectors are on the whole not selling, but would be prepared under the existing circumstances to get rid of one item or another."[27] Many collectors were quite patriotic and wanted to keep cultural treasures in the country. But certain dealers and speculators did sell art to the Germans. With so many people fleeing and trying to liquidate assets, both Dutch and German dealers experienced unprecedented opportunities to purchase objects. The Nazi regime, while imposing currency restrictions that varied from country to country, created a financial system that gave those with Reichsmarks (that is, the Germans) tremendous advantages. Because of the lopsided exchange rates and the sizeable reparations extracted from the defeated countries (the latter giving the occupiers additional funds with which to purchase), the Allies issued a declaration from London in January 1943 where they reserved the right to declare transactions in the occupied lands invalid, even "when they purport[ed] to be voluntarily effected."[28] This, like the Allies' Operation Safehaven, which followed in 1944 and aimed to deny refuge for the Nazis' assets, was meant to discourage collaboration, but neither measure dampened the art market in the West.[29]

The Parisian art market, which was depressed in the apprehensive climate of the Phony War in 1939–40, began to take off after the armistice in June 1940. So many agents and brokers gravitated to the French capital that the Resistance leader Jean Moulin disguised himself by masquerading as a dealer. Hector Feliciano described the precipitous

rise in business there: "in fact, the war was a godsend for Paris' art market. It brought an end to the crisis of the 1930s, when art prices declined by as much as 70 percent, forcing a third of Paris' galleries to close their doors."[30] Incomes soared for those who collaborated. The Hôtel Drouot, for example, enjoyed record profits during the war. Granted, the market remained very competitive. According to Wilhelm Jakob Mohnen, a German intelligence operative in Paris at the time, "German dealers, he told the OSS, never did any favors for each other, and the French traders' competition with one another was fierce."[31] But the Germans bought art like never before: even the Reichsbank spent "at least 40 million francs" on art and antiques.[32] They, like others, sought to acquire artworks as a hedge against inflation.[33] As one contemporary recalled, "people had plenty of cash, but there were no pretty clothes, no new cars, no vacations, and no restaurants and cabarets in which to spend money. All you could do was buy butter on the black market."[34] Art, which was highly fungible and easily transported, proved a very attractive investment.

Switzerland served as a kind of satellite to the French market. Feliciano, who has analyzed this link, wrote, "if the French capital was the place to stock up on art, Switzerland offered an outlet."[35] Switzerland did not have as many import or export restrictions, although the Germans had difficulty securing foreign currency they needed to do business. Switzerland also had a legal framework that made it a preferred center for trade: after possessing a work for five years, an "owner in good faith" had legal title to a work (regardless whether it was stolen).[36] The Swiss dealers were capable and enthusiastic businessmen who worked all of Western Europe's markets—not just Paris and Amsterdam, but also German cities. They flourished as intermediaries, as a kind of grease that lubricated the art market machine. A number of Swiss dealers lacked scruples and served as fences for plundered art. The most notable, as indicated earlier, was Theodor Fischer (1878–1957), who trafficked in works looted from French Jews by the ERR.[37] The trades were imbalanced, often with dozens of modern works exchanged for a desirable Old Master. But the deals satisfied the needs of both the Germans and Swiss. The Nazis needed a conduit for the confiscated art, and Fischer and his colleagues were prepared to enrich themselves.

The Nazi leaders, who devoted considerable time to artistic matters, were of two minds with respect to art dealers. In most cases, they had a long-standing mistrust of dealers, whom they viewed as profit minded and secretive. Hitler, in particular, thought that art dealers were avari-

cious and unscrupulous.[38] During the war, German dealers were closely watched by Himmler's and Heydrich's notorious SD. The dispatches that constitute the *Meldungen aus dem Reich* include regular reports on the art trade with informers throughout the profession, and those working abroad were also monitored closely.[39] One dealer, Walter Borchers, who after the war became the director of the art museum in Osnabrück, was pursued by the SD while he was in Paris because he uttered defeatist statements. He claimed that Robert Scholz and Bruno Lohse, who worked sorting objects looted from Jews by the ERR, saved him from a concentration camp.[40]

Yet in contrast to this desire for control was the realization that the market would dry up if there was too much interference. Price regulations or increased restrictions on the importing and exporting of artworks would reduce the number of available works. As noted earlier, Hans Posse suggested regulating the market in the Netherlands in a manner he thought would give him a competitive advantage. And in late 1941, the Reich Economic Ministry floated a proposal that would have established stricter guidelines for the art trade.[41] In both cases, Hitler, Bormann, and those who had the ultimate say in policy decided that the leaders' interests were best served by a free market. The Nazi leaders, after all, had the greatest resources at their disposal: Hitler alone spent over RM 163 million on artworks.[42] Art dealers in Germany and the occupied Western lands therefore proceeded without significant governmental interference, save the restrictions on foreign currency and the import of modern art into the Reich.

Certain dealers who were prominent during the Third Reich were devastated by the defeat in 1945. Bernhard Böhmer, who had sold purged modern artworks, helped Goebbels amass a collection, traded for works in occupied France, and overseen the estate of his close friend Ernst Barlach in Güstrow, committed suicide when Soviet troops invaded the Mecklenburg province.[43] Böhmer had made preparations for the Soviet invasion in early 1945. He had sold off some of his stock just prior to the capitulation, including a work by Paul Signac to a Herr von Praun of Berlin-Nikolassee.[44] But the combination of fear and the thought of life after defeat proved overwhelming. Indeed, when the Red Army units arrived, they behaved in the destructive fashion for which they became known and used Barlach's studio (which Böhmer had taken over after the artist's death in 1938) as a garage for military vehicles. According to Kurt Reutti, a German monuments officer active in the Soviet zone, Red Army troops even used certain canvasses to cre-

ate street signs.[45] What was left of Böhmer's estate went to the Nation-algalerie on the Museum Island in East Berlin and became an important part of the modern collection.[46]

Yet many of the dealers who collaborated with the National Socialist regime were able to resume their business activities after the war. Karl Haberstock, Theodor Abel (Cologne), Ferdinand Möller (Berlin/Cologne), Gustav Rochlitz (Baden/Baden), Bruno Lohse (Berlin/Munich), Maria Almas Dietrich (Munich), and Walter Andreas Hofer (Berlin/Munich) were among those dealers active during the Third Reich who returned to the art trade. In order to do this, they had to set up operations in western Germany.

Initially a few dealers attempted to work in the Soviet zone. Ferdinand Möller, for example, agreed to help the German Central Administration for People's Education in their project to create a gallery for modern art by supplementing the contents of former museums with works from his own collection.[47] As Kurt Reutti noted, "this museum was comprised of loans and gifts of artists and art dealers and gave an overview of the development of German Expressionism."[48] In pursuit of this goal, Möller suggested a conference between former Reich Aesthetic Adviser (Reichskunstwart) Edwin Redslob, architect Hans Scharoun, and Dr. Gerhard Strauss of the German Central Administration for People's Education. Their ambition was to make Berlin once again a center for modernism in Europe. Yet conducting business in the Soviet Military Administrative District was exceedingly difficult. The Central Administration passed a law that allowed for the seizure of all works confiscated as part of the Nazis' "degenerate" art campaign.[49] And before the museum could be created, as Reutti noted, "Socialist Realism was promoted in the Eastern Zone and therein, the 'degenerate art' was yet again degenerate in the East."[50] While the Soviet/East German aesthetic program did not bring about a purge of modern art or even completely prevent directors from acquiring such work, it was a sign of heavy-handed government intervention. In the face of the many restrictions, Möller decided that it was not possible to sustain an art gallery in the Soviet zone and fled west. In a September 1949 letter to Ludwig Justi of the Nationalgalerie, Reutti reported, "As I already told you, the art dealer Ferdinand Möller has fled to Cologne with all the works out of German museum collections that he had in his hands. I estimate the loss for the Eastern Zone to be approximately 1 million (eastern) marks."[51] He noted further that it was pointless to pursue the works

because of the legal code in the West, and on behalf of his agency, Reutti accepted blame for the Möller debacle.[52] Möller's flight was quite hasty, and he left certain works behind as he fled to the West.[53]

These machinations underlay the postwar development of separate artistic establishments in the two Germanies. The West German trade, of course, also had pathological elements. The revival of the careers of dealers who flourished during the Third Reich has already been noted. It was a strange reversal of history to see the dealers who had overseen the liquidation of the purged modern works play a central role in the reestablishment of modern collections in West German museums. They frequently offered paintings to the institutions that once possessed them— on occasion to museums in the GDR: Ferdinand Möller, for example, arranged to sell six modern pictures back to the Moritzburg Galerie in Halle for 350,000 marks before the currency reform.[54] After 1948, institutions in East Germany could rarely muster the foreign currency for such purchases. Even West German institutions had difficulty rebuilding their modern collections. Reutti noted, for example, that Möller erected a gallery at the Hanhnentor in Cologne for DM 100,000 and demanded such high prices that the West Berlin museums could not buy back property formerly in Berlin.[55] Although modern German art remained fairly inexpensive until about 1960, when prices skyrocketed,[56] German institutions, both in the East and West, had limited funds and other priorities, such as reconstructing the actual buildings.

Prominent among those who could afford the works that resurfaced were the Americans, and German dealers had little difficulty selling to the occupation forces, including the Office of the Military Government of the U.S. In one incident, in May 1946, it was discovered that the Horn Brothers' firm in Berlin had sold to the Americans a number of works to decorate the office of General Lucius Clay and his deputy Major General Frank Keating. It turned out that seven works, which the Americans had purchased for 89,000 marks, were stolen property from the Netherlands (they were promptly returned).[57] The immediate postwar period and the thriving black market, then, created precarious circumstances. This included experts who, for the right price, could be induced to testify about the authenticity of dubious works.[58] Kurt Reutti described a Professor Zimmermann, a nephew of "the great [Wilhelm von] Bode [who], "for coffee and butter will write what one wants."[59] Despite the hazards presented by the abundance of works

with problematic provenance, a number of ever-adaptable art dealers found a niche in a market that offered new opportunities.

\- - -

The life of Karl Haberstock reflected a Bavarian-Prussian dichotomy common in the German art world. Born in the Bavarian city of Augsburg into a Catholic family on 19 June 1878, Karl Haberstock established his reputation in Berlin and became the most successful dealer in the capital during the Third Reich. Haberstock's rise went so far that he has been called "the most important German and international art dealer of this time."[60] He stemmed from modest origins, what Theodore Rousseau described as "a middle class family of peasant origin" (only seven of the fifteen children born survived to adulthood), and he had a very limited education.[61] He finished *höhe Handelschule*, secondary trade school, in Augsburg in 1896.[62] Not only did he never attend university, but he reportedly "expressed contempt for people" who had the benefit of higher education.[63] His route to a career as an art dealer was determined more by business considerations than intellectual inclinations. Despite his eventual involvement with the Nazi leaders and his considerable role in the formulation of official aesthetic policies, Haberstock was never one of Robert Jensen's "ideological" dealers.[64] Upon finishing school in 1896, Karl Haberstock embarked on a business career.[65] He first became an intern at the bank of the Gutmann brothers in Augsburg, a Jewish-owned firm where he was employed as a bookkeeper and clerk. A few years later, in 1899, he set off for Brussels in search of international experience and was an employee of the Cassel brothers. He returned to Bavaria when his father died in 1900 and worked for the Bayerische Vereinsbank for three years. Haberstock gravitated to the art world by way of a porcelain shop. He had used his inheritance and savings to set up a store in Würzburg in 1903. Appropriately enough, he had sold artworks from his father's small collection, including works by Wilhelm Piloty (a family friend), in order to raise the capital for his shop.[66] Haberstock began selling paintings on the side, and this business proved so promising that he moved to the resort of Bad Neuenaar and established a gallery. This enterprise was short-lived. After six months, he moved to Berlin and opened what he later called a "picture shop." Haberstock was dealing in low-end merchandise, but the experience enabled him to learn about art. He spent summers at a resort on the North Sea island of Sylt, where he began to cultivate a more affluent

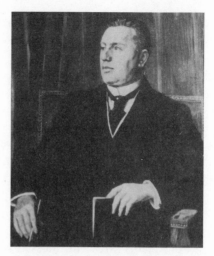

Karl Haberstock. *Portrait by Wilhelm Trübner, 1914 (Municipal Museum, Augsburg).*

clientele. By 1907, he had moved to a larger space on the Motzstrasse in Berlin; a year later he changed addresses to the Marburgerstrasse; and by 1912, he moved into stately quarters on the Bellevuestrasse. The latter was a truly impressive establishment, and he paid RM 14,000 per year in rent.

Haberstock was an energetic entrepreneur. Before World War I, he was a bachelor and was prepared to move wherever he thought he would find business. His experience at the resort on Sylt impressed upon him the profitability of upper-class customers, and Haberstock learned to cultivate a loyal clientele. The profiles of the individuals with whom he got on best became increasingly clear: they were typically wealthy, right wing, and anti-Semitic. He sold them what they wanted: mostly nineteenth-century German genre and landscape paintings, as well as Old Masters. They in turn gravitated to Haberstock because he was not Jewish. Haberstock played up this latter point and maintained (at least to his customers) that the art market was dominated by Jews. Later, during the 1930s, Haberstock's friend and associate in Switzerland, Theodor Fischer, tried to attract customers in a similar manner—and Fischer had even been trained at the Cassirers, the famed Jewish firm in Berlin.[67] Haberstock's anti-Semitism, which early on was a ploy to enhance his business, gradually became more pronounced. One observer after the war testified that Haberstock "demonstrated a ferocious anti-Semitism quite in sympathy with [the Nazis]."[68] However,

those who knew him better insist that he was not personally anti-Semitic, but just a highly competitive businessman who was prepared to play on others' prejudices. They point to his friendships with certain Jewish colleagues and collectors: among the former was art historian and curator Max Friedländer, who for many years headed the prints collection at the Kaiser Friedrich Museum in Berlin, as well as Jewish dealers such as the Seligmanns and Georges Wildenstein; among his customers was Felix von Mendelssohn-Bartholdy, whose illustrious family had long patronized the arts in Berlin.[69] While the sincerity of Haberstock's anti-Semitism is difficult to gauge, there is no doubt that he was an opportunistic businessman who continued to play both sides, catering to conservative anti-Semites while maintaining relationships with a select number of Jews.

Karl Haberstock's business in what he called "the great German masters of the 19th century[,] . . . Leibl, Trübner, Thoma, Böcklin, Feuerbach," flourished prior to World War I. By 1913, he reported an income between 200,000 and 300,000 gold marks and had become so closely identified with this German art that he boasted after the war that he "monopolized to a great extent" the trade in such works.[70] This claim was his ego talking, but he was certainly an important dealer and had an especially close relationship with the important Bavarian painter Wilhelm Trübner (1851–1917), who executed Haberstock's portrait in 1912. Haberstock gave Trübner credit for launching his career: in addition to providing valuable works to sell and helping Haberstock establish his reputation, Trübner helped him sell the works of his friends, including those in the estate of Carl Schuch in Vienna.[71]

Haberstock steadily built upon this foundation in German art, and in the 1920s, widened the scope of his activities to include more expensive Old Masters and an increasingly international clientele. He utilized the capital he had amassed prior to the war to take advantage of the economic crises that plagued the early years of the Weimar Republic. Beginning in 1919, Haberstock, in his own words, "bought substantial parts of collections to be dissolved at this time," when even wealthy individuals were forced to economize in order to survive.[72] His niece, who studied art history and visited the gallery on many occasions, noted that after 1919 Haberstock dealt in only "museum art."[73] Haberstock also married in 1919. His wife, Magdalene, was an impressive and well-educated person, and evidently quite charming: family members referred to her by the nickname "Möla" and even Bruno Lohse, a rival art dealer, admitted that he was smitten with her. Theodore Rousseau

Karl and Magdalene Haberstock, 1919
(from private sources).

observed in 1945, "When he was not successful in obtaining the results he wanted, Haberstock usually brought in his wife, who was known generally as one of the chief reasons for his success."[74] Karl and Magdalene Haberstock therefore formed an imposing team, although she let him assume the more public role.

Karl Haberstock gradually became a player in the international art world. He was also serious about educating himself, and beginning before the war, he made numerous study trips to world-class museums and top galleries. As he later noted, "The things I saw, I impressed in my mind [*sic*] anew at home through the study of art books."[75] It helped that he learned French and English. His file in the State Library in Berlin, which primarily contains correspondence from the 1920s, features letters from among others, Abraham Bredius (the Dutch expert on Old Masters who was later taken in by the Han van Meegeren Vermeer forgeries) and Otto von Falke (the director of the State Museums in Berlin), as well as the aforementioned Max Friedländer.[76] The art world, especially at that time, was circumscribed in size, and it is not surprising that the files contain correspondence with individuals who later played central roles in the cultural bureaucracy of the Third Reich, including the second Führermuseum director, Hermann Voss (then at the Kaiser Friedrich Museum), and the president of the Arts and Crafts Section of the Berlin Academy, Professor Arthur Kampf.[77] And as an obiturary of Haberstock noted years later, "Wilhelm von Bode, Gustave Glück, Dörnhöffer, von Falcke, Pauli, Posse, Koetschau, and many other

German and foreign art historians not only had business connections with him, but also private friendships."[78]

Because Haberstock emerged as a prestigious dealer, his clientele grew more illustrious and international and came to include many aristocrats, notably Baron Fritz von Thyssen-Bornemisza.[79] By 1928, Haberstock had standing associates in London: after the war there were reports that he had a branch gallery located there whose assets had been frozen as "enemy owned," but the evidence in this respect is skimpy.[80] Haberstock's business certainly extended to the United Kingdom, and he had a bank account in London with the Swiss Bank Corporation that was later utilized to sell off modern art from German state collections.[81] In mid-1920s he purchased a tapestry from the collection of James Simon for RM 1.5 million, a price suggestive of his move to a high-end trade.[82] By 1928, he could acquire an exquisite painting by Paris Bordone entitled *Venus and Amor* from the London dealer Otto Neumann. This work was to be the first that he sold to Hitler, but that did not occur until 1936; the fact that he was able to hold on to the work for so long is evidence that he had amassed ample resources. And that he sold it to Hitler for RM 65,000, after having paid "about half the amount," hints at the profits he reaped.[83] Haberstock maintained after the war that he took a commission of 10 percent on the works that passed through his hands, but he was referring largely to the deals that he brokered.[84] When he purchased art with his own funds and then resold it, the profits were usually much greater. At the highest level of the art world, one did not need many sales in order to sustain the business. Because works were so expensive, it was not uncommon to form partnerships to purchase stock. This is where the cooperation with the Seligmanns and the Wildensteins—the Jewish dealers mentioned above—came into play.

When the Nazis came to power in 1933, Haberstock was a well-established, forty-five-year-old dealer, although he was still not at the top of his profession. His gallery on the Bellevuestrasse, for example, although proximate to the Prussian Academy of Art, was not the most prestigious locale for an art dealer. Put simply, Haberstock wanted more, including a high-profile establishment in the fashionable West End: on the Kurfürstendamm. It was evidently this ambitious spirit that compelled Haberstock to join the Nazi Party in the spring of 1933. Like Ernst Buchner and so many others in the art world, he viewed Party membership as not only a type of insurance policy, but as a means of furthering his career. And Haberstock admitted that he, too, was

hard hit by the Depression. His business dipped after 1931, and he lost a considerable amount on the stock market. Haberstock nonetheless maintained a working capital in excess of RM 500,000, mostly in paintings.[85]

It is not clear to what extent he endorsed the Nazi program, but as noted earlier, Haberstock was not uncomfortable with the Party's anti-Semitism. Family members recall that he was very domineering, assuming the role of patriarch; more to the point, there was one episode where a younger brother wanted to marry a woman, but Haberstock opposed the union on the grounds that her complexion was too dark (ironic considering his own non-Nordic appearance, but it speaks to his prejudices).[86] Yet, his own postwar account of his gravitation to the Party stressed the economic advantages he sought. Haberstock claimed that he joined "because I hoped to gain influence and be able to avoid extreme measures."[87] In a file concerning his denazification proceedings, a Berlin neighbor corroborated this view, commenting that Haberstock "joined the Nazi Party out of pure business reasons. He in no way worked for the Party and almost never wore his Party pin."[88] OSS agent Rousseau, who interviewed Haberstock in 1945 elaborated on this theme, noting that Haberstock "never liked risks, and he always saw to it that he had something to fall back on should his plans miscarry. Even after he became a Nazi, he maintained his membership in International Rotary."[89] And scholar Günther Haase later went so far as to portray him as apolitical and described him as being "always an independent spirit."[90] This interpretation of his collaboration with the Nazis due to economic self-interest has become widely accepted. But it should be stressed that Haberstock endorsed many of the Nazis' political and cultural views and was fervently nationalistic (even before the outbreak of war between Germany and the USA he reportedly commented that "dollars would not be a desirable currency after they (the Germans) finished with America." Even prior to joining the Party in 1933, he attended events organized by the Combat League for German Culture, Alfred Rosenberg's pressure group, which attempted to organize culture along National Socialist lines. But it was with characteristic shrewdness that Haberstock cultivated contact with the new leaders while keeping his options open for as long as possible.

Haberstock worked to make himself known to the Nazi elite, a slow and arduous process. He reportedly approached the Propaganda Ministry in 1935 and inquired about selling off modern works, predominantly French Impressionists, from the collections of the state

Galerie Karl Haberstock

Neue Adresse:

BERLIN W 62

KURFÜRSTENSTRASSE 59

zwischen Lützowplatz und Nollen-

dorfplatz, an der Einemstraße

FERNSPRECHER 211764 UND 211788

*Advertisement for the Haberstock Gallery in
Berlin in the official Nazi magazine,* Kunst im
Deutschen Reich, *1940 (photo by author).*

museums, but this initiative was rebuffed.[91] It is interesting that he later testified to having known two individuals with connections to Goebbels: a Dr. Koska, a friend of the minister who purchased art for him in the occupied territories during the war, and Franz Hofmann, who was one of the instigators of the "degenerate art" purge.[92] Despite these contacts, it was Hitler's purchase of the aforementioned Paris Bordone, which hung in the dictator's Obersalzburg home until war's end, as well as a nineteenth-century historical painting, *Out of the War of Liberation* by Franz von Defregger, for RM 25,000 that provided Haberstock with real legitimacy and distinction. Haberstock claimed after the war that an unidentified member of Hitler's entourage approached him seeking the Bordone, but this claim must be viewed with skepticism. Regardless of who initiated the deal, Haberstock quickly capitalized on it and soon began to sell works to Göring, Goebbels, Speer, Wilhelm Frick (the Minister of the Interior), and other leaders.[93] Business picked up to the extent that he was able to move his gallery in 1938 to a larger and more desirable space at Kurfürstenstrasse 59, where he stayed until it was destroyed by bombs on 30 January 1944. It was a grandiose establishment, and the Haberstocks, who had a residence upstairs above the gallery, were waited on by white-gloved servants.[94] For someone who stemmed from a "pure peasant family" in the Allgäu, this constituted some pretty impressive social climbing.[95] The dealer did so well with his new Nazi clients that in postwar remarks to U.S. investigators he made these sales seem like a burden: "From that time [the sale of the Bordone and Defregger to Hitler] I was permanently pressed to supply paintings."[96]

Haberstock's most important customer, of course, was Hitler. The dealer sold him over a hundred works between 1936 and 1943.[97] The two shared a taste for nineteenth-century German art, as well as Old Masters, and all the works in their deals fall into these categories. Because of their like-minded views about art, the two developed a relationship between 1936 and 1938, one in which they discussed artistic matters. After Hitler had returned from a tour of Italy in May 1938, they met and agreed it was lamentable that Germany did not have museums of the same caliber as, for instance, the Uffizi in Florence. It is unclear whether Hitler approached Haberstock with the idea of creating such a collection or whether the idea formed out of their discussion; the former seems more probable. Regardless, Haberstock's enthusiasm encouraged Hitler, and in the process, he became increasingly influential as an artistic adviser. This meeting in the late spring of 1938 marked

the advent of the period of Haberstock's greatest influence over the nation's *Kunstpolitik*.

Hitler and the other Nazi leaders took Haberstock's opinions about aesthetic issues very seriously, and this is reflected in the success of his recommendation of Hans Posse as the first director of the Führermuseum. Haberstock regarded the distinguished scholar and director of the Dresden Paintings Collections as the preeminent expert on Old Masters in Germany. He was also aware of Posse's current difficulties stemming from the director's support of certain kinds of "degenerate art," which he had purchased during his nearly twenty-five-year tenure in Dresden. Posse, as noted earlier, had agreed to begin his pension in March 1938, and then, out of pride, resigned his office.[98] Haberstock's forceful recommendation was crucial in reviving Posse's career. When Hitler had asked Haberstock how he could make the art dealer happy on his birthday, Haberstock replied, "Put Posse back in his position as director."[99] The two men and their spouses were all friends. Posse repaid the favor by patronizing the art dealer on a vast scale, and his widow helped the Haberstocks out in early 1944 by providing them sanctuary when they had been bombed out of their Berlin residence.[100]

The first picture sold to Hitler by Haberstock,
Paris Bordone's Venus and Amor, *1936*
(BSGS).

Haberstock also had the ability to damage the careers of certain museum directors. He tried, albeit unsuccessfully, to engineer the dismissal of Walter Zimmermann, the director of the Germanisches Nationalmuseum in Nuremberg, when the latter rejected a trade proposed by Haberstock (a Spitzweg, which later proved to be a forgery, for a Pieter de Hooch).[101] Haberstock also undermined the career of Alfred Hentzen, a curator at the Kaiser Friedrich Museum. As Hentzen reported to his OSS interrogators after the war, in 1939 "he had to take a second nine-month enforced leave due to the influence of Herr Haberstock."[102] The involvement of an art dealer in matters of museum personnel was highly unusual and did not endear Haberstock to many in the museum establishment. Dr. Zimmermann, noted above, returned a cake Haberstock had sent him upon being appointed director of the Berlin Painting Gallery, and John Phillips and Denys Sutton of the OSS noted simply that he "liked to interfere in the direction of the Berlin Museum which had not made him popular."[103]

Haberstock's growing influence was also reflected in his involvement in the disposal of the "degenerate" art that had been purged from the state galleries. Although the removal of the works had begun in mid-1937 and was largely completed by the end of the year, the "liquidation"—to use Nazi parlance—took longer. Goebbels, who headed the entire project, appointed Haberstock to the Disposal Commission, which was charged with selling off the art. Haberstock attended every meeting between 17 November 1938 and 11 December 1941.[104] Additional members of this commission included Franz Hofmann, Hans Schweitzer, and Rolf Hetsch of the Propaganda Ministry; art/antiquities dealers Max Täuber and Hans Sauermann (both from Munich); as well as Robert Scholz from Rosenberg's office.[105] For practical reasons—as well as a wish to have the disposal carried out by nongovernmental figures who were not involved in the decision to purge the state collections—a number of prominent dealers were engaged; as noted earlier, this included Ferdinand Möller, Bernhard Böhmer, Karl Buchholz, and Hildebrand Gurlitt.[106] The dealers sold the works for foreign currency and were themselves allowed to acquire pieces for shockingly low prices.

Haberstock also personally disposed of certain purged modern works; moreover, he initiated this activity prior to the engagement of the other dealers. Notably, in June 1938 he received special permission to sell off Paul Gauguin's *Riders to the Sea* from the Wallraf-Richartz Museum in Cologne.[107] The picture fetched £2,901, but Haberstock delivered only £801 to the state because he arranged simultaneously to

hand over to Hitler Peter Paul Rubens's *The Miraculous Haul of Fish*, which came from his own holdings: Haberstock kept £2,100 as payment for the Rubens.[108] This incident reveals various aspects central to Haberstock's business during the Third Reich: he was very close to the Nazi leaders, he knew how to arrange creative and complicated deals that crossed national boundaries, and he ensured himself a handsome profit. There were subsequent deals where he "liquidated" modern works and used the proceeds to purchase Old Masters for Hitler; an initiative in May 1939, for example, brought a Canaletto and two still lifes from London, which were sent on to the dictator.[109]

By 1938, Karl Haberstock had been elevated from dealer to adviser with respect to the regime's visual arts program. His participation on the Disposal Commission, a body primarily concerned with carrying out policy, also provided the opportunity to play an advisory role. Haberstock told Bormann in November 1938 not to sell the confiscated works en masse to a Swiss concern called Fides in exchange for Sperrmarks or "blocked marks." He noted the minimal foreign currency that would be gained because Sperrmarks were not convertible.[110] It was also Haberstock who suggested the international auction of the finest works in Lucerne in June 1939. He approached Bormann with the suggestion and even identified his friend and colleague, Theodor Fischer, as the suitable intermediary.[111] Haberstock also suggested another auction for graphic art at the Swiss firm Gutekunst und Klipstein in Bern, although this did not come off.[112] He was clearly filled with ideas regarding the liquidation program, and this fit in well with the governing style of the Third Reich where subleaders were encouraged to suggest initiatives that could be decided upon by superiors. It helped that Haberstock's ideas were so profitable. Indeed, it seemed that everyone made out: even the Reich Chamber for the Visual Arts received a 7.5 percent commission on all sales of the purged art, and this sum amounted to approximately RM 120,000 for the years 1938 to 1941.[113]

Haberstock's involvement with the purged modern art extended to advising Hitler, Bormann, Goebbels, and other Nazi leaders about the legal implications of the project. Although Haberstock was not a lawyer, his business experience provided him with insight into the art of deal making, and he realized that without the proper legal foundation the disposal of the confiscated art would prove difficult. He therefore advised Hitler in two letters in April and May 1938 to pass a law that would entitle the regime to sell off artworks from state collections.[114] Haberstock perused drafts of what would become the Degenerate Art

Law of 31 May 1938, a statute that sanctioned the disposal of modern art in state collections (and was recognized in the postwar period as having been legal), therefore costing Germany much of its remarkable national patrimony of modern art.[115]

There were, of course, limits to the influence that Haberstock and the other art experts had on the Nazi leaders. At the meeting of 27 February 1939 of the Disposal Commission, they were asked to identify those works that could be sold and notified that the rest would be burned.[116] Haberstock, Scholz, and certain others were uncomfortable with this course of action and expressed their opposition, but they could not block it. Even though they stated for the record that they did not want to be associated with this action, and arranged for the minutes to read that they would be "released . . . from responsibility for this measure before the act of destruction," they cooperated with Propaganda Ministry officials and inspected the depot one more time to certify that the works slated for destruction were "fully worthless."[117] Therefore, while Haberstock opposed the immolation, he played a role in the process, and over a thousand oil paintings and 3,825 watercolors and graphic works were incinerated at Berlin's main fire station on 20 March 1939.[118] Franz Hofmann supported the measure, as did his chief, Joseph Goebbels. Haberstock's protest, not surprisingly, did not entail resigning any of his positions or breaking off his business relationship with the Nazi leaders.

As the career of Ernst Buchner showed how museum directors often moved from involvement in the "degenerate" art project to complicity in the expropriation of Jewish property, Haberstock's experience reveals how this was also the case with a number of dealers. Haberstock became engaged in the confiscation of Jewish-owned artworks in Austria after the 1938 annexation of Austria (the *Anschluss*), where this policy of dispossession was first implemented. Granted, Austrian Jews began to lose their property directly after the German troops crossed the border in March 1938 and Haberstock did not arrive as an adviser until March 1939,[119] when Hitler sent him to Austria in an effort to sort out conflicting claims on the confiscated art. Due to his knowledge of art and because foreign dealers had made offers to buy collections—the Duveens and Fischer, among others, had attempted to purchase the Rothschild and Guttmann collections—Haberstock appeared a logical choice to advise on the various options.[120] Hitler even considered giving Haberstock an official appointment as adviser on Austrian-Jewish art, but decided against this because the dealer was not Austrian and was

based in Berlin.[121] As Haberstock soon discovered, he had entered into a fiercely combative situation and did not possess the support from the local powers that he needed in order to act effectively.

The struggle to determine the fate of the art plundered from Austrian Jews revealed the nature of the alliances among Nazi leaders and the art professionals who served them. Haberstock, despite selling works to Göring and other Nazi elite, owed his status to Hitler alone. When Hitler decided not to interfere directly, or at least immediately, to resolve the dispute over the Austrian-Jewish art, Haberstock was left to flounder. The dealer's dispatches back to Berlin testify to his frustration, as local officials were so uncooperative that he could not even obtain inventories or photographs of the plunder housed in the Neue Burg and the Rothschilds' hunting lodge.[122] Kajetan Mühlmann, the subject of chapter 4, presented a rival plan, one that kept nearly all the artworks in Austria. Mühlmann had the support of Göring as well as Gauleiter Seyss-Inquart, although he, too, lost his position in June 1939 and was unable to realize his vision for the loot seized from Jews. After only four months in the Austrian capital, Haberstock returned to Berlin in the summer of 1939, but he took solace in the fact that his successor as Hitler's representative was his ally Hans Posse.

The increasing success of Hans Posse in amassing an art collection and influencing German art policy translated into a lucrative advantage for Haberstock. Theodore Rousseau commented that "Haberstock's career was crowned with his appointment by Hitler as chief adviser to Posse."[123] Once the war commenced, Haberstock carried highly effective letters of support from Bormann and Posse with him on all of his buying expeditions. As of 1940, he also took with him on trips to France letters from Göring, from the adjutant of Wehrmacht Field Marshal Walter von Brauchitsch (the German military commander of occupied France), and from Graf Wolff-Metternich of the Army's Kunstschutz unit.[124] While the privileges these endorsements permitted stemmed from his relationship to Posse, the relationship between the museum director and dealer was not entirely without friction or competition. Haberstock, of course, made a profit on the works he sold to Posse and Linz. But he was known widely as a shrewd and even devious businessman—someone difficult to trust fully.[125]

Even though Posse was indebted to Haberstock, he kept a watchful eye on him. When Posse embarked on his first purchasing expeditions to the Low Countries after the German victory in May 1940, he specified that he wanted to go alone. At the outset, Haberstock was not

granted the necessary visas to travel westward. The letters noted above from Göring, Brauchitsch's adjutant, and Metternich came later, in mid-1940, and permitted Haberstock to travel only to France. Posse had been so overwhelmed by the opportunities in the Netherlands that he had little time for the French market. He therefore consented to Haberstock's trips and effectively divided the western market. Posse rarely traveled to Paris during the war prior to his death in December 1942. Haberstock still faced competition from other German agents, but he enjoyed tremendous advantages by virtue of his access to Hitler, Göring, and other leaders and because he possessed permits to travel to both the occupied and unoccupied territories. In 1945, American agents described Haberstock as "the most prolific German buyer in Paris during the war."[126]

Haberstock's visits to France became legendary, even during his own time. He no doubt acted flamboyantly in order to attract attention. Prior to his arrival in Paris, he would place an advertisement in the *Beaux Arts Gazette* with an invitation to approach him with offers. He invariably stayed at the Ritz Hotel—perhaps also because this is where Göring, Speer, and many other top Nazis stayed—and among the receipts found after the war were bills for shipping crates of wine back to Germany.[127] While Haberstock's ostentatious ways served a purpose, especially at the beginning of the occupation when he sought a higher profile, he soon discovered that there were also negative consequences. Certain sellers inflated their prices when they approached him while others who needed to hawk works in order to survive, but who felt patriotic sentiments, did not want to sell to this German, let alone this front for the Nazi leaders. Haberstock, like other Germans, therefore cultivated a network of French dealers who cooperated with him. Pierre Assouline writes, "After the fact, most art dealers would claim that they had refused to have any dealings with [the Germans]. Yet a number of German officers used to frequent artistic circles in civilian dress. Also, agents would buy for German clients, both dealers and collectors. This situation gave rise to a complete network of middlemen, some of whom were suspicious characters indeed. Thus a dealer could honestly claim never to have seen a German military presence in his gallery and not to know the ultimate destination of his paintings."[128]

One such dealer was Roger Dequoy, whose gallery was located on the rue de La Boétie and who also served as the administrator of the Wildenstein dealership after it had been Aryanized, that is, taken over by a non-Jewish trustee. Prior to the war, Dequoy had been (according

to Haberstock) the business manager for Wildenstein in the London branch, and because Haberstock and Wildenstein had cooperated on ventures, there was a preexisting connection.[129] As Haberstock noted after the war, "when I arrived in Paris in 1940, it was clear to me that I should first look for my old business friends in order to speak about the possibilities of doing business again."[130] The two quickly built upon this mutually advantageous relationship as Dequoy began to serve as an intermediary. Haberstock apparently also used "the Wildenstein premises and the shop of the non-Aryan Hugo Engel as his branch offices in Paris."[131] The biggest deal engineered by Haberstock and Dequoy concerned the two Rembrandts of wine merchant Etienne Nicolas, *Portrait of Titus* and *Landscape with Castle* that Haberstock sold to Hitler in 1942 for 60 million ffrs. ($1.2 million); Dequoy received a commission of 1.8 million ffrs. The pictures are now in the Louvre.[132]

Haberstock's relationship to Dequoy and the Wildenstein gallery remains a murky and controversial subject, as does the connection between Dequoy and Wildenstein. Concerning the first, there is the question whether Haberstock met with Georges Wildenstein in Aix-en-Provence (the unoccupied zone) before the Jewish dealer emigrated to the United States; concerning the second, there is the question whether Wildenstein used Dequoy to control his business and in a sense engaged in sales to the enemy. Wildenstein denied both, and French courts backed him up after the war, but archival documentation casts doubt on both issues. (Haberstock twice testified that he met Wildenstein in the fall of 1940 and a Treasury Department official, during the war, reported on a conversation with Wildenstein where he recounted a meeting with Haberstock in Aix-en-Provence.[133]) Scholar Lynn Nicholas wrote of Georges Wildenstein's letters to Dequoy that "were full of advice and the gossipy information so vital to the art trade, all written with little codes and disguised names (Haberstock was referred to as 'Oscar')."[134] The topic of Wildenstein's behavior during the war, because it concerns one of the great art-dealing establishments in the world, prompted an extensive exposé in *Vanity Fair* as well as a lawsuit and countersuit between the Wildenstein family and author Hector Feliciano.[135] What is clear is that Haberstock and Dequoy had a very profitable arrangement and that they worked together closely, even if they never reached a formal partnership.[136] In the art world—and especially during World War II where restrictions concerning business, transportation, and communication were imposed due to ethnicity, political orientation, and nationality—cooperation among dealers was common.

At times, as with Haberstock and Dequoy, it occurred without a legal foundation (Haberstock described them as "*Geschäftsfreunde*"); in other instances, as with Walter Andreas Hofer (discussed below) and his counterparts Hans Wendland (1880–?) in Switzerland and Achilles Boitel in Paris, the relationship was more formal and prompted the OSS officers to use the phrase "dealing syndicate."[137] But Haberstock and Dequoy/Wildenstein apparently had a special business relationship: to quote a postwar OSS report, "Haberstock states that he always understood that the money was being paid to a secret account which would ultimately have been at the disposal of M. Georges Wildenstein."[138]

Roger Dequoy turned out to be only one of a number of collaborators whom Haberstock employed. These people knew one another and formed a circle, if not a syndicate. It is almost definitional that the collaborators were French, but there were also German expatriates living in France who supported themselves through the art market. For example, one member of Haberstock's group was a cosmopolitan aristocrat, Baron Gerhard von Pöllnitz, who had wide-ranging social and business connections. As a German (not to mention an ostentatious Nazi supporter), Pöllnitz faced problems similar to those of Haberstock, so the aristocrat often used his French mistress, Jane Weyll, as a screen.[139] Weyll bid for both Haberstock and Pöllnitz in auctions at the Hôtel Drouot and represented them in negotiations with other sellers.[140] Pöllnitz and Weyll would also qualify as what art dealers refer to as "runners," that is, individuals who scoured the market looking for works to purchase and used their contacts to gather information. Runners often worked on commission, although it is not clear how Haberstock remunerated his associates.[141] Haberstock and company were very successful in identifying business opportunities. The list of dealers with whom they worked is in itself truly stunning. The Art Looting Investigation Unit (ALIU) identified eighty-two individuals with whom he did business in France alone, and the British postwar researchers assembled a list of 150 individuals who sold art "to German museums and private German individuals."[142] And there were others, in addition to the familiar associates, who sought out Haberstock. He noted after the war, "I could hardly handle the many oral and written offers made by people mostly unknown to me."[143] Indeed, it was a rarity to find dealers in the occupied West who would not transact business with Haberstock. The Duveen brothers in Paris, for example, merited explicit credit in an OSS report for having declined to see Haberstock on 12 December 1940 and thereafter for having conducted no business with him.[144]

Among the German dealers in France, Haberstock was special because he was one of the very few who received authorization to travel to the unoccupied zone. Hans Posse noted of southern France, "there is much to be gotten in future, since this area for the moment has been spared from the many other German dealers."[145] Refugee French dealers, such as Daniel Kahnweiler, lived and worked there, as did a number of German émigrés. Haberstock, for example, did business with former Berlin colleague Arthur Goldschmidt, a Jewish dealer from whom he bought Dutch works that he then sold to Hitler.[146] There was often great intrigue surrounding the deals in Vichy France. The story of the Schloss collection, which included numerous important seventeenth-century Dutch paintings, is a prime example (see also the discussion of Erhard Göpel in chapter 3). Haberstock played a leading role in the search for the hidden collection, as when he met a mysterious woman—a "strange lady with a German-Jewish name"—at the Hôtel Negresco in Nice during the winter of 1940 and 1941 to explore her interest in selling the works.[147] Because of laws dating from 23 July and 4 October 1940, the Vichy regime was able to claim ownership of artworks belonging to non-French Jews in the unoccupied zone. The Vichy officials did so in this case, and the Schloss collection, once it was discovered in a château near Limoges, was administered by the art dealer Jean-François Lefranc.[148] Haberstock never obtained the Dutch artworks he so coveted, but this case illustrates the intrigue and the mingling of government officials and art dealers characteristic of wartime France.

While Haberstock was arguably the most active and successful German art dealer during the war, his behavior was hardly more criminal than others. His strategy was to make very little profit on the expensive and high-profile works that he sold to Hitler, but then mark up prices on the more modest pieces. The costly masterpieces he sold Hitler were so expensive that he could limit his commission. For example, he brokered the deal that sent Watteau's *The Dance* from the Hohenzollern crown prince to Hitler for RM 900,000 in 1942 (partly to cover the death duties incurred after the former Kaiser, Wilhelm II, passed away). Haberstock arranged to take a 10 percent commission, and even though this was reduced by half when the crown prince balked at the fee (and Haberstock agreed to take some of the payment in the form of furniture), the dealer's income was substantial.[149] This and numerous other exchanges enabled Haberstock to make several million marks in the early stages of the war. A selected few other dealers, such as Maria

Almas Dietrich (1892–1971), who reported an income of RM 500,000 in 1941, earned comparable sums.[150] Haberstock could therefore rationalize his behavior by claiming that if he did not buy the art, someone else would. He, at least, was paying the owners for their property.

There were many others, including the French collaborators, who were less ethical. In particular, those responsible for overseeing the Aryanization of Jewish firms (like Haberstock's business friend, Roger Dequoy) were responsible for egregiously unscrupulous behavior. Like leeches, they sucked the blood out of previously flourishing art dealerships and liquidated stock. The firms of Paul Rosenberg, Bernheim-Jeune, Lèonce Rosenberg, and others were Aryanized or put under "provisional administrators" organized by the French Society for Provisional Administrative Control.[151] One scholar described the process: "In the neighborhood where the galleries were located, the policy of Aryanization was in full force. On rue de La Boétie, the Paul Rosenberg Gallery was under the management of Octave Duchez. The Bernheim-Jeune Gallery was sold to a notorious anti-Semite who was none other than the office manager of Louis Darquier de Pellepoix, the Commissioner of Jewish Affairs. He paid only two million francs for the business when experts had placed its value at fifteen million francs. The stationery he used, due to the paper shortage, had the heading Bernheim-Jeune crossed out and replaced by the new name stamped in ink: 'Saint Honorée-Matignon.'"[152] These trustees were not only exceptionally exploitative, but they rationalized their behavior by maintaining that they helped prevent outright seizures by the commandos of the ERR, the Nazi agents who seized works from Jews without providing any compensation. The trustees who paid sums for businesses that were well below market value can hardly be considered humanitarians, and they competed with one another to secure the rights to Aryanize the establishments.

Haberstock himself did not assume control over an Aryanized business, nor, it seems, did he deal directly with the ERR agents in Paris. The evidence on this latter point, however, is still not entirely clear. Alfred Hentzen of the Kaiser Friedrich Museum reported that ERR art passed through Haberstock's hands.[153] It is indisputable that modern art seized by the ERR in France was traded on at least twenty-eight occasions between 1941 and 1943, and that these exchanges were engineered by the dealers Theodor Fischer, Walter Andreas Hofer, Hans Wendland, Gustav Rochlitz, and Bruno Lohse. But it is not possible to prove Haberstock's involvement. One scholar argued that he was excluded

because he "was outmaneuvered . . . and never had a chance to profit from the exchanges."[154] While Haberstock had extensive dealings with the figures who executed these deals (especially Fischer, and a voluminous correspondence from 1941 to 1942 is now in the National Archives in College Park), there is no hard evidence that he disposed of the plunder.[155] The same might be said of works in other important collections belonging to Jews not seized by the ERR. Time and again, Haberstock attempted to intercede in the disposition of extremely valuable works, whether it be the Schloss paintings or the Mannheimer collection in Amsterdam.[156] But in these and other cases, the art was so valuable that governmental agencies forced him to the periphery (the Mannheimer works were bought en masse by Kajetan Mühlmann's agency and sent to Munich).

Yet even without complicity in the liquidation of art plundered in France, Haberstock was kept busy as the Western European art market experienced its most active years ever. The Germans, sporting occupation currency, bought up everything in sight in Paris, Amsterdam, and other major cities. The German art market offered no exception to this trend, despite the Nazi government's attempts to control prices and the highly restrictive financial regulations that they imposed. Both older and contemporary artworks increased in price during the war: in 1942, the SD was calculating that the prices had increased 300 to 400 percent in one year, and overall, estimates point to prices as high as twenty times the prewar level.[157] While the SD considered the price increases to be "catastrophic," they represented a bonanza for Haberstock and other successful dealers.[158]

The real reason for Haberstock's success was his relationship with Hans Posse. Like so many individuals in the elite rank of the Third Reich, they capitalized on a mutually beneficial partnership (akin to Rosenberg and Göring, as well as Seyss-Inquart and Mühlmann). In return for serving the Nazi leaders, Posse received the chance to create a world-class museum from scratch, while Haberstock made the money. Yet Haberstock was not merely a Swiss banker laundering money; he was closely associated with the Nazi art program. An OSS agent noted, "It is recommended that he be tried on the same level as the leading members of the Sonderauftrag (Special Project) Linz. He was, beyond any possible doubt, one of the individuals most responsible for the policies and activities of this group, which dominated German official purchasing and confiscation of works of art from 1939 through 1944."[159] This conclusion, while correct in intent, is slightly misleading

in terms of the chronology. With Posse's death in December 1942, Haberstock lost his most important connection to Hitler and the Linz Project.

The new director, Hermann Voss, emerged from relative obscurity as head of the Wiesbaden Landesmuseum to take over the most dynamic collection in the country on 15 March 1943. This appointment shocked and even dismayed many, including Karl Haberstock. Voss was peripheral to the Nazi art administration and had even been forced out of his position at the Kaiser Friedrich Museum in Berlin and banished to provincial Wiesbaden in 1936. This stemmed from political motives not unrelated to the fact that Voss never joined the Nazi Party.[160] Voss, however, was widely respected for his expertise in Old Master paintings, and Posse reportedly recommended him as his successor from his sickbed in late 1942.[161]

While Voss did not control the entire Linz Project as had Posse—he was head of only the Führermuseum and not the collections of coins, armor, or books—he nonetheless precipitated a changing of the guard that relegated former insiders, such as Haberstock and Heinrich Hoffmann (1885–1957) (Hitler's photographer and close artistic adviser), to marginal positions. Both men, who had previously enjoyed access to Hitler via Bormann and Posse, were ostracized by the group that assumed power. While it is understandable why Voss would think poorly of Hoffmann, a staunch Nazi and artistic dilettante who was often duped by forgeries (which proliferated during the war), the tension between Voss and Haberstock is less clear. It was evidently long-standing: in one letter that Voss sent the dealer in 1923, Haberstock scribbled on the back, "as ever he is still crazy."[162] It is also likely that Voss had heard reports that Haberstock was conniving and self-interested. Regardless of the reasons, the new director of the Führermuseum cut Haberstock off from the funding he had previously used to acquire stock.[163] Furthermore, Voss issued specific orders prohibiting German agencies from doing business with Haberstock. He wrote to Fernand Niedermayer, head of the Enemy Property Administration in France in 1944, that Haberstock was not to be allowed to purchase works from the Mannheimer collection.[164] From 1943 to 1945, both Haberstock and Hoffmann struggled in vain for access to Hitler, and as a result they sold him virtually no pictures.

Haberstock's fortunes declined further in early 1944 when his Berlin gallery, which also served as his home, was bombed out in the 30 January air raid. The dealer wrote to Ernst Buchner from a makeshift office

in the garage that he was in need of a place to stay and inquired whether Buchner might be able to put two or three rooms at his disposal.[165] While Buchner responded with a suggestion about staying with a friend, the mayor of the town of Kempten in the Allgäu in the south, Haberstock and his wife Magdalene decided on an alternative plan: they joined Baron von Pöllnitz in his castle in Aschbach, located between Würzburg and Bamberg in Upper Franconia.[166] The Haberstocks also arranged to move their stock southward (though part of their magnificent library was destroyed in the bombing), and although a number of paintings joined them at Schloss Pöllnitz, they took care to distribute pieces to various safe havens, including depots in Heidenheim, Schloss Thurn und Taxis in Dischigen (Württemberg), one of Ernst Buchner's repositories in a castle at Dietramszell (Bavaria), and a safe house of Magdalene Haberstock's family in Oberstdorf (Allgäu).[167] Haberstock attempted to sustain his business under these trying circumstances: his 1943–45 correspondence with Buchner, for example, contains remarkable letters that often begin by detailing bomb damage or some other personal tribulation, and then go on to discuss a sale or trade. In one letter from March 1943, for example, Haberstock expresses his condolences about Buchner's son's injury by a phosphorous bomb explosion, and then inquires about two Renaissance portraits by Bronzino that were once the property of Prince Borghese.[168] From his base on the Pöllnitz estate, Haberstock continued his art-dealing operations until war's end.

Haberstock was found by the Americans at the Pöllnitz castle in May 1945, and they treated him with such consideration that he wrote to MFA & A officer Robert Posey that same month asking if he would be permitted to continue working as an art dealer.[169] The American response is not available, but their thinking was reflected in the decision to arrest him, which occurred later that summer in August. Haberstock was immediately sent to Altaussee for interrogation.[170] The American Art Looting Investigation Unit had set up their operation there in "House 71," and they assembled many of the leading figures of the Third Reich's art world, including Ernst Buchner, Hermann Voss, and Heinrich Hoffmann. Cells held multiple prisoners, and Haberstock, according to ERR cataloger Bruno Lohse, joined him and Göring's agent, Walter Andreas Hofer, for a good part of their confinement.[171] Haberstock was detained and questioned for thirty-six days. Like most of the others, he proved to be relatively cooperative.[172] His testimony was so damaging to the Nazi leaders that the Americans decided to send

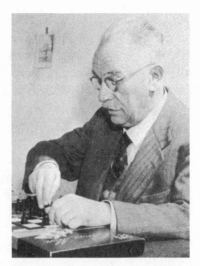

Karl Haberstock in American captivity at Altaussee, 1945 (NA).

him to Nuremberg, where prosecution teams were preparing for the trial of the major war criminals. Haberstock, with his knowledge of the Linz Project and ERR operations, as well as his familiarity with the other Nazi leaders, was one of the key witnesses with respect to art plundering.[173] His testimony, in which he described nearly all the figures in the Nazi art world, is further evidence of how tight-knit the circle really was. The Allies then moved him to the Civilian Internment Camp Number 4 at Hersbruck until 13 May 1946.[174] Haberstock earned his release in part because of his cooperation, in part because of his fragile health: he was sixty-seven and had false teeth, among other signs of his vulnerability. But more importantly, Haberstock avoided criminal prosecution and gained his release because he was able to rally defenders who testified that he had saved lives and actively resisted the regime.[175]

Haberstock arranged for a series of letters to be submitted on his behalf by a range of individuals, including former Finance Minister Heinrich Albert and Otto von Mendelssohn-Bartholdy (from the famous German-Jewish family). These supporters claimed that Haberstock had intervened to save them and others from the Gestapo and, in certain cases, from deportation.[176] One Jewish couple, Ernst and Dorothe Westphal, reported that Haberstock had prevented their deportation to Theresienstadt and added, "The evacuation would presumably have meant our end."[177] The extant documentation does not

provide much detail about the specific assistance provided by Haber-
stock, although Mendelssohn-Bartholdy reported that the dealer had
approached Reich Minister of the Interior Frick for assistance. These
people gave the impression of being genuinely grateful.[178] And indeed,
they were successful in helping Haberstock gain his freedom, although
he was placed on a kind of probation and was required to register with
the district magistrate, which he initially did in Aschbach.[179] Haber-
stock's wife had remained at Schloss Pöllnitz in the forester's house for
several years after the war and led the efforts to reclaim the couple's
artworks. By 1950, they had moved fifty miles south to the town of
Ansbach near Nuremberg, where they established a residence of their
own.[180]

Karl Haberstock, like many others, chose to undergo denazification.
His chief motivation was material: he wanted to reclaim property that
had been seized. This included not only his stock of artworks, but also
his bombed-out dealership in Berlin on the Kurfürstenstrasse.[181] Haber-
stock's denazification case was heard in the Ansbach branch of the Main
Chamber in Nuremberg. The surviving documentation is scant, but
Haberstock clearly availed himself of the affidavits noted above, as well
as a series of documents that had been confiscated by the OSS and uti-
lized to sort works at the Munich Central Collecting Point.[182] The affi-
davits certainly helped his cause and were so favorable so as to be
biased. One, for example, included the claim that "he handled every sin-
gle case most scrupulously, paid appropriate prices, and . . . showed no
indication that his fortune had materially increased."[183] The initial ver-
dict of 27 July 1949 found Haberstock to be a fellow traveler (category
IV) and sustained a fine of DM 200,000 that had been determined by
the Berlin Finance Office (evidently relating to the value of the prop-
erty he owned there).[184] This precipitated an appeal and led to a second
trial at the Ansbach Chamber of Appeal (Berufungskammer), which
ended as Haberstock had hoped: the first verdict was annulled and he
was declared to be "exonerated" and placed in category V. He even had
the fine reduced to DM 127,000 and was spared the cost of the trial,
which the judges decided should be paid by the state.[185]

Again, it is difficult to reconstruct the details of the denazification
process, but some deception seems to have been involved. For example,
Haberstock filled out a questionnaire the following year in which he
answered "no" to the question, "Have you supervised or controlled a
firm or an operation?"[186] While he may not have run a large enterprise,
this answer is somewhat misleading for the most successful art dealer in

the country, who had in fact engaged a number of employees. Regardless, the verdict enabled him to reclaim his Berlin property from the trusteeship.[187] As one judge noted, the Chamber of Appeals had enabled him to be "rehabilitated."[188] In February 1950, he had his lawyer write to the Americans and request the release of fifty-two confiscated paintings held at the Munich Central Collecting Point: the request was accompanied by a copy of the chamber's statement of exoneration.[189]

Karl Haberstock and his wife Magdalene decided that their chances for a new start would be best served by moving to Munich. Their past was not entirely behind them, as the attorney general in Nuremberg was still investigating them in 1950.[190] Some members of their own family also disavowed them: Haberstock's older brother, his grandson wrote, broke with them "during the denazification process" due to a "general political disagreement."[191] And many colleagues were not pleased that he had been let off the hook. Carl Georg Heise, director of the Hamburg Kunsthalle, wrote to Eberhard Hanfstaengl, the director of the Bavarian State Painting Collections in 1950, "the news that Haberstock is fully exonerated and can again pursue his old craft has naturally reached me and disconcerted me as it has you."[192] Heise and Hanfstaengl were conferring on how to induce Haberstock to return artworks that he had acquired in trades from Buchner—in particular a Renoir and a Degas that had been traded for Hans Thoma's *The Bible Lesson*—and Heise noted that he had it in his power to bring the matter to the attention of the press and generate unfavorable publicity for Haberstock. Heise noted that "carrying out a certain restitution could only contribute to the success of rebuilding his business."[193]

Although it appears that Haberstock did not surrender the works (he owned the Renoir jointly with the Munich dealer Julius Böhler, which complicated matters), he indeed revived his business. By 1951, as Lynn Nicholas has noted, "[Haberstock] was reported to have set up shop . . . near the Haus der Deutschen Kunst, and to have reestablished his contacts with his prewar trading cronies in Paris."[194] Haberstock was less public about his art dealing and worked out of his private apartment on the fashionable Königinstrasse; he chose not to advertise in magazines like *Die Weltkunst*, as he did before the war. But he was certainly back in business, and the major dealers and collectors in Western Europe were cognizant of his return. Many prominent members of the art world, like Julius Böhler (who was noted above) continued to call him a friend.[195] Haberstock assumed an air of propriety and zealously tried to defend his reputation. For example, Haberstock wrote to Janet Flanner at the

New Yorker "to complain about inaccuracies in her description of wartime operations in a series of articles she had written on the looting process. He did not deny having traded for the Führer, but complained that she had said he drove a Mercedes when in fact it had been a Ford."[196] Later, Haberstock penned letters to Ardelia Hall at the State Department encouraging her to investigate the theft of books by U.S. Army personnel.[197]

After reestablishing himself in the art world, Haberstock completed his rehabilitation by first donating part of his extensive art library to the Augsburg Municipal Art Museum (Städtische Kunstsammlung), an institution desperately in need of reference books because of wartime destruction, and then by agreeing to loan artworks to the museum.[198] Preparations for the delivery of the artworks were completed in 1955 and 1956, and Haberstock expressed his desire to inspect the space. But the seventy-eight-year-old dealer died on 6 September 1956. He was buried in a family grave in Oberstdorf in the Allgäu on the German-Austrian border; in another of the curious links that unite the figures in this book, he was laid to rest in a crypt that was designed by Josef Thorak (see chapter 5). Haberstock had commissioned the Nazi sculptor to design a family grave back in the late 1930s when his mother had died. Constructing this elaborate grave was part of his effort to play the role of patriarch and to make the family appear as grand as possible.[199]

This ambition was evidently also his intention with the donation of his art collection, and his wife Magdalene therefore carried out his wishes and established the Karl und Magdalene Haberstock Foundation. The name reflected the fact that Magdalene was a true business partner, and indeed one museum official noted that "after his death Magdalene had cared for the foundation with great engagement."[200] She arranged for twelve valuable paintings—mostly Old Masters—to be placed in the museum, which moved to the exquisite Schaezler palace adjoining St. Katherine's Church in the early 1960s. While these works were only on loan from the foundation to the Municipal Art Museum, they were welcomed by civic authorities with gratitude and fanfare in a ceremony on 28 September 1957. Years later, in continuing this tradition of celebrating Haberstock, the lord mayor praised the dealer for his loyalty to his *Vaterstadt* (hometown).[201] In 1972, the foundation was enlarged by eight more paintings, which also went into the museum.[202] The municipal gallery then grew again with Magdalene Haberstock's death on 21 August 1983. In what was termed "a powerful enlargement" of the collection, the foundation received twenty-nine paintings,

as well as graphic works.[203] In 1987, the rest of the collection made its way to Augsburg: the last addition included Canaletto's *St. Mark's Square*, as well as furniture, porcelain, and objets d'art.[204] These items complemented the earlier gifts of pictures by Cranach the Elder, Bordone, Veronese, Tiepolo, Van Dyck, Van Ruisdael, and Weenix and are such an important part of the museum that they usually merit mention in guidebooks.[205] They were exhibited in separate rooms in honor of the couple, and a bust of Haberstock was placed near the museum's entrance.

While the artistic value of the donated works is undeniable, many of the pieces have connections to Haberstock's problematic past. One finds, of course, the Trübner portrait of Haberstock, which echoes not only the dealer's love for nineteenth-century German art, but also the way that he cultivated a racist-nationalist clientele who also appreciated such works. A sketch of Magdalene by Arthur Kampf is another of the numerous portraits of the benefactors that grace the walls of the municipal gallery: if it is not disconcerting to see these individuals represented in such an honorific space, then the fact that Kampf was one of the most celebrated artists of the Third Reich should. The work is dated 1925 to 1930—while imprecise, it lessens the Nazi associations.[206] A closer look at the provenance of other works in the bequest also yields a glimpse of the Haberstocks' activities during the Third Reich. The Paris Bordone *Picture of a Woman with a Little Squirrel* was purchased in 1939 from Fürst zu Schaumburg-Lippe, a family known for pro-Nazi proclivities—one son, Christian, was Goebbels's adjutant. Paolo Veronese's *Venus and Adonis* was acquired in 1941 from Theodor Fischer in Lucerne. The Jan Weenix *Still-Life with Dead Hare* came from the Alte Pinakothek in 1939 in a trade approved by Ernst Buchner. And a painting of a satyr with a peasant family produced by Jakob Jordaens's atelier came from the "former Prussian royal house" in 1942—a reminder of the dealer's contact with the *haute monde* of the period.[207] Whether this last work was acquired in the wake of Kaiser Wilhelm II's death is not clear. Yet these pictures hold many mysteries. And while it is tempting to speculate on how, to take another example, a Philip Wouwerman picture found its way from the Edmond de Rothschild collection in Paris, where it had been since 1878, to the hands of the Haberstocks, the evidence does not permit solid conclusions.[208] The Municipal Museum in Augsburg rebuffed several attempts made by the author to research the Haberstock bequest.

Regardless of the propriety of the acquisitions—and one assumes

that they were all checked by the postwar Allied commissions, as well as the officials at the Municipal Art Museum—it is disturbing to see how the Haberstocks' Nazi past is concealed in information about the foundation. In the most recent catalog from 1991, published by the respected Munich house of Klinkhardt and Biermann, the essay by the volume's editor (and curator at the Augsburg Museum), Gode Krämer, titled "Concerning the History of the Karl and Magdalene Haberstock Foundation," does not even provide a cursory discussion of their activities during the Third Reich. The piece begins with an account of their postwar activities—the move from Berlin to Munich and the establishment of the foundation—and then goes back to their pre-World War I years. And while there are a plethora of details, including their Berlin address in 1912 and the specifics of various early transactions, there is no mention of Hitler, Posse, or any other figures from the most important phase of their lives.[209] One might argue that it is best not to tarnish these magnificent artworks with references to the Nazi past. But is it appropriate to honor the Haberstocks with multiple portraits in the gallery and glossy, opulent catalogs that sing their praise?[210] In this case, the intentions of the museum officials must be questioned. Did they also make their own ethical compromises in order to obtain the bequest? Perhaps their behavior may be attributed more to ignorance than venality, but the glaring omissions of the benefactors' Nazi past and the refusal to cooperate with researchers by hiding under the mantle of "data protection" does not permit a generous interpretation of their motives.[211] Karl Haberstock has gradually attracted more widespread interest.[212] The Augsburg museum officials do not comprehend the current climate if they believe that the dirt, as in earlier times, can be swept under the rug and sit undisturbed.

Art dealers in Nazi Germany constituted a closely knit but competitive profession. They almost all seemed to know one another. If they did not transact business, then they met at auctions or gained an awareness through mutual customers. Hitler and the Nazi leaders certainly facilitated the latter. The Art Looting Investigation Unit documented sixty-eight dealers in Germany alone who sold works to Hitler and the Führermuseum agents.[213] Hitler and his cohorts were at times at a disadvantage because they turned to so many dealers. For example, Lynn Nicholas observed with respect to Walter Andreas Hofer, "When

Göring hesitated, Hofer, like Posse, would suggest that others were ready to buy. Haberstock was a favorite threat."[214] This knowledge of colleagues' behavior and the competitive nature of the art-dealing business in turn contributed to the breaking of ethical constraints on the part of art dealers.

Walter Andreas Hofer (1893–1971?), who served as Göring's primary agent, was Haberstock's main competitor. Many dealers collaborated with National Socialist leaders for pecuniary reasons, and this also applied to Hofer. But he appeared more interested than most in enhancing his personal power. Hofer reveled in his position as Göring's agent, despite stating periodically that he coveted independence, and his increasingly arrogant, bullying behavior attests to his love of authority. It is difficult to explain psychological processes or their developmental roots, but Walter Andreas Hofer's fairly modest origins (by the standards of the art world) and the fact that he had to struggle to establish himself as a dealer may have contributed to his aggressive personality.

During World War I, Hofer married the sister of Kurt Walter Bachstitz, a successful Jewish dealer with galleries in Munich and the Hague, and this provided Hofer with an entrée into the art world. Although

Hermann Göring and Walter Andreas Hofer
in Carinhall, n.d. (GSAPK).

Hofer quarreled and broke with Bachstitz in 1928, he then assumed an unremarkable position as an assistant to the dealer J. F. Reber of Lausanne and eventually learned the business.[215] Hofer decided to make a go of it on his own and set up an office on the Augsburgerstrasse in Berlin in 1935. The capital's art market, boosted by the interest of the Nazi elite as well as the more general national economic recovery, was strong enough to support this move. It helped that Hofer's second marriage in 1937 was to an art conservation expert, Berta Fritsch, but he still did not rank among the leading Berlin dealers.[216] As Theodore Rousseau wrote, "Before he began his work for Göring he had been comparatively unknown, and as soon as he rose to prominence the fear of being displaced prevented him from forming any close associations in the art world."[217] Hofer met Göring in 1936, just as the Reichsmarschall began expanding his modest collection. At this point, Göring was relying on Max E. Binder, the director of the Berlin Armory and a part-time dealer, to assist him with his collection. Hofer recognized an opportunity, and according to another Göring aide, Bruno Lohse, he displaced his predecessor by way of intrigue.[218] Little is known about this changing of the guard, but Hofer was well aware that his means to wealth and power could come by way of assisting Göring with his collection.

By 1939 Hofer sold most of his works to Göring and his entourage, yet he still considered himself to be an independent dealer.[219] There were other instances where dealers cultivated a special relationship with a Nazi leader and still retained their independence. This was the case, for example, with the dealers Carl Meder and Dr. Rosso-Koska and their patron Joseph Goebbels. Meder attended auctions on behalf of Goebbels, such as a 24 May 1938 event in Leipzig; he received a "commission to purchase" and sent the works back to Goebbels for approval.[220] During the war Rossa-Koska bought for Goebbels in occupied France.[221] If the paintings displeased the Reich Minister, Meder and Rossa-Koska sold them to other customers. Because Hofer worked so closely and assiduously with Göring, he gradually became his representative. Rousseau even talks about Hofer becoming Göring's "alter ego as far as the Collection was concerned."[222] In March 1941, Hofer was offered the title "Director of the Art Collection of the Reichsmarschall." According to some reports, Hofer was not especially pleased by this development because he wanted to remain an independent dealer and sell to other clients.[223] The two men eventually came to an understanding whereby Hofer represented Göring and gave him first choice on all artworks he found, but also retained his status as an independent. This

was reflected in the fact that he received no salary from Göring, although one had been offered.[224]

Hofer quickly grew to appreciate the advantages of the title. Theodore Rousseau again provides an interesting perspective on this development, describing how "with most of Europe cowering in terror of the Luftwaffe, Hofer proudly flaunted his title. . . . It was engraved on his visiting cards and his stationery, and it was thus that he insisted on being known wherever he went. He was extremely jealous of his position. He suspected that others were constantly plotting to displace him, and his attitude to all who approached the Reichsmarschall was hostile."[225]

Hofer was cynical, even without conscience in terms of the manner in which Göring's collection was amassed. He not only accompanied his patron on visits to the ERR repository in the Jeu de Paume in Paris to select works from the plunder taken from French Jews, but would make trips himself and earmark desired pieces. He went so far as to work with various branches of the plundering bureaucracy in identifying works that might be subject to confiscation. For example, he was in contact with the Foreign Currency Protection Commando, which also answered to Göring, and had them freeze assets found in French bank vaults until they could ascertain if the owner was Jewish.[226] This was the case with the Joseph Rottier collection. Hofer also engineered complicated exchanges between the ERR, Swiss dealers, and Göring. These exchanges favored the Swiss dealers, even though the market for modern art had declined. In one deal proposed by Hofer to Theodor Fischer in April 1941, they exchanged four paintings by the Cranachs and a couple of other Old Masters for twenty-five Impressionist works to be selected by Fischer. The Swiss dealer paid Hofer commissions on these trades in what appeared to be a clandestine arrangement between the two dealers.[227] In all, Hofer engineered eighteen exchanges of ERR booty for Göring between March 1941 and November 1943.[228] After the war, Theodor Fischer claimed that Hofer had misled him about the origins of many works—that Hofer had not informed him that they had been confiscated from Jews. But most contemporaries who were knowledgeable about the trades and postwar researchers who have studied this history believe that the two dealers knew that they were trading in plundered art, and this is supported by the highly favorable terms for Fischer, who effectively was laundering the loot.[229]

Hofer was also notorious for driving a hard bargain, but he defended his comportment by arguing that sellers hiked prices when they learned

the identity of his client. Still, Hofer and his associates "would often joke about their success in forcing prices down. . . . These witnesses agree that Hofer inspired and encouraged Göring in his natural tendency to be mean and avaricious."[230] Hofer also had no difficulty issuing threats or offering inducements to recalcitrant sellers. Lynn Nicholas commented, "Over and over again an exit visa or some special form of payment of protection was part of the deal." She cites a series of examples, for instance, an Argentine national who sold Rembrandt's *Portrait of an Old Man Wearing a Turban* and four other works not only for money, but also an exit visa for Switzerland (the same also evidently occurred with his former brother-in-law, Kurt Walter Bachstitz, who was able to escape to Switzerland).[231] And in another example, Theodore Rousseau noted that "[Hofer] laughingly told how he had offered the painter [Georges] Braque a speedy release of his mistakenly confiscated collection if he would be willing to sell his Cranach, a picture which Hofer knew he never intended to part with."[232] Additionally, because a picture stemming from the Reichsmarschall's collection had enhanced value in Nazi Germany, Hofer did good business with other Nazi leaders. Hitler's photographer Heinrich Hoffmann and Reichskommissar Erich Koch, for example, both bought works deaccessioned by Göring.[233] Hofer maximized profits here, too, for "in bargaining, he was second to none, not even to his chief."[234] Hofer was such a slick operator that the Swiss authorities put him under surveillance during the war because they suspected that he might also be a spy. There is no evidence, however, that this was the case.[235]

Hofer was not only shrewd, but had a remarkable knack for self-preservation. During the war, for example, Göring protected Hofer by inducting him into the Luftwaffe and having him stationed at the Carinhall residence.[236] Hofer also proved very effective at concealing his own personal wealth. In 1945, Allied investigators found only a modest account in the Dresdener Bank in Berlin and could prove his ownership of just a small house in Neuhaus in the vicinity of Göring's Veldenstein castle.[237] Hofer's frequent business trips to Switzerland on behalf of Göring gave him an opportunity to conceal his wealth, and OSS agents suspected that Hofer might also have funds in The Hague.[238] With the vast sums that passed through his hands, Hofer surely generated a sizeable income. And even his Swiss colleagues knew what investigators later found out: that he bilked the Reichsmarschall in certain deals by quoting him inflated prices and then pocketing the difference.[239] While

profit was not the sole motivation for Hofer's collaboration with the Nazis, it was highest on his list of priorities.[240]

Like most other dealers, Walter Hofer escaped justice after the war. The OSS recommended that he be tried as a war criminal, and after being interrogated at Altaussee and Nuremberg, Hofer was sent to the internment camp at Hersbruck that also held Haberstock.[241] He was kept in custody longer than his preeminent rival and noted this in an appeal for release sent to the Americans in January 1947.[242] But his ultimate fate was not so very different, although it is not possible to ascertain precise information about Hofer's postwar life because he drifted out of public view. This is somewhat ironic because immediately after the German capitulation, Hofer had been inordinately talkative as a witness, showing the U.S. art experts around Berchtesgaden and mugging for the camera (his picture appeared in *Life* magazine). Hofer's last public appearance came in May 1950 in a trial instigated by Theodor Fischer: the Swiss dealer sued the Swiss state for compensation after being forced to return artworks in his possession that had been confiscated from the collections of French Jews. The Swiss authorities called Hofer as witness and he insisted that Fischer and the other dealers knew they were acquiring art plundered from French Jews. (The court's findings were inconclusive on this point, and they awarded the dealer partial compensation for the works he was forced to return.[243]) After testifying, Hofer quickly disappeared, and for good reason. That same year, a French Military Tribunal brought charges against him for art plundering. He was found guilty in absentia and sentenced to ten years imprisonment.[244] As much as one might be dismissive of his character, Hofer was indeed clever. He had learned much about both power and self-preservation.[245] Several sources interviewed for this book, including Bruno Lohse, reported that Hofer revived his career as a dealer and was active in Munich art circles in the 1960s and 1970s. Like Haberstock, he did so in a fairly circumspect manner and did not advertise nor assume a public posture. Moreover, Hofer lived on the same street in Munich as the Haberstocks (the Königinstrasse)as he lived out his days. He reportedly passed away in the early 1970s.

As has been noted, the art-dealing business has always attracted people of dubious ethics. This was why the OSS expected that they would find dealers involved in espionage: although spying is not necessarily unethical, the OSS art experts took it for granted that the dealers would engage in covert activities and were willing to double-cross people.

*Prince Philipp of Hesse and Princess Mafalda
on their wedding day, 1925 (BA).*

During the Third Reich, the case of Prince Philipp of Hesse (1896–1980) provided the most apt example of art dealing becoming enmeshed with espionage and secret diplomacy. Nephew of Kaiser Wilhelm II and president of Hesse-Nassau, Philipp had married Princess Mafalda, the daughter of King Vittorio Emmanuele III of Italy.[246] After their wedding in 1925, Philipp and Mafalda spent much of their time in Rome. Later, Philipp became a recognized liaison between Hitler and Mussolini. Although he was not a professional art dealer, Prince Philipp also helped procure over a hundred works for the Führermuseum, locating artworks through his social connections and utilizing his political influence to navigate the treacherous waters of export permits. In particular, the law prepared by Italian Education Minister Bottai of 9 May 1942 made the export of artworks considerably more difficult: in the speech in which he explained the provisions, Bottai mentioned not only Göring as a threat to the Italian cultural patrimony, but also Prince Philipp.[247]

Prince Philipp of Hesse took on the role of art procurer for Hitler, Göring, and other Nazis for complex reasons. He was in sympathy with their political views, but he was also described by American investigators as "a complete adventurer and not a convinced Nazi."[248] Prince

Philipp believed that he had joined forces with the Nazis on his own terms. He attended one of Hitler's speeches in Frankfurt in 1930 and was deeply impressed. His cousin Prince August Wilhelm, an early, if clandestine supporter of the Nazis, arranged a meeting with Hitler and the Görings in the latter's apartment on the Bademer Strasse.[249] Hitler personally explained his political program to the prince, and according to later reports, Karin Göring asked if the prince wanted to join the "movement." Philipp replied that he would, on the condition that he not be forced to sever contact with Jewish friends. Hitler gave his approval, supposedly commenting, "I honor your views completely and will respect them throughout and demand nothing of you in opposition to them."[250] At some level Philipp appeared to be looking for excitement. As he noted after the war, "I didn't have an actual profession," although he had been trained as an architect.[251] It probably also helped that his younger brother, Prince Christoph, also had close connections to various Nazi leaders; the latter began working for Goebbels and his assistant Karl Hanke and eventually had posts in both Göring's signals intelligence office and the SS.[252]

Because of their social standing, Philipp and Mafalda were in great demand in Nazi circles. Their presence lent events an air of sophistication and was frequently noted in the leaders' journals.[253] Philipp also played a central role in securing Mussolini's assent for the annexation of Austria in 1938 and served as a courier during the Sudeten crisis that followed.[254] Philipp took advantage of Hitler's interest in art as a means of currying favor with the dictator but also found acquiring artworks to be a source of excitement. He worked closely with Hans Posse—they made three trips together to Italy in 1941 alone—and Posse referred to these trips as "acquisition hunts" (*Erwerbungsjagd*).[255] The OSS agents determined that between March 1941 and March 1942 alone, Philipp obtained an estimated eighty-eight paintings for Hitler, of which the most important were the Corsini Memling, *Portrait of a Man*, and a *Leda and the Swan*, then attributed to Leonardo da Vinci, from the Spiridon collection.[256] Most of the works were, naturally, of Italian origin and were in private collections. Posse also recommended that Prince Philipp concentrate on seventeenth- and eighteenth-century works, believing it difficult to obtain scarce top-quality Renaissance pieces. But artists who were represented on this one OSS list included Titian, Tintoretto, Tiepolo, and Raphael.[257]

The consequences of collaboration, however, were terrible for both Prince Philipp and Princess Mafalda. Held responsible by Hitler for the

overthrow of Mussolini in July 1943, they were incarcerated in the Flossenbürg and Buchenwald concentration camps respectively.[258] The course of events during Princess Mafalda's internment in the camp are unclear. The OSS officers reported that reliable sources claimed that she was forced to live in the camp brothel, though others stated that she was housed in a barrack with Rudolf Breitscheid and his wife.[259] Less uncertain is that she was badly wounded in an Allied bomb attack on 24 August 1944 and died shortly thereafter.[260]

Prince Philipp's difficulties did not end with his liberation from Dachau—one of the camps to which he was transferred—by the Americans on 4 May 1945. The Americans interned him for two years, mostly at the Counter Intelligence Corps (CIC) facility at Darmstadt. Although he was treated as a privileged prisoner and occasionally given leave to visit his family, he was considered one of the main war criminals (*Hauptschuldiger*).[261] Philipp cooperated with the Americans and testified at the Flossenbürg and Dachau trials. His punishment from a Hessen denazification court in December 1947 nonetheless entailed two years "forced labor" and the confiscation of 30 percent of his property, which was never returned.[262] His birthplace, Schloss Rumpenheim was also bombed out.[263] Other family property, including Schloss Kronberg, suffered the depredations of the American occupying forces: wine cellars were depleted and valuable jewels were stolen, some of which were never recovered.[264] In 1949, after his release from the various camps, he went before another denazification board, which placed him in category III as a lesser offender.[265] Little information is available about his life after denazification, yet in 1968, he became the head of his family, the House of Hesse, held that position until his death in Rome in 1980.[266]

The reasons for Prince Philipp's collusion with Hitler and Göring, as noted above, are very complex. He evidently liked the excitement that the proximity to power afforded. Royals rarely view themselves as mere messengers, and he no doubt felt himself a part of history as an aide to Hitler. Philipp was a German nationalist, and he supported Hitler's project of creating the world's greatest museum in Linz. Furthermore, Hitler flattered him and made him feel appreciated. He was told by the Führer that he would acquire estates in Poland and other occupied territories, and while the prince was not in need of either land or wealth, he responded to the heady talk of *Übermenschen* colonizing and developing the primitive East.[267] Prince Philipp, while a refined and sophisticated person, enjoyed acting the part of a ruffian Nazi leader. His

remark after hearing that 25,000 Viennese Jews had fled across the bor-
der in the first twenty-four hours after the *Anschluss* conveys this qual-
ity: he remarked to Göring, "We could get rid of the entire scum like
that."[268] With similar callousness, Prince Philipp of Hesse put himself at
Hitler's and Göring's disposal and assisted them in their project to
remove cultural treasures from Italy.

Although it was rare for an aristocrat to play the role of dealer,
Philipp's behavior was similar to that of other cynical and self-
interested types who bought and sold art for the Nazi leaders. Of
course, there were many honest and reputable vendors, but there were
a host of others who were more in the mold of Haberstock, Hofer, and
Prince Philipp.[269] Another recent development that sheds light on deal-
ers, albeit in a less direct fashion, can be found in the response to the
1995 draft of the UNIDROIT Convention on Stolen or Illegally
Exported Cultural Objects, which aimed to halt the trade of artworks
with problematic origins. The opposition of many art dealers to this
important international agreement is illustrative of a certain mind-set.
As Elizabeth Simpson has written in discussing the response of many
dealers, "The interests of the international art market can thus be inter-
preted, in certain instances, to be contrary to the interests of the world
community at large. The age-old battle continues over the illegal trans-
fer of cultural property, in times of war and of peace, between those
from whom property has been stolen and those who would profit from
its theft."[270] Art dealers have a long history of self-interested behavior.
The actions of those who collaborated with the Nazi leaders offer per-
haps the extreme example in modern history.

Art dealers also tend to have excellent survival skills. Perhaps more
than any other profession discussed in this book, the dealers were able
to revive their careers after the war. In some cases, such as the German-
born Alexander Ball, who worked in Paris during the war and had deal-
ings with Nazi art looters, they moved to the United States and began
anew.[271] It is not clear how many dealers from the Third Reich contin-
ued to sell art, but circumstantial evidences suggest that the number is
sizeable. The members of the ALIU who, after the war, returned to civil-
ian jobs usually related to the art world would sometimes comment on
their former subjects' success at reviving their careers. Theodore
Rousseau, who returned to the Metropolitan Museum of Art as a cura-
tor of paintings, dropped a note to former colleague S. Lane Faison in
November 1948, where he talked about Haberstock's efforts to get off
the hook. Rousseau added, "This may amuse you. [It] makes me all the

more angry when I think of the wretched Lohse [who was one of the few in prison]. According to the latest news, even [Gustav] Rochlitz [a German dealer involved with the ERR] is out and doing business!" (he had a gallery on the Boulevard Montparnasse in Paris).[272]

Even though Rousseau, Faison, Plaut, and the others in the ALIU performed a remarkable service in documenting the activities of the art dealers who collaborated with the Nazis and even though they recommended in forceful terms that these dealers face criminal charges and be barred from the profession, they were ultimately unsuccessful in preventing the dealers' rehabilitation. Because the experts in the ALIU were shipped back to the United States and demobilized after completing their reports, there was insufficient expertise and motivation among those who remained to keep down these shrewd and self-interested individuals. Between 1945 and 1949, German dealers needed a license from the American Military Government in order to do business (notably, Haberstock, Hofer, Lohse, Dietrich and the other main Nazi dealers never received licenses).[273] But by the late 1940s the Allies, despite appreciating the importance of culture and cultural policy, left it to the Germans to manage, and due to the prevailing atmosphere, in which reconstruction took precedence over justice, the Nazi art dealers were able to resuscitate their careers.[274]

Art Journalists

Art critics served as extremely important mediators between the regime and the public during the Third Reich. They communicated to a broad audience the ideological precepts manifest in the contemporaneous artworks and played a crucial role in the campaign to generate enthusiasm for these products. Because they were a part of the propaganda machinery, they were closely regulated as a profession. Not only were all critics obliged to be members of the Reich Chamber of Culture and the discipline-specific Reich Chamber for the Visual Arts, but they were, as of November 1936, required to obtain certification from the Propaganda Ministry. At this critical juncture in the history of the Third Reich, when the Nazi leaders steered the government on a more radical and aggressive course, Goebbels proclaimed the Regulation of the Art Report, whereby only journalists with the rank of editor (*Schriftleiter*) could engage in art criticism.[1] In this 26 November law, which was also known as the Art Editor Law, Goebbels placed other restrictions on those who could discuss artworks in public organs. Editors, for example, had to be at least thirty years of age—

although this requirement was waived in February 1937 as long as the editor could demonstrate "a record of National Socialist service."[2] These provisions then, were part of the effort to control the discourse on culture: an element in the increasingly totalitarian trajectory of the regime.

Art criticism warranted specific measures because the Nazis had used art (and culture more generally) as a way of fashioning both their ideology and identity. Extending back approximately to the late 1920s with the emergence of *völkisch* pressure groups like the Combat League for German Culture, art had been used by factions within the Nazi Party to articulate fundamental ideas. This utilization of art to express broader concepts entered a new phase in April 1930 with the publication of Gottfried Feder's notorious article in the *Völkischer Beobachter*, "Against Negro Culture."[3] The scandal it created both within and outside the party—and more positively from the Nazi perspective, the attention it attracted—initiated a flurry of articles on the nature of a truly National Socialist aesthetic policy. While Hitler and the other Nazi leaders tolerated this debate in the early years of the Third Reich, their efforts to extend their control to all aspects of public life reached the point by 1936 whereby they were not prepared to allow anyone to comment on these "reflections of the Third Reich" in a way they did not approve. Art criticism was also central to the Nazi conception of Weimar culture, in which, to quote a 1935 publication of the Institute for the Study of the Jewish Question, "Jews administered the spiritual possessions of a people that deprived us of validity and competence. . . . [T]he art press, art trade, and art criticism were exclusively in the hands of Jews."[4] It was widely believed among Nazis that Jews had foisted un-German modern art on the nation because they, the latter, profited most. The Jewish art critic, then, played a central role in this nefarious conspiracy.

The career of an art critic in Nazi Germany was distinguished from those in other art professions in that it required an even greater degree of collaboration with the regime. While some museum directors, art dealers, art historians, and artists were not Party members, this was not possible for the critics. For them to realize their Faustian bargain, they had to trade away virtually all their independence. Critics also differed from certain other professions discussed in this study in that they were concerned, above all, with contemporary artistic products. While museum personnel and dealers focused most of their attention on products from the past, the critics dealt with what the Nazi bureaucrats called "living culture." Because critics were instrumental in helping

indoctrinate the German people, their importance was not lost on the Nazi leaders, who, despite total war measures after 1943 and the destruction caused by Allied bombs, kept them engaged with their duties as long as possible.

Robert Scholz was undoubtedly the most important art critic during the Third Reich. He progressed from an unknown contributor to provincial papers to become the lead critic of the Party paper *Der Völkische Beobachter*, where he played a leading role in the debates over aesthetic policy mentioned above. Because Scholz also held a position in the Amt Rosenberg, Alfred Rosenberg's Party office for ideological supervision, he gained the opportunity to participate in the formulation of the official art policy.[5] His links to Rosenberg also enabled him to become the editor of the glossy and high-profile art magazine that was launched in 1938: *Kunst im Dritten Reich* (*Art in the Third Reich*, later changed upon Hitler's order to *Kunst im Deutschen* [German] *Reich*). This post effectively made him the dean of art critics because he decided who would contribute to this, the official art journal of the regime. Scholz's involvement in the arts extended to the actual objects themselves as he was appointed director of the Moritzburg Gallery in Halle in 1939, and then during the war, he became a leading figure in the ERR. Despite his illegal activities, he retained a certain idealism that was not uncommon in the Third Reich. He remained committed to the idea of a strong leader, a united country, and a concomitant spiritual renewal. Scholz's record was not entirely negative. Like Buchner, he helped prevent the destruction of safeguarded art at war's end—never mind that the art in question was plundered from French Jews. Scholz's postwar fate and rehabilitation, however, differed from that experienced by Buchner and the others in this study. After his release from an internment camp, and a period as a fugitive, he found his niche as an art critic within radical right-wing circles in Germany. This devout servant of the regime remained unrepentant until the end.

Robert Scholz was born on 9 February 1902 at Olmütz in Moravia, then part of the Habsburg Empire. His father, Norbert Scholz, was a Sudeten-German merchant, and Robert enjoyed an unexceptional middle-class life as a child. Raised a Roman Catholic, he attended primary school and then academic high school (*Gymnasium*) (1914–19) in provincial Olmütz.[6] Scholz was too young to participate in World

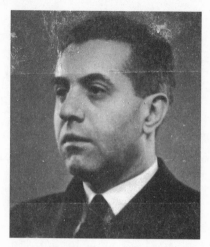

Robert Scholz, 1938 (BA).

War I. He left home only in 1920 when he traveled to Berlin in order to study painting at the State University (*Hochschule*) for Fine Arts. His parents proved very supportive, and Scholz was not only able to complete a four-year course in pictorial arts, but allowed to continue in a prestigious master class (*Meisterschule*) at the Berlin Academy of Art, a program that lasted until 1927. In order to generate additional income Scholz began freelancing as an artist: in one of the questionnaires he filled out during the Third Reich, he wrote that he spent the period 1924 through 1934 as an "independent artist." But, mainly to earn money, he simultaneously began writing about art. His professional career as a critic dates back prior to the Depression, as he exploited the artistic renaissance of this golden era in Berlin to forge contacts and fill out his résumé.[7]

The cultural life of the capital during the Weimar Republic was characterized by heterogeneity. While the avant-garde flourished—or according to Peter Gay's conception, the outsider from the prewar period became an insider—there were also a number of traditional conservative circles.[8] Scholz straddled both camps, a not uncommon position in this city that was part Prussian garrison and part cosmopolitan metropolis.[9] He studied art, first with Professor Ferdinand Spiegel at the Hochschule and then with the Professor Arthur Kampf; both later became leading painters during the Third Reich (and were the beneficiaries of promotional efforts by Scholz).[10] Scholz, according to a 1939

report, also wrote a couple of articles for Goebbels's Berlin paper, *Der Angriff*, in 1930. Although it has not been possible to locate these reviews—the paper frequently failed to identify authors with a byline and Scholz did not mention these freelance pieces when interrogated about his career after 1945—it is likely that they were consistent with the Nazis' general ideological orientation.[11] This same document noted that Scholz was active within Alfred Rosenberg's Fighting League for German Culture starting in 1932.

There are nonetheless many indications that Scholz's early aesthetic predilections were diverse and that his views were yet to become narrowly sectarian. In 1931 and 1932, he was also writing for the conservative (but non-Nazi) *Deutsche Tageszeitung*, and the more liberal *Steglitzer Anzeiger*, both published in Berlin.[12] In a 18 June 1932 review of the fin-de-siècle modernist Richard Gerstl that appeared in the *Deutsche Tageszeitung*, he complimented the artist with a comparison to Van Gogh.[13] And in a 24 January 1933 article in the *Steglitzer Anzeiger*, he gushed about the Expressionist works of Karl Schmidt-Rottluff and Erich Heckel, describing them as "masters of things most German."[14] In other articles he praised modernist sculptor Richard Haizmann as one of the "figures who . . . have dared to venture into the world of firsthand experience and unhackneyed means of expression."[15] Some of these early promodernist reviews, according to several witnesses at Scholz's denazification trial, were even placed in vitrines in the *Degenerate Art Exhibition* as evidence of wrongheaded art criticism (this was the work of rivals within the Party).[16] Even as late as 1936, Scholz wrote a piece titled "The Problem of Franz Marc" where he pointed out positive qualities in this artist whom many Nazis found so vexatious (it was not easy for them to vilify this "Aryan" and World War I casualty).[17]

While details about Scholz's early political and artistic views are difficult to ascertain, he was clearly sympathetic to certain kinds of modernism. He appears at this time to have an outlook very much like Goebbels and a number of the more youthful Nazis who regarded certain kinds of modern art as compatible with National Socialism. Student leaders in particular, such as Otto Andreas Schreiber and Hans Weidemann who headed the students' association in Berlin, became key proponents of the idea that modern art had a place in the new Reich.[18] Very early on then—prior to the Nazi seizure of power in January 1933—Scholz shared this view with many German youth and sought to reconcile modernism with National Socialism. Ferdinand Spiegel even claimed that "in 1933, a number of leading Berlin artists

who did not belong to the Party asked Scholz to accept an offer to write for the Party press so that he could mitigate the radicalism of the ruling Party organs."[19] Scholz's connections to modernist circles were so strong that renowned museum director Alois Schardt commented in the mid-1930s that Scholz had been "one of the most extreme modern painters, but one of inferior rank. . . . He was one of the small group of critics who interceded for the modern movement without any reservation and who could express his opinions in a well-versed way."[20]

Alois Schardt's description, however, captured only one aspect of Scholz, who up through 1933 was actually all over the spectrum with respect to political and aesthetic issues. While Scholz's early reviews reflected a certain independence—to the extent that he even praised a number of Jewish artists such as Max Liebermann, Max Oppenheimer, and Marc Chagall—he gradually became more cautious in expressing his support for modern artists.[21] Even before Hitler's appointment as chancellor, Scholz realized that the best way to secure his future was through the Nazi Party. He therefore increasingly asserted himself in the Nazi press and presented himself as a loyal Nazi. Scholz later reported that he was sympathetic to the NSDAP prior to the failed beer hall putsch of November 1923, and in a 1939 review of his career, a Propaganda Ministry report noted "that Scholz since at least 1930 has worked in a National Socialist sense."[22] It is a sign of his initially ambivalent feelings about the Nazis and their cultural policies that his early Party history is so confused: he evidently did not have formal Party membership until 12 August 1935.[23] Yet he moved steadily toward an illiberal and racist posture with regard to both politics and art. By 1933 he would still write positively about certain modern artists, but they were relatively "safe" figures such as the "Nordic" Edvard Munch, whom even Goebbels praised. An aspect of Scholz's Faustian bargain, then, was his decision to abandon certain kinds of modern art and instead toe the more conservative line, which endorsed representative depictions and Germanic themes (often referred to by the term "*völkisch*").[24]

Scholz soon realized that the promodernist faction was facing an uphill battle and that there were far more opportunities in the conservative camp. By mid-1933, the "debate over Expressionism" was reaching its apogee, and Alfred Rosenberg, the leader of the *völkisch* camp and the editor of the Nazi Party paper, *Der Völkische Beobachter*, welcomed allies—especially those with talent like Scholz.[25] Even as early as 15 February 1933, Scholz made his first step across the battle lines and wrote an article hostile to the promodernist camp. He penned a public

letter to the Prussian Education Ministry demanding the purge of the staff in the Nationalgalerie, among other "reforms."[26] It is not surprising that those whom he attacked, including a Nationalgalerie curator, Ludwig Thormaehlen, considered him an "opportunist."[27] Scholz was still an outsider during the first years after the seizure of power, and consistent with this situation, Prussian Education Minister Rust and the political commissioner, Hans Hinkel (later to be a high-ranking Propaganda Ministry and Reich Chamber of Culture employee), rejected Scholz's charges because they "considered 'any interference by unauthorized persons in unresolved questions of artistic policy to be undesirable.'"[28] Yet even though Scholz's first initiative failed, the prospects for the *völkisch* camp appeared promising. As one scholar noted, "after January 30, 1933, Alfred Rosenberg's Combat League developed its activities on a broad scale and it seemed likely that the [reactionary] art policy would become the general model."[29]

In an attempt to improve his standing within the new ruling circles, Scholz joined the Storm Division (Sturmabteilung, or SA) at the end of 1933, became a naturalized German citizen (early 1934), and most importantly, accepted a full-time position in April 1934 at the northern German edition of the Nazi Party paper, the *Völkischer Beobachter*.[30] This became necessary because both the *Steglitzer Anzeiger* and the *Deutsche Tageszeitung* were shut down as part of the *Gleichschaltung* process.[31] Yet the move to the *Völkischer Beobachter*, beyond being practical, provided a significant boost to his career because the paper had the largest circulation in the country and was growing: 600,000 copies daily in 1938, 1.7 million by 1944.[32] It is significant that Scholz, as he later claimed in his denazification trial, seriously considered turning down the position at the *Völkischer Beobachter* because he disagreed with the government's nascent *Kunstpolitik* (finding that it stifled creativity).[33] But he recognized a golden opportunity to advance his career as a critic and enhance his influence in the cultural sphere. Ambition proved stronger than his inclination to support embattled modern artists, and his articles were increasingly caustic. Scholz, for example, blasted the Italian futurists and their show of works treating airplanes (*aeropittura*), which opened in Berlin in March 1934: "Almost as in the hey-day of Marxism . . . decadent art is everywhere on the rise. . . . [This] so-called futurism . . . was a movement without significance in Italy itself."[34] Before long, Alois Schardt, who had previously described him as an effective promodernist, labeled Scholz "the most powerful adversary not only of modern German art, but of most German art."[35]

The position at the *Völkischer Beobachter* marked the start of Scholz's tenure with Alfred Rosenberg. The Reichsleiter, although frequently frustrated by initiatives that failed, tirelessly developed new projects. This style suited Scholz, who also had tremendous energy and self-confidence. For example, shortly after joining the Nazi Party newspaper, Scholz, with Rosenberg's support, founded an art magazine called *Kunst und Volk*, which was first published by the Mittelbach Verlag in Berlin.[36] Their penchant for planning was also reflected by Rosenberg's reaction to Scholz's renewed efforts to create the regime's official aesthetic program. Scholz had returned to the ideas he had unsuccessfully raised the year before in the memorandum he had sent to Prussian Education Minister Rust.[37] A thirteen-page report, titled "Reform of the State Cultivation of Art," was similarly vitriolic, with accusations of "racially alien elements" who had become too influential in the last ten years. Scholz also denigrated "so-called artists" such as Nolde, Pechstein, and Feininger and advanced the notion of a "conspiracy among Jewish art dealers such as Alfred Flechtheim and Paul Cassirer."[38] He again recommended personnel changes in the Prussian Education Ministry, as well as in various museums and art academies. The report was well received by Rosenberg, who recognized Scholz's expertise and insider knowledge of the art world. This and the Nazi leader's initially positive response to *Kunst und Volk* led to a position for Scholz within the Party ideologue's cultural organization, the National Socialist Cultural Community (Nationalsozialistische-Kulturgemeinde, NS-KG). More specifically, Scholz was made the division leader in July 1934, responsible for visual arts as well as monuments.[39] The NS-KG, which was headed by Dr. Walter Stang, comprised a central part of Rosenberg's larger Party organization for spiritual supervision the DBFU (its unwieldy title encouraged people to use the acronym or the term Amt Rosenberg). The NS-KG and its parent organization aimed to foster a *völkisch* culture and functioned simultaneously as a pressure group and a shadow propaganda ministry. Scholz's career as a cultural bureaucrat had begun, and it appeared the perfect calling for him. Robert Scholz arguably became the most energetic and effective cultural bureaucrat in the Nazi government below the level of Reichsminister.

Later in 1934, Scholz and Stang arranged for the NS-KG to take over *Kunst und Volk*, which it published until 1938, and this became one of Scholz's chief responsibilities. Scholz was also given the position delegate for the Protection of National Symbols and Pictures of the Führer, where he supervised Party designs and depictions of Hitler.[40] It is not

Press coverage from the Illustriete Beobachter
*of a meeting of the NS-Cultural Community
and Reichsleiter Alfred Rosenberg with guests
visiting the exhibition* Heroic Art,
25 June 1936 (BHSA).

clear to what extent this post enhanced Scholz's influence or even what kind of decisions he made in this capacity. Because portraits of the dictator were almost ubiquitous, it is unlikely that Scholz weighed in on every rendition (or even a fraction of them). But there were general policy decisions to be made. Some scholars have remarked on the relative rarity of truly monumental treatments of Hitler, in sculpture for example.[41] Busts and other works tended to be large, but not enormous (that is, comparable to the scale of Arno Breker's warriors). Yet the extant records do not reveal if Scholz played a role in formulating this and other related policies.

Aside from penning reviews, editing the magazine, and signing off on artistic treatments of Hitler, Scholz devoted much of his time to organizing exhibitions of what he considered meritorious art. His first coup came in March 1935 when he staged the "debut" show of sculptor Josef Thorak—another Austrian, who became one of the most important

"state sculptors" (*Staatsbildhauer*) during the Third Reich. The exhibition of Thorak's work, which was held in the Amt Rosenberg's gallery on the Tiergartenstrasse in Berlin, attracted a great deal of attention for both the agency and its leaders.[42] Moreover, it provided a much needed boost for Rosenberg and Scholz at a time when they were competing with Goebbels's Propaganda Ministry for primacy within the cultural bureaucracy. Because of its spectacular success and broad coverage in the press, the exhibition served as a kind of model initiative for cultural bureaucrats. It also nurtured a friendship between Thorak and Scholz, and they would remain close until Thorak's death in 1952. Rosenberg appreciated the attention that Scholz had garnered for him and his agency, and he encouraged Scholz to organize as many exhibitions as possible.

From 1935 to 1939, Scholz was responsible for organizing an array of exhibitions for the Amt Rosenberg. This included one featuring the art of Ferdinand Spiegel and Josef Thorak (1935), *Sea Travel and Art* (1935), the 1936 *Finnex* show of German and Scandinavian art, the work of painter Wilhelm Peterson (1937), and *Wife and Mother: Life Source of the Volk* (1939).[43] These exhibitions were important because they helped determine the official aesthetic program—a significant part of the art that the Nazis believed represented a new era. They also enhanced the influence of Rosenberg, Scholz, and their cohorts because the openings attracted the political and cultural elite of the Third Reich, thereby enabling them to network. To take one typical gala event, the opening of *Sea Travel and Art* drew, among various luminaries, Bernhard Rust, Erich Raeder, and Hjalmar Schacht.[44] As is evident from this study, the artistic and governmental elite of the Third Reich were often well acquainted with one another. Events like the exhibitions organized by Scholz and Rosenberg provided important venues for developing personal contacts.

Despite their conviction that they alone had the true vision of the Nazi aesthetic, Scholz and Rosenberg always sensed that they had embarked on an uphill journey. Goebbels and his colleagues in the Propaganda Ministry had the right to veto, and hence cancel, any exhibition proposed by the Amt Rosenberg. This happened in 1935, for example, with the plans for the show *Art Along the Way*. Artworks and posters were to be exhibited in pedestrian zones, to expose the masses to the new Nazi culture. Goebbels and the first president of the Visual Arts Chamber, Eugen Hönig, feared that the installation would appear kitschy and vetoed Scholz's proposal.[45] Those in the Amt Rosenberg,

and specifically, the subsection called Office for the Cultivation of Art (Dr. Stang's office, which at that time oversaw Scholz's Visual Arts Division), considered this act to be a serious insult, or in Stang's words, "an open attack against the authority of my office."[46] In addition to this susceptibility to the Propaganda Ministry veto, the Amt Rosenberg could also be shut out of major cultural-political campaigns. The "degenerate art" action, which entailed both purging modern works from state collections and the exhibition, was carried out with minimal involvement of the Amt Rosenberg. Scholz was invited to join the Disposal Commission and indeed made suggestions about selling off the unwanted artworks. But considering the nature of the program—it was the realization of a campaign that Rosenberg and his allies had initiated years earlier—their marginal position could only be interpreted as a function of relative power. It was not a case of Goebbels and Rosenberg disagreeing on the policy, but an instance where Goebbels froze out his rival. The organizers of the traveling *Degenerate Art Exhibition* included several of Scholz's pre-1933 articles on Max Liebermann and other artists rejected by the Nazis in a section of the show dedicated to "jottings on art during the period of decay," an act that constituted a further and gratuitous insult aimed at their rivals.[47]

Because Rosenberg and Scholz felt like outsiders in the cultural administration, they often resorted to what might be described as guerilla tactics. They undertook numerous initiatives, knowing full well that many would not succeed and would only annoy their rivals and enemies. But they did what they could. They collected information on opponents and organized it within their Kulturpolitisches Archiv. To take two examples, in 1937 Scholz was asked to comment on Professor Emil Waldmann, the director of the Bremen Kunsthalle, who wrote a book entitled *The History of German Painting*. The Kulturpolitisches Archiv report noted that Waldmann "glorified a series of Jewish art bolshevists, among them George Grosz."[48] In 1938, Scholz was consulted about the fate of the sculptor Professor Edwin Scharf, who was suspect because "his wife was not free of Jewish blood damage."[49] Through these evaluations that Scholz helped prepare—and more specifically, the allegations that followed—the Amt Rosenberg enhanced its power, as denunciations from an official quarter often had serious consequences. The Gestapo or the Propaganda Ministry were frequently informed, and they had the power to take more drastic action. Scholz and his colleagues also lobbied for the confiscation of books to which they objected. Such was the case with Alois Schardt's study of the Expres-

sionist painter Franz Marc, where they appealed to Himmler to utilize the police to seize the 5,000 copies.[50] Scholz, like his colleagues, felt part of a minority, but they shared a conviction in the correctness of their vision and worked unceasingly to pursue its realization. This sense of righteousness, when combined with their feelings as outsiders, enhanced the sense of camaraderie shared by those in Rosenberg's agency. These ideologues to a great extent remained in the service of Rosenberg until 1945, dedicated to this *völkisch* cultural vision.

Hitler rewarded Rosenberg and Scholz for their efforts, or for their dedication to certain aesthetic principles, by giving them responsibility in 1938 for the official art journal *Kunst im Dritten/Deutschen Reich*, or *KiDR*.[51] It is worth asking why these two received this desirable commission. Undoubtedly, Hitler's "divide-and-rule" philosophy entered into his deliberations: in the wake of the extensive and successful *Entartete Kunst* campaign, Goebbels had become too powerful. Rosenberg's prior experience as editor of the *Völkischer Beobachter* and publisher of the NS-KG-sponsored magazine *Kunst und Volk* (which appeared 1934–38) was also in his favor.[52] There were also a host of other periodicals published by the Amt Rosenberg (including *Die Bücherkunde*, *Die Musik*, and *Germanenerbe*), which showcased the

Cover of art magazine Die Kunst im Deutschen Reich, *which Scholz edited from 1937–1944 (photo by author).*

agency's ideological work.[53] But the crucial factor was Robert Scholz. He had continued to write art reviews and had established himself as the leading Nazi art critic, and he had gained valuable experience as the executive editor of *Kunst und Volk*.[54] Scholz and his colleague within the Amt Rosenberg's Visual Arts Division, Werner Rittich (1906–?) (also a well-known critic and editor, who held the post of managing editor of *Kunst und Volk*), therefore were given the prestigious jobs overseeing *KiDR*, irrespective of the grumbling from employees in other ministries.[55] In 1939, *KiDR* had a circulation of 52,000, and this grew to 94,000 by 1943 (with 50,000 going to the armed forces).[56] In the words of a Propaganda Ministry employee, the magazine was "unique and unmatched [in placing] an artwork before the entire population and a grandiose means of propaganda for the art of the Führer and his *Volk*."[57]

One scholar noted that "Scholz's greatest success was the periodical, *Die Kunst im Dritten Reich*," and indeed, his renown as a critic only increased in the post-1938 period.[58] In his denazification proceedings, Scholz referred to the magazine as "my periodical."[59] Besides serving as editor, Scholz published sixty-two articles in the magazine between 1937 and 1944.[60] During this same period, Scholz penned ninety articles for the *Völkischer Beobachter* and wrote pieces for other publications, such as *Völkische Kunst*, *Kunst und Volk*, and *Norden*.[61] *KiDR* received some competition as the leading art magazine in Germany beginning in 1939 when Heinrich Hoffmann used his considerable financial resources to purchase a modest art magazine published in Vienna called *Kunst dem Volk* and transformed it into a national publication (he claimed that it "was making millions for him in a few months").[62] But there was enough room for both periodicals in Germany, and despite the rivalry (which some called a *feindschaft*, or enmity), Scholz's career as an art critic and editor flourished during the war.[63]

Through his art criticism and editorial work, Scholz had the power to promote the artists he favored, as well as to contribute to the articulation of the National Socialist ideology. His reviews, in particular, offered him the opportunity to combine both enterprises. As examples, one sees this in Scholz's reviews of exhibitions by the sculptors Arno Breker and Josef Thorak. His article discussing Breker's show in Paris in May 1942 is particularly important in this respect. The only German artist to be accorded the honor of a French venue during the war, Breker represented the cultural vision of those who sought to create the New Order. Scholz phrased this in his typically nationalistic way, noting that

"sculpture always stands at the beginning of new, politically distinct art epochs," and that Breker, "as the first representative of the art of a new Germany, signifies an equally deep and final rejection of the leading cultural circles of France."[64] Scholz also used this opportunity to develop one of the pet ideas of the Nazis: that they represented the continuation of classical greatness. Scholz was particularly fond of this notion—he was a member of the Winckelmann Society, a group devoted to the appreciation of classical culture—and he noted in the Breker article that "[Breker] here follows the spirit and the spatial principle of antiquity, without classicizing, that is, being an imitator."[65] The thesis here was that the Aryans followed in the footsteps of the Hellenes, but did not merely copy them.[66]

Scholz, as mentioned above, was also responsible for furthering the career of Josef Thorak. Besides organizing the important 1935 Berlin exhibition, he wrote a number of reviews of the artist's work and even planned a book-length treatment. One article on Thorak, commemorating the sculptor's fiftieth birthday in 1939, claimed that the artist was responsible for "documenting the great artistic impulse of the Third Reich."[67] The article was a masterpiece of puffery, telling readers that Thorak was not only the embodiment of Nazi cultural greatness, but a fine person, or in Scholz's words, a "rare type, of great natural development and in this sense a brilliant artistic personality."[68]

Whether elaborating on some ideological principle or promoting an artist whom he admired, Scholz approached the subject with an undeniable passion and energy. One Propaganda Ministry employee described his reviews as featuring "forceful language"—that is, they were powerful even by Nazi standards.[69] One gains a sense of the tone of his prose just from the titles of some of his articles: "Emigrated Art Bolshevism"; "Art Swindle of London"; "German Art in a Great Time"; and "Victorious Affirmation of Art."[70] Perhaps it is not surprising that Scholz's reviews featured such a strident tone. Scholars Norbert Frei and Johannes Schmitz noted some general features of the *Völkischer Beobachter*: "The overheated idealizing of the Führer, the constant celebration of inner as well as outer victories, [and] a combat style that was characterized by the constant utilization of superlatives, exaggerations, and distortions."[71] In a representative passage, Scholz noted about the London exhibition, *German Art in the Twentieth Century*,

As patrons of this supposedly "unpolitical" exhibition we find some very well-known individuals in the catalog. First of all is the

Der Bildhauer des Monumentalen

Professor Josef Thorak 50 Jahre

Robert Scholz article on sculptor Josef Thorak
from the Völkischer Beobachter, *7 February*
1939 (photo by author).

architect Le Corbusier, the internationally notorious propagandist of building bolshevism, the inventor of the idea of the "living machine," and the founder of communist periodical *L'Esprit Nouveau*, which arrived in 1925 with the emblem of the Soviet star and the sickle. Another patron of this exhibition is the Spanish Jew, the Cubist painter and sculptor Pablo Picasso, who as art commissioner for Red Spain decorated the pavilion of the bolshevist arsonists with his grotesque sculptures. And we are not surprised to find among the patrons of this exhibition the famous Czech literary and salon bolshevist Karel Čapek, the well-known hater of Germany. The excesses of these international bolshevists in the exhibition committee is sufficient proof of the purely ethical intentions of this show.[72]

This diatribe made use of his favorite epithet, "cultural bolshevism," and included a more rare invocation of anti-Semitism.

Although there is no doubt that Robert Scholz espoused racist views, he usually resisted explicitly anti-Semitic formulations in the magazine *Kunst im Deutschen Reich*, the venue for his most ambitious pieces. Scholz never articulated the reasons for this, but he presumably

believed that discussions of "meritorious" and officially approved art should not be debased by vulgarity. In a sense, it was a continuation of the earlier idea that art should ennoble the viewer (or in this case, reader). The more highbrow publications, such as the weekly newspaper *Das Reich*, rarely featured the kind of blatantly anti-Semitic language that was found in *Der Stürmer* (in every issue) and in popular periodicals like the *Illustrierte Beobachter* (in most issues). Scholz, therefore, wrote sentences like, "the life of the individual and of the *Volk* is a permanent struggle against foreign and hostile forces": a formulation perhaps more refined, but hardly less pernicious than the more coarse anti-Semitic propaganda.[73] The Nazi regime, then, attempted to indoctrinate the German people simultaneously via high and low culture, and certain individuals, like Robert Scholz, served to mediate between the different ranges of the spectrum.[74]

Scholz could, of course, be a vicious adversary, and his tenacious nature found expression in many of his battles. Perhaps the most vivid example came with respect to Emil Nolde, whom Scholz vilified from early in the Third Reich. Nolde featured prominently in Scholz's 1934 brief to Rosenberg about the reform of the arts administration and was a favorite target in Scholz's salvos during the Expressionism debate that raged from 1933 to 1935. Even though Nolde tried to support the regime—he signed an election poster during the 1934 plebiscite on Hitler's position as Führer—Scholz sustained his attacks. In fact, he complained to the Propaganda Ministry that Nolde should not be allowed to sign these posters.[75] Nolde never found the official acceptance that he sought. Over a thousand of his works were confiscated in the "degenerate art" action, and he suffered a general ban on creating new works (*Malverbot*) in 1940. Still, Scholz remained vigilant. When rumors circulated in 1942 that Baldur von Schirach, the Reich Governor of Vienna who was known for certain promodern predilections, had met with Nolde to discuss patronage (including putting a studio at the artist's disposal), Scholz went on the offensive. He filed extensive reports with Rosenberg about this "known painter of the period of decay" and created such a stir that Schirach's support for Nolde became prohibitively costly.[76] Around this time, Scholz also led the campaign against the Schirach-sponsored exhibition in Vienna, *Young Art in the German Reich* (*Junge Kunst im Deutschen Reich*), which featured certain works that contained provocative abstractions. Hitler personally ordered the show closed, and it is not clear whether Scholz's input figured into the equation. But in his report to Rosenberg, Scholz claimed

to have rallied the support of key cultural figures including Arno Breker and Albert Speer.[77]

Scholz's position as a senior editor (*Hauptschriftleiter*) and a high-ranking official in Rosenberg's agency afforded him tremendous power within Nazi Germany. Walter Hansen of the Propaganda Ministry discovered this when his attacks against Scholz backfired. The former made critical comments supposedly because of Scholz's support for certain modernist artists prior to 1933 and his Catholicism, but in reality it was a reflection of their mutual antipathy. Yet Hansen was the one whose career was ruined, and he was arrested by the Gestapo and temporarily imprisoned.[78] Scholz's position as editor of *KiDR* enhanced this power. In the case of an SS exhibition that appeared in Salzburg and Prague, SS-Lieutenant Dr. Kaiser from the SS Main Office reportedly threatened Scholz after he refused to run an article on the exhibition. Kaiser remarked ominously "that enough material about Scholz had been collected."[79] Yet nothing ever came of this threat, and he continued to wield considerable power.

To this end, Scholz branched off into another sphere in 1939 when he arranged to assume the directorship of the prestigious Moritzburg Galerie in Halle. Even though his other responsibilities prevented him from more ambitious programs, this position afforded him new opportunities to organize exhibitions and patronize artists. His assistant, Frau Dr. Henny Weber, claimed after the war in an attempt to exonerate him that "he had above all also advanced artists whose artistic direction deviated fully from the official Party line."[80] Although this exaggerates the heterodox views held by Scholz, he certainly had the ability to promote artists who were his personal favorites, and he did this for Otto Geigenberger from Munich and Bernhard Kretzschmar from Dresden. After the war, these and other artists wrote statements on his behalf testifying to his effectiveness as a sponsor.[81]

While Scholz had genuine concern for the careers of many German artists, he relished the power that his positions afforded him.[82] Scholz loved the title of museum director, and his interactions with Mayor Weidemann of Halle and with Rust's Reich Education Ministry, the two sources providing the bulk of his budget, made him feel more important. It is revealing that Scholz did the job for free; he refused compensation in order not to be guilty of receiving a redundant salary. Scholz craved power and prestige far more than money. While one cannot accuse him of personal greed, he rarely turned down new appointments. To take one further example, he was chosen in 1940 to join the

Commission for the Artistic Evaluation of Certain Public Monuments for the Collection of Metal.[83] Here, he and others reviewed the approximately 18,000 monuments in Germany and selected some 10 percent for smelting. As he described it, "in the easiest way German cities and communities will be freed of all tastelessness from earlier times in the realm of artistic monuments (*Denkmalkunst.*)"[84]

By 1939, Scholz had transcended any narrow professional definition such as art critic and was recognized widely for both his organizational talents and National Socialist convictions. Goebbels, who like the other Nazi leaders always sought to increase his power, tried to do this by hiring Scholz away from Rosenberg. In August 1939, he offered Scholz the position of Head of Division IX (Visual Arts) within the Propaganda Ministry. This post offered certain advantages in comparison to the one he held within the Amt Rosenberg. Most importantly, he would have had greater resources at his disposal and more ready approval for projects. The files on Goebbels's attempt to make this appointment are instructive. The Propaganda Minister solicited the opinions of other leading cultural figures such as Albert Speer and Frau Gerdy Troost, wife of the deceased architect who had designed the House of German Art. It is not clear whether Scholz would have been able to keep his positions as editor and museum director had he accepted Goebbels's offer, but this is certainly what he sought. Scholz even talked of retaining his post within the Amt Rosenberg. The idea, as stated by the head of personnel in the Propaganda Ministry was that "a union of both offices—here and under Rosenberg—in one person would, in the interest of a frictionless development of cultural political leadership, be held as possible and desirable."[85] Scholz asked that he be allowed to approach Rosenberg with the idea—knowing very well that his discussions with the Propaganda Ministry could be interpreted as disloyalty by the highly competitive Reichsleiter. Despite Goebbels's and Scholz's proposed bureaucratic maneuver, no reform took place because the war broke out the following week and the negotiations were halted.

Scholz's increasingly positive reputation among Nazi leaders also found expression in the campaign to award him with the title of professor, a mark of tremendous distinction in Germany. Hitler himself made such appointments, often to mark his birthday on 20 April. In late 1938, Rosenberg suggested to a number of Nazi leaders that the title be awarded to Scholz, and their positive responses encouraged him. Minister of Interior Wilhelm Frick supported the idea to the point where he lobbied the president of the Reich Chamber for Writing. Goebbels also

backed the nomination and sent it on to the Chancelleries of the president and the Führer, which handled the bureaucratic preparations of Hitler's honorary appointments. Goebbels added the suggestion that Hitler make the award during ceremonies marking the annual "Day of German Art" in July.[86] And Rudolf Hess, representing the Party Chancellery, added that "the awarding of the professor title to Robert Scholz would be very much welcomed from here."[87] Although there was widespread support for the honor, a problem arose with respect to the academic discipline in which Scholz would be acknowledged. The president of the Visual Arts Chamber, Adolf Ziegler, noted that he could not evaluate Scholz because the latter had not produced any artworks since 1933, and there was nothing in Scholz's Visual Arts Chamber file on this subject.[88] Seven months later, in July 1939, when the appointment had still not gone through, Ziegler weighed in again, telling Goebbels, "Scholz can only be addressed as a writer, although, he must be viewed as the ideal art critic/editor (*Kunstschriftleiter*)."[89]

Despite a general anticipation of the award—to the point where the actual document was produced and awaited only Hitler's signature—it never occurred.[90] This time it was not the war that interrupted the discussions, but the decision, made by Hitler personally, that "Scholz in his professional activity as an art critic/editor does not belong among the members of freestanding scholarship and art."[91] Hitler believed that art critics were not scholars, but mere cogs in the regime's propaganda machinery. A supporter of Scholz, the painter Professor Schuster-Woldan, tried to make the case that Scholz was also a scholar, citing his contribution to the 1937 book *Lebensfragen der bildenden Kunst* and the volume in progress on the sculptor Josef Thorak, among other evidence of art historical work.[92] But this appeal proved unsuccessful. The rejection of Scholz's appointment was a comment on his profession rather than a reflection of his reputation (as further indicated by Goebbels's contemporaneous efforts to recruit him). Scholz was deeply disappointed, but his career was in no way damaged by the process. In 1943, Hitler awarded him the Golden Party Badge, which was given to "leading men of art, scholarship, and the economy."[93]

With numerous professional accomplishments and such widespread accolade, it is difficult to explain why Robert Scholz took the path toward criminality at the start of World War II. Was it a product of arrogance, as in the case of Ernst Buchner? Did it stem from greed, as with Karl Haberstock? In Scholz's case, the primary motivation was, ironically enough, idealism. Many would find this difficult to grasp. The head

of the Ukrainian National Restitution Commission, Alexander Fedoruk, has written, "All those persons who pillaged cultural objects 'never had God in their hearts' and never believed in any ideals."[94] Even before the war, in 1935, one of Scholz's colleagues, NS-KG manager Walter Stang, accused Scholz of being an "opportunist" (*Konjunkturist*), that is, riding the wave of Nazi popularity for personal gain.[95] Yet Scholz did subscribe to certain principles. One was loyalty, and he was committed to serving Alfred Rosenberg in an honest and faithful manner. A second ideal concerned National Socialism, which he thought entailed the promotion of the racially determined German *Volk*, including its material enrichment. Although he had personal ambitions, Scholz was not venal, and he abided by a certain, if peculiar, code of honor. As OSS officer Plaut noted, "it is believed that the motivation for Scholz' activity with the Einsatzstab was essentially ideological rather than material, and that he derived no financial profit from the confiscations effected with his knowledge and under his direction. In addition to his salary as Bereichsleiter, Scholz claimed to have received a monthly expense allowance of RM 300, and to have received no further compensation whatsoever. This statement is believed to be accurate."[96] He undoubtedly believed himself engaged in what was termed an "ideological struggle" and was prepared to make certain sacrifices for the cause.[97] As one of the witnesses later testified in his denazification trial, "The belief in his mission [to the looting program], however, was greater than his objections."[98]

As Rosenberg's expert on the visual arts, it was understandable that he would be called upon to advise the newly created ERR about the disposition of seized works, although it should be noted that Scholz initially did not assume a leading role in the organization. Gerhard Utikal, Rosenberg's chief administrator within the Amt Rosenberg, headed the ERR's Central Office, and Kurt von Behr, a corrupt adventurer, took over the local operations in Paris. Scholz remained based in Berlin and was appointed coleader (with Kurt von Behr) of the Special Staff Visual Arts (also referred to as Special Staff Louvre) within the Amt Westen (Western Office) of the ERR.[99] His first inspection tour in Paris occurred in December 1940, when he went to investigate the progress that had been made in the program to secure the "ownerless Jewish property."[100]

Scholz arrived on the scene in the Jeu de Paume six months after the start of the ERR's looting program, and he found the operation to be consistent with the above-noted "ideals." Granted, Rosenberg had entered into an alliance with Göring. The Reichsmarschall had put

*Alfred Rosenberg and Kurt von Behr inspect
ERR depot in the Jeu de Paume, 1941
(Librairie Plon).*

many of his resources at Rosenberg's disposal, including the Foreign Currency Protection Commando (Devisenschutzkommando), the Luftwaffe rail network, and a host of informers and contacts. Göring also promised a more general type of support in the form of influence that Rosenberg believed was necessary in this highly competitive environment. Both Rosenberg and Scholz were naïve about the avaricious intentions of the Reichsmarschall; but they soon found out. Still, because Scholz's role within the ERR was a supervisory one (Kurt von Behr and the Dienststelle Westen were responsible for the actual seizure of the artworks), he felt somewhat removed from most of the sordid day-to-day events.[101] One should not get the impression that the plundering was orderly or systematic. There were many cases where ERR personnel acted on their own apart from von Behr. The staff was sizeable: a British report from 1945 listed over fifty individuals working for the ERR in France alone.[102] OSS officer James Plaut conveyed a sense of the Paris operation in his report, writing that "the Einsatzstab employed a number of irresponsible men who would simply collect a truckload of objects and carry them off to the Jeu de Paume."[103] But Scholz visited Paris seldom enough that he was able to sustain certain illusions.

Göring quickly co-opted the plundering agency for his own purposes, as he directed some seven hundred paintings from the Jeu de Paume depot to his collection at Karinhall near Berlin. These maneu-

vers were not entirely secret, as he made twenty trips to the Jeu de Paume between 3 November 1940 and 27 November 1942 to select the works he desired.[104] Yet his refusal to make payment, despite promises to the contrary, and other acts of subterfuge (such as removing works before they could be inventoried) were the result of his surreptitious co-optation of ERR staff members—most notably von Behr, Utikal, and art historian Bruno Lohse. It is unclear how Göring induced these employees to be directly disloyal to Rosenberg and indirectly to Hitler, Göring's rival when it came to artworks. Utikal's defection is most surprising considering his long-standing service to Rosenberg (the same was not true for von Behr and Lohse). When Scholz caught wind of the misappropriation of the plunder, he raced from Berlin to Paris to file a report. He was the one who arrived at the calculation of seven hundred works directed to Karinhall. He informed Rosenberg immediately and demanded that the Reichsleiter take steps to remedy the situation.

Because Rosenberg was reluctant to alienate the still powerful Reichsmarschall or repudiate employees in his service (who knew the details of the very complicated operation), Scholz had to use all the leverage at his disposal to effect the desired reforms. Scholz ended up playing his trump card. He threatened to resign from Rosenberg's employ and requested a transfer to the Eastern Front unless the situation in Paris was remedied. Scholz was in a certain sense bluffing because he knew that he was indispensable to his chief and because he suffered from painful ulcers that made him ill-suited to combat (Rosenberg later protected him from military service by writing to Bormann that Scholz's "severe stomach pains" prevented him from being "capable of war duty").[105] Still, Scholz as a true believer repeatedly requested the opportunity to fight in the Wehrmacht. Nearly all those in Rosenberg's employ volunteered and some, such as chief of staff Gotthard Urban, even died in action.[106] Scholz therefore argued in an August 1943 letter to Rosenberg, "the essential part of his work was completed, his co-workers could carry on, and his exemption should be lifted so that [he] could enter the army."[107]

The struggle for primacy within the ERR waged by Scholz and von Behr proved central to the history of the agency. As OSS officer Jim Plaut commented, "The personal and ideological conflict between the two men was the dominant element in the internal relations of the Einsatzstab."[108] Scholz garnered allies in this fight, most importantly Hermann von Ingram, one of the associate directors of the ERR branch in

Kurt von Behr and his wife, 1942 (NA).

Paris. The two delivered a report to Rosenberg in August 1942 that "stressed the chaotic conditions under which the professional art historians, through lack of adequate personnel and constant friction with von Behr, had been obliged to report."[109] Scholz argued that the most important works in Jewish collections had already been seized, and what was now needed was a period to organize and inventory the art stored in the Jeu de Paume. Rosenberg found this argument compelling and also became aware of the extent of Göring's influence over members of his staff. He therefore ended the feud, as well as Göring's co-optation of his agency, by transferring von Behr away from the Jeu de Paume to head the M-Aktion (short for *Möbel*, or furniture, action), the seizure of Jewish-owned household property that had begun in March 1942 and entailed sending seized objects to victims of bombing in the Reich.[110] Plaut concluded, "von Behr was ousted from his position at the head of the art staff in Paris early in 1943, and Scholz took the dominant role in the professional guidance of the staff, von Ingram assuming the primary responsibility for its administration."[111]

Scholz remained based in Berlin (in 1944, he married his secretary in

the ERR-Berlin office, Johanna Grossmann[112]) and therefore entrusted much responsibility to his deputies in Paris, art historians Bruno Lohse and Walter Borchers.[113] But he still possessed considerable authority—for example, he signed off on a plan to ship artworks plundered in Belgium and northern France to Germany in August 1943—and he was viewed by other figures in the occupation of France as someone to be consulted when it came to cultural initiatives.[114] Scholz, as evidence of the latter, was consulted by the Propaganda Ministry about a proposal to transform the Wildenstein art gallery in Paris into the Institute for German-French Culture and Art, an idea he supported enthusiastically.[115]

After 1943 the ERR was to a considerable extent under Scholz's control. He penned an important report, the "Interim Report," that Rosenberg gave to Hitler as part of a birthday gift on 20 April 1943.[116] This report provided a compelling brief for the ERR to continue their custodianship of the art looted from French Jews. Historian Matila Simon also noted that Scholz "made frequent trips to Paris, controlled the assignment and removal of all personnel working in Paris, ordered and directed the list of modern works to be sold or exchanged, and represented Rosenberg in relations with the Reich Chancellery, the Party, and the military when questions of art arose."[117] Indeed, Scholz became so involved in the plundering operation that he engineered the trading of a number of modern works in the ERR stockpile. These deals are particularly intriguing because they offer insight into both his ideological and moral makeup. Scholz seems to have truly believed the biological metaphors employed by the Nazis with reference to Jews and modern art. He subscribed to the notions that the presence of modern art and Jews in Germany would contaminate organisms that were pure and good (Scholz was known to deliver lectures with titles like "Art and Race," in which he linked the two subjects).[118] Although Hitler had decreed that no modern art could be imported into the Reich, certain officials interpreted this order as permitting the disposal of such art in protectorates like Bohemia and Moravia, which were not legally Reich territory. Scholz did not accept such legalistic solutions, and because he thought of himself a man of culture, he opposed the destruction of any valuable artworks, regardless of their aesthetic deficiencies. Granted, the ERR authorities were responsible for a fire outside the Jeu de Paume in the Tuileries in July 1943 that many have believed contained modern artworks.[119] But careful examination of this event provides compelling evidence that, as Scholz later maintained, the incinerated

objects consisted of "frames, photographs, reproductions, and unsigned works by amateurs."[120]

For Scholz, the obvious solution was to sell or barter the undesirable works. The OSS report stated, "Scholz is considered, instead, to have sponsored the commercial exploitation for Germany of such material as was 'unsuitable' ideologically for importation into the Reich."[121] Bruno Lohse testified that Scholz tried to arrange complicated three-way trades with ERR-confiscated objects that would benefit the Halle Museum, which Scholz still headed; he approached Paris-based dealer Gustav Rochlitz with several proposals.[122] There was even an effort in early 1942, based on an order given by Göring, for Rosenberg's office to take on the project of liquidating the remaining works of "degenerate" art that had been seized in the Reich, although this transfer of authority away from Goebbels's ministry never came about.[123] Scholz and his cohorts continued to focus on the works seized in the West and therefore arranged for the involvement of art dealers, including Theodor Fischer, who accepted ERR plunder (evidently knowingly, as the agency's stamp was on all works that went through their hands at the Jeu de Paume). Yet Scholz grew uncomfortable with the stunningly one-sided trades: in 1944, he cancelled a deal that would have sent sixty paintings, including works by Picasso, Braque, and others, to a Parisian dealer because the transaction proved too embarrassing; as Matila Simon noted, "the possibility for scandal was too obvious."[124] Because Scholz believed that he was savvy about the art world, he feared that he would be viewed as a simpleton if he gave up works in grossly asymmetrical trades. In this matter, Scholz appeared more worried about the opinions of the other art experts than those of the Nazi leaders.

The scope of authority of this talented cultural bureaucrat expanded even further during the war because his chief, Alfred Rosenberg, served as the head of the Reich Ministry for the Occupied Eastern Territories (RMBO). Scholz held a position within the RMBO as leader of the Cultural Political Division. Although he told OSS investigators that he never traveled to the occupied territories of the East on official business, the ERR was very active in the region.[125] True, Scholz was preoccupied with other projects, but he was also unable to find a niche in the East. In an April 1943 meeting, he complained to Rosenberg that amidst the chaos and competing organizations it was impossible to carry out any initiatives and that the work was a horrible "bureaucratic war" (*Aktenkrieg*).[126] Rosenberg continued to assert himself among the Nazi leaders competing for influence in the East, but with respect to

cultural objects, turned instead to art historian Niels von Holst (discussed in chapter 4), conscripting the Baltic specialist into the ERR-East. Scholz was a member of the ERR-East in name only.

Despite his increasing responsibilities, Robert Scholz continued to write art reviews throughout the war. Considering his activities in Rosenberg's office, it is rather remarkable that he still found time to keep abreast of the contemporary art scene and to visit galleries and museums. Yet as sculptor Richard Scheibe noted about Scholz during the war, "I often met him at art exhibitions and juried events, where we were both invited as judges."[127] Scholz's art criticism, quite understandably, often reflected his other activities. He wrote on Arno Breker's exhibition in Paris in May 1942 in part because his responsibilities within the ERR required him to visit the French capital.[128] Later, in 1944, he penned a kind of editorial for *Kunst im Deutschen Reich* on safeguarding art; while this article did not delve into technical issues or mention specific strategies or locales, it reflected his concern at the time as he played a role in storing the over 21,000 artworks seized by the ERR.[129] In terms of the mind-set reflected in his reviews, one sees, not surprisingly, a certain provincialism in his thinking that at times crossed over into ignorance. For example, he opposed a memorial ceremony for modernist architect Peter Behrens because of the latter's ties to "emigrants and art bolshevists," among them Walter Gropius who "today is an instructor at Harvard University in New York" [*sic*].[130]

Germany after the total war measures of 1943 was in many respects very different from what it had been during the first ten years of the Third Reich. Whereas earlier one measured political fortunes by the rate by which an office or scope of authority was expanded, in the post-Stalingrad period the ability to retain what one had became a symbol of stature. Because many of Rosenberg's offices were Party organizations—including the Amt Rosenberg and the ERR—and because his Reich Ministry for the Occupied Eastern Territories had become a phantom entity with the westward movement of the front, Bormann, the head of the Party Chancellery, was in an ideal position to usurp power from the vulnerable minister. He had begun to do this prior to the total war decrees of February 1943. A 26 January letter articulated his plan to liquidate the Main Office for the Cultivation of Art and transfer Scholz to the Eher Verlag, where he could continue to edit *Kunst im Deutschen Reich*.[131] Rosenberg's response was based to a large extent on the operations conducted by Scholz: the work of the ERR was not yet complete, and *KiDR*, the Führer ordered, must continue to appear.[132] The maga-

zine continued on, despite production delays and various obstacles (Scholz complained that it was difficult to obtain original artworks to photograph because they were all in protective storage). Its demise did not come until the printing facilities in Munich were destroyed by Allied bombs in late summer 1944.[133]

Scholz did what he could to enhance his visibility. He sent numerous photo albums to Rosenberg that chronicled the loot amassed by his staff, and he proposed ideas that highlighted the resources under his control, such as running an article in *KiDR* on the art secured by the ERR (to be entitled "Important Works of European Painting as an Enlargement of the German Museum Property").[134] In January 1943, Rosenberg had written to Bormann requesting that Scholz be awarded the Golden Badge of Honor by the Führer, so Bormann was clearly aware of the role played by "the chief exponent of questions of art in the Party, as Rosenberg described Scholz."[135] While Rosenberg was prepared to give up certain offices, such as those concerned with prehistory, the Kulturpolitisches Archiv, and the Foreign Policy Office, he believed it essential that the Main Office for the Cultivation of Art remain unscathed so that Scholz could continue his work.[136] By August 1944, Rosenberg reckoned that 70 percent of the "political leaders" in the Amt Rosenberg had left for military service.[137] As it turned out, Scholz and seven staff members (including his second wife, Johanna, who oversaw the Picture and Personal Archive of the Führer and the Archive of National Symbols, and his nephew, who was the chief photographer for the ERR in Paris) were allowed to continue with their cultural activities.[138] And these included not only cataloging the ERR plunder, but providing input on the list of artists to be declared irreplaceable (*UK-Stellung*) and thus exempt from military duties.[139] The latter again enhanced Scholz's status as an arbiter of visual arts policy during the Third Reich.

Scholz's career is also typical of those at the top of the arts administration because of his involvement in safeguarding artworks at the end of the war. Scholz, in the words of an OSS report, "was responsible not only for the scientific recording of all art objects confiscated by the ERR and for their shipment to Germany, but for the maintenance of the various deposits within Greater Germany to which the confiscated material was brought."[140] Scholz initially opposed the idea of placing the artworks in mines, ostensibly because he believed that the mines contained too much moisture (he was incorrect in this respect). Another reason for his objections was his fear that others would take over the

safeguarding operation.[141] In particular, Scholz distrusted the Special Project Linz employees and gradually developed a rivalry with Voss and others. This tension reflected the struggle over the ERR at the next level up in the hierarchy (between Rosenberg and Bormann, as well as between Bormann and Göring—the Reichsmarschall had still not been entirely ousted from the ERR).[142] Finally, Rosenberg and Scholz argued that a comprehensive inventory of the plunder was not yet complete, therefore necessitating their continued control of the agency and the art it had seized.[143] The two men, true to form, continued this fight until war's end.

Like the others involved in the safeguarding measures, Scholz gravitated to the Austro-Bavarian Alps in 1944. His office in Berlin was destroyed in bombing raids in November 1943, and he sought a rural headquarters from which to operate.[144] Scholz was also twice bombed out of his Berlin residence, and as a result, became one of the recipients of the Jewish furniture confiscated by his rival Kurt von Behr in the M-Aktion.[145] Scholz ultimately decided to move to St. Georgen in Attergau, Austria where he established his base and housed his staff, including his wife Johanna, in Schloss Kogl. Scholz therefore joined Buchner and Mühlmann in the midst of the drama that unfolded in the Alps at war's end. So many of the leading figures of the Third Reich gravitated to this area in 1944 and 1945 that two scholars were moved to write, "this idyllic charming valley in the Salzkammergut was a kind of microcosm in which the rise and fall of the National Socialist regime, the capitulation and occupation, the denazification and reconstruction of Austria took place exactly on a small scale."[146]

Prior to the German capitulation, Scholz had primary responsibility for the 21,903 artworks the ERR had seized from French Jews and removed to the Reich.[147] The last transport of plunder had left France on 15 July 1944, and as mentioned in chapter 1, based upon Ernst Buchner's suggestions the objects were stored in Schloss Neuschwanstein, fifty miles south of Munich. Some of the ERR loot was transferred to seven other repositories, including the Altaussee mine, where it was stored in chambers a horizontal mile into the mountain.[148] Scholz meanwhile was entrusted with protecting the ERR inventories, including a card catalog and photographic file that was the key to identifying the plunder and determining actual ownership.[149] So valuable were these records that when the Red Army captured Vienna in February 1945 and threatened to push on to western Austria, Scholz sent Bruno Lohse, an art historian colleague from the ERR Paris branch, to

Neuschwanstein to guard them. This decision was rather courageous, especially in light of the fact that Scholz supposedly received instructions from the Party Chancellery (that is, from Bormann via Hummel) to destroy all documentary materials.[150] Scholz also drafted a letter to Lohse and ERR photographer/art historian Günther Schiedlausky (1907–?), ordering the two to safeguard the plunder and the records and "turn them over to the American authorities at such time as Füssen might be occupied."[151]

Scholz's movements at the end of the war are not entirely clear. He remained based in Kogl, where on 2 May, he reportedly received an order from Bormann, transmitted by von Hummel, which supported Gauleiter, Adolf Eigruber's plans to destroy the artworks before they fell into Soviet hands.[152] Evidently, Scholz instructed Lohse and the others with whom he was in contact to subvert this plan in whatever way was possible. Yet Scholz was not inclined to risk his own neck to do so. One report has it that he and other staff members went into hiding as the Americans approached. This source, however, was Lohse, who depicted himself as the savior of the plunder, the one responsible for circumventing Eigruber's orders.[153] A balanced and realistic perspective has been offered by historian Ernst Kubin, who argued that Scholz "attempted to make it seem that his role was far more important than it actually was" and that saving the salt mine was "neither his function nor within his factual realm of possible influence."[154] It is difficult to ascertain whether Scholz actually obtained weapons for the local forces who fought to subdue the fanatical and persistent SS troops—as he claimed—or whether he was part of the group who confronted Eigruber's men at the mine and dissuaded them from exploding the eight cases, which each contained a 500–kilogram aerial bomb.[155] These dramatic events simply elicited too many competing claims of heroism. At best one can offer a general characterization of Scholz's sentiments at this time, as did Kubin with the summary, "Scholz was a declared opponent of the destruction planned by Eigruber. His comportment was without a doubt suitable for strengthening the will to resist [the SS] among the men on the mountain."[156]

Scholz was captured at Schloss Kogl on 6 May 1945 along with many other members of the ERR by the Forty-Fourth Infantry Division of the American Seventh Army. He demanded to speak with American officers, but they were preoccupied with members of the SS, whom they were attempting to capture and disarm.[157] On 7 May, Scholz finally met with Colonel Utterback and held a discussion that was translated by a

Baroness Dorothea Doblhoff. After this debriefing, Scholz left Schloss Kogl and was incarcerated near Linz at the Civilian Internment Center No. 7 at Peuerbach, which fell under the jurisdiction of Patton's Third Army.[158] The MFA and A officers attached to the U.S. Army, led by Captains James Rorimer and Robert Posey, soon came to visit. They had discovered the ERR loot in Schloss Neuschwanstein and now sought a complete account. Scholz was required to write of his deeds at the end of the war. His 20 May 1945 statement featured a cover letter to Robert Posey that boasted that the report would "not only give a documentary account for the occupation authorities which contained the most important episodes, but also a truthful account of the involvement of the Special Staff Visual Arts [of the ERR] concerning measures to prevent these acts of terror."[159] He told of his efforts to organize reliable men to take the endangered Altaussee mine "by force of weapons" and of his concerns about inciting the destructive faction.[160] Alternatively, he claimed to have attempted to meet with Gauleiter Eigruber. But this never occurred because he could not find him.[161]

Ultimately, the job of sorting out Scholz's account fell to the OSS, and they arranged his transfer to Altaussee, where he was interrogated at House 71 from 27 June to 15 July 1945.[162] Unlike Buchner, who made a rather favorable impression on the American agents, Scholz struck them as an extremely unsavory character. As Plaut wrote, "Personally, Scholz is shrewd, hypocritical, and unreliable. He made a poor impression on his interrogators by attempting throughout to minimize his own responsibility, cloud the dominant issues and implicate his collaborators."[163] Because Kurt von Behr had taken the bulk of the files belonging to the Rosenberg office (as distinct from the ERR inventories) with him to Cloister Banz in Franconia and because his efforts to conceal them had failed, the Allies possessed extensive documentation with which to investigate Scholz's deeds during the Third Reich.[164]

After his two-and-a-half week OSS interrogation, Scholz was incarcerated at Peuerbach in Upper Austria (from 15 July until 19 September). He was then transferred to Camps Markus, a "civil internment camp" in Salzburg for just over a month (until 25 October), whereupon he was sent to another camp run by the Americans at Maisach (until 8 November).[165] Scholz was subjected to further interrogations by the Counter Intelligence Corps (CIC) in late 1945: at Civilian Internment Encampment 10 in Altenstadt, where he remained and worked until 31 May 1946; at the internment camps at Dachau (until June 1946) and Augsburg-Göggingen, where he came under the watch of G-1, Ninth

Infantry Division of the U.S. Army.[166] Scholz continued to make a poor impression. The commander of CIC Augsburg Detention Center, Lieutenant Ernest Hauser, noted in one report that Scholz "still is convinced that Nazism is Germany's best program" so that he was "forced to consider him a security threat."[167]

While the OSS agents were unimpressed with Scholz's testimony and felt strongly that he be tried as a war criminal—they noted that he was the highest-ranking member of the ERR in captivity because von Behr had committed suicide and Gerhard Utikal had not been apprehended—they were not in a position to initiate a judicial process. Scholz lacked the stature to be tried with the major war criminals. Even later, there was no undertaking at Nuremberg for art plunderers comparable to that for doctors or the leaders of industry. The Americans therefore passed him over to the German authorities, and they in turn began the denazification process in the court that had been established at the Augsburg-Göggingen internment camp where Scholz was incarcerated.[168] The three-person commission, which tried Scholz according to the Law for the Liberation from National Socialism and Militarism of 5 March 1946, conducted an extensive investigation. They gathered testimony from numerous witnesses, including his former ERR colleague, art historian Günther Schiedlausky, sculptor Josef Thorak, and the restorer who oversaw the Altaussee depot, Karl Sieber. A host of others in the world of art and architecture also made statements, including modernist artist Oskar Nerlinger, Professor Fritz Höger (designer of the Chilehaus in Hamburg), and his former teacher, Professor Ferdinand Spiegel.

Scholz and his attorney mounted a defense that was simultaneously impressive and dishonest. First, they took advantage of Scholz's early sympathy for modernism and pointed to instances when he had defended artists whose work was labeled "degenerate." Witness after witness testified that he tried to mitigate the severity of the artistic policies and that he had opposed those whom Scholz's attorney called the "art popes of the time (Walter Hansen, Wolfgang Willrich, and Heinrich Hoffmann, among the circle around Goebbels)."[169] Scholz also claimed that he had saved individuals from concentration camps; in particular, three Dutchmen who supposedly faced death sentences from the SS. Additionally, Scholz had his former colleague in the ERR Paris branch, Walter Borchers, testify that he saved him from the Gestapo after Borchers uttered defeatist sentiments in 1944 (and by 1948, Borchers had already rehabilitated his career as a museum director in

Osnabrück).[170] There was an element of truth to these claims, but then again, almost every figure of influence in the Nazi government could have pointed to some act of compassion (even Himmler commuted sentences). With regard to his work for the ERR, Scholz claimed that all of the confiscations had taken place between June and December 1940 and that he had become active in the agency only in early 1941. Like many other ERR employees, he took advantage of von Behr's death and blamed everything on his old rival.[171] Furthermore, Scholz stated that his Special Staff Visual Arts only cataloged the looted artworks—contrary to the findings of the American CIC and OSS agents, who stated in their reports that Scholz's branch had engaged in confiscations.[172]

The court believed this rendition of events, for example, an excerpt of the verdict noted "[t]he European art world thanks the accused who through his careful and incorruptible registration and cataloging, has today again made a large portion of the otherwise lost artistic treasures accessible."[173] Moreover, the judges were led to believe that Scholz was responsible for the removal of the bombs from the Altaussee mine on 2 May 1945, when this was not the case.[174] Scholz even played upon the judges' sympathies by noting that he suffered from rheumatism and "nervous ailments" and that his mother was sick.[175] In short, while there were elements of truth in the claims he made to the board, there was also considerable deception.

Despite the judges' attempts at thoroughness, they were badly misled by Scholz. He had initially been charged with belonging to Group I, or those most culpable, but the verdict placed him at the opposite end of the denazification spectrum in Group V, among those deemed least responsible.[176] Moreover, he not only won release from prison, but unlike Ernst Buchner was exempted from paying for the costs of the trial: the RM 14,400 bill was picked up by the state.[177] This constituted a stunning victory. In light of his contribution to the regime—both in terms of aesthetic policy and the glorification of Hitler—and the grievousness of his crimes during the war, the March 1948 verdict of the denazification court could only be viewed as a travesty of justice. The exoneration of Scholz was nonetheless one of the many instances when a denazification board did not render a just decision. As historian Clemens Vollnhals wrote, "through the hasty conclusion of denazification in the summer of 1948, exceptionally light sentences came about, so that for many former Nazi activists, internment represented the sole punishment."[178] It is worth noting that the judges were not permitted to

see the files on Scholz created by the CIC and the OSS, but were limited to excerpts and information that was "orally transmitted" from U.S. officials.[179] The Americans had classified these documents and shared them with German authorities only in very special cases. This reluctance to cooperate clearly undermined the judicial process.

In the wake of this anemic effort of the German denazification board to bring Scholz to justice, the French government was compelled to act and demanded that he be extradited.[180] This effort also proved unsuccessful, but that did not deter the French from carrying out proceedings. Because French archival law does not permit access into judicial records until a hundred years after the event, it is not entirely clear what transpired. But in 1950 a Parisian Military Tribunal tried Scholz and five others involved in the wartime expropriation of artworks in France according to Article 22 of the Code of Military Justice and the Ordinance of 28 August 1944 concerning war crimes. Neither Scholz nor the director of Hermann Göring's art collection, Walter Andreas Hofer, were present. Yet others involved in the ERR looting program, including Bruno Lohse, Georg Herbert, Arthur Pfannstiel, and Gerhard Utikal (the latter having finally been apprehended) did appear before the Tribunal Militaire in the Caserne de Reuilly in Paris.[181] Although tried in absentia, Scholz was represented by a team of French and German lawyers.[182] Dr. Klaus Voelkl from Nuremberg was particularly important for his defense, and he argued that his client had secured only property that had been abandoned by Jews who had fled. In short, he contended that Scholz was engaged in a safeguarding action that was actually laudable.[183]

The Paris trial proceeded expeditiously despite the persistent and resourceful efforts of the defense counsel. After three days of debate, both sides rested and the verdicts and sentences were handed down.[184] Lohse was found guilty of looting but set free (the Americans had recommended leniency because he had helped them locate missing works and because they recognized his attempts to mitigate the damage done by the ERR).[185] The functionaries Herbert and Pfannstiel received one and three years, respectively. The degree of Scholz and Hofer's guilt, however, prompted the harshest sentences. For having been found responsible for looting artistic objects in France, they received ten years in jail, which of course they never served.[186]

Scholz avoided imprisonment in France, but he kept an extremely low profile during the 1950s. In fact, these are missing years in his biography. The Americans contacted him in February 1949 and asked him

to come to the Central Collecting Point in Munich to help identify art-
works. According to the archival records, this is the last time he was
heard from for over a decade.[187] There were evidently efforts by gov-
ernment officials to locate him. As a result of a 1955 treaty between
Germany and France, the Germans pledged to renew their efforts to
repatriate artworks seized during the war, and a Frankfurt-based agency,
the Federal Office of External Restitution, undertook "an intensive
search for former ERR staff in the years that followed the signature of
the treaty."[188] The rationale underlying this effort was that the former
plunderers possessed knowledge about displaced art that was still miss-
ing. It is not clear whether these initiatives yielded any useful informa-
tion, but the fact remains that Robert Scholz was not found at the time,
even though he continued to live in the town of Fürstenfeldbruck near
Munich, which remained his home until his death. He surfaced only in
1960—once again an art critic—as he began writing for the extreme
right-wing paper, the *Deutsche Wochen-Zeitung*.[189] Because of his Nazi
past and the revival of his career in radical right circles, one suspects
that he received assistance during the 1950s from the mutual aid
groups that developed among Nazis after the war. But there is no hard
evidence for this (documentation for such activities being extremely
scarce).

It is only with Scholz's tentative efforts toward rehabilitation in the
early 1960s that one finds an address for him: in the town of Fürsten-
feldbruck, which is where he had lived since the late 1940s after his
internment.[190] Evidently he evaded justice merely by staying in his
hometown and refraining from publishing. When he did resurface in
the press, Scholz did so in an extremely circumspect manner, despite a
readership that was undoubtedly well-disposed toward him. In a 21
May 1960 piece in the *Deutsche Wochen-Zeitung*, he signed only "Sch."
By 1962, he had expanded this abbreviation to "R. Sch." It was not until
30 November 1963 that he attached his full name to a piece.[191] The rea-
sons for his secrecy can only be presumed, but his fugitive status was
probably a factor.

Scholz began to publish again seemingly because he could not con-
trol himself. He had too much he wanted to say. This was also the time
when the pioneering scholarly works on the Nazis' art policies and loot-
ing were produced. Rose Valland, for example, the Parisian curator who
had stayed on at the Louvre and informed the French resistance about
the ERR's activities, published her memoirs in 1961 and accused Scholz
of complicity in the burning of artworks in the Tuileries 23 July 1943.[192]

The journalist and dealer Wilhelm Arntz continued the investigation and published a series of articles in the magazine *Das Schönste* in 1962 elaborating upon these charges.[193] Arntz cited Valland's claim that 500 to 600 modern paintings, including works by Miro, Klee, Picasso, and Max Ernst, were incinerated upon Scholz's orders. Arntz's series of articles provoked Scholz to write the magazine on 10 August 1962 and then again on 22 October. The editor of *Das Schönste*, Herr Breil, was initially reluctant to publish the response, and Scholz's second letter was accompanied by a statement by his attorney from the 1950 Paris trial (Klaus Voelkl).[194] Ultimately, the magazine published an edited version of Scholz's rejoinder, where he denied burning any works of value (only frames and "worthless things").[195] Furthermore, Scholz claimed that he had not been found guilty of such destruction by the Parisian Military Tribunal (and phrased this point to sound as if he had won a more general acquittal).

Scholz managed to return to his writing on art, but his postwar rehabilitation differed from the other figures in this study in that he found his niche within far right-wing circles. By the mid-1960s, he was a regular contributor to the *Deutsche Wochen-Zeitung*, publishing a review almost every other week. In fact, he soon became the department chief (*Ressortleiter*) of the cultural section of the paper, although he answered to the editor of the domestic and cultural political section, Heinrich Härtle, a former colleague within Rosenberg's DBFU.[196] The *Deutsche Wochen-Zeitung*, a weekly paper with a circulation of about 25,000, was founded in 1959 and in its first year was already running advertisements for Holocaust denier Paul Rassinier's book *The Lie of Odysseus*, as well as taking up themes such as Rudolf Hess's "unjust" imprisonment.[197] The paper eventually became part of the vast media network created by right-wing activist Gerhard Frey. Even prior to its absorption into Frey's empire, many of the articles in the *Deutsche Wochen-Zeitung* appeared in the *Deutsche Nationalzeitung* and the *Deutsche Anzeiger*—the latter, the official organ of the extreme right-wing party, the Deutsche Volksunion.[198]

Not surprisingly then, Scholz's journalism in this second incarnation showed many similarities to his work during the Third Reich. Most notably, there was the continued abhorrence of abstract art, his belief that art dealers were promoting this art for pecuniary reasons, and his penchant for phrases like "cultural bolshevism" and "modern antispirit(*"Ungeist"*) that echoed their Nazi provenance.[199] A list of article titles conveys the essence of his views: "The Wave of Artistic Decadence

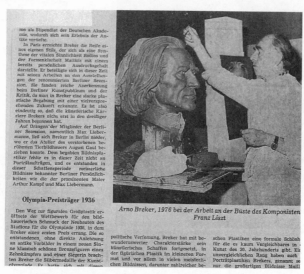

Arno Breker, 1976 bei der Arbeit an der Büste des Komponisten Franz Liszt

Robert Scholz article on Arno Breker from the
Deutsche Wochen-Zeitung, *17 October*
1980 (photo by author).

Subsides"; "Fantasy Prices for a Picasso Picture"; "Drawing and the Art of Decay: Supposition of a Change"; and "Actualization of Artistic Nihilism: A New Malevich Discussion."[200] Similar to his views concerning many styles of modern art was his continued praise for representational and monumental works. He wrote laudatory pieces about former Nazi artists, such as Wilhelm Peterson and Arno Breker. In a tactic commonly used by those in the radical right circles, he described their pre- and postwar accomplishments as part of a single continuum, with no critical observations about the Nazi period. About Peterson, Scholz noted that he was "named a professor in 1938. He received the Schleswig-Holstein Art Prize in 1940, the Honor Ring of German Cultural Achievement (*Deutsches Kulturwerk*) in 1969 and the Friedrich Hebbel Prize in 1975."[201] For many in these circles, it was as if nothing had changed since the 1930s. Scholz stressed continuity in his reviews. The piece noted above added that the "work and personality of Peterson confirms the belief that the spirit of the great German art tradition still lives, despite the current artistic decline."[202]

Although Scholz continued to combine nostalgia with cultural pessimism, his views evolved in certain respects. While he remained obsessed with ethnicity and commented frequently on individuals' Jewish heritage, this did not preclude a positive evaluation. Thus, for

example, Scholz praised the work of Max Liebermann on the thirtieth anniversary of the artist's death.[203] One gains the sense that Scholz could never entirely free himself from his prejudices. Liebermann is described as the "son of a rich Jewish commercial family."[204] But there were never any explicitly anti-Semitic remarks. (One might also recall that Scholz had praised Liebermann's work before 1933: so how much did he really grow?) But Scholz seemed to make an effort to be more open-minded about artistic styles. He evinced a sincere appreciation of Impressionistic painting, and even, on occasion, praised "classic" modernism, including "classicists of expressionism" such as Kokoschka, Schmidt-Rottluff, and Erich Heckel.[205] Scholz, however, was no friend of modern art, and the above-noted praise for certain artists was not only exceptional, but used in a broader attack against prevailing aesthetic tendencies, to grant Kokoschka and others some credit in an effort to decry other contemporary developments. And if an artist showed any connection to communism or the Soviet Union—such as Picasso and Malevich—they were almost certain to come under attack.

During the last twenty years of his career as an art critic, Scholz worked out his feelings about the National Socialist epoch in his writing. First, he attempted to defend the National Socialist art policies and the products that they helped yield. In one article, for example, entitled "Falsified Art History: Art Evidently Did Not Take Place in Germany Between 1933 and 1945," he maintained that those with a left-wing *"Kunstideologie"* had portrayed the art of the Third Reich as unremittingly bad.[206] In fact, he argued that sculpture in this period had enjoyed a particularly successful revival. Focusing on Georg Kolbe, whom he claimed was underappreciated, Scholz noted "long after 1945, the person and the work of Kolbe was taboo because of his positive evaluation in the Third Reich."[207] In other pieces, including the last article he wrote prior to his death, Scholz praised the work of Arno Breker.[208] His essay "Speer Against Speer: Betrayal of His Own Architecture" also proved memorable, as he castigated the Nazi architect for a critical reassessment of architecture during the Third Reich and for helping the "critics in the service of a historical condemnation of the epoch."[209]

A further effort to work through his past appeared in the article "Art Looting Under Napoleon," published in the journal *Deutsche Klüter-Blätter*.[210] This periodical, which was a more highbrow organ of the radical right, was a favorite venue for Scholz and others with kindred views (Heinrich Härtle from the *Deutsche Wochen-Zeitung* was a copublisher and editor).[211] In 1979, Scholz published twelve articles here, but in

light of his history as an art plunderer, his review of Paul Wescher's book, *Kunstraub unter Napoleon*, stands out. Scholz's attempts at exculpation repeatedly appear in this piece, as in his claims that the French emperor, "with the powerful extent of his art plundering in the campaigns between 1794 and 1814, as it were, therein set a historical world record."[212] Other sections are even more haunting. For example, he describes the Napoleonic "art experts and scholars . . . who confiscated and transported away to Paris the most valuable artworks and antiquarian objects out of public and at that time mostly royal and aristocratic property."[213] Scholz seemed to be describing his own experiences, which included the tactic of expropriating artworks during hostilities and confirming their transfer at the peace table—precisely Hitler's intention. Scholz's concluding remarks were also revealing. Typical of those on the extreme right, he cast Germans as victims. Moreover, he commented on historical parallels between the Napoleonic wars and World War II, and noted how "the book is also very instructive in connection with the evaluation of historical facts, such as how Germany experienced the collapse [in 1945]."[214]

By pointing to earlier wrongs endured by Germans, Scholz sought to rationalize his behavior: he and other Nazi art experts were only trying to address long-standing injustices. The reference to the Allies' depredations at war's end also served this purpose; if one accepted that all victors engaged in looting, there was nothing exceptional about the Germans during World War II. This attempt to relativize the Germans' wartime behavior, which predated the efforts of more mainstream conservative historians in the 1980s (see chapter 5), extended beyond generic revisionism in that it contributed to a larger project of many on the extreme right. As another contributor to the *Klüter-Blätter* noted in summing up the periodical's thirty-year history, they sought "to mobilize all remaining healthy internal forces in the European realm as a bulwark against the red flood from the East as well as the wave of Americanization."[215]

Members of the extreme right-wing in postwar Germany continued the Nazi tactic of using culture not only to express political ideas, but also to forge interpersonal connections. Through newspapers like the *Deutsche Nationalzeitung*, the *Wiking Ruf*, and the *Deutsche Wochen-Zeitung;* periodicals such as the *Deutsche Klüter-Blätter;* newsletters; and books published by presses like the Druffel Verlag (Leoni am Starnberger See), the Grabert Verlag (Tübingen), and the K. W. Schütz Verlag (Preussisch Oldendorf/Göttingen), they maintained a separate,

almost parallel culture to the mainstream one of the democratic and tolerant Federal Republic of Germany (FRG).[216] Of course, this was hardly a peaceful coexistence. By 1980, the right-wing publisher Gerhard Frey had already endured his 450th charge for promoting fascism or undermining the memory of victims. Yet even by this point he had not been convicted.[217]

This subculture fostered by the extreme right stands as a testament to the tolerance of the FRG: the government allowed these old Nazis to exist and to speak their minds (despite elaborate regulations limiting the distribution of Nazi ideas and cultural artifacts). But it remains disturbing that individuals like Scholz could successfully rehabilitate their careers with such unreconstructed views. And clearly he was not alone among the old Nazi art critics who returned to the cultural scene. Hans Severus Ziegler, who was a well-known journalist and propagandist prior to the Nazi seizure of power, also made regular contributions to the *Deutsche Wochen-Zeitung*.[218] The most famous Nazi visual propagandist, Hans Schweitzer (discussed in greater length below), who served under Goebbels in the Propaganda Ministry, revived his career in the postwar period by contributing anticommunist illustrations (such as the well-known *"Where To? End Station Moscow"*) to the *Deutsche Wochen-Zeitung* and other journals. Herbert Jankuhn and Hans Reinerth, leading figures in Himmler's cultural (and plundering) organization the Ahnenerbe, revived their careers as scholars of early German tribes and continued to publish into the 1990s.[219] Another figure, Jürgen Peterson, whom Norbert Frei and Johannes Schmitz labeled a *"Kulturjournalist*," had been one of the featured writers for Goebbels's prestigious paper, *Das Reich*. Peterson enjoyed a successful postwar career and ultimately served from 1961 to 1974 as director for cultural programs of German radio."[220] Postwar journalism, including art and cultural criticism, perhaps more than any other public occupation, sustained the revival of former Nazis' careers.

In the 1970s and 1980s, Scholz also turned to writing books. In 1977, he published *Architektur und Bildende Kunst, 1933–1945*, with the Preussisch Oldendorf Verlag. In this handsome volume—if one can say that about a book on Nazi art—Scholz repeated his defense of the artistic policies and products of the Third Reich.[221] He boasted of greater popular interest in art, of the financial well-being of artists (the *Great German Art Exhibitions [Grosse Deutsche Kunstausstellungen* or *GDK]* were a viable marketplace for their works), and, of course, of the genius of leading artists like Breker and Thorak.[222] Scholz also claimed that

many highly regarded figures in the arts supported the policies. For example, art historian Heinrich Wölfflin was supposedly a founding member of the Combat League for German Culture as he and others attempted a defense of European culture.[223] The most provocative of Scholz's claims came with respect to modern artists. While he continued his attack on supporters of the avant-garde (he tore into Ludwig Justi, the great director of the Berlin Nationalgalerie for buying such art), he also claimed that modern artists never suffered. His old bête noire, Emil Nolde, supposedly never experienced the *Malverbot* (never mind that the letter from the Propaganda Ministry forbidding him to paint had been published in the postwar period) and lived in a "luxurious residence."[224] The real objects of Scholz's ire, beyond the museum directors and artists, were the art dealers. He revived the old Nazi antipathy for the vendors of art and claimed not only that they profited on all sorts of art without any scruples, but that they initiated the "degenerate" art campaign for personal gain.[225] He decried them for their hypocrisy. While supposedly safeguarding this art, they were in fact arranging for its confiscation and sale (a claim with special irony because Scholz himself was on the Disposal Commission). About the only redeeming part of this tome was Scholz's remorse for the "degenerate" art show. While he himself denied any responsibility for it, he at least recognized that it was a mistake.[226] In particular, he noted that the show failed to take into account the evolutionary stages experienced by artists, giving as an example, Franz Marc, who in spite of his abstracted images was talented and really did possess a certain "artistic idealism."[227]

In 1980, Scholz published a subsequent book, entitled *Volk, Nation, Geschichte: Deutsche historische Kunst im 19. Jahrhundert*. While the title echoed the author's past—it was only marginally better than the official Nazi slogan of "ein Volk, ein Reich, ein Führer"—little else in the tome disclosed the previous history of the author. This was also the case with the earlier *Architektur und Bildende Kunst*: there was no biography of the author or preface. Rather, Scholz and his publisher attempted to give the impression that this work was an "objective" and conventional art history work. In fact, both books are more propaganda than scholarship. The texts are short (fifty-two pages in the case of *Volk*), and there is little scholarly apparatus. Rather, Scholz engaged in a veiled attempt to rehabilitate his pet ideas and favorite Nazi artists. Thus, for example, he put a reproduction of the work of one of his favorites, painter Wilhelm Peterson, on a full-color plate opposite the title page of *Architek-*

tur, and, in *Volk*, he included works by his old teacher, Arthur Kampf (one as late as 1915), and by his former Nazi colleague Wilhelm Kreis, alongside of works by Caspar David Friedrich, Adolph von Menzel, and other nineteenth-century artists. This was a variation of an old Nazi technique: to compare art they liked with more respectable precedents (Hitler thought Spitzweg to be the heir of Rembrandt). Sections of Scholz's text in *Volk* reverberate with Nazi ideas and rhetoric, although one must know something of the author in order to read between the lines.[228]

While these books from the 1970s and 1980s suggest that Scholz was in many respects still an unreconstructed Nazi, they did represent a slight change because, as noted above, he had softened his opposition to Impressionism, and because of his tone. The once aggressive and vitriolic critic had adjusted his rhetorical style to become more subtle and less ostentatious. Still, this transformation was more tactical than substantive. The racial and nationalistic principles that provided the underpinning of his worldview were still there, and Scholz could not help but advance his ideas in a polemical way.

Robert Scholz died shortly after the publication *Volk, Nation, Geschichte*. His obituary appeared in the *Deutsche Wochen-Zeitung* on 30 January 1981, which indicates that he passed away sometime after the first of the year.[229] No cause of death was given, and the quarter-page remembrance lacked details about his life. His earlier positions as a critic for the *Deutsche Tageszeitung* and editor for *Kunst im Deutschen Reich* were noted, as was his post as director of the Moritzburg-Museum in Halle. But there was no mention of his association with the *Völkischer Beobachter*, his work for the ERR, or his trial in France after the war. One of the interesting aspects of the obituary was its author, Erich Kern, whose full name was Kernmayr. Kern, who died in 1991, had been an SS-lieutenant and later a key employee of the SS veterans' organization (Hilfsgemeinschaft auf Gegenseitigkeit [HIAG], Auxiliary Fellowship for Reciprocity), as well as a prominent member of both the radical right-wing Nationaldemokratische Partei Deutschlands and the Deutsche Volksunion.[230] This unrepentant and unreconstructed Nazi, born like Scholz in Austria, worked to maintain the personal bonds left over from Third Reich. Scholz, of course, was part of this world, and so there is an element of truth in Kern's closing lines: "his death leaves behind a gap that cannot be filled; not only in our circles, but among those who are still dedicated to the beautiful."[231]

Scholz became a sincere believer in the National Socialist ideology,

Zum Gedenken an Robert Scholz
Der feinsinnige Künstler und unbestechliche Kämpfer hat uns für immer verlassen
Ehre seinem Angedenken

Robert Scholz wurde 1902 im mährischen Olmütz geboren und studierte nach dem Besuch des humanistischen Gymnasiums von 1920 bis 1924 an der staatlichen Hochschule für Bildende Künste in Berlin. In den Jahren 1924 bis 1927 war er im Fach für Kunstgeschichte Meisterschüler der Preußischen Akademie der Künste bei Professor A. Kampf.

Nach längerer Tätigkeit als Kunstkritiker bei der Deutschen Tageszeitung in Berlin wirkte er von 1937 bis 1944 maßgeblich als Hauptschriftleiter der Zeitschrift „Kunst im Deutschen Reich" und trug wesentlich zur Gestaltung dieses Blattes bei.

Im Jahre 1938 wurde Robert Scholz die Leitung des Moritzburg-Museums in Halle an der Saale als Direktor übertragen.

Nach Kriegsende betätigte sich Robert Scholz als freier Schriftsteller und Mitarbeiter der wenigen nationalen Blätter und betreute vor allem als Ressortleiter den Kulturteil der „Deutschen Wochen-Zeitung". In den „Klüter Blättern" erschienen seine Beiträge ständig.

Darüber hinaus erschienen aus seiner Feder die Werke: „Lebensfragen der Bildenden Kunst", „Vom Eros der Kunst", „Meisterwerke der Form und Farbe", „Architektur und Bildende Kunst 1933 bis 1945", „Große deutsche Baudenkmäler" und soeben als letztes Werk „Volk-Nation — Geschichte, deutsche historische Kunst im 19. Jahrhundert".

Daneben erschienen die Sonderdrucke „Architektur und Lebensqualität" sowie „Dürers lebendiges Werk". —

Robert Scholz war nicht nur der herausragende kulturpolitische Publizist in unseren Reihen, er

Robert Scholz
Er bleibt uns unvergessen

war auch ein tapferer Kämpfer gegen die Pervertierung der Kunstidee, und seine Aussagen, wie z. B. folgende, sind von bleibendem Wert:

„Den gesund empfindenden und klar denkenden Menschen ergreifen tiefes Unbehagen und schwere Besorgnis, wenn er wahrnimmt, in welch erschreckendem Ausmaß das Kulturleben und Kunstschaffen der Gegenwart von künstlerischer Abartung, Absurdität und Barbarismus unterjocht werden. Ein großer Teil des Publikums nimmt aber den herrschenden kulturellen Anarchismus aus Uninteressiertheit oder einer materialistisch-egozentrischen Lebenseinstellung nicht wahr. Dabei ist der kulturelle und künstlerische Verfall im Grunde gar nicht überprüfbar, da seine Produkte mit rücksichtsloser Brutalität der Öffentlichkeit aufgezwungen werden."

●

„In den antirationellen, sogenannten modernen Kunstrichtungen gibt es den Begriff der Schönheit überhaupt nicht mehr. Schöne Kunst, dieser Begriff ist im Munde modernistischer Kunstideologen und Theoretiker zu einem Schimpfwort geworden, man spricht unter modernistischen Intellektuellen vom Kunstschönen genauso verächtlich, wie man heute abwertend von der „heilen Welt" spricht, wenn man die kulturelle Tradition und die Grundsätze der konservativen Weltanschauung abwerten will. An die Stelle des Schönen ist im modernen Kunstbetrieb der Kult des Häßlichen und Absurden getreten. Ebenso deutlich und geistig zusammenhängend sind die Hinwendungen und das Interesse der kulturellen Schickeria zum seelischen und geistig Kranken, in dem moderne Kunstpsychologen eine reine Quelle künstlerischer Inspiration und Kreativität zu erkennen glauben. Die Pervertierung der Kunstidee geht bereits soweit, daß bildhafte und plastische Erzeugnisse von Geisteskranken und Insassen von Irrenhäusern in Ausstellungen öffentlicher Kunstbetriebe als Werke von echtem künstlerischen Wert präsentiert werden."

Unbestritten ist, daß Robert Scholz entscheidend gegen diese Zerstörung der Kunstidee angekämpft hat und damit nicht unwesentlich dazu beitrug, da der Begriff von Kunst im wahrsten Sinne der Bedeutung doch in einem großen Teil der Bevölkerung erhalten blieb.

Sein Tod hinterläßt eine nicht zu schließende Lücke. Nicht nur in unseren Kreisen, sondern bei allen jenen, die dem Schönen noch ergeben sind.

ERICH KERN

Obituary of Robert Scholz in the radical right-wing newspaper Deutsche Wochen-Zeitung, *30 January 1981. The headline reads, "Thoughts of Robert Scholz: Broad-Minded Artist and Incorruptible Fighter Has Left Us Forever."*

and his Faustian bargain came more from his desire to lead a crusade than from personal ambition or greed. His journalistic efforts in the 1930s contained an earnestness that is undeniable. And even when engaging in plundering in Paris during the war, he abjured personal enrichment and turned down offers from Göring to take pictures.[232] Yet one cannot exonerate him. James Plaut of the OSS noted in 1945, "It has not been established finally to what degree Scholz personally initiated German policy . . . all the evidence at hand would indicate that he was a burning protagonist of National Socialist cultural ideology, and that he participated actively in the 'struggle against Jews, Freemasons and enemies of the Reich.'"[233] What is evident first and foremost was the fervor of Scholz's convictions, and it was this belief in National Socialism that led him back to the radical right in the 1960s. More uncertain is the impact that Scholz had on the Nazi regime's policies. He himself con-

tributed to the impression that he was unimportant because he denied responsibility for events. For many years, Scholz was successful in convincing both investigators and historians that an art critic was peripheral to the Nazi regime. But the expertise that he possessed—he was arguably the most knowledgeable person during the Third Reich concerning contemporary art—helped the top leaders to carry out their criminal programs. Scholz, all denials aside, was the most important Nazi art critic and an outstanding example of how the second-tier operative was central to the National Socialist administration.

- - -

The leading figures in the field of art criticism in the Third Reich possessed certain skills, although the general level of writing declined in this period. They frequently were able to articulate the tenets of National Socialism in vivid terms that the masses could comprehend. Hitler, of course, had promulgated the idea of an art for the masses. One of his criticisms of modern art was that it was so esoteric it could be understood only by an elite. The art journalists played an important role in popularizing the Nazis' arts program. The fact remains that more people were exposed to works of art (and also theater, music, movies, and other kinds of culture) during the Third Reich than in any previous period of German history. While technological developments helped in this respect—relatively new media like film and radio, for example, were utilized to record tours of the annual *GDK* or to broadcast Hitler's and Goebbels's speeches on art—the regime also invested heavily in programs that exposed the masses to art. Outings to museums through the Strength Through Joy organization, as well as the special issues of art magazines and exhibition catalogs sent to the troops, offer cases in point.

In addition to serving as popularizers, art critics and publicists were often skilled polemicists. More specifically, they relished the opportunity to attack real and perceived enemies. This was true with Robert Scholz, who wrote a number of articles excoriating various artists and their ideas. Even more aggressive was Wolfgang Willrich (1897–1948), who made a name for himself through his first book, *The Cleansing of the Art Temple* (1937), which he described in 1941 as "the first strike in the great cleansing of art in 1937"; the book proved so radical and venomous with respect to modern art that even Alfred Rosenberg and Robert Scholz thought it too extreme.[234] Willrich himself was a painter

and specialized in portrayals of "racially pure" types that were every bit as stiff as Adolf Ziegler's frozen nudes (his work was showcased in a two-volume publication with the stilted title of *Nordic Blood Inheritance in the South-German Peasantry*).[235] While his art in itself did not suggest an agitated creator, Willrich was, even by Nazi standards, unusually vitriolic in his defense of a blood-and-soil vision of German culture. For starters, Willrich was a member of the SS. And one report noted that "Willrich was characterized by his own Party comrades as a pathological denouncer."[236]

Due to this reputation, he was one of the first to be charged by Goebbels to investigate the feasibility of purging state collections of modern art. Goebbels was not entirely sure of this project in 1936 when he commissioned Willrich to initiate it (the charge grew out of preparations for an ideological exhibition called *Give Me Four Years' Time*, which was to document how Germany had been transformed since the Nazi seizure of power), and as a result of this uncertainty, Willrich's efforts foundered. But Willrich's outlook remained unchanged. Earlier, Heinrich Himmler, of all people, had grown tired of Willrich's vituperation and wrote his SS subordinate after the latter's attacks against poet Gottfried Benn that "it would be more prudent for him to continue painting decent pictures than to pry into people's pasts and to persecute them until their very lives were destroyed."[237] Willrich was never able to follow this advice, yet his career as an art journalist, like that as an artist, never took off as he had hoped. His influence during the Third Reich remained limited, and he died embittered in 1948.

The same unrealized ambition applied to his main ally in the battle against modern art, Walter Hansen. Hansen was a well-known Nazi art critic who wrote for the SS paper *The Black Corps*, as well as the more obscure official publications, *The SA-Man* and *School Letter of Dr. Ley*.[238] Hansen, who was also known in professional circles for his strident anti-modernism (he was the one who attacked Rembrandt as "a painter of the ghetto" at Baudissin's meeting of museum directors) later gained broader exposure as a result of his infamous book, *Jewish Art in Germany*, an anti-Semitic diatribe published in 1941 by the Nordland Verlag, which Himmler and the SS operated.[239] Hansen worked closely with Willrich: the two collaborated in the early but largely unsuccessful effort to initiate a general purge of state collections. Among the opinions shared by the two agitators was a hatred of Robert Scholz and his aide, Werner Rittich, whom they saw as malevolent and misguided rivals.[240] Hansen attacked Scholz in a letter to Goebbels, in which he

complained that Rosenberg's expert supported modern art and served as an agent of the Catholic Church.[241] Hansen added that Scholz had stolen Willrich's ideas and then packaged them in a "powerless and philosophically saturated manner that our people could not understand."[242] Scholz responded with a defamation suit filed in the Nazi Party Supreme Court, and although the charges were dropped due to the exigencies of war, Hansen was put on the defensive.[243] Goebbels decided that employing Hansen was too much trouble and Scholz's countercharges, although never brought to conclusion, signaled the end of Hansen's career as a Nazi cultural bureaucrat.[244] He was viewed as a loose cannon (even by Nazi standards), and odd as it sounds, it was partially accurate for Scholz's assistant Henny Weber to note after the war that she and her chief "had battled with success the radical elements in the field of visual arts."[245] Perhaps the most apt description of Walter Hansen originated from fellow National Socialist journalist Johann von Leers, who observed that he was "as intellectually sterile as a mule: he is only happy when spying on others, stirring up trouble, collecting material, and engaging in unscrupulous, irresponsible, and yapping witch hunts"; he was a "terrible product of the age," a "spy, an informer, and a slanderer by profession and inclination."[246] More succinctly, one writer called Hansen "a cultural political court jester of Hitler."[247]

While it is hardly surprising that vulgar agitators like Willrich and Hansen served the Nazi regime, there were also instances when more refined critics became embroiled in the Nazi *Kunstpolitik*. Such was the case with Erhard Göpel (1906–66), who wrote scores of articles for a number of publications, including Karl Scheffler's *Kunst und Künstler* (which was shut down in 1933), the respectable *Vossische Zeitung, Berliner Tageblatt, Deutsche Allgemeine Zeitung*, and *Frankfurter Zeitung*. These were among the more liberal press organs prior to and early on in the Third Reich. For a period in the 1930s, Göpel was also the art critic for the *Neue Leipziger Zeitung*, but he gave this up in 1937.[248] A supporter of modern art who wrote on this topic until 1936, Göpel claimed that he did not want to write about the *Degenerate Art Exhibition* or "against his artist-friends," who included Käthe Kollwitz, Erich Heckel, and Karl Schmidt-Rottluff.[249] Göpel was especially close to Max Beckmann, whom he met in 1932. He later supported his friend in exile in the Netherlands, helped promote his art throughout the world, and then, after the painter's death, took the initiative to found the Max Beckmann Society. Göpel authored over sixty articles and publications on Beckmann, including a catalogue raisonné of the paintings, and his

widow still possesses many valuable letters and other items from the Beckmann estate.[250] Göpel was clearly very intelligent: he earned his doctorate summa cum laude in 1937 with a dissertation, "A Commission for Van Dyck."[251] And while he was to engage in a variety of activities in the art world—including serving as the technical assistant to the Dutch collector Frits Lugt (whose collection was seized during the war) and helping prepare a variety of exhibitions—his greatest talent lay in art criticism. As Ernst Buchner noted in a 1953 evaluation, Göpel worked "with unusual journalistic skill, with literary and artistic sensitivity, and above all, however, with an entirely original way of opening up contemporary art and a solid knowledge of recent and current artistic endeavors."[252]

Despite liberal inclinations and a distinguished career, Göpel was deeply embroiled in the Nazis' art plundering program, and he became Hitler's top agent in the occupied Netherlands. Bruno Lohse even claimed that Göpel aspired to become director of the Führermuseum.[253] It is not clear how a friend of modern art like Göpel joined forces with Hitler and Posse, although there are clues. One reason grew out of the requirement that he serve in the military. He had been drafted and served as a translator and press officer on the staff of the Sixth Army, then under General Field Marshal Walter von Reichenau.[254] But Göpel signed on with Posse and the Linz Project in February 1942, surely more attractive than remaining with the Sixth Army, which was redeployed on the Eastern Front and later met a terrible fate in Stalingrad. One intriguing question concerns Göpel's response to von Reichenau's 10 October 1941 order in which the Army commander emphasized "the necessity of a severe but just revenge on sub-human Jewry" and argued that "'an inexorable racial idea' . . . transcended all hitherto accepted codes of military honor."[255] Göpel never addressed the issue of genocide in accounts of his wartime experiences, so there is no evidence that he accepted the move to the Linz Project in order to avoid more direct complicity in the killing in the East. There is also no evidence that Posse and Göpel knew one another before the war, although they had acquaintances and colleagues in common (notably Dr. Robert Oertel, who held posts both in the Dresden and Linz museums). Göpel claims that it was Oertel who arranged for him to become what he described as a Linz "expert" in the Netherlands, although the OSS agents were more accurate in labeling him as the "chief buyer."[256] Göpel's activities in the occupied West indeed involved purchases, but they were not without complications. Some, for example, came through

Vitale Bloch, a Russian Jewish dealer. The OSS report noted, "Göpel had protected him from the anti-Semitic laws, and in return received first refusal on whatever Bloch discovered on the art market."[257]

Göpel, who frequently traveled to France in search of art, was also involved in the Schloss affair, which the OSS officers described as "the best example of acquisition for Linz by forced sale."[258] This stunning collection of 333 paintings, including many Dutch Masters, was confiscated in 1943 and divided between the Vichy government and the Linz agents, with the latter taking 262 at the price of 50 million ffrs. (the equivalent today of $20 million).[259] Members of the Schloss family, who were Jewish, suffered various tribulations, including arrest, and did not receive any payment during the war: the money paid by the Linz agents went into a fund controlled by commissioner of Jewish Affairs Darquier de Pellepoix.[260] Göpel claimed that he played a subordinate role in the affair—transferring negatives of the pictures and also creating a catalog intended for Hitler in the oversized type the dictator demanded.[261] But after the war, Linz Museum director Hermann Voss maintained "it was Göpel who came to know of the Schloss collection, which by some error had been brought to Paris, and he conceived the idea of acquiring it partly for Linz."[262] This was supported by a telegram Göpel sent Bormann on 26 April 1943, where he alerted Hitler's aide about the remarkable collection that "would represent a certain enrichment of the Führermuseum."[263] And when not all of the 262 Schloss pictures acquired for Linz were deemed of high enough quality for the museum, Göpel purchased some of the works that did not make the grade.[264]

After a typically difficult experience at the end of the war, in which Göpel fled Vienna and then Leipzig upon the invasion of the Red Army, he settled in western Germany, where he reestablished his career. The denazification court in Giessen placed him in Group V, or those deemed completely untainted; it helped that he had never joined the Party, despite repeated pressure.[265] After 1948, Göpel worked in Munich as an editor (*Lektor*) for the prestigious Prestel Verlag.[266] He continued to work as a critic, penning articles for magazines like *Kunstchronik* and *Merkur*, and reviews for the *Süddeutsche Zeitung* and the prestigious weekly *Die Zeit*, while also contributing essays to exhibition catalogs. In 1951, he wrote of his memories of Max Beckmann in Holland for a Munich retrospective.[267]

Göpel was almost fully rehabilitated in the postwar period—but not entirely. In 1953, a position opened up at the Bavarian State Painting Collections and Ernst Buchner tried to hire Göpel. While the position

was midrange as a curator (*Museumsassessor*), it required the approval of the officials in the Bavarian State Education Ministry. Buchner repeatedly wrote glowing letters about Göpel: he defended the latter's activities in the Netherlands (they were "ordered," he said), praised his abilities, and claimed that Göpel was vital to the work of reconstructing the German museum infrastructure.[268] Ministry officials were skeptical, however, and requested a full account of Göpel's career.[269] The file that emerged included letters on Göpel's behalf from Vitale Bloch, Mathilde Beckmann (widow of Max), and Dutch collaborationist dealer Pieter de Boer, among others.[270] While these testimonials on the surface were impressive, it was not lost on ministry officials that most of Göpel's supporters were complicit in the Linz Project.[271] It is not clear whether they were aware of the American Art Looting Investigation Unit's earlier recommendation that Göpel be tried as a war criminal.[272] After an eighteen-month inquiry, investigators found that Göpel had purchased pictures for Linz (it could not be determined if there were other "unlawful" acquisitions), that he had obtained works from Jews who had fled the country, and that on occasion, he had turned to the authorities in the Reichskommissariat for assistance when negotiations did not go as he had hoped. It could not be ascertained how the intervention of these Nazi officials influenced events. The Bavarian State Education Ministry report concluded that Göpel's "activities were relatively correct," but informed Buchner that Göpel could not be hired—in effect, that he simply carried too much baggage.[273] Buchner was permitted, however, to engage Göpel on a short-term or contractual basis, and the two finished up their careers arranging exhibitions in Munich. Erhard Göpel had a fascinating life with a number of meaningful friendships, including one with Ernst Jünger, with whom he developed a "friendly relationship during the war."[274] But given the circumstances, even Göpel succumbed to the entreaties of the Nazi leaders.

The category of art journalists can be conceived to extend beyond publicists and critics; specifically, one should mention the illustrators and satirists who contributed on a regular basis to many periodicals. The Nazi caricaturist Hans Schweitzer (1901–80), who worked under the name Mjölnir (the name for Thor's hammer in old Germanic mythology), was in a class by himself in this respect. Gerhard Paul described him as "the most important National Socialist poster maker who propagated like no other poster propaganda during the period of struggle."[275] Schweitzer established his reputation in artistic affairs during the 1920s by way of his posters of steel-jawed SA men that appeared in Party pub-

lications like *Der Angriff*. Goebbels, who published the Berlin paper, believed "it was often easier to express Nazi ideas in a political cartoon than with the written word" and often turned to Schweitzer.[276] The two collaborated on a volume, *Das Buch Isidor* (1928), which attacked and mocked the vice-president of the Berlin police, Bernhard Weiss, and Schweitzer has been called "the Gauleiter's closest companion during the Weimar years."[277] Schweitzer was later given a post in the Propaganda Ministry with the title Reich Delegate for Artistic Design, where he oversaw projects ranging from the civic decorations during the Olympic games to the creation of monuments and the casting of commemorative medals.[278] Schweitzer also sat on the board that gave out subventions to artists (*Spende Künstlerdank*), became a standing member of the jury for the *GDK*, and sat on numerous commissions—most notably that which organized the *Degenerate Art Exhibition* and the one subsequently charged with the disposal of the artworks.[279]

Like others responsible for determining the art policies of the Third Reich, Schweitzer contributed to both its "positive" and negative aspects. In terms of the "positive," Mjölnir contributed a style that became closely identified with the regime. With an unambiguous figurative style—albeit a sketchiness at times, borrowed from the Italian Futurists, to denote action or movement—as well as "nature true" colors, his art was more than mere propaganda. The genesis of this style is partly explained by his early alliance with Otto Strasser and the more socialistic and revolutionary wing of the NSDAP.[280] Schweitzer's work was arguably the first "Nazi art," and this "achievement" was later recognized when Hitler gave him the title of professor on 30 January 1937 and made him a Reich Cultural Senator.[281] He was also appreciated by peers, including Robert Scholz, who wrote that Schweitzer provided a "positive manifestation of the combative will with symbols of spirit and ideas."[282]

In terms of his negative agenda—and there was much here, including radical antimodernism and, somewhat ironically, his campaign against so-called kitsch—Schweitzer's anti-Semitism was particularly noteworthy.[283] A magazine cover he designed for the satirical Party periodical *Die Brennessel* in April 1933, for example, featured caricatures of Jews (large noses and exaggerated features) on a train, with the caption, "heads roll . . . into Switzerland."[284] This was intended as a double entendre—a reference not only to Jewish emigration, but also to the violence he envisioned (the term recalled the slogan of the French Revolution). While the caption communicated hateful sentiments, it was the way in which

Article on Hans Schweitzer in the Münchener
Illustrierte Zeitung, *2 July 1936 (photo
by author).*

he reinforced the Nazi stereotype of the Jews that was most harmful.
These depictions were carried to the extreme in publications like *Der
Stürmer*, where Philip Ruprecht ("Fips") and others would add a pruri-
ent sexual element.[285] Schweitzer was one of the creators of the Nazi
image of the Jew, even if his depictions were not the most egregiously
offensive. Yet his work was arguably among the most violent. As Peter
Paret noted, "images and text were couched in terms of extreme vio-
lence, which shocked but also attracted many. Their message was given
a still greater dynamic because cartoons, leaflets, and posters were part
of a continuum that ended in the threat and actual use of force."[286] Con-
sidering the anti-Semitism and violence in his work, it is not surprising
that Schweitzer himself became a member of the SS and was promoted
to the rank of colonel, even if the position was largely honorary.[287]

Schweitzer not only supported the regime by providing figurative
embodiments of the Nazi ideology (which complemented the rhetori-

cal versions of critics), but, as noted above, he played a significant role in the cultural bureaucracy. In many ways, his relationship to Goebbels mirrored that of Rosenberg and Scholz, and he had considerable influence over aesthetic policy. Besides the above-mentioned position as delegate for artistic design in the Propaganda Ministry, he held an office in the Reich Chamber for the Visual Arts and therefore served as a liaison between two of Goebbels's offices. Additionally, he chaired the Reich Committee of Press Illustrators and was a member of a propaganda company on the Eastern Front in 1943 and 1944. His opinions were generally taken seriously by Nazi leaders, and he had speeches opening art exhibitions published in *Kunst im Deutschen Reich*.[288] To take a phrase from a periodical of the time, Schweitzer "was devoted to advising state authorities and Party leaders in all questions concerning art."[289] In one instance, Schweitzer issued an evaluation of Graf von Baudissin and the institution he ran—where he noted "the Folkwang Museum is one of the worst museums in western Germany"—and the document found its way to Himmler's and Heydrich's Security Office in Berlin.[290] As this remark would indicate, Schweitzer possessed a character that was highly acerbic. Indeed, the central link between his work as an illustrator and as a cultural bureaucrat was his unflinching criticism. Even Schweitzer was conscious of this quality. He observed in 1936, "The mainspring of political satire is hate."[291]

It is ironic that Schweitzer's career took a downturn as a result of the perception that he had become too soft and moderate. Reich Minister Goebbels's confidence in him was shaken in mid-1937, evidently because he expropriated a painting by the Expressionist Willy Jaeckel and placed it in his office. (Schweitzer had got hold of the work as part of his work purging German museums![292]) Goebbels conveyed his disappointment in his longtime colleague in several diary entries: "[H]e hasn't fulfilled my expectations"; "he is too weak and inexperienced"; and "he is a good fellow, but without any firmness."[293] This decline in Schweitzer's career fortunes, which was not unlike that experienced by Goebbels between 1938 and 1942, proved temporary, and Schweitzer again found enemies to attack and reemerged as "perhaps the leading German poster designer in the Second World War."[294] This career revival was related to his increasingly radical stance, his rise within the SS, his stint at the front, and also, as of autumn 1944, his participation in the Volkssturm (home guard), which served to confirm his commitment to the Nazi cause. Schweitzer claimed after the war to have defended Berlin "weapon in hand" and to have suffered injury as a result.[295] But at

Opening of the Great German Art Exhibition
in Munich, 1938. Schweitzer is at the far left;
Goebbels, Gerdy Troost, and Rudolf Hess
stand at the center (BHSA).

war's end, he and his wife and children escaped to Schleswig-Holstein, and he was not arrested until May 1947. He claimed that he was turned in by a modernist artist whom he had earlier attacked.[296]

Like so many in the art world who worked for the Nazi regime, Schweitzer was treated very leniently by the postwar authorities. He was let off by a Hamburg denazification board with time served and a 500 DM fine after having maintained that he "was an artist with little interest in politics" who had not "witnessed any SS repression of Poles or Jews" while in Poland during the war.[297] After several appeals of this light sentence, Hans Schweitzer had his record completely expunged in 1955. He proceeded to rehabilitate his career in the postwar period, during which he continued to find work as an illustrator. Schweitzer nevertheless decided to assume a new name—presumably one that would help free him from some of the burdens of the past. Under the name "Herbert Sickinger," he taught painting in Westphalia to genera-

tions of German and American students. He also produced a new kind of art: One magazine described his work as follows: "peaceful symbols are in the foreground—happy villages, painterly ruins, flowers, children, woods and meadows." Schweitzer/Sickinger prospered until his death in 1980. The important role he had played in the cultural life of the Third Reich, however, was not completely forgotten. The radical right wing press in Germany, for example, noted his passing in glowing obituaries.[298]

The art journalists in this section shared much in common, beginning with an aggressive and often hateful disposition. They constituted arguably the most openly vicious profession in the art world during the Third Reich. Journalism, like many cultural enterprises, reflects the spirit of an age; just as "gonzo journalism" grew out of the countercul-ture at the end of the 1960s, attack journalism flourished during the Third Reich. The nature of the assault was predictably consistent with National Socialism. Founded upon racism and national chauvinism and dedicated to glorifying Hitler, this *Kunstpolitik* was inseparable from the Nazis' broader ideological program, which centered on conquest and genocide. Robert Scholz and the other art critics who served the regime articulated these policies by way of attacks on artists and their works that were officially proscribed and by glorifying the "representative" art of the epoch. It is in this sense explicable that a number of critics—and not just Robert Scholz—became involved in art looting during the war. The masthead of Heinrich Hoffmann's magazine *Kunst dem Volk* included as associates Joseph Mühlmann (who plundered with his half-brother Kajetan Mühlmann in Poland and the occupied West), and Franz Kieslinger (a Viennese art historian who helped loot art in the Netherlands).[299]

While the art journalists were effective propagandists, the quality of their criticism was low. They were often verbose and inclined to unimaginative stock phrases. Considering their odious cause and the general lack of freedom, one could expect little else. Even Hitler was aware of the general failure of the critics: as reported in a March 1944 entry in his "table talk," Hitler stated, "if we were completely deprived of art critics, we should not lose very much!"[300] Art journalism in the Third Reich was not the easiest of professions, and many shied away due the demands of ideological purity and the rigid enforcement by both Party and state authorities. As Oron Hale noted in his study of the press during the Third Reich, "recruitment of journalistic and publish-ing personnel was another problem that concerned both private and

Party publishers. . . . [I]t is evident that the flow of able young people into journalism was drying up, and that the profession was not attracting the considerable number of trained persons from other fields which had formerly supplied the press with writers, editors, and reporters."[301] Hale explains this dearth of talent by underscoring how "the Nazi system of restraints . . . made the profession unattractive to talented, original, and sincere young people."[302] Indeed, that the men considered in this chapter were the most accomplished art critics of the Reich attests to the generally uninspired and monotonous stream of ideological verbiage that rolled off the Nazi presses.

Art Historians

The art history profession has long been relatively diffuse because it included individuals outside academic departments: curators, dealers, and critics have all penned serious books on art history. If one takes Fogg Museum director Paul Sachs's list from the spring of 1945 in which he assessed the qualities and skills of individuals in a range of German artistic professions, one sees personnel across the spectrum, both inside and outside academia, described as "good scholar" or "fine scholar" (this includes, for example, the Berlin graphic arts curator Friedrich Winkler and the Munich curator Karl Feuchtmayr).[1] To focus on art historians with university appointments, then, would be too limiting and would not accurately convey the professional context in which scholarship was produced.

One can, of course, write a history of just the academic art historians during the Third Reich and how the profession was effectively bifurcated in 1933.[2] A tremendous number chose emigration, and this includes luminaries such as Erwin Panofsky, Aby Warburg, Walter Friedlaender, and Richard Krautheimer, among others.[3] Karen Michels wrote,

"The forced migration of German and Austrian art historians to the United States is now seen as the most momentous transmission process in the history of twentieth-century scholarship, comparable in its effects only to the migrations of sociologists and psychologists."[4] This flight was precipitated by both "pushing" and "pulling": the Nazis forced Jewish and left-wing scholars out of their positions (Reich Minister Rust reported in 1937 that eighty professors at art academies and universities had been "removed"), and foreign institutions—especially in the United States and Britain—sought to benefit from this brain drain.[5] As for the opportunities abroad, Michels described how

> in both Britain and the United States generous gestures of wel-
> come were made to art historians driven out of Germany and Aus-
> tria by the National Socialist regime. British colleagues gave up
> part of their own salaries to fund aid programs for the refugees,
> and the transfer of the Warburg Library from Hamburg to London
> was regarded as a valuable gift. In the United States, which opened
> its borders by issuing "nonquota" visas, one of the institutions that
> benefitted most from the influx of refugees gave thanks with a
> wisecrack: "Hitler shakes the tree," said Walter Cook, director of
> New York University's Institute of Fine Arts, "and I pick up the
> apples."[6]

Despite the gravitation of many German exiles to southern California (Thomas Mann, Bertolt Brecht, Alfred Döblin, among many others), art historians had more opportunities on the East Coast. This was the heart of the artistic establishment in the U.S. As art historian and museum director Alois Schardt wrote to his colleague Georg Swarzenski in January 1944, "since the opportunities here in the West are as good as hopeless, I am resolved to go East where perhaps I can find a position as college lecturer, museum official, or employee at a press."[7]

The emigration of art historians devastated the profession in Germany. Beyond losing a number of famous scholars, the Reich lost many of the most theoretically sophisticated. Bettina Preiss noted, "in academic art history before 1933 only a small part of their representatives were really prepared to pursue a serious critical method. These 'hard core of a soft discipline,' with their fundamental considerations concerning the history and theory of the humanistic fields, had a broad influence which is still evident today."[8] But many of these "hard core" were not welcome in Nazi Germany, where there was a widespread distrust of art historians that grew out of a pervasive anti-intellectualism.

For example, art critic and curator Walter Hansen wrote in 1937, "art historians, according to Jewish ways, insert themselves as supposed intermediaries between artist and artwork. . . . The past has shown that through this fully unnecessary engagement of supposedly essential intermediaries of German art (that is, agents for artists and art dealers), immeasurable damage has been done, and in the future this can be made passably good again only through a possible exclusion of art historians and art critics. Art historians in the last thirty years have been directly dependent on the advice of the Jewish art trade."[9] There was a sense that the entire discipline needed an overhaul, and some of the proposals for it were quite remarkable. This included Bernhard Rust's instructions that "the art historian must learn *everything* in his education, also the works of degeneration."[10]

The academic art historians who remained in Germany had two principle concerns that constituted the core of National Socialist art history. The first was the belief in a scholarship that was politically engaged. One Nazi art historian, Hans Weigert, explained this philosophy quite succinctly when he wrote, "the university stands in the service of politics."[11] He went on to say, "certainly it is the new ideal of the voluntaristic, soldierly type that must be adopted in order to secure the fearful threats to the foundations of our naked existence."[12] In other words, art historians were supposed to serve as intellectual shock troops for the regime and provide a key component of the cultural, and even spiritual, underpinning for the Nazi movement. One therefore finds examples such as the essays penned by renowned art historian Wilhelm Pinder (1878–1947), "Architecture as Morality" and "Duty and Claims of Scholarship," which both appeared in 1935, as well as a Festschrift that he helped compile to honor Adolf Hitler in 1939. An OSS report on Pinder added: "Originally a scholar of high standing . . . he is known to have worked with the Nazis in every respect and to have informed the Gestapo on his former friends."[13] Some German art historians served the regime in more particular ways, such as Dagobert Frey (1883–1962), who used his study trips to Poland and other Eastern European nations to compile inventories of valuable artworks—lists that were later used by plundering commandos (which Frey, among others in the field, staffed).[14] It is perhaps not surprising that Bernard Berenson referred to one of these scholars in service of the Nazi regime as the "Attila of art history."[15]

The other central tenet of National Socialist art history was the advancement of Germanic culture. This meant, of course, the glorifica-

tion of German artists and their work. Art historians were supposed to discover the roots of a great culture and therefore enhance national consciousness and this project helped distinguish them from scholars in other fields, including historians, whose support for the Nazi regime has recently become the subject of much discussion.[16] Heinrich Himmler and his cohort in the SS were especially enthusiastic about early Germanic cultural history and promoted the study of archeology, anthropology, and art history through organizations like the Ahnenerbe, the Society for the Promotion and Care of German Cultural Monuments, and the Nordland Press.[17] Others, including Hitler, sought to emphasize the emergence of the German spirit in the early modern and modern periods. One therefore finds works like Wilhelm Pinder's *On the Essence and Development of German Forms: The Visual Arts in the New German State*, where he, in Bettina Preiss's words, "supplied evidence of the success of National Socialist art historical writing, which among other high points of discovery, counted that [Hans] Memling, an original German (*Urdeutscher*) in Seligenstadt am Main, had caught sight of the first light of the world."[18] These art historians in the service of the Reich sought to document the rise of the Germans as the supposedly racially superior people who threw off their chains and finally realized their potential.

This undertaking of examining the emergence of the dominant Aryans included the more specific task of revealing the existence of German culture in neighboring lands. Most Nazi territorial claims were based upon the notion that meritorious culture found abroad—whether it be in Poland, the Baltic States, and other regions in the East or in Belgium, the Netherlands, and Denmark, chief among Western countries—had been created by Germanic peoples. The art historians were expected to use their scholarship to justify Nazi irredentism. During the war, cultural historian Hermann Aubin declared that "the work of our ancestors . . . represents the great legal brief for territory."[19] Another variation on this theme was supplied by Gustav Barthel, an art historian from the university in Breslau, who accused "Polish scholars [of] having falsely claimed the achievements of their own artists."[20] In the few cases where German art historians actually discussed Polish artists, they were viewed as pale imitators of German predecessors.[21] Lynn Nicholas adds a touch of humor when she describes these scholars as part of the "Poland-is-really-Germany school."[22] Of course, there was very little that was amusing about the Germanification programs undertaken by the regime. Cultural cleansing was accompanied by ethnic cleansing. Objects deemed to be Germanic in origin were preserved, while those

of Slavic, Jewish, Sinti, and Roma ("gypsy") cultures, among others, were destroyed. The art historians, like those in other professions in this book, played a role in the Holocaust that went far beyond that of bystander. They first provided intellectual justifications for the aggressive and genocidal program, then they served the Nazi leaders and helped denude the victims of their property. And as argued earlier, the expropriation of property was part of a continuum that culminated in murder.

It is admittedly sometimes difficult to take these art historians seriously. As noted above, most of those who were theoretically sophisticated went into exile, and of those few who stayed, such as Heinrich Wölfflin and Wilhelm Pinder, the glory days of most were in the past and they did not produce significant scholarship during the Third Reich (although Pinder in particular continued to publish). The main exception to this generalization is Hans Sedlmayr (1896–1984), an Austrian who was among what one scholar termed "the critical historians of art."[23] Sedlmayr, who subscribed to notions of collective psychology, attempted to apply them to artistic interpretation and build upon the concept of "artistic intention" (*Kunstwollen*) pioneered by his Viennese predecessor, Alois Riegl (1858–1905). Sedlmayr was a member of the NSDAP—and evidently supported the Party before the *Anschluss* in 1938 (making him an *Illegaler*, a member during the time when the Party was illegal in Austria).[24] But his formulations were somewhat more subtle and not as explicitly political as many of his colleagues. Sedlmayr talked of "purity" and "pure forms"—terms that had special meaning during the Third Reich—but he did not go so far as to call openly for German expansion into the East.[25] Sedlmayr was nonetheless compromised to the point where he was forced to give up his professorship at the University of Vienna in 1945. But he moved to Bavaria and in 1951 again became a professor, this time at the Ludwig Maximilian University, where he received the chair in art history once held by Heinrich Wölfflin and Wilhelm Pinder. Today, there is even a street named after him in the heart of Munich.

The majority of the art historians of the Third Reich who advocated political engagement and a nationalist agenda are now obscure and generally known only by scholars who study the period. Individuals like Hans Weigert and Alfred Stange in Bonn, Dagobert Frey in Breslau, and Paul Schultze-Naumburg in Weimar did very little to advance the study of art. In Bettina Preiss's words, "the entire art research of the Third Reich is therefore almost meaningless; it is simply the conscious accom-

modation to the cultural policy of the Third Reich that made art history subservient as an instrument of propaganda."[26] When one surveys the lists of art historians compiled by Allied investigators at war's end—they identified about 110 faculty at German universities, not counting those who worked for museums or as independent scholars—it is striking to see that at least half either produced explicitly National Socialist scholarship or played a role in the plundering program.[27] The art historians who remained in Germany, then, contributed to the culture of the Third Reich, but not to the advancement of their discipline.

Kajetan Mühlmann was arguably the single most prodigious art plunderer in the history of human civilization. This intelligent and, according to the testimony of contemporaries, rather congenial Salzburger stole artworks from victims first in his native Austria, then in Poland, and finally in the Netherlands. Mühlmann's story is instructive for a variety of reasons as well. With a doctorate in art history, Mühlmann was a successful member of the Austrian intelligentsia. His biography reminds us that National Socialism was not an exclusively lower-class phenomenon, but relied upon the cooperation and skills of the educated bourgeoisie. Beyond his personal descent into criminality, Mühlmann's case underscores the crucial role played by Austrians in bolstering the Nazi regime. Recent studies have drawn attention to the Austrians' involvement in the deportation measures and the extermination camp,[28] but Austrians served in other branches of the government, including the cultural bureaucracy. Finally, Mühlmann's story sheds light on the denouement and aftermath of the war and the ethically clouded environment precipitated by a devastated continent and the burgeoning cold war. He took advantage of the opportunities created by the competing intelligence agencies and, by finding accommodation with the Americans, carved out a fairly comfortable existence. Mühlmann, like many of the second-rank figures, avoided both postwar justice and the scrutiny of historians.

Mühlmann, whose friends called him Kai, was born in Uttendorf near Zell am See in western Austria on 26 June 1898. Emblematic of the mysteries that permeate his biography, it is unclear whether he spelled his first name, Kajetan, with a "K" or a "C" (most documents use the spelling Kajetan, but others, such as his folder in the SS Main Office, feature the alternative). While little is known about his child-

*Hans Frank and Kajetan Mühlmann in
Cracow, 1939 (NA).*

hood, it was quite tumultuous. Kajetan's father died when he was quite
young and his mother then married his father's cousin. Together, both
marriages yielded eight children, although two died in infancy. Among
Kajetan's siblings the most notable was his older half-brother Josef
Mühlmann (1886–1972), an art critic and restorer, who as a member of
the SS and the Gestapo teamed up with Kajetan as a plunderer in the
occupied lands.[29] Kajetan grew up on a farm and claimed in his official
biography in the late 1930s that he was of "peasant lineage."[30] This was
partly personal publicity, peasant stock being much valued among the
blood-and-soil Nazis. His childhood milieu was not entirely rural, how-
ever, as he attended school in nearby Salzburg. It is difficult to ascertain
much about his personality or views at this time, but he evidently
embraced the pan-Germanic ideas that were so popular among Aus-
trian youth and volunteered for the Salzburger Infantry Regiment

Number 59 as soon as he had reached the legal age of seventeen in 1915. It was typical of many ethnic Germans living in border regions to feel heightened attachment to *Deutschtum*, or all things German; Hitler, who grew up nearby, and Alfred Rosenberg, from Estonia in the Baltic, offer two better-studied cases.[31] Later, in a 1919 plebiscite, Salzburgers "voted overwhelmingly" (158,058 to 463) for a union with Germany.[32]

Mühlmann served with distinction in World War I and received multiple decorations. He was seriously wounded in 1918, and the injury was compounded by an illness that affected his lungs. He suffered considerable pain while recuperating in the years directly after the war and continued to experience problems with his lungs for the rest of his life.[33] Feeling that he had sacrificed a great deal during his service, Mühlmann viewed the ensuing Treaty of St. Germain as an unjust and unnatural fate for the Habsburg Empire. The third largest nation in Europe prior to the war, with a population of 52 million, was reduced to a country of seven million, dominated by an oversized, cosmopolitan capital of three million. The provision that Austria could never unite with Germany added to the sense of grievance felt by Mühlmann, as well as many other Austrians of a variety of political persuasions.[34] Injured and feeling a sense of betrayal, Mühlmann joined the Socialist Party in Salzburg, to which he belonged for several years.[35] While it may seem surprising that a nationalist like Mühlmann would join the socialists, membership in the Austrian Social Democratic Party offered a means to protest the general settlement in Europe and helped recreate the comradeship of the front.[36] But Mühlmann was left dissatisfied, and he gradually became less political following his demobilization.

Mühlmann finally pursued university studies in 1922, and he spent the next four years in Vienna and Innsbruck. He concentrated on art history, and he himself evidently had an interest in painting (when he disappeared after the war a Viennese newspaper actually described him as a "*Kunstmaler*," or painter).[37] He received his doctorate in 1926 from the University of Vienna, with his dissertation titled *Baroque Fountains and Water Art in Salzburg*.[38] Moving back to Salzburg in 1926, Mühlmann professed an interest in the city and its monuments. He wrote for many of the local newspapers, reviewed art exhibitions, and penned articles such as "The Redesign of the Salzburg Garden," and "The Endangering of the St. Peter's Cemetery."[39] He established a name for himself as a concerned civic activist, and in 1932, published a lavish book titled, *Civic Preservation and Renovation in Salzburg: The Example of the Restorer Franz Wagner*, which not only lauded the accomplish-

tiple years in jail" and noted that getting Mühlmann off with time served was "an exceptional success for the defense."[56] As Mühlmann had induced high-ranking members of the Austro-fascist regime to inter-cede on his behalf—most notably, the secretary of the Fatherland Front Guido Zernatto—the reason for the judge's leniency remains in doubt.[57]

Despite this experience, Mühlmann's association with the Austrian Nazi Party remained sufficiently concealed as to enable him to work as a seemingly independent front man or liaison during the period of the Nazi prohibition. The Nazi Party in Austria had been banned by Chan-cellor Kurt Schuschnigg in July 1934 after Nazi putschists had mur-dered Chancellor Engelbert Dollfuss. Even prior to this event, selected Austrian Nazi leaders had been arrested because of terrorist activities; the Viennese Gauleiter Alfred Frauenfeld, for example, was sent to an internment camp at Wöllersdorf in June 1933. These brushes with gov-ernment forces compelled the Nazis to move much of their organiza-tion and many of their paramilitary forces to Bavaria. The Austrian Legion had its headquarters in Dachau, where they shared training facilities with the German SA, SS, Army, and police.[58] Mühlmann was particularly valuable as a messenger, and he helped arrange shipments of illegal propaganda and weapons that were used to destabilize Aus-tria's Fatherland Front government.[59]

Even with his efforts to avoid the appearance of any firm commit-ments, Mühlmann was repeatedly embroiled in conflicts and contro-versy. He was arrested at least four times in the mid-1930s for offenses ranging from reckless driving to the "defamation of a public official."[60] Many of his greatest imbroglios occurred within the Nazi Party. Landes-leiter (head of the Austrian Nazi Party) Josef Leopold wrote in 1937 that Mühlmann "was rejected by the Salzburg Party members and accordingly not taken into the Party"; and five years later, the Salzburg Gauleiter, Dr. Gustav Scheel, wrote to Martin Bormann, the head of the Party Chancellery, "With respect to politics and character, the subject does not enjoy a good reputation among the Salzburg National Social-ists. . . . According to the views of the Salzburg Party members, Mühlmann should be kept away from all political activity."[61] These attacks were entirely consistent with the nature of the Austrian National Socialists in the 1930s: what one historian described as a party "rent with factions and . . . constant disagreements . . . that sometimes led to violent confrontations. The Gauleiter would not cooperate with one another and behaved in an irresponsibly egotistical manner."[62] Still,

while Mühlmann provoked criticism among his comrades, he also, as mentioned above, cultivated influential and loyal benefactors.

Mühlmann allied himself principally with Seyss-Inquart and other Austrian National Socialists who were viewed prior to the *Anschluss* as the moderates in the Party. This designation arose by way of contrast with two other principal factions. One, led by Captain Josef Leopold, frequently turned to terrorist acts and other radical tactics as a means of destabilizing the government. The second notable faction was headed by the Carinthians Odilo Globocnik and Friedrich Rainer. They were also not known for their willingness to compromise with the existing government, although they did work well enough with Mühlmann and the moderates that some observers view them as intraparty allies. It is significant that Mühlmann and Globocnik became friends: first, because of the implications for the Austrian Nazi Party prior to the *Anschluss*, with Mühlmann's emergence as an effective mediator in the intraparty feuds; second, because this relationship continued during the war when both were active in Poland in the General Government (the part of Poland not incorporated into the Reich or ceded to the Soviets in 1939).[63] Globocnik oversaw the Operation Reinhard death camps in the formerly Polish territory.

Prior to the *Anschluss*, the moderates distinguished themselves by their widespread contacts, both inside and beyond the Austrian Nazi Party. Most notably, they counted as a friend the poet and general secretary of the Fatherland Front, Guido Zernatto. Mühlmann was on a "*du*" basis with him.[64] Zernatto's efforts in 1935 to extricate Mühlmann from prison in Salzburg had helped solidify their friendship. Mühlmann repaid the debt when the Germans took over Austria in March 1938: he helped Zernatto escape out a side door of the Federal Chancellery, who then headed for Bratislava and exile.[65] Mühlmann also established ties with the very influential state secretary, Guido Schmidt, visiting him at the Federal Chancellery once or twice a month to discuss the political situation in Austria. Schmidt was the confidant of Schuschnigg, and their decision in June 1937 to place Seyss-Inquart on the State Council—the most influential organ for the initiation of legislation—reflected not only the progress that the moderate faction had made in terms of respectability, but also Mühlmann's rise in influence.[66] Mühlmann, then, had the ability to bridge existing gaps: first, within the Austrian Nazi Party and, second, between certain Nazis and officials in the Fatherland Front.

Because the moderate faction of the Austrian Nazi Party eventually

prevailed as the victors in this internecine conflict, their views warrant reconstruction. Significantly, the leading figures began their political careers outside the Party. Both Seyss-Inquart and Mühlmann underwent a process of gradually warming to the Nazi cause. In Seyss-Inquart's case, he first joined organizations affiliated with the Party, such as the German-Austrian People's League.[67] Mühlmann, as was his nature, tried to avoid any overt political commitments. Later, both developed loyalties to Hitler and sought closer relations between Austria and Germany, but neither ever imagined the complete evaporation of their country—a position not uncommon among Austrian Nazis.[68] They hoped that closer ties with the Reich would bring greater economic prosperity, as well as end the sense of being diplomatically isolated, a sentiment that became even stronger after the September 1936 agreement between Mussolini and Hitler. Instead of merely serving as Hitler's agents, they hoped to combine a pride in things local and Austrian with the notion of being a part of a larger German and fascist bloc. Wilhelm Keppler, an SD official and SS major general who served as one of the "point men" in Austria for the Berlin government, also put their views in perspective when he noted that they "favor[ed] the path of evolution . . . [versus] the other faction which was bent on continuing strictly revolutionary and illegal activities."[69]

Mühlmann and Seyss-Inquart were ambitious beyond their respective professional careers as an art historian and lawyer, and this in part explains why they assisted Hitler in the annexation of Austria. The interparty feud among the Austrian Nazis helped induce them to cooperate with Berlin authorities as the moderates sought the upper hand. Prior to the famous Berchtesgaden meeting between Hitler and Schuschnigg in February 1938, Mühlmann met with the German dictator and briefed him about earlier discussions between Seyss-Inquart and Schuschnigg. This violated promises of confidentiality to the Austrian Chancellor, but improved Hitler's opinion of the moderates.[70] Mühlmann revealed what Schuschnigg's maximum concessions would be, and Hitler exploited this advantage by using them as a starting point in the Berchtesgaden negotiations.[71] Historian Bruce Pauley summarized, "In a final effort to eliminate his rival [Leopold], Seyss-Inquart sent the moderate Nazi and art historian Kajetan Mühlmann to Berchtesgaden ahead of Schuschnigg. Mühlmann was instructed to insist to Hitler and Keppler . . . that Leopold and the Landesleitung be removed from Austria. Seyss-Inquart got his way."[72]

Hitler sacrificed Leopold in return for official toleration of the Aus-

*Arthur Seyss-Inquart (left), Mühlmann, and
Goebbels meet with the Viennese* Kanal-
Brigade, *who were previously illegal National
Socialists, 29 March 1938 (BA).*

trian Nazi Party. Seyss-Inquart advanced his careerist ambitions by
receiving the post of Minister of the Interior on 16 February. The fol-
lowing month, he even acted as Chancellor for forty-eight hours of the
critical phase of the *Anschluss*. Still, Seyss-Inquart was duped by Hitler
in that he never received the autonomy that he desired—either indi-
vidually or for the government in Austria in which he served. Forced to
settle for the position of Reich Governor (*Reichsstatthalter*), he was
hemmed in when Josef Bürckel was sent from the Reich and given the
title Reich Commissioner for the Reincorporation of Austria, a position
of direct competition. For good measure, and true to form in the poly-
cratic Nazi state, the power was divided further when Odilo Globocnik
from the more radical faction obtained the powerful post of Gauleiter
of Vienna.

Yet Mühlmann benefited from his efforts in helping prepare the

Anschluss because Seyss-Inquart appointed him state secretary, first in the Federal Chancellor's Office for a month (in March 1938) and then, after changes in the governmental structure, in the Ministry for Interior and Cultural Affairs.[73] Mühlmann also had a position directly subordinate to Seyss-Inquart as the Representative for State Art Policy and as Foreign Tourism and Leader of Department III of the Office of the Reich Governor. These positions offered great promise because Mühlmann administered the budgets for all state cultural organizations and played an important role in the personnel changes that were then taking place.

The Nazis worked rapidly to award adherents the plum positions. For example, Dr. Friedrich Dworschak, reportedly a former *Illegaler*, was made the director of the Kunsthistorisches Museum in Vienna on 15 March 1938. The rector of the University of Vienna, Ernst Späth, took a little time to ascertain the nature of the new order. After sending Hitler a congratulatory telegram on the day of the *Einmarsch*, he quit three days later, recognizing the university could be led only by a Party member.[74] Kajetan Mühlmann, with his connections and an influential post, appeared to have been one of the fortunate ones. But like many other Austrian officials, he quickly became frustrated with the arrogant and assertive *Reichsdeutsche* (Germans from the "old Reich," prior to the *Anschluss*). To start with, the Reich Minister of the Interior, Wilhelm Frick, and his associates in Berlin refused to recognize Mühlmann's appointment as state secretary in the Chancellor's Office because Seyss had made the appointment after he had legally ceased to be Chancellor.[75] This dispute was largely semantic, with Mühlmann continuing to work with the full authority of his title. However it prefigured subsequent bureaucratic battles.

Seyss-Inquart and Mühlmann tried in their own ways to combat the growing influence of the "Prussians," as the Austrians often referred to those from the *Altreich*. They, like many other Austrians, believed in a type of National Socialist rule for Austria that differed (primarily in tone, but also in substance) from that originating in Berlin. It was a very delicate balancing act. On the one hand, they pledged obeisance to the Reich authorities. Mühlmann and his brother Josef, for example, played a role in the city of Salzburg giving Hitler a Spitzweg painting from the Carolino Augusteum Museum and Göring a picture by C. P. List from St. Peter's cloister (also in the heart of the city). Mühlmann also directed funds to an SS excavation project in Carinthia, noting in a letter to Himmler, "Reichsführer! I may further assure you of my pre-

paredness to undertake tasks for the SS" (signing it as an SS captain).[76] Yet on the other hand, Mühlmann and many of his Austrian colleagues promulgated the notion of a distinct Austrian (*Östmärkisch*) culture and, accordingly, interceded on behalf of artists under attack, including the former director of the Mozarteum in Salzburg, Bernhard Paumgartner, and a Salzburg painter, Eduard Bäumer.[77] Mühlmann tried to pursue a cultural program that was more open and less heavy-handed than that which prevailed in the *Altreich*. While he was openly anti-Semitic and gave speeches where he talked of the threat of Jewry, he permitted performances by a cabaret called the Wiener Werkel, which produced satirical pieces that were at times directed at the authorities in Berlin.[78] He also tolerated certain genres of modern art—or so claimed his bitter critic, Reich Student Leader and Gauleiter Gustav Scheel, who complained during the war that he "earlier expressly supported expressionistic art."[79] Indeed, going back as far as 1926, Mühlmann wrote reviews praising the modernist artist Anton Faistauer, whose mural for the Salzburg Festival House was removed by zealots after the *Anschluss*.[80] In late 1938, Mühlmann provided the funds for the fresco's preservation in his capacity as the state administrator for art and then reportedly kept a painting by the artist in his private residence.[81] He also approved the purchase of art by Austrian Expressionist painter Herbert Böckl, and although the remuneration was small (RM 200), it helped the artist, who had eight children.[82] Mühlmann's second wife, Hilde, on reflecting on Kajetan's appreciation of certain kinds of modern art, as well as his depricating remarks made in private about certain works in the official Nazi style, observed that "He was never entirely true to the Nazi line."

Besides attempting to protect a few associates from the pre-*Anschluss* period, Mühlmann also pursued a program to support the culture of Vienna and other Austrian cities. Even though Austria—or as the Nazis initially called the formerly independent country, the *Ostmark* (Eastern Marches)—was subsumed into the Reich, there were still opportunities for autonomous initiatives. Mühlmann had considerable success diverting funds to Salzburg and other provincial centers, but it proved more difficult for him to realize his ambitions for Vienna.[83] He had long held the idea that Vienna had previously served as a bulwark on the fringes of German civilization and should reemerge as a great metropolis on the Danube.[84] Mühlmann's chief Seyss-Inquart also subscribed to this vision and together they tried to advance policies that would enhance Vienna's reputation. Perhaps most notably, they pro-

posed the creation of a Viennese (or alternatively, *Ostmärkisches*) Cultural Institute, which would oversee all cultural activities in the *Ostmark*. Seyss-Inquart planned to make Mühlmann the director of the institute.[85] The Reich Governor drafted a series of long and detailed memoranda and submitted them to Hitler seeking approval; he even sent Mühlmann to Berlin to explain the proposal to Hitler in person.[86] Yet their plan was energetically opposed by Reich Commissioner Bürckel, and this precluded the chances for reform. Hitler did not wish to alter the balance of power and therefore issued a "standstill order," which directed the structure of the cultural administration to remain unchanged. Although Bürckel, Seyss-Inquart, and Mühlmann all left Vienna during the early stages of the war and assumed other duties, the issue of a separate Austrian culture persisted up until the end of the Third Reich.[87]

Despite Mühlmann's more liberal ideas about culture, he subscribed to a racist worldview, even believing that Austrians were a quasi-distinct German tribe.[88] He also did nothing to soften the regime's anti-Semitic program. This attitude was typical in the *Ostmark*, where anti-Semitism was equally if not more severe than in the *Altreich*. The "Viennese model" entailed pioneering measures regarding both Aryanization and anti-Semitic legislation. The Austrians carried out organized and what were called "wild Aryanizations" from the outset, with 8,000 "legal" seizure of Jewish residences prior to 1939 and an estimated 25,000 wild Aryanizations also taking place in the first months before the process was effectively bureaucratized.[89] Mühlmann and his brother Josef, who hired on with the Gestapo, availed themselves of the opportunities presented by the new regime. Kajetan lived in an apartment in Schloss Belvedere, and his office was in a confiscated building on the Prinz Eugenstrasse, while Josef also received an Aryanized residence.[90] Later, during the war, Kajetan and his wife Poldi used their connections to obtain a villa on the outskirts of Salzburg that belonged to a Jewish woman, Helen Taussig. After the intervention of the local Gauleiter Friedrich Rainer and other high ranking officials (to whom Mühlmann wrote from Poland in 1941, requesting their assistance) the Villa Taussig in Salzburg-Anif was put in the name of Poldi Woytek Mühlmann.[91] The marriage of Mühlmann and Poldi ended later that year (after securing Himmler's permission, Mühlmann married his mistress Hilde Ziegler in 1942); and Poldi, so neighbors reported in 1997, lived in the house on her own—even in the postwar period.[92] The fate of Helena Taussig is unknown.

Back in Vienna, a branch of the Gestapo was established with the acronym Vugesta (*Vermögensumzugsgut Gestapo*, or Transferred Property of the Gestapo), which liquidated the property of Jews who had left the country or who were incarcerated. As an employee of the Vienna Gauleitung noted to the NSDAP Treasurer in Munich, "The sale of this furniture to old Party members and also offices of the NSDAP was carried out at that time by the 'Vugesta' at extremely favorable prices."[93] Postwar investigators determined that Mühlmann gave his sister (who lived in Strobl and went by the name Frau Esch) a painting as a wedding gift that they described as "a beautiful Heda"; it came from seized Jewish property, and it was claimed that she burned it in May 1945 knowing that it had been acquired in a problematic way.[94] The Mühlmanns, then, personally benefited in a material sense from this anti-Semitic program.

Kajetan Mühlmann also played an important role in helping determine the anti-Semitic measures imposed by the government. He attended meetings in which the guidelines for expropriating Jewish property were formulated.[95] The protocols from these meetings represented the hands-on implementation of the series of laws that were passed in the second half of 1938. The 20 November Ordinance for the Attachment of the Property of the People's and State's Enemies and the 3 December Ordinance for the Employment of Jewish Property were the most important of these anti-Jewish measures at this time.[96] While Göring and the other top leaders in Berlin assumed chief responsibility for these laws, the importance of on-site advice from figures like Mühlmann, Adolf Eichmann, and Hans Fischböck cannot be underestimated.[97] It seems fitting that Eichmann ran his Jewish deportation office in the Rothschild palace just across the street from Kajetan Mühlmann's new apartment and office.[98]

The expropriation of Jewish property in Austria that began in 1938 entailed more than persecution and self-enrichment, as heated battles over jurisdiction arose when the plunder began to accumulate. Historian Hans Witek has written that with the "dispossession of the Jews, the fights between the interest groups had not only a power-political character, but were also indivisibly linked to the struggle to 'divide the booty.'"[99] With regards to the Jewish-owned artworks confiscated by the Gestapo, SS, and police in the course of the Aryanizations—and these artworks were the chief concern of Mühlmann—the primary issue was their custody. Upon Hitler's direct order, the artworks were initially stored in the Neue Burg palace in the heart of the city, as well as in the

Rothschild's hunting retreat, Schloss Steinbach, which was located a short distance from Vienna.[100] Later, in August, Hitler issued what was called the "Reservation of the Führer" in which he claimed the prerogative to determine the fate of artworks.

This order did not prevent the subleaders from formulating their own plans or from lobbying vigorously to implement them. Seyss-Inquart and Mühlmann represented the opinion that the most important artworks must stay in Austria, and above all, in Vienna. They argued that pieces that came from Vienna's Jews were a part of the city's cultural patrimony. No one saw an inherent contradiction in the idea that the art was Vienna's "cultural patrimony" and should be kept there, while it was perfectly acceptable to take it from the hands of Jews who had brought it to the city in the first place. Mühlmann, who played a central role in expropriating the Rothschilds' art collection, wrote Hitler a report in mid-1939 pleading that the confiscated artworks, which all told were valued at sixty to seventy million Reichsmarks, be kept in Vienna.[101] Seyss-Inquart suggested selling off a third of the works, thereby raising enough money to build a new natural history museum and allowing the Kunsthistorisches Museum to expand into the preexisting Naturhistorisches Museum across the plaza.[102]

Most of the other *Reichsdeutsche* viewed the works as booty that should benefit the Reich. They believed that just as the Holy Roman Empire treasures were shipped from Vienna to Nuremberg to right a historic injustice (Mühlmann helped organize the transfer) and just as much of Austria's wealth was in the process of heading to the *Altreich*, these Jewish-owned works should meet a similar fate.[103] Himmler made very concrete suggestions to Hitler, writing him that he was prepared to take over an operation to send the plunder to storage depots in Berlin and Munich.[104] Mühlmann was a fairly practical individual and was prepared to sacrifice certain works to the *Reichsdeutsche*, and especially to his patrons. He sent Göring lists of objects from both Jewish collections and confiscated church property and expressly noted that the works were for the Reichsmarschall to take: one letter, for example, stated that the objects came from the "Viennese (Jewish) collections of Lederer and Bondy."[105] Mühlmann hoped that passing on a limited number of works to Nazi leaders would enable him to keep the majority of the art in Vienna. Because he was backed by Seyss-Inquart and Reich Commissioner Bürckel (in a rare instance of agreement), this was not a completely unreasonable expectation.[106] As was frequently the case, Hitler refrained from arbitrating this dispute and ordered the SS and SD to

*Mülhmann follows Göring at opening of
exhibition,* Victory in the West, *as they
parade across the Heldenplatz in Vienna,
November 1940. The exhibition featured war
booty from Western Europe (ÖIfZG-BA).*

guard the treasures while art experts, including Karl Haberstock, pre-
pared an inventory. But Hitler was very much interested in the matter
and, accompanied by Mühlmann, inspected the seized works housed in
the Neue Burg in June 1939.[107] Mühlmann's desire to keep the bulk of
the art in Vienna should not be underestimated: when Haberstock vis-
ited his office and told him of his plan to sell the Rothschild collection
to Dutch dealers, the Austrian, according to his postwar testimony,
"threw him out."[108]

The confiscation of Jewish artworks marked a new phase in the per-
secution of the Jews. These measures first carried out in Vienna, and
then in the wake of *Kristallnacht* (November 1938) in the *Altreich*, were
an important juncture on what Karl Schleunes called "the twisted road
to Auschwitz."[109] There is widespread agreement among historians that
material interests were part of the motivation for persecuting Jews. As
Robert Koehl has written, "While Heydrich and later Eichmann seized
the initiative in organizing the resettlement and killing of the Jews, they
were continually abetted and even rivaled by other government and

Party agencies. Not the least of the motives involved in this initiative was the seizure of Jewish wealth."[110] Mühlmann and his associates in the Reich Governor's office were important players in the rivalry for the booty.

Despite Mühlmann's apparent zealousness in contributing to the Nazi takeover in Austria, he was fired from his post in June 1939 by Josef Bürckel, who, having assumed Globocnik's position as Gauleiter of Vienna, was now the most powerful figure in the *Ostmark*. The official reason for the dismissal, as stated in Bürckel's notification letter to Mühlmann of 23 June 1939, was that the Wiener Werkel cabaret group had been allowed to produce "anti-Prussian scenes" and that this laxness had undermined Bürckel's authority.[111] The underlying motivation for the dismissal was not only to vanquish a rival, but also to weaken those who represented what was referred to as "Austrian tendencies." Mühlmann was not alone among the Austrians in suffering discrimination at the hands of the *Reichsdeutsche*. Art historian Jan Tabor has written of the second-class status to which many Austrian artists and architects were relegated, even with respect to "domestic" projects such as the creation of a cultural center in the city of Linz.[112] Mühlmann's efforts to keep the art confiscated from Viennese Jews in the city, as well as his funding of provincial cultural institutions in the *Ostmark*, were the primary offending actions.[113]

Even Seyss-Inquart was not in a fortuitous position to battle Bürckel and save his colleague and friend. His appointment as Reich Governor expired on 30 April 1939, and Hitler subsequently shuffled him off as ambassador to Slovakia.[114] Seyss-Inquart still held a cabinet position in the *Ostmark*, and by way of this position, he attempted to arrange Mühlmann's reinstatement. Seyss-Inquart contacted Hermann Göring, who just weeks earlier had talked about expanding Mühlmann's scope of authority by placing him in charge of the Berlin state museums.[115] He also challenged Bürckel directly. His letters of 29 June 1939 and 8 August 1939 included a litany of complaints and criticism, above all, that the replacement of Austrians by functionaries from the *Altreich* was having a very negative effect.[116] Finally, Seyss-Inquart wrote yet another power in Berlin, Heinrich Himmler, on 19 August, hoping to induce someone with clout to intercede.[117] Yet because none of the top leaders would intervene and because Bürckel could not be vanquished by Seyss-Inquart alone, the net result of this showdown left Mühlmann unemployed and the two chiefs of Vienna completely alienated.[118]

With the German success in the Polish campaign in September

1939, Göring found himself in a position to offer Mühlmann a post in the occupation administration. Göring contended at Nuremberg that Mühlmann approached him with the request to confiscate art. If this is true, it represents an important instance of a policy initiative coming from a secondary leader.[119] Göring's assertion must be treated skeptically. Mühlmann's widow reported how they were in Berlin when war broke out in September 1939 and that Mühlmann, a World War I veteran was "deeply shaken" about what might come, which is not the reaction one would expect from someone intent upon plundering.[120] But Göring's claim is not outside the realm of possibility. In a parallel case, Wolfram Sievers (1905–48), who was the business manager of Heinrich Himmler's purported research organization, the Ahnenerbe, wrote to the Reichsführer-SS on 4 September 1939, requesting permission to seize objects that related to "Germanic and German culture and history in the East."[121]

Regardless of the source of the initiative, there is no doubt that Göring and Mühlmann met in Berlin on 6 October 1939 and that Göring appointed him Special Delegate of the Reichsmarschall for the Securing of Artistic Treasures in the Former Polish Territories.[122] Three days later, Göring arranged for his aide, Erich Gritzbach, to sign a written commission granting Mühlmann wide-ranging powers to secure all artworks belonging to Jews, to the "former" Polish state, and to other "enemies" of the National Socialists, which came to include the Roman Catholic Church. Mühlmann also received orders to plunder from Hitler via Reinhard Heydrich and from General Governor Hans Frank and, therefore, had considerable bureaucratic muscle behind him. Although there were other Nazi operatives in Poland, such as the Dutchman Pieter Menten (1899–1987), Mühlmann was the chief plunderer.[123] For example, he chaired one notable meeting in Cracow on 28 October 1939 that was attended by not only Wolfram Sievers and Peter Paulsen (1892–?) (who led an SD commando that snared the Veit Stoss altar from its hiding place on the Vistula), but also Heinrich Müller, the head of the Gestapo.[124] In this meeting, many of the practical details of the plundering operation were ironed out: Sievers and Paulsen were given priority over archaeological and anthropological objects, which they noted were of great concern to their chief, Himmler, while Mühlmann asserted that he was interested in "objects of art historical value." The group delineated spheres of influence and pledged to cooperate with one another. Mühlmann also "declared that Polish scholars and museum officials must not be utilized for his work; the work would

be completed with men taken from Vienna, thereby clarifying a security police question."[125]

Mühlmann was joined by a host of other Austrians in occupied Poland. This is to some extent explained by the fact that parts of Poland, such as Lower Silesia, had once been included in the Habsburg Empire, which gave rise to an Austrian scholarly tradition of studying the culture of this area.[126] Personal connections were also often a factor: in the 28 October 1939 meeting discussed above, Mühlmann claimed to be "absolutely disinterested" in scientific objects, but noted that he had been acquainted with a Professor Tratz from Salzburg for twenty-five years who was perfect for the job. (Tratz was also an SS captain.)[127] Yet, the deployment of Austrians was also a conscious tactic on the part of the leaders in Berlin—to send those officials with *österreichischen Tendenzen* ("Austrian tendencies") away from the *Ostmark* to serve the Reich in the newly incorporated territories.[128] After hearing of Mühlmann's appointment, Hitler was said to have remarked, "Mühlmann—you are sending him there? I had to kick him out of Vienna . . . he did not want to let anything be taken out. . . . Beware that he does not carry everything to Vienna."[129] This was said half in jest, but there was logic behind the decision to make Seyss-Inquart Deputy General Governor in rump-state Poland under Hans Frank and to appoint other Austrian officials to prominent posts in the East.[130]

Mühlmann was charged with forming squads of agents to locate, transport, and catalog the artworks in Poland. He oversaw two commandos of about a dozen men each. One, led by his half-brother Josef, operated in the northern part of Poland above the fifty-first parallel and included Warsaw (the Polish National Museum served as their main depot). The unit in the south, headed by Gustav Barthel, was based in Cracow, more specifically, the Jagellonian Library. Mühlmann traveled back and forth between the two commandos, but spent most of his time in the south. Much of the work, especially early on in the fall of 1939 and the first half of 1940, entailed raids on museums, grand residences of the Polish nobility, and selected churches and monasteries. Mühlmann's commandos had their own trucks and cars and in most cases carried out the seizures by themselves, but there were instances when they called upon Himmler and Heydrich's security forces for assistance. Because the Poles had concealed many of the cultural treasures, there was often an element of detective work for Mühlmann and his staff; as he noted after the war, "[we had] to look for them in cellars and hiding-places."[131] Indeed, the Poles had undertaken safeguarding

Publishing information for Gustav Barthel
and Kajetan Mühlmann's book, Cracow:
Capital of the German General
Government in Poland, 1940. The caption
reads, "published by the office of the General
Governor for Poland. The Special Delegate
for the Securing of Art and Cultural Goods,
SS-Lieutenant Colonel Dr. Kai Mühlmann"
(photo by author).

measures such that Mühlmann could claim after the war, "I never found pictures hanging in the museums."[132] At a minimum, the works would have been taken down and put in secure places. It cannot be determined whether physical coercion was used to induce Poles to reveal the locations of artworks, but the confiscations often involved force as the commandos swept in and ran roughshod over any who opposed them. At other times, though, Mühlmann acted more like a messenger, as in 1941, when he took his automobile to Lvov to pick up Dürer drawings from the Lubomirski collection and drove them to Berlin or when he transported paintings by Raphael, Rembrandt, and Leonardo from Cracow to Berlin by carrying them with him on a train.[133]

Much of the work of Mühlmann and his colleagues in Poland involved sorting and cataloging. Indeed, they made a concerted effort to give their activities a scholarly veneer: Mühlmann's task was called "coordinated scientific leadership," he and his colleagues were not stealing, but "securing" (Sicherstellen). Their scientific endeavors extended to

the creation of two restoration workshops in Warsaw and Cracow and cataloging the works according to their quality, with the best called "Choice I" (*Wahl I*). Josef Mühlmann was so convinced of the scholarly nature of the work that he reported in 1963 that the commandos had only dealt with "state museums," and that they had compiled two inventories (one for the north and one for the south) of such great scientific value that they were sent to major libraries and still of use. He presumed that a copy of the catalog could be found in the National Library in Vienna and went so far as to sometimes represent himself as "Professor Mühlmann." Josef Mühlmann claimed furthermore that the works were sent to the Reich only upon the advance of the Soviet troops.[134] This was false: certain works, including the Veit Stoss altar, were transported immediately upon seizure. After the war, Kajetan Mühlmann provided a less embellished account of his commandos' work, "I confirm that the official policy of General Governor Hans Frank was to take into custody all important artworks of Polish public institutions, private collections, and churches. I confirm that the mentioned artworks were actually confiscated and I myself am clear that in the case of a German victory they would not have remained in Poland, but would have been used for the completion of German art holdings."[135] Mühlmann played a key role in the plan that Hans Frank described most succinctly: "the Polish lands are to be changed into an intellectual desert."[136]

The culture that survived was to be Germanic in character, and Mühlmann worked to contribute to the intellectual underpinnings of the Nazis' policies throughout Europe. Despite the enormous task before him in denuding Poland of its artistic patrimony, Mühlmann still found time to write art and cultural historical studies elaborating the "Poland-is-really-Germany" argument. Kajetan Mühlmann even published two short books based on his "research" in Poland, which had scholarly pretenses, even if they were baldly ideological.[137] Hans Frank, for example, wrote the introduction for Mühlmann and Gustav Barthel's volume on Cracow and Frank closed his remarks with "Cracow, on the Birthday of the Führer 1940." Mühlmann and Barthel's volume on culture in Poland was part of a larger Nazi literature on the region, which included Dagobert Frey's *Krakau* (1941), where he "refused to identify Cracow as a Polish city," and Karl Baedeker's guide to the General Government, which announced Cracow and Lublin were now "*Judenfrei*."[138] Mühlmann and Barthel, to give a sense of their argument, began their study with the observations, "The *Ostmark*, the

Sudetenland, Eastern Silesia, the region of the river Weichsel—many names characterize a piece of German history from an inner consistency that affects us all deeply. German history in the East: that is the fulfillment of a thousand year old struggle and fight of Germanic life-energy. . . . Securing German living space (*Lebensraum*) is the task. Achieving it through German spirit and culture is the result. Already centuries ago [this region] was settled and secured by our Germanic ancestors."[139] Barthel and Mühlmann appropriated words and concepts central to the Nazi ideology and articulated a racist and nationalist cultural history, all with the aim of justifying the Germans' conquest of the region.

As with his interlude in Vienna, Mühlmann had to contend with the personal politics of his superiors while he carried out his plundering commission in Poland. Göring, who had been appointed Reichsmarschall and Hitler's official successor on 1 September 1939, and who had first engaged Mühlmann, warranted Mühlmann's primary allegiance. Göring had used a favorite tactic among the top Nazi leaders by hiring Mühlmann at a time when the latter was unemployed and had no visible career prospects (just as Hitler had recruited Hans Posse to head the *Führermuseum* after the director had been sacked). This strategy of making subordinates beholden to superiors partly explains, perhaps, their willingness to engage in criminal activities. Regardless of his motivations, Mühlmann made sure to appease his benefactor, and he directed prized artworks to the Reichsmarschall as special gifts, including Antoine Watteau's *Polish Girl* from the Lazienski palace and thirty-one "especially valuable and world famous drawings by Albrecht Dürer from the Lubomirski collection in Lemburg [Lvov]."[140]

Mühlmann also had to contend with the other Nazi powers in Poland. Hans Frank made regular selections from the plunder, which was stored in the Jagellonian Library in Cracow. Frank decorated two castles with the help of Mühlmann, earning the sobriquet "King Stanislas V."[141] Heinrich Himmler, the other notable potentate in the region, likewise made claims on Mühlmann, his SS subordinate. This relationship matured later when Mühlmann moved to the Netherlands and Himmler arranged to obtain artworks for both private and official purposes (one document lists thirty-one objects that Mühlmann acquired for the Reichsführer-SS).[142] Other Nazi leaders, such as his old ally, Salzburg Gauleiter Friedrich Rainer, also tried to induce Mühlmann to forward artworks. Rainer had previously obtained pieces from the Rothschilds' collection in Vienna, and he again asked Mühlmann for art

to decorate "castles in Salzburg," above all his official quarters in the *Residenz*.[143] Mühlmann could not accommodate Rainer in this instance, although he wisely advised the Salzburg Gauleiter to raise the matter with Hitler (who also turned him down).[144] Mühlmann simply had too many Nazi leaders making requests for art, and he therefore often rebuffed the second-rank leaders who sought works. He initially rejected the request of Nuremberg mayor Willy Liebl, who sought the Veit Stoss altar from Cracow (on the grounds that the artist was born in Nuremberg) and handed it over only after Hitler's express orders to Hans Frank.[145] Mühlmann made sure to cultivate Hitler's good will, and this included sending him five volumes of photographic albums depicting the "Choice I" artworks, of which there were 521. Hitler reportedly studied the catalogs carefully, with an eye toward enhancing the collection of his Führermuseum.[146]

Because he and his staff had worked very expeditiously in Poland— Mühlmann reported to Hitler that "within six months almost the entire artistic property of the land was seized"—he developed a reputation for efficiency and simultaneously freed himself to engage in other enterprises.[147] In Poland Mühlmann had become acquainted with Wolfram Sievers, who was both the business manager of the Ahnenerbe and one of the leaders of the *Haupttreuhandstelle Ost* (Main Trusteeship East). The former was an organization under Himmler's aegis that was concerned with prehistorical matters, such as excavations and folklore studies; the latter was one of the plundering agencies in the occupied East, which again fell under the joint leadership of Göring and Himmler. Sievers and his associates in the Ahnenerbe were also involved in reclaiming Germanic cultural objects from the South Tyrol region, having been commissioned to do so by Himmler in his capacity as Reich Commissioner for the Strengthening of the German People (the same post that placed him in charge of the population transfers undertaken by the Nazis). Because Hitler had sacrificed the South Tyrol to Mussolini in an effort to bolster the Axis alliance in 1939 (and arguably as compensation for the acceptance of the *Anschluss*), the Nazis were particularly anxious that all artworks and cultural objects from the region came back to Germany (*heim ins Reich*). Sievers called Mühlmann down to the Ahnenerbe's operation base for the South Tyrol in Bolzano in the spring of 1940 and discussed the possibility of Mühlmann lending his expertise to the project. Mühlmann was eager to participate, noting that Hans Posse "did not want to care for the entire Tyrol complex" and that "[Mühlmann's] personal intervention could be effective,"

but he made his involvement conditional upon being named to head the operation, then euphemistically called the "Kulturkomission."[148] Sievers consulted his colleagues about this demand, and he reported in a memorandum that while he had nothing against this arrangement there were "objections from the men of the Art Group in the Kulturkomission, who know Dr. Mühlmann very well."[149] Mühlmann's reputation in 1940 entailed a mixture of admiration, which stemmed from this technical prowess, and apprehension, which grew out of his desire to dominate and his wish to get ahead by catering to his superiors. Mühlmann never went into action in the Tyrol, although he did proffer advice to the experts deployed there. For example, he wrote them a letter in his capacity as Special Delegate for the Securing of Art Treasures in the Occupied Polish Territories and advised that all German cultural goods, whether they be private, church, or state owned, be seized to benefit the Reich.[150]

Mühlmann attending rally in Vienna wearing SS uniform; he sits in the second row behind Arthur Seyss-Inquart (far right), May 1939 (ÖIfZG-BA).

Mühlmann could not have been too upset that his services were not needed in the South Tyrol because by the time the matter had been decided, he had been engaged by the Reich Commissioner of the Occupied Netherlands, Seyss-Inquart, to ply his trade in the Low Countries.[151] A Dutch intelligence officer, Jean Vlug, noted dramatically in his postwar report on art looting, "Rotterdam was still burning when Kajetan Mühlmann in his SS-uniform arrived in Holland to take up the task of his *Dienststelle* [agency]."[152] Vlug's report is flawed in many ways (Mühlmann normally wore a brown Party uniform or, more frequently in the Netherlands, civilian clothes), yet his observation is accurate with respect to Mühlmann's assiduousness as a plunderer. In fact, Mühlmann welcomed the opportunity to work with his friend in the Netherlands because he had felt uncomfortable with the brutal policies that had prevailed in the East. He had, for example, complained to Hans Frank about the dynamiting and melting down of the "monument before the Wavell [castle]."[153] Mühlmann's guidelines in the Low Countries differed significantly from those in effect in Poland. The Dutch were perceived by Hitler, Himmler, and other policymakers as racially kindred to the Aryan Germans, and the occupation was supposed to be more benign. Hitler had chosen Seyss-Inquart because of his reputation for moderation, a misassessment in light of the findings of the International Military Tribunal that determined that Seyss-Inquart had ordered hostages shot, deported five million workers to the Reich, and played a leading role in killing 117,000 of the Netherlands' 140,000 Jews—one of the highest fatality ratios in German-occupied Europe. Yet if one is to preserve distinctions, the occupation of the Netherlands must be recognized as having differed from that in the General Government, and Seyss-Inquart was much more in his element in the West as he tried to nurture collaboration while overseeing the exploitative economic measures.

Mühlmann as usual adapted to his surroundings, and just as he had created looting commandos in Poland, he was able with equal ease to establish a type of art dealership for processing works taken from Jews and other enemies. The agency also sought out any other artworks that could be acquired inexpensively and resold for a profit. Mühlmann's operation became relatively sophisticated. With headquarters in The Hague (where he could be near Seyss-Inquart, who provided him with three bank accounts and the initial capital to start the venture), he eventually opened branches in Amsterdam, Brussels, Paris, Vienna, and Berlin.[154] Because the agency received works from the SD and the

Reichskommissariat for Enemy Property, it in many ways resembled a clearing house.[155] Mühlmann stipulated that a commission of 15 percent would be made on all sales, except on those to Hitler and his agents, and this revenue made the operation self-supporting. He also personally dabbled in the art market and acquired works that he shipped back to his family in Salzburg; although there are documented instances when, to quote Jean Vlug, "Mühlmann worked for his *own* profit" (he cites a deal with Adolf Weinmüller), it remains unclear to what extent he enriched himself while in the Netherlands.[156] Profit was certainly among the motives that drove Mühlmann during the Third Reich (although probably not as significant as his belief in the Nazi ideology). Hilde Mühlmann rationalized his activities during the Third Reich along these lines, noting that "he had to 'trade' in art or else he would have had no financial means *(Existenz)*."[157]

Mühlmann surrounded himself with a small staff, including his half-brother Josef, two Viennese art historians—Franz Kieslinger and Bernhard Degenhart—and Eduard Plietzsch (1886–1961), a Berlin specialist on Dutch art who continued to publish monographs while he worked for the agency.[158] Mühlmann's efforts to gain a hint of respectability entailed not only employing these well-regarded experts, but also publishing catalogs. Mühlmann wrote in the introduction to one volume concerning the seized art of the Mannheimer family, "this catalog contains the results of scientific work and extends to description, critical listing and some new attributions and therein is an essential contribution to German art research."[159] This posturing in the case of the Mannheimer's art is particularly striking because the forced sale of the collection belonging to a deceased Jew (confiscation by the Enemy Property Custodian was threatened) was one of the more unseemly episodes with which Mühlmann was involved in the Netherlands.[160] This veneer of "research" included cultivating relationships with members of the art establishment back in the Reich. He consigned works from the agency to a number of reputable auction houses, including the Dorotheum in Vienna, Adolf Weinmüller in Munich and Vienna, and Hans Lange in Berlin.[161] Records show that the Mühlmann agency sold at least 1,114 artworks during the war.[162]

The pretenses of propriety could not conceal one of the main components of Mühlmann's project, which was to expropriate the artistic property of enemies of the regime and to ensure that the booty flowed in an orderly manner to the top Nazi leaders. During the occupation, Seyss-Inquart issued a series of orders that required Jews to take their

valuables, including jewelry and artworks, to the (Aryanized) Bankhaus Lippmann, Rosenthal, and Co. in Amsterdam.[163] Without any tangible compensation given to the owners, this "administered" property was then handed over to the chief of the economic division of the Reichskommissariat: Dr. Hans Fischböck, with whom Mühlmann had earlier worked in Vienna. Fischböck then arranged for the artworks to be delivered to the Mühlmann agency, where they were assessed by the art experts, and then put up for sale—with Hitler and Göring accorded the right of first refusal.[164] As a result of this arrangement, Mühlmann was in a position to direct works to other members of the Nazi elite (unlike in Poland, where he was given less room to maneuver). His customers included Heinrich Himmler, Ernst Kaltenbrunner, Hans Frank, Baldur von Schirach, Erich Koch, Fritz Todt, Julius Schaub, Josef Thorak, and Heinrich Hoffmann.[165] The Mühlmann agency was not only the Nazi elites' chief source of art in the Netherlands, but also served the dual functions of liquidating seized property. And through the purchase of works with the working capital provided by Seyss-Inquart, it contributed to the economic exploitation of the country. This clearing house/art dealership was unique in Nazi-occupied Europe.

Despite his apparent freedom of action and the profits he was reaping, Mühlmann was in a difficult position as he tried to appease a number of top leaders. He admitted in postwar interviews with OSS officers that "the competition between Hitler and Göring caused a pressure from which one could not escape. . . . I personally was in a very difficult position."[166] In the autumn of 1944, his Austrian friend Ernst Kaltenbrunner, the successor to Heydrich as head of the Reich Security Main Office, informed him that Bormann had talked of placing Mühlmann in a concentration camp as a result of his delivering an insufficient quantity of art to Hitler.[167] Mühlmann had previously left his position in Poland in October 1943 after having supposedly incurred General Governor Frank's displeasure for failing to deliver certain valuable pictures. And Göring threatened him with imprisonment when he discovered that Mühlmann had taken Leonardo da Vinci's *Lady with an Ermine* and transported it upon Frank's orders from Berlin back to Cracow.[168] Obtaining artworks for the Nazi leaders could be a hazardous enterprise.

Yet Mühlmann had a talent for self-preservation. He arranged for Hitler to receive a lavish album of photographs which documented the works the agency had acquired for Linz, and sent an accompanying letter signed "from a loyal servant to the Führer."[169] These same survival instincts induced him to pull out of the Netherlands in the summer of

1944. As the Allies invaded the Continent, Mühlmann decided to return to the relative security of Vienna. Because he had provided many artworks to the city's Nazi chieftain, Baldur von Schirach, he thought there were good prospects for a safe haven there.[170] At this point, his main objective was survival. Accordingly, he reduced his business activities to a minimum. Mühlmann reported after the war that from July 1944 until June 1945, he was "without any duties—more or less on sick leave."[171] Because of the deteriorating military situation, he was especially concerned about the welfare of his wife and children. Previously, as early as 1943, he had arranged for them to stay with friends outside of Munich, and then in a house on the Attersee in the Austrian Alps (a residence they shared with opera diva Elisabeth Schwarzkopf). It was in the latter that they took refuge at war's end lest they experience the Red Army's assault on Vienna.[172] Mühlmann nonetheless kept a residence in the former Austrian capital; when the OSS agents arrived in Vienna in the spring of 1945, they located Mühlmann's vacated but well-stocked home at Rennweg 6 and found not only a triptych that came from a Jewish art dealer named Rosenbaum but also reported, "In his cellar are stored cases with Dutch products: soap, Bols [liqueur], rugs, lamps, etc."[173] (This hoarding was not unique by any means. The same agents noted the efforts of his half-brother: "Josef Mühlmann was

Mühlmann with two of his four children,
c. 1944 (BDC).

an SS captain in Poland, but was deprived of this worthy grade for installing a lady friend with objects destined for the Reich."[174]) Kajetan was successful in his corruption in part due to his connections to those with power who could offer him some sort of protection. Mühlmann stayed in touch with powerful Nazi figures right up until the end of the Third Reich. Ernst Kaltenbrunner, for example, consulted with him in April 1945 about forming a transitional Austrian government—one to counter that proposed by Social Democrat Karl Renner (who became the first president of postwar Austria)—as both factions sought to create a regime that would be acceptable to the Allies.[175]

After the war, Mühlmann told his captors grand stories about battling SS commando Otto Skorzeny and his contingent of fanatics in the Tyrol. Mühlmann also claimed to have liberated Hermann Göring from incarceration by SS forces in Schloss Mauthendorf, where Göring had been imprisoned by order of Hitler on charges of treason, and then delivered the Reichsmarschall to the Americans.[176] Mühlmann never considered that this story of heroic deeds was inconsistent with his other claim that he was sick and inactive at the time. In any case, the veracity of his tales remains highly doubtful. But it is ironic that Mühlmann's last act for his one time benefactor very well may have been to deliver him to the enemy just as the war was ending.

The manner in which Mühlmann escaped prosecution after the war is similarly extraordinary. The Americans captured him in Seewalchen on the Attersee in the Austrian Alps on 13 June 1945 and took him to Camp Markus in Salzburg. On 20 July, he was transferred to the camp at Payerbach in Upper Austria, where he was interrogated by the CIC unit that worked on culture (also known as Culture Intelligence).[177] They induced him to discuss the deeds of Göring, Seyss-Inquart, Frank, and Kaltenbrunner; his blunt and damning testimony was submitted to the International Military Tribunal at Nuremberg and helped in the convictions and subsequent death sentences of these leaders.[178] Regarding his own actions, Mühlmann admitted responsibility in a way similar to that of Albert Speer. He confessed to a specific and noncapital offense (the expropriation of Jewish property), but claimed to know nothing about the Holocaust. This assertion was a bald-faced lie considering his friendship with Globocnik and his deployment in the General Government; even his friend Wilhelm Höttl told the author that Mühlmann had been aware of the killing.[179] More credibly, Mühlmann claimed to have saved the lives of a number of individuals and to have helped arrange the transfer onto his staff of an art historian named

Asmus von Troschke, whom, Mühlmann maintained, had been drafted into the SS and stationed at Auschwitz where he had "dreadful tasks."[180] This latter assertion, while intended as self-exculpatory, actually indicates that Mühlmann knew about the genocide. Unlike Speer, he failed to make a positive impression on the victors. The assessment of one Allied interrogator read, Mühlmann "is obstinate; he has no conscience; he does not care about art; he is a liar and a vile person."[181] The CIC sent Mühlmann back to the Austrian authorities in October 1946, although the intelligence agents demanded a written pledge that he not be released without prior U.S. approval.[182]

Art plunderers rarely faced prosecution after the war. Nonetheless, the only other subleader to rival Mühlmann in terms of scale and net worth of the artworks, Robert Scholz (another Austrian), was tried by the French, albeit in absentia.[183] With similar intentions, the Poles sought Mühlmann's extradition and pressured the Austrians to relinquish him. Historian Robert Herzstein has described how in the summer of 1947, Austria passed a new law that appeared designed to restrict further extradition of accused war criminals of Austrian nationality.[184] While the Allied Council vetoed this provision, the Austrian authorities proved very accomplished at footdragging. In 1951, for example, they falsely maintained that Mühlmann was either in Switzerland or Lichtenstein and that delivering him to Poland was not feasible.[185] Mühlmann remained the subject of a domestic investigation, but the Austrian government did not want a citizen featured in a potentially high-profile foreign trial at this point when the state treaty securing the country's autonomy hung in the balance. The Austrians based their claims for independence on the Allies' Moscow Declaration of 1943, which posited that Austria was a victim of fascist aggression, and it was not in their interest to have nationals on trial for Nazi war crimes.[186]

Prior to 1948, Mühlmann remained in a camp for SS men because members of this organization, which was declared criminal at the Nuremberg trials, were automatically supposed to serve two-year prison terms. In 1947, Mühlmann testified in the celebrated treason case of Guido Schmidt.[187] In this public forum, he attempted to pass himself off as an insignificant bureaucrat, and he denied both his SD ties and any illegal pre-*Anschluss* Nazi Party membership. By this time, he was also denying that he had intended to plunder artworks in Poland and the Netherlands. Directly controverting the statement he signed in Nuremberg in 1945 about the Germans' intentions to take control of the seized works, he now stated that he had simply tried to safeguard

the art and that he had "not engaged in any criminal activities."[188] He hoped to avoid attention and slip away after his release from the SS prison camp, and in light of the vastness of the internment facilities— the occupation powers detained more than 300,000 individuals active within the NS-regime in a network of camps—this did not seem such a remote possibility.[189] But the ongoing inquiries into his past by both the Austrians and the Americans made this development increasingly unlikely.

Mühlmann placed his hopes in the exculpatory story that he had turned resistance fighter at the end of the war. This was difficult for him to verify, especially because his activities at war's end had rested upon a series of deceptions. In the spring of 1945, Mühlmann had convinced the Americans that he was in the resistance; he had secured papers signed by American Major General Harry J. Collins, commander of the 42nd (Rainbow) Division, attesting to his anti-Nazi activities and permitting him to carry a gun and drive a car.[190] He then took these documents to Karl Gruber, the leader of the resistance in the Tyrol (and subsequently the Austrian foreign minister), who signed another document stating that Mühlmann had been of great service to the resistance movement.[191] Yet Gruber actually met Mühlmann for the first time in mid-May 1945, two weeks after the capitulation and knew virtually nothing of the latter's activities.[192] It is curious that the head of the resistance would vouch for someone that he did not actually know, but Gruber had very close ties to the Americans, and the Counter Intelligence Corps in particular, and evidently viewed Mühlmann's papers as compelling evidence.[193]

It appears, then, that Mühlmann played Gruber and the Americans against one another to secure a certificate that he participated in the resistance. Whether the Americans also assisted Mühlmann as a result of his postwar cooperation with the CIC—as they did with SS commando Otto Skorzeny (who "won immunity by denouncing his own comrades in American internment camps") and Klaus Barbie (who was protected in return for anti-Soviet intelligence)—and whether Gruber intentionally helped his fellow Austrian evade justice remains difficult to determine.[194] If Mühlmann actually delivered Göring to the Americans in 1945, this deed, along with the information he gave to the Art Looting Investigation Unit and the damning testimony that proved so useful to prosecutors at Nuremberg, may have earned him generous treatment. The CIC documents released under the Freedom of Information Act have been blacked out by censors so that it is impossible to

determine what transpired. Wilhelm Höttl, who also collaborated with American intelligence officers after the war, reported in an interview that Mühlmann helped the CIC by identifying potentially useful informants and by providing information about former Nazis.[195] While Mühlmann himself did not have much that would help the Americans wage the cold war, he had met so many important individuals by way of his art plundering and dealing, as well as in his capacity as an SS officer, that he could serve as a guide through the maze of surviving Nazis and offer a kind of "who's who." Additionally, as OSS officer Sterling Callisen wrote to his chief, William Casey, in 1945, "minor informers are chosen because they are more 'pliable' than the more important Nazis."[196] Therefore, in the wake of Mühlmann's testimony at the Guido Schmidt trial, the Americans arranged for his transfer back to Munich, where on 18 August 1947, he became the responsibility of the Office of the Military Government of Bavaria.[197]

Despite Mühlmann's apparent usefulness to the Americans, they did not guard him closely enough so as to prevent his escape.[198] Mühlmann had tried to flee from the OSS officers in 1945 while they interrogated him at Altaussee, but they had apprehended him immediately and made it clear that his fortunes would improve if he cooperated. Yet circumstances had changed by 1948, in part because security measures were more lax and the Allies were not searching for war criminals with the same energy or thoroughness as between 1945 and 1947. The Americans in particular were in the process of concluding their occupation and transferring responsibility for justice to the Germans; they were therefore not especially inclined to prosecute "minor" war criminals.[199] The Americans, however, were still overseeing the restitution of artworks, and OSS agents interrogated Mühlmann about some of the problem cases, such as the Dürer drawings Mühlmann had taken from Lvov that had not been located (they were actually lost in a storeroom of the Central Collecting Point in Munich). Mühlmann also helped sort out objects belonging to Dutch collections that had found their way to Bavaria; as one official noted in fall 1947, "Mühlmann could identify several paintings and pieces of furniture. It proved again that it is a big help having Dr. Mühlmann sent from Vienna to Munich."[200] In February 1948, Mühlmann fell ill and was transferred to the local Hospital Carolinum, where he was kept under guard. But on the sixteenth of February he nonetheless managed to flee and was never again apprehended.[201]

The details of Mühlmann's escape remain a mystery, but there was

*Mühlmann on a clandestine visit to Austria in
the 1950s. Note that the fugitive, who
continued to deal art, now wears a mustache
(from private sources).*

clearly little resolve to recapture him. Like the Americans, the West
Germans also had other priorities, and it helped Mühlmann that he was
Austrian and not guilty of a capital offense. Other Austrian war crimi-
nals, such as Adolf Eichmann, Alois Brunner, and Hans Fischböck also
escaped, in their cases, to South America.[202] In short, the effort to locate
Mühlmann was halfhearted at best.

Mühlmann had fled to southern Bavaria near Lake Starnberg, a
favored locale for many former Nazis. However, the pressure was not
completely off. The Poles, for their part, sought his extradition in the
late 1940s and early 1950s.[203] This terrified Mühlmann, who would
later inform his attorney, "extradition and sentencing in the wake of my
poor health would surely have meant my death." (Mühlmann's widow
also speculated that the Poles' plans for extradition had earlier moti-
vated the Americans to permit him to escape).[204] The Austrians also
pursued Mühlmann through judicial means—both because he was
deemed an *Illegaler* and because more evidence about his wartime
deeds was coming to light—and they issued an arrest warrant in August
1951.[205] They tried to contact Mühlmann by way of his wife's address
in Seewalchen on the Attersee, east of Salzburg, although it was appar-
ent that Mühlmann himself was not living there. From his hiding place
in southern Bavaria, Mühlmann kept in touch with his family. He was
apparently very nervous about the investigation. In 1951, he contacted
Bruno Lohse in Munich, the art historian who had worked in the ERR
depot in Paris and just emerged from a Paris prison. Lohse reported that
Mühlmann was in a panic and was trying to determine if his name was
on wanted lists.[206] Mühlmann considered returning to Austria and

undergoing denazification, but he believed that he had too many ene-mies and feared the consequences of being tried as an *Illegaler*.[207] Indeed, while Austrian justice was not harsh with respect to most crimes committed by the National Socialists, stiff sentences were often handed down for those found guilty of undermining the independent Austrian state prior to 1938.

The Austrian authorities therefore tried Mühlmann in a Viennese court in absentia, beginning in 1951. Through a Viennese attorney named Otto Tiefenbrunner, Mühlmann wrote to the Austrian presi-dent, Dr. Theodor Körner, and asked for an amnesty.[208] Tiefenbrunner filed a number of documents on behalf of Mühlmann, but never divulged his client's whereabouts. The verdict came in 1952. A notice in a local paper, the *Wiener Kurier*, reported on the ruling: "A People's Court Senate considered the high treasonous activities of the notorious Nazi painter [*sic*] Dr. Kajetan Mühlmann on Friday, after the state pros-ecutor of Vienna motioned for the forfeiture of his entire property. Mühlmann, a fugitive of unknown whereabouts, stood in closest con-nection to the leaders of the illegal NSDAP during the period of the Nazi Party ban in Austria."[209] The Austrian authorities therefore attached his property—or what in fact turned out to be a portion of it—but did not apprehend him.

Kajetan Mühlmann's circumstances were not nearly as desperate as they might have been. First, he had established the financial means to survive in exile. Wilhelm Höttl told the author that prior to war's end, Mühlmann, always adroit at self-preservation, had prepared for the postwar period by hiding property throughout Bavaria and Austria. Most of this property was in the form of artworks, and he generated an income by selling these pieces. Allied investigators in 1945 had also found evidence of Mühlmann stashing pictures and described instances when he entrusted works to various friends in Salzburg and in several villages on the Attersee.[210] There were also persistent rumors that he had evacuated artworks to Switzerland and that they remained at his disposal after the war.[211] Höttl explained that Mühlmann had main-tained connections to figures in the art world—specifically to dealers in and around Munich, where Haberstock, Walter Andreas Hofer, Bruno Lohse, Maria Almas Dietrich, Julius Böhler, and many others who had sold to the Nazi elite reestablished their businesses after the war. Mühlmann therefore played a role, albeit a fairly clandestine one, in these circles. Another interesting aspect of Mühlmann's underground life in the 1950s concerned his romantic relationships. Mühlmann,

often described as tall and handsome, by many accounts had a number of romantic liaisons. One of these, according to Höttl, was with film-maker Leni Riefenstahl. They had taken up during the war (Höttl suggested that Riefenstahl was also a client), and their relationship continued after Mühlmann returned from incarceration.[212] Riefenstahl lived in Pöcking on Lake Starnberg and Mühlmann evidently resided nearby, although the possibility of periodic cohabitation is not out of the question. This relationship also sheds light on the network of individuals who were prominent in the Third Reich and who gravitated to southern Bavaria: even the professedly unpolitical Riefenstahl maintained contacts with former Nazis.

While the Austrians did not completely forget about Mühlmann, they were less than industrious in apprehending him. In the mid-1950s, there were several reports, including testimony from half-brother Josef Mühlmann, that Kajetan was living abroad near Munich, although Josef, too, denied any contact.[213] Mühlmann's second wife Hilde continued to live on the Attersee in a charming lakeside house, where she worked as a *Gymnasium* teacher in the village of Seewalchen, but she also refused to reveal the location of her husband.[214] Mühlmann, according to Höttl, made periodic trips back to Austria to see Hilde and the children. And even Mühlmann's first wife, Poldi Woytek, resided nearby in Salzburg-Anif in the Aryanized villa they had obtained during the war (although the Americans confiscated the pictures that were in the house at war's end).[215] The Austrian authorities, then, had some clues that Mühlmann was nearby in Bavaria, but they did not actively pursue him or even request that the Federal Republic of Germany extradite him. While one can perhaps understand the unwillingness of Austrians to release their citizens to Soviet bloc governments during the cold war, it is remarkable that justice did not transcend Western European borders.[216]

Mühlmann lived abroad as a fugitive up until his death. This was in marked contrast to his half-brother Josef. The former Gestapo agent and plunderer had never thought it necessary to leave the country and had managed an almost complete rehabilitation of his reputation in his capacity as an art restorer and curator in the Salzburg royal *Residenz-galerie*, one of the city's most important cultural institutions. A visitor to Josef Mühlmann in January 1963, who reported back to Simon Wiesenthal, described the following: "he lives here very contentedly, and despite his advanced age (78) is still active as an art restorer."[217] In the 1960s, Josef Mühlmann published books on Christmas songs and their folkloric origins.[218] He was apparently well-regarded within the com-

munity—a member of the Arts Society, among other organizations—and various local institutions, including the Carolino Augusteum Museum, still possess portraits of him.[219] While Kajetan Mühlmann did not live as comfortably nor live as long, he was able to evade the authorities. Mühlmann had told Allied interrogators in 1947 that he had hoped to take advantage of all that he had learned and become an art dealer.[220] He therefore found a remarkable niche in the circle of surviving Nazis and those sympathetic to them. Kajetan Mühlmann battled stomach cancer throughout the late 1950s and this necessitated an operation that took place in Munich in 1958. He succumbed to this cancer and died there at the age of sixty on 2 August 1958. His widow Hilde arranged for his body to be returned to Salzburg, and he was buried in a family grave at the Maxglan cemetery.[221]

- - -

Art historians who served the Nazi regime from both inside and outside academia were very successful at effecting the rehabilitation of their careers. The case of Herbert Jankuhn (1905–92), an expert on prehistory who worked for Heinrich Himmler and the SS-administered research organization, the Ahnenerbe, then revived his academic career, was mentioned in chapter 3. There were other academic art historians who launched their careers during the Third Reich but did not become explicitly involved in the plundering operations, and it was not uncommon to see them go on to have successful careers. Austrian scholar Hans Sedlmayr, mentioned in the introduction to this chapter, provides a case in point. While he appears to have embraced National Socialism early on, he was not complicit in the looting. Sedlmayr did attract some attention in the Allied intelligence reports of 1945, but there were so many others in the art world whose behavior was worse that the OSS largely ignored Sedlmayr. The Austrian art historian was able to sweep most of his past under the rug and enjoy a successful career.

It is more surprising that an individual like Niels von Holst (1907–81) was able to regain his professional reputation to the extent that he did. An expert on Baltic art, Holst published nine books and also served as a critic, writing about contemporary art for newspapers and magazines. He was also an employee of the Berlin State Museums, a functionary in the Education Ministry and Foreign Office, and an operative for the ERR in the East. Although Holst does not qualify as one of the great scholars of the twentieth century, his career featured a num-

ber of successes, and his work on German and Baltic German cultural history constitutes a valuable scholarly contribution.[222] The longevity of Holst's scholarly career, which lasted from 1930 to 1981, was impressive—a testament to the effectiveness of his postwar rehabilitation. But it is his activities on the Eastern Front from 1940 to 1945 that are most remarkable.

Niels von Holst was an ethnic German born in Riga, and his lifelong objective was to advance the German culture of the Baltic lands to the point where these states would assume a German identity and organically link up with the Reich. The trajectory of Holst's career involves an escalation of chauvinistic pro-German sentiment, leading to his work as a plunderer from 1941 to 1944. Holst was an intelligent individual—Paul Sachs described him in a 1945 OSS report as "gifted, ambitious, a Nazi, though rather for opportunistic than political reasons"—and he used his abilities to provide part of the intellectual underpinning for the Nazis' claims over these regions.[223] In his work, one sees the shift from nationalistic, but politically moderate early work on German culture (such as his 1930 book, *German Portrait Painting in the Time of Mannerism*) to the intellectual prostitution that he performed from 1933 to 1945.[224] By 1941, Holst was working with Himmler's research institute the Ahnenerbe, and he and his colleagues were exchanging letters talking about Copernicus as "a German astronomer."[225] In short, he compromised his scholarly integrity in order to promote a larger geopolitical goal of German rule in the East. Holst is typical not just because he compromised his behavior and scholarship to serve the Nazi rulers, but because there were so many Baltic Germans who were prepared to do so. Spurred on by a hatred of the Soviet Union, there were a number of Balts (including another Riga native, Alfred Rosenberg) who joined the Nazi cause because they preferred German rule.

It is not entirely clear how Holst became an art plunderer, but it is perhaps relevant that he had previously gained experience in the Baltic states in 1919 and 1920 when he traveled there on behalf of wealthy exiles and brought back property that had been confiscated during the communist revolution.[226] It is also significant that he held an appointment at the Berlin State Museums under Otto Kümmel, who, as noted earlier, played an important role in formulating the initial looting plans. Holst had become head of the External Office in 1934 and was in charge of the museum's relations with foreign institutions; and this extended to helping organize exhibitions abroad, including the German pavilion at the 1937 Paris World Exposition.[227] In 1940, this collabora-

tion with Kümmel entailed organizing the "repatriation" program, which aimed to bring back all artworks of German origins, whether they were taken by Swedes during the Thirty Years' War or the French during the Napoleonic invasions. Holst not only collected and synthesized the information culled from museum directors, curators, and art historians throughout the Reich, but also made research trips to France to explore firsthand what might be "regained."[228]

Holst's membership in the SS also had a discernible impact on his career, and his first experiences as a plunderer came in the East in the service of Heinrich Himmler, who as Reich Commissioner for the Strengthening of Germandom not only moved people, but also their cultural property. In 1940, Holst was made a member of the German commission that undertook negotiations with the Soviets concerning the fate of the Baltic lands.[229] Holst joined the German ambassador to the USSR, Werner von der Schulenberg, and other high-ranking figures in Moscow for difficult and protracted negotiations from February 1940 through June 1941. Holst was charged with making recommendations about the disposition of cultural property, including artworks, archives, books, coins, and religious artifacts, among other objects. He appeared both knowledgeable and firm: at least his SS chiefs seemed pleased with his performance. This was partly due to the fact that the Soviets initially appeared prepared to meet the Germans' demands regarding Germanic cultural property.[230] Holst even induced the normally secretive Soviets to take him on tours of major Russian museums, including the Hermitage. As a result of his investigation, Holst was able to compile a list that included some three hundred works of German origin, including a number that were formerly in private collections but had been confiscated by the Soviet government after 1917. Copies of the report went to Hans Posse, as well as to the Foreign Office and the German embassy in Moscow, among other places.[231] The SS leaders also grew less critical of Holst because of his increasingly close cooperation with the SS pseudoscholarly organization the Ahnenerbe. Specifically, Holst oversaw a program to make thousands of photographs of cultural objects in the Baltic lands and the Ahnenerbe provided the funding.[232] This was a project comparable to Dagobert Frey's in Poland and Otto Kümmel's in the occupied Western lands, essentially creating a wish list.[233] By late 1940, Holst was working closely with Ahnenerbe manager Wolfram Sievers in making plans to move Baltic cultural property westward to Poland where it would be placed in, among other places, depots under Sievers's control.[234] Some of these plans were premature, as the Soviets were not

quite as forthcoming about handing over Germanic property as they initially appeared. But the Germans did recover certain objects.[235] Holst also continually gave his superiors grounds for optimism, despite the German decision to halt negotiations in May 1941.

The Germans' movement toward a policy of outright plunder reached the critical point with the outbreak of war in June 1941, when Holst was charged with "safeguarding" artworks in the East. In the first documents he drafted after the commencement of Operation Barbarossa, Holst talked about his activities concerning the "safeguarding from air attack of artworks in warehouses in Danzig" and about "art protection measures in the Baltic lands after the occupation."[236] This sounded relatively innocent, but among his other concerns was the safeguarding of artworks in "the interior of Russia, for example, in Petersburg (the Hermitage)," and "determining which Baltic German artworks ended up inside the Soviet Union through theft or war . . . [and] . . . whose delivery can be demanded."[237] Holst's concerns were far from altruistic, although he indeed wished to protect much of the art in the Soviet Union. He traveled eastward with the advancing German forces in the summer and fall of 1941, initially attached to the Wehrmacht as a special leader (*Sonderführer*). Holst had support from the highest levels. Hans Posse, for example, wrote Martin Bormann on 22 September 1941, requesting an order whereby Holst "would be charged with the supervision of art objects in St. Petersburg that are of high value to us."[238] Bormann granted Posse's request and issued orders for Holst in Hitler's name, which gave the art historian considerable autonomy to move about the Eastern Front in search of treasure.[239]

Although it is not exactly clear what Holst did on the Eastern Front, he evidently did it well because he was much in demand. Posse, a very critical individual, had a high opinion of him, describing Holst "as a Balt and as an expert already with experience in the Eastern territories [who is] soundly trained."[240] By early 1942, Alfred Rosenberg's staffers had extended an offer for Holst to join the ERR in its confiscation campaign in the East, and the Baltic art historian received an official transfer to the organization. The occupied territories in the East were generally chaotic and lawless, and German officials made a concerted effort to delineate spheres of influence among the various agencies that had come into existence. Rosenberg and Heydrich, for example, exchanged letters in September and October 1941 where they talked of the SS/SD pursuing "political and police tasks" and the ERR being made responsible for "cultural goods, that means all artistic treasures worthy of museums, [as well

as] libraries, archives."[241] Holst's assignment to the ERR was part of this effort to achieve some organizational clarity.[242] Yet despite his affiliation with the ERR-Ost (ERR-East), Holst worked quite independently in the northern section of the Eastern Front. He traveled about inspecting castles, museums, and other repositories and utilized the ERR-Ost resources mainly to help with transportation and storage. His method, like that of his superiors, was to secure and transport whatever he found and determine at a later point the disposition of the objects.[243] Significantly, Hitler, Göring, and most other Nazi leaders were dismissive about cultural objects in the Soviet Union: as noted earlier, they were mostly interested in Western art that had found its way there, mostly as purchases of Russian aristocrats. In fact, Hitler had only one painting in the Führermuseum collection from the ERR-Ost (a canvas from 1632 by Frans Francken).[244] Most of Holst's booty remained in depositories.

Holst remained engaged in the territories of the Eastern Front throughout the war. Toward the end, he became involved in the evacuation of artworks westward in the face of the advancing Red Army. This was dangerous duty, and many personnel involved in safeguarding artistic treasures in these eastern regions suffered as a result of their assignments. For example, of the fifty-eight scholarly employees who were engaged at the Berlin State Museums in 1943, only twenty-nine could be found in 1946, according to curator Paul Rave.[245] Holst was one of those who was listed as "missing," although there was a report that he, along with six other members of the Berlin State Museums, was in a Soviet prisoner of war camp.[246] Rave also noted that six other colleagues had died in combat and that twelve had perished from other causes.[247]

A remarkable aspect of Niels von Holst's career was his ability to continue his scholarship both during and after the war. He had a longstanding ambition to make a name for himself as an art expert. In one questionnaire he filled out early in the Third Reich, he noted that he wished to write "popular scholarly" works, that is, to reach a broad audience.[248] Even during the war he published a book titled *Art of the Baltic in Light of New Research, 1919–1939* (1942) and an article in the journal *Baltenland* in 1943.[249] The thrust of his scholarship remained the same after the war, as indicated by the titles of his books: *Danzig—a Book of Remembrance* (1949); *Breslau—a Book of Remembrance* (1950); and *Riga and Reval—a Book of Remembrance* (1952).[250] Holst advanced the pan-German view of the region's history and bemoaned the political and demographic changes that occurred after the war. Throughout his career, he maintained an ethnocentric outlook and viewed both his-

tory and art history as weapons with which to fight for German hegemony in the region. This view persisted up through the end of his career as an art historian: in 1981, he published *The German Order of Knights and Their Buildings*, which glorified the Teutonic knights' "civilizing" mission and documented the Germans' historic presence in regions now "lost."[251] Holst also continued to pursue his dream of becoming a popular art historian. To some extent he achieved this by the 1960s, authoring a glossy coffee-table book in 1967 titled *Creators, Collectors, Connoisseurs: The Anatomy of Artistic Taste from Antiquity to the Present Day*; it was published in the United Kingdom by Thames and Hudson and in the United States by Putnam, both reputable presses. Holst also continued to write scholarly articles and penned dozens of articles for the prestigious journal *Die Weltkunst*. Niels von Holst died in 1981, and there is no evidence that he was ever exposed in the postwar period as an art plunderer.

Some figures who were complicit in the Nazis' looting program felt so shamed by their actions that at war's end they could not imagine rehabilitation. Such was the case with art historian Hermann Bunjes, who was an expert on French medieval sculpture and architecture and who headed the SS-run Art Historical Institute in Paris. While Bunjes was far from the worst of the Nazi plunderers, he was involved with various criminal schemes, including the plundering of Jewish art in France by the ERR and an effort late in the war to abscond with the Bayeux Tapestry. Bunjes evidently could not live with the guilt, and after a debriefing by American MFA & A officers in Trier in late spring 1945, he committed suicide.

Bunjes had a rigorous academic training that included a stint as an exchange student at Harvard University and a period in Paris, where he was a student of the curator of sculpture at the Louvre, Marcel Aubert (with whom he later had dealings during the war).[252] Bunjes completed his dissertation at the University of Marburg in October 1935, writing on sculpture in the Ile de France. His first position was at the Rhineland Provincial Administration, where he inventoried architectural and artistic monuments in the city of Trier, and as part of his job he published books and articles on monuments and sculpture in both Trier and France.[253] He completed his *Habilitationsschrift* in late 1938, an "investigation into the artistic geography of the Mosel region in Roman and early Gothic times."[254] Amidst this increasing success, Hermann Bunjes completed his service in the Wehrmacht (1937–38) and joined the SS (January 1938). His motives for entering the latter organization are

unclear, but they appear a mixture of ideology and practicality: Bunjes was enthusiastic about the Nazi program, but also aware that SS membership would help his career. The SS provided him with financial assistance for his scholarly work, for example, financing a project on "Forest and Tree in Aryan-German Spiritual and Cultural History" (he noted in the application that he came from near the Teutoberger forest).[255] There were also political advantages to be gained from this association. At a minimum, he would be assured of enthusiastic evaluations from the Party bureaucrats, which factored into all civil-service appointments.

At this stage in his career Bunjes sought, above all, academic success, and in September 1939 he joined the faculty of the Rheinische Friedrich-Wilhelm University as a lecturer (*Dozent*). Yet he did not spend much time at the university in Bonn, for he was called for a special assignment in France, effective 5 August 1940.[256] His colleague and nominal superior Wolff-Metternich had been appointed head of the Army's Kunstschutz unit—one of the few German organizations that did a credible job safeguarding and not stealing artworks, as they consciously followed in the tradition of the Kunstschutz unit led by Paul Clemen in World War I.[257] Bunjes joined Metternich in France in the summer of 1940, and they toured the country inspecting repositories of artworks (for example, at the Loire chateaus of Chambord and Cheverny). They met with French museum officials, including Bunjes's former teacher Marcel Aubert, and reassured the French that the works would be safe.[258] Bunjes initially disapproved of the ERR and took certain steps to resist them. He wrote in a May 1941 report that "the measures of the ERR threaten to be a shameful mark on German scholarship and German museum practices. I am asking finally for measures to control Rosenberg's Special Staff."[259] But Bunjes, unlike Wolff-Metternich, finally came to accept the looting campaign and was far more inclined to collaborate with the Nazi leaders. In particular, he was drawn into the plans drafted by Göring. By late 1941, he was part of the smoothly running occupation machinery.

Bunjes, then, was gradually co-opted by the Nazi leaders, and the more accommodating he became, the more power he received. In addition to his position at the Kunstschutz agency, he was given a post within the German Military Government in Paris, where he was a war administration adviser and responsible for "all questions of French cultural life."[260] This position required him to respond to French objections about the seizure of Jewish-owned artworks (he argued that the French people and not the Jews had concluded an armistice) and to coordinate

the reopening of certain French museums, such as the Musée de Carnavalet.[261] He also continued to work on his scholarship and published several books on French, Dutch, and German architecture and monuments during the war.[262] These projects came together when he was appointed director of the Art Historical Research Institute in Paris in January 1942.[263] This organization, largely funded by the SS, was extremely ideological: it advanced interpretations of art history and history that were racist and excessively pro-German. Bunjes, then, had fashioned a stellar career as a Nazi art historian. His 1942 evaluation from the commandant of Greater Paris noted that "thanks to his outstanding technical knowledge, his extraordinarily effective negotiating skills, and his tireless industriousness [Bunjes] had preserved the artworks in France, as well as performed entirely special service in safeguarding German interests."[264] Furthermore, Himmler personally promoted him to SS lieutenant in 1942, and after recommendations to Reichsminister Rust from colleagues in Bonn, he was made a professor in 1944.[265]

The price Bunjes paid for this "success" came in the form of subservience to Göring and Himmler. In fact, he became such a tool of the Nazi leaders that Wolf-Metternich released him from the Kunstschutz agency in 1942; whereupon the Reichsmarschall engaged him as an employee of the Luftwaffe.[266] Göring used him for a variety of tasks, but most notably, for the procurement of artworks for his own collection. Perhaps most significantly, Bunjes coordinated most of the twenty "exhibitions" of plundered Jewish art at the Jeu de Paume, where the Reichsmarschall selected works for his personal collection.[267] Bunjes was never a member of the ERR, but he had good relations with its members and used these links to outmaneuver Robert Scholz, who sought to block the transfer of artworks to Göring.[268]

Bunjes's close ties to Göring did not end his relationship with Himmler, as he also served the Reichsführer-SS in much the same vein. Specifically, Bunjes coordinated the project to seize the Bayeux Tapestry and transport it to Germany. Bunjes and Himmler shared a Nazi conception of art history and history, and accordingly, they viewed the remarkable Norman artifact as an example of Teutonic artistic accomplishment. The fate of the tapestry was of utmost importance to these two men, as well as to Wolfram Sievers and others in the SS. Since early in the war Bunjes and other members of the Ahnenerbe had been working on a project to publish photographs of the tapestry, along with annotations advancing the Nazi interpretation.[269] The project was sometimes

Hermann Göring, Kurt von Behr, and
Hermann Bunjes (in white cap) leaving
Jeu de Paume after making selection from
ERR confiscated art, 1941 (NA).

referred to as Special Project Brittany (*Sonderauftrag Bretagne*) and they used the code name "Matilda" for the tapestry.[270] The episode offered great intrigue and drama as the Nazis tracked down the tapestry. There were all sorts of rumors, including one that the Americans had removed it across the Atlantic.[271] The German plan entailed arranging its transfer from the provincial repository to Paris, whereupon it would be seized by an SS commando (an action comparable to seizure of Michelangelo's *Bruges Madonna* just prior to the liberation of Belgium in August 1944).[272] Evidently, in the summer of 1944, General Dietrich von Choltitz, the Wehrmacht commander of Paris who is often credited with saving the city from destruction (a lingering point of controversy), "talked the SS out of taking the Bayeux tapestry off to the Fatherland."[273] Bunjes, who made regular reports to Himmler, was even sending updates as late as 21 February 1945, when he noted, "I have evacuated my entire institute from Paris to Germany. The Norman tapestry has been brought on our orders from its safekeeping place [Sourches] to Paris where it has been entrusted into the custody of the

Louvre."[274] But by this point it was too late: the Germans had been forced from Paris the previous August and had not managed to take the tapestry with them.

The life and career of Hermann Bunjes represents the gradual corruption of an art historian. Of course, like Mühlmann and Holst, those who subscribed to the Nazi worldview were probably inclined toward criminal behavior. Bunjes's racism and his nationalism helped lead him to support Göring and Himmler in the implementation of their programs. But there was also his own personal ambition. This was not for wealth—Bunjes received modest salaries for his various positions (for example, RM 600 per month for head of the Art History Research Institute).[275] Rather, he sought academic accolades and advancement, which he received within the Nazi-controlled scholarly establishment. After the war, American investigators asked Robert Scholz and Bruno Lohse about Bunjes and reported "both are agreed that Bunjes is a man of fantastic ambition, who wished to become the leading figure in the arts in Germany. Scholz is certain that Bunjes wished to become German Minister of Culture."[276] Bunjes also appears to have been tremendously impressed by the Nazi leaders and their display of power. Lynn Nicholas identified this as a source of motivation when she wrote, "officers who at heart condemned the confiscations were still dazzled enough to betray their consciences. This was certainly true of Dr. Bunjes."[277]

Yet Hermann Bunjes ultimately became conscious of his immoral behavior. The most telling evidence of this came at war's end when American MFA & A officers Robert Posey and Lincoln Kirstein apprehended him in Trier. Nicholas described the events, as told to her by Kirstein,

> The house was decorated with photographs of French monuments, undoubtedly from the documentation project undertaken by the German Institute in Paris. Bunjes, who in a very short time poured forth volumes of information—including the existence of Altaussee—did not fail to mention that he had once studied at Harvard and, now that the war was over, would like to work for the Americans. It also soon appeared that he would even more like to have a safe-conduct for himself and his family to Paris so that he could finish his research on the twelfth-century sculpture of the Ile de France. In the course of these outpourings he confided that he had been in the SS and now feared retribution from other Germans. Posey and Kirstein, who as yet knew little of the machina-

tions of the ERR, found him rather charming, but could offer him nothing, and left. Charm had masked desperation: after a subsequent interrogation, Bunjes shot himself, his wife, and his child.[278]

His suicide was not entirely unique (although murder was far less common). A number of individuals involved with the Nazis' criminal program for the arts took their lives in 1945, including ERR Paris chief Kurt von Behr and a range of museum officials. Among the latter were E. F. Bange (sculpture collection in Berlin), Dr. Gelpke (from the ethnographic museum in Berlin), Dr. Sieveking in Hamburg, Dr. Waldmann (and his wife) in Bremen, Dr. Feulner in Cologne, and Dr. Kloss in Breslau.[279] Paul Rave noted that others, like Dr. Körte of Freiburg, took their life by "seeking death in battle."[280] For Bunjes and these others, the pact with the devil in the end was no bargain.

The Nazi leaders relied on art historians first to determine the location of artworks and then to catalog the plunder. This chapter has discussed a relatively small number of the art historians who were co-opted by the regime. A list of those involved in plundering programs would extend to several score, and perhaps even hundreds, which is remarkable considering the limited size of the profession.[281] Of those who collaborated, one can discern certain tendencies: some art historians, like Mühlmann, Holst, and Bunjes, assumed largely supervisory roles in the looting bureaucracy, while others worked in a hands-on manner with the thousands of artworks that filled the depots. There are a plethora of examples of this latter type: from Professor Otto Reich in Vienna, who was engaged by the Gestapo to appraise the Gomperz collection (among others), to Günther Schiedlausky, who worked in the Jeu de Paume as a cataloger for the ERR.[282] These art historian technocrats were very effective in ordering the massive quantities of loot and keeping precise records—especially considering that many works had been carelessly hauled out of homes and depots in commando raids. Like the conservationists who attended to the physical conditions of the works, these art historians in a certain sense performed acts that helped safeguard the art. The Allied officers utilized their records and relied on their recollections to effect the massive restitution program after the war. The positive services rendered by the art professionals constitute one of the ironies of this history.

Artists

As noted in the introduction, it is possible to gain an overview of artists during the Third Reich because they were regulated by the professional organization, the Reich Chamber for the Visual Arts. Although this neocorporatist body turned professionalization models on their head because the organization stemmed from above, rather than from the members themselves, there can be no doubt about a professional identity for the vast majority of the practicing artists during the Third Reich. The Reich Chamber for the Visual Arts was designated a public law corporation and, as such, had the power to regulate the issues that were important to the artists' professional livelihood: training, economic conditions, awards, among others.[1] Because membership in one of the seven Reich Chambers of Culture was required of all individuals "who participated in the 'creation, reproduction, intellectual or technical processing, dissemination, preservation, and sale of cultural goods' " and because the First Decree for the Implementation of the Reich Chamber of Culture Law included a crucial provision in paragraph 10, according to which "admission into a cham-

ber may be refused, or a member may be expelled, when there exist facts from which it is evident that the person in question does not possess the necessary reliability and aptitude for the practice of this activity," the Reich Chamber for the Visual Arts quickly emerged as the decisive body regulating the lives and work of artists.[2]

While the arts-specific chambers comprising the Reich Chamber of Culture were unprecedented in many respects, Goebbels and his colleagues who oversaw their creation attempted to link them with the professional associations and lobbying organizations (the *Berufsverbände* and *Interessenverbände*) that had existed previously. They did this not only by noting the common qualities and functions shared by the pre- and post-1933 bodies, but by arranging for the actual incorporation or subsumation of the preexisting organizations into the Reich Chamber of Culture. This occurred primarily in late 1933 and 1934, although in a few cases, associations maintained their independence for a few years.[3] But in general, the Reich Chamber of Culture complex took over the cultural sphere in a rapid and comprehensive manner. The reasons for this are manifold and complex, but Alan Steinweis is correct to observe, "the readiness of several prominent non-Nazis to accept important positions in the new chambers reflected broad approval, or at least acceptance, of the new institutional framework for the arts professions."[4]

According to the occupational census of 1933, there were 14,750 visual artists in Germany, divided among various subfields such as painters, sculptors, and illustrators.[5] Later that year, when the Reich Chamber for the Visual Arts was formed, it counted 35,060 members, largely because of the inclusion of architects, as well as dealers and others in auxiliary professions.[6] These numbers remained fairly constant until the second half of the war, when conscription and wartime service for artists reduced the number to 22,000.[7] Most of the artists lived in German cities, specifically, in "cultural centers" like Munich, Dresden, and Berlin.[8] The percentage of the workforce involved in the arts varied in these cities from about 1 to 2 percent, with Munich having the highest concentration at 2.04 percent.[9]

When the National Socialists came to power in 1933, artists, like many others in Germany, were suffering from the Depression. But for many in the arts these difficulties extended back further. Alan Steinweis noted that their economic difficulties extended back to the early years of the Weimar Republic and that "the plight of artists in the early 1920s was seen as symptomatic of a more general, widely recognized 'crisis of intellectual workers.'"[10] The Nazi leaders, a number of whom (includ-

ing Hitler) were failed artists or writers, were quite sensitive to their situation and implemented programs to bolster employment.[11] They stipulated in a 22 May 1934 law, for example, that at least 2 percent of all expenditures on public buildings needed to be devoted to artistic decoration.[12] Furthermore, the Nazi leaders increased the number of official commissions, sponsored exhibitions, and awards. By 1936, Goebbels alone controlled the RM 2 million *Stiftung Künstlerdank* (Foundation for the Recognition of Artists) that went to patronize artists.[13] For those artists who remained in Germany and were able to work, there was a gradual but discernible improvement in their economic circumstances that paralleled the more general recovery.

Despite the support for those who garnered official approval, artists were among the first to be persecuted by the Nazi regime, and this precipitated a massive emigration. Some, like the Communist Party member George Grosz, saw the warning signs and departed prior to Hitler's appointment as Chancellor in 1933. Others got the message with the "reorganization" of the prestigious Prussian Academy of Art, which began in February 1933, and the purging of the civil service in April 1933.[14] For certain non-Jewish and noncommunist figures, the decision came later: Max Beckmann, for example, left in July 1937 when the *Degenerate Art Exhibition* made it clear that his work had no place in Germany. Others held on still longer. Heinz Trökes, who had an exhibition at the Galerie Nierendorf in Berlin closed down in 1938, left for Zurich the following year.[15] For those artists who remained but could not accommodate themselves to the regime, the quiet life of "inner emigration" was sometimes an option. Otto Dix pursued this course after losing his position at the Dresden Academy in 1933. He moved to relative isolation on Lake Constance in 1936, although at war's end, he was inducted into the People's Militia (*Volkssturm*).

There was always strong pressure to support the regime. For those suspected of subversive behavior, regular searches by the Gestapo were common. Professor Oskar Nerlinger, who was a prominent member of the leftist November-Gruppe during Weimar, was subjected to house searches and periodic imprisonment by the Gestapo, and even Max Liebermann's funeral in 1935 elicited Gestapo surveillance.[16] The regime, of course, was lethal at times, especially for those like painters Felix Nussbaum (1904–44), Charlotte Salomon (1917–43), and sculptor Otto Freundlich (1878–43), who were murdered on racial grounds at Auschwitz and Maidanek.[17] It is worth noting however, that no artist was killed because of his or her work.

In examining these case studies of individuals who collaborated actively with the National Socialist leaders, the question arises whether the decision was sudden and conscious or gradual and difficult to perceive. One is tempted to imagine a sudden one, not only because of the sense of drama but because it satisfies one's desire for a clear explanation. Such a rendering proved irresistible to Arno Breker, despite the fact that he continued to view himself as untainted by National Socialism and blameless of the crimes of the regime. A journalist following Breker's recollection described the fateful moment as follows: "on a 'gray November day in the year 1938' the Berlin sculptor Arno Breker received a short but urgent order: Hitler's chief architect Albert Speer requested the artist in his office in five minutes and informed him that he had eight days to model sculptures for the Chancellery of the Führer. 'On this day,' sensed Breker, . . . 'my fate was decided.' "[18] This dramatic version of events, full of fate, destiny, and reckless gambles, must be viewed with skepticism.

It was true nonetheless that once one had struck a deal it was difficult to extricate oneself. Arno Breker's version of events took shape in the years after the war. One of the foundation stones, for example, was set in 1948 before the Donauwörth denazification board, when the sculptor claimed that "in my capacity as an artist I could hardly reject artistic commissions, especially those from leading personalities of the Third Reich."[19] Here then was the explanation he provided when absolutely forced: he had struck the deal with Hitler via Speer (another misled artist) and thereafter had no choice. He was obliged to accept the commissions and to create artistic representations of the Nazi regime. The reality was far different. While important meetings occurred and fateful decisions were made, the process of becoming a *Staatsbildhauer* (official sculptor) was a gradual one, and there were numerous occasions when he could have brought it to a halt. Breker offers a case of an individual who embraced a myth because of his inability to accept full responsibility for his actions.

Born on 19 July 1900 in Elberfeld, a town just outside Wuppertal near Düsseldorf, Breker was the son of a stonecutter and sculptor. Educated at the elementary school and the vocational secondary school in Elber-

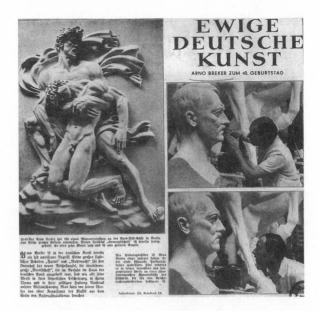

Article on Arno Breker titled "Eternal German Art" in the Illustrierte Beobachter, *18 July 1940 (BHSA).*

feld, Breker appeared headed for a life as a craftsman, and he spent six years as an apprentice with his father.[20] While his father was evidently something of a disciplinarian, they seemed to get along, and Breker in 1930 still had sufficiently warm feelings so as to describe his experiences "in the grasp of the energetic and secure hands of my old man."[21] Breker's father remained active cutting stones until well past the age of seventy, and then moved to his son's workshop in Wriezen in 1942 to assist in the production of state commissions. Well prior to that, the young Breker had demonstrated such ability that he took over the leadership of the small operation in 1916 when his father was declared "suitable for labor service" and required to work in a local factory.[22] From 1914 to 1920 Breker simultaneously attended evening classes at the arts and crafts school (*Kunstgewerbschule*) in nearby Wuppertal and supplemented this training with private lessons in drawing. At the end of the war, his father reassumed control of the workshop, which freed Breker to concentrate on his art. In 1920 he moved into an artists' dormitory (*Künstlerheim*) and matriculated at the State Art Academy in Düsseldorf, where he spent five years studying sculpture with Hubertus Netzer and architecture with Wilhelm Kreis (1873–1955).[23]

During his training, Breker was torn between modernism and classicism. This reflected a major tension within the Düsseldorf Academy as individuals in groups such as Das junge Rheinland, which included the highly provocative Otto Dix (who faced pornography charges in 1923), challenged the establishment. The ensuing debates, which were often passionate and politicized, induced Breker to attempt to negotiate the relationship between tradition and modernity. He talked of "reconciling the classicism of Hildebrand with the pathos of Rodin."[24] Breker had been particularly influenced by Rilke's book about Rodin, which he had read when it first appeared in 1919, and at this early stage in his career, it seemed most likely that his art would feature a modernist orientation.[25] His work was not radically modern, but it included expressionistic flourishes and was in fact more abstract than Rodin's. A number of his early works resembled those executed by Ernst Barlach. In 1922, he decorated one of the Düsseldorf Academy's exhibition rooms with abstract sculptures, including pillars vaguely shaped as umbrellas and set off with electric lights. Later, in 1937, he had one of these early sculptures confiscated as part of the "degenerate" art purges of the Nazi regime (he was not alone in this respect, as other artistic titans of the Third Reich, such as Werner Peiner and Wolfgang Willrich, also had certain early works confiscated).[26]

During this period, Breker's commitment to modernism brought him on a pilgrimage to Weimar to visit Walter Gropius, Paul Klee, and other members of the Bauhaus.[27] But his journey to this modernist mecca, he reported later, proved disillusioning. In particular, he was aghast at how Klee worked on numerous paintings simultaneously, which for him "did not represent real creativity."[28] Another encouragement away from abstraction was Breker's increasingly close relationship to the neoclassicist architect Wilhelm Kreis, who granted the young artist his first important commission in 1925: a monumental statue of Aurora that adorned the courtyard of honor (*Ehrenhof*) of the Düsseldorf complex built on the banks of the Rhine for the exhibition known as GESOLEI.[29] Kreis and Breker were later to collaborate in the Third Reich, and the architect encouraged the sculptor to work in a more conservative and monumental style.[30]

In 1926 Breker had the opportunity to study in Paris, using the income from his commissions to fund the trip. His initial stay lasted seven months, but he returned the following year and remained in the French capital until 1932. While in France, Breker fell under the influence of the renowned sculptors Aristide Maillol and Charles Despiau,

who continued in the style begun by August Rodin. Breker subsequently viewed these years in highly sentimental terms; he described them as "the only epoch in which I was happy."[31] Paris at that time was the "center of modern sculpture," and he indeed had the opportunity to meet a number of extraordinary individuals, including Jean Cocteau and Alfred Flechtheim, among others.[32] Breker also met his wife at this time, Demetra Messala, who was Greek and a former model of Picasso and Maillol. His experience abroad enabled him to network with prominent figures in the art world and gain exposure. He exhibited his work at the Salon des Tuileries, and the Salon d'automne, among other venues. Breker also gradually improved his technical facility as a sculptor. These developments—making connections and becoming a better artist—came together when he secured a dealer to represent him. And Breker soared right to the top. As Walter Grasskamp wrote: "One of the first gallery owners who exhibited the young Breker was Alfred Flechtheim, a cultured and successful Jewish dealer of modern art who had to flee from Germany whilst his former protégé ascended rapidly in his career."[33] While it is perhaps an exaggeration to describe Breker as Flechtheim's "protégé," the important dealer provided a positive assessment of the sculptor's talents and certainly helped advance his career by showing his work in his Düsseldorf and Berlin galleries.[34]

Breker's early career suggests that he possessed considerable ability. In 1932, he received greater recognition by winning the Rome Prize, which was awarded by the Prussian education minister in combination with the Prussian Academy of Arts. This entailed a six-month fellowship at the exquisite Villa Massimo in the Italian capital.[35] Between October 1932 and March 1933 he worked alongside fellow recipient Felix Nussbaum, the aforementioned German Jewish painter.[36] Breker spent much of the year working on the restoration of Michelangelo's *Rondanini Pietà*, which the Renaissance sculptor himself had partially destroyed.[37] But his experience in fascist Italy was arguably more noteworthy because of his exposure to the monumental, "imperial style" art then in ascendency.[38] His stay in Rome also marked his introduction to future propaganda minister, Joseph Goebbels, who visited the German colony during a trip south in early 1933 and, according to Breker, encouraged the "artists to return to Germany where a great future was awaiting [them]."[39]

Breker returned to Paris in 1933 after stopping for short visits in Munich and Berlin. But he did not stay long in Paris. Breker claimed after the war to have returned to Germany because of the anti-German

sentiment that prevailed in France after Hitler's rise to power. One must question this statement about his motivations for moving to the Reich. He also claimed to return "in order to save what was to be saved," but actually enjoyed tremendous benefits, including the use of a Berlin studio belonging to Professor Gaul and the patronage of a number of socially influential people, including Bertha Siemens (born Gräfin Yorck von Wartenburg), who commissioned him to execute a bust of her thirteen-year-old son.[40] One scholar hinted at this opportunism, noting, "he came as the others were forced to go."[41] Because Breker's wife came from a well-to-do family (her father was a Greek diplomat in Paris) and was a successful international art dealer who brought money with her to Germany, he had few financial concerns. They lived comfortably in an impressive home decorated with costly antiques, and there were sufficient resources to undertake an expansion and remodeling of Gaul's atelier.[42]

There were certainly challenges for Breker, which partly stemmed from his having spent so much time abroad. Some in the Berlin art world considered him a "Frenchman" or at least overly influenced by foreigners.[43] Indeed, there are reports of his feelings of alienation and dissatisfaction in "the new Germany." One patron described him as "filled with a deep pessimism, because he as an artist with connections to other lands and cultures—in his specific case France—instead saw coming a political isolation and barbarization."[44] He also had concerns about the persecution of Jews. He was well acquainted with Max Liebermann, among other German-Jewish cultural figures, and was troubled by their plight. Yet he was soon able to assuage most of these concerns.

Breker's transformation into a Nazi *Staatsbildhauer* was both gradual and complicated. Because Breker possessed talent—a fact recognized by experts across the political and aesthetic spectrum, from Flechtheim to Speer—he sensed the opportunities available to him. Yet Breker was also an idealist. He was an artist who believed in concepts of lasting and indisputable beauty, ideas that formed the basis of his philhellenism. This then was his project in 1933. He believed that the resulting works, massive figures built upon timeless Hellenic precedents, would define the aesthetic idiom both domestically and abroad. They would be the counterpart of the monumental and streamlined neoclassical buildings being constructed at the time in a number of countries, including the United States.[45] Despite the parallels with structures in other cities, Nazi architecture was different, both in terms of style (the huge scale, the

severity of form) and process (the stone quarried by prisoners). There is no doubt that the official Nazi commissions required him to transform his style. Breker's senior colleague, Georg Kolbe (1877– 1947), later observed, "from then on, a change in his artistic views became visible; the earlier one which stood close to the French view sank under the strongest Nazi influence."[46] After the war, Dr. Victor Dirksen of the Städtisches Museum in Wuppertal-Elberfeld observed, "that his artistic style went through a change after 1933 is not to be disputed. . . . He became a state sculptor. . . . From his freestanding works and portrait busts of the time one can see that he never entirely gave up his earlier style. Otherwise, I occasionally had the impression that Breker deep down was unhappy about the development which he had experienced."[47] In short, Breker preserved certain elements of his pre-1933 work—above all the Hellenic and mythical motifs—while adding monumentality and frequent political allegory to suite the taste of the regime. His ambitions, then, induced him to sacrifice certain aesthetic ideals.

Arno Breker's gradual accommodation with the new regime is not easy to explain. He was perhaps vulnerable to National Socialism because his political consciousness had previously not been very highly developed. Prior to 1933, his life revolved around art, and he appeared naïve about politics and contemporary affairs. He was also very susceptible to Nazi propaganda. Indeed, by the time he met Hitler in summer 1936, when he attended a reception for the prize winners of the Olympic arts competition, the dictator's many domestic and foreign policy successes and his general popular support had helped alleviate the artist's concerns.[48] Breker's feelings about Hitler mirrored the changes in his art: just as the onetime modernist evolved into the producer of the monumental, the apolitical cosmopolitan grew into a gushing follower. This was communicated in a breathless letter of February 1938 to architect Emil Fahrenkamp, the director of the State Art Academy in Düsseldorf: "Thank God I had the luck again recently to see and to speak with the Führer."[49] That Breker did not join the Party until 1937 suggests he was not fully committed to the Nazi regime in the early 1930s, but when he did join, his support was not half-hearted, as he not only became a Party member, but a "political leader"—a position that entailed a brown uniform as "official dress."[50] Later, Breker was given awards which attested to his political reliability, such as the Golden Badge of the Nazi Party bestowed by Hitler personally on Breker's fortieth birthday in 1940.[51]

Along with Hitler, Breker's most important patron was Albert Speer. In his memoirs, Breker suggested that his collaboration with Speer, which began in 1938, marked the commencement of his work for the regime (the section is subtitled "First State Commissions").[52] In fact, Breker had a commission from the Berlin Finance Ministry in 1935, and then in 1936 executed two large sculptures, *Victor* and *Decathalete*, for the Reichssportfeld in Berlin.[53] These figures were also submitted to the Olympic arts competition, and the resulting silver medal only helped solidify his reputation.[54] Breker met Goebbels again during the games, and the latter commissioned a portrait bust and "a figure . . . the theme of which was left up to Breker."[55] Breker also met Speer for the first time in November 1936 when the two were introduced by Wilhelm Kreis. This indeed proved to be an important development.[56] Just as the architect had Hitler's complete trust (Speer noted in his memoirs, "there were very few persons besides myself who had been so favored. Hitler had undoubtedly taken a special liking to me"), so Breker quickly earned the confidence of the architect.[57]

As recounted by Breker, the genesis of the commission for the statues to adorn the main entrance to the New Reich Chancellery reveals a great deal about the relationship. First, he was beckoned by Speer in November 1938. Speer had the funds and the power of decision making, and the sculptor therefore went to the patron and listened to his instructions. Speer acknowledged that the proposals of other artists would be considered for this important project, but nonetheless gave Breker tremendous latitude with regard to artistic conception: "The theme is up to you, but we'll meet again in eight days."[58] Breker always maintained that he possessed artistic freedom—a claim that was intended to exonerate him from charges of serving as a tool of the criminal leaders, but actually implicated him more because he bore primary responsibility for the messages communicated by his art. His first creations for Speer were the two monumental figures, *Torch Bearer* and *Sword Bearer*, which adorned the New Reich Chancellery. It was the start of a collaboration that would turn into a genuine friendship, as they traveled together to Italy, France, and other parts of Europe and jointly visited with Hitler, among other activities.[59] The relationship was not without complications, partly because the two men were not equal in terms of power.[60] Yet they enjoyed each other's company and took pride in calling one another a friend both during and after the Third Reich.

Breker joined Speer as a key figure in the articulation of the regime's aesthetic style. Hitler explicitly identified Breker as his favorite sculptor,

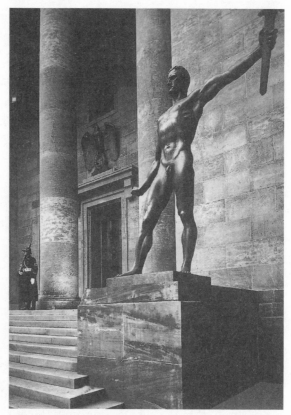

Breker sculpture, The Torch Bearer *(also known as* The Party*) at entrance of the New Reich Chancellery in Berlin (SV-B).*

supplanting Josef Thorak in this respect, and nearly all the Nazi leaders saw their ideology expressed in his work.[61] Alfred Rosenberg, for example, thought that his "monumental figures [were] a representation of the 'force and willpower' of the age."[62] Robert Scholz thought his "sculpture stood at the beginning of a new politically determined epoch, because it could embody most immediately the intended rejuvenation of the world. . . . Arno Breker's sculptural works are symbols of the dignity and creative drive that is at the basis of the political idea of National Socialism."[63] Breker was therefore entrusted with creating works with special import for the regime. In addition to the heroic statues for New Reich Chancellery, forty-two of his works appeared in the eight *Great German Art Exhibitions (GDK)* held annually in Munich,

where the regime exhibited officially sanctioned art.[64] His works, according to a later critic, "glorified the racial struggle, they were symbolic stone piles of Aryan beliefs."[65] They were "a beatification of 'militarism' and 'racial soundness' based on the struggle against and even liquidation of all things not beautiful."[66] Another scholar noted, "While it was the function of cartoonists to circulate a negative picture of 'inferior' races, the art of Breker and Thorak provided, perfected and emphasized a positive image of a Nordic super-race within a scheme of classicizing representation. *Stürmer*-caricature and Breker sculpture cannot be separated from one another. They were both equally and simultaneously promoted because they endorsed and illustrated racist policy."[67] Jost Hermand took this idea to its conclusion, observing, "National Socialist art is thus not unproblematically 'beautiful,' not merely devoted to perfect forms and empty content; it is also eminently brutal, an art based on convictions which, when realized, literally left corpses in their wake."[68]

In his memoirs, Albert Speer remarked that Hitler expressed his ideology through his building projects: "These monuments were an assertion of his claim to world dominion long before he dared to voice any such intentions even to his associates."[69] Breker's works offered a sculptural equivalent. In other words, he helped disseminate this ultranationalistic, hegemonic, and racist ideology—even though he included a swastika in only one of his works.[70] One must also point to his idealizing portraits of Hitler, which supported the notion of the Führer cult— a quasi-religious glorification and veneration of the dictator.[71] After the war, a monuments officer in the East, Kurt Reutti (1900–1967), reported that he found in Breker's Berlin-Grünewald atelier "a mass production of Hitler busts out of ceramics. They were stored by the hundred in the pond that adjoined the property."[72] In addition to creating (and reproducing) art that bolstered the regime, Breker broadcast lectures on the radio to the general public concerning art and National Socialism.[73]

Recognition in the form of gifts and honors poured down upon the Reich's leading sculptor. Besides the monetary awards mentioned above, Breker was often the recipient of more tangible presents. These were significant not because of what was bestowed, but by whom. Göring, for example, invited Breker to Carinhall on a number of occasions; during one visit in November 1944, he gave the artist cartons of cigarettes, but also asked if there was anything more generally that he could do to help him.[74] Karl Wolff, the SS general who served as Himm-

ler's adjutant and who assumed control over northern Italy after Mussolini's downfall in July 1943, sent Breker a birthday present that very month. Breker replied, "My dear Wolff! Somewhat tardy I send you my heartfelt thanks for the good wishes that you sent to me on my birthday. I hardly need to say what joy your little package gave me."[75] In this, as in many other cases, it was not the actual object, but the message communicated that was significant. These gifts helped establish reciprocal bonds between patron and artist. And in fact, Breker had considerable contact with Himmler and his subordinates regarding commissions for the SS.[76] Breker also received more awards than any other artist in the Third Reich. They varied in significance: his being placed on the list of irreplaceable artists in 1939 had a more tangible effect on his life than many other expressions of his distinction.[77] Foreign awards were also common for the Third Reich's most illustrious artist. Breker, for example, won the Prize of the Duce at the Venice Biennale in 1940.[78] Yet the effect of this relentless stream of honors was to empower the artist in a way that made him unique in Nazi Germany. As a result of his metaphoric pact with the Nazi leaders, he gained fame, fortune, and resources for his sculptures and power.

Breker's preeminence among artists ultimately found expression in the titles he was given and offices he held. His professorship in 1937 at the School for Fine Art in Berlin and later at the Prussian Academy of the Arts, as well as his appointment as vice-president of the Reich Chamber for the Visual Arts in April 1941, stand out as milestones in his Nazi career.[79] These posts afforded him the opportunity to affect the regime's arts policy. The sculptor noted that "[Hitler] told me it was my duty to get rid of degenerate artists and that I should be the intermediary between the government and the artists."[80] According to Albert Speer, Breker later turned down the presidency of the Reich Chamber for the Visual Arts, among other positions offered to him by Hitler and Goebbels.[81] Breker put them off by arguing that the additional responsibilities would cut into his artistic production. The sculptor, it seems, at times found ways to say no to the Nazi leaders.

Arno Breker wielded remarkable power for an artist in the Third Reich. One journalist noted that Breker once admitted "a sign from him was enough to render the critics deathly silent."[82] Additionally, he could call on his patrons when someone crossed him. Speer, for example, wrote Goebbels in August 1941 complaining about a review of Breker's work in the *Frankfurter Zeitung*.[83] There is no record of the propaganda minister's response, but one suspects that pressure was brought to bear.

Hitler's "art trip" to Paris, June 1940. From left, Karl Wolff, Hermann Giesler, Wilhelm Keitel, Wilhelm Brückner, Albert Speer, Adolf Hitler, Martin Bormann, Arno Breker, and Otto Dietrich (BA).

Goebbels later wrote in his journal, "I am most comfortable with Breker since I naturally can work best with him. So we'll certainly stand by Breker."[84] The sculptor, like Albert Speer, was virtually unassailable in the Third Reich.

Breker became a familiar figure in Hitler's inner circle. The dictator and the artist had regular contact, although this tended to be cyclical. Breker commented in 1980, "I was invited to the Chancellery from time to time for breakfast. I was often sitting across from Hitler."[85] Speer, of course, was usually responsible for these meetings, and this was increasingly the case late in the war, when there was so much interaction between the architect and sculptor that some have claimed that Speer actually moved into Breker's Jäckelsbruch residence.[86] Speer, who was bombed out of his Berlin home, was often away on inspection tours. Still, his frequent stays chez Breker warranted the establishing of "a special telephone connection that reached the Führer's headquarters."[87] Breker had previously also joined Speer and other artistic types in escorting Hitler on his famed tour of Paris, the day following the armistice in June 1940. Because Breker knew the cultural sites of the city very well, he shined during this encounter.[88] Hitler tended to monopolize conversations, and this episode offered no exception as the dictator determined the itinerary and studied up before hand. Nonetheless, the so-called art trip (*Kunstreise*) to Paris proved important not only for developing the relationship between artist and dictator, but for the specifics of their projects. Hitler, Speer, and Breker, for example, discussed the Arc de Triomphe and compared it to the one planned for Berlin. They agreed that theirs in the German capital would be double the size of the one in Paris, and Breker was commissioned to create sculptures to decorate the structure.

Breker enjoyed a grand lifestyle after 1937. The pronouncement of Dr. Helene Vogt, the chair of the denazification board that heard Breker's case in 1948, that he "had received only unimportant profits from his activities," is either a testament to the artist's ability to create illusions or the obtuseness of the commission.[89] Breker became an extraordinarily wealthy individual as a result of commissions, salaries for his various posts, and gifts from Hitler and other leaders, among other sources. One of the more lucrative enterprises for the sculptor was the Arno Breker Works. This was actually a collaborative project with Speer, organized in connection with the latter's office, the General Building Inspector for the Reich Capital (GBI). The Arno Breker Works were created in order to manufacture the artistic accoutrements for the

new buildings that were springing up across the Reich. In an industrial complex in Wriezen, sixty miles southeast of Berlin, Breker and his employees produced sculptures, bas-reliefs, ornate lampposts, or whatever artistic objects were needed. The sums of money that poured into the Arno Breker Works were remarkable—unprecedented for a German artist. One scholar noted that the "commitments to honoraria by the GBI considering the circumstances of the time was the truly astronomical sum of RM 27,396,000"; in fact, even though this was the extent of the commissions and the accompanying budgetary allocations, the GBI paid Breker and his firm "only" about RM 9 million prior to 1945.[90] While much of this went toward expenditures for supplies and labor, Breker took a commission of between 50 and 70 percent, according to the calculations of the GBI.[91] Speer was known to allocate additional sums for Breker personally. One document from March 1945, which showed payments from the GBI to Breker, included RM 60,000 listed as "Gift of Reichsminister Speer."[92] Hitler noted in one of his late night conversations with his inner circle that Breker should have an income of at least a million marks per year, and that he would look into special tax breaks (reductions would be kept below 15 percent) so as to avoid cutting into his income.[93] While it is not certain that Breker ever received the exemptions under consideration, extant documents show large cash payments from the dictator to the artist. Martin Bormann, for example, signed over a tax-free honorarium of RM 250,000 in April 1942.[94] In short, there is no doubt about the wealth the artist amassed during the war.[95] To give some perspective to these figures, an average worker earned RM 1,800 per year, a curator just over RM 4,000, and a museum director about RM 14,000.[96]

Breker's grand lifestyle was reflected by his residences, which were numerous and lavish. Of note was a villa in Berlin Dahlem at Kronprinzenallee 54/56, which was put at his disposal by Speer. For a short time previously, the sculptor had also lived in the Rathenau House on the Königsallee.[97] Breker's discussions in 1939 with the architect German Bestelmeyer about moving to Munich to join the faculty at the academy there was evidently a key factor motivating Speer to other acts of generosity. Because the Inspector General of Building for the Reich Capital wished to keep his most cherished artist near him, he built Breker an atelier in Grünewald, which one official described as "in the style and proportions of the Reich Chancellery."[98] Breker claimed that he paid rent for his dwellings (he also had a cabin on the Teubnitzsee), but he could well afford it. With their income, the Brekers were there-

fore able to amass a large art collection. One observer recalled that "the living rooms held variously works of Old Masters and contemporary art—partly abstract artists like Streker, Schumacher, Gilles, very many modern French like Vlaminck, Derain, Picasso, Leger, Ozenfont, among others."[99] The modern works were in part an expression of Breker's elite status—there was a double standard that exempted top leaders from the official aesthetic policy when it came to their private collections—and it also helped that Demetra Breker was a dealer and a foreign national.

The most notable of Arno Breker's residences, and the place where most of the art collection was kept, was the Jäckelsbruch estate near Wriezen, which Hitler gave to him for his fortieth birthday in July 1940.[100] Located near the Oder River, east of Berlin, this property centered around Schloss Jäckelsbruch, a country house built in the eighteenth century for Frederick the Great. Hitler and Speer jointly provided the funds for the renovations, which were carried out by a member of Speer's staff, the noted architect and Autobahn designer, Friedrich Tamms. The cost of this work was exorbitant, as it included furniture and valuable rugs and featured a sculpture garden (with works by Breker next to those by Rodin—as well as antique sculptures—all reportedly removed by the Red Army in 1945).[101] There was even a swimming pool. One estimate of the grant from the Nazi leaders for renovations cited at Breker's denazification proceedings stated that the cost came to around RM 450,000, but records in the GBI's files suggest even greater expenditures (one document states that through January 1943, the GBI alone had provided RM 540,655).[102] In the extant records from Speer's office, there is a file with over 150 pages documenting the GBI's payment of bills for Jäckelsbruch.[103] It is worth noting that despite the abundant documentation about this gift, including an encomium in Hitler's name signed by Bormann, Breker was very deceptive about the development of this and his other properties both in his denazification trial and later in his memoirs. During the former, he was able to show that he actually bought Jäckelsbruch (for a bargain price—alternatively RM 27,000 or RM 33,000), just as he paid rent for his Berlin villa and studio.[104] Breker would later admit that he received financial assistance from Hitler and Speer, but he invariably made it sound modest. He also justified the multiple residences and ateliers on the grounds of wartime damage. For example, he noted that the Jäckelsbruch property was developed "because of the severe bomb damage to his Berlin atelier"—a questionable assertion in light of the fact that

the first British raid did not strike Berlin until 25 August 1940, well after the 19 July gift from Hitler (even then it is improbable that the suburban home was struck).[105]

Breker's postwar account of his involvement in the Arno Breker Works, which were located near Schloss Jäckelsbruch, is also dubious. Most notably, he tried to deflect criticism by stressing that the sculpture factory at Wriezen belonged to the GBI (like the Dahlem villa and Grünewald atelier) and that he just worked there. In fact, he played a key role in the administration of the operation.[106] While he was not the hands-on manager, Breker was integral to the entire production process, from the design of works to the procurement of labor.[107] The enterprise, like his sculpture, was characterized by monumentality, and the complex included three work halls, a storage depot, five barracks, and a tapestry workshop. The GBI facility at Wriezen reflected National Socialism in practice not only in terms of scale, but also in the subjugation of its workers. The manager of the complex, Walter Hoffmann, who held the title Leader of the Central Office for Culture Under Reichsminister Speer, has been described by different observers as "a brutal Nazi" and "a vampire . . . the typical tyrant of the Third Reich."[108] He lorded over a workforce that included sculptors (twelve by 1943) and various other skilled and unskilled laborers, many of whom were French and Italian prisoners of war. Estimates of the number of workers range from a hundred to a thousand.[109] While an exact figure for those employed at the facility remains unclear, there is no doubt about the harsh living conditions there. The workers were quartered in "primitive barracks" and poorly fed.[110]

Walter Hoffmann, of course, was not alone in running this enterprise. In a letter to SS-General Karl Wolff, Breker reported how Himmler had facilitated the transfer of workers to the site (Breker also requested more Volksdeutsche workers).[111] After the war, a witness recalled that "there were a large number of French prisoners of war, who stood under Breker's direction," and Breker admitted approaching a General Kaiser requesting him to discharge POWs to the facility—evidence suggesting that Breker was not as distant from the operation as he later maintained.[112] Breker was therefore a kind of general executive who had authority over these unfortunate workers. And contrary to the postwar reports by Breker and Speer, the laborers were forced to stay at the facility as the Eastern Front moved ever closer and hardships increased. Breker's postwar description of the facility was very misleading. He made it sound like a resort and he talked about saving workers from

prison camps, paying them more than they would earn in Paris, and treating them to model housing and luxuries like a cinema. Most other accounts offer a very different portrayal.[113]

The workers despised Breker, perceiving him as arrogant and insensitive. One reported that while they suffered, "Breker gave parties. In the woods stood great sheds with plundered goods from all the occupied lands."[114] This witness remembers a "glittering party for the VIPs of the woods" on 15 January 1945: even at this late date, they had a Berlin quartet play Mozart and Schubert and enjoyed "a cold buffet with delicacies from all around the world."[115] The account adds the intriguing detail, "later they danced to jazz music in the basement," which suggests Breker's relative license: he was a powerful figure, permitted to venture into forbidden territory of proscribed culture, as long as this opposition was not too open or explicit.[116] In sum, as Professor Bernhard Heiliger noted in an affidavit for the denazification board, "in comparison with the standard of living of most Germans during the war, one can characterize his lifestyle as extraordinarily luxurious."[117]

During the war, Breker also had a residence in Paris put at his disposal, although he often stayed at the Ritz.[118] The dwelling, a splendid townhouse on the Ile St. Louis (Quai de Béthune 24), had been Aryanized: in fact, it belonged to the cosmetics manufacturer Helena Rubinstein, who was an "American Jew."[119] The house was under the control of Ambassador Otto Abetz, who put it at the disposal of the sculptor because "the ambassador considers the presence of Breker, who is often in Paris, to be important."[120] Abetz hoped that the luxurious residence would serve as the site for receptions and would facilitate an interaction between various artistic and military elites. More generally, Breker was one of a number of cultural figures to benefit from such plundered property: the actor and Prussian State Theater intendant, Gustaf Gründgens, had a confiscated estate (*Gutsschloss*) at Zeesen in Brandenburg put at his disposal; and sculptor Josef Thorak received the fifteenth-century Schloss Prielau in Zell am See near Salzburg.[121]

Breker enjoyed the good life while in Paris. He patronized establishments like the restaurant Maxim's, and he bought a number of works by French artists; those he did not keep with him in Paris, he shipped back to Germany.[122] His collecting in France was sufficiently extensive to warrant an investigation after the war by the curator and resistance figure Rose Valland, who worked with the Americans and authorities in the Soviet zone to ascertain his acquisitions.[123] An April 1945 report from the British branch of the MFA and A division stated that Breker

purchased from the French dealers "[Frères] Kalebdjian, [B.] Fabre, Jansen, Rudier, Flammarion, Rodin, Champesne" and used military transport to send the works back to Germany.[124] American investigators noted complaints "that Parisian art dealers did not especially care to do business with him because they couldn't get the money they wanted." They added that Breker was also "a passionate buyer of books" and had a notable collection.[125] Accompanying these shipments of artworks and books were tons of plaster, as well as wine and perfume. Breker also played a role in the Nazi leaders' acquisition of artworks in France, although his actions are far from clear. The American OSS agents noted reports that he "worked in close connection" with Hermann Bunjes and listed him as complicitous in the project to create the Führermuseum.[126] Hans Posse's journal includes in the entry for 16 February 1942 the observation, "Midday: Professor Breker telephones from Berlin. Lionardo [sic], Mona Lisa in Paris!"[127] It is not possible to grasp the intentions of Breker and Posse, although the sculptor was, in fact wrong and Leonardo da Vinci's celebrated painting was hidden in the unoccupied zone in the south.

Breker was one of the leading German figures in the occupation of France. Prior to the war he had been active in groups that tried to foster better bilateral relations between the two nations: in 1938, Breker had worked with the German-French Society in order to help organize an exhibition of French sculpture in Germany (despite the support of the Propaganda Ministry and the Foreign Office, the show did not come off).[128] It was therefore not surprising that Breker was active within occupation agencies like the Deutsches Institut (L'Institut Allemand), where he encountered Hermann Bunjes, and was repeatedly mentioned by Goebbels in his diaries as an expert on French cultural life.[129] He was also the only German artist to have an exhibition in the conquered land, a much publicized show put together by the German Labor Front's Strength Through Joy organization (on behalf of the armed forces) and staged in the Orangerie of the Louvre.[130] For the show, Breker turned to Goebbels to help him requisition special freight cars to transfer his models to the French capital.[131] He also worked through the Propaganda Ministry to arrange for two expert French casting technicians to be freed from two stalags to come and execute the work at the leading Paris founder, Rudier.[132] Because casting in bronze and other metals was virtually prohibited in the Reich after 1940, Breker brought from Germany only the plaster figures. The French were forced to supply the scarce and valuable bronze themselves.[133] Postwar scholars have

claimed that a significant portion of the thirty tons used to cast the figures in the show came from smelted down French statues.[134] Breker admitted in a postwar interview that "the monuments [of] the generals [and] the politicians" were removed from Paris during the war ("but not the artistic objects"), and he maintained that they were never smelted down.[135] The source of the bronze for his works remains disputed, as is his role in procuring it.[136]

The May 1942 opening of Breker's show at the Orangerie drew a number of cultural and political luminaries. As one scholar described it, "the great exhibition in the Orangerie of the Tuileries was an affair of state. The Education Minister of the Vichy regime, Abel Bonnard, gave the opening speech. Prime Minister Pierre Laval and other ministers and state secretaries were present. Artists like Breker-intimate Despiau and the venerable Maillol found themselves confronted with a delegation of uniformed National Socialist leaders."[137] Speer and Göring had evidently also wanted to attend, but Hitler vetoed the idea because of the security risk.[138] Both visited the exhibition later, albeit separately,

Delivery of Breker's sculpture to the Orangerie
in Paris, May 1942 (BHSA).

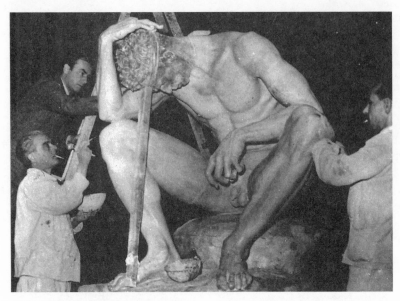

Breker and assistants put finishing touches on
work in the Orangerie show, May 1942
(BHSA).

and were taken on private tours by the artist. Göring commissioned copies of eight of the works, including several with martial themes such as *Fighting Scene* and *Battle Against the Snakes*, and then had Hermann Bunjes arrange for Rudier to make the casts (again raising the issue of the source of the bronze) and ship them back to Carinhall.[139] The exhibition was tremendously successful: it attracted large crowds (estimated at 80,000) and elicited many positive reviews, even from some relatively neutral observers (Maillol remarked on the occasion of a formal dinner at the Lapérouse restaurant that Breker qualified as the "German Michelangelo").[140] The Breker show in Paris therefore became the focal point in an extensive propaganda campaign. The French newspaper *Le Gerbe* reprinted excerpts from speeches at the opening on the front page. The German magazine for the occupation forces, *Signal*, also featured a cover story. The *Völkischer Beobachter* had a full page review by Robert Scholz. And the catalog was widely circulated.[141] To insure a positive reception, the German News Service (*Deutsche Wochendienste*), which answered to Goebbels, issued "language regulations" that stipulated that reporters should emphasize Breker's "'towering position' among European artists" and should avoid comparisons to any artists, living or dead, whose reputation might in any way be questionable.[142]

Breker also played an important role in organizing the famous trip of French artists to the Reich in autumn 1941, although the initiative came from Goebbels and the Propaganda Ministry.[143] Of the thirteen artists who accepted the invitation—lured with the promise that French POWs would be released in exchange for their cooperation—Breker knew at least half personally. (There are stories of his solicitations of other artists in Paris who opted out of the trip).[144] One of the "highlights" of the excursion was a visit to Breker's Berlin studio. The massive atelier, which was 140 meters long, seemingly had the desired effect on the French delegation. Breker's friend Despiau reported that what he saw struck him "as in a kaleidoscope, the vision of a new art. And this art, grandiose, larger than life, might perhaps have frightened rather than seduced me, had I not found Arno Breker heading its promoters."[145] It is instructive that upon the return of the French artists to their native country, when they did make comments to the press, they uttered positive, if at times guarded statements. The president of the Salon, Henri Bouchard, remarked that artists in Nazi Germany "are the cherished children of the nation."[146] This suggests not only that Breker helped make this propaganda exercise a success, but that he presented himself as contented and well supported. He did not appear victimized, as he later claimed.

The prominence that Breker gained as an artist provided him with important political connections. His relationships with Hitler, Speer, and Göring, among other Nazi leaders, have been noted above. But Breker's interactions with members of the Vichy regime also warrant mention, and his dealings with them on behalf of the Reich undercut his later statements that he was exclusively an artist. While his contact with the French initially related to his work as an artist—Marshal Pétain, for example, could not attend the Orangerie exhibition for security reasons but sent Breker flattering letters—the scope of his dealings with Vichy officials gradually broadened in scope. In his memoirs, he described attending a meeting with Pierre Laval, Otto Abetz, and Fritz Sauckel (the Nazi labor minister) to facilitate negotiations about French laborers in Germany.[147] He was also involved in discussions with Gaston Bruneton, the Commissioner General of the Social Policy for French Working in Germany.[148] On yet another occasion, he traveled to Burgundy with the assignment of evaluating the feasibility of resettling the region with ethnic Germans. Breker was to report back to Speer, but the impetus for the project came from Himmler, who fancied the idea of moving people up from the South Tyrol.[149] The artist also knew the

head of the German military administration in northern France, General von Stülpnagel, and broached various subjects with him. On one occasion, Breker inquired about an execution, but he was told to stay out of the matter.

This situation, which combined access to high-ranking officials and limited power, was not uncommon for Breker. For example, he recounted in his memoirs that tried to hinder the German policy of reprisals in response to actions carried out by the French resistance.[150] He raised his concerns about summary executions in a long face-to-face meeting with Bormann, who passed them along to Hitler. According to Breker, the Führer ordered that in the future executions could not take place without a trial. But, of course, executions without trials did not become appreciably less common. This latter episode is suggestive not only of the self-exculpatory nature of his memoirs, but also of the fact that he had direct access to Bormann and Hitler, and that they often placated him with empty words.

Breker's wartime record also contains some creditable deeds. Because of his contacts and his position as vice president of the Reich Chamber for the Visual Arts (where among his duties he recalled artists from the front), he could intervene to assist those in trouble.[151] This was the case for the publisher Peter Suhrkamp, on whose behalf he approached both Himmler and Kaltenbrunner personally in 1944, as well as sculptors Hermann Blumenthal and Willy Schwinghammer and architect Jean Walter.[152] Previously, in 1943, he had also helped save Maillol's Russian-born Jewish (and communist) model Dina Vierny from deportation to a death camp by visiting the chief of the Gestapo, Heinrich Müller, and compelling him to arrange for her release from the internment camp at Fresnes.[153] In the same year, he came to the aid of Picasso, who found himself in trouble in Paris. The Gestapo discovered that the artist was surreptitiously transferring foreign currency to both Spain and the Soviet Union. As their surveillance increased, and with it the danger for the artist, Breker sent warnings through their mutual friend, Jean Cocteau, for the painter to halt this activity.[154] Breker claimed that he ultimately went to Hitler to resolve the matter and that the dictator uttered his famous phrase, "I am going to tell you once and for all: in politics, artists are like Parsifal; they don't understanding anything."[155] This successful intervention led Breker to maintain in 1981 that "never in my life did I protest against another direction of art, defame, or intrigue."[156]

The evidence suggests, however, that this was not the case. Robert

Scholz claimed during the war in a letter to Alfred Rosenberg that Breker supported him in opposing Baldur von Schirach's patronage of Emil Nolde and shared his outrage with the Expressionist works exhibited in the Schirach-sponsored show, *Junge Kunst im Deutschen Reich*, and Goebbels confirmed this in his diary, noting "Schirach's Viennese exhibition *Junge Kunst* elicits strong opposition. Breker wrote me a letter asking to close the exhibition."[157] It would seem then, that Breker suffered from selective amnesia. While he fashioned himself as an artist and a humanist, and did show considerable sympathy for others who were creative, he was also part of the Nazis' repressive arts administration.[158]

The complexity of Breker's situation is also evident in the fact that many others besides the Nazis saw their ideological aspirations reflected in his work. Josef Stalin was so impressed by the works that were shown in the German pavilion at the 1937 World Exposition in Paris that he expressed an eagerness to engage Breker. This offer was repeated in 1946 at a time when Breker, considering his difficult circumstances, was perhaps more inclined to accept. Yet Breker demurred, noting rather humorously, "one dictatorship is sufficient for me."[159] A pattern developed during the Third Reich and continued after the war whereby "strong" leaders often admired Breker's sculptures, indicating that Breker's style had application beyond a Nazi (or even fascist) context. The list of those who acquired and utilized his works includes Mussolini, Haile Selassie, Leopold Senghor, and Mohammad V of Morocco. This raises a number of questions, including whether he actually tailored his work to the marketplace of Third Reich and whether he (or any other artist) bears responsibility for his or her creations. While Breker responded directly to the patronage of certain leaders (including not only Hitler and other Nazis, but also Mussolini), the appropriation of his work by others was often beyond his control. This led to some strange developments, such as sculptures by Breker that were exhibited in Eberswalde, forty kilometers northeast of Berlin in the former East Germany, at a sports complex adjoining a Red Army military base. Although it is unclear when Breker's sculptures were placed there, it is evident that some came from the World War II booty that fell into the hands of the Soviets after having been taken from the remnants of Breker's workshop at Wriezen some 20 kilometers away (Breker also reported sculptures stolen from a warehouse near his Berlin studio).[160] Breker's pieces there were next to works sculpted by Josef Thorak (one of his 1939 Reich Chancellery figures) and Fritz Klimsch (pieces for the 1936 Olympiad). This appropriation of his work by the Soviets and

East Germans was clearly contrary to Breker's will. He remained polit-
ically conservative and had no desire to bolster either communist
regime.

The sculptures noted above fell into Soviet hands at war's end
because Breker, like most other figures in this study, fled with his wife
to the Alps in search of safety.[161] One of those present at Wriezen,
Marta Mierendorff, recounted how on 8 February 1945, before the Red
Army invaded the area in the final battle for Berlin, "all that was mov-
able, including Breker's property in Jäckelsbruch, was loaded on trans-
port wagons sent on its way to Bavaria."[162] Breker maintained after the
war that he had been unable to evacuate much of his property, and he
was certainly unsuccessful in attempting to move many of his sculp-
tures to southern Germany.[163] He did, however, apparently keep his
promise to evacuate the foreign workers, although the majority were
permitted to head to Bavaria at a tortuously late stage in the war and
then landed in "an uncomfortable mass camp, while Breker lived in
comfort."[164] In February 1945, Breker took refuge in a stately fifteenth-
century castle in Leutstetten on Lake Starnberg. The entire castle had
been commandeered by Breker's friend and former mentor, Wilhelm
Kreis, who arranged for many of his colleagues to join him.[165] Later,
Breker moved on to a sanatorium at Ebenhausen near Munich, where
the Americans found him upon their arrival.[166] His behavior at the end
of the Third Reich reflected much of his experience during the entire
epoch. As an employee of Jäckelsbruch noted, "there is judicial and
moral responsibility. Judicially there may have been nothing against
Breker, however it's hard to be sure. Morally, he was in such denial that
no insight ever came."[167]

After taking refuge in Bavaria toward the end of the war, Breker
remained in the area in the months following the capitulation. The
American occupation forces did not appear very concerned with the
Reich's most prominent artist, although they did launch an investiga-
tion into his conduct.[168] Breker was finally called in by John Streep, the
head of the Munich office of the CIC, in the autumn of 1945. In his
memoirs Breker describes the extraordinary meeting that took place in
the agency's office in the Führerbau (one of the former administrative
buildings of the Nazi Party).[169] The Americans, if Breker is to be
believed, were remarkably friendly. He noted, "fortunately, the chief of
the house was surprisingly obliging."[170] Breker quotes the CIC chief as
saying, "there is not a single charge in our papers. There is just one thing
that we, that is the Americans, cannot pardon you for: that you helped

Hitler to world renown in the cultural sector!"[171] Evidently, due to bureaucratic error, the Munich CIC was ignorant of important facts in Breker's case: while Berlin sources had extensive information about the sculptor, including his position in the Reich Chamber for the Visual Arts, the Munich office files were deficient and even reported that he was not a Party member.[172] John Streep nonetheless made the suggestion that Breker repent publicly in order to keep to a minimum the difficult years that would certainly follow. Breker's response was telling: "can you explain to me how I should define this repentance? I have never occupied a political office assumed either by accident or inclination, but was a sculptor."[173] In fact, his positions as vice president of the Reich Chamber for the Visual Arts and a cultural senator render this statement patently false.[174] But the Americans had no interest in pursuing justice in this case. One journalist even contended in 1947 that Breker "maintained good relations with the occupation authorities and modelled [a bust of] General Eisenhower."[175] While this last claim has never been substantiated, it suggests Breker's general adaptability.

It is evident that the Americans intended to let the denazification board examine his record and determine his fate. They merely kept an eye on him and helped Breker and his wife move north to the town of Wemding near Nördlingen in October 1945. The Office of the Military Government, and specifically a Major Snap, gave them use of a thirteen-room house that had previously belonged to the local mayor and was scheduled to be shared by two families.[176] Through a friend, a member of the local municipal government, Breker was given an atelier at a time when space was extremely precious.[177] In fact, his work was interrupted for a very short time by the culmination of the war and ensuing occupation. Thanks to the support of the Military Government, his wife Demetra was able to purchase an automobile, a prized object whose acquisition she defended in a June 1946 letter as being "for the procurement of materials, like plaster, clay, stone samples, and tools."[178] In an area flooded with homeless refugees, these provisions were especially generous. Breker later attempted to deflect criticism by pointing out that he housed various needy associates, including his favorite model Gustav Stührk and his wife, and that he repaired the dwelling at his own expense.[179]

Breker was one of the few sculptors to be tried by the denazification courts, although he was fortunate not to face war crimes charges as well. He and his attorney, Werner Windhaus, mustered an aggressive defense, submitting some one hundred sixty affidavits about the artist's

comportment during the Third Reich.[180] They also won important pre-
liminary battles: first, when the court granted their petition for an expe-
dited trial, which prevented public opinion from mounting against
Breker; and second, when they had the case tried in the small Bavarian
town of Donauwörth, close to Wemding, where the Brekers had resided
for a short time after the war, rather than in Munich.[181] The decision to
try the case here ran contrary to the denazification laws, which specified
that the case be heard in the primary place of work or residence (the
Bavarian Education Ministry argued for Munich and pointed to thirteen
years of exhibitions in the provincial capital), but Breker and his coun-
sel fought for Donauwörth, presumably because this locale offered
more sympathetic and lenient judges.[182]

While Breker was originally charged as a *Nutzniesser* within category
II of the Liberation Law (that is, an opportunist who benefitted either
economically or politically due to connections to Nazi leaders), the
commission placed him in category IV and found him to be only a "fel-

Breker stands before a de-nazification court as
the verdict is read; the Munich paper Die
Abendzeitung reports that Hitler's
Michelangelo was categorized as a fellow-
traveler and fined the nominal sum of 100
marks, 2 October 1948 (BHSA).

low traveler"—a category, as explained earlier, that permitted him to work again.[183] He was also fined DM 100 plus the costs of the trial.[184] The denazification board, in fact, portrayed him more as a victim than opportunist. They pointed, for example, to the two monumental figures that Breker created to adorn the New Reich Chancellery, which he had titled *Torch Bearer* and *Sword Bearer*. They observed that the sculptures were renamed by Hitler after their submission, becoming known as *Party* and *Wehrmacht*, respectively, thereby giving them a political meaning that the artist had not intended. Breker's grand residences and ateliers, as well as his extraordinary income, also did not compromise his supposed innocence. The structures were deemed state property and the wealth characterized as unexceptional for an artist with his talent (his lawyer had compared his life style to Rubens, Rembrandt, and Lenbach and noted that it was relatively modest).[185] The judges' astonishing verdict was based on the notion that Breker had tried to behave in a scrupulous and modest manner, even though the Nazi leaders had made this difficult. His efforts to help certain friends escape persecution was seized upon: the court declared that "according to the measure of his power[, he] managed to resist the National Socialist rule of violence."[186] If Breker's activities during the Third Reich could be regarded as resistance, it comes as no surprise that the regime was not toppled by domestic forces.

Breker himself later built upon the findings of the denazification board in his representations of his life during the Third Reich. Clearly, the truth was not served.[187] At a minimum, his dishonesty is comparable to that of other artists, like Leni Riefenstahl, who denied responsibility for fashioning a Nazi aesthetic or bolstering the regime. Like the filmmaker, Breker maintained that art had nothing to do with politics, even though both were responsible for producing stylized representations of the political leaders for public consumption. Just as *Triumph of the Will* depicted Hitler and his entourage in a heroic, even mythological fashion, Breker crafted idealized busts of not just the Führer, but also Speer, Rust, Goebbels, and others.[188] Breker lied about his relationships, his official positions, and more generally, the power he wielded: he was far from being "just a sculptor."[189] Damaging evidence, such as his inhabitancy of Helena Rubinstein's apartment in Paris, continued to mount *after* the denazification proceedings. The United States Office of Chief of Counsel for War Crimes brought this incident to the attention of the Bavarian government in early 1949 in the wake of the denazification trial.[190] It would have been possible to retry Breker (and this was done

in some cases where prosecutors were dissatisfied with the initial verdict—see Adolf Ziegler's experience discussed below). But Breker was set free and allowed to fashion his own version of his career.

Breker returned to Düsseldorf in 1950, in part because the Landhaus at Jäckelsbruch had been destroyed by retreating SS troops at the end of the war and the property was located in the Soviet zone.[191] He always professed a certain dedication to Düsseldorf—"my first and hot love," he called the city.[192] Perhaps this sense of *Heimat* (strong affinity for one's home) is unsurprising considering his political views, yet his decision to move back to North Rhine-Westphalia also had a material motivation. The denazification board in Donauwörth had made him responsible for the costs of the trial, which amounted to DM 33,179, and Breker refused to pay. The Donauwörth Finance Office went to court in order to force him to remit the money, but the judge ruled that it was a regional matter and that as long as Breker remained in North Rhine-Westphalia, there was no way to make him pay.[193]

Despite the familiarity of his surroundings, Breker was forced to endure a number of significant changes in his life. He had fallen from a position of privilege and power. Moreover, as he noted in a 1956 letter to his friend Walter Hammer, "unfortunately I had to carry my wife to the grave six months ago [Demetra died in an automobile accident]. My parents died in 1952/53. All my works are destroyed. In short, that is how things look to me. The result is that I have fully withdrawn and in essence feel as though I am living in a ghetto."[194] That the artist could compare his own fate to the experience of those who had been forced to endure a real ghetto reveals his lack of historical awareness and his generally unreconstructed behavior. But it also speaks to the depression that overtook him, and evidence suggests that in this respect he was not alone among cultural figures who had been part of the Third Reich. Leni Riefenstahl, for example, described her mind-set in the early postwar period: "I was personally so shaken, but there were only two possibilities for dealing with this horrible burden and guilt—to live or to die. It was a continuous struggle, to live or to die."[195]

Breker was indeed unrepentant about his behavior and changed little in the postwar period. He attempted to recapture as much of his former life as was possible: to this end, he utilized a Swiss friend and patron, the collector Edwige Soder, to travel to Paris and serve as his representative at an auction where thirty-six of his works were sold by the famed dealer Durand Ruel in 1961 on behalf of the French government.[196] Officials of the Fifth Republic had stipulated that German cit-

izens were prohibited from bidding on the works and Breker used Soder to circumvent the restriction. The works had a varied provenance, ranging from the German pavilion of the 1937 World Exposition to the 1942 Orangerie exhibition (and hence were made of French bronze), although none of them were busts of Hitler. They had been stored in the cellar of the Museum of Modern Art in Paris. Soder was among the approximately fifty people who attended the auction. According to one reporter, who called the event a "dazzling failure," most came out of curiosity.[197] Yet the sale brought in approximately DM 76,000—a considerable sum for Nazi art. It is not exactly clear how many of the figures Soder purchased for Breker, but a number of them were sent to Düsseldorf and displayed in the garden of his home.[198] While it is difficult to fault any artist for wanting to retain his or her work, the idea of exhibiting in one's home works that had been official Nazi art suggests an uncritical view of the Third Reich.

Breker, like most figures in this book, also consorted with former Nazis after the war. He consulted with Werner Naumann in 1950 at a time when Goebbels's former state secretary in the Propaganda Ministry tried to revive a radical right-wing party. Breker, according to Naumann's diary, counseled caution, but was supportive and thought that Naumann was the only one "who could master the situation."[199] Naumann and his right-wing cohorts were apprehended by the British in 1953 and passed over to the West German authorities for "secret associations which endanger the state" (violating the West German constitutional prohibition against reviving the Nazi Party).[200] Yet Breker had kept sufficiently distant so as to avoid difficulties. Previously, the CIC had also reported that Breker was "attempting to revive Nazism," but files of the U.S. intelligence do not contain precise evidence to support this charge.[201] Breker, like Haberstock, Mühlmann, and others, proved adroit at surviving and avoiding career-ending missteps.

Arno Breker's contacts with colleagues from the Third Reich served him well in the postwar period. Specifically, he reunited with a number of architects formerly in the employ of the GBI as they undertook the reconstruction of West German cities. One writer noted that "with his experience as a decorator of monumental architecture, he could soon resaddle on the lucrative work of the architects in the economic miracle of Germany."[202] Friedrich Tamms and Rudolf Wolters, for example, commissioned him to execute sculptures for buildings in Düsseldorf.[203] These were evidently so successful that they led to further work (projects for the city included his *Aurora* for a local cemetery and his sculp-

ture of Matthew for the Mathäuskirche). In 1951, the Commerzbank in Duisburg commissioned him to do two pieces. Later, the Cologne Gerling-Konzern in Cologne contracted him to sculpt a relief of the "three holy queens," a work that today still stands in front of their building in the heart of the city. The Weserbergland clinic in the town of Höxter placed a group of figures entitled *Eternal Life* in front of their building in 1970, and Siemens was also a patron.[204] Many of the same businessmen who commissioned him to make sculptures that adorned buildings also had him execute portrait busts: Hugo Henkel and Hermann Josef Abs were notable among the industrialists who helped lend him respectability by way of their patronage.[205] Interestingly, Breker had first helped establish a reputation in the late 1920s by executing portraits of industrialists, including Robert Gerling and Andreas von Siemens.[206] After 1950, Breker again found his niche. One East German critic labeled him the "court artist of the West German economic miracle companies."[207]

Despite the revival of his career, Breker was by no means fully rehabilitated. One critic summed up his position in 1954 as "officially scorned, unofficially working at full capacity."[208] He was, of course, widely identified with the Third Reich, and, as a result, perceived himself as marginalized. Breker felt tremendous self-pity in the decades after the war. He felt so estranged from mainstream West German culture that he first published his memoirs in French in 1970 (he always believed France to be a nation devoted to art and apparently believed he had a better chance there of being viewed as an unpolitical artist). When his memoirs appeared two years later in German, the publisher was a radical right-wing press by the name of K. W. Schütz (which also published Robert Scholz's study of Nazi art). In both *Paris, Hitler et Moi* and *Im Strahlungsfeld der Ereignisse* (*In the Limelight of Events*), Breker depicted himself as the victim of unjust discrimination and criticism and bemoaned the absence of patronage from the Bonn republic.

Despite his struggle for widespread acceptance, Breker had an undeniable ability to please his clients, whether they were Nazi *Bonzen* (big wigs) who wanted themselves and their regime glorified, or industrialists who fancied portraits in a neoclassical style. One critic noted of Breker's postwar work, "a comparison between his models and their portraits shows Breker's talent for a profession which unfortunately he never took up, in which he would have achieved much greater fame after the war, that of cosmetic surgeon. His portrait sculptures are compliments chiselled in '*Schmalz*' which ought to be embarrassing for their

subjects the moment they discover how cleverly the artist has specu-
lated on their vanity."[209] It was, indeed, this ability to create idealized fig-
ures that attracted so many clients. Such vanity, of course, existed
outside Germany, and many commissions, as noted earlier, came from
foreign patrons. So successful were these flattering sculptures that
Breker gradually emerged as one of the most requested portraitists of the
postwar period.[210] In addition to those noted above, Breker sculpted
busts of Ernst Jünger, Konrad Adenauer, and his old friend Jean Cocteau.
Many, but not all, of his subjects had antidemocratic proclivities.

Breker's appeal extended beyond the flattering rendition of his sub-
jects. His supporters earnestly believed that he was an important artist
who represented fundamental and eternal artistic truths. Such senti-
ments were often articulated in the descriptions of his work, such as
Georges Hilaire's introduction to a 1961 exhibition catalog, which
identified Breker among the "most cultivated artists of the century"
because of the permanence of his art.[211] This theme of permanence, one
might note, had been favored by Nazi art theorists as they argued for
the enduring meaning of all great art, whether Hellenic or Germanic.[212]
Breker's defenders often revived ideas from the Third Reich. A 1970
article in the radical right-wing *Deutsche Nationale Zeitung*, for example,
described Breker's work as "a spiritual revolt against nihilism," a phras-
ing that implied that more abstract art had negative qualities.[213]

Breker's exhibitions also brought together figures who had been

*Breker receives the Hutten Medal from two of
the leading radical right wing publishers in
Germany: Gert Sudholt (Druffel Verlag) and
Karl Waldemar Schütz (of K. W. Schütz
Verlag), 1980 (photo by author).*

prominent in the cultural life of the Third Reich. The Society for Free Journalism (Gesellschaft für freie Publizistik), an organization closely affiliated with radical right wing publishing houses, such as Druffel and K. W. Schütz, awarded Breker the Hutten Medal in 1980, describing him as an "artist of European rank, whose creations count among the great achievements of German art history."[214] The society bestowed the award in Frankfurt during the important annual book fair and invited Robert Scholz to deliver a speech evaluating the artist's career.[215] A 1978 exhibition of his work in Salzburg induced Winifred Wagner to attend the opening. It was also perhaps symptomatic of the Austrians' longtime reluctance to confront the history of the Third Reich that local politicians were also in attendance, but this was not entirely inconsistent with the city's cultural-political identity and the frequently unsuccessful efforts to "master the past."[216] One might make a similar argument about the city of Bayreuth. As early as 1951, organizers of the festival sought to display a Breker bust of Wagner created during the Third Reich, a conspicuous linkage of Hitler's favorite composer with his favorite sculptor.[217] Subsequent efforts by municipal leaders to commission Breker to execute statues of Franz Liszt in 1971 and Cosima Wagner in 1978 were also marked by a certain insensitivity.[218] For these patrons to commission an artist so closely associated with the Third Reich reflected a lack of historical awareness and to have as subjects two people related to Richard Wagner—another figure struggling to emerge from the shadow of National Socialism—only added to the impression that they sought to whitewash the Nazi past.

At times Breker's supporters were rather deceptive in their efforts to rehabilitate the sculptor. One catalog from the Galerie Marco in Bonn (an establishment that also exhibited the works of Werner Peiner and other artists from the Third Reich) featured a work from 1938 titled *Herold* and included the information that the monumental bronze rendition of an athlete had been in the recent exhibition *Seventy-five Years of Art in Germany* at the Hamburg Kunsthalle, as well as in a show at the Lenbach House in Munich.[219] The implication was that these respectable institutions had seen fit to include the artist's work and that Breker was therefore more legitimate. In fact, both exhibitions included *Herold* as an example of the official art of the Third Reich, and their intention was not positive as implied in the Galerie Marco catalog.[220] Beginning in the 1970s, Breker's supporters began to act in increasingly bold and provocative ways. For a steadily broader segment of the public, the artist lost much of the earlier stigma. The Galerie Marco, for

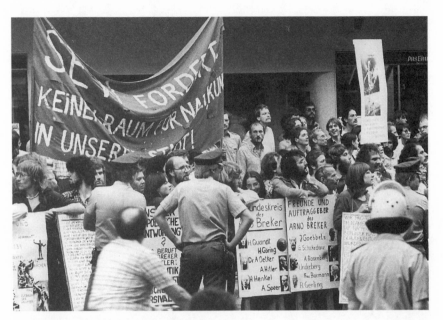

*Protest against an exhibition of Breker's art in
the Gallery von Langen in Berlin, 22 May
1981 (Ullstein-deutsche presse agentur).*

example, circulated photographs of the artist with German President
Walter Scheel, Salvador Dali, and other highly esteemed figures.[221]

Because of his prominence both in the past and in the postwar
period, Arno Breker became the focus of controversy in the early 1980s.
The efforts at his rehabilitation, which moved from radical right-wing
circles to more mainstream conservative ones, provoked outspoken
opposition. By 1981, the opening of a Berlin exhibition of Breker's art
attracted hundreds of protesters (it coincided with the much less pub-
lic founding of the Museum Arno Breker—Collection of European Art,
located in Schloss Nörvenich near Cologne). Not surprisingly, those
who supported Breker dismissed the protesters, many of whom were
evidently art students, as left wing and professional agitators (*Berufs-
krakeeler*); they "celebrated Breker all the more as a result."[222] The issue
for individuals on both sides of the debate centered around the degree
to which Breker was tainted by his association with the National Social-
ist government and the burden of guilt that came with it. Yet the dis-
cussion grew more complex with the emergence of defenders of the
artist who were not part of the radical right. While generally conserva-
tive, they were not political extremists. They argued that Breker should

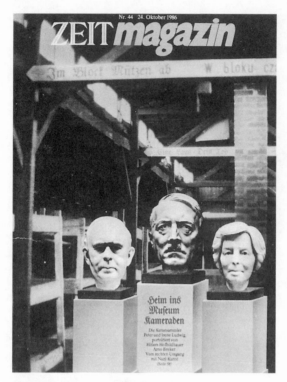

*The efforts of art patron Peter Ludwig to
rehabilitate the work of Arno Breker
precipitated an acrimonious public debate in
the mid-1980s. Here, the influential periodical
Die Zeit places one of Breker's busts of Hitler
next to more recently commissioned portraits
of Ludwig and his wife (photo by author).*

be permitted to put his National Socialist past behind him and exhibit
his postwar creations. The debate about Breker prefigured the "histori-
ans' controversy" (*Historikerstreit*)—the debate about whether the Ger-
mans' past was "masterable," that is, whether one could normalize this
history by placing it in a comparative context—that erupted four years
later.

The ideas advanced by Breker's most important defender in the
1980s, chocolate manufacturer and art collector Peter Ludwig, in many
ways paralleled the provocative theses of Ernst Nolte and others who
agitated for a "usable past."[223] Ludwig went on West German television
and stated, "I have not intervened [in museum policy] in order that
Nazi art be shown, but in order that art from the years 1933 to 1945,

art that was produced in Germany, and also that which was exhibited at that time, not be saddled with a general taboo—not to be the subject of what is in practice a ban on exhibition (*Ausstellungsverbot*)."[224] Putting aside Ludwig's appropriation of a term from the Third Reich (that is, *Ausstellungsverbot*), the issue was whether the art of the period could be normalized—or shown in museums as a part of Germany's artistic evolution. Ludwig and his allies argued that many countries in the interwar period had political art and that much of it was monumental. It was very much like Nolte saying that other countries had undertaken genocidal programs and that the Germans should not carry any special burden of guilt. Both Nolte and Ludwig were highly influential figures: the former held a professorship in Berlin and the latter collected so much art that a museum featuring his name, the Ludwig Museum, merged in 1986 with the Wallraf-Richartz Museum in Cologne. Both Nolte and Ludwig went out on a limb for the cause of a "masterable" past: Nolte, in a sense, wagered the respect he had earlier acquired with innovative and impressive scholarship and Ludwig gambled his reputation by defending Breker, going so far as to commission busts of him and his wife, which he sought to place in the new Rhine building that housed the Ludwig and Wallraf-Richartz Museums.[225]

While Nolte and Ludwig undoubtedly created sensations with their arguments, and in the process attracted supporters, they ultimately failed to win over the intelligentsia or the general public. Most Germans, notwithstanding Nolte's arguments, were not prepared to renounce a sense of guilt for the Holocaust.[226] Ludwig and the defenders of Breker also failed to convince the public that the sculptor deserved to be rehabilitated. Exhibitions of Breker's work continued to provoke passionate responses: Klaus Staeck assembled many of the critical reactions in a 1987 book, *Nazi-Kunst ins Museum?*, and in the late 1980s, an exhibition of Breker's work in a commercial gallery in Berlin, in the words of a *Frankfurter Allgemeine Zeitung* correspondent, "'endangered the internal peace and reputation of Berlin' and invited the intervention of the Allies."[227]

Most observers realized that a rehabilitation of Breker was difficult for a variety of reasons. First, there was the obvious fact that he had been a Nazi artist. Second, he was dishonest about his own past. And third, even years later, he remained an apologist for the Nazi regime. Breker, for example, wrote in 1977 to architect Paul Giesler, who had headed the team commissioned to design the Special Project Linz buildings: "Hitler's primitive, deluded opponents had no idea that here

stood a man who sought to create a new epoch (also architecturally).
. . .The world is still deceived today and has misunderstood all of
Hitler's policies."[228] In 1980, he admitted that his friendship with Albert
Speer had come to an end, noting, "I haven't had any contact with him
for four years. . . . I don't like his view of the past. . . . I can't condemn
my work. . . . I have nothing to regret, nothing to repent for, nothing to
add."[229] In that same year, Breker even denied that French Jews had
been dispossessed of their property—an opinion that is comparable to
Holocaust denial in its absurdity and insensitivity.[230] There was also the
foreign reaction to consider. The French, for example, viewed Breker as
a symbol of the painful occupation years. The 1981 exhibition *Paris
1937—Paris 1957*, which was held at the Centre Pompidou and sched-
uled to include Breker's sculpture from the Third Reich provoked such
an outcry (including a petition) that the curator of the exhibition, Ger-
main Viatte, was compelled to withdraw Breker's works.[231]

The mainstream German and world press, then, refused to accept
Breker's rehabilitation or to view his art apart from the Third Reich. A
1987 review of Breker's oeuvre by the highly regarded art historian
Max Imdahl featured a subtitle that played upon Maillol's earlier com-
pliment: "Arno Breker—No Successor to Michelangelo."[232] In a detailed
and scholarly way, Imdahl definitively explained why Michelangelo's
art was so vastly superior to that of the Nazi sculptor. Walter Grasskamp
noted of Imdahl's article, "In different circumstances it might seem
absurd that proof of the groundlessness of this comparison had to be
produced by a respected art historian who certainly had better things to
do; but under the circumstances we must be grateful to Imdahl for hav-
ing taken the trouble and for having dissociated the two artists so con-
vincingly."[233] Karl Ruhrburg, a former director of the Ludwig Museum
in Cologne wrote an article titled "No Place for Arno Breker," in which
he argued that "Breker's subservience to the National Socialist ideology
destroyed his gift" and that "the devil's sculptor . . . celebrated triumphs
while the best artists of the German nation were oppressed, persecuted
and killed."[234] The mainstream art establishment thus remained critical
of Breker, even though the artist won over many supporters in other
sectors.

Arno Breker died in February 1991. He evidently had never over-
come his feelings of victimization. One visitor in 1984 commented,
"Considering his life-style and his elegant house, surrounded by immac-
ulately kept gardens dotted with replicas of his statues, he appeared to
me excessively bitter. In one breath, he maintained that art, including

his own, had nothing to do with politics, and that he had always been free to sculpt as he pleased. The next moment, he would exonerate himself of the taint of Nazism by referring to the many people he had saved during the war."[235] Breker's goal, his "credo concerning art" as he called it, had been "the portrayal of a human, ideal representation of man."[236] His own life, in comparison, revealed the ethical fragility and imperfectibility of humans. On his ninetieth birthday, Eduard Beaucamp wrote in the *Frankfurter Allgemeine Zeitung*, "he is the classic example of a seduced, deluded and also overbearing talent. Breker's case teaches that the modern artist may not give into blind creative illusions, that one needs 'self-awareness.' Breker's all too conspicuous, all too unreflective natural gift became his fate. He put his talent at the disposal of his patrons and identified with their will."[237] Breker indeed possessed considerable talent. He himself, never lacking in self-confidence, believed this and probably accommodated himself to the various political systems in which he worked for this reason. Art took precedence over morality. It is ironic that the great proponent of the philhellenic style and concomitant idea of permanent accomplishment in art turned out to be such a chameleon, riding the waves of taste and market forces: from modernist in the twenties to Nazi in the thirties and forties to a toned down, sober naturalism in the postwar period. He never seemed to realize this. In this way Breker deviated from the character of Faust: in most versions, the mythic figure repented and asked to be pardoned for his transgressions. Arno Breker lived his life in denial.

In Arno Breker's denazification trial in 1948, his lawyer Werner Windhaus quoted the former president of the Prussian Academy of Art, Professor Arthur Kampf: "One used to say that one could not measure artists by the standard used for other people because they are big children. I contend that the powers of judgment of artists are now measured on a standard that far exceeds that which is applied to the sons of other muses."[238] Windhaus elaborated on his belief that visual artists were being persecuted as he named creative figures in other fields, including composer Richard Strauss and actor Gustaf Gründgens, who had been exonerated. Windhaus argued that "great artists must actually be measured by standards other than those applied to normal mortals."[239] It is not clear whether this separate standard ever existed: while artists who collaborated with the Nazi regime were extremely success-

ful in escaping responsibility for their actions, this, as earlier chapters have demonstrated, also proved to be the case for the other professions in the art world. One should note, however, that a number of modern artists in the postwar period—primarily from the ranks of those who had suffered attacks during the Third Reich—became angered by the success of "Nazi" artists and in 1950, signed a petition titled, "Against Hitler's Favorites: A Protest of German Artists."[240] Prominent figures, including Erich Heckel, Karl Hofer, Willi Baumeister, Gerhard Marcks, and Karl Schmidt-Rottluff were certainly of the opinion that those artists who had served the regime were unacceptably successful in reviving their careers.

In Germany, where artists have traditionally been held in high esteem, there is also a tendency to view them as exceptionally scrupulous or divorced from corrupting political and economic influences. Even former Chancellor Kohl remarked, "if an artist sells his soul to a political system, he also in a fundamental sense ends his existence as an artist."[241] While there was a minority of mostly modernist artists who remained in Germany and repudiated the regime—usually living in isolation in "inner emigration"—this was a fairly rare phenomenon. Indeed, the notion of artists resisting the Nazis has been exaggerated and is now part of the myth of the avant garde. The reality was that most painters and sculptors who remained in the country found accommodation with the regime, and this extended to many who had, and retained, positions at the acme of their profession. The sculptor Fritz Klimsch, for example, who was highly regarded during the Weimar Republic and who regained considerable respect in the postwar period, executed portrait busts, of Hitler, Frick, and others, among his commissions for the regime. He had even permitted Robert Scholz and Alfred Rosenberg to organize an exhibition in the former house of the promodernist Secession in Vienna.[242] Georg Kolbe, who was initially not in favor with the regime (and was even accused of communist sympathies, which he denied) ultimately had his art exhibited at the Olympic stadium in Berlin and the German pavilion in Paris, among other notable venues. He executed busts of General Franco of Spain (which Hitler owned) and Reich Labor Leader Konstantin Hierl, and Hitler awarded him the Goethe Medal for Art and Science in 1942. Kolbe is now recognized as one of the great sculptors of the twentieth century, and there is a museum in Berlin dedicated to his work.[243] The experience of Expressionist painter Emil Nolde, who was an early supporter of the National Socialists and tried for years to gain official acceptance, is another well-

known example.[244] In light of the complicity of so many notable artists, one must pose the question whether it really was those who were less talented and less established who joined forces with the Nazi leaders.

It appears that both gifted artists and those lacking real talent surrendered to the totalitarian temptation; however, there were far more of the latter. Additionally, individuals who had yet to make their careers were often more willing to accommodate themselves in exchange for support and publicity. There is also the fact that the aesthetic policies laid out by Hitler, Goebbels, and their cohorts hardly constituted a recipe for great art. Those who adhered to the official line were likely to produce uninspired work (though it does raise the contentious question whether there was "good" Nazi art). Suffice to say that there was art produced in service of the regime that displayed real technical ability and that elicited reactions from contemporaries in a manner desired by both the artist and the Nazi leaders. But if one is to understand artists and their work during the Third Reich, one must consider the many ambitious painters and sculptors who produced the strange and sterile art now associated with the regime. Even Hitler and Goebbels were cognizant of the unsatisfactory quality of much contemporary art and commented on it after visits to the GDK.[245]

The classic example of the successful painter producing a sterile, yet somehow distinctively National Socialist art, is Adolf Ziegler (1892–1959), who also served as president of the Reich Chamber for the Visual Arts from 1936 to 1943. Even during the Third Reich he was mocked as the "master of the German pubic hair" because of his stiff, hyperrealistic nudes.[246] Despite this ridicule, Ziegler cannot be disregarded. He possessed considerable technical ability, which was adequate for him to gain an important appointment as a professor at the Academy of Fine Arts in Munich (1933–34) and become director of the highly prestigious Doerner Institute for the Techniques of Painting— although the professorship was later disavowed because his appointment was never approved by a vote of the Academy members but had come as a result of an executive order.[247] Ziegler's work usually pleased Hitler and Goebbels: the Führer, for example, purchased his triptych, *The Four Elements,* and hung it in a prominent place in the Führerbau in Munich (it was also rendered as a huge tapestry and hung in a central location of the German pavilion at the Paris World Exposition of 1937, where it was awarded the Grand Prize for painting and tapestry).[248] Ziegler's success enabled him to amass power steadily so as to become one of the most prominent cultural bureaucrats in the Third Reich.[249]

Both his career and art make Ziegler representative of Nazi Germany: his career serves as a prototypic case of finding accommodation with the new rulers, and his art captured in a difficult to describe way a mind-set and style so common at this time (Ziegler's canvases have been included in nearly all exhibitions about Nazi, fascist, and totalitarian aesthetics).[250]

Although Ziegler's association with Hitler dates back to 1925, he evidently gave up an early modernist style and compromised his work in order to cultivate the Führer's favor. Not surprisingly, there are no extant examples of Ziegler's modernist work (the master purger of "degenerate" art did not leave his own creations to be found). But contemporaries reported on his youthful predilection for Expressionism. Museum director Alois Schardt noted while in exile in the United States in the late 1930s that Ziegler, "whose name and works became so very important in the new Germany, was in former times a modern painter and a zealous admirer of the works of Franz Marc. . . . His transmutation proceeded by slow degrees. . . . Before he took this position, he was one of the most extreme modern painters, but one of inferior rank."[251] Additionally, Ziegler came from "an old Bremen art family" (his father was an architect), and he studied at academies in Weimar and Munich.[252] Ziegler was knowledgeable about art and grew up surrounded by art students. He switched to a representational and realistic style in the 1920s at a time when he had increased contact with Hitler. The two met on numerous occasions in Munich to discuss aesthetic issues in the years prior to 1933 and got on so well that Hitler appointed him the Party expert on art and gave him a corresponding official position (as *Sachbearbeiter für Bildende Kunst*) within the Reich Leadership of the Nazi Party.[253] Nonetheless, the nature of Ziegler's transformation remains unclear. Perhaps he had first embraced the work of the New Objectivity, which at times also featured a form of realism. Exiled museum director Alois Schardt thought that Ziegler "continued the technique of Richard Müller," whom he called "the inventor of the New Realism."[254] What is less murky is the evolution of his political views.

Adolf Ziegler was a convinced National Socialist who got on well with the most ideologically inclined Nazi leaders. His file in the former Berlin Document Center contains an active correspondence with Peasant Leader (*Bauernführer*) Richard Walther Darré, the blood-and-soil enthusiast who, for example, was wont to compare the breeding of horses with the engineering of human populations.[255] Ziegler's art, which he consciously populated with "racially pure" figures, had quali-

Ziegler's triptych The Four Elements *as illustrated in* Kunst im Deutschen Reich *(photo by author).*

ties that enthralled many Nazis. Education Minister Bernhard Rust, to take one case, noted in November 1936 that "[Ziegler's] last work . . . is an incomparably beautiful masterpiece [of] classical Hellenism."[256] Hitler also praised Ziegler for both his political views and art (the two were related), and offered private commissions (a postmortem portrait of Geli Raubal in 1933), as well as visible support that translated into widespread exposure.[257] His works were reproduced on postcards and featured in periodicals throughout Germany. Certain artists in the Third Reich even modeled their work after Ziegler's. One group of followers called themselves the "*Nachziegler*" (after Ziegler) and emulated his style, colors, and posed figures.[258] There was something peculiar and trivial about Ziegler's art that elicited humorous, and often snide, comments from observers. As mentioned above, even Party members joked about him as the master of the German pubic hair. When Hitler heard this, he noted (his humorous intentions being unclear—although he

was reportedly laughing), "Ziegler is the best flesh painter in the world."[259] Yet Hitler also once remarked about a Ziegler painting portraying nude women, "They don't have the right breasts. Botticelli, yes, he understood it."[260]

For Hitler to comment on women's cleavage suggests that there was indeed something about the works which was jarring and disquieting. Ziegler's precise yet unreal style, his naked but unnatural figures, and his rich but cold colors all made for unsettling results. Even the phrase sometimes used to describe the style of his art—"pseudo-neoclassicism"—suggests a strange combination.[261] Observers have often been thrown off by the paradoxes of his work (for example, it featured "the most basic" poses but "a certain luxurious element in [the] depiction of the naked human form [that became] stronger with every passing year").[262] This incongruity also evidently applied to his personality. One American observer who interviewed him in 1937 noted, "This man, I thought, either has a perverse Swiftian sense of humor or else is an imbecile."[263]

While Hitler sensed the odd qualities of Ziegler's work, he did not question the latter's intelligence—though perhaps more importantly, he liked the fact that Ziegler was very subservient. Therefore, toward the end of the tumultuous and divisive debate over Expressionism—a protracted affair that lasted well into 1936 and involved officials at the highest level (most notably Goebbels and Rosenberg)—Hitler replaced the relatively independent-minded president of the Reich Chamber for the Visual Arts, Eugen Hönig, with the more obedient Ziegler. Hitler knew that putting Ziegler in this position would afford him more control in the arts administration, that his hard line antimodernist policy would be enforced without questions or troubling deviations. Ziegler was so passive that, according to the findings of the postwar denazification court, he learned of his appointment over the radio: Hitler had not even bothered to ask his consent for the appointment.[264] Ziegler welcomed the December 1936 appointment because it confirmed his position as a leading artist and entailed considerable power. Six months later Hitler entrusted him with a momentous project: purging modern artworks from the state galleries.[265]

In postwar statements, Ziegler presented himself as a moderate in his views about modern art, but one who was forced into a leading role in the "degenerate" art program. He talked about wanting to help artists such as Oskar Kokoschka, about his attempts to help the museum directors cope with the disastrous purges, and about his opposition to

"hard-liners" like Willrich, Hansen, and Schweitzer.[266] Such assertions may have elements of truth to them—it is believable that Ziegler appreciated a select few modern artists and behaved in a more professional and decorous way than some of the other agitators—but these protestations obscure the leading role he played in the defamation of modern art and artists during the Third Reich. While he may have still evinced some sympathy for the work of his early favorite, Franz Marc, he obediently removed Marc's canvases from the museums.[267] He also escorted Hitler through the *Entartete Kunst* exhibition in Munich and took much of the credit for the initiative. In the end, Ziegler wanted to have it both ways: to be viewed as having been important, yet also innocent. At his denazification trial, he admitted that he had delivered a famous radio address opening the 1937 exhibition, but claimed that he did not write the vitriolic and anti-Semitic diatribe against modern art, and was handed a prepared text by the Propaganda Ministry.[268] If this is in fact true, it is an indication of the price he had to pay for his power.

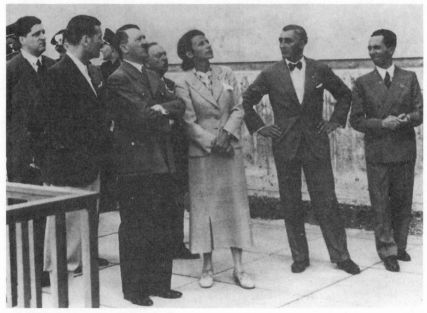

A visit to the newly constructed House of German Art in Munich: from right, Goebbels, Ziegler, Gerdy Troost, unidentified man, Hitler, Munich mayor Karl Fiehler, and August von Finck (chair of the board of the House of German Art), May 1937 (BA).

From this position atop the art world of the Third Reich, Ziegler appeared unassailable. As a result, his fall from grace in 1943 is all the more dramatic. During that summer, Ziegler was arrested by the Gestapo and imprisoned in a concentration camp for six weeks because of "behavior detrimental to the state."[269] The reasons for this turn of events were twofold: first was his defense of Professor Constantin Gerhardinger, an artist who refused to deliver paintings to the House of German Art for the 1943 GDK out of fear that they would be destroyed in a bombing raid. When Hitler got wind of this "defeatist" thinking, he reacted hysterically, and Ziegler, who had defended Gerhardinger's decision in a letter to Goebbels, also suffered the consequences.[270] The second reason for his imprisonment stemmed from his association with Arnold Rechberg, a sculptor who was concerned about the course of the war and attempted to mobilize support for a cease-fire with the Western Allies. Ziegler evidently approached Munich Gauleiter Paul Giesler with Rechberg's plan for sending peace feelers to the Americans and British, and the fanatical Gauleiter reported him to the Reich Security Main Office.

The consequences could have been worse. The regime was far more malignant at this point, and thousands lost their lives due to behavior that was considered subversive. In 1942, Hitler had formalized his position as Germany's "supreme judicial authority" and appointed former president of the People's Court, Otto Thierack ("a notorious Nazi radical"), as the new Minister of Justice, but two symbols of the more brutal and lethal regime that was imposed during the last years of the war.[271] Historian Robert Gellately has written, "The growing awareness of what was in store for anyone suspected of the slightest sign of 'treason,' even if they merely voiced the slightest doubts, began to give some citizens cause to reflect about running to the authorities with denunciations."[272] Ziegler's case was, of course, exceptional, and Hitler personally issued orders that he be released from the Dachau camp and allowed to retire.[273] After the war, Professor Leonhard Gall reported that Hitler "at that time (in 1943) himself declared that 'Ziegler should be happy that he was not shot.'"[274]

Adolf Ziegler lived about as quietly as possible after this amnesty. This was facilitated because newspapers were ordered in August 1943 not to publish anything about him.[275] He moved to the town of Soltau near Hannover, where he remained until apprehended by the occupation authorities in early 1947. Ziegler had kept such a low profile that the search to find him had taken two years: there had been, for exam-

ple, rumors of him living near Baden-Baden and Lake Constance.[276] His first trial for his activities during the Third Reich occurred in 1949 under the auspices of the Denazification Main Committee for the Producers of Culture of the City of Hannover.[277] In the verdict of 18 May, the judges were most critical about his involvement in the "degenerate" art program; that complicity was the main reason they placed Ziegler in Category IV as a "fellow traveler" and charged him DM 500 for court costs. While most would consider this a remarkably lenient sentence, Ziegler did not. He was no doubt aware that many peers had been completely exonerated. Ziegler, after expressing an interest in settling in Bavaria, arranged through his lawyer for his case to be retried by the Munich Main Chamber in 1953. This trial yielded an acquittal, with the state picking up the costs, which ran to DM 39,600.[278] The judges, in the opinion of the chair, A. Blitz, were convinced that during the war Ziegler effected a "distancing from National Socialism and its violent methods."[279]

Because Ziegler's paintings were closely associated with the Third Reich, he was unable to rehabilitate his career in the postwar period to any significant extent. There were published reports that the Ben Uri Gallery in London exhibited his work in the 1950s, but the gallery, which still exists today, reports that the artist in question was an Adolf Zeigler (and not Ziegler), a Jewish painter from the East End of London.[280] Not that a postwar rehabilitation was fully out of the question: a recent visit to the Galerie Wimmer on the chic Briennerstrasse in Munich found works there by Paul Hey, known during the Third Reich for idealized blood-and-soil landscapes, and Paul Matthias Padua, who had painted the sexually explicit *Leda and the Swan* that created a scandal at the *GDK* in 1939 (and was purchased by Martin Bormann). The German magazine *Der Spiegel* reported in 1965 that Ziegler's works, "once the 'incarnation of German art,' were treated as souvenirs in 1945—the majority disappeared in America. The Nationalist Socialist works now hang in the homes of middle class Americans."[281] Yet Ziegler, unlike many other artists from the period, struggled in vain for rehabilitation. In the 1950s, he made repeated attempts to be reinstated at the Academy of Fine Arts in Munich (taking advantage of the same reappointment clause as had Ernst Buchner), but German authorities were not prepared to let him return and denied all his lawyers' petitions between 1955 and 1958.[282] Ziegler also penned an elaborate response to Paul Ortwin Rave, arguing with assertions made by the National Gallery curator in his pathbreaking book *Kunstdiktatur im Dritten Reich*

(1949).[283] But experts like Rave were also not prepared to view him in a positive light. Ziegler, unlike Breker, did not revive his career and lived his last years quietly in the town of Varnhalt near Baden-Baden. He died in September 1959 at the age of sixty-seven.

– – –

During the Third Reich, only one other artist rivaled Arno Breker and Adolf Ziegler in terms of official approbation: the Austrian-born sculptor Josef Thorak. Thorak's early life fits the pattern established by the other two. His roots lay in the modern movement. He possessed considerable technical facility and used this ability to glorify the Nazi leaders and to articulate ideological tenets. And Thorak struggled for a postwar rehabilitation—although he did not live long enough to enjoy it.

Josef Thorak rose to prominence as a sculptor at an early age. Born in Vienna in 1889, but with a Prussian father (which enabled him to become a German citizen), he trained from 1911 to 1915 at the Viennese Academy of Visual Arts under Anton Hanak, whom one scholar called "the most important Austrian sculptor of this time."[284] If this was not impressive enough, Thorak came to the attention of famed museum

Josef Thorak's early work in the winter exhibition of the Berlin Secession, 1926 (BHSA).

Thorak's atelier, n.d. (BA).

director and art historian Wilhelm von Bode, who became a key sup-
porter and arranged for him to travel to Berlin in 1915 to study in the
master class of Professor Ludwig Manzel.[285] Bode recognized Thorak's
considerable talent (which was more in evidence at this early stage,
prior to his adoption of a monumental style) and even penned a mono-
graph about Thorak in the year of his death (1929)—according to
Robert Scholz, the only study concerning a living artist that Bode ever
published.[286] The museum director also sat for a portrait bust. Bode's
backing helped the young sculptor gain recognition. In 1928, the Edu-
cation Ministry of the Weimar Republic awarded Thorak the State
Prize.[287] By 1932, his yearly income had already reached RM 70,000.[288]
Official commissions began in 1933, and Thorak gradually became an
international figure: in 1933 he executed a bust of Poland's leader, Mar-
shal Pilsduski; in 1934, he won a Golden Papal Medal for his submission
to the *Exhibition for International Christian Art* at the Vatican; and in
that same year, he won a competition sponsored by the Turkish govern-
ment to complete the National Monument in Ankara (begun by his
teacher Hanak) and to create a series of new monuments, including a
massive statue of Kemal Ataturk on horseback.[289] Thorak, who special-
ized in large and figurative sculptures at an early point, did not abandon
a style as radically modern as Breker's (although he exhibited with the
Berlin Secession in the 1920s and his early work, which featured natu-
ralist elements, was grouped with more abstract art). Thorak's accom-
modation with the Nazi regime was on the whole more subtle than
Breker's: his sculptures became larger and the subjects became more
suggestive of the Nazi ideology. More specifically, Thorak favored his-
torical figures and themes from German myth.

Thorak's early success, combined with his prominence in the capital,
brought him to the attention of Hitler and other National Socialist lead-
ers. Although Hitler and Thorak did not meet personally until 1936, the
dictator was evidently aware of him much earlier.[290] Thorak became a
doyen of the Nazis in 1935 after Alfred Rosenberg and Robert Scholz
organized an exhibition of his work in the Natonal Socialist Cultural
Community's (NS-KG) gallery in the heart of the Berlin Tiergarten.
This show was publicized in both the Party and the national press and
launched his career as a state artist (*Staatskünstler*).[291] Thorak was one
of the first sculptors chosen by the Nazi leaders to represent the regime
and ideology. Conscious of this position, Thorak wrote a letter to Hitler
thanking him for the first of the "new ateliers" of the Third Reich.[292]
Among the early venues for his works were the Olympic stadium

(*Reichssportfeld*) in Berlin in 1936; the propagandistic exhibition *Give Me Four Years Time* in 1936; the German pavilion in the Paris World Exposition of 1937; the inaugural *GDK* in the House of German Art (1937); the grounds of the Nuremberg Party rallies (the commission came in 1939, though the work was never completed); and the new Autobahn, where he executed a gigantic monument near Freilassing.[293] Thorak longed for recognition: in a 1935 divorce trial in which he testified, he identified himself as a "professor," and was subsequently reprimanded for this impropriety (at that time he had an appointment at the Pforzheim Arts and Crafts School, which did not permit him to use the title).[294] Later in the decade he received the honors he so coveted. Hitler signed his professor title in 1937, and Thorak was made the leader of a master class at the Academy of Visual Arts in Munich (Breker, although also appointed a professor in 1937, did not receive a *Meisterklasse* until 1944). Hitler's appreciation of Thorak's work was also expressed by his commissioning a portrait of a beloved niece, Geli Raubal (an honor earlier accorded Adolf Ziegler). This bust of his deceased niece was placed in the Reich Chancellery.[295]

Because the Nazi leaders expected important work from Thorak, they offered generous support in return. Hitler visited Thorak's Berlin studio in 1936 and the two men discussed "great projects." In January 1937, Thorak wrote Adolf Wagner—a Gauleiter and the Bavarian minister of interior, education, and culture—and requested a new studio,

Thorak showing a model to Hitler and Speer, n.d. (SV-B).

reporting, of course, on his recent meeting with Hitler.[296] This initiative paid off, and in October, Wagner accompanied the recently appointed professor at the Munich Academy to the lake region fifteen kilometers southeast of Munich to inspect potential sites.[297] This led to the construction of (the first) studio at Baldham, which was paid for with state funds—a sum in excess of RM 215,000.[298] The initial structure, however, was soon perceived as too small, and the following year, Hitler commissioned Albert Speer, a good friend of Thorak's, to design another. The new atelier was so large—over four stories high—that it easily accommodated figures with heights in excess of fifty feet, as was the case for the Autobahn monument.[299] The massive stone atelier, which postwar experts considered razing but deemed "virtually indestructible," cost around RM 1,500,000.[300] This structure reflected the usual grand patronage of the Nazi leaders, but also their typical means of proceeding: after the war, the man who owned the land used for the Thorak structures claimed that it was "earlier his family property which he had sold only under pressure."[301] Such considerations were of slight importance at the time, however, and amidst the construction of Speer's building in February 1939, Thorak held a huge party (*ein Richtfest*) which attracted a throng of Nazi Germany's political and cultural luminaries.[302] A week later, Thorak departed on a trip to Sicily and southern Italy with Speer, Magda Goebbels, Arno Breker, Wilhelm Kreis, and Nazi physician Karl Brandt.[303]

Josef Thorak's income also rose rapidly along with his stature and fame. His work fetched among the highest prices for contemporary artists: a bust of Nietzsche that Hitler bought in the 1944 *GDK* for RM 50,000 was the most expensive item purchased that year by the dictator.[304] As with Breker, the government gave him enormous sums to maintain his atelier and to work on various commissions. Speer's GBI also funded Thorak's projects, such as works for the assembly field (*Märzfeld*) at the Reich Party Grounds in Nuremberg, in a way comparable to, but not equal to, Breker's.[305] With his considerable wealth—for example, he reported an income of RM 343,000 in 1943—he had no difficulty purchasing Schloss Prielau in Zell am See near Salzburg in April 1943 for the bargain price of RM 60,000.[306] The property was available at that price because it had been seized from a Jewish owner, the widow of Hugo von Hofmannsthal.[307] In autumn 1942, when Gauleiter Scheel had begun to make the arrangements for the castle, he requested that the sculptor keep the deal "confidential."[308] One writer later described Schloss Prielau as a "small fifteenth-century residence, beautifully fur-

nished and immaculately maintained. . . .A majestic eight-by-ten-foot fifteenth-century French fireplace was built into its entrance hall. Equally imposing were the Greek marble columns and Byzantine Christ on the Cross that were the centerpieces of value for the estate. An assortment of Austrian peasant furnishings was scattered throughout in a most agreeable manner."[309] The sculptor also had a fine art collection, which was comprised of a combination of historic and contemporary works.[310] Additionally, Thorak possessed another property: a castle in Hartmannsberg, Bavaria, where he settled after the war.[311] This residence was also well appointed. As one paper noted upon his death in 1952, "behind his studio he had created a small museum in a second room, in which gothic sculptures and wonderful period furniture stood."[312] It is not clear exactly what works Thorak had in his art collection nor how he obtained them, but some of them came from Kajetan and Joseph Mühlmman: OSS investigators determined that he purchased from them at least five medieval stone sculptures, six Renaissance chairs, two gothic chests, and a wood carving of the Madonna and child.[313]

The degree to which Thorak subscribed to National Socialist ideological tenets remains unclear. One would suspect a certain sincerity of convictions in light of his muscular *Übermenschen*, teutonic themes, and his close relationship to Nazi patrons, as well as his willingness to acquire property taken from Jewish victims. Yet Thorak became a Party member only in 1941. (This membership was backdated on Hitler's explicit orders to 30 January 1933 for the sake of appearance.)[314] The situation is not clarified much by Martin Bormann's observation that Thorak had made halfhearted requests to join in previous years.[315] At times Thorak used Nazi rhetoric. For example, he frequently signed letters with "Heil Hitler" and he wrote to Adolf Wagner in 1937 with reference to his appointment as a professor that "under no circumstances is it known to me that my parents are not of Aryan extraction."[316] But such language does not necessarily speak of political convictions. Karl Meier, a sculptor who worked with Thorak for eleven years prior to 1935, said, "Thorak was always modest, politically clueless, and naïve."[317] Perhaps, then, Thorak was simply a naïve artist who was carried with the ebb and flow of the political tide because he wanted to work. Indeed, this was the thrust of many defense witnesses in his first denazification trial. One press report noted that the "certificate of release" portrayed Thorak as a "a primitive, peasant-like man."[318]

A more damning interpretation of Thorak's career is also feasible—one based on the indications of his desire for fame and fortune. There

are clues from his complicated personal life:. Thorak struck many as lacking scruples or character. His SS/SD file contained a range of reports that included being banished from one of the ateliers at the academy for taking some silk material and then lying about what had happened to it, and avoiding front-line service during World War I by securing easy service as a sketch artist.[319] Additionally, in 1929 he entered into his second marriage with a British citizen of Russian Jewish extraction named Gilde Lubowska.[320] According to the Provincial Court in Berlin, the two separated in December 1933—with Thorak bearing the responsibility for breaking off the relationship. However, the couple continued to share the same residence throughout the 1930s. Thorak told the SS that he could not afford a divorce, which they, of course, found implausible.[321] After the war, Thorak told the denazification board that the attacks by ardent Nazis had become so intense that the artist and his wife feigned the separation.[322] This, however, would constitute damning evidence, for if he cared for his wife and sought her protection, their union would have been considered a "privileged mixed marriage" and would have maximized her security. Thorak evidently sought to have it both ways: his relationship and the support of Nazis. To his credit, Thorak did assist his wife in her return to England in 1939.[323] But there are grounds for the claim of one postwar critic who called him "a pitiful example of a man, who broke the trust of his Jewish wife because the acceptance of the Nazi leaders was more important."[324] Thorak's motivations remain unclear, although there can be no doubt about his ambition. The SS investigators concluded in a 1938 report that Thorak was an "outspoken careerist."[325]

The findings of the SS investigators may have more merit than those of the majority of the postwar judges who evaluated Thorak's behavior during the Third Reich. Granted, the members of the various tribunals who heard his case were not in complete agreement. Josef Thorak was first tried in Austria and acquitted of all charges.[326] Then, a German *Spruchkammer* (a denazification board) rendered a verdict, this in Munich on 24 May 1948, which cleared him, deeming him "not affected by the law" (with the costs of the trial covered by the state).[327] The panel found that "Thorak had neither rank nor position within the Nazi Party, his works had no discernible National Socialist tendencies or characteristics, [and] he was completely indifferent politically. With his artistic creations he also cannot have contributed to the strengthening of a National Socialist-rule of violence."[328] A Munich Court of Appeal rendered the same verdict in a 25 July 1949 decision.[329] But Thorak was

not yet in the clear. Government authorities, specifically the minister for political liberation in Bavaria, negated these exonerations and reopened the case in a judgment of 4 October 1950.[330] They argued that Thorak was not "a normal sculptor, but classified as the sculptor of the Third Reich."[331] They noted the many political works he created—from SA monuments in Nuremberg to Führer busts in Berlin—and cited documents where Thorak acknowledged that his art served as "foreign propaganda."[332] With the lifting of previous judgments setting him free, Thorak went through one final round of denazification. This culminated in a 9 February 1951 decision by another appellate court, where Thorak was once again exonerated.[333] The judges were convinced that he "only nominally participated in National Socialism" and rejected the prosecutor's claims that he should be considered a "fellow traveler" (that is, put in category IV); Thorak, they ruled, should "again be recognized as 'not affected.'"[334] Therefore, in June 1951, Thorak had his position as a civil servant (*Beamter*) restored and qualified for a full pension of DM 10,500 per year.[335]

Despite the legal proceedings, Thorak had already resumed his career as an artist after 1945. He remained in the quiet town of Hartmannsberg near Rosenheim, but received commissions from further afield. Monks at a cloister in Linz, for example, commissioned him to execute statues for their grounds.[336] Indeed, most of his art in the postwar period dealt with religious themes. There is little doubt that Thorak would have enjoyed increased success with time had he not died in 1952 (at age sixty-three). In the summer of 1951, for example, he induced a Bundestag deputy to write on his behalf to the Bavarian Education Ministry and successfully plead his case for a revision of his pension.[337] Despite the opportunity to work and his victories in the denazification courts, Thorak's last years were characterized by bitterness and alienation. The right-wing *Deutsche Nationalzeitung*, which continued to celebrate his career and work, published one of his last letters: "I have little social contact—none whatsoever with colleagues. . . . I drink my bottle of wine alone. Now and then I head into Salzburg where I get the impression that the people are nicer. . . . It all seems over, cold and bitter, just like the art of this [postwar] time. It was a truthful statement when a man once said 'art is an expression of the events of the time'— and see, now we have it."[338] In addition to this nostalgia for the Third Reich, Thorak was deeply bitter that some of his bronze works from this period (including figures that had stood in front of the German pavilion at the 1937 World Exposition in Paris) had been confiscated by

the German state from his Hartmannsberg studio, smelted down, and turned into church bells.[339] Thorak's bitterness, however, was really more a reflection of how well he had once had it, for there was little reason for him to complain about his life after 1945. He had kept his home, had a family (three children), and was given the opportunity to work again.

Josef Thorak was not nearly as marginalized as he claimed. During the Salzburger Festspiele of 1950, Thorak was celebrated with an exhibition of fifty of his works, including the colossal *Grünewald-Pilgrim*, *Nursing Mother*, *Copernicus* and *Paracelsus*, among others. An official announcement stated that "[t]he exhibition is an expression of a debt of thanks to Salzburg's famous son, who made a gift to his hometown of [the statues of] *Paracelsus* and *Fischer von Erlach*."[340] The show was very well attended (4,000 visitors during the first three days as compared to 500 who visited an Egon Schiele exhibition in an entire month). The critical reception was quite positive, and few noted that many of these works had once been in the *Great German Art Exhibition* at the House of German Art.[341] And not long thereafter, his funeral was covered in both the German and Austrian press and attended by "numerous well known artists and personalities from public life."[342] Thorak was buried in a prominent place in the central cemetery of Salzburg (St. Peter's), where one can still visit his elaborate crypt, decorated with a large marble sculpture. It is little known that he purchased the crypt with express permission from Gauleiter Gustav Adolf Scheel in 1943.[343] But Thorak

The street in Salzburg honoring Josef Thorak,
1999 (photo by Mary Louise Ryback).

remains a source of pride for the Salzburgers: his large sculpture of Paracelsus from the Third Reich today stands in the garden of Schloss Mirabel and one of the affluent western suburbs features a prominent road called the Josef Thorak Strasse.[344]

As the cases of Thorak, Ziegler, and Breker reveal, it was very difficult to prove, at least in a judicial sense, that their artistic creations had bolstered the Nazi regime or contributed to the crimes of the period. The artists themselves agreed that their work expressed the times, but they denied responsibility for how the public responded to them. And because the issues raised are fundamentally unresolvable (who is to say if the monumental sculptures really enhanced support for Hitler or incited certain individuals to pursue a program of war and genocide?), the artists were by in large exonerated in postwar trials.[345] Prosecutors, of course, tried to show that these premier figures enriched themselves as a result of their collaboration. But this was not unique in the Third Reich: there were scores of industrialists and businessmen who had given their support to the regime in exchange for huge profits. Most of the artists who served the Nazi leaders sought a double standard. On the one hand, they thought of themselves as gifted and above the quotidian concerns of most compatriots. Yet after the war, they argued that they had behaved like everyone else and should not bear any special responsibility. German and Austrian laws worked in their favor, but the difficult question remains, what were the consequences of their Faustian bargain? The personal histories discussed in this book suggest that these consequences were serious indeed: propaganda was "the war that Hitler won"; it was used effectively to generate support for the regime and its policies; and the Nazi leaders relied on these experts, in a sense artistic technocrats, to implement their ideological aesthetic program.

Conclusion

As hostilities in Europe came to an end in the summer of 1945, Thomas Mann already understood the central and even criminal role played by many intellectuals during the Third Reich. He wrote to Joseph Pulitzer, "Should one make accountable only the visible political and military figures of the regime who are now assembled in the hotel-prisons? What about that thoroughly guilty stratum of intellectuals who stood and served National Socialism?"[1] This book has offered an examination of approximately twenty figures who, unlike Mann, worked with the Nazi leaders to implement a repressive and rapacious aesthetic program. Of course, there are many other figures who might have been included. One could have discussed, for example, of Baron Eberhard von Künsberg (1909–45), who was commissioned by the Foreign Ministry to lead plundering commandos in France and the northern section of the Eastern Front; or SS officer Pieter Menten; who stole artworks from vulnerable Poles; or a scholar like Franz Dölger, "an important Byzantinist" who headed the ERR Sonderkommando in Greece.[2] It must be underscored that there were many individuals who

carried out the National Socialists' artistic initiatives. The multiple branches of the ERR alone had over 350 employees.[3] In total, thousands participated in the greatest art plundering operation ever, and there were additional thousands in the Nazi art world who played supporting roles.

This study has dealt with a stratum that lay somewhere between the top leaders and the faceless bureaucrats. Buchner, Haberstock, Scholz, Mühlmann, Breker, and the others discussed here were accomplished and respected figures in powerful positions. They may subsequently have been largely forgotten, but they had considerable influence during the Third Reich and made important decisions. They also, as noted earlier, had direct contact with Hitler, Göring, Goebbels, Himmler, and other Nazi leaders. It is the relatively elevated and even distinguished position of these subjects that makes Timothy Garton Ash's query so relevant: after examining individuals who informed on him for the East German secret police, Garton Ash asked, "What is it that makes one person a Stauffenberg, another a Speer? Twenty years on, I am little closer to an answer. A clear values system or faith? Reason and experience? Sheer physical strength or weakness? Firm roots in family, community, nation? There is no simple rule, no single explanation."[4] The figures in this book had the capacity to become members of the resistance like Stauffenberg, but instead chose the route of collaboration, like the shrewd and self-interested architect-armaments minister. The reasons behind their career paths, as Garton Ash notes, defy easy explanation.

Scholars have suggested various motivations for intellectuals who supported the Nazi regime. Most recently, Daniel Goldhagen has advanced the idea of an "eliminationist anti-Semitism," or a deep-seated hatred of Jews shared by large segments of the German population, including the intelligentsia.[5] While the members of the Nazi art world discussed here were often anti-Semitic, this prejudice in itself cannot account for their behavior. It is an ingredient in the recipe for their motivation, but insufficient on its own. Joachim Fest added another element, writing, "The problems of the intellectual with a longing for contact with the idealistically misconstrued world of the primitive man of violence— the 'noble savage' returned in a barbaric modern guise—led thousands of members of the educated classes to take the way of National Socialism."[6] This notion has appeal because it denotes the violence inherent in the Nazis' plundering program (that is, the direct connection to the Holocaust) and because it conveys the arrogant mentality of a conqueror, which was indeed common among the Germans. However Fest's thesis, if taken literally, would apply to only a few in this study: primar-

ily the leaders of the plundering commandos, like Mühlmann. Most of the figures in this study were not out on the front lines assuming the role of the *Übermensch* run rampant. Yet they were not exactly *Schreib-tischtäter* (desk-bound perpetrators).[7] Rather, they represented a mixture of bureaucrat and conqueror. If one interprets Fest's formulation more loosely—that these individuals wanted to be *associated* with violence—then there is broader application: one could have contact with the world of the primitive man of violence by cataloging the loot in a warehouse or by creating a sculpture called *Swordbearer*.

It is not clear that the individuals in the Nazi art world had an entirely lucid picture of themselves during the twelve-year Reich, although all had a sense of what they were doing when they dispossessed people of their cultural property and helped glorify the regime through grandiose aesthetic projects. Subsequently, in the postwar period, this awareness became less straightforward. Primo Levi has observed,

> anyone who has sufficient experience of human affairs knows that the distinction . . . good faith/bad faith is optimistic and smacks of the Enlightenment, and is all the more so, and for much greater reason, when applied to men such as those such mentioned [perpetrators of the Holocaust]. It presupposes a mental clarity which few have and which even these few immediately lose when, for whatever reason, past or present reality arouses anxiety or discomfort in them. Under such conditions there are, it is true, those who lie consciously, coldly falsifying reality itself, but more numerous are those who weigh anchor, move off, momentarily or forever, from genuine memories, and fabricate for themselves a convenient reality. The past is a burden to them. . . . The silent transition from falsehood to self-deception is useful: anyone who lies in good faith is better off. He recites his part better, is more easily believed by the judge, the historian, the reader, his wife, and his children.[8]

The art experts who implemented the Nazis' policies often retouched the mental photos they had from the Third Reich. One of the reasons why it is so difficult to write this history, and more specifically, to ascertain their motives, is that they were not honest with themselves. They rarely admitted to wrongdoing or searched for the reasons underlying their own behavior. They rationalized their conduct by saying that they were "merely" art dealers or artists, or that in their heart of

hearts they were "opposed" to the Nazis' policies. Robert Scholz, to take one specific example, argued in his denazification trial that he had not been a plunderer. He had merely ameliorated an unacceptably chaotic situation by cataloging "ownerless" property that had been abandoned by Jews as they fled in panic.[9]

One of the more difficult issues to answer is whether those in the art world who implemented the official aesthetic program were subjected to extreme pressures by the Nazi leaders, or in other words, whether they were forced to plunder. This was a common claim. Conscription and the increasingly onerous demands made by the government were not insignificant considerations, and individuals sometimes assumed positions that they would not have taken if they had been completely free or independent. Even Kajetan Mühlmann maintained that he hated his assignment in Poland and asked for a transfer out of the General Government. But in his case, the request came when the plundering in Poland was virtually completed, the situation had grown increasingly unpleasant and tense because of the infighting between Nazi leaders (Frank, Göring, and Himmler), and because this was where much of the killing occurred. A request to move on and plunder elsewhere hardly seems a mitigating factor. There were also instances where the plunderers tried to resign and serve at the front. Robert Scholz and Bruno Lohse both asked out of the ERR at certain points. Others, such as their ERR colleague Walter Borchers, felt threatened by the Gestapo. There is no doubt that the work was unpleasant at times and that the operatives felt the pressures of a police state. Yet the subjects of this book also frequently found moments of enjoyment (the champagne flowed in Paris, even for the ERR staff), and they themselves still initiated certain looting actions. It is very difficult to view them as victims of coercion. Indeed, their claims that they had no alternatives but to plunder must be rejected in a manner similar to those of Holocaust perpetrators who said that they had no choice but to shoot or release Zyklon-B gas pellets.[10]

In addition to arguing that they were forced to carry out the Nazi leaders's policies, the complicit members of the Nazi art world offered a variety of additional claims after the war that were meant to be exculpatory. The first was that the Nazi leaders deceived them about the nature of their policies. In a version of the old compartmentalization argument, some in the art world maintained that they were small cogs in a large machine and did not grasp the implications of the entire operation. In a related claim, some reported that they discovered what was

transpiring too late and were unsuccessful when they tried to distance themselves from the regime. Others contended that they had attempted to act scrupulously, most commonly pointing to the safeguarding of cultural property for humanity. It was also not uncommon to find those who said that they exerted a moderating influence and counteracted radicals. They sometimes pointed to cases throughout history where individuals took positions of responsibility in order to mitigate the harshness of a government. In Germany, for example, Thomas Mann joined the theater censor board in Munich in 1911 because "he believed that he could fight for artistic freedom on the council."[11]

Despite the potential merits of the aforementioned arguments, one must recognize the special and unambiguous circumstances that prevailed during the Third Reich. While some may not have comprehended the scope of the depredation—after all, millions of objects were stolen or destroyed—it was indisputably clear that the National Socialists were oppressing those whom they declared their enemies and were contravening international law to acquire cultural objects.[12] It may be true that the figures who implemented the Nazi cultural program were not entirely without a conscience and that there were limits to resistance, but this does not mitigate their actions. Just because Hans Frank submitted his resignation as General Governor in Poland does not absolve him of responsibility for what transpired there.

As Primo Levi observed, it is much easier to create versions of the past in which one is a passive actor rather than own up to one's deeds. These fictions also help explain why these individuals felt so little remorse for their actions. Of course, this self-deception was not unique to the art world. In discussing managers at Daimler-Benz, Neil Gregor noted, "It is . . . indicative of the extent to which the Third Reich had eroded moral norms that the appalling suffering of the victims was not discussed."[13] Thomas Mann also remarked about his countrymen, "They have learned nothing, understood nothing, regret nothing."[14] This blindness and lack of compassion occurred both during and after the Third Reich, although the motivations usually changed. Whereas earlier there was the concern that the regime might pursue them, in the postwar era there was anxiety about judicial proceedings.

This study has confirmed prior findings about the failure of denazification. The breakdown of the judicial process began with the Allies, who, while doing an admirable job with the restitution of artworks and the investigations into the looting, did not seek justice for the vast majority of the perpetrators. It was the Allies who began the

"amnesties" of individuals in various categories as early as July 1946 and then subsequently failed to remain involved in the rebuilding of the German arts administration.[15] The Americans also engaged many of the Nazi art experts to help locate and identify works: Buchner, Haberstock, Scholz, Mühlmann, Hofer, Lohse, and many others were regularly brought to the Central Collecting Point in Munich in the late 1940s, and the appearance of cooperating with the Americans afforded them a veneer of respectability that facilitated the rehabilitation of their careers. Despite the Americans' softness with respect to denazification, more responsibility lies with the Germans. Even in 1949, Harry Sperber observed in *Congress Weekly* that "the American occupation forces turned these courts over to the Germans early in 1947. It took but a few months to show that Nazi after Nazi, big and small, got off scot-free or with a ridiculously low fine because these courts were impotent or dishonest."[16]

Subsequent studies have refined our understanding of why the courts were so lenient.[17] Most have stressed the West Germans' wish to move beyond their painful past in order to focus on rebuilding their country (the *Wirtschaftswunder*) and develop a new sense of collective self-worth (*"Wir sind wieder wer,"* or "we are again someone"). Some have noted Chancellor Konrad Adenauer and others were increasingly preoccupied with communism as a threat and therefore had greater faith in former Nazis than in Social Democrats or others on the Left.[18] In certain cases there was inadequate information: in Josef Thorak's denazification trial, for example, the judges did not even realize that he was a Party member. It was also significant that the denazification judges in the American zone in the south were not professional jurists.[19] These factors combined to create a highly imperfect system—what Lutz Niethammer and others have called the fellow-traveler factory (*Mitläuferfabrik*)—where those who implemented the policies of the regime were rarely saddled with full responsibility.[20] This, as Niethammer showed, was especially the case in conservative Bavaria, the heartland of the Nazi movement, and it is no coincidence that most of the figures in this study settled there after the war. Yet throughout Germany, these individuals were helped by the widespread devastation and dislocation, which created a pressing need for artistic experts. One finds an analogous situation with respect to architects, who were required to design buildings for the reconstruction of cities. One review of a book on German architects from 1900 to 1970 summed up the situation in its title, "We were all in the Party."[21]

The most notable quality of the members of the art world who collaborated with the Nazi regime was their instinct to survive. This goes a long way toward explaining how individuals who were intelligent, professional, and in certain cases, even progressive (such as Hans Posse, who was once a supporter of modernism) accommodated themselves to Hitler and his cohorts. In the postwar period, it was this intelligence, combined with elaborate social and business networks, as well as wealth acquired during an earlier epoch, that facilitated the rehabilitation of their careers. One finds a similar trend, albeit with different particulars, in Germany today with respect to those who flourished in the former East Germany. Tomas Venclova noted in a review of Timothy Garton Ash's *The File*, "Incidentally, many of [the Stasi officials who oversaw the informers] have already found their niche in neocapitalist society." This, he noted, was in contrast to the many dissidents who have continued to struggle.[22]

The majority of the elite in the art world during the Third Reich revived their careers after the war. Perhaps more strikingly, they kept in touch with one another and maintained an informal network that afforded both security from investigators and profits from the sale of artworks. There were also a number who emigrated and enjoyed success outside Europe: the restorer Eduard Kneisel, who had worked with the Mühlmann brothers in Poland, moved to the United States and reportedly continued his craft at the Frick Collection in New York; while the dealer Alois Miedl, who had sold a tremendous quantity of art to Göring, is reported to have plied his trade in Australia and South Africa, among other countries. Yet the majority of the elite in the Nazi art world remained in Germany and continued their activities as before. Some, like Haberstock, Mühlmann, Walter Andreas Hofer, Eduard Plietzsch, Bruno Lohse, and Maria Almas Dietrich, concentrated on commercial activities. Whether all of the art they sold had clear and legitimate provenance is highly doubtful. Marc Masurovsky, an expert on Nazi art plundering who has worked for the Holocaust Art Restitution Project, believes that certain individuals "used what they stole as their pension."[23] He talks of a parallel market that existed completely out of private view, where plundered works changed hands among those who were trusted. The works would remain in homes, or quite commonly, be smuggled to Switzerland where they were laundered (Swiss laws facilitate this by granting legal title to a work regardless of provenance or previous ownership five years after the theft).[24]

Obtaining evidence of this parallel market is, of course, very difficult.

But one finds many clues. The so-called Krinner case, for example, where approximately three dozen paintings were stolen in 1947 from the Central Collecting Point in Munich by a German guard and then recovered by American investigators, offers one series of clues. It was discovered that these works changed hands numerous times immediately after the theft; that a number were sold to "respectable" individuals; and that there was also a concerted effort to transport works over the border to Switzerland.[25] Appropriately, most of the works were of the Austro-Bavarian school favored by the Nazi elite (Spitzweg, Leibl, Grützner). The clandestine art world of former Nazi dealers is a kind of puzzle: one can locate pieces—and even the general outline is visible—but many blank spots remain. The larger picture, however, is clear beyond a doubt. The elite of the Nazi art world rehabilitated their careers after 1945, and they maintained contact with one another in a manner that protected their own interests and impeded the restitution of looted artworks.

In a sense, this situation leads back to the issues of guilt and justice. This book has stressed the ethical implications of the art experts' behavior. Granted, this is but one possible approach, but morality lies at the center of this history.[26] It is also inextricably linked with the concept of a Faustian bargain, as Doctor Faustus struggled to reconcile ambition with ethics. Just after the war, philosopher Karl Jaspers, like many German intellectuals, thought carefully about the issue of ethical transgressions, and he constructed four categories of (decreasing) culpability: criminal, political, metaphysical, and moral.[27] These categories entail complex ideas and cover a spectrum ranging from the contravention of national and international law (criminal guilt) to the failure to oppose the regime (moral guilt). What is most striking about Jasper's structural analysis of ethical responsibility as it relates to the art experts of the Third Reich is that these figures came up short in all four categories. The art experts were not merely devoid of courage or integrity; in most cases they were responsible for criminal actions. While certain officials in the immediate postwar period recognized this—the Americans who investigated art looting recommended that most of the figures in this book be tried for war crimes—there was insufficient resolve to take action.[28] The art experts of the Third Reich largely avoided punishment while they were alive; it is therefore imperative that they not be exonerated by history.

Notes

Introduction

1 Lynn Nicholas, *The Rape of Europa: The Fate of Europe's Treasures in the Third Reich and the Second World War* (New York: Alfred Knopf, 1994), 68–69.

2 Mühlmann interview by Charles Estreicher and Bernard Taper, 20 August 1947. Protocol provided to the author by Bernard Taper.

3 Bayerisches Hauptstaatsarchiv (BHSA), MK 44778, Buchner's recollection, "Bergung des Genter Altars der Gebrüder van Eyck," 15 June 1945. See also Theodore Rousseau, *Detailed Interrogation Report (DIR) No. 2: Ernst Buchner* (Washington, DC: Office of Strategic Services [OSS], Art Looting Investigation Report [ALIU], 31 July 1945), 3.

4 For portrayals of the art world that reflect the qualities noted above, see Frank McDonald's novel, *Provenance* (New York: Atlantic Monthly Press, 1979), 124. See also Peter Watson, *The Caravaggio Conspiracy* (New York: Doubleday, 1984); Peter Watson, *Sotheby's: The Inside Story* (New York: Random House, 1997); and Robert Lacey, *Sotheby's: Bidding for Class* (Boston: Little Brown, 1998).

5 George Steiner writes of the pervasive view prior to World War I that "education would ensure a steadily rising quality of life. Where culture flourished, barbarism was, by definition, a nightmare from the past." George Steiner, *In Bluebeard's Castle: Some Notes Towards the Redefinition of Culture* (New Haven: Yale University Press, 1971), 30, 76.

6 See Sterling Callisen to Whitney Shepardson, Chief, Special Intelligence Branch, OSS, 19 February 1945. Documents provided to the author by the family of OSS officer Sterling Callisen.

7 Fritz Ringer, *Decline of the German Mandarins: The German Academic Community, 1890–1933* (Cambridge, MA: Harvard University Press, 1969); Max Weinreich, *Hitler's Professors: The Part of Scholarship in Germany's Crimes against the Jewish People* (New York: Yiddish Scientific Institute (YIVO), 1946); Alice Gallin, *Midwives to Nazism: University Professors in Weimar Germany* (Macon, GA: Mercer, 1986); and more specifically, James Dow and Hannjost Lixfeld, eds., *The Nazification of an Academic Discipline: Folklore in the Third Reich* (Bloomington: Indiana University Press, 1994). In a related case, some scholars have noted that Albert Speer was perhaps saved from the gallows at Nuremberg because of his persona as an artist/intellectual. See the discussion in Paul Jaskot, *Oppressive Architecture: The Interest of the SS in the Monumental Building Economy* (New York: Routledge, 1999).

8 Timothy Garton Ash, *The File: A Personal History* (New York: Random House, 1997), 88.

9 Michael Kater, *The Twisted Muse: Musicians and Their Music in the Third Reich* (New York: Oxford University Press, 1997). See, for example, Vernon Lidtke's review in *American Historical Review* 103 (June 1998): 921–22.

10 Anja Heuss, "Der Kunstraub der Nationalsozialisten: Eine Typologie," *Kritische Berichte* 23 2 (1995): 32–43. Heuss posits three types of art looter: the passionate lover of art (*Liebhaber*), the scholar, and the historian. I am not convinced that the subjects of this book fit neatly into any of these categories.

11 Garton Ash, *The File*, 252.

12 Michael Hirsh, "Secret Bankers for the Nazis," *Newsweek* (24 June 1996), 50–51.

13 Among the key treatments of Faust, who was a sixteenth-century magician and researcher, are Christopher Marlowe's play of 1593, Johann Wolfgang von Goethe's treatments in 1808 and 1832, and Gounod's 1859 opera. See William Grim, *The Faust Legend in Music and Literature*, 2 vols. (Lewiston, NY: Edwin Mellen, 1997). Perhaps more relevant here is Klaus Mann's use of the metaphor in his roman à clef about Gustaf Gründgens, *Mephisto* (New York: Penguin, 1977).

14 Arcadai Nebolsine, "A Key to Arno Breker's Art" (Internet: www.meaus.com/articles/key.html).

15 Dan van der Vat, *The Good Nazi: The Life and Times of Albert Speer* (London: Weidenfeld & Nicolson, 1997), 53.

16 Robert Herzstein, *The War That Hitler Won: The Most Infamous Propaganda Campaign in History* (New York: Putnam, 1978).

17 Lynn Nicholas noted that the U.S. operatives who managed the collecting points in the western parts of Germany had "processed several million 'items'" prior to 1951. Lynn Nicholas, "World War II and the Displacement of Art and Cultural Property," in Elizabeth Simpson, ed., *The Spoils of War: World War II and Its Aftermath: the Loss, Reappearance, and Recovery of Cultural Property* (New York: Harry Abrams, 1997), 43.

18 Examples of histories of the above-noted professions: Michael Kater, *Doctors Under Hitler* (Chapel Hill: University of North Carolina Press, 1989); Robert Jay Lifton, *The Nazi Doctors: Medical Killing and the Psychology of Genocide* (New York: Basic Books, 1986); Götz Aly, Peter Chroust, and Christian Pross, *Cleansing the Fatherland: Nazi Medicine and Racial Hygiene* (Baltimore: Johns Hopkins University Press, 1994); Robert Proctor, *Racial Hygiene: Medicine Under the Nazis* (Cambridge, MA: Harvard University Press, 1988); Ingo Müller, *Hitler's Justice: The Courts of the Third Reich* (Cambridge, MA: Harvard University Press, 1991); Geoffrey Herf, *Reactionary Modernism: Technology, Culture and Politics in Weimar and the Third Reich* (Cambridge, MA: Harvard University Press, 1984); Kristie Macrakis, *Surviving the Swastika: Scientific Research in Nazi Germany* (New York: Oxford University Press, 1993); Ute Deichmann, *Biologists Under Hitler* (Cambridge, MA: Harvard University Press, 1996); Pamela Potter, *Most German of the Arts: Musicology and Society from the Weimar Republic to the End of Hitler's Reich* (New Haven: Yale University Press, 1998); and more generally, Konrad Jarausch, ed., *The Unfree Professions: German Lawyers, Teachers, and Engineers, 1900–1950* (New York: Oxford University Press, 1990).

19 Deborah Dwork and Robert Jan van Pelt, *Auschwitz, 1270 to the Present* (New Haven: Yale University Press, 1996). Götz Aly and Suzanne Heim, *Vordenker der Vernichtung: Auschwitz und die deutsche Pläne für eine neue europäische Ordnung* (Hamburg: Hofmann und Campe, 1991). See also Michael Neufeld, *The Rocket and the*

Reich: Peenemünde and the Coming of the Ballistic Missile Era (New York: Free Press, 1995). To these studies about the collaboration of technocrats, one could add recent works dealing with business and industry. Neil Gregor, *Daimler-Benz in the Third Reich* (New Haven: Yale University Press, 1998); and Hans Mommsen, *Das Volkswagenwerk und seine Arbeiter im Dritten Reich* (Düsseldorf: ECON, 1996).

20 Among the numerous studies on Heidegger, see Hans Sluga, *Heidegger's Crisis: Philosophy and Politics in Nazi Germany* (Cambridge, MA: Harvard University Press, 1993).

21 While there were a wide range of artistic styles under fascist regimes, especially in Italy, it is not inaccurate to associate this art with muscular figures in aggressive poses. See, for example, Klaus Wolbert, *Die Nackten und die Toten des "dritten Reiches"* (Giessen: Anabas-Verlag, 1982).

22 For a more topically related example of prosapographical scholarship, see Isabel Hull, *The Entourage of Kaiser Wilhelm II, 1888–1918* (Cambridge: Cambridge University Press, 1982). There is a sizeable literature on prosapography and biography. For example, see Susan Groag Bell and Marilyn Yalom, *Revealing Lives: Autobiography, Biography, and Gender* (Albany: SUNY Press, 1990).

23 McDonald, *Provenance*, 402.

24 See Kater, *Doctors Under Hitler*, 222–40; Müller, *Hitler's Justice*, 201–300; Kater, *Twisted Muse*.

25 Christopher Simpson, *Blowback: America's Recruitment of Nazis and Its Effects on the Cold War* (New York: Weidenfeld & Nicolson, 1988); Tom Bower, *The Paperclip Conspiracy* (London: Michael Joseph, 1987); and Linda Hunt, *Secret Agenda: The United States Government, Nazi Scientists, and Project Paperclip, 1945 to 1990* (New York: St. Martin's Press, 1991).

26 Frank Whitford, "The Reich and Wrong of Twentieth Century Art,"

Sunday Times (8 October 1995), 8–9. There are a number of other treatments of the problematic behavior of modernist figures in the Third Reich. See, for example, Elaine Hochman, *Architects of Fortune: Mies van der Rohe and the Third Reich* (New York: Weidenfeld & Nicolson, 1989).

Chapter One

1 Nikolaus Pevsner, *Academies of Art, Past and Present* (New York: Penguin, 1973). One also sees this with respect to Jakob Heinrich von Hefner-Alteneck, who helped establish the Bavarian Nationalmuseum. See Cornelia Andrea Harrer, *Das ältere Bayerische Nationalmuseum an der Maximilianstrasse in München* (Munich: dtv, 1993), 49–56. See also Ludwig Pallat, *Richard Schöne, Generaldirektor der königlichen Museen zu Berlin: Ein Beitrag zur Geschichte der preussischen Kunstverwaltung, 1872–1905* (Berlin: W. de Gruyter, 1959); and Manfred Ohlsen, *Wilhelm von Bode: Zwischen Kaisermacht und Kunsttempel* (Berlin: Gebrüder Mann, 1995).

2 Peter Paret, *The Berlin Secession: Modernism and Its Enemies in Imperial Germany* (Cambridge, MA: Harvard University Press, 1980); Christopher With, *The Prussian Landeskunstkommission, 1862–1911: A Study in State Subvention of the Arts* (Berlin: Gebrüder Mann, 1986); Robin Lenman, *Die Kunst, die Macht und das Geld: zur Kulturgeschichte des kaiserlichen Deutschland, 1871–1918* (Frankfurt: Campus, 1994).

3 Kater, *Doctors Under Hitler*, 56–57.

4 Geheimes Staatsarchiv Preussischer Kulturbesitz (GSAPK), I HA 92 Rave Mappe I/4, Paul Rave, "Kriegschronik der Berliner Museen," May 1946.

5 Jackson Spielvogel, *Hitler and Nazi Germany: A History*, 3d ed. (Upper Saddle River, NJ: Prentice Hall, 1996), 73.

6 BHSA, MK 44814 (file of Professor Friedrich Wagner), Dr. Georg Lill, Direktor der Bayerischen Lan-

desamtes für Denkmalpflege, to
Meyer, 26 May 1948.

7 Norbert Frei, *Vergangenheitspolitik: Die
Anfänge der Bundesrepublik und die
NS-Vergangenheit* (Munich: C. H.
Beck, 1996), 13, 20.

8 In Berlin, for example, Generaldirek-
tor Otto Kümmel and eight other
employees were released after the
war. GSAPK, I HA 92 Rave Mappe
I/4, Paul Rave, "Kriegschronik der
Berliner Museen," May 1946.

9 Brigitte Reinhardt, ed., *Kunst und Kul-
tur in Ulm, 1933–1945* (Ulm: Ulmer
Museum, 1993), 48–50.

10 Ibid., 48.

11 Ibid., 20, 48. See also Reinhard
Merker, *Die bildenden Künste im
Nationalsozialismus: Kulturideologie,
Kulturpolitik, Kulturproduktion*
(Cologne: DuMont, 1983), 50, 123.
Also Paul Ortwin Rave, *Kunstdiktatur
im Dritten Reich* (Hamburg: Gebrüder
Mann, 1949), 14. Joseph Wulf, *Die
bildenden Kunst im Dritten Reich: Eine
Dokumentation* (Frankfurt: Ullstein,
1963), 85, 445. Annegret Heffen, *Der
Reichskunstwart: Kunstpolitik in den
Jahren 1920–1933* (Essen: Blaue Eule,
1986). Note, too, that there were a
number of directors of art academies
who also lost their positions. These
included Walter Kaesbach in Düssel-
dorf and Fritz Wichert in Frankfurt.
See Getty Center, Arntz Papers, Box
26, "Personalveränderungen in
deutschen Museen," (1933).

12 See the example concerning Julius
Baum in Reinhardt, ed., *Kunst und
Kultur in Ulm*, 22, 48, 65.

13 For a discussion of overseas opportu-
nities, see Vivian Endicott Barnett,
"Banned German Art: Reception and
Institutional Support of Modern Ger-
man Art in the United States,
1933–1945," in Stephanie Barron, ed.,
*Exiles and Emigrés: The Flight of Euro-
pean Artists from Hitler* (New York:
Abrams, 1997), 273–84. See also Jar-
rel Jackman and Carla Borden, eds.,
*The Muses Flee Hitler: Cultural Trans-
fer and Adaptation, 1930–1945*

(Washington, DC: Smithsonian Insti-
tution Press, 1983). In terms of Ger-
man art abroad, note, for example,
that Harvard University had no spe-
cialist in German art in the 1920s and
chose to import two professors from
Germany in 1927–28 to make use of
the collection in the Germanic
Museum (now the Busch-Reisinger
Museum). See Peter Nisbet and Emi-
lie Norris, *The Busch-Reisinger
Museum: History and Holdings* (Cam-
bridge, MA: Harvard University Art
Museums, 1991), 11.

14 National Archives, Washington,
DC/College Park (NA), RG
331/130.05, SHAEF report on figures
in the German art world.

15 Peter Gay, *Art and Act: On Causes in
History—Manet, Gropius, Mondrian*
(New York: Harper & Row, 1976),
159. For more on Munich as the cen-
ter of the German art world, see
Kirsten Schrick, *München als Kunst-
stadt* (Vienna: Holzhausens, 1994);
Maria Makela, *The Munich Secession:
Art and Artists in Turn-of-the-Century
Munich* (Princeton: Princeton Univer-
sity Press, 1990); and David Clay
Large, *Where Ghosts Walked: Munich's
Road to the Third Reich* (New York: W.
W. Norton, 1997). Also Robin Len-
man, "A Community in Transition:
Painters in Munich, 1886–1914," *Cen-
tral European History* 15 (1982): 3–33;
and Lenman, "Politics and Culture:
The State and the Avant-Garde in
Munich, 1886–1914," in Richard
Evans, ed., *Society and Politics in Wil-
helmine Germany* (London: Croon
Helm, 1978), 90–111.

16 BHSA, SLG 4628 (Sammlung F. J.
Rehse), Dr. Wilhelm Hausenstein,
"Ernst Buchner," *Süddeutsche Sonntag
Post* (26 February 1933). See also the
entry for Georg Buchner in Günter
Meissner et al., eds., *Sauer Allgemeines
Künstler-Lexikon* (Munich: K. G.
Sauer, 1996), 683.

17 Munzinger Archiv, 7 July 1957 entry;
BHSA, SLG 4628 (Sammlung F. J.
Rehse), "Des Menschen Streben ist

sein Schicksal," *Münchener Merkur* 73 (26 March 1953).

18 BHSA, SLG 4628 (Sammlung F. J. Rehse), Dr. Wilhelm Hausenstein, "Ernst Buchner," *Süddeutsche Sonntag Post* (26 February 1933).

19 To take examples from figures mentioned above, Tschudi's maternal grandfather was a painter; and Justi's uncle was the art historian Carl Justi (1832–1912). For more on the cultural milieu of Imperial Germany, see Lenman, *Die Kunst.*

20 Thomas Mann, *Reflections of a Nonpolitical Man* (New York: Frederick Ungar, 1983), 99. For the broader context, see Wolfgang Mommsen's chapter "Die geistige Mobilmachung der akademischen Eliten," in *Bürgerliche Kultur und Künstlerische Avantgarde, 1870–1918* (Berlin: Propyläen, 1994).

21 Rousseau, *DIR No. 2*, 10.

22 Bundesarchiv (BA), R21 Anhang/10002: biography of Ernst Buchner.

23 Neil Gregor, "Business of Barbarity," *Financial Times* (7–8 March 1998), IIa.

24 BHSA, MK 44778, Buchner, "In eigener Sache," 15 June 1945.

25 Michael Podro, *The Critical Historians of Art* (New Haven: Yale University Press, 1982), 98. Note that Wölfflin had a remarkable array of students, including modernist (and Jewish) sculptor Otto Freundlich.

26 Justin Harald, *"Tanz mir den Hitler": Kunstgeschichte und (faschistische) Herrschaft* (Münster: SZD-Verlag, 1982), 18.

27 Ibid., 45. Harald quotes Wölfflin's use of such language in *Kunstgeschichtliche Grundbegriffen* (1929).

28 BA, R21 Anhang/10002: biography of Ernst Buchner. The German title is "Jan Polack der Stadtmaler von München."

29 BHSA, MK 44791, file of Ernst Holzinger; and BHSA, SLG 4628 (Sammlung F. J. Rehse), Dr. Wilhelm Hausenstein, "Ernst Buchner," *Süddeutsche Sonntag Post* (26 February 1933).

30 BHSA, MK 41275, Dörnhöffer to the Bayerisches Staatsministerium für Unterricht und Kultus (BSUK), 9 July 1926.

31 BHSA, MK 44778, Dr. Georg Lill to Dr. Walter Keim (BSUK), 6 September 1948.

32 BA, R21 Anhang/10002: biography of Ernst Buchner.

33 The German titles are *Das deutsche Bildnis der Spätgotik und der frühen Dürerzeit; Historien- und Schlachtenbilder der deutschen Renaissance;* and *Zum Werke Hans Holbeins des Älteren* and *Martin Schongauer als Maler.* Other works by Buchner include *Die Werke Fr. Herlins; Studium zur mittelrheinischen Malerei und Graphik der Spätgotik und Renaissance; Der junge Schäufelein als Maler und Zeichner; Die Augsburger Tafelmalerei der Spätgotik; Jörg Breu; Leonhard Beck; Urban Görtschacher;* and *Das Bildnis des Grafen Rieneck von Mattius Grünewald.*

34 BHSA, MK 50859, Buchner to Hendschel, 21 July 1932. For more on the process of making appointments to cultural institutions in this milieu, see Ursula Haass, "Die Kulturpolitik des Bayerischen Landtags in der Zeit der Weimarer Republik, 1918–1933" (Ph.D. diss., Ludwig-Maximilian-Universität, [Munich] 1967).

35 BHSA, SLG 4628 (Sammlung F. J. Rehse), "Dörnhöffers Nachfolger: Dr. Ernst Buchner," *Münchener Neueste Nachrichten,* (30 July 1932). For the correspondence concerning Buchner's interview for the post, see BHSA, MK 50859.

36 A 1990 publication listed 34 museums as branches of the State Museums in Bavaria, with seven in preparation and eight more in the planning stages. Edgar Baumgartl, *Zweigmuseen der Staatlichen Museen in Bayern* (Munich: Staatliche Museen und Sammlungen in Bayern, 1990).

37 "Das bayerische Stiefkind," *Süddeutsche Zeitung* 24 (30 January 1953) 3. Susanne Carwin, "Unter der Sonne

des Artikels 131," *Frankfurter Hefte* 11 (November 1956), 791.

38 BHSA, MK 50859 and MK 44791.

39 Spielvogel, *Hitler and Nazi Germany*, 75. This one million compares to the 850,000 who were Party members in January 1933. Richard Grunberger, *The 12–Year Reich: A Social History of Nazi Germany* (New York: Holt, Rinehart & Winston, 1979), 56.

40 As a comparison, although not perfect because of their different ranks, one can point to Franz Xaver Durneder, a restorer. In a postwar evaluation of Durneder's career, Eberhard Hanfstaengl, in a 12 January 1948 letter, notes the decision Durneder made not to join the NSDAP and how this cost him 6 percent of his wages because with Party membership he would have been placed in a higher category. See BHSA, MK 44780.

41 "Eine jüdischer Kunstparasit in Schutzhaft," *Völkischer Beobachter (VB)* 87 (28 March 1933). See also BHSA, MK 44778, Buchner, "In eigener Sache," 15 June 1945; and BHSA, MK 50859, BSUK memorandum, 27 February 1953.

42 BHSA, MK 44779, Buchner to BSUK, 20 August 1948.

43 Berlin Document Center (BDC), Buchner file, Partei Gesamturteil der Ortsgruppe München, 20 March 1940.

44 Ibid.

45 Martin Broszat, "Der Zweite Weltkrieg: Ein Krieg der 'alten' Eliten, der Nationalsozialisten oder der Krieg Hitlers?" in Martin Broszat and Klaus Schwabe, eds., *Die deutschen Elite und der Weg in den Zweiten Weltkrieg* (Munich: C. H. Beck, 1989), 25–27.

46 BDC, Buchner file, Partei Gesamturteil der Ortsgruppe München, 20 March 1940. Note that Buchner married Hildegard Torchlin in 1922 but was divorced in 1931.

47 BHSA, MK 41275, Buchner to BSUK, 9 October 1934. See similar language in the same file in Buchner's recommendation concerning Dr. Ernst

Holzinger, 12 April 1933.

48 BHSA, MK 44780, F. X. Durneder file, Buchner report of 31 March 1948.

49 BHSA, MK 44778, "Ein jüdischer Kunstparasit in Schutzhaft," in *VB* 87 (28 March 1933). See also ibid., Buchner, "In eigener Sache," 15 June 1945.

50 Klaus Schumann, "Beim dritten Schlag zersprang der Hammer," *Süddeutsche Zeitung* 238 (15/16 October 1983), 18.

51 BHSA, MK 44778, Buchner, "In eigener Sache," 15 June 1945.

52 In 1938, Buchner also oversaw the complete renovation of the Neue Pinakothek, and in the process, reordered the collection, as well as those in the Neue Staatsgalerie and the Alte Pinakothek. BHSA, MK 41274, Buchner to BSUK, 19 December 1938.

53 Bayerische Staatsgemäldesammlungen (BSGS), file 1755, Feuchtmayr to NS-Kulturgemeinde Gaudienststelle Oberbayern, 24 September 1935, and ibid., file 1760, Reichsführer-SS (staff) to Direktion of the Alte Pinakothek, 21 May 1937.

54 BSGS, file 1755, Scholz to Direktion BSGS, 11 August 1935.

55 Ibid., Buchner to BSUK, 15 May 1935.

56 BDC, Buchner file, Partei Gesamturteil der Ortsgruppe München, 20 March 1940.

57 BHSA, MK 44778, Buchner, "In eigener Sache," 15 June 1945.

58 Ibid.

59 Earlier, Buchner organized the show *The Beginning of Munich Panel Painting*, which was held in 1935.

60 BHSA, SLG 4628 (Sammlung F. J. Rehse), Hans Fitz, "Brief an den 60 jährigen Freund," *Münchener Merkur* (21 March 1952). Also BHSA, MK 44778, Buchner, "In eigener Sache," 15 June 1945; and ibid., Buchner to BSUK, 20 August 1948.

61 BHSA, MK 44778, Buchner to BSUK, 20 August 1948.

62 Martin Schawe, "Vor 50 Jahre—Die

Bayerischen Staatsgemäldesammlungen im Zweiten Weltkrieg," *Bayerische Staatsgemäldesammlungen Jahresbericht* (Munich, BSGS 1994), 14.

63 BHSA, MK 41271, Buchner to BSUK, 23 November 1935, and Buchner to Rust, 18 December 1935.

64 Jonathan Petropoulos, *Art as Politics in the Third Reich* (Chapel Hill: University of North Carolina Press, 1996), 27, 55–62.

65 BHSA, MK 40849, Buchner's report on the *Entartete Kunst* program, 16 July 1937. See also Buchner's letter protesting the visit of the Ziegler commission to the Alte Pinakothek on 25 August in ibid., Buchner to BSUK, 1 September 1937.

66 Rousseau, *DIR No. 2*, 10.

67 BHSA, MK 40840, BSUK to Reichsfinanzministerium (RFM), 2 September 1937. The letter includes a list of the 108 confiscated works but notes that the works should not yet be sent on to Berlin. BHSA, MK 40840, Rust to BSUK, 19 December 1939 notes the compensation paid for the seized works. BHSA, MK 50862, Rust to BSUK, 29 November 1941, notes that in addition to the RM 100,00 already paid, the BSGS also received Johann Weidner, *Portrait of the Sister of the Painter Waldmüller*, and Wilhelm Busch, *The Romance Novel*.

68 Günter Haase, *Kunstraub und Kunstschutz: Eine Dokumentation* (Hildesheim: Georg Olms Verlag, 1991), 57. For the defense of Munch, see BHSA, MK 40849, Buchner to Staatsministerium der Finanzen, 1 September 1937. For his attitude toward the art of political émigrés, see BHSA, MK 41271, Staatsministerium des Innern to BSUK, 16 December 1933. In 1935, the director of the Nationalgalerie, Eberhard Hanfstaengl, was instructed to select "historically valuable works" from the Littmann collection: he saved five paintings and ten drawings, but the rest were burned. Anja Heuss, "Das Schicksal der jüdischen Kunstsammlung von Ismar Littmann," *Neue Züricher Zeitung* 188 (17 August 1998), 23.

69 BSGS, file 1755, Buchner to Nolde, 9 May 1935. BHSA, MK 40849, Buchner to Lösche, 20 August 1937.

70 One indication of Buchner's views about modern art is his acceptance of an invitation to serve on the honor committee for a Van Gogh retrospective in Paris. See BSGS, file 1760, Buchner to John Rewald, 3 June 1937.

71 BHSA, MK 41271, Buchner to Fischer in BSUK, 23 December 1933.

72 See Avraham Barkai, *From Boycott to Annihilation: The Economic Struggle of German Jews, 1933–1943* (Hanover, N.H.: University of New England Press, 1989).

73 S. Lane Faison, *Supplement to Consolidated Interrogation Report (CIR) No. 4; Linz: Hitler's Museum and Library* (Washington, DC: OSS, ALIU, 15 December 1945), Attachment 33, Posse to Bormann of 26 November 1940.

74 BHSA, MK 41230, Buchner to BSUK, 10 September 1940.

75 Rousseau, *DIR No. 2*, 4.

76 Ibid., 4–5, and Attachment D (which lists the works). See also NA, RG 260/482, "Auszug aus dem Verzeichnis der Erwerbungen der BSGS ab 1939."

77 BHSA, MK 51498, Bayerisches Nationalmuseum to BSUK, 16 August 1948.

78 Ibid.

79 BHSA, MK 50862, Giesler to the Oberfinanzpräsident of Munich, 22 May 1943.

80 Ibid., Buchner to BSUK, 28 April 1944.

81 Ibid., Buchner to Wagner, 3 March 1942.

82 BHSA, MK 44778, Buchner, "In eigener Sache," 15 June 1945.

83 Ibid., "Anmeldung," 28 January 1948.

84 Ibid., Statement of Otto Marx, 13 September 1945.

85 Rousseau, *DIR No. 2*, 5.

86 BHSA, MK 44778, for Buchner's account, "Erwerbungstätigkeit (1933–1945);" and BHSA, MK 40849, "Verzeichnis durch die Direktion der BSGS seit November 1918 aus etatmässigen Mitteln erworbenen Gemälde und Plastiken neuer Meister." This trend is also reflected in the files on Buchner's acquisitions, BHSA, MK 41272, MK 41229, and MK 41230. For the number of works in the BSGS collections see "Der Retter der alten Pinakothek im Ruhestand," *Würtmal-Bote* (Munich-Pasing) (3 October 1957); and *Frankfurter Zeitung* 407/8 (12 August 1938), 9.

87 Hector Feliciano, *The Lost Museum: The Nazi Conspiracy to Steal the World's Greatest Works of Art* (New York: Basic Books, 1997), 129–30. He cites the Schenker Papers, which show that five museums in western Germany spent at least 31 million francs to acquire 204 paintings. For other directors exploiting opportunities to expand their collections, see Bettina Bouresch, "'Sammeln sie also Kräftig!' 'Kunstrückführung' ins Reich—im Auftrag der Rheinischen Provinzialverwaltung 1940–1945," in Bazon Brock and Achim Preiss, eds., *Kunst auf Befehl?* (Munich: Klinkhardt & Biermann, 1990), 41–58.

88 NA, RG 260/482, "Auszug aus dem Verzeichnis der Erwerbungen der BSGS ab 1939." See also S. Lane Faison, *CIR No. 4*, 53; and Rousseau, *DIR No. 2*, 6–9.

89 BSGS, file 220, Haberstock to Buchner, 8 December 1942.

90 BHSA, MK 50862, Buchner to BSUK, 21 April 1943. See also BSGS, file 200, Buchner to Haberstock, 8 February 1943. For the dealer giving the *Monatsschrift der Akademie der Künste* from 1788 to the BSGS, see ibid., Feuchtmayr to Haberstock, 2 July 1943.

91 BHSA, MK 40849, Buchner to BSUK, 10 January 1940.

92 The 10 December 1938 from the Reich and Prussian Economic Ministry is noted in BHSA, MK 41230, Buchner to BSUK, 29 December 1938.

93 BHSA, MK 50862, Buchner to BSUK, 20 January 1942.

94 Ibid., BSUK to Buchner, 23 April 1942.

95 Ibid., Buchner to BSUK, 22 January 1942. BHSA, MK 40849, Buchner to BSUK, 17 February 1942.

96 BHSA, Buchner to BSUK, 22 January 1943; ibid., BSUK to RFM, 11 February 1943; Krosigk to Bayerischer Staatsministerium der Finanzen (BSMF), 28 April 1943; and ibid., Schwerin von Krosigk (im Auftrag Augustin) to BSMF, 26 June 1944.

97 BHSA, MK 50862, BSUK to the Reichsfinanzministerium, 11 February 1943. For more on the "Hitler cities," see Jost Dülffer, Jochen Thies, and Josef Henke, *Hitlers Städte: Baupolitik im Dritten Reich* (Cologne: Böhlau Verlag, 1978).

98 BHSA, MK 44778, Buchner report on acquisition of the *"Kleriker-Bildnis"* by Grünewald, n.d. He notes the paucity of *Devisen* and the high price of the picture (approximately RM 850,000).

99 Ibid., report of BSUK to Bayerischer Ministerpräsident, 5 March 1953. The same file contains Buchner's accounts of "acquisition activities" 1933–45.

100 The link between Buchner and Hitler in this respect is supported by archival documentation where their agreement in aesthetic matters is noted. See, for example, BHSA, MK 41272, Buchner to BSUK, 15 August 1938.

101 BHSA, MK 44778, report of BSUK to Bayerischer Ministerpräsident, 5 March 1953, list titled "Im Tausch abgegebene Staatsgemälde." This document details 112 works deaccessioned by trade and 29 by sale, but does not appear to be complete. Another document, for example, lists 12 works that were deaccessioned, and they do not appear on the 5 March 1953 report. See BHSA, MK 40849, BSUK to Direktion BSGS, 6

March 1940. See also Carwin, "Unter der Sonne," 790.

102 BHSA, MK 41272, Fischer in BSUK to Buchner, 9 January 1940.

103 Rousseau, *DIR No. 2*, 6; BHSA, MK 50859, BSUK memorandum, 27 February 1953. For the number of works he deaccessioned, see "Um den staatlichen Galeriedirektor," *Süddeutsche Zeitung* 64 (18 March 1953). See also Buchner's accounts of these trades in BHSA, MK 44778.

104 BHSA, MK 50859, BSUK memorandum, 27 February 1953.

105 BHSA, MK 44778, Hans von Rauscher auf Weeg to BSUK, 2 March 1953. For the seventy-four Dutch works that were deaccessioned, see BHSA, MK 44778, report of BSUK to Bayerischer Ministerpräsident, 5 March 1953.

106 BHSA, MK 50862, Buchner to BSUK, 20 January 1942, and ibid., BSUK to Buchner, 9 February 1942.

107 These eighteen works went to the Führermuseum in 1940 and 1941. Faison, *CIR No.4*, 56; Faison, *Supplement to CIR No. 4*, Attachment 76.

108 BSGS, file 304, Buchner to the Howard Young Gallery, 12 July 1939; ibid., file 200, Haberstock to Buchner, 17 November 1942; and ibid., Buchner to Haberstock, 6 December 1942.

109 BSGS, file 220, Hanfstaengl to Carl Georg Heise, 26 January 1950. See also ibid., file 633, where Hanfstaengl in 1949–50 tried to undo a trade via Eduard Plietzsch with Paul Graupe involving works by Lorenzo di Credi and Canaletto from the BSGS.

110 Konrad Renger to author, 12 August 1998, Munich.

111 Paraphrasing of William Honan and quote from Eisler in William Honan, *Treasure Hunt: A New York Times Reporter Tracks the Quedlinburg Hoard* (New York: Delta, 1997), 28. Honan describes how one of the panels was stolen from the Cathedral of St. Bavo in Ghent in 1934. Also see Thomas Carr Howe, *Salt Mines and Castles:*

The Discovery and Restitution of Looted European Art (Indianapolis: Bobbs-Merrill, 1946), 144–48.

112 Jacques Lust, "The Spoils of War in Belgium during the Second World War," in Simpson, ed., *The Spoils of War*, 59.

113 Rousseau, *DIR No. 2*, 3.

114 Ibid.

115 Buchner, too, realized the implications of this storage arrangement: in 1956, when the controversy over the Ghent altar reemerged, Buchner secured a letter from Dr. Emmerin Pöchmüller, the overseer of the Altaussee mine, which stated that the Van Eyck and Bouts altars had been stored apart from the confiscated artworks. BHSA, MK 4478, Buchner to BSUK, 19 November 1956 (with a statement by Pöchmüller attached).

116 Howe, *Salt Mines*, 146–47.

117 Carwin, "Unter der Sonne," 796.

118 Haase, *Kunstraub*, 57. See also BHSA, MK 44778, Buchner, "Bergung des Genter Altars," 15 June 1945.

119 BHSA, MK 44778. See also BHSA, MK 40849, Buchner report on visit of Ziegler's commission, 1 September 1937.

120 See the letters in the BDC, Ahnenerbe file: specifically, the Beauftragte des Chefs der Sicherheitspolizei und des SD für Belgien und Frankreich ("Dr. Tho./Str.") to Dörner (Persönlicher Stab RF-SS), 23 August 1941; Himmler's Adjutant to Reinhard Heydrich, 19 September 1941; Heydrich to Bormann, 17 November 1941; and Der Chef der Sicherheitspolizei und des SD to Sievers, 26 September 1942. See also, BDC, Konrad Martin file, Adjutant of Himmler to Kasse of Persönlicher Stab RF-SS, 24 June 1941. Konrad was given RM 1,500 in order to "save the Ghent Altar from destruction."

121 BSGS, file 699, Buchner to Abert, 10 August 1942. For the SS accompanying Buchner, see Karl Schumann, "Münchens Pinakotheksdirektor im Kreuzfeuer," *Mannheimer Morgen Post*

301 (29 December 1956). For "three German officers," see Howe, *Salt Mines*, 146. For "police" as escorts in Paris, see Haase, *Kunstraub*, 58.

122 BSGS, file 699, Buchner to Kümmel, 10 August 1942.

123 NA, RG 260/486, Bormann to Lammers, 27 June 1941. BHSA, MK 50859, BSUK memorandum, 27 February 1953. Also BHSA, MK 44778, article from *Neue Presse* (Coburg) 275 (24 November 1956).

124 Lust, "Spoils of War in Belgium"; and Lawrence Kaye, "Laws in Force at the Dawn of World War II," in Simpson, ed., *The Spoils of War*, 58–62 and 100–106.

125 Buchner's role as instigator is stated explicitly in a Reich Chancellery document, a memorandum by an unspecified Ministerialdirektor, 20 July 1942. The document is reproduced in Hildegard Brenner, *Die Kunstpolitik des Nationalsozialismus* (Reinbek: Rowohlt, 1963), 226–27. The proposal for seizure was also made by a curator in the BSGS to the Bavarian Education Ministry in BHSA, MK 41226, Feuchtmayr to BSUK, 5 June 1940.

126 Schumann, "Münchens Pinakotheksdirektor."

127 For the Reich Chancellery document of 20 July 1942, see Brenner, *Kunstpolitik*, 227.

128 BSGS, file 699, Buchner to Kümmel, 6 July 1942.

129 BSGS, file 699, BSGS (Feuchtmayr) to BSUK, 5 June 1940.

130 BA, R55/1476, Bl. 51–52. For a more general discussion of Goebbels's program, see Petropoulos, *Art as Politics*, 124–27.

131 BSGS, file 699, Buchner to Heinz Braune, 15 June 1940.

132 BHSA, MK 41226, Buchner to BSUK, 10 October 1940.

133 Ibid., Wagner to Ribbentrop, undated "Briefentwurf," Rust to Wagner, 4 November 1940, which notes receipt of a letter from 14 October 1940.

134 Ibid., Feuchtmayr to BSUK, 5 June 1940. The letter notes that the list is almost complete. See also BSGS, file 699, for numerous reports and extensive research on effecting the "return" of artworks to Bavaria.

135 Rousseau, *DIR No. 2*, 7.

136 Nicholas, *Rape of Europa*, 32.

137 BHSA, MK 50862, Buchner to BSUK, 22 July 1941.

138 Rousseau, *DIR No. 2*, 1.

139 BHSA, MK 51500, Buchner to the BSUK, 4 March 1954. Note that in 1956 the Hauptkammer München revised a decision from 1950 and determined that Hoffmann could keep RM 350,000 of his property, including a number of artworks. For twenty-four paintings once housed in the Central Collecting Point that went to the BSGS, see ibid., Buchner to BSUK, 12 March 1954.

140 BHSA, MK 40849, Bormann to Wagner, 15 March 1940. The letter concerns Hitler's interest in fifteen works that the BSGS has put up for sale, including Makart's *Abundantia*.

141 Rousseau, *DIR No. 2*, 2. Examples of these reports are in BSGS, file 1972.

142 BSGS, file 1972, Buchner to Hummel and Bormann, 20 December 1943. See also Faison, *Supplement to CIR No. 4*, Attachment 27, Dr. Voss's statement on the Schloss affair, 20 August 1945.

143 NA, RG 260/275, Hans Rössner (SS-Sturmbannführer) to Buchner, 1 July 1942; and NA, RG 260/486, (illegible name) to Gottfried Reimer, 23 March 1945, which discusses Buchner helping Himmler with his art. According to this letter, Buchner is not impressed with the quality of the pictures considered by Himmler.

144 BHSA, MK 50859, BSUK memorandum, 27 February 1953. Also BHSA, MK 44778, article from *Neue Presse* (Coburg) 275 (24 November 1956).

145 For the original document signed by Hitler, see NA, RG 260/275, Kriegsverdienstkreuz 2. Klasse, 30 January 1943.

146 BSGS, file 305, Buchner to Hummel,

11 May 1943. This panel, like that which considered potential acquisitions for the Führermuseum, included Helmut von Hummel and Gottfried Reimer. The commission responded to a suggestion to utilize the mine made by the restorer Dr. Herbert Seiberl. Ernst Kubin, *Sonderauftrag Linz: Die Kunstsammlung Adolf Hitler. Aufbau, Vernichtungsplan, Rettung: Ein Thriller der Kulturgeschichte* (Vienna: Orac, 1979), 79. Also Haase, *Kunstraub*, 56.

147 Kubin, *Sonderauftrag Linz*, 159.

148 Institut für Zeitgeschichte (IfZG), Munich, MA-1452, Bl. 0154693, Buchner to Bormann, 30 January 1941. For more on Buchner's involvement in the early stages of wartime art conservation, see BHSA, MK 41221.

149 IfZG, Munich, MA-1452, Bl. 0154724, Posse to Bormann, 15 April 1941.

150 For the number of works from the BSGS in Schloss Neuschwanstein, see MFA & A receipt for the removal of artworks in (NGA), MSS2 (Edward Adams Papers), Box 1, Captain Edwin Rae to Director of OMG in Füssen, 10 December 1945. Later, in autumn 1944, some of these works were moved to Altaussee mine. Rousseau, *DIR No. 2*, 4.

151 W. Christlieb, "Ernst Buchner wird 70," *Münchener Abendzeitung* (19 March 1962), 7. The BSGS lost only one painting as well as some graphic works.

152 Schawe, "Vor 50 Jahre," 10–12.

153 BSGS, file 220, Buchner to Haberstock, 17 March 1943 and 15 February 1944.

154 BHSA, SLG 4628 (Sammlung F. J. Rehse), "*Der Retter der alten Pinakothek.*"

155 For Buchner's role in saving private collections, see ibid., (Sammlung F. J. Rehse), Dr. E. W., "Generaldirektor zur Wiederverwendung," *Münchener Merkur* (20 February 1953).

156 Nicholas, *Rape of Europa*, 80. Note that Buchner did, however, help safeguard Himmler's collection. See NA,

RG 260/486, (illegible name) to Gottfied Reimer, 23 March 1945.

157 See, for example, the accounts in Kubin, *Sonderauftrag Linz*, 271–75. See also Katherina Hammer, *Glanz im Dunkel: Die Bergung von Kunstschätzen im Salzkammergut am Ende des 2. Weltkrieges* (Vienna: Österreichisches Bundesverlag, 1986). Note that Gauleiter Martin Mutschmann apparently issued similar orders for repositories in mines in Saxony. Simpson, ed., *The Spoils of War*, 146.

158 NA, RG 239/74, Daniel Kern (Monuments, Fine Arts, and Archives [MFA & A]) to Major Blosom, 29 June 1945.

159 BHSA, MK 44778, Rousseau to Professor Lorenz Eitner, 10 January 1957. See also NA, RG 331/130.21, Robert Posey (of the MFA & A) to the Commanding General of the U.S. Third Army, 13 March 1945, where he says that Buchner "was Hitler's personal expert, nevertheless, he played a double game and is actually an anti-Nazi."

160 Interview with Bruno Lohse, Munich, 10 August 1998.

161 BHSA, MK 44778, Buchner to BSUK, 20 August 1948, where he describes his efforts to help search for works by Van Dyck and Van Wynants that had been stolen.

162 For the formal letter releasing Buchner from his post, see NA, RG 260/274, BSUK to Buchner, 10 July 1945.

163 Christian Zentner and Friedemann Bedürftig, eds., *The Encyclopedia of the Third Reich* (New York: MacMillan, 1991), 190. See also Clemens Vollnhals, ed., *Entnazifizierung: Politisch Säuberung und Rehabilitierung in den vier Besatzungszonen, 1945–1949* (Munich: Deutscher Taschenbuch Verlag, 1991), 333.

164 BHSA, MK 50859, BSUK memorandum, 27 February 1953.

165 Ibid.

166 Amtsgericht, Munich, Judgment (Sühnebescheid) for Ernst Buchner, 20 May 1948. Note that he was ordered to pay the costs of the trial,

which came to RM 16,000. With regard to his reinstatement, the relevant section of the *Grundgesetz* was Article 131. For Buchner's application for "Wiederverwendung," see BHSA, MK 44778, Buchner to BSUK, 20 August 1948. See more generally, Carwin, "Unter der Sonne," 789–97.

167 BHSA, MK 50859, BSUK to Rektor of Ludwig-Maximilian-Universität, n.d.

168 BHSA, MK 44478, Walter Keim, memorandum, 11 November 1948 and 13 December 1948.

169 BHSA, MK 44778, Georg Lill to Dr. Keim of the BSUK, 6 September 1948.

170 BHSA, MK 50859, Hanfstaengl to Schwalber, 12 March 1953.

171 BHSA, SLG 4628 (Sammlung F. J. Rehse), Dr. E. W., "Generaldirektor zur Wiederverwendung," *Münchener Merkur* (20 February 1953); and *Süddeutsche Zeitung* 70 (25 March 1953), 7. Most other local papers appeared relatively neutral, for example, *Die Abendzeitung München* 70 (25 March 1953).

172 Bayerische Rundfunk broadcast, 23 March 1953. The text is in BHSA, MK 44778. Erhard Göpel's broadcast was on 30 March 1953.

173 Carwin, "Unter der Sonne," 791.

174 Ibid.

175 Ibid. See also Walter Farmer, "Custody and Controversy at the Wiesbaden Collecting Point," in Simpson, ed., *The Spoils of War*, 131–34; and Nicholas, *Rape of Europa*, 394–404.

176 "Ernst Buchner neuer Staatsgaleriedirektor," *Süddeutsche Zeitung* 70 (25 March 1953), 7.

177 BHSA, SLG 4628 (Sammlung F. J. Rehse), "Des Menschen Streben ist sein Schicksal," *Münchener Merkur* 73 (26 March 1953); and ibid., "Buchner Nachfolger Hanfstaengls," *Die Neue Zeitung* 72 (26 March 1953).

178 For Buchner speaking out in favor of traditional architecture for the Alte Pinakothek, see BHSA, SLG 4628 (Sammlung F. J. Rehse), "Hüter der

Kunst: Dr. Buchner," *Die Welt* 143 (23 June 1953).

179 "Wir gehen wieder in der Pinakothek," *Münchener Merkur* 47 (23 February 1957).

180 BHSA, SLG 4628 (Sammlung F. J. Rehse), "Des Menschen Streben ist sein Schicksal," *Münchener Merkur* 73 (26 March 1953).

181 For more on the rebuilding of modernist collections after the war, see Leopold Reidemeister, "Reconstruction-Reparation: A Report," in Berthold Roland, ed., *Banned and Persecuted: Dictatorship of Art Under Hitler* (Cologne: DuMont, 1986), 370.

182 "Um den staatlichen Galeriedirektor," *Süddeutsche Zeitung.*

183 *Süddeutsche Zeitung* 280 (22 November 1956); *Süddeutsche Zeitung* 282 (24 November 1956); *Süddeutsche Zeitung* 285 (28 November 1956); *Süddeutsche Zeitung* 304 (20 December 1956); and Carwin, "Unter der Sonne," 789–97.

184 For Buchner's response, see *Frankfurter Hefte* 1 (January 1957), 71.

185 Schumann, "Münchens Pinakotheksdirektor." BHSA, MK 44778, BSUK to Bavarian Ministerpräsident, 18 March 1957.

186 BHSA, MK 4478, Kurt Martin to Walter Keim, 18 September 1962.

187 BHSA, SLG 4628 (Sammlung F. J. Rehse), "Der Retter der Alten Pinakotheken im Ruhestand," *Württmal-Bote* (3 October 1957).

188 Ibid.

189 Ernst Buchner, *Malerei der Spätgotik: Meisterwerke der alten Pinakotheken München* (Munich: Hirmer, 1960).

190 Ernst Buchner, *Von Tischbein bis Spitzweg: Deutsche und Österreichische Malerei von 1780–1850: Ausstellung von Werken aus bayerischen Privatbesitz* (Munich: Kunstverein München, 1960).

191 BHSA, MK 44778, Dr. Martin (generaldirektor of the BSGS) to Dr. Keim in the BSUK, 18 September 1962.

192 Ibid. See also BHSA, MK 4478, Christian Salm to BSUK, 15 September

1964; and ibid., a BSUK memorandum, 12 November 1962, which notes that the state had paid him DM 10,500 in 1949–51 to work on a history of Bavarian painting.

193 Rousseau, *DIR No. 2*, 10.

194 For reflections on German national identity, see Mark Spaulding, "Economic Influences on the Constructions of German Identity," in Scott Denham, Irene Kacandes, and Jonathan Petropoulos, eds., *A User's Guide to German Cultural Studies* (Ann Arbor: University of Michigan Press, 1997), 287–96; and Harold James, *A German Identity* (London: Weidenfeld & Nicolson, 1990).

195 "Das bayerische Stiefkind," *Süddeutsche Zeitung*, 3.

196 Ibid.

197 BHSA, MK 44778, Lill to Dr. Keim, BSUK, 6 September 1948. Lill's title in German is Direktor des Bayerischen Landesamtes für Denkmalpflege.

198 BHSA, MK 44801, Personnel file of Hermann Lohe.

199 Gordon Craig, "Working Toward the Führer," *New York Review of Books* (18 March 1999), 35.

200 Österreichisches Staatsarchiv (ÖSA), Archiv der Republik (AdR), Bundesministerium für Unterricht (BMfU), H 3128 (file of Friedrich Dworschak), Adolf Schärf award, 25 March 1960. See also ibid., 15/B1, Kunstwesen Ankauf, 1940–1954, in carton 71, where Dworschak reports to the Reichsstatthalter about discussions with Dr. Mühlmann concerning the acquisition of works in the Netherlands that had left Austria via "Jewish dealers." Ibid., cartons 130 and 161 report on Dworschak's buying trips to France. More generally, see Herbert Haupt, *Jahre der Gefährdung: das Kunsthistorische Museum, 1938–1945* (Vienna: Kunsthistorisches Museum, 1995).

201 Rijksinstituut voor Oorlogsdocumentatie (RIOD), Doc. II 685 B, List of Personnel in Art World, n.d. This

report notes that Martin was also in charge of "all museums in Alsace during the occupation" and that while he "had strong anti-Nazi leanings. . .he played a double game."

202 Posse's sympathy for modern art was discussed by Ulrich Bischoff in a paper at the conference, *Überbrückt: Ästhetische Moderne und Nationalsozialismus* (Berlin: 1997). For attacks on Posse, see Kubin, *Sonderauftrag Linz*, 15–16; 37; David Roxan and Kenneth Wanstall, *The Rape of Art: Hitler's Plunder of the Great Masterpieces of Europe* (New York: McCann, 1965), 18; Harald, *"Tanz mir den Hitler,"* 30; and Nicholas, *Rape of Europa*, 34.

203 "Hans Posse zum Gedächtnis," *Frankfurter Zeitung* 632 (11 December 1942); and Robert Oertel, "Ein Hort europäischer Kunst," *Das Reich* 14 (31 January 1943).

204 Posse received RM 1,000 per month plus expenses: a salary that was not extraordinary. Matila Simon, *The Battle of the Louvre: The Struggle to Save French Art in World War II* (New York: Hawthorn, 1971), 78. Also Nicholas, *Rape of Europa*, 34. See also Posse's file in the Sächsisches Hauptstaatsarchiv, Dresden, No. 29/1.

205 Reichsminister Lammers informed Bormann in October 1944 that RM 106,300,000 had been spent on purchases for Linz. Kubin, *Sonderauftrag Linz*, 67. Nicholas, *Rape of Europa*, 49. Note that this estimate of 8,000 works is on the high end. Other scholars, such as Ernst Kubin, have placed the number around 5,000.

206 For Posse in Vienna, see BA, R 43 II/1269a, Bl. 157–60, Lammers's memorandum, 30 January 1939. Note that Posse's initial distribution plan was dated 20 October 1939. See Faison, *Supplement to CIR No. 4*, Attachment 72. This opening assignment made it clear that Posse had no qualms about the origins of works for his museum: he immediately earmarked 182 works for Linz. See NA,

RG 260/388, Posse to Bormann, 16 May 1940. For the estimate of art in Jewish hands in Austria, see ÖSA, AdR, Reichsstatthalter, 2429/3, Bl. 9–14, Trinkewald to Reich Economic Ministry, 15 July 1939.

207 For Posse selecting artworks taken from Jews in Munich and stored in the Bayerisches Nationalmuseum, see NA RG 260/298, statement of Dr. Buchheit, Director of the Bavarian National Museum, 18 April 1946. For Posse's exploitation of neighboring lands, such as his trip to conquered Poland in November 1939, see Faison, *Supplement to CIR No. 4*, Attachment 5, Posse to Bormann, 14 December 1939. For other instances when Posse acquired plundered or engaged in force sales (including working with the ERR in France to obtain works taken from the Rothschilds), see Nicholas, *Rape of Europa*, 111, 131.

208 Haase, *Kunstraub*, 40–41. Posse repeatedly solicited orders from Hitler giving him priority over the artistic property confiscated from Jews both within and outside the Reich. See, for example, BA, R 2/31098, Wagner to Reinhardt, 25 February 1942.

209 For an example of Posse reserving works for Hitler, see BDC, Posse file, Posse to Sievers, 25 May 1940. For a reproduction of a letter discussing controls for the Dutch art market, see Bormann to Posse, 11 February 1941 in the appendix to Haase, *Kunstraub*, n.p.

210 Bormann to Posse, 11 February 1941 in the appendix to Haase, *Kunstraub*, n.p.

211 Albert Speer, *Inside the Third Reich* (New York: Avon, 1969), 245.

212 "Der Staatsakt in Dresden für Dr. Hans Posse," *VB* 346 (12 December 1942).

213 NA, RG 260/482, Gottfried Reimer to Hans Konrad Röthel, 16 June 1947. Note that Posse's diaries are now housed in the Germanisches Nationalmuseum in Nuremberg (ZR ABK 1697, 2070, 2387).

214 "Hans Posse zum Gedächtnis," *Frankfurter Zeitung*.

215 Faison, *Supplement to CIR No. 4*, 86.

216 BA, NS 15/260, Bl. 253, Kulturpolitisches Archiv notice about Kümmel, 11 October 1937.

217 NA, RG 239/9, Douglas Cooper, "Memorandum," 11 April 1945.

218 Wulf, *bildenden Künste*, 202.

219 Kümmel, for example, chaired an important meeting of museum officials and cultural bureaucrats at the Propaganda Ministry in Berlin on 22 August 1940. BA, R 55/1476, Bl. 51–52.

220 Konstantin Akinsha, Gregori Kozlov, with Sylvia Hochfield, *Beautiful Loot: The Soviet Plunder of Europe's Art Treasures* (New York: Random House, 1995), 73, 92–93. Also Nicholas, *Rape of Europa*, 363–64.

221 "Bericht über die von den Staatlichen Museen Berlin getroffenen Massnahmen zum Schutze gegen Kriegsschaden" was dated 11 November and addressed to Mr. Norris of the MFA & A. See Berliner Staatlichen Museen (BSM), Zentalarchiv (ZA), 5042.

222 Nicholas, *Rape of Europa*, 364. and Hans Ebert, "Die Generaldirektion der Staatlichen Museen zu Berlin, 1830–1980," in BSM-ZA, no signature.

223 The Kandinsky picture is now in the Guggenheim Museum in New York. Baudissin, "Deutsches Geisterwachen im Westen," *National Zeitung* 60 (2 March 1934). Frank Nicolaus, "Als Hitlers Kunst-Schergen kamen," *Art* 10 (October 1987), 85. Andrea Schmidt, "Klaus Graf von Baudissin: Kunsthistoriker zwischen Weimarer Republik und Drittem Reich" (masters thesis, Ruprecht-Karls-Universität Heidelberg, 1991), 31–32.

224 Schmidt, "Klaus Graf von Baudissin," 7. Because of his earlier sympathy for modernism, Baudissin was accused by Alfred Rosenberg's staff of having sympathy for the pro-Expressionists. BA, NS 15/35, Bl. 55–56, Kulturpolitisches Archiv of Amt Rosenberg to

Sicherheitsdienst, 2 February 1937. For other programmatic statements about art, see Baudissin, "Deutsches Geisterwachen im Westen," "Gedenken zur Formgebung einer nationalen arteigenen Kultur Westdeutschlands," and "Die Legende von der verweggenommen Kunst aus Blut und Boden," *Nationalzeitung* 60 (2 March 1934); and Baudissin, "Der bestimmende Wert und die germanische Frühgeschichte," *Nationalzeitung* 199 (22 July 1934).

225 For more on *Novembergeist: Kunst im Dienste der Zersetzung* as a prototypic ideological exhibition, see Christoph Zuschlag, *"Entartete Kunst": Ausstellungsstrategien in Nazi-Deutschland* (Worms: Wernersche Verlagsgesellschaft, 1996). See also Nicolaus, "Als Hitlers Kunst-Schergen kamen," 81; Mario-Andreas von Lüttichau, "'Deutsche Kunst' und 'entartete Kunst,'" in Peter-Klaus Schuster, ed., *Nationalsozialismus und "Entartete Kunst": die "Kunststadt" München 1937* (Munich: Prestel, 1987), 94; and Karin von Maur, "Bildersturm in der Staatsgalerie Stuttgart," in Heinrich Geissler and Michael Semff, eds., *Bildzyklen—Zeugnisse verfemter Kunst in Deutschland, 1933-1945* (Stuttgart: Stuttgarter Staatsgalerie, 1987).

226 See Baudissin's letter to Direktor Seippel, 25 November 1935, in Schmidt, "Klaus Graf von Baudissin," 56. Nicolaus, "Als Hitlers Kunst-Schergen kamen," 82.

227 Baudissin entered the NSDAP in April 1932, became an SS-Untersturmführer in October 1935 and was steadily promoted to the rank of Oberführer in September 1943. See Wulf, *Die bildenen Künste*, 344.

228 BDC, Baudissin file, Kommandatur der SS-Truppen Üb. Pl. Heidelage in Pustkow, Dist. Cracow, 11 May 1943; and ibid., Kommandeur der Kriegsgefangenen im Wehrkreis VII to SS-Personalhauptamt, 22 January 1945.

229 BDC, Karl Diebitsch file, Himmler

memorandum, 9 November 1940.

230 Baudissin completed his doctorate in 1922 with a thesis on the Scottish Romantic painter Georg August Wallis. Subsequent publications include Baudissin, "Rembrandt und Cats," *Repertorium für Kunstwissenschaft* 45 (1925), 148–79.

231 On 1 October 1936, Baudissin had written a piece for the *Hakenkreuzbanner* (Mannheim) where he argued for the purging of private collections. "Der Kampf gegen 'entartete Kunst,'" *Frankfurter Zeitung* 497 (28 September 1936). For more on Baudissin and the purging commission, see Petropoulos, *Art as Politics*, 60–62; Andreas Hüneke, "On the Trail of the Missing Masterpieces: Modern Art from German Galleries," in Stephanie Barron, ed., *"Degenerate Art": The Fate of the Avant-Garde in Nazi Germany* (New York: Abrams, 191), 124; and BA, R 43 II/1646, Bl. 133, Göring to Rust, 28 July 1937.

232 Maurice van Moppès, "Die Exzesse der Logik," *Les Beaux Arts* 264 (21 January 1938). Paul Westheim, "Museumskrieg," *Die Weltbühne* 4 (1938), 8. See also von Lüttichau, "'Deutsche Kunst,'" 96; and Armin Zweite, "Franz Hofmann und die Städtische Galerie 1937," in Peter-Klaus Schuster, ed., *Nationalsozialismus und "Entartete Kunst": Die "Kunststadt" München 1937* (Munich: Prestel, 1987), 262–68.

233 Westheim, "Museumskrieg," 8.

234 Bruno Lohse, interview with author, Munich, 10 August 1998.

235 Schmidt, "Klaus Graf von Baudissin," Anhang, 36.

236 Ibid., 97.

237 Ibid., 98.

238 Ibid., 94; and Nicolaus, "Als Hitlers Kunst-Schergen kamen," 82. Note that Baudissin had tried to regain his position during the Third Reich, but that opponents had blocked this move. The issue gradually became irrelevant because the Folkwang Museum was destroyed by bombs. BDC, Baudissin

file, Dr. Wolpert to Dr. Bode, 17 January 1945.

239 Schmidt, "Klaus Graf von Baudissin," 97–98. In August 1950, he underwent denazification and was placed in Group IV as a *Mitläufer*; two months later, he was placed in Group V.

240 NA, RG 239/9, "Notes on Cooper List of German Art Personnel," 22 March 1945.

241 Schmidt, "Klaus Graf von Baudissin," 99.

242 Ibid., 99.

243 Ibid., 100.

244 Nicholas, *Rape of Europa*, 171.

245 Among the compromising documents that implicate Rave in the liquidation of the modern collections, see his report to Otto Kümmel, Generaldirektor der Staatlichen Museen in Berlin, about the percentage of purchasing funds allocated for the art of decay (*Verfallskunst*), 1924–37 in BSM/ZA, Spec. 29, Beiheft 2, Bd. 2, "Entartete Kunst," Bl. 137–38, Rave to Kümmel, 15 February 1938. See also Rave, "Bertel Thorvaldsen," *Kunst im Deutschen Reich* (1944), 62–75.

246 Akinsha, Kozlov, with Hochfield, *Beautiful Loot*, 139–41.

247 See the "Exposé du Comte F. Wolff-Metternich," in Jean Cassou, *Le Pillage par les Allemands des Oeuvres d'art et des Bibliothèques Appartenant à des Juifs en France* (Paris: CDJC, 1947), 149–77.

248 Nicholas, *Rape of Europa*, 381.

249 Reinhardt, ed., *Kunst und Kultur in Ulm*, 99.

Chapter Two

1 Faison, *Supplement to CIR No. 4*, Attachment 43, Haberstock to Tschernikoff, 31 October 1941.

2 Robert Jensen, *Marketing Modernism in Fin-de-Siècle Europe* (Princeton: Princeton University Press 1994), 49. A similar conception of certain dealers serving as partisans for modern art is offered by Stephan von Wiese, "Der Kunsthändler als Überzeugungstäter: Daniel-Henry Kahnweiler und Alfred

Flechtheim," in Kunstmuseum Düsseldorf, eds., *Alfred Flechtheim: Sammler, Kunsthändler, Verleger* (Düsseldorf: Kunstmuseum Düsseldorf, 1987), 45–58.

3 Peter Watson, *From Manet to Manhattan: The Rise of the Modern Market* (New York: Random House, 1992), 159.

4 Getty Center, Arntz papers, box 23, Weinmüller to members of the Bund Deutscher Kunst- & Antiquitätenhändler (BDKAH), 25 July 1934; ibid., Weinmüller to Bundesmitglieder des BDKAH, 10 October 1934.

5 Ibid., Weinmüller to Bundesmitglieder des BDKAH, 10 October 1934.

6 Ibid. The German name is Kampfgemeinschaft arischer Kunsthändler Berlin.

7 Propaganda Minister Goebbels passed subsequent measures that explicitly prohibited Jews from dealing art, including the February 1936 decree limiting the activities of Jews who were purveying culture. See BA, R 43II/1238c, Bl. 17, Reichsministerium für Volksaufklärung und Propaganda (RMVP) *Rundschreiben*, February 1936.

8 Otto Thomae, *Die Propaganda-Maschinerie: Bildende Kunst und Öffentlichkeitsarbeit im Dritten Reich* (Berlin: Gebrüder Mann, 1978), 150–51,

9 BHSA, MK 60900, Max Heiss, the Referent beim Landeskulturverwalter (Landesleitung für bildende Künste) to Bayerisches Staatsministerium des Innern (BSdI), 3 May 1940. For more on the Aryanization process, see Barkai, *From Boycott to Annihilation*.

10 BHSA, MK 60900, Heiss to BSdI, 3 May 1940.

11 Ibid.

12 See the Aryanizations in Munich documented in BA, R 2/31098. For example, the Bernheimer Gallery became the Münchener Kunsthandelsgesellschaft.

13 Christian Zentner and Friedeman Bedürftig, eds., *The Encyclopedia of the*

Third Reich (New York: Macmillan, 1991), 233.

14 Ibid.

15 NA, RG 239, box 75, "Paul J. Sachs Lists: German Dealers in New York," October 1943.

16 Michael Fitzgerald, *Making Modernism: Picasso and the Creation of the Market for Twentieth Century Art* (New York: Farrar, Straus & Giroux, 1995), 263–68.

17 Roland, ed., *Banned and Persecuted*, 394. The biographical entry notes that Fuhr was prohibted from working in 1936.

18 Reidemeister, "Reconstruction-Reparation," 367.

19 Getty Center for the History of Art and the Humanities, Arntz papers, box 23, Reutti papers, "Liste der Firmen, die vom Propaganda Ministerium Aufträge erhalten haben, 'Verfallskunst gegen Devisen zu verkaufen.'"

20 Karl Haberstock to Gabriele Seibt, 27 April 1944 (correspondence provided to the author by Gustav Seibt).

21 Heuss, "Das Schicksal der jüdischen Kunstsammlungen," 23. See also chapter 1, note 68.

22 Getty Center, Arntz papers, box 23, Reutti papers, "Erläuterungen zum Gesetz über die Einziehung von Erzeugnissen entarteter Kunst."

23 Bundesarchiv Lichterfelde (BAL), R 5001/1019, Bl. 68, Böhmer to RMVP, 11 January 1941.

24 Thomas Buomberger, *Raubkunst— Kunstraub: Die Schweiz als Drehscheibe für gestohlene Kulturgüter zur Zeit des Zweiten Weltkrieges* (Bern: Bundesamt für Kultur, 1998), 55.

25 BAL, R 5001/1017, Bl. 8–15, Karl Buchholz to RMVP, 1941; ibid., Bl. 183, Buchholz to RMVP, 13 March 1939. See also GSAPK, I HA 92 Reutti Nachlass, 1, Reutti, "Erinnerungen," 217.

26 Faison, *Supplement to CIR No. 4*, Attachment 38, Posse to Bormann, 15 January 1941.

27 Ibid., Attachment 10, Posse to Bormann, 24 August 1940.

28 The text of the Inter-Allied Declaration Against Acts of Dispossession Committed in Territories Under Enemy Occupation or Control of 5 January 1943 is reproduced in Simpson, ed., *Spoils of War*, 287. For more on currency rates and the art market, see Simon, *Battle of the Louvre*, 66.

29 William Slany, *U.S. and Allied Efforts to Recover and Restore Gold and Other Assets Stolen or Hidden by Germany During World War II* (Washington, DC: United States Department of State, 1997).

30 Feliciano, *Lost Museum*, 123.

31 Paraphrase of Mohnen in ibid., 142.

32 Ibid., 146.

33 Seeking to transfer assets into art and other fungible products is common during wartime. Even the American market took off at the start of the war: in mid-1941, Parke-Bernet in New York declared profits up 54 percent from the previous year (it was the best season since 1929), and many of the buyers were European exiles. Nicholas, *Rape of Europa*, 165. Watson, *From Manet to Manhattan*, 267–68.

34 Alfred Dabert quoted by Feliciano, *Lost Museum*, 123.

35 Ibid., 156.

36 Ibid., 155.

37 For more on the Swiss dealers during the war, see Buomberger, *Raubkunst*, 47–87.

38 See, for example, the entry for 20 February 1942 in Adolf Hitler, *Hitler's Table Talk, 1941–1944* (New York: Oxford University Press, 1988), 321–22.

39 Heinz Boberach, ed., *Meldungen aus dem Reich, 1938–1945: Die geheimen Lageberichte des Sicherheitsdienstes der SS*, 17 vols. (Nuwied: Herrsching, 1965). See also the treatment of these reports in Thomae, *Propaganda-Maschinerie*, 177–80.

40 Amtsgericht, Munich, Scholz file, Sund to Spruchkammer Augsburg Göggin-

gen, 29 January 1948. Also Borchers'
statement of 26 August 1946.

41 For the "Anordnung über Ver-
steigerung und Verkauf von Kunst-
werken von 15. Dezember 1941," see
BA, NS 18/291, Bormann to Tiessler,
15 December 1941.

42 Janet Flanner, "Annals of Crime: The
Beautiful Spoils," *New Yorker* 40 (22
February 1947), 33.

43 Getty Center, Arntz papers, box 23,
report of Kurt Reutti, undated (pre-
sumably 1947).

44 Ibid., Reutti to Dr. Strauss, 21 August
1945.

45 Ibid.

46 Annegret Janda, "The Fight for Mod-
ern Art: The Berlin Nationalgalerie
after 1933," in Barron, ed., *"Degenerate
Art,"* 114.

47 GSAPK, I HA 92 Reutti Nachlass, 1,
Reutti "Erinnerungen," 221. The Ger-
man title for the agency reads,
Deutsche Zentralverwaltung für
Volksbildung.

48 Getty Center, Arntz papers, box 23,
"Arbeitsbereich" of Kurt Reutti, 18
November 1946.

49 For the 8 October 1946 provision of
the Culture Division of the Soviet
Military Administration, which stipu-
lates that works purged as part on the
"degenerate art" campaign during the
Third Reich be confiscated, see Getty
Center, Arntz papers, box 23, Reutti
to Generaldirektor der National-
galerie, 26 February 1950.

50 GSAPK, I HA 92 Reutti Nachlass, 1,
Reutti "Erinnerungen," 221.

51 Ibid., Reutti to Justi, 7 September
1949.

52 In another letter, Reutti observed that
the program of restituting "degener-
ate" art undertaken in the Soviet zone
did not apply in the West. Getty Cen-
ter, Arntz papers, box 23, Reutti to Dr.
Köhn of the Folkwang Museum, 25
November 1951.

53 Getty Center, Arntz papers, box 23,
Reutti to Justi, 7 September 1949.

54 GSAPK, I HA 92 Reutti Nachlass, 1,
Reutti "Erinnerungen," 222. Getty

Center, Arntz papers, box 23, Reutti
to Kohn, 25 November 1951.

55 GSAPK, I HA 92 Reutti Nachlass, 1,
Reutti "Erinnerungen," 224.

56 Ibid., 220.

57 "Americans in Berlin Bought Stolen
Art," *New York Times* (26 May 1946).
From National Gallery of Art, Wash-
ington, DC (NGA), Parkhurst Papers,
box 5.

58 Rave noted that some of the works
from museums stored in repositories
like the Flak towers "were determined
to have [later] been in the Berlin art
trade." GSAPK, I HA 92 Rave Mappe
I/4, Paul Rave, "Kriegschronik der
Berliner Museen," May 1946. For the
illicit selling of works by Soviet per-
sonnel, see Akinsha and Kozlov, with
Hochfield, *Beautiful Loot*, 102.

59 GSAPK, I HA 92 Reutti Nachlass, 1,
Reutti "Erinnerungen," 78.

60 Haase, *Kunstraub*, 47.

61 Interview with Gabriele Seibt, niece
of Karl Haberstock, Munich, 8 August
1998.

62 Theodore Rousseau, *DIR No. 13: Karl
Haberstock* (Washington, DC: OSS,
ALIU, 1 May 1946), 1. See also, infor-
mation obtained from Freedom of
Information Act (FOIA), Haberstock
documents, CIC Staff Civilian Camp
No. 4 (Hersbruck), Haberstock's Per-
sonal Data, 9 May 1946. Note that
one biographical treatment of Haber-
stock states that he attended St.
Stephan Gymnasium. Gode Krämer,
"Zur Geschichte der Karl und Magda-
lene Haberstock-Stiftung," in Städt-
ische Kunstsammlungen Augsburg,
*Mythos und Bürgerliche Welt: Gemälde
und Zeichnungen der Haberstock
Stiftung* (Munich: Klinkhardt & Bier-
mann, 1991), 12.

63 Rousseau, *DIR No. 13*, 1

64 Landesarchiv Berlin, Spruchkammer
files of Karl Haberstock, Akt No.
2045, Haberstock "Meldebogen," 24
June 1950. Interestingly, in this ques-
tionnaire, he lists his profession as
"merchant," rather than using a more
arts-related term.

65 The subsequent biographical information is taken from NGA, MSS3 (Faison Papers), box 4, Translation of Statement of Karl Haberstock, 5 June 1945.

66 "Karl Haberstock gestorben," *Die Weltkunst* (15 September 1956), 10.

67 Some scholars have claimed that Haberstock worked for the Cassirers, but I have found no evidence to support this contention. For the claim that Haberstock worked for Cassirer, see Buomberger, *Raubkunst*, 51. Marianne Feilchenfeldt rejected this assertion in a letter to the author, 18 November 1997. For more on Fischer, see Stephanie Barron, "The Galerie Fischer Auction," in Barron, ed., *"Degenerate Art,"* 137. For the Haberstock-Fischer relationship, see Faison, *CIR No. 4*, 48, and Nicholas, *Rape of Europa*, 25.

68 Nicholas, *Rape of Europa*, 32.

69 NA, RG 260/446, for Seligmann-Haberstock correspondence. Berliner Staatsbibliothek, Haberstock Nachlass, No. 228, for correspondence between Friedländer and Haberstock, 1920–32. Haberstock-Cassirer dealings are documented in NA, RG 260/446.

70 NGA, MSS3 (Faison Papers), box 4, Translation of Statement of Karl Haberstock, 5 June 1945.

71 Haberstock also organized a retrospective of Trübner's work at his gallery in 1927. Galerie Haberstock, *Wilhelm Trübner: Gedächtnisausstellung in der Galerie Haberstock* (Berlin: Galerie Haberstock, 1927).

72 NGA, MSS3 (Faison Papers), box 4, Translation of Statement of Karl Haberstock, 5 June 1945.

73 Interview with Gabriele Seibt, niece of Karl Haberstock, Munich, 8 August 1998.

74 Rousseau, *DIR No. 13*, 2.

75 NGA, MSS3 (Faison Papers), box 4, Translation of Statement of Karl Haberstock, 5 June 1945.

76 Berliner Staatsbibliothek, Haberstock Nachlass, No. 228. See more specifically, ibid., Bredius to Haberstock, 2 October 1924; ibid., Falke to Haberstock, 3 May 1924, 5 May 1924, and 17 October 1930. For more on Bredius, his work as a consultant, and Van Meegeren, see Thomas Hoving, *False Impressions: The Hunt for Big-Time Art Fakes* (New York: Simon & Schuster, 1996), 169–75.

77 Berliner Staatsbibliothek, Haberstock Nachlass, No. 228, Voss to Haberstock, 20 January 1923; ibid., Kampf to Haberstock, n.d.

78 "Karl Haberstock gestorben," *Die Weltkunst*, 10.

79 Conxa Rodriguez, a Spanish art historian working on the Thyssen-Bornemisza collection, wrote the author that the Baron bought from Haberstock at least six works, including Lucas Cranach, *St. Isobel with the Duke of Saxony* in 1928, two portraits by Nicolaes Maes in 1930, and Christoph Amberger, *Mathäus Schwarz* in 1935. See also NA, RG 260/446, for bills of sale from Haberstock to Thyssen.

80 NA, RG 260/447, Edith Standen to Theodore Rousseau, 21 October 1946.

81 Getty Center, Arntz papers, box 23, Dr. Ott in the RMVP to Julius Schaub, 16 May 1939.

82 NGA, MSS3 (Faison Papers), box 4, Translation of Statement of Karl Haberstock, 5 June 1945.

83 BDC, Haberstock file, Reichsleitung der NSDAP to Haberstock, 20 May 1936. NGA, MSS3 (Faison Papers), box 4, Translation of Statement of Karl Haberstock, 5 June 1945.

84 Simon, *Battle of the Louvre*, 81.

85 NGA, MSS3 (Faison Papers), box 4, Translation of Statement of Karl Haberstock, 5 June 1945.

86 Interview with Gabriele Seibt, niece of Karl Haberstock, Munich, 8 August 1998.

87 Nicholas, *Rape of Europa*, 22. The quote is from NGA, MSS3, (Faison papers), "Statement of Karl Haberstock," 4 June 1945.

88 Landesarchiv Berlin, Spruchkammer files of Karl Haberstock, Akte No. 2045, memorandum of Herr Becher, 19 August 1950.

89 Rousseau, *DIR No. 13*, 1.

90 Haase, *Kunstraub*, 47.

91 Nicholas, *Rape of Europa*, 33.

92 NGA, MSS3 (Faison Papers), box 4, Translation of Statement of Karl Haberstock, 5 June 1945. For more on Hofmann, see Zweite, "Franz Hofmann," 261–88.

93 Haberstock's sales to Goebbels are noted in Bundesarchiv Lichterfelde BAL, R 50.01/17b, "Erwerb von Gemälden und Kupferstichen für Reichsminister Joseph Goebbels," n.d. Examples include Lenbach's *Picture of a Woman* for RM 12,500 and Eglon van der Neer's, *Cleopatra* for RM 5,800; bill dated 28 March 1941. See also NA, RG 260/446, RMVP bills, 18 June 1941 and 4 May 1942. Haberstock noted that he sold three to five works to Speer and a Pannini to Frick in NGA, MSS3 (Faison Papers), box 4, Translation of Statement of Karl Haberstock, 5 June 1945.

94 Interview with Gabriele Seibt, niece of Karl Haberstock, Munich, 8 August 1998.

95 Ibid.

96 NGA, MSS3 (Faison Papers), box 4, Translation of Statement of Karl Haberstock, 5 June 1945.

97 For a list of Haberstock's sales to Hitler and Linz, see Faison, *Supplement to CIR No. 4*, Attatchment 48.

98 Kubin, *Sonderauftrag Linz*, 15. This episode is reconstructed by the author's examination of Posse's journal, which is located in the Germanisches Nationalmuseum, Nuremberg, Posse Nachlass, ZR ABK 1697, 2070, 2387.

99 Ibid.

100 BSGS, file 220, Haberstock to Buchner, 22 March 1944.

101 Nicholas, *Rape of Europa*, 34.

102 NA, RG 239/81, John Phillips and Denys Sutton, *Report on Preliminary*

Interrogation of P. W. Alfred Hentzen, 22 June 1945.

103 Ibid. Nicholas, *Rape of Europa*, 34.

104 Getty Center, Arntz papers, box 23, Kurt Reutti Papers, Ministerium für Volksbildung to Oberstaatsanwaltschaft, Munich, 6 June 1950: report entitled "Mitwirkung des Kunsthändlers Karl Haberstock an der Goebbels-Aktion 'Entartete Kunst.'"

105 Getty Center, Arntz papers, box 21, Protocol of the meeting of 17 November 1938.

106 Andreas Hüneke, "Dubiose Händler operieren im Dunst der Macht," in Kunstmuseum Düsseldorf, eds., *Alfred Flechtheim*, 101–05.

107 Getty Center, Arntz Papers, box 23, Reutti report, "Mitwirkung des Kunst händlers," 6 June 1950. Prior to this time, only Göring had engaged in the sale of the purged works. See also ibid., Haberstock to the RMVP, 5 June 1939. The Gauguin eventually found its way to the United States, where it was purchased by actor Edward G. Robinson.

108 Ibid., box 21, "Aus den Akten der 'Entarteten Kunst,'" 1.

109 Ibid., box 23, Dr. Ott in the RMVP to Julius Schaub, 16 May 1939.

110 Ibid., Haberstock to Bormann, 19 November 1938.

111 Ibid., Fischer to Haberstock, 6 March 1939. See also Petropoulos, *Art as Politics*, 81–82.

112 GSAPK, I HA 92 Reutti Nachlass, 1, Reutti "Erinnerungen," 236.

113 Alan Steinweis, *Art, Ideology, and Economics in Nazi Germany: The Reich Chambers of Music, Theater, and the Visual Arts*, (Chapel Hill: University of North Carolina Press, 1992), 146.

114 BA, NS 10/339, Bl. 95, Haberstock to Wilhelm Brückner (Hitler's adjutant), 26 April and 20 May 1938.

115 The Law of 31 May 1938 was published in the *Reichsgesetzblatt* on 2 June 1938. For more on Haberstock's involvement with this law, see the documents in the Stefan George

Archiv in Stuttgart, Nachlass Ludwig Thormaelen.

116 GSAPK, I HA 92 Reutti Nachlass, 1, Reutti "Erinnerungen," 236. See also Getty Center, Arntz Papers, box 23, Kurt Reutti Papers, Ministerium für Volksbildung to Oberstaatsan-waltschaft, Munich, 6 June 1950.

117 Hüneke, "Dubiose Händler," 103. He cites the Disposal Commission records in BAL, R 50.01/1020, Bl. 18.

118 Ibid.

119 BA, R 43II/1269a, Bl. 167–68, Lammers to Himmler, 30 March 1939.

120 Nicholas, *Rape of Europa*, 34, 41.

121 BA, R 43II/1269a, Bl. 162, Lammers memorandum, 27 February 1939.

122 Ibid., Bl. 186, Lammers memoran-dum, 24 June 1939; and ibid., Bl. 191, Haberstock to Lammers, 6 June 1939.

123 Rousseau, *DIR No. 13*, 2.

124 Ibid. For the Bormann and Posse let-ters mentioned above, see NA, RG 260/446, Bormann to Walter Hewel, 16 December 1940; and ibid., undated letter from Posse.

125 Note that doubts were initially expressed about the wisdom of grant-ing Haberstock a blanket pass for the occupied West because he would take a profit before selling works to Hitler. See Faison, *Supplement to CIR No. 4*, Attachment 49, Hanssen to an unspecified Stabsleiter, 22 June 1940.

126 RIOD, Doc. II 685 B, List of Personnel in Art World, no date.

127 NA, RG 260/447, bill titled "Wein-sendung aus Paris," 8 August 1941.

128 Piere Assouline, *An Artful Life: A Biog-raphy of D. H. Kahnweiler, 1884–1979*, (New York: Fromm Inter-national, 1990), 284.

129 NA, RG 239/79, Haberstock, "Beziehung zu Galerie Wildenstein," 2 September 1945.

130 Ibid.

131 Nicholas, *Rape of Europa*, 162.

132 Ibid., 422–23. Rousseau, *DIR No. 13*, 4.

133 NGA, Parkhurst papers, "Statement of Karl Haberstock," 4 June 1945, 7. He repeats this claim in NA, RG 239/79, Haberstock, "Beziehung zu Galerie Wildenstein," 2 September 1945. NA, RG 131/12, J. Homer Butler to John Pehle, 9 October 1941.

134 Nicholas, *Rape of Europa*, 163.

135 Suzanna Andrews, "Bitter Spoils," *Van-ity Fair* 451 (March 1998), 239–55.

136 Besides the Rembrandts noted above, Haberstock purchased from Dequoy two works by Claude Lorrain, a Courbet, a Jan Fyth, two by Heinsius, a Poussin, a Paul Brill, two from a "German school." NA, RG 239/79, Haberstock, "Beziehung zu Galerie Wildenstein," 2 September 1945.

137 Ibid. Rousseau, *DIR No. 9: Walter Andreas Hofer* (Washington, DC: OSS, ALIU, 15 September 1945), 7. Note that Fischer in Lucerne and C. W. Buemming in Darmstadt also worked in tandem. Faison, *CIR No. 4*, 48.

138 NA, RG 260/446, anonymous OSS report, "Special Report on the firm of Wildenstein & Cie," August 1945. Note, too, that Robert Scholz told American investigators, "Haberstock was the manager (*Verwalter*) of the Galerie Wildenstein." NA, RG 260/483, Scholz testimony, n.d.

139 NA, RG 260/446, "Report on Castle Poelnitz [*sic*] and Karl Haberstock," n.d.

140 Rousseau, *DIR No. 13*, 5.

141 For a fictional account of how "run-ners" operated, see McDonald, *Prove-nance*, 52–53.

142 Faison, *Supplement to CIR No. 4*, Attachment 48. For a synopsis of the British list, known as the Schenker Papers, see Watson, *From Manet to Manhatten*, 273.

143 NGA, MSS 3 (Faison Papers), box 2, Haberstock to Breitenbach, 13 August 1947.

144 Ibid. See NA, RG 260/446, Duveen brothers to Haberstock, 12 December 1940, where they inform him they are closed.

145 Nicholas, *Rape of Europa*, 159; and

NA, RG 260/387, Posse to Bormann, 24 February 1941.

146 Goldschmidt escaped to Cuba in the summer of 1941. NA, RG 239/79, Haberstock, "Arthur Goldschmidt," 2 September 1945. Nicholas, *Rape of Europa*, 160.

147 Kubin, *Sonderauftrag Linz*, 45.

148 Ibid., 44–46. Also Feliciano, *Lost Museum*, 96–102.

149 BSGS, file 220, Walter Weidmann, Referent der Vermögensverwaltung, memorandum, 9 February 1948. See also NA, RG 260/446, Generalverwaltung des Preussichen Königshauses to Haberstock, 14 October 1941.

150 Faison, *CIR No. 4*, 8.

151 Nicholas, *Rape of Europa*, 161.

152 Assouline, *An Artful Life*, 281.

153 NA, RG 239/81, John Phillips and Denys Sutton, *Report on Preliminary Interrogation of P. W. Alfred Hentzen*, 22 June 1945.

154 Nicholas, *Rape of Europa*, 166. For details of these trades of art confiscated by the ERR, see Getty Center, Cooper Papers, box 39, Douglas Cooper, *Looted Works of Art in Switzerland* (London: MFA and A, 21 January 1946); and James Plaut, *DIR No. 4: Gustav Rochlitz* (Washington, DC: OSS, ALIU, 15 August 1945), 6–7.

155 NA, RG 239/79, Fischer-Haberstock correspondence. For more on Fischer, see NA, RG 260/480 and 260/481.

156 Kubin, *Sonderauftrag Linz*, 44–57. For Haberstock's inquiry into the Mannheimer collection, see NA, RG 260/446, Ferdinand Niedermeyer to Haberstock, 13 May 1944.

157 BA, R 58/172, Bl. 309–14, report of 22 June 1942; and R 58/181, Bl. 132–36, report from 22 March 1943.

158 BA, R 58/181, Bl. 132, 22 March 1943.

159 Rousseau, *DIR No. 13*, 7.

160 S. Lane Faison, *DIR No. 12: Hermann Voss* (Washington, DC: OSS, ALIU, 15 January 1946), 1.

161 Kubin, *Sonderauftrag Linz*, 62.

162 Staatsbibliothek Berlin, Haberstock Nachlass, No. 228, Voss to Haberstock, 20 January 1923.

163 Nicholas, *Rape of Europa*, 174.

164 Ibid. Faison, *Supplement to CIR No. 4*, Attachment 35a.

165 BSGS, file 220, Haberstock to Buchner, 3 February 1944.

166 BSGS, file 220, Buchner to Haberstock, 15 February 1944. Landesarchiv Berlin, Spruchkammer files of Karl Haberstock, Akte No. 2045, Berufungskammer Senat Nürnberg, Zweigstelle Ansbach, 16 December 1949. See also NA, RG 260/482, for the American investigation into the Pöllnitz family.

167 Rousseau, *DIR No. 13*, 7. BSGS, file 220, Magdalene Haberstock to Eberhard Hanfstaengl, 14 April 1946. See also NA, RG 260/481, Jean Vlug to Edgar Breitenbach, 7 June 1946.

168 BSGS, file 220, Haberstock to Buchner, 23 March 1943. See also, ibid., Haberstock to Buchner, 22 March 1944, where he discusses evacuating Berlin and also the sale of Menzel's *At the Piano*.

169 NA, RG 260/481, Haberstock to Robert Posey, 11 May 1945.

170 FOIA, Haberstock documents, Joel Smietana, internal CIC memorandum, n.d. April 1946. Previously, Magdalene Haberstock was interrogated by the CIC. See NA, RG 260/446, memorandum of Lieutenant Frank and Captain Posey, 5 June 1945.

171 Bruno Lohse, interview with author, 10 August 1998, Munich.

172 Kubin, *Sonderauftrag Linz*, 164.

173 Simon, *Battle of the Louvre*, 137.

174 FOIA, Haberstock documents, Bruce Robbins, "Release Civilian Internment Camp," 13 May 1946.

175 FOIA, Haberstock documents, "Detention Report: Karl Haberstock," n.d.

176 FOIA, Haberstock documents, Heinrich Albert (listed as secretary of the treasury in 1923), "Statement," 18 January 1946; and ibid., Otto von Mendelssohn-Bartholdy to Haberstock, 29 January 1946.

177 Ibid., Ernst and Dorthee Westphal, "Erklärung," 8 January 1946.

178 Getty Center, Arntz papers, box 23,

Dorothe Westphal to Kurt Reutti, 14 November 1952.

179 FOIA, Haberstock documents, Bruce Robbins, "Release Civilian Internment Camp," 13 May 1946.

180 Landesarchiv Berlin, Spruchkammer files of Karl Haberstock, Akte Nr. 2045, Meldebogen, 24 June 1950. Also NA, RG 260/481, for MFA & A documents that record the Haberstocks' movements and the disposition of some of their property in the late 1940s.

181 Landesarchiv Berlin, Spruchkammer files of Karl Haberstock, Akte No. 2045, memorandum of Herr Becher, 19 August 1950.

182 NA, RG 260/481, list of documents given to Haberstock on 28 October 1948. The Americans had confiscated twenty-six binders of documents from Haberstock.

183 FOIA, Haberstock documents, Heinrich Albert, "Statement," 18 January 1946.

184 Landesarchiv Berlin, Spruchkammer file of Karl Haberstock, Akte No. 2045, Berufungskammer Senat Nürnberg, Zweigstelle Ansbach, 16 December 1949. Copies of the documents are in NA, RG 260/448. The file also includes a copy of the article, "Kunst-Kolleg vor der Spruchkammer," *Nürnberger Nachrichten* 158 (17 December 1949).

185 Landesarchiv Berlin, Spruchkammer file of Karl Haberstock, Akte No. 2045, Berufungskammer Senat Nürnberg, Zweigstelle Ansbach, 16 December 1949.

186 Ibid., Haberstock *Meldebogen*, 24 June 1950.

187 Ibid., Anna von Schoenebeck (Haberstock's attorney) to Berzirksamt Tiergarten, Berlin, 27 February 1950.

188 Ibid., Germer (chair of Appeals Board), memorandum, 2 October 1950.

189 NA, RG 260/448, Martin Horn to Theodore Heinrich, 2 February 1950.

190 GSAPK, I HA 92 Reutti Nachlass, 1, Reutti "Erinnerungen," 235.

191 Dr. Gustav Seibt, letter to the author, 29 April 1998.

192 BSGS, file 220, Heise to Hanfstaengl, 24 January 1950.

193 Ibid. See also ibid., Hanfstaengl to Heise, 26 January 1950.

194 Nicholas, *Rape of Europa*, 436.

195 Letter of Dr. Julius Böhler to author, 25 September 1998.

196 NGA, MSS3 (Faison) Papers, box 2, Haberstock to Breitenbach, 13 August 1947.

197 NA, RG 59/10, Haberstock to Hall, 1 July 1956.

198 Städtische Kunstsammlungen Augsburg, *Mythos und Bürgerliche Welt*, 11. The Haberstock bequest is also documented in a privately produced volume: *Hundert Bilder aus der Galerie Haberstock: Zur Erinnerung Karl Haberstock* (Munich: Satz und Druck Privatdruck, 1967). A copy is in the possession of Gabriele Seibt.

199 Interview with Gabriele Seibt, Munich, 8 August 1998.

200 Krämer "Zur Geschichte Karl und Magdalena Haberstock-Stiftung," 14.

201 Oberbürgermeister Dr. Peter Menacher quoted in Städtische Kunstsammlungen Augsburg, *Mythos und Bürgerliche Welt*, 7.

202 Ibid.

203 Ibid.

204 Ibid., 10.

205 See, for example, Peter Stepan, *Die Deutschen Museen* (Braunschweig: Westermann, 1983), 28.

206 Städtische Kunstsammlungen Augsburg, *Mythos und Bürgerliche Welt*, 120. Note that Kampf seemed to have some success at rehabilitation. The description of the provenance of the portrait of Magdalene Haberstock cites an Arthur Kampf exhibition in Düsseldorf in 1954, as well as its mention in Irmgard Wirth's study, *Berliner Malerei im 19. Jahrhundert* (Berlin, 1991).

207 Städtische Kunstsammlungen Augsburg, *Mythos und Bürgerliche Welt*, 53, 62, 76, 106.

208 Ibid., 95.

209 Ibid., 11–15. Note that one paragraph in this essay mentions the names of some of the sellers—such as the Schaumburg-Lippe family—but there are no references to National Socialism.

210 Ibid., 10. The director of the Municipal Art Collection, Björn Kommer, for example, thanks them for "such farsighted and generous patronage."

211 "Data protection" was the rationale used in a letter from Gode Krämer to the author, 18 July 1995.

212 Andrews, "Bitter Spoils," 238–55; and Maureen Goggin and Walter Robinson, "Murky Histories Cloud Some Local Art," *Boston Globe* (9 November 1997), A1.

213 Faison, *Supplement to CIR No. 4*, Attachment 54, "List of German Dealers Not Specifically Discussed in Chapter IV Who Sold to Linz."

214 Nicholas, *Rape of Europa*, 168.

215 The postwar OSS report on him noted that "[Hofer] acted as a secretary and companion accompanying [Reber] on trips to England, France, Holland, and Berlin." Rousseau, *DIR No. 9*, 1.

216 Hofer's second wife was an art restorer of international renown: Berta Fritsch Hofer had undertaken important assignments all over Europe and even spent two years at the Metropolitan Museum in New York. Haase, *Kunstraub*, 90; and NA, RG 260/179.

217 Theodore Rousseau, *DIR No. 9: Walter Andreas Hofer* (Washington, DC: OSS, ALIU, 15 September 1945), 4–5.

218 Haase, *Kunstraub*, 88.

219 Rousseau, *DIR No. 9*, Attachment 2: list of Hofer's sales as an independent dealer.

220 BAL, R 5001/10014, Bl. 235, Meder to Goebbels, 27 May 1938.

221 For Rosso-Koska and Goebbels, see BA, R 55/667, RMVP to Reichskreditkasse, 13 April 1944. See also BAL, R 5001/17b, Bl. 18, Galerie St. Lucas receipt for Goebbels's purchase of

Van Dyck's *Apostle St. Peter* through Rosso-Koska, 21 March 1941.

222 Rousseau, *DIR No. 9*, 2.

223 Haase, *Kunstraub*, 90–91.

224 Simon, *Battle of the Louvre*, 65.

225 Rousseau, *DIR No. 9*, 2.

226 Ibid., 3.

227 Ibid., 6.

228 Nicholas, *Rape of Europa*, 166.

229 GSAPK, I HA 92 Reutti Nachlass, No. 5, "Der letzte zahlt die Zeche: 'Kunsthändler' Görings vor einem Schweizer Gericht" (from 1950: no citation is provided). Buomberger, *Raubkunst*, 128–45. For more on Fischer, see also NA, RG 260/169, RG 260/480, RG 260/481.

230 Rousseau, *DIR No. 9*, 4.

231 Nicholas, *Rape of Europa*, 106. See also Faison, *CIR No. 4*, 57.

232 Rousseau, *DIR No. 9*, 3.

233 Ibid., 4. Theodore Rousseau, *CIR No. 2: The Goering Collection* (Washington, DC: OSS, ALIU, 15 September 1945), 154. For six additional works Göring sold to Koch, see RIOD, Archive, No. 211, box 2, Hofer memorandum, 27 March 1943. It is noted here that Hofer and Göring also sold works at auction via Hans Lange (?-1945).

234 Rousseau, *DIR No. 9*, 3.

235 Buomberger, *Raubkunst*, 134.

236 Haase, *Kunstraub*, 90.

237 Rousseau, *DIR No. 9*, 8.

238 Ibid.

239 Ibid., 6.

240 Nicholas, *Rape of Europa*, 168.

241 Rousseau, *DIR No. 9*, 9. NGA, MSS 3 (Faison Papers), box 4, Lieutenant Charles Kuhn, Special Report on the Hermann Göring Collection at Berchtesgaden, May 1945. See also Nicholas, *Rape of Europa*, 343–44, 379; and Hasse, *Kunstraub*, 91.

242 NA, RG 260/486, Hofer to Military Government for Bavaria, 24 January 1947. Note that Hofer experienced certain misfortunes while interned, for example, he was somehow accidentally shot through the jaw. Ibid., Tudor Wilkenson to Colonel Tomlinson, U.S.

Army, 4 September 1946. Note also that Hofer, despite being so garrulous, made a highly unfavorable impression on his American interrogators. Theodore Rousseau's notes include the observation, "The interrogation of H. is a thankless task. He is an alcoholic and has all the weaknesses which go with his vice." NA, RG 260/179, Theodore Rousseau, notes, n.d.

243 The court also tried to determine whether collector Emil Bührle, who acquired the stolen works from Fischer, was aware of their origins. This led to lawsuits between Bührle and Fischer. The most extensive treatment of these cases is Buomberger, *Raubkunst*, 116–56. See also GSAPK, I HA 92 Reutti Nachlass, No. 5, magazine article, "Der letzte zahlt die Zeche," n.p. For Hofer at war's end, see Nicholas, *Rape of Europa*, 379.

244 Dépot Central d'Archives de la Justice Militaire, copy of judgment for Scholz et al., no. 951/3577, 3 August 1950. The French sought his extradition from the Americans beginning in 1947, and this move was initially supported; but Hofer still managed to extricate himself and got released from American custody before the transfer could occur. NA, RG 260/486, Clifford Townsend to Director of Military Government for Bavaria, 14 April 1947.

245 Marianne Feilchenfeldt, whose husband previously operated the Cassirer Gallery, knew Hofer as well as his business partners Hans Wendland and Theodor Fischer; she noted that "all three were never Nazis but all were opportunists." Marianne Feilchenfeldt quoted on website "Der Fall Theodor Fischer" at http://web.aec.at/freelance/rax/KUN_POLITIK?ORG/fischer1.html.

246 NA, RG 260/76, Hofer to Central Collecting Point, 26 March 1952. Bruno Lohse, interview with author, in August 1998, Munich.

247 BDC, file of Philipp Prinz von Hessen, *Lebenslauf* from 1943. Also IfZG,

Munich, press clippings, Wilhelm Ellinghaus, "Der Prinz, der Hitlers Werkzeug war," *Hannoversche Presse* (27 March 1948). Also BHSA, Slg. Personen 5458: "Oberpräsident Prinz Philipp von Hessen," *Hamburger Nachrichten* 226 (22 May 1933). BHSA, Slg. Personen 5458: "Die Amtseinführung des Prinzen Philipp von Hessen," *Berliner Illustrierter Zeitung* (8 June 1933).

248 Rousseau, *CIR No. 2*, 97. When no export waivers were granted, the Germans sometimes used the sealed diplomatic pouch to smuggle out works. Göring in particular turned to Ambassador Mackensen to help arrange this subterfuge. Rousseau, *CIR No. 2*, 97.

249 NA, documents (record of internment) from American Occupation forces, FOIA.

250 IfZG, Munich, ZS 918, Interrogation of Prince Philipp, 6 May 1947.

251 IfZG, Munich, press clippings, Ellinghaus, "Der Prinz," n.p.

252 IfZG, Munich, ZS 918, Interrogation of Prince Philipp, 1 March 1948.

253 Göring and Christoph attended school together at the Lichterfelde Academy in Berlin. BDC, file of Christoph Prinz von Hessen, Göring memorandum, 24 January 1936. David Irving, *Göring: A Biography* (London: Macmillan, 1989), 104. IfZG, Munich, ZS 918, Interrogation of Prince Philipp, 1 March 1948.

254 Goebbels, for example, in his journal described an evening (13 June 1933) when Hitler, Philipp, and Leni Riefenstahl joined him for a get-together. Joseph Goebbels, *Die Tagebücher von Joseph Goebbels: Sämtliche Fragmente*, edited by Elke Fröhlich (Munich: K. G. Sauer, 1987), 16 June 1933. For contact with Göring, Ribbentrop, and other Nazi leaders, see Goebbels, *Tagebücher*, 4 June 1933; Irving, *Göring*, 104; and Petropoulos, *Art as Politics*, 298.

255 IfZG, Munich, ZS 918, Interrogation of Prince Philipp, 6 May 1947.

256 Faison, *Supplement to CIR No. 4,* Attachment 71, Posse to Bormann, 25 May 1941. Note that Prince Philipp's trips were paid by the Reich Ministry for the Interior. See BA, R 43 II/1089b, Bl. 172.

257 Faison, *CIR No. 4,* 10–11.

258 Ibid., Attachment 65. Kenneth Alford, *The Spoils of World War II: The American Military's Role in the Stealing of Europe's Treasures* (New York: Birch Lane, 1994), 113.

259 Hitler's rationale for turning on the loyal couple is complicated. It in part reflected Hitler's growing distrust of aristocrats, whom he thought potentially disloyal. The 19 May 1943 decree deposing "internationally connected personalities" was applied to the prince on 25 January 1944: in a document signed by both Hitler and Göring that is in Philipp's Berlin Document Center file, he was removed as Oberpräsident "in the name of the German Volk." BDC, file of Philipp Prinz von Hesse. For more on their imprisonment and subsequent fate, see Ellinghaus, "Der Prinz"; IfZG, Munich, MA 1300/2, Bl. 0281–83, anonymous CIC report, "Hesse, Prince Philipp of," 21 July 1945; IfZG, Munich, ZS 918, Interrogation of Prince Philipp, 1 March 1948. See also IfZG, ZS 576, testimony of Enno von Rintelen and subsequent comment by Helmut Heiber, 11 April 1957. Efforts by family members to ascertain their fate, including appeals to Himmler from the prince's mother and sister-in law (whose husband Christoph had been in the SS before his death), proved fruitless. BDC, file of Philipp Prinz von Hesse, SS-Obergruppenführer Taubers to Himmler, 30 November 1943.

260 For the brothel version see Faison, *CIR No. 4,* 53; and Alford, *Spoils of World War II,* 113. For the alternative, see Ellinghaus, "Der Prinz."

261 Ellinghaus, "Der Prinz."

262 NA, documents obtained through FOIA, HQ 66th CIC Division, U.S. Army, n.d.

263 IfZG, press clippings, "Prinz Philipp von Hessen verurteilt" (no paper given), (19 December 1947), n.p.

264 IfZG, Munich, ZS 918, Interrogation of Prince Philipp, 1 March 1948.

265 Alford, *Spoils of World War II,* 111–38.

266 Gerhard Frey, ed., *Prominente Ohne Maske* (Munich: FZ Verlag, 1991), 276.

267 Frey, ed., *Prominente Ohne Maske,* 276.

268 IfZG, Munich, MA 1300/2, Bl. 0281–83, anonymous CIC report, "Hesse, Prince Philipp of," 21 July 1945.

269 Irving, *Göring,* 210.

270 Among the recent books on the art trade that suggest behavior that is less than scrupulous, see Watson, *Caravaggio Conspiracy* and *Sotheby's.*

271 Elizabeth Simpson, introduction, Simpson, ed., *The Spoils of War,* 15.

272 The revival of careers in the United States by dealers who had been active in Nazi Germany is treated by Maureen Goggin and Walter Robinson, "Murky Histories Cloud Some Local Art," *Boston Globe* (9 November 1997), A1. Among those listed are Alexander and Richard Ball, César Mange de Hauke, and Hans Wendland. More generally, Bernard Taper, "Investigating Art Looting for the MFA & A," in Simpson, ed., *The Spoils of War.* NGA, MSS3 (Faison Papers), box 2, Rousseau to Faison, 16 November 1948. BHSA, MK 51491, for documents about the revival of the art trade. James Plaut observed some fifty years later that even Lohse returned to art dealing in Munich, despite having been tried for crimes in France. James Plaut, "Investigation of the Major Art-Confiscation Agencies," in Simpson, ed., *The Spoils of War,* 125.

273 U.S. Military Law 52 "was promulgated in September 1944 shortly after U.S. troops moved across the German

border to Aachen" and remained in effect through 1949. NA, RG 260/86, OMGUS press release, 22 March 1949. See also NA, RG 260/271, for the continuation of licensing provisions. The file also includes lists of licensed dealers.

274 For the argument that the American occupation authorities had a largely "passive and reactive" arts policy, see Marion Deshmukh, "Recovering Culture: The Berlin National Gallery and the U.S. Occupation 1945–1949," *Central European History* 27 (1994): 411–39, as well as Diethelm Prowe's review of the article for H-German, (October 1995).

Chapter Three

1 The Verordnung des "Kunstberichtes" is reproduced and translated in Robert Wistrich, *The Third Reich: Politics and Propaganda* (London: Routledge, 1993), 168–69.

2 Ibid., 168. Merker, *bildenden Künste*, 329. Note that the Kunstschriftleitergesetz was preceded by other measures to control the press, including the Editors' Law of 4 October 1933.

3 For more on Feder's 6 April 1930 article, "Gegen Neger Kultur," see Barbara Miller Lane, *Architecture and Politics in Germany, 1918–1945* (Cambridge, MA: Harvard University Press, 1968), 151.

4 Institut zum Studium der Judenfrage, *Die Juden in Deutschland* (Munich: Eher Verlag, 1935), 164–66.

5 The full German title of Rosenberg's office was Der Beauftragte des Führers für die Überwachung der gesamten geistigen und weltanschaulichen Schulung und Erziehung der NSDAP (DBFU).

6 James Plaut, *DIR No. 3: Robert Scholz* (Washington, DC: OSS, ALIU, 15 August 1945), 1; and Military Government of Germany Fragebogen, 13 December 1945. Also, BA, NS 15/252, résumé of Scholz from early 1944.

7 Among Scholz's early contacts, for example, was the editor of the Kunst-Feuilleton of the *Deutsche Tageszeitung*. Amtsgericht, Munich, Scholz file, Ernst Hermann Sund to Spruchkammer Augsburg-Göggingen, 29 January 1948.

8 Peter Gay, *Weimar Culture: The Outsider as Insider* (New York: Harper & Row, 1970), 7, 107–12.

9 Peter Jelavich, "Berlin's Path to Modernity," in High Museum of Art, ed., *Art in Berlin, 1815–1989* (Atlanta: High Museum of Art, 1990), 19–20.

10 BA, NS 15/252, resume of Scholz from early 1944. Scholz arranged an exhibition of Spiegel's work in 1935. Kampf was honored by the Nazi regime with numerous awards, including the Adlerschild des Deutschen Reiches in 1938. Mortimer Davidson, *Kunst in Deutschland, 1933–1945*, 3 vols. (Tübingen: Grabert, 1988), 2/1: 331–32 and 2/2: 422–23. For a discussion of ways to honor Kampf on his seventy-fifth birthday, see BA, NS 8/242, Bl. 33, Scholz to Rosenberg, 27 September 1939.

11 BA, R 55/119, Bl. 28, Stang to Goebbels, 10 January 1939. *Der Angriff* was one of the top three of approximately 150 papers affiliated with the Nazi Party. Larry Wilcox, "The Nazi Press Before the Third Reich: *Völkische Presse, Kampfblätter, Gauzeitungen*," in *Germany in the Era of the Two World Wars: Essays in Honor of Oron J. Hale*, edited by F.X.J. Homer and Larry Wilcox, (Charlottesville, VA: University of Virginia, 1986), 100. See more generally, Russel Lemmons, *Goebbels and Der Angriff* (Lexington: University of Kentucky Press, 1994).

12 Examples of Robert Scholz's short reviews on film, art, and other cultural subjects in the *Deutsche Tageszeitung* (*DT*) are in *DT* 221 (20 September 1931); *DT* 81 (22 March 1932); *DT* 143 (24 May 1932); *DT* 152 (2 June

1932); *DT* 169 (18 June 1932); and *DT* 175 (25 June 1932).

13 Robert Scholz, "Eines Malers Ende und Wiederkehr: Der Nachlass des Wiener Malers Richard Gerstl," in *DT* 169 (18 June 1932).

14 For a report on the article concerning Schmidt-Rottluff, see Amtsgericht, Munich, Scholz file, Hansen to Amann, 8 August 1937.

15 Hüneke, "On the Trail," 121. Haizmann later had several works in the *Degenerate Art Exhibition*.

16 Amtsgericht, Munich, Scholz file, statements of Klaus Richter, 17 May 1947, and Hans List, 19 August 1946.

17 Scholz, "Das Problem Franz Marc," *VB* 135 (14 May 1936). Note that Marc's works were later removed from the state collections and five were initially included in the inaugural Munich *Entartete Kunst Ausstellung*, although they did not appear in subsequent venues of the traveling show because of the general reluctance to denigrate the artist.

18 Hildegard Brenner, "Art in the Political Power Struggle of 1933 and 1934," in Hajo Holborn, ed., *Republic to Reich: The Making of the Nazi Revolution* (New York: Random House, 1972), 395–432.

19 Amtsgericht, Munich, Scholz file, statement of Ferdinand Spiegel, 19 December 1946.

20 Getty Center, Schardt papers, box 6, folder 1, Alois Schardt lecture (undated), "Art Under the Nazis." Schardt also discusses Scholz's praise for Heckel, Schmidt Rottluff, and others.

21 See Scholz's articles on these artists in the *Steglitzer Anzeiger* from 1 June 1932, 19 October 1932, and 15 November 1932.

22 BA, NS 15/252, résumé of Scholz from early 1944. BA, R 55/1000, Bl. 17–18, report on Scholz, 22 August 1939.

23 Amtsgericht Munich, Scholz file, *Meldebogen*, 24 August 1946.

24 For more on the *völkisch* conception

of art, see Brenner, "Art in the Political Power Struggle," 395–98; and Jost Hermand, *Old Dreams of a New Reich: Volkish Utopias and National Socialism* (Bloomington: Indiana University Press, 1992).

25 Miller Lane, *Architecture and Politics*, 170–80. See also Brenner, "Art in the Political Power Struggle," and Stefan Germer, "Kunst der Nation. Zu einem Versuch, die Avantgarde zu nationalisieren," in Brock and Preiss, eds., *Kunst auf Befehl?* 21–40.

26 Janda, "The Fight for Modern Art," 106. Robert Scholz, "Neuordnung im Kronprinzen-Palais," *Der Steglitzer Anzeiger* (15 February 1933).

27 Janda, "The Fight for Modern Art," 106.

28 Ibid. See also Wulf, *Die bildenden Künste*, 399–403. For Scholz's unsuccessful attempts to establish a working relationship with Hans Hinkel, see BDC, Scholz file, Scholz to Hinkel, 23 March 1933.

29 Brenner, "Art in the Political Power Struggle," 400.

30 Amtsgericht, Munich, Scholz file, Sund to Spruchkammer Augsburg-Göggingen, 29 January 1948; and ibid., Protokoll der öffentlichen Sitzung, 25 March 1948.

31 Amtsgericht, Munich, Scholz file, *Klageschrift*, 15 December 1947; and ibid. Spruch, 8 April 1948.

32 Zentner and Bedürftig, eds., *Encyclopedia*, 1002; Norbert Frei and Johannes Schmitz, *Journalismus im Dritten Reich* (Munich: C. H. Beck, 1989), 99.

33 Amtsgericht, Munich, Scholz file, Sund to Spruchkammer Augsburg-Göggingen, 29 January 1948.

34 Brenner, "Art in the Political Power Struggle," 412.

35 Getty Center, Schardt papers, box 6, folder 1, Schardt lecture (undated), "Art Under the Nazis."

36 Amtsgericht, Munich, Scholz file, Sund to Spruchkammer Augsburg-Göggingen, 29 January 1948.

37 BA, NS 8/109, Bl. 129–42, Scholz to

Rosenberg, 19 February 1934. Note that a copy of the report, "Reform der staatlichen Kunstpflege," is in BDC, Scholz file.

38 BA, NS 8/109, Bl. 129–42, Scholz to Rosenberg, 19 February 1934. Among those Scholz attacked were museum directors Wilhelm Waetzoldt, Ludwig Justi, and Eberhard Hanfstaengl; cultural bureaucrats Dr. Wolf Meinhard von Staa, Dr. Hans von Oppen, Edwin Redslob, and Hans Weidemann; and Professors Ammersdorfer, Scharff, Glaser, Pölzig, and Thormadsen.

39 BA, NS 22/849, Rosenberg, *Rundschreiben*, 31 October 1934. Amtsgericht, Munich, Scholz file, Sund to Spruchkammer Augsburg-Göggingen, 29 January 1948.

40 Scholz took over this job from Ernst Schulte-Strathaus of the Bavarian State Library in October 1941. BA, NS 8/186, for the Bormann-Rosenberg correspondence about the subject. His title was Beauftragter zum Schutze Nationalen Symbolen und Führerbildern.

41 James Fenton, "Subversives," *New York Review of Books* (11 January 1996), 52. Fenton reviewed the following in his article subversives: Irina Antonova and Jörn Merkert, *Berlin-Moscow, 1900–1950*; Dawn Ades, ed. *Art and Power: Europe Under the Dictators, 1900–1945*; Volker Krahn, *Von Allen Seiten Schön*.

42 See BA, NS 15/169, for more on the exhibition.

43 BA, NS 1/553; BA, NS 8/167; BA, NS 8/254; BA, NS 8/255; and BA, NS 8/203.

44 BA, NS 8/254, Bl. 40, Scholz to Philo von Trotha, 6 October 1935.

45 BA, NS 8/253, Bl. 131, Stang to NS-KG, 23 September 1935; and ibid., Bl. 122–27, Scholz to Rosenberg, 28 September 1935.

46 Ibid., Bl. 135–38, Stang to Hönig, 30 September 1935.

47 Amtsgericht, Munich, Scholz file, Henny Weber, "Eidesstattliche Erklärung," 24 August 1946. The section of the show was titled "Art Jottings of the Time of Decay."

48 BA, NS 15/131, Bl. 7, Kulturpolitisches Archiv (KPA) to Scholz, 17 August 1937.

49 BA, NS 15/131, Bl. 12, KPA to Scholz, 6 July 1938. Note that this file contains the evaluations of numerous cultural figures of prominence, such as Otto Kümmel (Bl. 66). For more on the archive, see BA, NS 15/38; BA, NS 15/64; BA, NS 15/259.

50 For more on Scholz providing information to the Gestapo, see BA, NS 15/69, concerning the sculptor Edwin Scharf; and BA, NS 8/208, Bl. 169–70, Rosenberg to Bouhler, where he requests that a journal (a *kunstbolschewistische Zeitschrift*) be seized by the Gestapo.

51 Note that the magazine changed names on Hitler's order in 1939. The rationale given was that Hitler believed there was only one German Reich. This, then, constituted an effort to connect the current government with the Germanic past. See CDJC, CXLIII-363, Rosenberg to Bormann, 29 June 1939.

52 Note that technically, *KiDR* entailed a merging of *Kunst und Volk* and a magazine with the same name, *Kunst im Dritten Reich*, that had been started by Bavarian Gauleiter Adolf Wagner in January 1937. *KiDR* was not designated the official organ of the Party until January 1938.

53 Willem de Vries, *Sonderstab Musik: Music Confiscations by the Einsatzstab Reichsleiter Rosenberg under the Nazi Occupation of Western Europe* (Amsterdam: Amsterdam University Press, 1996), 24.

54 BA, NS 8/255, Bl. 21, Rittich to Trotha, 10 January 1936. Note that Scholz later claimed to have personally founded *Kunst und Volk*. Amtsgericht Munich, Scholz file, Protokoll der öffentlichen Sitzung, 25 March 1948.

55 The German title for Rittich was Ver-
antwortlich Schriftleiter. Walter
Hansen, for example, complained to a
number of Nazi leaders about the
appointment. Amtsgericht Munich,
Scholz file, Hansen to Amann, 8
August 1937. Reinhard Bollmus, *Das
Amt Rosenberg und seine Gegner*
(Stuttgart: Deutsche Verlags-Anstalt,
1970), 111.

56 BA, R 55/119, Bl. 41, report on
Scholz from 1939. The wartime figure
of 94,000 is in CDJC, CXLIV-400,
Scholz memorandum, 29 January
1943.

57 BA, NS 8/182, Bl. 166–69, Rosenberg
to Bormann, 28 July 1939.

58 Bollmus, *Amt Rosenberg*, 111.

59 Amtsgericht Munich, Scholz file, Pro-
tokoll der öffentlichen Sitzung, 25
March 1948.

60 Thomae, *Propaganda-Maschinerie*, 442.

61 Ibid.

62 Theodore Rousseau, *DIR No. 1: Hein-
rich Hoffmann* (Washington, DC: OSS,
ALIU, 1 July 1945), 2.

63 Amtsgericht, Munich, Scholz file,
Weber, "Eidesstattliche Erklärung," 24
August 1946. Weber noted, for exam-
ple, that the two periodicals com-
peted for paper during the war.

64 Scholz, "Vorschau auf Paris: Die
Botschaft der deutschen Plastik," in
VB 130 (10 May 1942).

65 Ibid.

66 Gunnar Brands, "Zwischen Island und
Athen: Griechische Kunst im Spiegel
des Nationalsozialismus," in Brock and
Preiss, eds., *Kunst auf Befehl?* 103–36.

67 Scholz, "Der Bildhauer des Monu-
mentalen: Professor Josef Thorak 50
Jahre," *VB* 38 (7 February 1939).

68 Ibid.

69 BA, R55/119, Bl. 41, report on
Scholz, 1939.

70 Scholz, "Emigrierter Kunstbolschewis-
mus," *VB* 179 (27 June 1936); "Kun-
stschwindel von London," *VB* 213 (1
August 1938); "Deutsche Kunst in
Grosser Zeit," *VB* 209 (27 July 1940);
and "Sieghaftes Bekenntnis der
Kunst," *VB* 178 (27 June 1943), 3.

71 Frei and Schmitz, *Journalismus im
Dritten Reich*, 101.

72 Scholz, "Der Kunstschwindel von
London," *VB*.

73 Scholz, "Bewahrungszeit der Kunst,"
KiDR 8 (1944), 157.

74 Jost Hermand, "Art for the People:
The Nazi Concept of a Truly Popular
Painting," in Reinhold Grimm and Jost
Hermand, eds., *High and Low Cul-
tures: German Attempts at Mediation*
(Madison: University of Wisconsin
Press, 1994), 36–58.

75 BA, NS 8/208, Bl. 171–72, Scholz
report on meeting with Propaganda
Ministry employee von Keudell, 22
January 1935.

76 BA, NS 8/243, Bl. 96–97, Scholz to
Rosenberg, 16 November 1942.

77 BA, NS 8/243, Bl. 110, Scholz,
"Bericht für den Reichsleiter: Besichti-
gung der Ausstellung 'Junge Kunst im
Deutschen Reich' in Wien," 24 March
1943.

78 Bollmus, *Amt Rosenberg*, 106.

79 Amtsgericht, Munich, Scholz file,
Henny Weber, "Eidesstattliche Erk-
lärung," 24 August 1946.

80 Ibid.

81 Amtsgericht, Munich, Scholz file,
statements by the following artists:
Bernhard Kretzschmar, Gerhart
Kraaz, Rudolf Agricola, Otto Antoine,
Hans List, Raffael Schuster-Woldan,
Otto Dill, Richard Schiebe, Oskar
Nerlinger, Klaus Richter, Richard Mar-
tin Werner, Ferdinand Spiegel, Carl
Kayser, and Josef Thorak.

82 Amtsgericht, Munich, Scholz file, Pro-
tokoll der öffentlichen Sitzung, 25
March 1948.

83 Kommission für die künstlerische
Wertung der für die Metallspende
bestimmten öffentlichen Denkmäler

84 BA, NS 8/242, Bl. 51, Scholz report,
11 June 1940.

85 BA, R 55/1000, Bl. 17–18, report on
Scholz, 22 August 1939.

86 BA, R 55/119, Bl. 27–51, letters from
6 January 1939 to 28 June 1939.

87 BA, R 55/119, Bl. 27–51, letters from
6 January 1939 to 28 June 1939.

88 Ibid., Bl. 26, Ziegler to Goebbels, 31 December 1938.

89 Ibid., Bl. 52, Ziegler to Goebbels, 5 July 1939.

90 Ibid., Bl. 36, 53.

91 Ibid., Bl. 54, Meissner (Führer's Chancellery) to the Propaganda Ministry, RkdbK, and Reichsministerium des Innern (RMdI), 25 July 1939. Note that the actual decision was made earlier, evidently in May.

92 Ibid., Bl. 46–48, Raffael Schuster-Woldan to Frick, 25 May 1939.

93 Amtsgericht Munich, Scholz file, Protokoll der öffentlichen Sitzung, 25 March 1948; *Klageschrift*, 15 December 1947; and Spruch, 8 April 1948. Efforts to have Scholz appointed a professor were tabled on 5 June 1941 because he had taken on new responsibilities as the Leader of the Special Staff Visual Arts in the ERR. See Thomae, *Propaganda-Maschinerie*, 314.

94 Alexander Fedoruk, "Ukraine: The Lost Cultural Treasures and the Problem of their Return," in Simpson, ed., *The Spoils of War*, 72.

95 BA, NS 8/253, Bl. 106, Stang to Rosenberg, 9 October 1935.

96 Plaut, *DIR No. 3*, 4.

97 M. Kinder, *Das Findbuch zum Bestand NS 30: Einsatzstab Reichsleiter Rosenberg* (Koblenz: Bundesarchiv, 1968), vi.

98 Amtsgericht, Munich, Scholz file, Hans List, "Eidesstattliche Erklärung," 19 August 1946.

99 Thomae, *Propaganda-Maschinerie*, 314. See also de Vries, *Sonderstab Musik*, 93. De Vries also lists the various Sonderstäbe within the Amt Westen of the ERR: Visual Arts (Behr/Scholz); Churches (Anton Deindl); Music (Herbert Gerigk); the East (Dr. Leibbrandt); Library Acquisitions for the Hohe Schule (Walther Grothe); Prehistory (Hans Reinerth/Dr. Hülle); Racial Policy (Dr. Schubert).

100 Amtsgericht, Munich, Scholz file, *Klageschrift*, 15 December 1947; and ibid., Spruch, 8 April 1948.

101 Scholz also oversaw the eight to ten art historians and professional staff of the Sonderstab Bildende Kunst who cataloged the plunder. Plaut, *CIR No. 1: Activity of the Einsatzstab Reichsleiter Rosenberg in France* (Washington, DC: OSS, ALIU, 15 August 1945), 15–16.

102 NGA, MSS33 (Faison Papers), box 4, Central Control Commission for Germany (British Component), MFA & A Branch, "The Einsatzstab Reichsleiter Rosenberg," 30 March 1945.

103 Plaut, *CIR No. 1*, 15.

104 Ibid., 6.

105 BA, NS 15/20, Rosenberg to Bormann, 15 August 1944.

106 Gotthard Urban died in 1941 on the Eastern Front. Herbert Rothfeder, "A Study of Alfred Rosenberg's Organization for National Socialist Ideology." (Ph.D. diss., University of Michigan, 1963), 35.

107 BA, NS 8/139, Bl. 174–75, Scholz to Rosenberg, 12 August 1943.

108 Plaut, *DIR No. 3*, 2.

109 Ibid.

110 BA, NS 8/167, Bl. 9, Rosenberg to Göring, 3 June 1943, where the repercussions of von Behr's transfer are made evident to the Reichsmarschall.

111 Ibid.

112 War Department, Strategic Services Unit, *Art Looting Investigation Unit Final Report* (Washington, DC: OSS, ALIU, 1 May 1946), 72.

113 Plaut, *DIR No. 6: Bruno Lohse* (Washington, DC: OSS, ALIU, 15 August 1945), 3.

114 De Vries, *Sonderstab Musik*, 173.

115 CDJC, Demartini Collection, Box 3, anonymous to Geheimrat Kreuter, November 1943. The German name is Institut für deutsch-französischen Kultur-und Kunstausschuss.

116 Scholz, "Interim Report" of 16 April 1943 is translated and reproduced in Cassou, *Le Pillage par les Allemands*, 117–21.

117 Simon, *Battle of the Louvre*, 38–39.

118 BA, NS 8/242, Bl. 158–59, for Scholz's lecture during the Course of

the Main Office for the Cultivation of Art of the Amt Rosenberg, 19–24 January 1943. Getty Center, Schardt papers, box 6, folder 1, Schardt lecture (undated), "Art Under the Nazis."

119 Rose Valland, *Le Front de l'Art* (Paris: Plon, 1961), 179–82. Dealer Gustav Rochlitz later testified that "Scholz talked frequently in almost hysterical terms about the 'degenerate' nature of all modern French painting, and stated that this material would under no circumstances be taken to Germany." James Plaut, *DIR No. 4: Gustav Rochlitz* (Washington, DC: OSS, ALIU, 15 August 1945), 5.

120 Simon, *Battle of the Louvre*, 88–89. She quotes a letter coauthored by Scholz in 1962 where he responded to claims made in the Munich exhibition *"Entartete" Kunst: Kunstbarbarei im Dritten Reich*.

121 Plaut, *DIR No. 3*, 4.

122 NA, RG 239, box 6, Lohse testimony, 16 July 1945.

123 BHSA, MK 40849, Biebrach of the RMVP to BSUK, 12 August 1942.

124 Simon, *Battle of the Louvre*, 89.

125 Hitler enhanced the ERR's position in the East with a 1 March 1942 order. Plaut, *DIR No. 3*, 2. For the ERR in the East, see also BA, NS 8/260, Bl. 54–61, Utikal memorandum, 4 January 1943, and more generally, ibid., RG/170. For the relationship between the ERR and other plundering organizations in the East, see Ulrike Hartung, *Raubzüge in der Sowjetunion: Das Sonderkommando Künsberg, 1941–1943* (Bremen: Edition Temmen, 1997), 53–57.

126 BA, NS 8/131, Bl. 72, protocol of meeting between Rosenberg and Scholz, 5 April 1943.

127 Amtsgericht, Munich, Scholz file, Richard Scheibe, "Eidesstattliche Versicherung," 25 August 1946.

128 Scholz, "Vorschau auf Paris."

129 Scholz, "Bewahrungszeit der Kunst," 156–75.

130 BA, NS 8/242, Bl. 48–49, Scholz to Rosenberg, 1 June 1940.

131 The text of Bormann's 26 January 1943 order is provided in BA, NS 8/242, Bl. 162–64, Stang, "Stellungnahme zu dem Erlass des RL Bormann vom 26 Januar 1943," 28 January 1943. See also BA, NS 15/20 and NS 8/157, for the correspondence between Bormann and Rosenberg from 1943 and 1944.

132 BA, NS 8/242, Bl. 162–64, Stang, "Stellungnahme," 28 January 1943.

133 BA, NS 8/131, Bl. 42, report on conference at Party Chancellery, 19 March 1943; BA, NS 8/243, Bl. 128, Scholz to Rosenberg, 28 January 1944; and BA, NS 15/20, Rosenberg to Bormann, 15 August 1944.

134 BA, NS 8/243, Bl. 161, Koeppen to Scholz, 11 October 1944 (concerning the seventh album sent by Scholz); and ibid., Bl. 128, Scholz to Rosenberg, 28 January 1944. The German title of the article is "Bedeutende Werke der Europäischen Malerei als Zuwachs des Deutschen Museumbesitzes."

135 BA, NS 8/130, Bl. 44, Rosenberg to Bormann, 15 January 1943.

136 BA, NS 8/188, Bl. 134, Bormann to Rosenberg, 2 February 1943, concerning the closing of offices. BA, NS 8/243, Bl. 117, Rosenberg order, 22 October 1943.

137 BA, NS 8/131, Rosenberg to Bormann, 17 August 1944.

138 BA, NS 15/102, overview of DBFU, 4 August 1944. The German titles read Bild und Persönlich Archiv and the Archiv Nationale Symbole. For Scholz's nephew, who had the same last name, see James Plaut, *DIR No. 10: Karl Kress* (Washington, DC: OSS, ALIU, 15 August 1945), 2.

139 BA, NS 15/73, Gerigk to Scholz, 18 November 1944. The two employees of Rosenberg discuss individuals' suitability for "irreplaceable artist status." Also BA, NS 8/243, Bl. 123–25, Scholz to Rosenberg, 18 January 1944.

140 Plaut, *DIR No. 3*, 3. For Scholz's involvement in the shipment of art-

works to Germany from France, see BA, NS 8/243, Bl. 145, Scholz to Rosenberg, 1 July 1944.

141 BA, NS 8/131, Scholz report, 30 April 1943.

142 BA, NS 8/188, Bl. 49–55, Rosenberg to Bormann, 4 May 1943. This letter reflects the conflation of conservation issues with the ongoing political rivalries.

143 BA, NS 8/157, Rosenberg to Bormann, 21 April 1943. See also their correspondence in BA, NS 8/132. See also BA, NS 8/262, ibid. Bl. 12–14, Scholz to Rosenberg, 29 April 1944; and ibid., Bl. 17–23, Scholz to Rosenberg, 17 February 1944.

144 BA, NS 15/19, Scholz's report to the Reichsleitung der NSDAP about the bombing raid, 21 December 1943. Scholz lost his uniforms and even his pistol in the raids. See also BA, NS 8/163; BA, NS 8/208, and BA, NS 15/252.

145 RIOD, Doc. II, 685, box 422, Map K, Rose Valland, "Notices individuelles sur les membres suivants du service Rosenberg," n.d.

146 Rena Giefer and Thomas Giefer, *Die Rattenlinie: Fluchtwege der Nazis: Eine Dokumentation* (Frankfurt: Hains, 1991), 39.

147 For the number of objects taken by the ERR in France, see Scholz's "Interim Report," in Cassou, *Le Pillage par les Allemands*, 117–21.

148 NA, RG 260/483, Robert Scholz testimony, n.d. He lists ERR depots at Traunstein (Chiemsee); Kloster Buxheim (Memmingen); Schloss Kogl (Vöcklabruck); Schloss Seisenegg (Amstetten); Schloss Nikolsburg (Nikolsburg); Kolmberg (Ansbach); and Schloss Bruck (Lienz).

149 Howe, *Salt Mines and Castles*, 149.

150 Plaut, *DIR No. 6*, 4. Also Amtsgericht Munich, Scholz file, Protokoll der öffentlichen Sitzung, 25 March 1948.

151 Plaut, *DIR No. 6*, 4. See also Amtsgericht, Munich, Scholz file, Scholz "Anweisung," 24 April 1945.

152 Simon, *Battle of the Louvre*, 184.

153 Ibid.

154 Kubin, *Sonderauftrag Linz*, 272.

155 Amtsgericht, Munich, Scholz file, Protokoll der öffentlichen Sitzung, 25 March 1948, testimony of Karl Sieber and Walter Fleischer.

156 Kubin, *Sonderauftrag Linz*, 272.

157 RIOD, Doc. II, 685, box 422, Map N, Scholz report on Altaussee, 20 May 1945, 11.

158 Plaut, *DIR No. 3*, 4.

159 RIOD, Doc. II, 685, box 422, Map N, Scholz report on Altaussee, 20 May 1945.

160 Ibid., 5.

161 Ibid., 8.

162 Plaut, *DIR No. 3*, 1.

163 Plaut, *DIR No. 3*, 4

164 Bollmus, *Amt Rosenberg*, 151.

165 Amtsgericht, Munich, Scholz file, Sund, list of transfers, 24 March 1948.

166 Documents supplied by Department of the Army (FOIA), Lt. Ernest Hauser, Report of 21 June 1946.

167 Ibid.

168 Amtsgericht, Munich, Scholz file, *Klageschrift*, 15 December 1947.

169 Amtsgericht, Munich, Scholz file, Sund to Spruchkammer Augsburg-Göggingen, 29 January 1948.

170 Ibid. Scholz, along with "art adviser" Heinrich Heim, reportedly helped two men in 1942 charged with anti-German activities, one who was taken hostage, according to a sworn statements by Dr. J. F. Hubert Menten, 9 September 1946, and Hans List, 19 August 1946. See ibid., for Walter Borchers's statement, 26 August 1946. For Borchers in Osnabrück, see NA, RG 260/483, Herbert Leonard, chief of MFA & A section, memorandum, 6 August 1948.

171 This was a tactic used by others, including Lohse and Schiedlausky. See Feliciano, *Lost Museum*, 168.

172 Amtsgericht, Munich, Scholz file, Protokoll der öffentlichen Sitzung, 25 March 1948, and ibid., Sund to Spruchkammer Augsburg-Göggingen, 29 January 1948. Note that the denazification board did not have

access to the CIC or OSS reports, but received scattered information orally from the "American camp administration in Augsburg-Göggingen." Ibid., Justizangestellte Truchsess, "Bestätigung," 11 January 1957.

173 Amtsgericht, Munich, Scholz file, *Klageschrift*, 15 December 1947; and ibid., Spruch, 8 April 1948.

174 Ibid.

175 Note that there were provisions in the denazification laws that made these mitigating factors, such as Article 19/3, "because of the incapacity of the mother."

176 Amtsgericht, Munich, Scholz file, *Klageschrift*, 15 December 1947; and ibid., Spruch, 8 April 1948.

177 Ibid., Spruch, 8 April 1948.

178 Vollnhals, ed., *Entnazifizierung*, 238.

179 Amtsgericht, Munich, Scholz file, Truchsess' confirmation, 11 January 1957.

180 The trial of wartime "ambassador" Otto Abetz in 1949 was an important precedent in terms of the charges as a war criminal under the military code of 28 August 1944. See Nicholas Atkin, "France's Little Nuremberg: The Trial of Otto Abetz," in H. R. Kedward and Nancy Wood, eds., *The Liberation of France: Image and Event* (Oxford: Berg, 1995), 197–208.

181 *Bulletin Quotidien d'Informations de L'Agence Telegraphique Juive*, 3 August 1950, and ibid., 4 August 1950. Note that Utikal was transferred to French authorities in January 1948. CDJC, CCIII-6, "Des criminels de guerre allemands," *Combat*, 27 January 1948.

182 *Bulletin Quotidien d'Informations de L'Agence Telegraphique Juive*, 1 August 1950.

183 Getty Center, Arntz papers, box 23, Scholz to Chefredaktion of *Das Schönste*, 22 October 1962, and ibid., Klaus Voelkl to *Das Schönste*, 22 October 1962.

184 Dépôt Central d'Archives de la Justice Militaire, copy of judgment for Scholz et al., no. 951/3577, 3 August 1950.

185 Ibid., 4 August 1950. There is correspondence between Lohse and James Plaut, Theodore Rousseau, and S. Lane Faison of the ALIU in NGA, MSS 3 (Faison Papers), box 2, Lohse case. See also Simon, *Battle of the Louvre*, 184; Plaut, *DIR No. 6*, 14.

186 *Bulletin Quotidien d'Informations de L'Agence Telegraphique Juive*, 4 August 1950. Note that after the war, the French tried a select few in the art world, such as the dealers Gustav Rochlitz and Hans Wendland. Feliciano, *Lost Museum*, 168; and Bernard Taper, "Investigating Art Looting for the MFA & A," in Simpson, ed., *The Spoils of War*, 137.

187 NA, RG 260/483, Dorette Preyss to Scholz, 4 February 1949. Ther Americans interrogated Scholz and his wife repeatedly through 1948, and this file contains a record of these meetings.

188 De Vries, *Sonderstab Musik*, 234.

189 The first review that can be positively attributed to Scholz appeared in the *Deutsche Wochen-Zeitung (DWZ)* 2/21 (21 May 1960).

190 Getty Center, Arntz papers, box 23, Scholz to *Das Schönste*, 22 October 1962.

191 Scholz, "Wiedergeburt des Nationaltheaters," *DWZ* 48 (30 November 1963).

192 Valland, *Le Front de l'Art*. Note that her story served as the basis for the popular film *The Train*, which starred Burt Lancaster. She changed the date of the bonfire from 23 May to 23 July in a correction published in *Das Schönste* 2 (February 1963), 45.

193 Wilhelm Arntz, "Bildersturm in Deutschland," *Das Schönste* 5–10 (May-October 1962).

194 Getty Center, Arntz papers, box 23, Scholz and Voelkl to *Das Schönste*, 10 August 1962 and 22 October 1962.

195 The letter was signed by Scholz and Walter Borchers and published in *Das Schönste* 12 (December 1962), 75.

196 Erich Kern, "Zum Gedenken an Robert Scholz," *DWZ* 23/6 (30 January 1981). "Rosenberg-Buch nicht

staatsgefährdend!," *DWZ* 2/20 (14 May 1960), 5. Reinhard Pozorny, "Heinrich Härtle gestorben," *DWZ* 28/5 (24 January 1986), 3. Note, too, that Härtle, like Scholz, was exonerated by a denazification board in 1948, after having worked closely with Rosenberg for many years.

197 For the advertisement of Rassinier's book and the call for the release of Hess, see respectively *DWZ* 1/30 (25 July 1959), 7; and *DWZ* 4/18 (5 May 1962), 3.

198 The "close cooperation" between the three papers and the Deutsche Volksunion is discussed in Astrid Lange, *Was die Rechten lesen* (Munich: C.H. Beck, 1993), 77–79. Frey took over the *DWZ* in 1986.

199 Scholz, "Gegen den modernistischen Ungeist," *DWZ* 7/6 (5 February 1965), 5; and Scholz, "Zerstörung des Menschenbildes, *DWZ* 6/25 (18 June 1965), 5.

200 See the *DWZ* for 6 October 1962, 15 January 1965, 4 April 1980, and 25 April 1980. The original titles are "Die Welle künstlerischer Dekadenz verebbt"; "Phantasiepreis für Picasso-Bild"; "Zeichnung und Kunstverfall: Voraussetzung einer Wende"; and "Aktualisierung des Kunst-Nihilismus: Eine neue Malewitsch Diskussion."

201 Scholz, "Wilhelm Peterson—ein Maler Poet: Zum 80. Geburtstag des Malers aus dem deutschen Norden," *DWZ* 22/32 (8 August), 1980, 9.

202 Ibid.

203 Scholz, "Gegen den modernistischen Ungeist," 5.

204 Ibid.

205 Scholz, "Die Welle künstlerischer Dekadenz Verebbt," *DWZ* 4/40 (6 October 1962), 5.

206 Scholz, "Verfälschte Kunstgeschichte: Kunst fand offenkundig zwischen 1933 und 1945 in Deutschland nicht statt," *DWZ* 22/6 (8 February 1980), 9.

207 Ibid.

208 Scholz, "Die Bedeutung der Kunst Arno Brekers," *DWZ* 22/42 (17 October 1980).

209 Scholz, "Speer Gegen Speer: Verrat an seiner eigenen Architektur," *Die Klüter-Blätter* 30/4 (April 1979), 12.

210 Scholz, "Kunstraub unter Napoleon: Aus ganz Europa wanderte das Beutegut nach Paris," *Die Klüter-Blätter* 30/2 (February 1979), 13.

211 In 1979, the thirtieth year of publication for the *Die Klüter-Blätter*, other well-known former Nazis who wrote pieces included architect Hermann Giesler, Rosenberg's former adjutant Werner Koeppen, and Goebbels's aide Wilfred Oven.

212 Scholz, "Kunstraub Unter Napoleon."

213 Ibid., 15.

214 Ibid., 18.

215 Erika Neubauer, "Der Weg vom Klüt: 30 Jahre Klüter Blätter," *Die Klüter Blätter* 30/10 (October 1979), 21.

216 For more on this subject, see the chapter on "Kunst und Kultur," in Rainer Fromm, ed., *Am rechten Rand: Lexikon des Rechtsradikalismus* (Marburg: Schuren, 1993), 207–17.

217 Th. Borowski, "Rechtaussen," *Journalist* 80/1 (January 1980), 16. See also, "Neonazi Frey feierte 408. Freispruch," *Tat* 34 (13 August 1977).

218 Erich Kern, "Hans Severus Ziegler ist nicht mehr," *Deutsche Wochen-Zeitung* 19 (12 May 1978), 10.

219 Herbert Jankuhn (1905–present) authored dozens of books in the postwar period, most recently, *Haus und Hof in Ur- und Frühgeschichtlicher Zeit* (Göttingen: Vandenhoeck & Ruprecht, 1997); while Hans Reinerth (1900–present) became the director of the Open-Air Museum of German Prehistory on Lake Constance.

220 Frei and Schmitz, *Journalismus im Dritten Reich*, 168. A number of the journalists discussed in the book were successful in rehabilitating their careers after 1945, including Ursula von Kardorff, Rudolf Kircher, and Giselher Wirsing. See also Jens Mecklenburg, ed., *Handbuch Deutscher Rechtsextremismus* (Berlin: Elefanten Press, 1996), 266–68.

221 Peter Plagens's review of Peter Adam,

Art of the Third Reich, "Hitler Knew What He Liked: A Handsome New Book About the Ugly Third Reich," *Newsweek* (15 June 1992), 78.

222 Scholz, *Architektur und Bildende Kunst, 1933–1945* (Preussisch Oldendorf: K. W. Schütz 1977), 43.

223 Ibid., 41.

224 Ibid., 46.

225 Ibid., 45.

226 Ibid., 46.

227 Ibid., 46.

228 Scholz, *Volk, Nation, Geschichte,* 8. For example, Scholz decried the "liberal and antinational tendencies" of the art historical publications after World War I.

229 Kern, "Zum Gedenken an Robert Scholz." For another celebration of Scholz's life from a leader of the German radical right, see Heinrich Härtle, "Europäischer Kultur verpflichtet: Schicksal und Werk von Robert Scholz," *Klüter-Blatter* 32/2 (February 1981), 19–23.

230 Note that Kern also wrote under the name Hans-Joachim Richard. Lange, *Was die Rechten Lesen,* 142–43. Also Harold Neubauer, "Was ein Wort oft wirken Kann," *Deutsche Nationalzeitung* 10 (27 February 1981). HIAG is an acronym for Hilfsgemeinschaft auf Gegenseitigkeit der Soldaten der ehemaligen Waffen-SS.

231 Kern, "Zum Gedenken an Robert Scholz." Note also that the imagery of creating a gap in a circle is very common among those on the extreme right: Reinhard Pozorny's obituary of Heinrich Härtle, for example, also includes this phrasing. Pozorny, "Heinrich Härtle gestorben," 3.

232 Amtsgericht, Munich, Scholz file, *Klageschrift,* 15 December 1947; and ibid., Spruch, 8 April 1948.

233 Plaut, *DIR No. 3,* 4.

234 Amtsgericht, Munich, Scholz file, Willrich to Rosenberg, 3 November 1941. Wolfgang Willrich, *Die Säuberung des Kunsttempels: Eine Kunstpolitische Kampfschrift zur Gesundung deutscher Kunst im Geiste nordischer*

Art (Munich: J. F. Lehmann, 1937).

235 Wolfgang Willrich and Oskar Just, *Nordisches Bludtserbe im Süddeutsche Bauerntum,* introduction by Richard Walther Darré (Munich: F. Bruckmann, 1938). Among Willrich's other publications are *Des Edlen ewiges Reich* (Berlin: Verlag Grenze & Ausland, 1939) and *Des Reiches Soldaten* (Berlin: Verlag Grenze & Ausland, 1943).

236 BDC, Willrich file, G. Tappert, "Naziverbrecher und Nützniesser in der Kunst," 15 July 1946.

237 Janda, "The Fight for Modern Art," 112.

238 BDC, Willrich file, G. Tappert, "Naziverbrecher und Nützniesser in der Kunst," 15 July 1946. The German title of the second publication is *Schulungsbriefe des Dr. Ley.*

239 A number of Nazi functionaries wrote vulgar anti-Semitic tracts like Hansen's *Judenkunst in Deutschland.* See, for example, the book published by Alfred Rosenberg's chief of staff, Gerhard Utikal, *Der Jüdische Ritualmord: eine nichtjüdische Klarstellung* (Berlin: Hans Pötsche, 1942).

240 Werner Rittich also wrote for *Kunst und Volk* and later *KiDR.* There was in fact some truth to Hansen's claim about Rittich. Like Scholz and many other figures in this study, Rittich experienced a conversion into an antimodernist that reversed his earlier views. His aesthetic interests prior to 1933 are perhaps best reflected in his dissertation at the university in Greifswald, which focused on Herwarth Walden's celebrated promodernist journal *Der Sturm.* Amtsgericht, Munich, Scholz file, Hansen to Amann, 8 August 1937, and Willrich to Rosenberg, 3 November 1941.

241 Amtsgericht, Munich, Scholz file, Hansen, "Kritischer Überblick über die Veröffentlichungen in der '*Völkischen Kunst*' 1. Jahrgang 1935"; and ibid., Anlage to Hansen to Amann, 8 August 1937. See also BA, NS 8/179.

242 Ibid., Walter Hansen's letters to Max Amann of 8 and 23 August 1937.

243 BDC, Willrich file, G. Tappert, "Naziverbrecher und Nützniesser in der Kunst," 15 July 1946.

244 Amtsgericht, Munich, Scholz file, Weber, "Eidesstattliche Erklärung," 24 August 1946.

245 Ibid.

246 Janda, "The Fight for Modern Art," 112. Leers wrote for *Der Angriff*, among other Nazi publications. Lemmons, *Goebbels and Der Angriff*, 30.

247 Kurt Fassmann, "Bildersturm in Deutschland," *Das Schönste* (May 1962), 42.

248 BHSA, MK 60488, *Lebenslauf* of Göpel, undated (presumably 1953).

249 Ibid.

250 See the biographical entry for Erhard Göpel, *Max Beckmann: Berichte eines Augenzeugen* (Frankfurt: Fischer, 1984). His wife, Barbara Sperling Göpel, who also worked on the catalogue raisonée, is still active as an art historian and edited the volume noted above.

251 BHSA, MK 60488, Buchner to Wallenreiter (BSUK), 25 April 1953. The dissertation was titled, "Ein Bildnisauftrag für van Dyck."

252 Ibid.

253 Faison, *CIR No. 4*, 47. Faison writes, "Lohse recalls that Göpel was restive under the direction of Voss, and believes that he desired the position held by him."

254 Among Göpel's duties were interviewing prisoners, translating during negotiations in Brussels, and writing for occupation publications, including the magazine *Bretagne*. BHSA, MK 60488, *Lebenslauf* of Göpel, n.d.

255 Robert Wistrich, *Who's Who in Nazi Germany* (New York: Bonanza Books, 1982), 241–42.

256 BHSA, MK 60488, *Lebenslauf* of Göpel, n.d. Faison, *CIR No. 4*, 46.

257 Faison, *CIR No. 4*, 46. Göpel claimed to have helped save noted art historian and museum official Max Friedländer, who survived by collaborating with

several Nazi leaders. See BHSA, MK 60488, Friedländer to Buchner, 8 July 1954, where he said that Göpel tried to "soften" the Nazi policies in the Netherlands. This file also contains letters on Göpel's behalf from Vitale Bloch, Mathilde Beckmann (widow of Max), and collaborationist dealer Pieter de Boer, among others.

258 Faison, *CIR No. 4*, 29.

259 For a good account of the entire story and the currency conversion, see Feliciano, *Lost Museum*, 95–102.

260 Faison, *CIR No. 4*, 31.

261 Ibid., 33.

262 Ibid., Attachment 27.

263 BHSA, MK 60488, Göpel to Bormann, 26 April 1943. See also Kubin, *Sonderauftrag Linz*, 46.

264 Faison, *CIR No. 4*, 34.

265 Göpel's relationship to the Nazi Party remains in doubt. In BHSA, MK 60488, a BSUK memorandum of 27 December 1954 notes that Göpel was a "convinced National Socialist (beflissener Nationalsozialist)" who had joined the Party.

266 BHSA, MK 60488, *Lebenslauf* of Göpel, n.d.

267 Erhard Göpel, "Erinnerungen aus der holländischen Zeit," in Erhard Göpel, ed. *Max Beckmann Gedächtnis Ausstellung* (Munich: Piper Verlag 1951), 7–8. Other publications include "Die Sprache des Holzschnittes," *Kunstchronik* 4 (1951), 73–76, and "Jugendstil?" in *Merkur* 6 (1952), 1098.

268 BHSA, MK 60488, Buchner to Wallenreiter (BSUK), 25 April 1953.

269 For opposition to Göpel's appointment as Museumsassessor, see ibid., Walter Keim, memorandum, 12 May 1953.

270 Ibid., Vitale Bloch to Buchner, 30 June 1954; ibid., Mathilde Beckmann to Buchner, 23 September 1954; ibid., Pieter de Boer to Buchner, 8 February 1954.

271 Ibid., Keim memorandum, 23 October 1954.

272 NA, RG 239/77, ALIU, "German Per-

sonnel Connected with Art Looting,"
n.d.

273 BHSA, MK 60488, BSUK to Buchner,
14 December 1954 and 10 January
1955.

274 Ibid., *Lebenslauf* of Göpel, n.d.

275 Gerhard Paul, *Aufstand der Bilder: Die
NS-Propaganda vor 1933* (Bonn:
Dietz, 1990), 161.

276 Lemmons, *Goebbels and Der Angriff,*
27.

277 Ibid. Peter Paret also cites Goebbels's
diaries where Schweitzer is frequently
lauded as "my trusty comrade," and
"the best, the most intelligent, the
most uncompromising of all." Peter
Paret, "God's Hammer," *Proceedings of
the American Philosophical Society* 136
2 (1992): 233.

278 "Der künstlerische Ratgeber des
Reiches," *Der Angriff* 212 (9 Septem-
ber 1936). The German title is Der
Reichsbeauftragte für künstlerische
Formgebung.

279 Thomae, *Propaganda-Maschinerie,*
394, 426.

280 For the connection between mod-
ernism and the left, see Joan Wein-
stein, *The End of Expressionism: Art
and the November Revolution in Ger-
many* (Chicago: University of Chicago
Press, 1990).

281 Thomae, *Propaganda-Maschinerie,*
426.

282 Scholz, "Der VB zum Gebürtstag
seines Kampfzeichners Hans
Schweitzer-Mjölnir," *VB* 205 (24 July
1941).

283 Schweitzer chaired a committee for
the review of meretricious artistic
products (Ausschuss zur Begutach-
tung minderwertige Kunsterzeug-
nisse). Created upon the authority of
Goebbels, Reich Economics Minister
Funk, and President Ziegler of the
Visual Arts Chamber in 1940, this
body had the authority to prohibit
any works they deemed kitschy. "Min-
derwertige Kunsterzeugnisse," *Münch-
ener Neueste Nachrichten* 287 (23
October 1940).

284 *Die Brennessel* 3/16 (19 April 1933).

Die Brennessel, a weekly publication
that first appeared in 1931, was mod-
eled after *Simplicissimus* and had a cir-
culation of approximately 80,000.
Paul, *Aufstand der Bilder,* 145.

285 Dennis Showalter, *Little Man, What
Now? "Der Stürmer" in the Weimar
Republic* (New York: Greenwood
Press, 1986).

286 Paret, "God's Hammer," 227.

287 Schweitzer also arranged for Himmler
to be the godfather of his son Helge.
Davidson, *Kunst in Deutschland,* 366.
Paret, "God's Hammer," 235.

288 Schweitzer's speech opening an exhi-
bition in Hamburg is reproduced in
KiDR 11 (November 1937) and his
speech at the *Grosse Berliner Kun-
stausstellung* is in *Das Reich* 30 (15
December 1940). See also Thomae,
Propaganda-Maschinerie, 128.

289 "Der Zeichner Mjölnir," *Münchner
Illustrierte Zeitung* 27 (2 July 1936).
During the Third Reich, Schweitzer
was celebrated in the Nazi press for
his "Doppelbegabung des Politikers
und Künstlers," as well as for his
"glühenden Leidenschaft." See "23
Jahre an der politischen Front: Profes-
sor Hans-Schweitzer-Mjölnir zum 40.
Geburtstag," *Der Angriff* 178 (25 July
1941).

290 BA, NS 15/35, Bl. 55–56, Kultur-
politisches Archiv of Amt Rosenberg
to Sicherheitsdienst, 2 February 1937.

291 Paul, *Aufstand der Bilder,* 164.

292 Paret, "God's Hammer," 236.

293 Goebbels cited in numerous entries
between March 1937 and January
1938 in ibid., 236.

294 Ibid., 236.

295 Ibid., 244.

296 Ibid.

297 Ibid., 244–46. The quotes are a para-
phrasing of Schweitzer by Paret. Paret
also notes that Schweitzer "lied" about
his income and his relationship with
Goebbels. The court in Hamburg-
Bergedorfer fined him DM 500 and
sentenced him to time already served
because of his SS membership, not
because of his art or his work as a cul-

tural bureaucrat. Paul, *Aufstand der Bilder*, 163–64.

298 "Schweitzer gestorben," *Das Freie Forum: Mitteilungsblatt der Gesellschaft für Freie Publizistik* 4 (October–December 1980), 9. Zentner and Bedürftig, eds., *Encyclopedia*, 852. Paret, "God's Hammer," 246.

299 See, for example, staff listed in *Kunst dem Volk* 10/6 (June 1939).

300 Hitler, *Hitler's Table Talk*, entry for 13 March 1944, 716.

301 Oron Hale, *The Captive Press in the Third Reich* (Princeton: Princeton University Press, 1964), 240–41.

302 Ibid., 241.

Chapter Four

1 NA, RG 239/9, Paul Sachs, in consultation with J. Rosenberg and G. Swarzenski, "Notes on Cooper List of German Art Personnel," 22 March 1945.

2 See Heinrich Dilly, *Deutsche Kunsthistoriker 1933–1945* (Berlin: Deutsche Kunstverlag, 1988); Viktor Pröstler, *Die Ursprünge der nationalsozialistischen Kunsttheorie* (Munich: Dissertations- und Fotodruck, Frank, 1982); and Harald, "*Tanz mir den Hitler.*"

3 Kevin Parker, "Art History in Exile: Richard Krautheimer and Erwin Panofsky," in Stephanie Barron with Sabine Eckmann, eds., *Exiles and Emigres: The Flight of European Artists from Hitler* (New York: Abrams, 1997), 317–25. More generally, see Colin Eisler, "Kunstgeschichte American Style: A Study in Migration," in Donald Fleming and Bernard Bailyn, eds., *The Intellectual Migration: Europe and America, 1930–1960* (Cambridge, MA: Charles Warren Center for Studies in American History, 1969), 544–629; and Ulrike Wendland, "Verfolgung und Vertreibung deutschsprachiger Kunsthistoriker/-innen im Nationalsozialismus: Ein biographisches Handbuch" (Ph.D. diss., Hamburg University, 1995).

4 Karen Michels, "Transfer and Transformation: The German Period in Ameri-

can Art History," in Barron, with Eckmann, eds., *Exiles and Emigres*, 304.

5 BHSA, MK 40849, protocol concerning meeting of leaders of Prussian art academies and museums, 2 August 1937.

6 Michels, "Transfer and Transformation," 304.

7 Getty Center, Alois Schardt papers, box 1, folder 7, Alois Schardt to Georg Swarzensky, 24 January 1944.

8 Bettina Preiss, "Eine Wissenschaft wird zur Dienstleistung: Kunstgeschichte im Nationalsozialismus," in Brock and Preiss, eds., *Kunst auf Befehl?* 50.

9 Amtsgericht, Munich, Scholz file, Anlage zum Brief, Hansen to Amann, 8 August 1937.

10 BHSA, MK 40849, Protocol concerning meeting of leaders of Prussian art academies and museums, 2 August 1937. Emphasis in the original.

11 Weigert cited by Preiss, "Wissenschaft," 44.

12 Ibid., 41.

13 Wilhelm Pinder, "Architektur als Moral" and "Pflicht und Anspruch der Wissenschaft," in Leo Bruhns, ed., *Gesammelte Aufsätze aus den Jahren 1907–1935* (Leipzig: E. A. Seaman, 1938), 204–218. Pinder and Alfred Stange, eds., *Festschrift Hitler— Deutsche Wissenschaft, Arbeit und Aufgabe: Dem Führer und Reichskanzler legt die deutsche Wissenschaft zu seinem 50. Geburtstag Reichenschaft ab über ihre Arbeit im Rahmen der gestellten Aufgaben* (Leipzig: 1939). All cited in Preiss, "Wissenschaft," 41, 58. Also NA, RG 239/26, OSS report on Wilhelm Pinder, 1 April 1944.

14 Harald, "*Tanz mir den Hitler,*" 22–23. Also NA, RG 260/484, Dagobert Frey, "Bericht über meine Tätigkeit in Polen," December 1947.

15 Harald, "*Tanz mir den Hitler,*" 48.

16 The chair of the German Historical Association, Professor Johannes Fried, made the collaboration of historians in the Third Reich the focal point in his address at the forty-second annual congress on 8 September 1998. "His-

toriker verlangen Aufarbeitung der Nazizeit," *This Week in Germany* (11 September 1998), 7.

17 See Michael Kater, *Das Ahnenerbe der SS* (Stuttgart: Deutsche Verlags-Anstalt, 1974); Enno Georg, *Die Wirtschaftliche Unternehmungen der SS* (Stuttgart: Deutsche Verlags-Anstalt, 1963); and Petropoulos, *Art as Politics*. The German title of the second organization is Gesellschaft zur Förderung und Pflege Deutscher Kulturdenkmäler.

18 Wilhelm Pinder, *Vom Wesen und Werden deutschen Formen: Die bildende Kunst im neuen deutschen Staat* (Leipzig: E. A. Seamann, 1935). Preiss, "Wissenschaft," 55.

19 Aubin quoted in Harald, *"Tanz mir den Hitler,"* 50.

20 Nicholas, *Rape of Europa*, 71. There is a significant literature on the intellectual underpinnings of Nazi expansionism. See, for example, Hermand, *Old Dreams of a New Reich*; and Weinreich, *Hitler's Professors*.

21 See the example of Johannes Jahn's analysis in Harald, *"Tanz mir den Hitler,"* 53.

22 Nicholas, *Rape of Europa*, 70.

23 Podro, *Critical Historians of Art*.

24 Sedlmayr was a professor at the University of Vienna whom the OSS described as follows: "an interview source states that he made his career through Catholic connections and turned Nazi before the occupation of Austria in 1938." NA, RG 239/26, OSS Research and Analysis Biographical Report, 14 April 1944. His career in the Third Reich remains a source of controversy. For example, it is not clear if he is the "Hans Seidlmayr" who authored *Streifzuge durch altbayerisches Brauchtum* (Berlin: Nordland Verlag, 1938), which was published by the Ahnenerbe. In the postwar period, he went on to write dozens of books, including *Verlust der Mitte: die bildende Kunst des 19. und 20. Jahrhunderts als Symptom und Symbol der Zeit* (Salzburg: Otto Müller,

1948). For more on Sedlmayr, See Gert Kerschbaumer and Karl Müller, *Begnadet für das Schöne: Der rot-weisse Kuturkampf gegen die Moderne* (Vienna:Verlag für Gesellschaftskritik, 1992.)

25 Harald, *"Tanz mir den Hitler,"* 64. For Sedlmayr's contribution to the Pinder *Festschrift*, see ibid., 25.

26 Ibid., 50.

27 NA, RG 239/8, "German Universities: Faculties of Art History," materials sent to J. Walker.

28 See Hans Safrian, *Die Eichmann-Männer* (Vienna: Europa Verlag, 1993); and Bruce Pauley, *From Prejudice to Persecution: Anti-Semitism in Austria* (Chapel Hill: University of North Carolina Press, 1992). See also the chapter titled "Modell Wien," in Aly and Heim, *Vordenker der Vernichtung*, 33–42.

29 Hilde Mühlmann, interview with author, 7 June 1999, in Kammer am Attersee. For Josef Mühlmann's affiliation with the Gestapo, see Österreichisches Staatsarchiv (ÖSA), Sammelmappe 245, Bergungsaktion, Bundesministerium für Unterricht (BMfU) II, Josef Mühlmann to Baldur von Schirach, 17 January 1944 (on the stationery of the Geheime Staatspolizei marked "*Geheim!*").

30 Biography of Mühlmann issued by the Reichsstatthalterei, Vienna, 8 December 1938, as reproduced in the Munzinger-Archiv. More generally, see Jonathan Petropoulos, "The History of the Second Rank: The Art Plunderer Kajetan Mühlmann," *Contemporary Austrian Studies* 4 (1995): 177–221.

31 For this theory of common worldviews in border areas, see Isaiah Berlin, *Against the Current: Essays in the History of Ideas* (New York: Viking, 1980), 258. For pan-German sentiment and the accompanying sense of mission, see William McGrath, *Dionysian Art and Populist Politics in Austria* (New Haven: Yale University Press, 1974); and Gerhard Botz, "Eine

Deutsche Geschichte 1938 bis 1945? Österreichische Geschichte zwischen Exil, Widerstand und Verstrickung," *Zeitgeschichte* 16/1 (October 1986): 24–25.

32 Bruce Pauley, *Hitler and the Forgotten Nazis: A History of Austrian National Socialism* (Chapel Hill: University of North Carolina Press, 1981), 205.

33 Hilde Mühlmann, telephone interview with author, 1 April 1999.

34 Jerry Pyle, "Austrian Patriotism: Alternative to *Anschluss*," in F. Parkinson, ed., *Conquering the Past: Austrian Nazism Yesterday and Today* (Detroit: Wayne State University Press, 1989), 72; and Michael Gehler, "Der Hitler-Mythos in den 'nationalen' Eliten Tirols," *Geschichte und Gegenwart* 4 (November 1990): 279–318.

35 *Der Hochverratsprozess gegen Dr. Guido Schmidt vor dem Volksgericht* (Vienna: Österreichische Staatsdruckerei, 1947), 244.

36 Although there is no section of the book explicitly devoted to Austria, this pattern is explored by Charles Maier, *Recasting Bourgeois Europe: Stabilization in France, Germany, and Italy in the Decade After World War I* (Princeton: Princeton University Press, 1981).

37 "Vermögensverfall für Bilderkäufer des 'Reichsmarschalls' beantragt," *Wiener Kurier* (28 July 1952).

38 The German title is *Barocke Brunnen und Wasserkunst in Salzburg;* a copy of the dissertation is in the University Library in Innsbruck.

39 Kajetan Mühlmann, "Neugestaltung der Salzburger Gärten," *Salzburger Chronik* 254 (5 November 1926); Mühlmann, "Wo ist das Denkmalamt?" *Salzburger Chronik* 264 (18 November 1926); and Mühlmann, "Der St. Peters Friedhof gefährdet," *Mitteilung des Stadt-Verschönerungsvereines Salzburg* 3 (1928), 3. These and other articles by Mühlmann can be found in the Salzburger Landesarchiv.

40 For coverage of his lecture, "Die Ziele einer modernen Stadtverschönerung in Salzburg," see *Mitteilung des Stadt-Verschönerungsvereines Salzburg* 4 (1927), 3. Kai Mühlmann, *Stadterhaltung und Stadterneuerung in Salzburg an Beispielen der Restaurierungen Franz Wagners* (Munich: Industrie und Gewerbe Verlag, 1932).

41 Flanner, "Annals of Crime," 34. Note that Mühlmann's formal ties to the Salzburg Festival appear to have ended in 1932, when he became responsible for the more general promotion of the city of Salzburg. NA, RG 260/435, *Interrogation of Mühlmann*, 17 July 1947.

42 Michael Steinberg, *The Meaning of the Salzburg Festival: Austria as Theater and Ideology, 1890–1938* (Ithaca: Cornell University Press, 1990).

43 Kajetan Mühlmann, "Festspiele in Salzburg," *Münchener Illustrierte Fremden-Zeitung* (25 June 1927), 3.

44 For examples of his positive reviews, see his treatment of an exhibition of Georg Behringer in the *Salzburger Volksblatt* 32 (6 February 1927), and later, his two-part review of a show in the Salzburger Künstlerhaus in the *Salzburger Chronik* 255 and 257 (4 and 7 November 1933).

45 Radomir Luza, *Austro-German Relations in the Anschluss Era* (Princeton: Princeton University Press, 1975), 35. Also A. J. van der Leeuw, *Die Bestimmung der vom deutschen Reich entzogenen und von der Dienststelle Mühlmann übernommenen Kunstgegenstände* (Amsterdam: Rijksinstituut voor Oorlogsdocumentatie, 1962).

46 *Der Hochverratsprozess gegen Dr. Guido Schmidt*, 246.

47 Olga Göring's husband, a lawyer named Friedrich Riegele, for example, brought Mühlmann to visit Göring on the Obersalzburg in July 1936 when the important German-Austrian agreement was being negotiated. See Irving, *Göring*, 183.

48 Wolfgang Rosar, *Deutsche Gemeinschaft: Seyss-Inquart und der Anschluss* (Vienna: Europa Verlag), 75–82.

49 A friend of Mühlmann's, artist Alfons Walde, advanced the improbable thesis that Mühlmann became Nazi after being sued for killing a woman in a car accident in 1936: the financial ruin caused by the damages he was forced to pay supposedly so embittered him that he became sympathetic to the Nazis' ideas. Dokumentationsarchiv des österreichischen Widerstandes (DÖW), Vienna, Mühlmann file, Walde's testimony, 27 March 1947.

50 Eidliche Erklärung des SS Oberführers Dr. Kajetan Mühlmann, 19 November 1945, Nuremberg trial document 3042–PS, *Prozesse der Hauptkriegsverbrecher*, 31: 512–13. *Hochverratsprozess gegen Dr. Guido Schmidt*, 244. Mühlmann was given a NSDAP number of 6,106,589 in March 1938. This membership number was part of the group reserved for the "illegal block," although such a number did not in all cases denote that the person had been an illegal Party member (that is, in certain cases it was honorific). DÖW, Vienna, Mühlmann file, Otto Tiefenbrunner brief, 21 July 1952.

51 Documents supplied by Department of the Army (FOIA), date illegible.

52 Wilhelm Höttl, interview with author, Altaussee, 15 August 1998. DÖW, Vienna, Mühlmann file, Wilhelm Höttl protocol, 11 December 1967. This assertion was supported by historian Wolfgang Rosar. Rosar, *Deutsche Gemeinschaft*, 142, 386. Radomir Luza offered the careful formulation that "Mühlmann was probably an SD collaborator." Luza, *Austro-German Relations*, 35. See also Peter Black, *Ernst Kaltenbrunner: Ideological Soldier of the Third Reich* (Princeton: Princeton University Press, 1984), 81, 83.

53 Rosar, *Deutsche Gemeinschaft*, 91, 321.

54 *Hochverratsprozess gegen Dr. Guido Schmidt*, 243–44.

55 BDC, Mühlmann file (SSO), Seyss-Inquart to SS-Gruppenführer Rauter, 27 April 1943, and Kaltenbrunner to Himmler, 17 February 1942.

56 BDC, Mühlmann file (SSO), Seyss-Inquart to SS-Gruppenführer Rauter, 27 April 1943. The source of the information is SS-Oberführer Albert Reitter of Salzburg.

57 *Hochverratsprozess gegen Dr. Guido Schmidt*, 243–44. Mühlmann was friends with the *Heimatdichter* Heinrich Waggerl, who inveighed upon his friend Zernatto to help free Mühlmann. Schmidt also evidently helped gain Mühlmann's release.

58 Martin Kitchen, *The Coming of Austrian Fascism* (London: Croom Helm, 1980), 71.

59 ÖSA, Archiv der Republik (AdR), Mühlmann Gauakten, for the notation that "during the time the Nazi Party was banned, he was installed as a liaison between the group of Captain Leopold and Dr. Seyss-Inquart." A letter from Odilo Globocnik of 14 April 1938 describes Mühlmann's other work for the Party "after the time of the ban of the NSDAP."

60 BDC, Mühlmann file (SSO), Kaltenbrunner to Himmler, 17 February 1942. ÖSA, AdR, Mühlmann Gauakten, for notes on an arrest in Salzburg for fighting, 11 October 1937.

61 BDC, Mühlmann file (SSO), Scheel to Bormann, 12 November 1942. Also, IfZG, Munich, Nuremberg Trial document NG-3578, Leopold to Hitler, 22 August 1937.

62 Kitchen, *Austrian Fascism*, 68–69.

63 The General Government expanded in the summer of 1941 after the initial success of the Germans on the Eastern Front. For more on Mühlmann and Globocnik, see Pauley, *Forgotten Nazis*, 202; Black, *Kaltenbrunner*, 89; and Guido Zernatto, *Die Wahrheit über Österreich* (New York: Longmans, Green, 1938), 312. ÖSA, AdR, Mühlmann Gauakten, for Globocnik's glowing letter of support for Mühlmann, 14 April 1938. Wilhelm Höttl also testified to this lasting friendship in an interview with author, Altaussee, 15 August 1998.

64 *Hochverratsprozess gegen Dr. Guido Schmidt*, 245–46.

65 Fritz Rebhann, *Die Braunen Jahre: Wien, 1938–1945* (Vienna: Edition Atelier, 1995), 7. *Hochverratsprozess gegen Dr. Guido Schmidt*, 245–46.

66 See Hans Haase, "Der Anschluss," in Emmerich Talos, Ernst Hanisch, Wolfgang Neugebauer, eds., *NS-Herrschaft in Österreich, 1938–1945* (Vienna: Verlag für Gesellschaftskritik, 1988), 4.

67 Erich Stockhorst, *Fünftausend Köpfe: Wer ist Was im Dritten Reich* (Wiesbaden: VMA Verlag, 1987), 362. Luza, *Austro-German Relations*, 38. The German title is Deutsch-Österreich Volksbund.

68 Maurice Williams, "Captain Josef Leopold: Austro-Nazi and Austro-Nationalist?" in Parkinson, ed., *Conquering the Past*, 58 and 68.

69 Keppler to Bormann, 2 November 1937. Cited in Luza, *Austro-German Relations*, 36.

70 Pauley, *Forgotten Nazis*, 197. The betrayal of Schuschnigg and the Austrian government by Seyss-Inquart and Mühlmann is stressed in the Nuremberg Trial by Prosecutor Dodd in his examination of Seyss-Inquart. *Prozesse der Hauptkriegsverbrecher*, 16: 102–5.

71 Pauley, *Forgotten Nazis*, 197.

72 Ibid., 197–98.

73 Mühlmann headed Gruppe 4, Kunstpflege und Museen, in the Ministerium für innere und kulturelle Angelegenheiten, Abteilung IV, Erziehung, Kultus, Volksbildung. He was subordinate to State Commissioner Professor Dr. Friedrich Plattner.

74 Brigitte Lichtenberger-Fenz, "Österreichs Hochschulen und Universitäten und das nationalsozialistische Regime," in Talos, Hanisch, and Neugebauer, eds., *NS-Herrschaft in Österreich*, 269.

75 Bürckel also contested the appointment of Mühlmann as State Secretary. Rosar, *Deutsche Gemeinschaft*, 295, 340.

76 BDC, Mühlmann file (Ahnenerbe), Mühlmann to Himmler, 13 May 1939.

77 The city of Salzburg gave two pictures to Hitler in early April 1938: Spitzweg's *Sunday Walk* and Josef Mayburger's *Panorama of Salzburg*. Hitler returned the Spitzweg when he found out that it came from a municipal gallery. Göring received a *"Hunting Picture"* by C. P. List. See the illustrated articles by Josef Mühlmann in *Kunstchronik*, 2 (1938), 4–6. See also Gert Kerschbaumer, "Alltag, Feiern und Feste im Wandel: Nationalsozialistische Regie des öffentlichen Lebens und Praktierten Kulturen in Salzburg von 1938 bis 1945" (Ph.D. diss., University of Salzburg, 1986), 988–91. Mühlmann also helped deliver tapestries and other art objects from the Kunsthistorisches Museum to the Reich Chancellery in 1939. ÖSA, Allgemeines Verwaltungsarchiv (AVA), Kunstwesen 15, 1667–1945. Stephen Gallup, *A History of the Salzburg Festival* (London: Weidenfeld & Nicolson, 1987), 106; and Gert Kerschbaumer, *Faszination Drittes Reich: Kunst und Alltag der Kulturmetropole Salzburg* (Salzburg: Otto Müller Verlag, 1988), 212.

78 Mühlmann's speech of November 1938 in the Viennese Secession at the opening of the exhibition *Salzburgs Bildende Kunst* was cited in the *Völkischer Beobachter* (3 November 1938), as described in Oliver Rathkolb, *Führertreu und Gottbegnadet: Künstlereliten im Dritten Reich* (Vienna: OBV, 1991), 66.

79 BDC, Mühlmann file (SSO), Scheel to Bormann, 12 November 1942.

80 *Salzburger Chronik* 231 (8 October 1926). For the painting by Faistauer, see DÖW, Vienna, Mühlmann file, Josef Mühlmann *Zeugenvernehmung*, 2 September 1957.

81 DÖW, Vienna, Mühlmann file, restorer Alberto Susat statement, 5 March 1947.

82 ÖSA, AVA, 3065, 15024/1938, Mem-

orandum, Ministerium für innere und kulturelle Angelegenheiten, 10 February 1939.

83 Rathkolb, *Führertreu*, 64–65.

84 Rebhann, *Braunen Jahre*, 66–67.

85 Felix Kreissler, *Der Österreicher und seine Nation: Ein Lernprozess mit Hindernissen* (Vienna: Hermann Böhlaus, 1984), 149.

86 IfZG, Munich, MA-597, Bl. 001412–17, Seyss-Inquart to Hitler, 18 January 1939; and ibid., 001435–42, Seyss-Inquart to Hitler, 4 May 1939.

87 Oliver Rathkolb, "Nationalsozialistische (Un-) Kulturpolitik in Wien, 1938–1945," and Jan Tabor, "Die Gaben der Ostmark: Österreichische Kunst und Künstler in der NS-Zeit," both in Hans Seiger, Michael Lunardi, and Peter Josef Populorum, eds., *Im Reich der Kunst. Die Wiener Akademie der bildenden Künste und die faschistische Kunstpolitik* (Vienna: Verlag für Gesellschaftskritik, 1990), 247–96.

88 Rebhann, *Braunen Jahre*, 66.

89 The Austrian economic expert Hans Fischböck arrived at the figure of 25,000 wild Aryanizations, which has been used by most historians. Pauley, *Prejudice to Persecution*, 284. A higher figure of 45,000 to 48,000 is provided by Gerhard Botz, *Wohnungspolitik und Judendeportation in Wien 1938 bis 1945* (Vienna: Geyer, 1975), 61.

90 For Kajetan Mühlmann's office and residence, ÖSA, AdR, Bürckel Materiel, 2428/0. For Josef Mühlmann moving into an Aryanized apartment, see ÖSt, AdR, Bundesministerium des Inneres, Karton 7682, memorandum dated November 1938. For a vivid account of the confiscation of Jewish residences in Vienna, see Jörg Friedrich, "'The Apartment Keys are to Be Relinquished to the House Manager': The Cannibalization of Jewish Estates," in Jörg Wollenberg, ed., *The German Public and the Persecution of the Jews, 1933–1945* (Atlantic Highlands, NJ: Humanities Press International, 1996), 141–53.

91 For an extensive correspondence of the Aryanization of the Villa Taussig, see Salzburger Landesarchiv, Reichsstatthalter Rep. 286, 6/1941. The intervention of Gauleiter Rainer was required because there was a competing claim for the residence: Siegfried Hummer, a longtime Party member, argued that he had the "first right to purchase."

92 BDC, Mühlmann's file, Himmler to Mühlmann, 19 September 1942. The author interviewed neighbors of Poldi Woytek in June 1997, Salzburg-Anif. For more on Poldi Woytek Mühlmann, who was a Nazi Party member and the author of a biography of Hitler intended for young people, see Mühlmann's Gauakten in ÖSA, AdR, BMfU.

93 ÖSA, AdR, NS-Parteistellen, Karton 40, Schulze in the Wiener Gauleitung to the Reichsschatzmeister, 7 April 1941. Note that the Vugesta also liquidated artworks owned by Jews. Office of the Military Governor of the United States (OMGUS) 3/347 - 3/3, for Schirach's purchases from the Vugesta.

94 Jean Vlug, *Report on Objects Removed to Germany from Holland, Belgium, and France during the German Occupation on [sic] the Countries* (Amsterdam: Report of Stichting Nederlands Kunstbesit, 25 December 1945), 50.

95 ÖSA, AdR, Inneres, Bürckel Materiel, 2429/2; as well as ÖSA, AdR, Inneres, 7680 and 7691. In the latter, there is correspondence between Mühlmann and local Gestapo chief Ebner from May 1939. For a parallel case, see Paul Jaskot, "Anti-Semitic Policy in Albert Speer's Plans for the Rebuilding of Berlin," *Art Bulletin* 78/4, (1996): 622–32.

96 Diemut Majer, *Recht, Verwaltung und Justiz im Nationalsozialismus: Ausgewälte Schriften, Gesetze und Gerichtsentscheidungen* (Cologne: Bund-Verlag, 1984), 269. For the key laws passed in 1938, see Hans Witek, "Arisierungen in Wien: Aspekte

nationalsozialistischer Enteig-
nungspolitik," in Talos, Hanisch,
Neugebauer, eds., *NS-Herrschaft in
Österreich*, 199–216.

97 For the advisory role of experts similar
to Mühlmann in preparing the way
for the "final solution," see Aly and
Heim, *Vordenker der Vernichtung*.
Hans Fischböck, who like Mühlmann,
later played a key role in the occupied
Netherlands, was in charge of "eco-
nomics and Aryanization" in Austria.
See IfZG, Munich, MA-597, Bl.
001445.

98 Eichmann installed his Central Office
for Jewish Emigration at Prinz Eugen-
strasse 22. For more on individuals
and offices within the Nazi bureau-
cracy taking over "Aryanized" prop-
erty, see Dieter Stiefel,
Entnazifizierung in Österreich (Vienna:
Europaverlag, 1981), 57.

99 Witek, "Arisierungen," 203.

100 Mühlmann took Hitler on an inspec-
tion of the Neue Burg depot on 25
October 1938, and Hitler decided
that the rooms would be a suitable
annex to the Kunsthistorisches
Museum. Most of the seized works
were transferred and then put in more
secure depots during the war. Haupt,
Jahre der Gefährdung, 41.

101 For Mühlmann's appeal to Hitler not
to remove the Viennese art, see IfZG,
Munich, MA-145/1, Bl. 10406–15,
attachment to a letter from K. Barth
to J. Bürckel, 3 June 1939. For the
value of the articles cataloged in the
Neue Burg, see Luza, *Austro-German
Relations*, 280.

102 Seyss-Inquart cites an estimate that
selling off a third of the confiscated
art would raise RM 12–15 million, a
plan supported by Viennese Bürger-
meister Hans Neubacher. IfZG,
Munich, MA-597, Bl. 001435–42,
Seyss-Inquart to Hitler, 4 May 1939.

103 Mühlmann signed the protocol for the
transfer of the Holy Roman Empire
treasures at the ceremony of 29
August 1938; it is reproduced in
Haupt, *Jahre der Gefährdung*, 102.

Regarding the material impoverish-
ment of Austria to the benefit of the
Altreich, see Stiefel, *Entnazifizierung in
Österreich*, 223.

104 BA, R 43II/1269a, Bl. 27, Himmler to
Lammers, 18 June 1938.

105 NA, RG 260/486, Mühlmann to
Göring (Limberger), 18 July 1939. For
objects taken from cloisters, see ibid.,
Mühlmann to Göring, 3 February
1939.

106 ÖSA, AdR, Inneres, Bürckel Materiel,
2429, Bürckel to Bormann, 25 May
1939. Luza, *Austro-German Relations*,
287.

107 BA, R 43II/1269a, Bl. 31, Lammers to
Himmler, 13 August 1938. NA, RG
260/435, Statement of Kajetan
Mühlmann, August 1947.

108 Vlug, *Report on Objects Removed to
Germany*, 53.

109 Karl Schleuenes, *The Twisted Road to
Auschwitz: Nazi Policy towards Ger-
man Jews* (Urbana: University of Illi-
nois Press, 1972).

110 Robert Koehl, *The Black Corps: The
Structure and Power Struggles of the
Nazi SS* (Madison: University of Wis-
consin, 1983). See also Hans Momm-
sen, "Die Realisierung des Utopischen:
Die "Endlösung der Judenfrage" im
"Dritten Reich," *Geschichte und
Gesellschaft* 9 (1983): 400. See also
Safrian, *Eichmann-Männer*, 58; and
Hannah Arendt, *Eichmann in
Jerusalem: A Report on the Banality of
Evil* (New York: Viking, 1963),
68–79.

111 Kreissler, *Der Österreicher*, 149 and
206. The letter is reproduced in Rosar,
Deutsche Gemeinschaft, 339.

112 Tabor, "Die Gaben der Ostmark,"
277–95.

113 This interpretation is confirmed by
Heinrich Hoffmann. DÖW, Vienna,
Mühlmann file, Hoffmann testimony,
28 August 1951.

114 Mühlmann's fortunes were so closely
tied to Seyss-Inquart's that his official
date of termination was back-dated to
30 April 1939. See Oswald Knauer,
Österreichs Männer des öffentlichen

Lebens von 1848 bis heute (Vienna: Manzsche Verlag, 1960), 65.

115 IfZG, Munich, Nuremberg Trial document 2219–PS, Seyss-Inquart to Göring, 14 July 1939. See also K. Barth to Bürckel, 3 June 1939, where he discusses a meeting in which Göring raised the possibility of Mühlmann taking over the state museums in Berlin. He then explains why this assignment must be blocked. IfZG, Munich, MA-145/1, Bl. 10362–64.

116 Rosar, *Deutsche Gemeinschaft*, 340–65. See also BA, NL 180, Seyss-Inquart to Bürckel, 29 June 1939, and Seyss-Inquart to Bürckel, 8 August 1939.

117 Rosar, *Deutsche Gemeinschaft*, 359–65.

118 BA, NL/180, Seyss-Inquart to Bürckel, 8 August 1939.

119 Göring stated on 14 March 1946, "Actually Mühlmann, whom I knew, came to me and said that he should try to secure the art treasures there [in Poland]." Göring then argued that he was merely protecting the artworks from the dangers of combat. *Prozesse der Hauptkriegsverbrecher*, 11: 352.

120 Hilde Mühlmann, telephone interview with author, 1 April 1999.

121 BDC, Peter Paulsen file, Sievers to Himmler, 4 September 1939.

122 NA, RG 260/435, Mühlmann interview by Estreicher and Taper, 20 August 1947. Mühlmann claimed that he was recommended by Armaments Minister Fritz Todt, who was to undertake construction projects in the East. Also BA, R 43 II/1341a, Mühlmann, "Die Gesamttätigkeit des Sonderbeauftragten für die Erfassung der Kunst und Kulturschätze im Generalgouvernement," [1943?].

123 The order from Hitler via Heydrich is noted in BDC, Peter Paulsen file (Ahnenerbe), "Besprechung am 28.10.39 17 h. in Krakau." For Frank's decrees, see BA R 43 II/1341a, Mühlmann, "Gesamttätigkeit," Bl. 47, 15 November 1939, Verordnung über die Beschlagnahme des Vermögens des früheren polnischen Staates innerhalb

des Generalgouvernements, as well as the follow-up on 16 December 1939. For a discussion of Menten in Poland, see Reuben Ainsztein, "The Collector," *New Statesman* (13 February 1981), 6–8, and Malcolm MacPherson, *The Last Victim: One Man's Search for Pieter Menten, His Family's Friend and Executioner* (London: Weidenfeld and Nicholson, 1984).

124 BDC, Peter Paulsen file (Ahnenerbe), "Besprechung am 28.10.39 17 h. in Krakau."

125 Ibid.

126 Those staff members who were not Austrians usually came from Wroclaw (Breslau), another geographically proximate city. Mühlmann's staff included twelve from Austria and four from Breslau. See Mühlmann's printed report on the confiscation action in Poland, *Sichergestellte Kunstwerke im Generalgouvernement*, in IfZG, Munich, MA-174.

127 BDC, Peter Paulsen file (Ahnenerbe), "Besprechung am 28.10.39 17 h. in Krakau."

128 Pauley, *Forgotten Nazis*, 221.

129 Nicholas, *Rape of Europa*, 66.

130 Among Austrians in the East were Hermann Neubacher, Odilo Globocnik, Adolf Eichmann, Alfred Frauenfeld, Franz Stangl, and Alois Brunner. A statistic cited by Bruce Pauley— that 40 percent of the staff of the extermination camps was Austrian, even though Austrians made up only 8 percent of the Reich's population— is perhaps even more striking. Pauley, *Prejudice to Persecution*, 297–98.

131 Vlug, *Report on Objects Removed to Germany*, 54. See also NA, RG 260/479, "Statement of Dr. Barthel," n.d.

132 NA, RG 260/435, Mühlmann interview by Estreicher and Taper, 20 August 1947.

133 Ibid. Michael Dobbs, "Stolen Beauty," *Washington Post Magazine* (21 March 1999), 12–29. Also BA, R 43 II/1341a, Mühlmann, "Gesamttätigkeit," [1943?].

134 See the summary of a meeting between Josef Mühlmann and Hermann Einziger (a representative of the Dokumentationszentrum der Israelischen Kulturgemeinde Wien) on 16 January 1963. The report was provided to the author by Simon Wiesenthal.

135 IfZG, Munich, Nuremberg Trial document 3042–PS, Eidliche Erklärung des SS-Oberführers Dr. Kajetan Mühlmann, 19 November 1945.

136 Richard Lukas, *The Forgotten Holocaust: The Poles Under German Occupation, 1939–1944* (Lexington: University of Kentucky, 1986), 10–11.

137 Kajetan Mühlmann, *Sichergestellte Kunstwerke im Generalgouvernement*, and Kajetan Mühlmann and Gustav Barthel, *Krakau: Hauptstadt der deutschen Generalgouvernements Polen, Gestalt und künstlerische Leistung einer deutschen Stadt im Osten* (Breslau: Korn Verlag, 1940). Note that the second volume is edited and published by Mühlmann, but the text is attributed to Gustav Barthel. Because of their close working relationship, I am treating this book as a collaborative venture.

138 Karl Baedeker, *Das Generalgouvernement: Reisehandbuch* (Leipzig: Karl Baedeker, 1943), 50, 129. Quotation from Weinreich, *Hitler's Professors*, 193. Dagobert Frey, *Krakau* (Berlin: Deutscher Kunstverlag, 1941). See also Gerhard Sappok, *Krakau: Hauptstadt des deutschen Generalgouvernements* (Leipzig: S. Hirzel, 1944).

139 Mühlmann and Barthel, *Krakau*, 5.

140 Göring placed the Watteau in his home on the Obersalzburg and gave the Dürer drawings to Hitler, who long kept them at his headquarters before sending them to the salt mine at Altaussee. Jakob Kurz, *Kunstraub in Europa, 1938–1945* (Hamburg: Facta Oblita, 1989), 100. Dobbs, "Stolen Beauty." The quotation regarding the Dürer drawings, which Mühlmann handed over to Göring in person, comes from Nuremberg prosecutor Colonel Storey, *Prozesse der Hauptkriegsverbrecher,* 4: 94 and 11: 353.

141 Frank's castles were in Cracow and in Krzeszowice (Kressendorf).

142 NA, RG 260/481, "Extract from Muehlmann Dossier concerning purchases for Himmler."

143 Ernst Hanisch, "'Gau der Guten Nerven': Die nationalsozialistische Herrschaft in Salzburg 1939–1940," in *Sonderdruck der Politik und Gesellschaft im alten und neuen Österreich* (Vienna: Verlag für Geschichte und Politik, 1981), 206.

144 Ernst Hanisch, *Nationalsozialistische Herrschaft in der Provinz. Salzburg im Dritten Reich* (Salzburg: Landespressbüro, 1983), 141.

145 NA, RG 260/435, Mühlmann interview by Estreicher and Taper, 20 August 1947.

146 Kurz, *Kunstraub in Europa*, 112–13. Some of the catalogs from Poland are in RIOD, Doc. II, 685 B, box 422.

147 Mühlmann, introduction to *Sichergestellte Kunstwerke im Generalgouvernement,*

148 BDC, Mühlmann file (Ahnenerbe), Sievers memorandum to file, 15 May 1940, and his report on a meeting with SS-Brigadierführer Greifelt, Obersturmbannführer Luig, and Stabsführer Winkler, 30 July 1940.

149 BDC, Mühlmann file (Ahnenerbe), Sievers report, 30 July 1940.

150 BDC, Mühlmann file (Ahnenerbe), Mühlmann report, "Zur Frage der Rückführung des deutschen Kulturgutes," 3 May 1940.

151 Note that while Seyss-Inquart had his jurisdiction confined to the Netherlands, the Dienststelle Mühlmann's sphere of activity would be extended to Belgium.

152 Vlug, *Report on Objects Removed to Germany*, 5.

153 NA, RG 260/435, Mühlmann interview by Estreicher and Taper, 20 August 1947.

154 Ibid., 7. See van der Leeuw, *Dienststelle Mühlmann*, 9. Vlug, *Report on Objects Removed to Germany*, 50.

155 Mühlmann's cooperation with the SD in the Netherlands was so close that he lived for some time in The Hague with Peter Gern, the SD chief for Holland. See Vlug, *Report on Objects Removed to Germany*, 21.

156 Vlug, *Report on Objects Removed to Germany*, 34, 95.

157 Hilde Mühlmann, interview with the author, 7 June 1999, Kammer am Attersee. She added that a friend of her husband, an engineer from the Tyrol, provided some of the capital he used to acquire works which he then resold. But the archives do not contain documents confirming this.

158 Plietzsch, who had been trained by Wilhlelm von Bode and earlier written books on Vermeer and other Dutch masters, published a book on Gerard ter Borch in Vienna in 1944. See Haase, *Kunstraub*, 184–88. Plietzsch wrote his memoirs after the war and did not mention Mühlmann. He merely said that "during the war years I was active in The Hague with an official position concerning familiar Dutch paintings." Eduard Plietzsch, ". . . *heiter ist die Kunst": Erlebnisse mit Künstlern und Kennern* (Gütersloh: Bertelsmann, 1955), 107.

159 Kajetan Mühlmann, *Sichergestellte Kunstwerke in der besetzten niederländischen Gebieten* (The Hague: Reichskommissariat Niederland, 1943). The catalog is in RIOD, Doc. II, 685 B, box 421, and in NA, 260/182.

160 NA, RG 260/486, Mühlmann, "Bericht über die Sammlung Mannheimer," 18 November 1947. This deal, which was brokerd by Alois Miedl, was paid for with funds provided by Seyss-Inquart. See also NA RG 260/435, Mühlmann statement, n.d., point 7. Nicholas, *Rape of Europa*, 111–14, 422–23.

161 Faison, *CIR No. 4*, 45.

162 Although nearly all of the Dienststelle Mühlmann's records were burned in The Haag toward the end of the war, certain documents and a accounts book survived. Van der Leeuw, *Dienststelle Mühlmann*, 5.

163 Kurz, *Kunstraub in Europa*, 256. The crucial orders were Verordnung no. 189/1940 of 8 August 1941, which applied to securities, cash, and bank holdings, and Verordnung no. 58/1942 of 21 May 1942, which applied to jewelry and art.

164 Note that Lammers explicitly claimed the "Reservation of the Führer" in a November 1940 decree, while Göring used his influence for a less official kind of preferential treatment. Faison, *CIR No. 4*, 7. Göring's acquisitions from Mühlmann are also documented in RIOD, Archive, No. 211, boxes 1–3.

165 Vlug, *Report on Objects Removed to Germany*, 49–148.

166 Ibid., 52.

167 NA, RG 260/435, Mühlmann interview by Estreicher and Taper, 20 August 1947.

168 NA, RG 260/483, Mühlmann memorandum, 15 December 1942; and ibid., "Auszug aus dem Diensttagebuch des Herrn Generalgouverneurs vom 13 July 1943." Also, Haase, *Kunstraub*, 94–95, 184; and NA R6 260/435, Mühlmann interview by Estreicher and Taper, 20 August 1947.

169 Charles de Jaeger, *The Linz File: Hitler's Plunder of Europe's Art* (Exeter: Webb & Bower, 1981), 91–92. The album listed the origins of the works (in many cases they came from Jewish owners), and this proved very incriminating after the war.

170 Henrietta von Schirach, *Der Preis der Herrlichkeit* (Wiesbaden: Limes Verlag, 1956), 220.

171 Ibid., 253.

172 Hilde Mühlmann, interview with author, 7 June 1999, Kammer am Attersee.

173 Vlug, *Report on Objects Removed to Germany*, 12, 101.

174 Ibid., 63.

175 See the 30 April 1945 report of OSS chief William Donovan, in Oliver Rathkolb, ed., *Gesellschaft und Politik am Beginn der Zweiten Republik: Ver-*

trauliche Berichte der US-Militärad-
ministration aus Österreich 1945 in
englischer Originalfassung (Vienna:
Böhlaus, 1985), 217. Kaltenbrunner
was friends with other important fig-
ures in the arts administration, includ-
ing Fritz Dworschak, the director of
the Kunsthistorisches Museum in
Vienna. See NA, RG 239/26, OSS
Research and Analysis Biographical
Report, Fritz Dworschak, 17 April
1944.

176 See the testimony of Alfons Walde in
a Kitzbühel court on 27 March 1947.
He tells of Skorzeny and 3,000 SS
men in a *Sprengkommando* whom
Mühlmann supposedly helped thwart
in the Tyrol. He also claims that
Mühlmann freed Göring from SS
guards by invoking the authority of
Field Marshal Kesserling. DÖW,
Vienna, Mühlmann file, Walde's testi-
mony, 27 March 1947.

177 DÖW, Vienna, Mühlmann file,
Mühlmann testimony, 30 October
1946. Also NA, RG 260/435, August
Prossinger, synopsis of interview with
Mühlmann, 17 July 1947.

178 IfZG, Munich, Nuremberg Trial docu-
ment, 3042–PS, Mühlmann's Eidliche
Erklärung, 19 November 1945.

179 Höttl said that Mühlmann knew of
the death camps and pointed to the
latter's close friendship with Globoc-
nik, who oversaw these facilities
(Operation Reinhard) from May 1942
until August 1943. Wilhelm Höttl,
interview with author, 15 August
1998, Altaussee.

180 These and other claims of helping
individuals are repeated in NA, RG
260/435, Mühlmann's interview with
Estreicher and Taper, 20 August 1947.
This file also contains a series of let-
ters from individuals who claimed
that Mühlmann helped save them
from persecution.

181 Vlug, *Report on Objects Removed to
Germany*, 12.

182 DÖW, Vienna, Mühlmann file, CIC
agreement with the Austrian Govern-
ment, 26 October 1946.

183 Haase, *Kunstraub*, 59.

184 Robert Edwin Herzstein, *Waldheim:
The Missing Years* (New York: Arbor
House, 1988), 190.

185 DÖW, Vienna, Mühlmann file, Drech-
sler to Borutik of the Landesgericht
für Strafsachen Wien, 14 August
1951.

186 Günter Bischof, "Die Instrumental-
isierung der Moskauer Erklärung nach
dem 2. Weltkrieg," *Zeitgeschichte* 20
(November/December 1993):
345–66.

187 *Hochverratsprozess gegen Dr. Guido
Schmidt*, 58–59. In the denazification
trial, Schmidt was first convicted
(declared "burdened"), then cleared
on appeal.

188 This innocence is maintained in NA,
RG 260/435, Mühlmann's interview
with Estreicher and Taper, 20 August
1947.

189 Vollnhals, ed., *Entnazifizierung*, 237.
By 1947, the number of those
detained in camps had been reduced
by almost half, but the facilities were
still large operations.

190 NGA, MSS8 (Parkhurst Papers), box
4, Headquarters Seventh Army, Judge
Advocate Section, 30 August 1945.
DÖW, Vienna, Mühlmann file, Alfons
Walde's testimony, 27 March 1947.

191 DÖW, Vienna, Mühlmann file, Karl
Gruber interrogation, 15 November
1947.

192 Note that this admission came in a
libel case against a newspaper. For an
account of Gruber's *Ehrenbeleidigungs-
prozess* against the *Tagblatt am
Montag*, see the *Salzburger
Nachrichten* 67 (21 March 1950), 4.

193 Herzstein, *Waldheim*, 167.

194 Friedrich Schwind, to take another
relevant example, "was allowed to
emigrate to South America after
telling the Americans some of the
truth about the SS treasure hoards."
Magnus Linklater, Isabel Hilton, and
Neal Ascherson, *The Nazi Legacy:
Klaus Barbie and the International Fas-
cist Connection* (New York: Holt, Rine-
hart & Winston, 1984), 135–36.

195 Wilhelm Höttl, interviews with author, Altaussee, 15 August 1998 and 6 June 1999.

196 Sterling Callisen to William Casey, 24 March 1945. Document provided to the author by the family of Sterling Callisen.

197 Department of the Army (FOIA), document titled "Rogues Gallery #35," n.d.

198 Information provided to author by S. Lane Faison, 20 January 1995.

199 Linklater, Hilton, and Ascherson, *The Nazi Legacy*, 135.

200 NA, RG 260/486, H. J. Stack (a Dutch official working on restitution) to Herbert Leonard (MFA & A), 14 October 1947.

201 Department of the Army (FOIA), document titled "Rogues Gallery #35," n.d.

202 Safrian, *Eichmann-Männer*, 321–25.

203 DÖW, Vienna, Mühlmann file, Maximilian Machalski in Warsaw, appeal of 18 February 1949.

204 DÖW, Vienna, Mühlmann file, Tiefenbrunner to Körner, 17 August 1951. Hilde Mühlmann, interview with author, 7 June 1999, Kammer am Attersee. See also NA, RG 260/435, Mühlmann statement, 2 September 1947.

205 DÖW, Vienna, Mühlmann file, Drechsler for the Bundesminister für Justiz to Landesgericht für Strafsachen Wien, 14 August 1951.

206 Bruno Lohse, interview with author, 10 August 1998, Munich.

207 Wilhelm Höttl, interviews with author, Altaussee, 15 August 1998 and 6 June 1999.

208 DÖW, Vienna, Mühlmann file, Tiefenbrunner to Körner, 17 August 1951.

209 "Vermögensverfall für Bilderkäufer des 'Reichsmarschalls' beantragt," in *Wiener Kurier* (28 July 1952). Note that Mühlmann's own art collection is described as consisting of a "few unimportant pictures" (but this speaks only to the works that were seized).

210 Vlug, *Report on Objects Removed to Germany*, 76, 94–96. Fifteen works, including two Cranachs, were found in Kammer. NGA, MSS 8, Parkhurst Collection, box 4, Headquarters of Seventh Army, Judge Advocate Section, Report of Investigation of Possible War Crimes, 30 August 1945. The reports note that Mühlmann asked Herbert Huber, Fritz Daghofer, and other friends to store artworks.

211 Ibid.

212 Wilhelm Höttl, interviews with author, Altaussee, 15 August 1998 and 6 June 1999. Note that there is no extant documentation proving that Riefenstahl purchased art from Mühlmann (although her friend, filmmaker Luis Trenker, was a client). See NA, RG 260/435.

213 DÖW, Vienna, Mühlmann file, Zeugenvernehmung of Josef Mühlmann, 2 September 1957. Note that in this document, Josef Mühlmann places his half brother on the nearby Ammersee.

214 DÖW, Vienna, Mühlmann file, Hilde Mühlmann to the Landesgericht in Vienna, 12 March 1960.

215 Vlug, *Report on Objects Removed to Germany*, 95.

216 Stiefel, *Entnazifizierung in Österreich*, 89.

217 See the report of Hermann Einziger, 17 January 1963 (provided to the author by Simon Wiesenthal). Josef Mühlmann died in June 1972. There was no mention of his wartime activities in any of the published obituaries.

218 Josef Mühlmann, *Franz Xäver Gruber: Sein Leben* (Salzburg: Residenz Verlag, 1966). Gruber wrote Christmas songs. Salzburg Landesarchiv, Josef Mühlmann Nachlass, for the research for this and other projects.

219 The portraits are by Felix Harta, Anton Faistauer, and Sergius Pauser (the latter was a leading painter during the Third Reich). Information provided to the author by the Salzburg painter and restorer Annemarie Fiebich-Ripke, letter of 20 November 1993. See also Gerhard Plasser, *Residenzfähig: Sammlungsgeschichte der*

Residenzgalerie Salzburg, 1923–1938 (Salzburg: Residenzgalerie Salzburg, 1998).

220 NA, RG 260/435, Mühlmann interview by Estreicher and Taper, 20 August 1947.

221 Hanisch, *Herrschaft in der Provinz*, 338. Hilde Mühlmann, telephone interviews with author, 26 October 1998 and 1 April 1999.

222 Niels von Holst, *Creators, Collectors, Connoisseurs: The Anatomy of Artistic Taste from Antiquity to the Present Day* (New York: Putnam, 1967).

223 NA, RG 239/9, Paul Sachs, in consultation with J. Rosenberg and G. Swarzenski, "Notes on Cooper List of German Art Personnel," 22 March 1945.

224 Holst, *Die Deutsche Bildnismalerei zur Zeit des Mannerismus* (Strassbourg: J. H. E. Heitz, 1930). Part of the series Studien zur Deutschen Kunstgeschichte. Note also that Holst wrote for the promodernist journal *Kunst der Nation*. See his article "Deutsche Kunst am Pranger vor 100 Jahren" in *Kunst der Nation* (15 December 1933) cited in Germer, "Kunst der Nation," 35.

225 BDC, Holst file, Alfred Kraut to Holst, 27 August 1941.

226 Harald, *"Tanz mir den Hitler,"* 25.

227 BSGS, file 1760, Holst to Buchner, 20 March 1937, where he seeks photographs of the Alte Pinakothek for a part of the pavilion concerning German museums.

228 BSGS, file 699, Holst circular, 1 August 1940.

229 Holst was made a member of the Parity Commission (also known as the Baltic German Art Commission) that met in 1940. BDC, Holst file, Sievers' memorandum, 1 February 1940; and ibid., Holst to Sievers, 6 May 1941.

230 Ibid., Holst to Sievers, 6 May 1941.

231 Ibid., Holst, "Kurzer Gesamtbericht," 24 June 1941. The list was called the "Verzeichnis deutscher Kunstwerke in

der Sowjetunion." Despite the preparation of the two lists, Holst did not succeed in purchasing artworks from the Soviets (although Lenin and Stalin had both earlier sold off significant parts of the nation's artistic holdings). Akinsha and Kozlov with Hochfield, *Beautiful Loot*, 41.

232 BDC, Holst file, Himmler to Sievers, 1 February 1940.

233 Another example of scholars who conducted research with some expectation of future property claims is the Publikationsstelle Berlin-Dahlem. Heuss, "Kunstraub der Nationalsozialisten," 33.

234 BDC, Holst file (Ahnenerbe), Himmler (im Auftrag Dr. Walter) to Sievers, 13 December 1940. One letter in Holst's BDC file came from Himmler, who approved Holst's suggestion to store Latvian artworks in a Danzig museum and books in a Posen depot.

235 The Soviets, for example, handed over museum quality silver pieces from Latvia to the Germans in 1940. BDC, Holst file, Holst, "Kurzer Gesamtbericht," 24 June 1941.

236 Ibid., Holst, "Kurzer Gesamtbericht," 24 June 1941.

237 Ibid.

238 BA, R 6/170, Bl. 12, Posse to Bormann, 22 September 1941.

239 Ibid., Bl. 13, Bormann order, 26 September 1941. Also Hartung, *Raubzüge in der Sowjetunion*, 10.

240 BA, R 6/170, Bl. 12, Posse to Bormann, 22 September 1941.

241 Ibid., Bl. 22, Rosenberg to Heydrich, 13 October 1941.

242 General Wagner at the Führer headquarters had written Rosenberg to arrange a "delineation of areas of jurisdiction." Ibid., 32–33, Wagner to Rosenberg, 25 October 1941.

243 For examples of Holst reporting on the removal of artworks, see BDC, Holst file, Sievers's memorandum to file, 29 October 1941; and ibid., Sievers' memorandum to file, 30 March 1940.

244 Heuss, "Kunstraub der Nationalsozial-
 isten," 37, 43.
245 GSAPK, I HA 92 Rave Mappe I/4,
 Paul Rave, "Kriegschronik der Berliner
 Museen," May 1946.
246 Ibid.
247 Ibid.
248 BDC, Holst file, Questionnaire for the
 Reichsschrifttumskammer, n.d.
249 Holst, *Die Kunst der Baltenlandes im
 Lichte neuer Forschung* (Munich: E.
 Reinhardt, 1942). Also *Baltenland* 37
 (1943).
250 Holst, *Danzig—ein Buch der Erin-
 nerung* (Hameln: F. Siefert, 1949);
 Breslau—ein Buch der Erinnerung
 (Hameln: F. Siefert, 1950); and *Riga
 und Reval—ein Buch der Erinnerung*
 (Hameln: F. Siefert, 1952).
251 Niels von Holst, *Der Deutsche Ritter-
 orden und seine Bauten: von Jerusalem
 bis Sevilla* (Berlin: Gebrüder Mann,
 1981). Note that Holst resumed his
 career as scholar after the war first by
 writing as a journalist: for example, he
 penned an article for the *Neue Zeitung*
 titled "Asyl verfemter Kunst," in which
 he discussed the activities of the Basel
 Museum officials who bought purged
 modern works at the Lucerne auction
 of June 1939. Getty Center, Arntz
 papers, box 23, report of Ernst Reutti,
 n.d.
252 Nicholas, *Rape of Europa*, 120, 332.
 For his language skills, see BDC, Bun-
 jes file, Kartei des SS-Hauptamt.
253 Among Bunjes's publications while
 working for the Rhineland Provincial
 Administration are "Pläne und
 Ansichten zur Baugeschichte der
 Stadt Trier im Mittelalter," *Trier Zeit-
 geschichte* 11 (1936); *Die Steinernen
 Altaraufsätze der hohen Gotik und der
 Stand der gotischen Plastik in der Ile-de-
 France um 1300* (Marburg: Wit-
 tich'sche Hofbuckdruckerei, 1937);
 "Die Skulpturen der Liebfraukirche in
 Trier," *Trier Zeitgeschichte* 12 (1937);
 Die Kunstdenkmäler der Rheinprovinz
 (1937); Römische und gotische
 Baukunst im Trierer Raum," *Rheinis-
 che Vierteljahresblätter* 8 (1938); and

 *Die Kirchlichen Denkmäler der
 Stadt Trier* (Düsseldorf: L. Schwann,
 1938, reprinted in 1981 by the
 Akademischer Buchhandlung in Düs-
 seldorf).
254 BDC, Bunjes file, W. Busch to Rektor
 of the Friedrich-Wilhelm University
 Bonn, 4 January 1939.
255 BDC, Bunjes file, for his application to
 the SS for financial support, June 1938.
256 BDC, Bunjes file, Generalleutnant
 Kommandant von Gross-Paris,
 Abschluss Beurteilung von Hermann
 Bunjes, 8 August 1942. See more gen-
 erally, NA, RG 239/6, MFA & A
 Branch, "The Bunjes Papers: German
 Administration of the Fine Arts in the
 Paris Area during the First Year of the
 Occupation," February 1945.
257 Wolff-Metternich himself is a fascinat-
 ing and complex figure. He was fired
 in 1942, supposedly for resisting
 Göring's and Himmler's rapacious
 policies, and provided detailed testi-
 mony (much of it self-serving) about
 the Nazis' *Kunstraub* to the Allies after
 the war. His dismissal provided the
 foundation for the revival of his career
 after the war, and he served as provin-
 cial curator of Rhineland Westphalia
 where he worked closely with the
 Americans restituting looted and dis-
 placed art. Wolff-Metternich's Party
 membership is documented in his
 BDC file. Comparable figures are
 Leopold Reidemeister, who served as a
 kunstschutz officer in Italy and then
 later became general director of the
 Berlin State Museums and Bernhard
 von Tieschowitz, Wolff-Metternich's
 successor as head of the Kunstschutz
 in France who, after the wra, worked
 for the West German Foreign Office
 helping restitute art. Margot Günther-
 Hornig, *Kunstschutz in den von
 Deutschland besetzten Gebieten,
 1919–1945* (Tübingen: Institut für
 Besatzungsfragen, 1958).
258 Nicholas, *Rape of Europa*, 120.
259 Bunjes cited by Buomberger, *Kun-
 straub—Raubkunst*, 31.
260 BDC, Bunjes file. Also BA, NS 30/2,

Bl. 20, Rosenberg to Bormann, 13 November 1940.

261 Plaut, *CIR No. 1*, 18 and Attachment 9. Also Nicholas, *Rape of Europa*, 137, 177.

262 During the war Bunjes published several books, including *Les Chateux de la Loire* (Paris: 1943) and *L'Architecture allemande du Moyen-âge* (Paris: 1944); as well as numerous articles, including "Die Baukunst des Mittelalters in den Niederlandern," *Jahrbuch des Rheinischen Geschichtlichen Verlag* (1941), and "Der gotische Lettner der Kathedrale von Chartres," *Wallraf-Richartz Jahrbuch* (1943).

263 The German name is the Kunsthistorisches Forschungsstätte. Bouresch, "Sammeln Sie Also Kräftig," 60.

264 BDC, Bunjes file, Generalleutnant Kommandant von Gross-Paris, Abschlus Beurteilung von Hermann Bunjes, 8 August 1942.

265 BDC, Bunjes file, Alfred Stange to Rust, 7 May 1944.

266 Nicholas, *Rape of Europa*, 134. Rousseau, *CIR No. 2*, 20–21.

267 Nicholas, *Rape of Europa*, 132.

268 Plaut, *CIR No. 1*, 7.

269 BDC, Bunjes file, Bunjes to Sievers, 16 October 1941. Also BDC, Bernhard von Tieschowitz file, Sievers-Tieschowitz correspondence, 24 April 1941 to 13 April 1943. They discuss commissioning a painter named Jeschke to copy the tapestry.

270 For the massive correspondence of the SS scholars devoted to the Bayeux Tapestry, see BDC, Ahnenerbe file, 259 II. Lynn Nicholas also cites relevant documents in the Archives Nationales de France (AJ40/573) in *Rape of Europa*, 285 and 458.

271 BA, NS 21/807, letter to Sievers from unidentifiable member of the SS, 19 December 1944.

272 Lust, "Spoils of War in Belgium," 60.

273 Nicholas, *Rape of Europa*, 293.

274 BA, NS 21/807, Bunjes to Sievers, 21 February 1945.

275 BDC, Bunjes file, *Lebenslauf*, 15 May 1944.

276 NA, RG 239/7, Joint Interview with Lohse-Scholz, 16 July 1945.

277 Nicholas, *Rape of Europa*, 134.

278 Ibid., 332.

279 GSAPK, I HA 92 Rave Mappe I/4, Paul Rave, "Kriegschronik der Berliner Museen," May 1946. Rave also notes others who committed suicide who did not technically work for museums, including Generaldirektor Krüss of the Berlin State Library.

280 Ibid. See also *ARTnews* files, memorandum of Hans K. Röthel of BSGS at meeting of museum officials in Dresden, October 1947.

281 Among the art historians and cultural historians who played a role in the plundering programs, one finds (besides those discussed in this chapter) Friedrich Barge, Walter Borchers, Karl Heinz Classen, Dr. Dannehl, Bernhard Degenhart, Helga Eggemann, Richard Ernst, Dr. W. Esser, Dr. Hans Gerhard Evers, Dagobert Frey, Walter Frodl, Dr. Holzmeier, Herbert Jankuhn, Heinrich Jershel, Franz Kieslinger, Karl Kraus, Dr. Werner Kudlich, Friedrich Kuntze, Peter Paulsen, Werner Rosskamp, Günther Schiedlausky, Alfred Stange, Dr. Strenger, Bernhard von Tieschowitz, Oswald Trapp, Asmus Freiherr von Troschke, and Hans Ulrich Wirth.

282 OFD, binder XA/127: a letter from Zabransky to Reimer, 18 September 1943. James Plaut, *Detailed Interrogation Report No. 5: Günther Schiedlausky* (Washington, DC: OSS, ALIU, 15 August 1945).

Chapter Five

1 Steinweis, *Art, Ideology, and Economics*, 46.

2 Ibid., 44–45.

3 Ibid., 46.

4 Ibid., 47.

5 Ibid., 7.

6 Wulf, *bildenden Künste*, 109. The breakdown given here is 10,500 painters and graphic artists; 3,200 sculptors, and 13,750 architects.

7 Steinweis, *Art, Ideology, and Economics*, 169.

8 Ibid., 7.

9 Ibid.

10 Ibid., 8–9.

11 O. K. Werckmeister, "Hitler the Artist," in *Critical Inquiry* 23 (Winter 1997), 270–97.

12 BA, R 2/26722, Bl. 5–6, for the 22 May 1934 law.

13 Frank Steele, "Die Verwaltung der bildenden Künste im 'New Deal' und 'Dritten Reich,'" in Berthold Hinz and Hans Mittig, eds., *Die Dekoration der Gewalt: Kunst und Medien im Faschismus* (Giessen: Anabas, 1979), 201.

14 Among those forced out of the Prussian Academy were Käthe Kollwitz and Heinrich Mann. Hildegard Brenner, *Ende einer bürgerlichen Kunst-Institution: Die politische Formierung der Preussischen Akademie der Künste ab 1933* (Stuttgart: Deutsche Verlags-Anstalt, 1972); and Monika Hingst, Marita Gleiss, and Christoph Martin Vogtherr, eds., *"Die Kunst hat nie ein Mensch allein besessen": Akademie der Künste, Dreihundert Jahre Hochschule der Künste* (Berlin: Henschel Verlag, 1996).

15 Roland, ed., *Banned and Persecuted*, 408.

16 Ibid., 404. Amtsgericht, Munich, Scholz file, Sund to Spruchkammer Augsburg-Göggingen, 29 January 1948.

17 The above noted are only a partial list of the most famous artists murdered by the Nazi regime. Christine Fischer-Defoy, "Artists and Institutions in Germany, 1933–1945," in Brandon Taylor and Wilfried van der Will, eds., *The Nazification of Art: Art, Design, Music, Architecture, and Film in the Third Reich* (Winchester: Winchester Press, 1990), 93.

18 "Memoiren. Breker: Lebender Leichnam," *Der Spiegel* 53, (28 December 1970), 80–81.

19 "Arno Breker wurde Mitläufer," *Augsburger Allgemeine Zeitung* (2 October 1948).

20 Arno Breker, *Schriften*, edited by Volker Probst (Bonn: Marco, 1983), 19.

21 Ibid.

22 Herbert Stabenow, "Arno Breker," in *Arno Breker* (Stuttgart: Galerie am Hauptbahnhof Günter Galetzki, 1965). Amtsgericht, Munich, Breker file, Bielefeld (Polizeibehörde Wuppertal) to Spruchkammer Donauwörth, 7 August 1947.

23 Laszlo Glozer, "Plastik im Dienst des Grossdeutschen Reiches: Arno Breker," in Karl Corino, ed., *Intellektuelle im Bann des Nationalsozialismus* (Hamburg: Hoffmann & Campe, 1980), 92.

24 Eduard Beaucamp, "Dienstbarer Athletiker: Arno Breker, der Bildhauer, wird neunzig," *Frankfurter Allgemeine Zeitung* 165, (19 July 1990), 27. For more on the tensions present at the Düsseldorf Academy, see Anja Hesse, *Malerei des Nationalsozialismus: Der Maler Werner Peiner, 1897–1984* (Hildesheim: Georg Olms, 1995), 20–27.

25 Rainer Maria Rilke, *Rodin* (1919; Paris: Editions du Courrier Graphique, 1926).

26 Stephanie Barron, "1937: Modern Art and Politics in Prewar Germany," in Barron, ed., *"Degenerate Art,"* 18. For Peiner, see Hesse, *Malerei des Nationalsozialismus*, and Davidson, *Kunst in Deutschland*, 385. For the purge of Willrich's *Spring Landscape*, see BSM/ZA, Spec. 29, Beiheft 2, Bd. 2, 195, "Verzeichnis der entarteten Kunstwerke des Reichserziehungsministerium."

27 Volker Probst, "Biographie chronologique d'Arno Breker," in Jacques Damase, ed., *Arno Breker: 60 ans de sculpture* (Paris: Jacques Damase, 1981), 207. Probst notes other evidence that suggest Breker's sympathy to modernism, from a portrait he did of Otto Dix to a memorable meeting with Alexander Calder in 1926. None of Breker's abstract pieces seem to have survived.

28 Volker Probst, *Der Bildhauer Arno*

Breker (Bonn: Galerie Marco, 1978), 14.

29 GESOLEI was an acronym for "Gesundheitspflege, soziale Fürsorge, und Leibesübungen" (healthcare, social welfare, and physical excercise). The exhibition took place in 1926. Winfried Nerdinger and Ekkehard Mai, eds., *Wilhelm Kreis: Architekt zwischen Kaiserreich und Demokratie, 1873–1955* (Munich: Klinkhardt & Biermann, 1994), 128, 134, 249.

30 Probst, *Der Bildhauer*, 14. Stabenow, "Arno Breker." In 1927 Kreis awarded Breker other commissions for the monuments in Budberg and and Kleve. See Magdalena Bushart, "Kunstproduzent im Dienst der Macht," in Magdalena Bushart, ed., *Skulptur und Macht: Figurative Plastik im Deutschland der 30er und 40er Jahre* (Berlin: Frölich & Kaufmann, 1983), 155.

31 "Lebender Leichnam," 80–81.

32 Stabenow, "Arno Breker." Dorothee Müller, "Ein deutscher Lieblingsbildhauer," *Süddeutsche Zeitung* 40 (17 February 1991), 14.

33 Walter Grasskamp, "The Denazification of Nazi Art: Arno Breker and Albert Speer Today," in Taylor and van der Will, eds., *The Nazification of Art*, 238. One of the first works exhibited by Breker in Flechtheim's gallery was a portrait bust of President Friedrich Ebert. His relationship with Flechtheim appears to have predated the stay in Paris: in a résumé from 5 February 1947, Breker claims to have been represented by the dealer in 1924. Amtsgericht, Munich, Breker file.

34 Flechtheim, for example, staged the exhibition *De Carpeaux à Breker* in 1930. Michele Cone, *Artists Under Vichy: A Case of Prejudice and Persecution* (Princeton: Princeton University Press, 1992), 159. Breker claims to have continued his business relationship with Flechtheim until the "Jewish laws" in the 1930s. Amtsgericht, Munich, Breker file, *Lebenslauf*, 5 Feb-

ruary 1947. For more on Flechtheim, who represented George Grosz, Paul Klee, and other modern artists, see Barbara McCloskey, *George Grosz and the Communist Party: Art and Radicalism in Crisis, 1918 to 1936* (Princeton: Princeton University Press, 1997), 106; and Kunstmuseum Düsseldorf, *Alfred Flechtheim*. Breker's connection to Flechtheim is ignored in this otherwise extensive catalog.

35 Probst, *Der Bildhauer*, 24. Note that this prestigious award had political ramifications: Breker, for example, described it as recognition from "the Brüning government." Amtsgericht, Munich, Breker file, *Lebenslauf*, 5 February 1947. Among the academy members who voted for him were Käthe Kollwitz, Fritz Klimsch, and Arthur Kampf. See the archives of the Preussische Akademie der Künste, 2.1/004, 2.1/005, 2.2/092, and 1268. See also Dietmar Schenk and Gero Seelig, "Die Deutsche Akademie in Rom: Felix Nussbaum und Arno Breker in der Villa Massimo 1932/33," in Hingst et al., eds., *"Die Kunst hat nie ein Mensch allein besessen,"* 433–37.

36 Beaucamp, "Arno Breker, der Bildhauer," *Frankfurter Allgemeine Zeitung* 165 (19 July 1990), 27.

37 Peter Adam, *Art of the Third Reich* (New York: Abrams, 1992), 196.

38 For the type of Fascist art that had the greatest influence on Breker, see Claudia Cavallar, "Monumentale Jämmerlichkeiten: Heldendenkmäler in Italien," in Jan Tabor, ed., *Kunst und Diktatur* (Vienna: Verlag Grasl, 1994), 668–81. More generally, see Marla Stone, *The Patron State: Culture and Politics in Fascist Italy* (Princeton: Princeton University Press, 1998); and Edward Tannenbaum, *The Fascist Experience: Italian Society and Culture, 1922–1945* (New York: Basic Books, 1972).

39 Jeanne Vronskaya, "Sculptor to the Third Reich," *Daily Telegraph Sunday Magazine* (1981). Schenk and Seelig, "Deutsche Akademie," 433.

40 Amtsgericht, Munich, Breker file, Werner Windhaus to Spruchkammer Donauwörth, 2 August 1948; ibid., Bertha Siemens to Spruchkammer Donauwörth, 16 July 1947.

41 Glozer, "Plastik im Dienst," 83.

42 Amtsgericht, Munich, Breker file, Werner Windhaus to Spruchkammer Donauwörth, 2 August 1948.

43 Stabenow, "Arno Breker."

44 Amtsgericht, Munich, Breker file, Bertha Siemens to Spruchkammer Donauwörth, 16 July 1947.

45 Speer, Inside the Third Reich, 124–25.

46 Amtsgericht, Munich, Breker file, Georg Kolbe to Spruchkammer Donauwörth, 16 July 1947.

47 Ibid., Breker file, Dirksen to Spruchkammer Donauwörth, 12 July 1947.

48 Breker interview of 16 April 1980 in Laurence Bertrand Dorléac, Histoire de l'Art: Paris, 1940–1944 (Paris: Publications de la Sorbonne, 1986), 417.

49 Breker to Fahrenkamp, 24 February 1938, reproduced in Klaus Staeck, ed., Nazi-Kunst ins Museum? (Göttingen: Steidl Verlag, 1988), 133.

50 BDC, Breker file, Party card file, n.d.

51 Ibid.

52 Arno Breker, Im Strahlungsfeld der Ereignisse: Leben und Wirken eines Künstlers (Preussisch Oldendorf: K. W. Schütz, 1972), 93.

53 Magdalena Bushart, "Überraschende Begegnungen mit alten Bekannten: Arno Brekers NS-Plastik in neuer Umgebung," in Berthold Hinz, ed., NS-Kunst: 50 Jahre danach, Neue Beiträge (Marburg: Jonas, 1989), 35, 51. Bushart, "Kunstproduzent," 156. Breker had also submitted entries for other projects, including the first competition for sculpture in the Third Reich—a monument to Richard Wagner in Leipzig in 1933.

54 An Italian sculptor won first prize, but some viewed this as a concession because they had fared poorly in the athletic events.

55 Amtsgericht, Munich, Breker file, Protokoll der öffentlichen Sitzung, 1 October 1948. Note that Breker fin-

ished the portrait bust in 1937 and the figure he created became among his best known, Prometheus. He was not paid for the first (he claims because Goebbels refused to accept the finished product in that it "unmasked" him), but received RM 12,500 from the RMVP for the second.

56 Amtsgericht, Munich, Breker file, Stührk to Spruchkammer, 5 August 1947. "Lebender Leichnam," 80–81.

57 Speer, Inside the Third Reich, 72.

58 Glozer, "Plastik im Dienst," 90. Breker, Im Strahlungsfeld, 94.

59 For the March 1939 trip to Italy, see Speer, Inside the Third Reich, 204. A detailed account of their activities can be found in the "Speerchronik" compiled by Rudolf Wolters in BA R 3/1735–1740. It details a trip they took together (eine Studienreise) to Paris from 29 September to 7 October 1941, as well as a visit together to the Führer Headquarters on 17 October. At the end of the month, Breker finished a bust of Speer.

60 See the incident in Paris in 1940 when Speer played a joke on Breker by having him picked up by the Gestapo. Van der Vat, The Good Nazi, 94.

61 D. Müller, "Ein deutscher Lieblingsbildhauer," 14.

62 Bedürftig and Zentner, eds., Encyclopedia, 12.

63 Scholz, "Vorschau auf Paris," n.p.

64 Bedürftig and Zentner, eds., Encyclopedia, 112. Also Bushart, "Kunstproduzent," 156. In terms of Breker's importance as an arbiter of official aesthetic policy, note that he served on many exhibition committees, including the Grosse Berliner Kunstausstellung 1934; he was a juror for the German artworks included in the 1937 Paris World Exposition and the first GDK in 1937; and he served as Kommissar for the exhibition of German sculpture in Poland in 1938. Amtsgericht, Munich, Breker file, Breker Lebenslauf, 5 February 1947.

65 Müller, "Eine deutscher Lieblingsbildhauer."

66 Hermand, *Old Dreams of a New Reich*, 233.

67 Grasskamp, "Denazification of Nazi Art," 242.

68 Hermand, *Old Dreams of a New Reich*, 233.

69 Speer, *Inside the Third Reich*, 110.

70 Amtsgericht, Munich, Breker file, Protokoll der öffentlichen Sitzung, 1 October 1948. Also Beaucamp, "Dienstbarer Athletiker."

71 Zentner and Bedürftig, eds., *Encyclopedia*, 304–5.

72 GSAPK, I HA Rep. 92, Kurt Reutti Nachlass, NL 1, Kurt Reutti, "Erinnerungen," 193.

73 Amtsgericht, Munich, Breker file, Albert Stenzel (BSUK) Gutachten, 16 January 1947.

74 Arno Breker, *Paris, Hitler, et Moi* (Paris: Plon, 1970), 165.

75 BDC, Breker file, Breker to Wolff, 29 August 1943.

76 BDC, Breker file. See, for example, a discussion of a commission to Breker to contribute to a "SS Ehrenmal," Wilhelm Vahrenkamp to Gottlob Berger, 29 December 1944. The file also contains a receipt for a drawing by Breker purchased by Himmler.

77 There were twelve artists on this list, which is rendered in German alternatively as *unersetzliche Künstler* or *unabkömmlich gestellt*.

78 *Münchener Neueste Nachrichten* 159 (7 June 1940).

79 "Arno Breker und Leonhard Gall—Vize-Präsidenten der Reichskammer der bildenden Künste ernannt," *Münchener Neueste Nachrichten* 97 (7 April 1941). In 1944, he was made the head of a Meisteratelier at the Prussian Academy and appointed a German academic senator. Breker had also been made a member of the Reich Cultural Senate in 1940. Merker, *bildenden Künste*, 130, 167, 308.

80 Vronskaya, "Sculptor to the Third Reich." Breker told American investigators after the war that he and Prince Philipp of Hesse had tried to prevent the *Degenerate Art Exhibition* in 1937,

but there is no corroborating documentation. NA, RG 260/86, "Curriculum Vitae of Prof. Breker," 5 February 1947.

81 Amtsgericht, Munich, Breker file, Speer "Affidavit," 27 August 1946.

82 Amtsgericht, Munich, Breker file, Konrad Hämmerling to Spruchkammer Donauwörth, 20 January 1947.

83 BA, R 3/1580, Bl. 9, Speer to Goebbels, 14 August 1941.

84 Goebbels, *Tagebücher* II/7, 509, 9 March 1943. The entry concerns selection to the Deutsche Akademie.

85 Breker interview of 16 April 1980 in Dorléac, *Histoire de l'Art*, 423.

86 Breker, *Schriften*, 67.

87 Ibid.

88 See Breker, *Paris, Hitler et Moi*; also Breker, *Im Strahlungsfeld der Ereignisse*.

89 "Arno Breker wurde Mitläufer."

90 Bushart, "Überraschende Begegnungen," 35. See BA, R 120/3460a, "Zusammenstellung der tatsächlichen Leistung bis März 1945." In addition to Haus Jäckelsbruch and adjoining studio, Breker was the recipient of RM 1,099,000 capital from the General Bauinspektor, Berlin (GBI), to establish and then expand the Arno Breker Works a few kilometers away in another part of Wriezen. Bushart, "Kunstproduzent," 157.

91 Speer's staff calculated that 30 percent of the payments went for "operating costs," while Speer wanted that figure raised to 50 percent. BA R 43II/986, Bl. 51–55, GBI memorandum, January 1942.

92 BA, R 120/3460a, Bl. 13.

93 Henry Picker, ed., *Hitlers Tischgespräche im Führerhauptquartier, 1941–1942* (Bonn: Athenäum Verlag, 1951), 391. There were other discussions about helping Breker avoid taxes. See Speer's efforts in BA R 43II/986, Bl. 52–55.

94 BA, R 43 II/986, Bl. 51.

95 Amtsgericht, Munich, Breker file, *Klageschrift*, 21 July 1948; and ibid., Protokoll der öffentlichen Sitzung,

1 October 1948. The prosecutor
Dr. Frey puts Breker's income for the
Berlin commissions alone at RM 3.2
million. In 1946, Breker himself
reported income levels as follows: RM
45,622 in 1937; RM 99,087 in 1938;
RM 566,023 in 1942; RM 660,239 in
1943; RM 766,544 in 1944. Ibid.,
Anhang zu den Einkommens-Fragen,
14 June 1946.

96 Spielvogel, *Hitler and Nazi Germany*,
183.

97 Konrad Hämmerling, "Der 'Michelan-
gelo' des Dritten Reichs," *Berliner Tele-
graph* 176 (2 November 1946), 3.
Amtsgericht, Munich, Breker file,
Konrad Hämerling to Spruchkammer
Donauwörth, 20 January 1947.
Breker, *Im Strahlungsfeld*, 297. For the
city providing the Berlin residence, see
BA, R 120/1641, Rudolf Wolters,
"Speerchronik," 23 July 1938. This file
also notes how Breker had previously
worked in an atelier in Berlin on the
Frauenhoferstrasse, which was evi-
dently given to him in 1937. Adam,
Art of the Third Reich, 199.

98 Amtsgericht, Munich, Breker file,
Windhaus to Spruchkammer
Donauwörth, 2 August 1948. Ibid.,
Dr. Kreisselmeyer quoted in Hämmer-
ling, "'Michelangelo' des Dritten
Reichs," 3.

99 Amtsgericht, Munich, Breker file,
Tamms to Spruchkammer
Donauwörth, 27 August 1947. Ibid.,
Windhaus to Spruchkammer
Donauwörth, 2 August 1948.

100 See Breker's BDC file, for the "Certifi-
cate of Gift" from Hitler to Breker, 19
July 1940. Breker, *Im Strahlungsfeld
der Ereignisse*, 100.

101 In the sculpture garden were Rodin's
Walking Man and *The Thinker*. For an
account of conditions at Jäckelsbruch,
see IfZG, Munich, ZS 2410, account
of Marta Mierndorff, "Der Untergang
der Steinbildhauerwerkstätten Arno
Breker GMBH in Wriezen/Oder." For
a discussion of the castle after the war,
with damaged sculptures scattered
about, see GSAPK, I HA Rep. 92,

Reutti Nachlass, NL 1, Kurt Reutti,
"Erinnerungen," 192. See also Akin-
sha, Kozlov, with Hochfield, *Beautiful
Loot*, 62.

102 Amtsgericht, Munich, Breker file,
Hämmerling to Spruchkammer
Donauwörth, 20 January 1947. BA, R
120/1264, GBI Aktenvermerk, 22
January 1943. Bushart notes that the
renovations, which were undertaken
under the direction of the GBI, cost
more than RM 500,000. Bushart,
"Kunstproduzent," 157. Probst,
"Biographie chronologique d'Arno
Breker," 208. Hämmerling,
"'Michelangelo' des Dritten Reichs,"
3.

103 BA, R 120/3946.

104 Amtsgericht, Munich, Breker file,
Windhaus to Spruchkammer
Donauwörth, 2 August 1948, where
his defense claims that he rented the
Dahlem facility, bought the *Landhaus*
in 1939 for RM 33,000, and then paid
for the atelier himself, although Speer
did help him procure the materials.
He claims to have turned down an
offer of an estate (*Gutshof*).

105 Amtsgericht, Munich, Breker file,
Breker, *Lebenslauf*, 5 February 1947.

106 Konrad Hämmerling, "Die Arno-
Breker-Werke GmbH," *Berliner
Telegraf* 182 (9 November 1946), 3.

107 Ibid. Also Amtsgericht, Munich,
Breker file, Tamms to Spruchkammer
Donauwörth, 27 August 1947.

108 IfZG, Munich, ZS 2410, account of
Marta Mierendorff. Hämmerling, "Die
Arno-Breker-Werke," 3.

109 Cone, *Artists Under Vichy*, 160; and
Adam, *Art of the Third Reich*, 199.

110 IfZG, Munich, ZS 2410, account of
Marta Mierendorff.

111 BDC, Breker file, Breker to Wolff, 20
November 1941. He notes how he
had talked to Himmler at the Führer
Headquarters and discusses the "labor
already provided by the Reichsführer-
SS."

112 IfZG, Munich, ZS 2410, account of
Marta Mierendorff. Hämmerling, "Die
Arno-Breker-Werke," 3. NA, RG

260/86, "Curriculum Vitae of Prof. Breker," 5 February 1947.

113 Amtsgericht, Munich, Breker file, Breker, *Lebenslauf*, 5 February 1947.

114 IfZG, Munich, ZS 2410, account of Marta Mierendorff.

115 Ibid.

116 Ibid. Note that "jazz" was a broad category, entailing very different kinds of music, and that it had different implications for various Nazi leaders. See Michael Kater, *Different Drummers: Jazz in the Culture of Nazi Germany* (Oxford: Oxford University Press, 1992).

117 Amtsgericht, Munich, Breker file, Heiliger to Spruchkammer, 10 August 1947. Ibid., Hämmerling to Spruchkammer Donauwörth, 20 January 1947.

118 Breker interview of 16 April 1980 in Dorléac, *Histoire de l'Art*, 421.

119 CDJC, LXXI-98, Karl Theodor Zeitschel to Gesandter Rahn, 3 June 1942.

120 Ibid. For more on the wartime seizure of residences in Paris, as well as the postwar disposition of many of these properties, see Brigitte Vital-Durand, *Domaine Privé* (Paris: Éditions Générales First, 1996).

121 "Buffeted by the Winds of History, Manor's Fate Remains Undecided," *The Week in Germany* (24 January 1992), 7. Alford, *Spoils of World War II*, 69–70.

122 For an account of a visit to Maxim's, see Breker, *Im Strahlungsfeld*, 252. For purchasing artworks, see Nicholas, *Rape of Europa*, 155.

123 GSAPK, I HA Rep. 92, Reutti Nachlass, No. 6, Rose Valland to Kurt Reutti, 6 April 1948.

124 NGA, MSS 3 (Faison Papers), box 4, Douglas Cooper, *Accessions to German Museums, and Galleries during the Occupation of France* (Schenker Papers, Part I), 5 April 1945.

125 NA, RG 260/86, Lt. Hauschild of MFA & A to Capt. Hathaway, October 1945.

126 NA, RG 239/7, report on Bunjes

quoting Gisela Limburger, 2 July 1945.

127 Germanisches Nationalmuseum, Nuremberg, Posse Nachlass, ZR ABK 2387, *Tagebuch, 1936–1942*, entry from 16 February 1942.

128 BAL, R 5001/1003, Bl. 38–48, for documents April-June 1938 concerning the exhibition of French sculpture in Germany, sponsored by the Deutsch-Französische Gesellschaft.

129 See, for example, Goebbels, *Tagebücher* II/2, 396, 30 November 1941 and II/3, 317, 15 February 1942. For Breker and Bunjes, see RIOD, Doc. II, 685 B, List of Personnel in Art World, n.d.

130 For Breker and l'Institut Allemand, which was headed by Karl Epting, see Breker's interview of 16 April 1980 in Dorléac, *Histoire de l'Art*, 417. For the catalog, see Albert Buesche, *Arno Breker: Einführung und Geleit durch die Ausstellung in der Orangerie des Tuileries* (Paris: Kraft durch Freude, 1942).

131 BAL, R 5001/1003, Bl. 214–30.

132 BAL, R 5001/1003, Bl. 227, Stoehr to Biebrach (RMVP), 23 August 1941.

133 Amtsgericht, Munich, Breker file, Hoffmann to Breker, 26 and 27 June 1944. The letters cite bills for over ffrs. 3,000,000 from Rudier from 23 April 1943. Breker, *Im Strahlungsfeld*, 335.

134 Cone, *Artists Under Vichy*, 162. Yvon Bizardel, *Sous l'occupation: Souvenirs d'un conservateur de musée, 1940–1944* (Paris: Calman-Levy, 1964), 107.

135 Dorléac, *Histoire de l'Art*, 422.

136 Ibid.

137 Glozer, "Plastik im Dienst," 87.

138 Breker, *Paris, Hitler et Moi*, 147; Dorléac, *Histoire de l'Art*, 92, 422.

139 NA, RG 260/169, Hermann Bunjes to Walter Hofer, 8 March 1944.

140 For the attendance figure, see Probst, "Biographie chronologique d'Arno Breker," 210. Because Maillol was a friend of Breker, it is not clear how neutral he really was (the same would apply to the positive comments of

Despiau, Cocteau, and others). James Fenton evinces some skepticism about Maillol's remarks in "The Secrets of Maillol," *New York Review of Books* (9 May 1996), 55.

141 "Le 'Sculpteur' oeuvre les perspectives," *La Gerbe* (28 May 1942); and Robert Scholz, "Vorschau auf Paris," n.p. For more on the French press coverage, see Cone, *Artists Under Vichy*, 162–63.

142 Bushart, "Kunstproduzent," 157. Thomae, *Propaganda-Maschinerie*, 117, 538.

143 Breker interview of 16 April 1980 in Dorléac, *Histoire de l'Art*, 418.

144 Cone, *Artists Under Vichy*, 155–61. For the French artists who participated in the trip, including Despiau, Vlaminck, Derain, and Belmondo, see Dorléac, *Histoire de l'Art*, 94–95.

145 Nicholas, *Rape of Europa*, 182. Note that Despiau published a flattering book on Breker's art during the war (a copy of which was found in Breker's studio during the war according to the inscription of MFA & A officer Charles Fleischner in the volume in Harvard University's Fine Arts Library). Charles Despiau, *Arno Breker* (Paris: Flammarion, 1942).

146 Cone, *Artists Under Vichy*, 157.

147 Breker, *Paris, Hitler, et Moi*, 170.

148 BA, R 3/1578, Bl. 147, Speer to Bruneton, 16 October 1944.

149 Ibid., 151.

150 Breker, *Schriften*, 67.

151 Amtsgericht, Munich, Breker file, Gotthold Schneider to Spruchkammer, 16 August 1947. Ibid., Protokoll der öffentlichen Sitzung, 1 October 1948.

152 Amtsgericht, Munich, Breker file, letters to Spruchkammer Donauwörth from Heinrich Peter Suhrkamp (5 August 1947), Jean Walter (27 December 1946), and Willy Schwinghammer (10 September 1947). Breker provided American investigators with lists of fifty-one individuals whom he claimed to have helped in various ways, including release from concentration camps and exemption from

military service. NA, RG 260//86, "Curriculum Vitae of Prof. Breker," 5 February 1947.

153 Cone, *Artists Under Vichy*, 161. Breker interview of 16 April 1980 in Dorléac, *Histoire de l'Art*, 420. Amtsgericht, Munich, Breker file, Dina Vierny statement, 27 February 1947. Here she reports a second intervention when Breker helped her gain release from the Gestapo's Parisian headquarters on rue des Saussais in November 1943. For more on Vierny, see Vicki Goldberg, "A Sculptor's Obsession, A Model's Devotion," *New York Times* (11 August 1996), H 31.

154 Breker, *Schriften*, 67.

155 Breker interview of 16 April 1980 in Dorléac, *Histoire de l'Art*, 423. Here he states that a second discussion with Hitler was needed to help Picasso.

156 Breker, *Schriften*, 99.

157 BA, NS 8/243, Bl. 110, Scholz, "Bericht für den Reichsleiter: Besichtigung der Ausstellung 'Junge Kunst im Deutschen Reich' in Wien," 24 March 1943. Goebbels, *Tagebücher* II/7, 402, 23 February 1943.

158 In his denazification trial, Breker listed those whom he claims to have aided. Amtsgericht, Munich, Breker file, *Lebenslauf*, 5 February 1947.

159 "Lebender Leichnam," 80–81.

160 For works taken from the Kautzchensteig warehouse, see NA, RG 260/86, "Extracts from 'Curriculum Vitae' of Prof. Breker," 5 February 1947. Bushart, "Überraschende Begegnung," 39–40. Eberswalde was originally one of the depots for art; witnesses report that the sculptures appeared in the early 1950s.

161 Some scholars have claimed that the Soviets destroyed a large number of Breker's works that fell into their hands, although this is far from certain. Probst, *Der Bildhauer*, 28.

162 IfZG, Munich, ZS 2410, account of Marta Mierendorff.

163 Amtsgericht, Munich, Breker file, Windhaus to Spruchkammer Donauwörth, 2 August 1948.

164 IfZG, Munich, ZS 2410, account of Marta Mierendorff.

165 Breker, *Im Strahlungsfeld*, 336.

166 Amtsgericht, Munich, Breker file, Breker, *Lebenslauf*, 5 February 1947.

167 IfZG, Munich, ZS 2410, account of Marta Mierendorff. Breker, *Im Strahlungsfeld*, 336–37. Amtsgericht, Munich, Breker file, Property Control Questionnaire, 5 March 1947; and ibid., Breker, *Lebenslauf*, 5 February 1947.

168 FOIA materials on Arno Breker extend from 26 October 1945 to 14 June 1955.

169 Amtsgericht, Munich, Breker file, Breker, *Lebenslauf*, 5 February 1947.

170 Breker, *Im Strahlungsfeld*, 331.

171 Ibid., 332.

172 FOIA materials concerning Arno Breker. Compare, for example, the undated document from Berlin (with the file number MP-B-102—perhaps for "Military Police-Berlin"), with the memorandum from Charles Froelicher, Agent in Charge CIC Donauwörth, 14 March 1946, where he reports that Breker "was not a Party member (but made plenty of 'hay' during the Nazi years)."

173 Breker, *Im Strahlungsfeld*, 333.

174 Note, too, that there have also been claims that he served as acting president of the chamber for a period in 1943, although this is difficult to confirm. "Nazi Künstler und Bonner Prominenz: Andrang bei Hitlers Lieblingsbildhauer," *Die Tat* 50 (9 December 1972). Wolfram Werner, *Findbücher zu Beständen des Bundesarchivs, Bd. 31: Reichskulturkammer und Einzelkammer* (Koblenz: Bundesarchiv, 1987). Breker is reported to have succeeded Leonard Gall and preceded the last president, Julius Paul Junghanns.

175 Amtsgericht, Munich, Breker file, Konrad Hämmerling to Spruchkammer Donauwörth, 20 January 1947.

176 Amtsgericht, Munich, Breker file, *Meldebogen*, 6 May 1946; ibid., Ben-

ninger (office of Regierungspräsident) to Bayerisches Staatsministerium für Verkehrsangelegenheiten, 28 November 1946; ibid., Breker, *Lebenslauf*, 5 February 1947; ibid., Demetra Breker to Ministerialrat Frohberg, 5 June 1946.

177 The studio had belonged to Joseph Franz Pallenberg, known for animal sculptures. Probst, *Der Bildhauer*, 39. Breker interview of 16 April 1980 in Dorléac, *Histoire de l'Art*, 424.

178 Amtsgericht, Munich, Breker file, Demetra Breker to Frohberg, 5 June 1946.

179 NA, RG 260/86, "Curriculum Vitae of Prof. Breker," 5 February 1947.

180 Amtsgericht, Munich, Breker file, Windhaus to Spruchkammer Donauwörth, 2 August 1948.

181 Ibid., Breker to Spruchkammer Donauwörth, 20 January 1947.

182 Ibid., Wolfgang Vogel to Troberg, 16 January 1947.

183 Ibid., *Klageschrift*, 21 July 1948.

184 "Lebender Leichnam," 80–81. "Arno Breker wurde Mitläufer."

185 Amtsgericht, Munich, Breker file, Spruch, 1 October 1948; and ibid., Windhaus to Spruchkammer Donauwörth, 2 August 1948.

186 Ibid., Spruch, 1 October 1948, Anlage 3.

187 Note that many who knew him were outraged by the prospect of Breker's denazification, let alone the exculpatory verdict. Artist Karl Hofer claimed to speak on behalf of the Berlin artistic community in protesting his exoneration. Amtsgericht, Munich, Breker file, Karl Hofer to Spruchkammer, 1 August 1947.

188 For reproductions of portraits of the Nazi leaders mentioned above, see the exhibition catalog, GBI, ed., *Arno Breker* (Potsdam: Garnisonmuseum Lustgarten, 1944). Note that Riefenstahl, unlike Breker, never joined the NSDAP. The verdict of her denazification trial cleared her completely, placing her in Group V. See her file in BHSA, MK 60815.

189 Breker interview of 16 April 1980 in Dorléac, *Histoire de l'Art*, 424.

190 Amtsgericht, Munich, Breker file, Office of Chief of Counsel for War Crimes to Hans Sachs, 13 January 1949. The compromising documents included a letter from Karl Theodor Zeitschel, the Jewish expert (*Judenreferent*) within the German Embassy in Paris, putting the residence at his disposal.

191 Ibid., Anlage zur Vermögenserklärung, 5 March 1947. NA, RG 260/86, "Extracts from 'Curriculum Vitae' of Prof. Breker," 5 February 1947.

192 Breker, *Schriften*, 19.

193 Amtsgericht, Munich, Breker file, Windhaus to prosecutor Dr. Knirsch, 24 August 1951.

194 IfZG, Munich, ED 106, Walter Hammer, Bd. 63, Breker to Hammer, 14 June 1956.

195 Ray Müller, *The Wonderful Horrible Life of Leni Riefenstahl* (New York: Kino on Video, 1993).

196 Heinz Ohff, "Breker als Beute," *Der Tagesspiegel* 4815 (13 July 1961), 4.

197 S. H., "Arno Brekers 'Gipswert,'" *Montags Echo* 15, Nr. 32 (7 August 1961). See also GSAPK, I HA 92, Reutti Nachlass, Kurt Reutti, "Erinnerungen," 193.

198 Breker, *Im Strahlungsfeld*, 335. See also "Arno Breker's Sculpture Garden" at (Internet: www.rycroft.com/garden/brekerGarden.html).

199 Wiener Library, London, "Auszüge aus der deutschen und österreichischen Presse. Sonderausgaben: Aus den Naumann-Dokumenten," 18 June 1953.

200 "Die Verhafteten in Werl übergeben," *Frankfurter Allgemeine Zeitung* (2 April 1953).

201 FOIA materials on Arno Breker. The claim about Breker's revival of Nazism is made repeatedly: for example, in a report by William Ingals, 11 February 1946, and on a file card, 22 July 1953.

202 Glozer, "Plastik im Dienst," 85.

203 Bushart, "Kunstproduzent," 158. Note that these compromised architects had earlier been approved by the British occupation authorities. Tamms also wrote two letters on behalf of Breker in his denazification trial. Amtsgericht, Munich, Breker file, Tamms to Spruchkammer Donauwörth, (both) 27 August 1947. For continuities among architects, see Werner Durth, *Deutsche Architekten: Biographishe Verflechtungen* (Braunschweig: Vieweg, 1986).

204 "Nazi Künstler und Bonner Prominenz," *Die Tat*. Bushart, "Überraschende Begegnung," 43.

205 "Lebender Leichnam," 80–81.

206 Bushart, "Kunstproduzent," 155.

207 GSAPK, I HA Rep. 92, Reutti Nachlass, NL 1, Kurt Reutti, "Erinnerungen," 197.

208 "Lebender Leichnam," 80–81.

209 Grasskamp, "Denazification of Nazi Art," 228.

210 Ibid. Also Müller, "Eine deutscher Lieblingsbildhauer."

211 Georges Hilaire, "Rückkehr zur plastischen Ordnung," in *Arno Breker* (Düsseldorf: Galerie Manfred Strake, 1961).

212 Ibid. Note that the author also revives here the comparison between the Greeks and the Germans favored by the Nazis, as he relates Breker's art to the ideas of Winckelmann. For a Nazi publication that presents the theme of the permanence of Breker's art, see the discussion of how his figures convey "the timelessness of the German soul," in Johannes Sommer, *Arno Breker* (Bonn: Ludwig Röhrscheid Verlag, n.d.).

213 Quoted by Uwe Möller, "Die Kunst des Porträts: Professor Arno Breker zum 70. Geburtstag," *Deutschland Nachrichten* 30 (4 July 1970).

214 Reinhold Pozorny, "Hutten-Medaille für Arno Breker," *Deutsche Wochen Zeitung* 42 (17 October 1980). In this same year, President Senghor awarded Breker the Senegalese Order in Recognition of Service toward Euro-African Cultural Cooperation.

215 Ibid.

216 Timothy Ryback, "Letter from Salzburg," *New Yorker* (30 December 1991), 62–75.

217 Regarding the efforts of the Bayreuth festival organizers to obtain the Wagner bust, which was found in the Soviet zone, see GSAPK, I HA Rep. 92, Reutti Nachlass, NL 1, Kurt Reutti, "Erinnerungen," 196.

218 Menzel, "Arno Breker in Salzburg: Winifred Wagner unter den Ehrengästen," *Deutsche Wochen-Zeitung* (13 October 1978). Probst, "Biographie chronologique d'Arno Breker," 212.

219 For the Peiner exhibition in 1974, see Davidson, *Kunst in Deutschland*, 2/1: 385. Laszlo Glozer, "Karriere im Nebel," *Süddeutsche Zeitung* 19/20 (July 1975).

220 Glozer, "Karriere im Nebel."

221 Ibid.

222 "Breker-Ausstellung in Berlin," *Deutsche Wochen-Zeitung* (29 May 1981). Note also that in 1979, the Arno Breker Association was founded in Bonn with the intention of rehabilitating the artist.

223 See Charles Maier's chapter, "A Usable Past? Museums, Memory, and Identity," in *The Unmasterable Past: History, Holocaust, and German National Identity* (Cambridge, MA: Harvard University Press, 1988), 121–59.

224 Peter Ludwig quoted in Klaus Staeck, ed., *Nazi-Kunst ins Museum?* (Göttingen: Steidl, 1988), 17.

225 Peter Sager, "Comeback der Nazi-Kunst?" *Zeitmagazin* 44 (24 October 1986), 58–73; also Staeck, ed., *Nazi Kunst ins Museum?* Note that certain works by Breker did find their way into museums (aside from Schloss Nörvenich in Cologne). One example is Breker's bust of Jean Cocteau from 1963, located in the Museo Dali in Figueras.

226 See, for example, the discussion of the German reaction in Amos Elon, "The Antagonist as Liberator," *New York Times Magazine* (26 January 1997), 40–44.

227 Beaucamp, "Dienstbarer Athletiker."

228 Breker to Giesler, 29 November 1977, quoted in Klaus Scheel, "Gesinnung: unverändert braun," *Der antifaschistische Widerstandskämpfer* (August 1981), 17.

229 Ben Witter, "Arno Brekers Kunstschaffen geht weiter," *Die Zeit* 26 (20 June 1980), 23.

230 Breker interview of 16 April 1980 in Dorléac, *Histoire de l'Art*, 422. He maintains that the Rothschilds did not lose their art—that they along with "the big names had left Paris."

231 Dorléac, *Histoire de l'Art*, 92. Also, Bernard Noël, *Arno Breker et la sculpture officielle*.

232 Max Imdahl, "Pose und Menschenbild," *Die Zeit* 51 (11 December 1987), 56.

233 Grasskamp, "Denazification of Nazi Art," 241.

234 Karl Ruhrberg, "Kein Platz für Arno Breker," in Staeck, ed., *Nazi-Kunst ins Museum?*, 110–11.

235 Cone, *Artists Under Vichy*, 164.

236 Breker, *Schriften*, 97, where he writes of his "Credo concerning art:" "the portrayal of a human, ideal human form."

237 Beaucamp, "Dienstbarer Athletiker."

238 Amtsgericht, Munich, Breker file, Windhaus to Spruchkammer Donauwörth, 2 August 1948.

239 Ibid.

240 IfZG, Munich, Thorak file, clipping from the *Frankfurter Allgemeine Zeitung* (16 November 1951).

241 Kohl quoted from speech at the opening of the exhibition *Kunst und Macht im Europa der Diktatoren, 1930–1945*. See *Deutschland Nachrichten* (14 June 1996), 7.

242 Gauleitung Wien and Hauptstelle Bildende Kunst in der DBFU, *Fritz Klimsch: Kollektiv Ausstellung* (Vienna: DBFU, 1941). Note that Scholz wrote the text of the catalog.

243 Davidson, *Kunst in Deutschland*, 1: 462–64.

244 For an overview of the scholarship concerning Nolde and National

Socialism, see Monika Hecker, "Ein Leben an der Grenze: Emil Nolde und die NSDAP," *Nord Friesland* 110 (June 1995), 9–15.

245 For critical statements by Hitler and Goebbels after visiting the *GDK*, see Petropoulos, *Art as Politics*, 58–59 and 196.

246 The German reads, "Meister des Deutschen Schaamhaares."

247 BHSA, MK 60627, BSUK (anonymous) to Bayerisches Staatsministerium der Finanzen (BSMdF), 22 June 1955; and ibid., Walter Keim to BSUK, 26 December 1958. Note that appointments by Hitler's order became commonplace (such was the case with Thorak, for example, in 1937). See Thomas Zacharias, ed., *(Art) Reine Kunst: die Münchener Akademie um 1937* (Munich: Akademie der bildenden Künste, 1987), 14. Ziegler helped found the Doerner Institut in 1934, and it steadily grew in prominence. Thomas Hoving noted that "Munich's Doerner Institute . . . since the war has been the top conservation laboratory in the world" and called the directorship "the dream position in Europe for [this] profession." Hoving, *False Impressions*, 236, 244.

248 Kathrin Hoffmann-Curtius, "Die Frau in ihrem Element: Adolf Ziegler's Triptychon der 'Naturgesetzlichkeit,'" in Berthold Hinz, ed., *NS-Kunst: 50 Jahre danach, Neue Beiträge* (Marburg: Jonas, 1989), 9–34. See also Achim Preiss, "Das Dritte Reich und seine Kunst," in Brock and Preiss, eds., *Kunst auf Befehl?* 261; and Davidson, *Kunst in Deutschland*, 2/1: 468.

249 Wulf, *bildenden Künste*, 416. Wulf describes him as one of the "most important functionaries."

250 Robert Wistrich, for example, called him "the foremost official painter of the Third Reich." Wistrich, *Who's Who*, 347. For exhibitions on Nazi and fascist art that feature Ziegler's work, see, for example, Georg Bussmann, ed., *Kunst im Dritten Reich:*

Dokumente der Unterwerfung (Frankfurt: Frankfurter Kunstverein, 1975); David Britt, ed., *Art and Power: Europe Under the Dictators* (Stuttgart: Oktagon, 1995); and Tabor, ed., *Kunst und Diktatur*.

251 Getty Center, Schardt papers, box 6, folder 1, Schardt lecture, "Art Under the Nazis," n.d.

252 "Dr. Goebbels beglückwünscht Professor Adolf Ziegler," in *VB* 290 (17 October 1942).

253 Wistrich, *Who's Who*, 347. The exact date of this appointment as Sachbearbeiter is unclear, and this is the case for his joining the Nazi Party. While Ziegler claimed in his denazification trials that the year was 1929, the press reported during the war that he joined in 1925. See "Dr. Goebbels beglückwünscht Professor Adolf Ziegler," *VB* 290 (17 October 1942). Ziegler was awarded the Golden Party Badge in 1937.

254 Getty Center, Schardt papers, box 6, folder 1, Schardt lecture, (n.d.), "Art Under the Nazis." See more generally, Olaf Peters, *Neue Sachlichkeit und Nationalsozialismus: Affirmation und Kritik, 1931–1947* (Bonn: Reimer, 1998).

255 Wistrich, *The Third Reich*, 67.

256 BDC, Ziegler file, Rust Memorandum, 16 November 1936.

257 Hitler paid Ziegler RM 5,000 for the Raubal portrait in 1935. Amtsgericht, Munich, H/10451/53 (Ziegler file), Robert Bandorf and Hanns Baumann, *Klagerwiderung*, 11 September 1953. This file contains a document noting that Ziegler's income rose from RM 4,500 in 1933 to RM 40,000 in 1938. Ibid., Der öffentliche Kläger, *Klageschrift*, 4 September 1953.

258 "Kunst: NS-Aktmalerei," *Der Spiegel* 19/120 (5 May 1965), 122.

259 Ibid., 122.

260 Ibid., 120.

261 Ibid., 122.

262 Hermand, *Old Dreams of a New Reich*, 231.

263 Barrie Stavis, "Hitler's Art Dictator

Talks," *New Masses* (7 September 1937), 4.

264 BHSA, MK 60627, Ziegler file, Hauptkammer München Spruch of 29 October 1953. Amtsgericht, Munich, H/10451/53, Ziegler file, contains Ziegler's, "Meine Stellungnahme zur 'Kunstdiktatur im Dritten Reich,'" a response to Paul Rave's 1949 book.

265 Ziegler received multiple commissions from Goebbels and Hitler. Diether Schmidt, ed., *In letzter Stunde: Künstlerschriften, 1933–1945* (Dresden: VEB Verlag der Kunst, 1963), 217.

266 Amtsgericht, Munich, H/10451/53, Ziegler file, Ziegler, "Meine Stellungnahme zur 'Kunstdiktatur.'"

267 Von Lüttichau, "'Deutsche Kunst'" 97; and Arntz, "Bildersturm in Deutschland," part 2 (May 1962), 46.

268 Amtsgericht, Munich, H/10451/53, Ziegler file, Protokoll der öffentlichen Sitzung, 29 October 1953. Ziegler's speech is reproduced in Schuster, ed., *Nationalsozialismus und "Entartete Kunst,"* 217.

269 BDC, Ziegler file, von Stengel to Rust, 28 April 1944.

270 Amtsgericht, Munich, H/10451/53, Ziegler file, Elaboration of Charges (*Klagerwiderung*) by Dr. Robert Bandorf and Dr. Hanns Baumann, 11 September 1953. See also BA, R 43II/1242b, Bl. 2–3, Bormann to Lammers, 9 May 1943.

271 Robert Gellately, "'War Revolutionizes the Revolution': Social Control and Terror on the Homefront in Hitler's Germany," in Geoffrey Giles and Eberhard Jäckel, eds., *The Genesis of Nazi Policy* (Cambridge: Cambridge University Press, forthcoming).

272 Ibid.

273 BDC, Ziegler file, von Stengel to Rust, 28 April 1944. Ziegler lost his position in December 1943 and was officially pensioned the following October.

274 Amtsgericht, Munich, H/10451/53, Ziegler file, Gall quoted in Spruch, 11 December 1953.

275 Davidson, *Kunst in Deutschland*, 2/1: 468.

276 Amtsgericht, Munich, H/10451/53, Ziegler file, Generalkläger Huf to Frau Hartmann, 24 June 1948; and ibid., Haftbefehl of the Munich Berufungskammer, 5 December 1946.

277 Entnazifizierung-Hauptausschuss für Kulturschaffende der Stadt Hannover. BHSA, MK 60627, Ziegler file, Hauptkammer München Spruch, 29 October 1953.

278 Ibid.

279 Ibid.

280 Davidson, *Kunst in Deutschland* 2/1: 468. Jo Volleman, the director of the Ben Uri Art Society, wrote the author about Ziegler/Zeigler, 22 July 1998.

281 "Kunst: NS: Aktmalerei," 124. Painter Adolf Wissel (1894–1973), one of the most representative artists of the Third Reich, also revived his career after the war. Ingeborg Bloth, *Adolf Wissel: Malerei und Kunstpolitik im Nationalsozialismus* (Berlin: Gebrüder Mann, 1994), 173–81.

282 BHSA, MK 60627, Karl Fees (Ziegler's lawyer) to BSUK, 2 September 1955, and Walter Keim to Academy for Fine Arts, 26 December 1958. His reappointment was denied because they determined that he initially received the position due to "an artistic wish of Hitler."

283 BHSA, MK 60627, Ziegler file, Hauptkammer München Spruch of 29 October 1953. Amtsgericht, Munich, H/10451/53, Ziegler file, Ziegler, "Meine Stellungnahme zur 'Kunstdiktatur.'"

284 Gertrud Pott, *Verkannte Grösse: Eine Kulturgeschichte der Ersten Republik, 1918–1938* (Vienna: Kremayr & Scheriau, 1989), 76.

285 Ibid., 76.

286 Wilhelm von Bode, *Der Bildhauer Joseph Thorak* (Berlin: J. J. Ottens1929). Karl Bent, "Verfemte Kunst," *Deutsche Wochen-Zeitung* (7 February 1964). Scholz, "Bildhauer des Monumentalen.". More generally, Peter-Klaus Schuster, "Bode als Prob-

lem," in Angelika Wesenberg, ed., *Wilhelm von Bode als Zeitgenosse der Kunst: Zum 150. Geburtstag* (Berlin: Staatlichen Museen zu Berlin, 1995), 1–29.

287 BHSA, MK 44686, Thorak *Lebenslauf.*

288 Amtsgericht, Munich, Thorak Spruchkammer file, Spruch, 24 May 1948.

289 Scholz, "Bildhauer des Monumentalen."

290 Ibid. Hitler and Thorak were introduced by Heinrich Hoffmann and his wife.

291 Nazi philosopher Alfred Rosenberg delivered the opening address and identified Thorak as representative of the new monumental art. Because he was also the editor of the *VB* at this time, the press coverage was especially good. See the clipping from the *VB* of 5 March 1935 in BA, NS 15/169.

292 BDC, Thorak file, Thorak to Hitler, 23 February 1939.

293 Munich, Amtsgericht, Thorak Spruchkammer file, Spruch, 24 May 1948.

294 BDC, Thorak file, "Bericht" attached to SS report, 1938. The German is Kunstgewerbeschule Pforzheim.

295 Zentner and Bedürftig, eds., *Encyclopedia*, 755–56.

296 BHSA, MK 44686, Thorak to Wagner, 17 January 1937. Thorak complains here of the size of his Berlin studio on the Lützowerstrasse.

297 BHSA, MK 44686, Note to file.

298 Ibid., Wagner's state secretary to Julius Schaub, 14 December 1937.

299 "'Erbschaft' aus dem Dritten Reich: Ein Koloss soll belebt werden," *Süddeutsche Zeitung* (31 December 1980).

300 BHSA, MK 44686, Bayerisches Ministerium der Finanzen to BSUK, 5 November 1945. Regarding their friendship, Speer noted that he and Thorak used the *du* form of address in *Inside the Third Reich*, 203–4. See also Bernd Böttcher, "Gefragtes Relik aus dem Dritten Reich," *Süddeutsche Zeitung* 281 (6 December 1978), 19.

301 BHSA, MK 44686, Bayerisches Ministerium der Finanzen to BSUK, 5 November 1945.

302 BDC, Thorak file, numerous documents concerning the party, including Thorak to Brückner, 15 February 1939.

303 Ibid. See also Speer, *Inside the Third Reich*, 204.

304 BA, R 43II/111c, Bl. 15–18, Rechnung über die vom Führer am 10. Juli 1944 aus der "GDK 1944" angekauften Arbeiten.

305 BA, R 120/2883, GBI Aktenvermerk, 9 March 1945. The GBI gave Thorak millions of marks for his work; this included RM 550,000 in *Honoraria* prior to October 1944. The GBI's files also include multiple payments to Thorak for construction and various purchases, for example, RM 150,000 in February 1942 and RM 200,000 in February 1944. See BA, R 120/1564 for receipts.

306 BDC, Thorak file, for the correspondence concerning the projects for Nuremberg and the enormous sums involved, 1937–42. Concerning the advantageous price of Schloss Prielau, the Court of Appeals noted in 1949 that Thorak was undoubtedly conscious of the history of the property. BHSA, MK 44686, Berufungskammer verdict of 25 July 1949, signed by Purzer. For the 1943 income, see "Er stand vor dem Entnazifizierungsgericht," *Oberland Volksblatt* (*Interlaken*) (24 August 1948).

307 BHSA, MK 44686, note to file, n.d. Also Alford, *Spoils of World War II*, 70.

308 Salzburger Landesarchiv, Rep. 286, Reichsstatthalter 45/1942, Scheel to Thorak, 26 September 1942.

309 "Auch Thorak 'nicht betroffen,'" *National Zeitung* (28 July 1949). Alford, *Spoils of World War II*, 70.

310 Vlug, *Report on Objects Removed to Germany*, 104.

311 Alford, *Spoils of World War II*, 70.

312 *Südost-Kurier* (Bad Reichenhall) 33 (29 February 1952).

313 Vlug, *Report on the Objects Removed to Germany*, 111.

314 BDC, Thorak file, Schneider to Radtke, 17 February 1943. Thorak was given the low number 1,446,035.

315 Ibid., Bormann to F. X. Schwarz, 10 December 1942.

316 BHSA, MK 44686, Thorak to Wagner, 19 February 1937.

317 BDC, Thorak file, "Bericht" attached to SS report, 1938.

318 "Vor dem Entnazifizierungsgericht."

319 Ibid.

320 Thorak's first wife, Herta Kroll, whom he married in 1919, died in the 1928, the year after their divorce. There were also rumors that she was not "fully Aryan." BHSA, MK 44686, Anzeige über Verheiratung, 9 May 1937, and ibid., anonymous memorandum, 9 July 1937. Also, BDC, Thorak file, SS report, 1938.

321 Ibid.

322 Amtsgericht, Munich, Thorak file, Spruch of 24 May 1948.

323 Yet subsequently Thorak took on a mistress, an American named Erna Hoehnig whom he married after the war. Alford, *Spoils of World War II*, 70.

324 "Vor dem Entnazifizierungsgericht."

325 BDC, Thorak file, "Ausführliches Gesamturteil" signed by Pöller, 22 September 1938. This critical report listed transgressions ranging from driving "a luxurious car" to not raising the Nazi flag on appropriate occasions.

326 Amtsgericht, Munich, Thorak file, Spruchkammer judgment signed by Vorsitzender Raab, 24 May 1948.

327 Ibid.

328 Ibid.

329 BHSA, MK 44686, Berufungskammer Spruch, 25 July 1949.

330 Ibid., C. Sachs (for Der Minister für politische Befreiung in Bayern), "Beglaubigte Abschrift," 4 October 1950.

331 Ibid.

332 Ibid., Thorak sent to Adolf Wagner, 17 January 1939.

333 BHSA, MK 44686, Berufungskammer Begründung, 9 February 1951.

334 Ibid.

335 BHSA, MK 44686, Ringelmann

336 Wistrich, *Who's Who*, 316.

337 BHSA, MK 44686, P. Luchtenberg (Düsseldorf) to Keim, 18 July 1951.

338 Tobis Quist, "Erinnerungen an Josef Thorak," *Deutsche Nationalzeitung* 1 (5 January 1968), 7.

339 BSHA, MK 44686, Bayerisches Landesamt für Vermögensverwaltung memorandum, 6 February 1950. Earlier, Thorak's lawyer reported that works were destroyed in the Baldham studio on the orders of the Education Ministry to make room to store paper. Ibid., Weihrauch to BSUK, 9 October 1949.

340 IfZG, Munich, Thorak press clipping file, unidentified newspaper article: H. St., "Die ganz grossen Massstäbe."

341 Ibid.

342 IfZG, Munich, Thorak press file, clipping from Deutsche Presse Agentur article, 1 March 1952.

343 Salzburger Landesarchiv, Rep. 284, GK 305/1943, Hausner to Thorak, 8 November 1943.

344 Although it is unclear precisely how the city acquired the statue of Paracelus, Thorak presented a model to Gauleiter Scheel as a gift in 1943. See Salzburger Landesarchiv, Rep. 286, Reichsstatthalter 95/1943, Scheel to Thorak, 19 June 1943.

345 Among those who collaborated with the Nazi regime and enjoyed postwar rehabilitation are Paul Mathias Padua, Conrad Hommel, Rudolf Eisenmenger, Wilhelm Dachauer, Josef Dobrowsky, and Ernst von Dombrowski (Dom). For the biographies of these artists, see the entries in Davidson, *Kunst in Deutschland*, 2/1, 2/2.

Conclusion

1 Thomas Mann quoted in Frei and Schmitz, *Journalismus im Dritten Reich*, 7.

2 For Künsberg, see Hartung, *Raubzüge in der Sowjetunion*. For Menten, see Ainsztein, "The Collector," and MacPherson, *The Last Victim*. For the

(BSMF) to BSUK, 9 July 1951.

Dölger, see Merker, *bildenden Künste*, 172–74. One can also only point to the Ahnenerbe, which had some three hundred employees.

3 Watson, *From Manet to Manhattan*, 271.

4 Garton Ash, *The File*, 253.

5 Daniel Goldhagen, *Hitler's Willing Executioners: Ordinary Germans and the Holocaust* (New York: Vintage, 1997), 80–128.

6 Joachim Fest, *The Face of the Third Reich* (New York: Random House, 1970), 211.

7 For more on the *Schreibtischtäter*, including a discussion of the ideas of Hannah Arendt, Raul Hilberg, and others, see Guy Adams and Danny Balfour, *Unmasking Administrative Evil* (Thousand Oaks, CA: SAGE Publications, 1998), 53–105.

8 Primo Levi, *The Drowned and the Saved* (New York: Vintage International, 1989), 26–27.

9 Amtsgericht, Munich, Scholz file, Ernst Hermann Sund to Spruchkammer Augsburg-Göggingen, 29 January 1948. Scholz's lawyer (Sund) also quotes him about saving art so that "it should again be in the possession of humanity." Another version of this notion of self-sacrifice was advanced by Breker, who wrote in 1947 that he moved from Paris to Berlin in 1934 in order to "deflect the threatening increase of Party people in the art sector." Amtsgericht, Munich, Breker file, Breker *Lebenslauf*, 5 February 1947.

10 For a critical treatment of the claim that one had no choice but to kill, see Goldhagen, *Hitler's Willing Executioners*, 239–62, 375–454.

11 Marven Krug, "Civil Liberties in Imperial Germany" (Ph.D. diss., University of Toronto, 1995), 172. Note that Mann quit the Board of Censors in 1913 when Franz Wedekind's *Lulu* was banned.

12 Kaye, "Laws in Force at the Dawn of World War II," in Simpson, ed., *The Spoils of War*, 100–106.

13 Gregor, "Business of Barbarity," IIa.

14 Donald Prater, *Thomas Mann: A Life* (New York: Oxford University Press, 1995).

15 The first to receive a general amnesty were the young (those born after 1 January 1919) who were not category I or II. Constantine FitzGibbon, *Denazification* (London: Michael Joseph, 1969), 140. Note, however, that the first amnesties began when denazification was a joint Allied-German undertaking.

16 Harry Sperber, "German Justice: 1949," *Congress Weekly* (7 March 1949), 10.

17 See most recently, Frei, *Vergangenheitspolitik*; and Timothy Vogt, "Denazification in the Soviet Occupation Zone of Germany: Brandenburg, 1945–1948" (Ph.D. diss., University of California at Davis, 1998).

18 Diethelm Prowe, H-German review (May 1996) of Curt Garner, "Public Service Personnel in West Germany in the 1950s: Controversial Policy Decisions and Their Effects on Social Composition, Gender Structure, and the Role of Former Nazis," *Journal of Social History* 29/1 (fall 1995): 25–80.

19 Karl Ludwig Schneider, "Moral Twilight and Political Failure," *The Wiener Library Bulletin* 1 (January 1949): 3. The British Zone in the north utilized professional judges, while in the south the main qualification was to have been a proven adversary of the Nazi regime.

20 Lutz Niethammer, *Die Mitläuferfabrik: Die Entnazifizierung am Beispiel Bayerns* (Berlin: J. H. W. Dietz, 1982). For denazification decisions as a whole, the most common finding was category IV or "Mitläufer." Within the western zones prior to 1949–50, out of 3,660,648 cases that were tried, 755,954 were deemed *Mitläufer*, while 1,667 were in group I; 23,060 were in group II; 150,425 in group III; and 1,213,873 in group V. Vollnhals, ed., *Entnazifizierung*, 333.

21 IfZG, Munich, press clippings on

architecture, Wolfgang Pehnt, "'Wir waren alle in der Partei': Die Karrieren deutscher Architekten zwischen 1900 und 1970," *Frankfurter Allgemeine Zeitung* (no citation, 1986).

22 Tomas Venclova, "State of Snitch" *New York Times Book Review* (12 October 1997), 15.

23 Statement of Marc Masurovsky to author, 9 January 1999, Washington, DC. Thanks also to Anne Webber for her insights into the subject of the Nazi dealer's ability to revive their careers.

24 Jonathan Petropoulos, "Business as Usual: Switzerland, the Commerce in Artworks during and After World War II, and National Identity," *Contemporary Austrian Studies* 8 (1998): 229–43.

25 NA, RG 260/485, for a file on the Krinner case. One document lists thirty-six works that were stolen, of which nine had yet to be recovered. Among those contacted by the American authorities with respect to the stolen works were Eduard Probst, a film producer from Zurich; A. Wid-
mer, a director at the Schweizer Bank in Zurich; and Fritz Nathan, a well-known dealer in St. Gallen/Zurich, who worked closely with Emil Bührle to help build the industrialist's collection.

26 Fritz Stern counseled "tact and caution" when writing about moral responsibility, but he did not disavow judgment. He added, "we cannot avoid measuring the followers and advocates of National Socialism by the standards of their own contemporaries." Fritz Stern, "National Socialism as Temptation," a chapter in *Dreams and Delusions: The Drama of German History* (New York: Alfred Knopf, 1984), 151.

27 Karl Jaspers, *Die Schuldfrage: Ein Beitrag zur deutschen Frage* (Zürich: Artemis Verlag, 1946). Also, Elliot Neaman, *A Dubious Past: Ernst Jünger and the Politics of Literature After Nazism* (Berkeley: University of California Press, forthcoming.).

28 NA, RG 239/77, ALIU, "German Personnel Connected with Art Looting," n. d.

Bibliography

Archives Consulted

Amtsgericht Munich.
Archives Nationales de France, Paris.
Bayerisches Hauptstaatsarchiv, Munich.
Bayerische Staatsgemäldesammlungen.
Berliner Staatlichen Museen, Zentralarchiv, Berlin.
Bundesarchiv Koblenz.
Bundesarchiv Lichterfelde, Berlin.
Bundesarchiv, Zweigstelle Dahlem (formerly Berlin Document Center), Berlin.
Centre Documentation Juive Contemporarine, Paris.
Dokumentationszentrum des Österreichischen Widerstandes, Vienna.
Germanisches Nationalmuseum, Nuremberg.
Getty Center for the History of Art and the Humanities, Los Angeles.
Institut für Zeitgeschichte, Munich.
Institut für Zeitgeschichte, Vienna.
Landesarchiv Berlin.
National Archives, Washington, DC/College Park.
National Gallery of Art, Washington, DC.
Österreichisches Staatsarchiv, Vienna.
Preussische Akademie der Künste, Berlin.
Preussisches Geheimes Staatsarchiv, Berlin Dahlem.
Rijksinstituut voor Oorlogsdocumentatie, Amsterdam.
Sächsisches Hauptstaatsarchiv, Dresden.
Salzburger Landesarchiv, Salzburg.
Süddeutscher Verlag Bilderdienst, Munich.
Ullstein Bilderdienst, Berlin.
Wiener Library, London.

Interviews and Conversations

S. Lane Faison
Walter Farmer
Walter Griebert
Bruno Lohse
Mario-Andreas von Lüttichau
Wilhelm Höttl
Marc Masurovsky
Hilde Mühlmann
James Plaut
Konrad Renger
Gabriele Seibt
Bernard Taper
Anne Webber

Printed Sources

Ackerl, Isabella, and Friedrich Weissensteiner. *Österreichisches Personen Lexikon der Ersten und Zweiten Republik.* Vienna: Überreuter, 1992.

Adam, Peter. *Art of the Third Reich.* New York: Harry Abrams, 1992.

Adams, Guy, and Danny Balfour. *Unmasking Administrative Evil.* Thousand Oaks, CA: SAGE Publications, 1998.

Ainzstein, Reuben. "The Collector." In *The New Statesman* (13 February 1981).

Akademie der Künste, eds. *"Die Kunst hat nie ein Mensch allein besessen."* Berlin: Henschel Verlag, 1996.

Akinsha, Konstantin, and Girgori Kozlov, with Sylvia Hochfield. *Beautiful Loot: The Soviet Plunder of Europe's Art Treasures.* New York: Random House, 1995.

Alford, Kenneth. *The Spoils of World War II: The American Military's Role in the Stealing of Europe's Treasures.* New York: Birch Lane, 1994.

Aly, Götz, and Suzanne Heim. *Vordenker der Vernichtung: Auschwitz und die deutsche Pläne für eine neue europäische Ordnung.* Hamburg: Hoffmann und Campe, 1991.

"Americans in Berlin Bought Stolen Art." *New York Times* (26 May 1946).

"Die Amtseinführung des Prinzen Philipp von Hessen." *Berliner Illustrierter Zeitung* (8 June 1933).

Andrews, Suzanna. "Bitter Spoils." *Vanity Fair* 451 (March 1998), 238–55.

Arendt, Hannah. *Eichmann in Jerusalem: A Report on the Banality of Evil.* New York: Viking, 1963.

Arntz, Wilhelm. "Bildersturm in Deutschland." *Das Schönste.* (May–October 1962).

Assouline, Pierre. *An Artful Life: A Biography of D. H. Kahnweiler, 1884–1979.* New York: Fromm International, 1990.

Atkin, Nicholas. "France's Little Nuremberg: The Trial of Otto Abetz." In *The Liberation of France: Image and Event,* edited by H. R. Kedward and Nancy Wood. Oxford: Berg, 1995.

Baedeker, Karl. *Das Generalgouvernement: Reisehandbuch.* Leipzig: Karl Baedeker, 1943.

Barkai, Avraham. *From Boycott to Annihilation: The Economic Struggle of German Jews, 1933–1943.* Hanover, NH: University of New England Press, 1989.

Barnett, Vivian Endicott. "Banned German Art: Reception and Institutional Support of Modern German Art in the United States, 1933–1945." In *Exiles and Emigres: The Flight of European Artists from Hitler,* edited by Stephanie Barron. New York: Harry Abrams, 1997.

Barron, Stephanie. "The Galerie Fischer Auction." In *"Degenerate Art": The Fate of the Avant-Garde in Nazi Germany,* edited by Stephanie Barron. New York: Harry Abrams, 1991.

———. "1937: Modern Art and Politics in Prewar Germany." In *"Degenerate Art," The Fate of the Avant-Garde in Nazi Germany,* edited by Stephanie Barron. New York: Harry Abrams, 1991.

Baudissin, Klaus Graf von. "Der bestimmende Wert und die germanische Frühgeschichte." *Nationalzeitung* 199 (22 July 1934).

———. "Deutsches Geisterwachen im Westen." *Nationalzeitung* 60 (2 March 1934).

———. *George August Wallis. Maler aus Schottland, 1768–1847.* Heidelberg: Carl Winters, 1924.

———. "Rembrandt und Cats." *Repertorium für Kunstwissenschaft* 45 (1945): 148–79.

Baumgartl, Edgar. *Zweigmuseen der Staatlichen Museen in Bayern.* Munich: Staatliche Museen und Sammlungen in Bayern, 1990.

"Das bayerische Stiefkind." *Süddeutsche Zeitung* 24 (30 January 1953).

Beaucamp, Eduard. "Dienstbarer Athletiker: Arno Breker, der Bildhauer wird neunzig." *Frankfurter Allgemeine Zeitung* 165 (19 July 1990).

Bell, Susan Groag, and Marilyn Yalom. *Revealing Lives: Autobiography, Biography, and Gender* (Albany: SUNY Press, 1990).

Bent, Karl. "Verfemte Kunst." *Deutsche Wochen-Zeitung* (7 February 1964).

Bischof, Günter. "Die Instrumentalisierung der Moskauer Erklärung nach dem 2. Weltkrieg." *Zeitgeschichte* 20 (November/December 1993), 345–66.

Bizardel, Yvon. *Sous l'occupation: Souvenirs d'un conservateur de musée, 1940–1944.* Paris: Calman-Levy, 1964.

Black, Peter. *Ernst Kaltenbrunner: Ideological Soldier of the Third Reich.* Princeton: Princeton University Press, 1984.

Bloth, Ingeborg. *Adolf Wissel: Malerei und Kunstpolitik im Nationalsozialismus.* Berlin: Gebrüder Mann, 1994.

Bode, Wilhelm von. *Der Bildhauer Josef Thorak*. Berlin: J. J. Ottens, 1929.

Bollmus, Reinhard. *Das Amt Rosenberg und seine Gegner: Studien zum Machtkampf im nationalsozialistischen Herrschaftssystem*. Stuttgart: Deutsche Verlags-Anstalt, 1970.

Borowski, Th. "Rechtaussen." *Journalist* 80/1 (January 1980), 16.

Böttcher, Bernd. "Gefragtes Relik aus dem Dritten Reich." *Süddeutsche Zeitung* 281 (6 December 1978).

Botz, Gerhard. "Eine Deutsche Geschichte 1938 bis 1945? Österreichische Geschichte zwischen Exil, Widerstand und Verstrickung." *Zeitgeschichte* 16/1 (October 1986), 24–25.

———. *Wohnungspolitik und Judendeportation in Wien 1938 bis 1945*. Vienna: Geyer, 1975.

Bouresch, Bettina. "Sammeln sie also Kräftig!" 'Kunstrückführung" ins Reich—im Auftrag der rheinischen Provinzialverwaltung 1940–1945." In *Kunst auf Befehl?*, edited by Bazon Brock and Achim Preiss. Munich: Klinkhardt & Biermann, 1990.

Bower, Tom. *The Paperclip Conspiracy*. London: Michael Joseph, 1987.

Brands, Gunnar. "Zwischen Island und Athen: Griechische Kunst im Spiegel des Nationalsozialismus." In *Kunst auf Befehl*, edited by Bazon Brock and Achim Preiss. Munich: Klinkhardt & Biermann, 1990.

Breker, Arno. *Im Strahlungsfeld der Ereignisse: Leben und Wirken eines Künstlers*. Preussisch Oldendorf: K. W. Schütz, 1972.

———. *Paris, Hitler et Moi*. Paris: Plon, 1970.

———. *Schriften*, edited by Volker Probst. Bonn: Marco, 1983.

"Breker-Ausstellung in Berlin." *Deutsche Wochen-Zeitung* (29 May 1981).

Brenner, Hildegard. "Art in the Political Power Struggle of 1933 and 1934." In *Republic to Reich: The Making of the Nazi Revolution*, edited by Hajo Holborn. New York: Random House, 1972.

———. *Ende einer bürgerlichen Kunst-Institution: Die politische Formierung der preussischen Akademie der Künste ab 1933*. Stuttgart: Deutsche Verlags-Anstalt, 1972.

———. *Die Kunstpolitik des Nationalsozialismus*. Reinbek: Rowohlt, 1963.

Broszat, Martin. "Der Zweite Weltkreig: Ein Krieg der 'alten' Eliten, Der Nationalsozialisten oder der Krieg Hitlers?" In *Die deutschen Elite und der Weg in den Zweiten Weltkrieg*, edited by Martin Broszat and Klaus Schwabe. Munich: C. H. Beck, 1989.

Britt, David, ed. *Art and Power: Europe Under the Dictators*. Stuttgart: Oktagon, 1995.

Buchner, Ernst. *Malerei der Spätgotik: Meisterwerke der alten Pinakotheke München*. Munich: Hirmer, 1960.

———. *Von Tischbein bis Spitzweg: Deutsche und Österreichische Malerei von 1780–1850*. Munich: Kunstverein München: 1960.

Buesche, Albert. *Arno Breker: Einführung und Geleit durch die Ausstellung in der Orangerie des Tuileries*. Paris: Kraft durch Freude, 1942.

———. *L'Architecture allemande du Moyen-âge*. Paris: no publisher. 1944.

Bunjes, Hermann. *Les Châteaux de la Loire*. Paris: no publisher, 1943.

Buomberger, Thomas. *Raubkunst—Kunstraub: Die Schweiz als Drehscheibe für gestohlene Kulturgüter zur Zeit des Zweiten Weltkrieges*. Bern: Bundesamt für Kultur, 1998.

Bushart, Magdalena. "Kunstproduzent im Dienst der Macht." In *Skulptur und Macht: Figurative Plastik im Deutschland der 30er und 40er Jahre*, edited by Magdalena Bushart. Berlin: Frölich & Kaufmann, 1983.

———. "Überraschende Begegnungen mit alten Bekannten: Arno Breker NS-Plastik in neuer Umgebung." In *NS-Kunst: 50 Jahre danach, Neue Beiträge*, edited by Berthold Hinz. Marburg: Jonas, 1989.

Bussmann, Georg, ed. *Kunst im Dritten Reich: Dokumente der Unterwerfung*. Frankfurt: Frankfurter Kunstverein, 1975.

Carwin, Susanne. "Unter der Sonne des Artikels 131." *Frankfurter Hefte* 11 (November 1956), 789–97.

Cassou, Jean. *Le Pillage par les allemands des oeuvres d'art et des bibliothèques appartenant à des juifs en France*. Paris: CDJC, 1947.

Cavallar, Claudia. "Monumentale Jammerlichkeiten: Heldendenkmäler in Italien." In *Kunst and Diktatur*, edited by Jan Tabor. Vienna: Verlag Grasl, 1994.

Christlieb, W. "Ernst Buchner wird 70." *Münchener Abendzeitung* (19 March 1962), 7.

Cone, Michele. *Artist Under Vichy: A Case of Prejudice and Persecution*. Princeton: Princeton University Press, 1992.

Cooper, Douglas. *Accessions to German Museums, and Galleries during the Occupation of France* (Schenker Papers, Part I), 5 April 1945.

———. *Looted works of Art in Switzerland*. London: MFA and A, 21 January 1946.

Craig, Gordon. "Working Toward the Führer." *New York Review of Books*, 18 March 1999, 32–35. Reviewed Peter Fritzsche, *Germans into Nazis;* Ian Kershaw, *Hitler 1889–1936, Hubris*; Brigitte Hamann, *Hitler's Vienna: A Dictator's Apprenticeship;* and David Clay Larse, *Where Ghosts Walked: Munich's Road to the Third Reich.*

Davidson, Mortimer. *Kunst in Deutschland 1933–1945: Eine wissenschaftliche Enzyklopädie der Kunst im Dritten Reich*. 3 vols. Tübingen: Grabert Verlag, 1988.

Deichmann, Ute. *Biologists under Hitler*. Cambridge, MA: Harvard University Press, 1996.

de Jaeger, Charles. *The Linz File: Hitler's Plunder of Europe's Art*. Exeter: Webb & Bower, 1981.

Deshmukh, Marion. "Recovering Culture: The Berlin National Gallery and the

U.S. Occupation, 1945–1949." In *Central European History* 27 (1994), 411–39.

Despiau, Charles. *Arno Breker*. Paris: Flammarion, 1942.

Dilly, Heinrich. *Deutsche Kunsthistoriker 1933–1945*. Berlin: Deutsche Kunstverlag, 1988.

Dobbs, Michael. "Stolen Beauty." *Washington Post Magazine*, (21 March 1999).

Dorléac, Laurence Bertrand. *Histoire de l'art: Paris, 1940–1944*. Paris: Publications de la Sorbonne, 1986.

Dow, James, and Hannjost Lixfeld, eds. *The Nazification of an Academic Discipline: Folklore in the Third Reich*. Bloomington: Indiana University Press, 1994.

Dülffer, Jost, Jochen Thies, and Josef Henke. *Hitlers Städte. Baupolitik im Dritten Reich*. Cologne: Böhlau Verlag, 1978.

Durth, Werner. *Deutsche Architekten: Biographische Verflechtungen*. Braunschweig: Vieweg, 1986.

Dwork, Deborah, and Robert Jan van Pelt. *Auschwitz, 1270 to the Present*. New Haven: Yale University Press, 1996.

Eagleton, Terry. *The Function of Criticism: From the Spectator to Post-Structuralism*. London: Verso, 1984.

Eichwede, Wolfgang, and Ulrike Hartung, eds. *"Betr. Sicherstellung": NS-Kunstraub in der Sowjetunion*. Bremen: Edition Temmen, 1998.

Eisler, Colin. "Kunstgeschichte American Style: A Study in Migration." In *The Intellectual Migration: Europe and America, 1930–1960*, edited by Donald Fleming and Bernard Bailyn. Cambridge, MA: Charles Warren Center for Studies in American History, 1969.

Ellinghause, Wilhelm. "Der Prinz, der Hitler's Werkzeug war." *Hannoversche Press* (27 March 1948).

Elon, Amos. "The Antagonist as Liberator." *New York Times Magazine* (26 January 1997): 40–44.

"Er stand vor dem Entnazifizierungsgericht." *Oberland Volksblatt (Interlaken)* (24 August 1948).

" 'Erbschaft' aus dem Dritten Reich: Ein Koloss soll belebt werden." *Süddeutsche Zeitung* (31 December 1980).

"Ein jüdischer Kunstparasit in Schutzhaft." *Völkischer Beobachter* 87 (28 March 1933).

Evans, Richard, ed. *Society and Politics in Wilhelmine Germany*. London: Croon Helm, 1978.

Faison, S. Lane. *Consolidated Interrogation Report No. 4; Linz: Hitler's Museum and Library*. Washington, DC: OSS, ALIU: 15 December 1945.

———. *Detailed Interrogation Report No. 12: Herman Voss*. Washington, DC: OSS, ALIU, 15 January 1946.

———. *Supplement to Consolidated Interrogation Report No. 4: Linz: Hitler's Museum and Library*. Washington, DC: OSS, ALIU, 15 December 1945.

Farmer, Walter. "Custody and Controversy at the Wiesbaden Collecting Point," In *The Spoils of War*, edited by Elizabeth Simpson. New York: Harry Abrams, 1997.

Fassmann, Kurt. "Bildersturm in Deutschland." *Das Schönste* (May 1962): 41–42.

Fedoruk, Alexander. "Ukraine: The Lost Cultural Treasures and the Problem of their Return." In *The Spoils of War*, edited by Elizabeth Simpson. New York: Harry Abrams, 1997.

Feliciano, Hector. *The Lost Museum: The Nazi Conspiracy to Steal the World's Greatest Works of Art*. New York: Basic Books, 1997.

Fenton, James. "The Secrets of Maillol." *New York Review of Books*, 9 May 1996, 55–62.

———. "Subversives." *New York Review of Books* (11 January 1996), 48–60.

Fest, Joachim. *The Face of the Third Reich*. New York: Random House, 1970.

Fischer-Defoy, Christine. "Artists and Institutions in Germany, 1933–1945." In *The Nazification of Art*, edited by Brandon Taylor and Wilfried van der Will. Winchester: Winchester Press, 1990.

Fitzgerald, Michael. *Making Modernism: Picasso and the Creation of the Market for Twentieth Century Art*. New York: Farrar, Straus & Giroux, 1995.

FitzGibbon, Constantine. *Denazification*. London: Michael Joseph, 1969.

Flanner, Janet. "Annals of Crime: The Beautiful Spoils." *New Yorker* 40 (22 February 1947), 31–44.

Frehner, Matthias. *Das Geschäft mit der Raubkunst: Fakten, Thesen, Hintergründe*. Zurich: Verlag Neue Zürcher Zeitung, 1998.

Frei, Norbert. *Vergangenheitspolitik: Die Anfänge der Bundesrepublik und die NS-Vergangenheit*. Munich: C. H. Beck, 1996.

Frei, Norbert, and Johannes Schmitz. *Journalismus im Dritten Reich*. Munich: C. H. Beck, 1989.

Frey, Dagobert. *Krakau*. Berlin: Deutscher Kunstverlag, 1941.

Frey, Gerhard, ed. *Prominente Ohne Maske*. Munich: FZ Verlag, 1991.

Friedrich, Jörg. " 'The Apartment Keys are to Be Relinquished to the House Manager': The Cannibalization of Jewish Estates." In *The German Public and the Persecution of the Jews, 1933–1945*, edited by Jörg Wolleberg. Atlantic Highlands, NJ: Humanities Press International, 1996.

Fromm, Rainer. "Kunst und Kultur." In *Am rechten Rand: Lexikon des Rechtsradikalismus*, edited by Rainer Fromm. Marburg: Schuren, 1993.

Gallin, Alice. *Midwives to Nazism: University Professors in Weimar Germany*. Macon, GA: Mercer, 1986.

Gallup, Stephen. *A History of the Salzburg Festival*. London: Weidenfeld & Nicolson, 1987.

Garton Ash, Timothy. *The File: A Personal History*. New York: Random House, 1997.

Gates, David. "Inside a Third Reich Insider." *Newsweek* (30 October 1995), 80.

Gay, Peter. *Art and Act: On Causes in History—Manet, Gropius, Mondrian*. New York: Harper & Row, 1976.

————. *Weimar Culture: The Outsider as Insider*. New York: Harper & Row, 1970.

Gehler, Michael. "Der Hitler-Mythos in den 'nationalen' Eliten Tirols." *Geschichte und Gegenwart* 4 (November 1990), 279–318.

Gellately, Robert. " 'War Revolutionizes the Revolution': Social Control and Terror on the Homefront in Hitler's Germany." In Geoffrey Giles and Eberhard Jäckel, eds. *The Genesis of Nazi Policy*. Cambridge: Cambridge University Press, forthcoming.

Generalbauinspektor für die Reichshauptstadt. *Arno Breker*. Potsdam: Garnisonsmuseum Lustgarten, 1944.

Georg, Enno. *Die Wirtschaftliche Unternehmungen der SS*. Stuttgart: Deutsche Verlags-Anstalt, 1963.

Giefer, Rena, and Thomas Giefer. *Die Rattenlinie: Fluchtwege der Nazis: Eine Dokumentation*. Frankfurt: A. Hain, 1991.

Glozer, Laszlo. "Karriere im Nebel." *Süddeutsche Zeitung* (19/20 July 1975).

————. "Plastik im Dienst des Grossdeutschen Reiches: Arno Breker." In *Intellektuelle im Bann des Nationalsozialismus*, edited by Karl Corino. Hamburg: Hoffmann & Campe, 1980.

Goebbels, Joseph. *Die Tagebücher von Joseph Goebbels: Sämtliche Fragmente*, edited by Elke Fröhlich. Munich: K. G. Sauer, 1987.

————. *Die Tagebücher von Joseph Goebbels: Teil II*, edited by Elke Fröhlich. Munich: K. G. Sauer, 1996.

Goggin, Maureen, and Walter Robinson. "Murky Histories Cloud Some Local Art." *Boston Globe*, (9 November 1997).

Goldhagen, Daniel. *Hitler's Willing Executioners: Ordinary Germans and the Holocaust*. New York: Vintage, 1997.

Goldberg, Vickie. "A Sculptor's Obsession, A Model's Devotion." *New York Times* (11 August 1996).

Göpel, Erhard. "Die Sprache des Holzschnittes." In *Kaiserchronik* 4 (1951).

————. "Erinnerungen aus der Holländischen Zeit." In *Max Beckmann Gedächtnis Ausstellung*, edited by Erhard Göpel. Munich: Piper Verlag, 1951.

————. "Jugendstil?" In *Merkur* 6 (1952).

————. *Max Beckmann: Berichte eines Augenzeugen*. Frankfurt: Fischer, 1984.

Grasskamp, Walter. "The Denazification of Nazi Art: Arno Breker and Albert Speer." In *The Nazification of Art: Art, Design, Music Architecture and Film in the Third Reich*, edited by Brandon Taylor and Wilfried van der Will. Winchester: Winchester Press, 1990.

Gregor, Neil. "Business of Barbarity." *Financial Times* (7–8 March 1998).

————. *Daimler-Benz in the Third Reich*. New Haven: Yale University Press, 1998.

Grim, William. *The Faust Legend in Music and Literature*, 2 vols. Lewiston, NY: Edwin Mellen, 1997.

Grunberger, Richard. *The Twelve-Year Reich: A Social History of Nazi Germany*. New York: Holt, Rinehart & Winston, 1979.

Günther-Hornig, Margot. *Kunstschutz in den von Deutschland besetzten Gebieten, 1919–1945*. Tübingen: Institut für Besatzungsfragen, 1958.

Haase, Günther. *Kunstraub und Kunstschutz: Eine Dokumentation*. Hildesheim: Georg Olms Verlag, 1991.

Haase, Hans. "Der Anschluss." In *NS-Herrschaft in Österreich 1938–1945*, edited by Emmerich Talos, Ernst Hanisch, and Wolfgang Neugebauer. Vienna: Verlag für Gesellschaftskritik, 1988.

Haass, Ursula. "Die Kulturpolitik des Bayerischen Landtags in der Zeit der Weimarer Republik, 1918–1933." Ph.D. diss., Ludwig-Maximilian Universität (Munich), 1967.

Haberstock, Karl. *Wilhelm Trübner: Gedächtnisausstellung in der Galerie Haberstock*. Berlin: Galerie Haberstock, 1927.

"Karl Haberstock gestorben." *Die Weltkunst* (15 September 1956), 10.

Hale, Oron. *The Captive Press in the Third Reich*. Princeton: Princeton University Press, 1964.

Hämmerling, Konrad. "Die Arno-Breker-Werke GmbH." *Berliner Telegraf* 182 (9 November 1946).

Härtle, Heinrich. "Europäischer Kultur Verpflichtet: Schicksal und Werk von Robert Scholz." *Klüter-Blätter* 32/2 (February 1981), 19–23.

Hammer, Katharina. *Glanz im Dunkel: Die Bergung von Kunstschätzen im Salzkammergut am Ende des 2. Weltkrieges*. Vienna: Österreichisches Bundesverlag, 1986.

Hanisch, Ernst. "'Gau der Guten Nerven': Die nationalsozialistische Herrschaft in Salzburg 1939–1940." In *Sonderhefte der Politik und Gesellschaft im alten und neuen Österreich*. Vienna: Verlag für Geschichte und Politik, 1981.

———. *Nationalsozialistische Herrschaft in der Provinz: Salzburg im Dritten Reich*. Salzburg: Landespressbüro, 1983.

"Hans Posse Zum Gedächtnis." in *Frankfurter Zeitung* 632 (11 December 1942).

Harald, Justin. *"Tanz mir den Hitler": Kunstgeschichte und faschistische Herrschaft: Die Entfaltung einer Idee, exemplarisch Verdeutlicht an Theorie und Praxis Prominenter Kunsthistoriker unter dem Nationalsozialismus*. Münster: SZD-Verlag, 1982.

Harrer, Cornelia Andrea. *Das ältere bayerische Nationalmuseum an der Maximilianstrasse in München*. Munich: Deutscher Taschenbuch Verlag, 1993.

Hartung, Ulrike. *Raubzüge in der Sowjetunion: Das Sonderkommando Künsberg, 1941–1943*. Bremen: Edition Temmen, 1997.

Haupt, Herbert. *Jahre der Gefährdung: das Kunsthistorische Museum, 1938–1945*. Vienna: Kunsthistorisches Museum, 1995.

Hausenstein, Dr. Wilhelm. "Ernst Buchner." *Süddeutsche Sonntag Post* (26 February 1933).

Hecker, Monika. "Ein Leben an der Grenze: Emil Nolde und die NSDAP." *Nord Friesland* 110 (June 1995), 9–15.

Heffen, Annegret. *Der Reichskunstwart: Kunstpolitik in den Jahren 1920–1933.* Essen: Blaue Eule, 1986.

Hentzen, Alfred. "Das Ende der Neuen Abteilung der Nationalgalerie." *Jahrbuch Preussischer Kulturbesitz* 8 (1970): 78.

Herf, Geoffrey. *Reactionary Modernism: Technology, Culture and Politics in Weimar and the Third Reich.* Cambridge, MA: Harvard University Press, 1984.

Hermand, Jost. "Art for the People: The Nazi Concept of a Truly Popular Painting." *High and Low Cultures: German Attempts at Mediation,* edited by Reinhold Grimm and Jost Hermand. Madison: University of Wisconsin Press, 1994.

———. *Old Dreams of a New Reich: Volkish Utopias and National Socialism.* Bloomington: Indiana University Press, 1992.

Herzstein, Robert Edwin. *Waldheim: The Missing Years.* New York: Arbor House, 1988.

———. *The War That Hitler Won: The Most Infamous Propaganda Campaign in History.* New York: Putnam, 1978.

Hesse, Anja. *Malerei des Nationalsozialismus: Der Maler Werner Peiner, 1897–1984.* Hildesheim: Georg Olms, 1995.

Heuss, Anja. "Der Kunstraub der Nationalsozialisten: Eine Typologie." *Kritische Berichte* 23/2 (1995): 32–43.

———. "Das Schicksal der jüdischen Kunstsammlung von Ismar Littmann." *Neue Züricher Zeitung* 188 (17 August 1998), 23.

Hilaire, Georges. "Rückkehr zur plastischen Ordnung." In *Arno Breker.* Düsseldorf: Galerie Manfred Strake, 1961.

Hingst, Monika, Marita Gleiss, and Christoph Martin Vogtherr, eds. *"Die Kunst hat nie ein Mensch allein besessen": Akademie der Künste. Dreihundert Jahre Hochschule der Künste.* Berlin: Henschel Verlag, 1996.

Hinz, Berthold. *Art in the Third Reich.* New York: Random House, 1979.

———. "1933/45: Ein Kapitel Kunstgeschichtlicher Forschung seit 1945." *Kritische Berichte* 14/4 (April 1986): 18–33.

Hinz, Berthold, and Hans Mittig, eds. *Die Dekoration der Gewalt: Kunst und Medien im Faschismus.* Giessen: Anabas, 1979.

Hirsch, Michael. "Secret Bankers for the Nazis." *Newsweek* (24 June 1996), 50–51.

"Historiker verlangen Aufarbeitung der Nazizeit." *This Week in Germany* (11 September 1998), 7.

Hitler, Adolf. *Hitler's Table Talk, 1941–1944.* New York: Oxford University Press, 1988.

Hochman, Elaine. *Architects of Fortune: Mies van der Rohe and the Third Reich.* New York: Weidenfeld & Nicolson, 1989.

Der Hochverratsprozess gegen Dr. Guido Schmidt vor dem Volksgericht. Vienna: Österreichische Staatsdrückerei, 1947.

Hoffmann, Paul. *The Viennese Splendor, Twilight and Exile*. New York: Anchor Press, 1988.

Hoffmann-Curtius, Kathrin. "Die Frau in ihrem Element: Adolf Ziegler's Triptychon der 'Naturgesetzlichkeit.'" In *NS-Kunst: 50 Jahre danach, Neue Beiträge*, edited by Berthold Hinz. Marburg: Jonas, 1989.

Holst, Niels von. *Baltenland*. Berlin: Deutscher Kunstverlag, 1942.

——. *Breslau—ein Buch der Erinnerung*. Hameln: F. Siefert, 1950.

——. *Creator, Collectors, Connoisseurs: The Anatomy of Artistic Taste from Antiquity to the Present Day*. New York: Putnam, 1967.

——. *Danzig—ein Buch der Erinnerung*. Hameln: F. Siefert, 1949.

——. "Deutsche Kunst am Pranger vor 100 Jahren." In *Kunst der Nation* (15 December 1933).

——. *Die Deutsche Bildnismalerei zur Zeit des Mannerismus*. Strassbourg: J. H. E. Heitz, 1930.

——. *Die Kunst der Baltenlandes im Lichte neuer Forschung, 1919–1939*. Munich: E. Reinhardt, 1942.

——. *Der deutsche Ritterorden und seine Bauten: von Jerusalem bis Sevilla*. Berlin: Gebrüder Mann, 1981.

——. *Riga und Reval—ein Buch der Erinnerung*. Hameln: F. Siefert, 1952.

Honan, William. *Treasure Hunt: A New York Times Reporter Tracks the Quedlinburg Hoard*. New York: Delta, 1997.

Hoving, Thomas. *False Impressions: The Hunt for Big-Time Art Fakes*. New York: Simon & Schuster, 1996.

Howe, Thomas Carr. *Salt Mines and Castles: The Discovery and Restitution of Looted European Art*. Indianapolis: Bobbs-Merrill, 1946.

Hull, Isabel. *The Entourage of Kaiser Wilhelm II, 1888–1918*. Cambridge: Cambridge University Press, 1982.

Hundert Bilder aus der Galerie Haberstock: Zur Erinnerungen Karl Haberstock. Munich: Privatdruck, 1967.

Hüneke, Andreas. "On the Trail of the Missing Masterpieces: Modern Art from German Galleries." In *"Degenerate Art": The Fate of the Avant-Garde in Nazi Germany*, edited by Stephanie Barron, 121–33. New York: Harry Abrams, 1991.

Hunt, Linda. *Secret Agenda: The United States Government, Nazi Scientists, and Project Paperclip, 1945 to 1990*. New York: St. Martin's Press, 1991.

Imdahl, Max. "Pose und Menschenbild." *Die Zeit* 51 (11 December 1987).

Institut zum Studium der Judenfrage. *Die Juden in Deutschland*. Munich: Eher Verlag, 1935.

Irving, David. *Göring: A Biography*. London: Macmillan, 1989.

Jackman, Jarrel, and Carla Borden, eds. *The Muses Flee Hitler: Cultural Transfer and Adaptation, 1930–1945*. Washington, DC: Smithsonian Institution Press, 1983.

James, Harold. *A German Identity*. London: Weidenfeld & Nicolson, 1990.

Janda, Annegret. "The Fight for Modern Art: The Berlin Nationalgalerie after

1933." In *"Degenerate Art": The Fate of the Avant-Garde in Nazi Germany*, edited by Stephanie Barron. New York: Harry Abrams, 1991.

Jankuhn, Herbert. *Haus und Hof in ur- und frühgeschichtlicher Zeit*. Göttingen: Vandenhoeck & Ruprecht, 1997.

Jarausch, Konrad, ed. *The Unfree Professions: German Lawyers, Teachers, and Engineers, 1900–1950*. New York: Oxford University Press, 1990.

Jaskot, Paul. "Anti-Semitic Policy in Albert Speer's Plans for the Rebuilding of Berlin." *Art Bulletin* 78/4 (December 1996): 622–32.

———. *Oppressive Architecture: The Interest of the SS in the Monumental Building Economy*. New York: Routledge, 1999.

Jaspers, Karl. *Die Schuldfrage: Ein Beitrag zur deutschen Frage*. Zurich: Artemis Verlag, 1946.

Jelavich, Peter. "Berlin's Path to Modernity." In *Art in Berlin, 1815–1989*, edited by High Museum of Art. Atlanta: High Museum of Art, 1990.

Jensen, Robert. *Marketing Modernism in Fin-de-Siècle Europe*. Princeton: Princeton University Press, 1994.

"Der Kampf gegen 'entartete Kunst.'" *Frankfurter Zeitung* 497 (28 September 1936).

Kater, Michael. *Das Ahnenerbe der SS*. Stuttgart: Deutsche Verlags-Anstalt, 1974.

———. *Different Drummers: Jazz in the Culture of the Nazi Germany*. Oxford: Oxford University Press, 1992.

———. *Doctors Under Hitler*. Chapel Hill: University of North Carolina Press, 1989.

———. *The Twisted Muse*. Oxford: Oxford University Press, 1997.

Kaye, Lawrence. "Laws in Force at the Dawn of World War II." *The Spoils of War*, edited by Elizabeth Simpson. New York: Harry Abrams, 1997.

Kern, Erich. "Hans Severus Ziegler ist nicht Mehr." *Deutsche Wochen-Zeitung* 19 (12 May 1978), 10.

———. "Zum Gedenken an Robert Scholz." *Deutsche Wochen-Zeitung* 6 (30 January 1981).

Kerschbaumer, Gert. "Alltag, Feiern und Feste im Wandel: Nationalsozialistische Regie des öffentlichen Lebens und praktierten Kulturen in Salzburg von 1938 bis 1945." Ph.D. diss., University of Salzburg, 1986.

———. *"Faszination Drittes Reich: Kunst und Alltag der Kulturmetropole Salzburg*. Salzburg: Otto Müller Verlag, 1988.

———. *Begnadet für das Schöne: Der rot-weisse Kulturkampf gegen die Moderne*. Vienna: Verlag für Gesellschaftskritik, 1992.

Kinder, M. *Das Findbuch zum Bestand NS 30: Einsatzstab Reichsleiter Rosenberg*. Koblenz: Bundesarchiv, 1968.

Kitchen, Martin. *The Coming of Austrian Fascism*. London: Croom Helm, 1980.

Kleindel, Walter, ed. *Das grosse Buch der Österreicher: 4500 Personen Darstellungen in Wort und Bild*. Vienna: Kremayr & Scheriau, 1987.

Klessmann, Eckart. "Hitler und seine Helfer plündern Europas Sammlungen aus." *Art* (June 1993): 64–68.

Knauer, Oswald. *Österreichs Männer des öffentlichen Lebens von 1848 bis heute.* Vienna: Manzsche Verlag, 1960.

Koehl, Robert. *The Black Corps: The Structure and Power Struggles of the Nazi SS.* Madison: University of Wisconsin, 1983.

Kovacs, Mari. *Liberal Professions and Illiberal Politics: Hungary from the Hapsburgs to the Holocaust.* Oxford: Oxford University Press, 1994.

Krämer, Gode. "Zur Geschichte der Karl und Magdalene Haberstock-Stiftung." In *Mythos und Bürgerliche Welt: Germälde und Zeichnungen der Haberstock Stiftung,* edited by Städtische Kunstsammlungen Augsburg. Munich: Klinkhardt & Biermann, 1981

Kreissler, Felix. *Der Österreicher und seine Nation: Ein Lernprozess mit Hindernissen.* Cologne: Bohlau Verlag, 1984.

Krug, Marven. "Civil Liberties in Imperial Germany." Ph.D. diss., University of Toronto, 1995.

Kubin, Ernst. *Sonderauftrag Linz: Die Kunstsammlung Adolf Hitler. Aufbau, Vernichtungsplan, Rettung: Ein Thriller der Kulturgeschichte.* Vienna: Orac, 1979.

"Kunst: NS-Aktmalerei." *Der Spiegel* 19 (5 May 1965).

Kurtz, Michael. *Nazi Contraband: American Policy on the Return of European Cultural Treasures.* New York: Garland, 1985.

Kurz, Jakob. *Kunstraub in Europa, 1938–1945.* Hamburg: Facta Oblita, 1989.

Lacey, Robert. *Sotheby's: Bidding for Class.* Boston: Little Brown, 1998.

Lane, Barabara Miller. *Architecture and Politics in Germany, 1918–1945.* 1968. Reprint, Cambridge, MA: Harvard University Press, 1985.

Lange, Astrid. *Was die Rechten Lesen.* Munich: C. H. Beck, 1993.

Large, David Clay. *Where Ghosts Walked: Munich's Road to the Third Reich.* New York: W. W. Norton, 1997.

Leeuw, A. J. van der. *Die Bestimmung der von deutschen Reich entzogenen und von der Dienststelle Mühlmann übernommenen Kunstgegenstände.* Amsterdam: Rijksinstituut voor Oorlogsdocumentatie, 1962.

Lenman, Robin. "A Community in Transition: Painters in Munich, 1886–1914." *Central European History* 15 (1982): 3–33.

———. *Die Kunst, die Macht und das Geld: zur Kulturgeschichte des kaiserlichen Deutschland, 1871–1918.* Frankfurt: Campus, 1994.

———. "Politics and Culture: The State and the Avant-Garde in Munich 1886–1914." *Society and Politics in Wilhelmine Germany,* edited by Richard Evans. London: Croon Helm, 1978.

"Der Letzte zahlt die Zeche: 'Kunsthändler' Göring vor einem Schweizer Gericht." (From 1950 [no other citation provided by Preussisches Geheimes Staatsarchiv]).

Levi, Primo. *The Drowned and the Saved.* New York: Vintage International, 1989.

Lemmons, Rusel. *Goebbels and Der Angriff.* Lexington: University of Kentucky Press, 1994.

Lichtenberger, Brigitte. "Österreichs Hochschulen und Universitäten und das nationalsozialistiche Regime." In *NS-Herrschaft in Österreich, 1938–1945,* edited by Emmerich Talos, Ernst Hanisch, and Wolfgang Neugebauer. Vienna: Verlag für Gesellschaftskritik, 1988.

Lifton, Robert Jay. *The Nazi Doctors: Medical Killing and the Psychology of Genocide.* New York: Basic Books, 1986.

Linklater, Magnus, Isabel Hilton, and Neal Ascherson. *The Nazi Legacy: Klaus Barbie and the International Fascist Connection.* New York: Holt, Rinehart & Winston, 1984.

Lukas, Richard. *The Forgotten Holocaust: The Poles under German Occupation, 1939–1944.* Lexington: University of Kentucky, 1986.

Lust, Jacques. "The Spoils of War in Belgium During the Second World War." In *The Spoils of War,* edited by Elizabeth Simpson. New York: Harry Abrams, 1997.

Lüttichau, Mario-Andreas von. "'Deutsche Kunst' und 'entartete Kunst.'" In *Nationalsozialismus und "Entartete Kunst": die "Kunststadt" München 1937,* edited by Peter-Klaus Schuster. Munich: Prestel, 1987.

Luza, Radomir. *Austro-German Relations in the Anschluss Era.* Princeton: Princeton University Press, 1975.

MacPherson, Malcolm. *The Last Victim: One Man's Search for Pieter Menten, his Family's Friend and Executioner.* London: Weidenfeld and Nicholson, 1984.

Macrakis, Kristie. *Surviving the Swastika: Scientific Research in Nazi Germany.* New York: Oxford University Press, 1993.

Maier, Charles. *Recasting Bourgeois Europe: Stabilization in France, Germany, and Italy in the Decade After World War I.* Princeton: Princeton University Press, 1981.

———. *The Unmasterable Past: History, Holocaust, and German National Identity.* Cambridge, MA: Harvard University Press, 1988.

Majer, Diemut. *Recht, Verwaltung und Justiz im Nationalsozialismus: Ausgewählte Schriften, Gesetze und Gerichtsentscheidungen.* Cologne: Bund-Verlag, 1984.

Makela, Maria. *The Munich Secession: Art and Artists in Turn-of-the Century Munich.* Princeton: Princeton University Press, 1990.

Mann, Klaus. *Mephisto.* New York: Penguin, 1977.

Mann, Thomas. *Reflections of a Nonpolitical Man.* New York: Frederick Ungar, 1983.

Manasse, Peter. *Verschleppte Archive und Bibliotheken: Die Tätigkeiten des Einsatzstab Rosenberg während des Zweiten Weltkrieges.* St. Ingbert: Röhrig Universitätsverlag, 1997.

Massey, Stephen. "Individual Responsibility for Assisting the Nazis in Persecuting Civilians." *Minnesota Law Review* 71/97 (October 1986): 97–170.

Maur, Karin von. *"Bildersturm in der Staatsgalerie Stuttgart" in Bildzyklen—Zeugnisse verfemter Kunst in Deutschland, 1933–1945,* edited by Heinrich

Geissler and Michael Semff. Stuttgart: Stuttgarter Staatsgalerie, 1987.

McCloskey, Barbara. *George Grosz and the Communist Party: Art and Radicalism in Crisis, 1918 to 1936.* Princeton: Princeton University Press, 1997.

McDonald, Frank. *Provenance.* New York: Atlantic Monthly Press, 1979.

McGrath, William. *Dionysian Art and Populist Politics in Austria.* New Haven: Yale University Press, 1974.

"Memoiren. Breker: Lebender Leichnam." *Der Spiegel* 53 (28 December 1970).

Mecklenburg, Jens, ed. *Handbuch deutscher Rechtsextremismus.* Berlin: Elefanten Press, 1996.

Meissner, Günter, et al., eds. *Sauer Allgemeines Künstler-Lexikon.* Munich: K. G. Sauer, 1996.

Menzel. "Arno Breker in Salzburg: Winifred Wagner unter den Ehrengästen." *Deutsche Wochen-Zeitung* (13 October 1978).

Merker, Reinhard. *Die bildenden Künste im Nationalsozialismus: Kulturidiologie, Kulturpolitik, Kulturproduktion.* Colgone: DuMont, 1983

Michaels, Karen. "Transfer and Transformation: The German Period im American Art History." *Exiles and Emigrés: The Flight of European Artists from Hitler,* edited by Stephanie Barron, with Sabine Eckmann. New York: Harry Abrams, 1997.

Möller, Uwe. "Die Kunst des Porträts: Professor Arno Breker zum 70. Geburtstag." *Deutschland Nachrichten* 30 (24 July 1970).

Mommsen, Hans. *Das Volkswagenwerk und seine Arbeiter im Dritten Reich.* Düsseldorf: ECON, 1996.

Moppes, Maurice von. "Die Exzesse der Logik." *Les Beaux Arts* 264 (21 January 1938).

Mühlmann, Josef. *Der Dom zu Salzburg im Mittelalter.* Vienna: Kristallverlag, 1925.

———. *Franz Xäver Gruber: Sein Leben.* Salzburg: Residenz Verlag, 1966.

———. "Der St. Peters Friedhof gefährdet." *Mitteilung des Stadt-Verschönerungsvereines Salzburg* 3 (1928), 3.

Mühlmann, Kajetan. "Festpiele in Salzburg." *Münchener Illustrierte Fremden-Zeitung* (25 June 1927), 3.

———. "Neugestaltung der Salzburger Gärten." *Salzburger Chronik* 254 (5 November 1926).

———. *Sichergestellte Kunstwerke in den Besetzten niederländischen Gebieten.* The Hague: Reichskommissariat Niederland, 1943.

———. *Stadterhaltung und Stadterneuerung in Salzburg am Beispielen der Restaurierungen Franz Wagners.* Munich: Industrie und Gewerbe Verlag, 1932.

———. "Wo ist das Denkmalamt?" *Salzburger Chronik* 264 (18 November 1926).

Mühlmann, Kajetan, and Gustav Barthel. *Krakau: Hauptstadt der deutschen Generalgouvernements Polen, Gestalt und künstlerische Leistung einer deutschen Stadt im Osten.* Breslau: Korn Verlag, 1940.

Müller, Dorothee. "Ein deutscher Lieblingsbildhauer." *Süddeutsche Zeitung* 40 (17 February 1991).

Müller, Ingo. *Hitler's Justice: The Courts of the Third Reich*. Cambridge, MA: Harvard University Press, 1997.

Müller, Ray. *The Wonderful Horrible Life of Leni Riefenstahl*. New York: Kino on Video, 1993.

"Nazi Künstler und Bonner Prominenz: Andrang bei Hitlers Lieblingsbildhauer." *Die Tat* 50 (9 December 1972).

Neaman, Elliot. *A Dubious Past: Ernst Jünger and the Politics of Literature After Nazism*. Berkeley: University of California Press, forthcoming.

Nebolsine, Arcadai. "A Key to Arno Breker's Art." Internet: www.meaus.com/articles/key.html.

Nerdinger, Winfried, and Ekkehard Mai, eds. *Wilhelm Kreis. Architekt zwischen Kaiserreich und Demokratie*. Munich: Klinkhardt & Biermann, 1994.

Neubauer, Erika. "Der Weg vom Klut: 30 Jahre Klüter Blätter." *Die Klüter Blätter* 30/10 (October 1979), 21.

Neubauer, Harold. "Was ein Wort oft wirken kann." *Deutsche Nationalzeitung* 10 (27 February 1981).

Neufeld, Michael. *The Rocket and the Reich: Peenemünde and the Coming of the Ballistic Missile Era*. New York: Free Press, 1995.

Nicholas, Lynn. *The Rape of Europa: The Fate of Europe's Treasures in the Third Reich and the Second World War*. New York: Alfred Knopf, 1994.

———. "World War II and the Displacement of Art and Cultural Property." In *The Spoils of War*, edited by Elizabeth Simpson. New York: Harry Abrams, 1997.

Nicolaus, Frank. "Als Hitlers Kunst-Schergen kamen." *Art* 10 (October 1987): 81–87.

Niethammer, Lutz. *Die Mitläuferfabrik: Die Entnazifizierung am Beispiel Bayerns*. Berlin: J. H. W. Dietz, 1982.

Nisbet, Peter, and Emilie Norris. *The Busch-Reisinger Museum: History and Holdings*. Cambridge, MA: Harvard University Art Museums, 1991.

"Oberpräsident Prinz Philipp von Hessen." *Hamburger Nachrichten* 226 (22 May 1933).

Oertel, Robert. "Ein Hort europäische Kunst." *Das Reich* 14 (31 January 1943).

Ohff, Heinz. "Breker als Beute." *Der Tagesspiegel* 4815 (13 July 1961).

Ohlsen, Manfred. *Wilhelm von Bode: Zwischen Kaisermacht und Kunsttempel*. Berlin: Gebrüder Mann, 1995.

Pallat, Ludwig. *Richard Schöne, Generaldirektor der Königlichen Museen zu Berlin: Ein Beitrag zur Geschichte der preussischen Kunstverwaltung, 1872–1905*. Berlin: W. de Gruyter, 1959.

Paret, Peter. *The Berlin Succession: Modernism and its Enemies in Imperial Germany*. Cambridge, MA: Harvard University Press, 1980.

Paret, Peter. "God's Hammer." *Proceedings of the American Philosophical Society* 136/2 (1992): 226–46.

Parker, Kevin. "Art History in Exile: Richard Krautheimer and Erwin Panofsky." In *Exiles and Emigrés*, Stephanie Barron with Sabine Eckmann, eds. New York: Harry Abrams, 1997.

Paul, Gerhard. *Aufstand der Bilder: Die NS-Propaganda vor 1933*. Bonn: Dietz, 1990.

Pauley, Bruce. *From Prejudice to Persecution: Anti-Semitism in Austria*. Chapel Hill: University of North Carolina Press, 1992.

———. *Hitler and the Forgotten Nazis: A History of Austrian National Socialism*. Chapel Hill: University of North Carolina Press, 1981.

Peters, Olaf. *Neue Sachlichkeit und Nationalsozialismus: Affirmation und Kritik, 1931–1947*. Bonn: Reimer, 1998.

Petropoulos, Jonathan. *Art as Politics in the Third Reich*. Chapel Hill: University of North Carolina Press, 1996.

———. "Business as Usual: Switzerland, the Commerce in Artworks during and After World War II, and National Identity." *Contemporary Austrian Studies* 8 (1998): 229–43.

———. "The History of the Second Rank: The Art Plunderer Kajetan Mühlmann." *Contemporary Austrian Studies* 4 (1995): 177–221.

Pevsner, Nikolaus. *Academies of Art, Past and Present*. New York: Penguin, 1973.

Picker, Henry, ed. *Hitlers Tischgespräche im Führerhauptquartier, 1941–1942*. Bonn: Athenäum Verlag, 1951.

Pinder, Wilhelm. "Architektur als Moral," and "Pflicht und Anspruch der Wissenchaft." In *Gesammelte Aufsätze aus den Jahren 1907–1935*, edited by Leo Bruhns. Leipzig: E. A. Seaman, 1938.

Pinder, Wilhelm. *Vom Wesen und Werden deutschen Formen: Die bildende Kunst im neuen deutschen Staat*. Leipzig: E. A. Seaman, 1935.

Pinder, Wilhelm, and Alfred Stange, eds. *Festschrift Hitler—Deutsche Wissenschaft, Arbeit und Aufgabe: Dem Führer und Reichskanzler legt die deutsche Wissenschaft zu seinem 50. Geburtstag Reichenschaft ab über ihre Arbeit im Rahmen der gestellten Aufgaben*. Leipzig: 1939.

Plagens, Peter. "Hitler Knew What He Liked: A Handsome New Book About the Ugly Third Reich." *Art of the Third Reich*, by Peter Adam. *Newsweek* (15 June 1992), 78.

Plasser, Gerhard. *Residenzfähig: Sammlungsgeschichte der Residenzgalerie Salzburg, 1923–1938*. Salzburg: Residenzgalerie Salzburg, 1998.

Plaut, James. *Consolidated Interrogation Report No. 1: Activity of the Einstatzstab Reichsleiter Rosenberg in France*. Washington, DC: OSS, ALIU, 15 August 1945.

———. *Detailed Interrogation Report No. 3: Robert Scholz*. Washington, DC: OSS, ALIU, 15 August 1945.

———. *Detailed Interrogation Report No. 4: Gustav Rochlitz.* Washington, DC: OSS, ALIU, 15 August 1945.

———. *Detailed Interrogation Report No. 5: Günther Schiedlausky.* Washington, DC: OSS, ALIU, 15 August 1945.

———. *Detailed Interrogation Report No. 6: Bruno Lohse.* Washington, DC: OSS, ALIU, 15 August 1945.

———. *Detailed Interrogation Report No. 10: Karl Kress.* Washington, DC: OSS, ALIU, 15 August 1945.

Plietzsch, Eduard. ". . . *heiter ist die Kunst." Erlebnisse mit Künstlern und Kennern.* Gütersloh: Bertelsmann, 1955.

Podro, Michael. *The Critical Historians of Art.* New Haven: Yale University Press, 1982.

Pott, Gertrude. *Verkannte Grosse: Eine Kulturgeschichte der Ersten Republik, 1918–1938.* Vienna: Kremayr & Scheriau, 1989.

Potter, Pamela. *Most German of the Arts: Musicology and Society from the Weimar Republic to the End of Hitler's Reich.* New Haven: Yale University Press, 1998.

Pozorny, Reinhard. "Heinrich Härtle gestorben." *Deutsche Wochen-Zeitung* 28/5 (24 January 1986).

———. "Hutten-Medaille für Arno Breker." *Deutsche Wochen-Zeitung* 42 (17 October 1980).

Prater, Donald. *Thomas Mann: A Life.* New York: Oxford University Press, 1995.

Preiss, Achim. "Das Dritte Reich und seine Kunst." In *Kunst auf Befehl?*, edited by Bazon Brock and Achim Preiss. Munich: Klinkhardt & Biermann, 1990.

Preiss, Bettina. "Eine Wissenschaft wird zur Dienstleistung: Kunstgeschichte im Nationalsozialismus." In *Kunst auf Befehl?*, edited by Bazon Brock and Achim Preiss. Munich: Klinkhardt & Biermann, 1990.

Probst, Volker. *Die Bildhauer Arno Breker.* Bonn: Galerie Marco, 1978.

———. "Biographie chronologique d'Arno Breker." In *Arno Breker: 60 ans de sculpture*, edited by Jacques Damase. Paris: Jacques Damase, 1981.

Proctor, Robert. *Racial Hygiene: Medicine Under the Nazis* (Cambridge, MA: Harvard University Press, 1988).

Pröstler, Viktor. *Die Ursprünge der nationalsozialistichen Kunsttheorie.* Munich: Dissertations-und Fotodruck, Frank, 1982.

Pyle, Jerry. "Austrian Patriotism: Alternative to Anschluss." In *Conquering the Past: Austrian Nazism Yesterday and Today*, edited by F. Parkinson. Detroit: Wayne State University Press, 1989.

Puloy, Monika Ginzkey. "High Art and National Socialism Part II. Hitler's Linz Collection: Acquisition, Predation and Restitution." *Journal of the History of Collections* 10/2 (1998): 207–24.

Quist, Tobis. "Erinnerungen an Josef Thorak." *Deutsche Nationalzeitung* 1 (5 January 1968).

Rathkolb, Oliver. *Führetreu und Gottbegnadet: Künstlereliten im Dritten Reich.* Vienna: OBV, 1991.

———. "Nationalsozialistische (Un-) Kulturpolitik in Wien, 1938–1945." In *Im Reich der Kunst: Die Wiener Akademie der bildenden Künste und die faschistische Kunstpolitik,* edited by Hans Seiger, Michael Lunardi, and Peter Josef Populorum. Vienna: Verlag für Gesellschaftskritik, 1990.

Rathkolb, Oliver,. ed. *Gesellschaft und Politik am Beginn der Zweiten Republik: Vertrauliche Berichte der US-Militäradministration aus Österreich 1945 in englischer Originalfassung.* Cologne: Bohlau Verlag, 1985.

Rave, Paul Ortwin. "Bertel Thorvaldsen." *Kunst im Deutschen Reich* (1944), 62–75.

———. *Kunstdiktatur im Dritten Reich.* Hamburg: Gebrüder Mann, 1949.

Rebhann, Fritz. *Die Braunen Jahre: Wien, 1938–1945.* Vienna: Edition Atelier, 1995.

Reidemeister, Leopold. "Reconstruction-Reparation: A Report." In *Banned and Persecuted: Dictatorship of Art Under Hitler,* edited by Berthold Roland. Cologne: DuMont, 1986.

"Der Retter der alten Pinakotheke im Ruhestand." *Würtmal-Bote* (3 October 1957).

Reinhardt, Brigitte, ed. *Kunst und Kultur in Ulm, 1933–1945.* Ulm: Ulmer Museum, 1993.

Rilke, Rainer Maria. *Rodin.* 1919. Reprint, Paris: Editions du Courrier Graphique, 1926.

Ringer, Fritz. *Decline of the German Mandarins: The German Academic Community, 1890–1933.* Cambridge, MA: Harvard University Press, 1969.

Rohrback, Charlotte. *Arno Breker.* Königsberg: Kanter-Verlag, 1943.

Roland, Berthold, ed. *Banned and Persecuted: Dictatorship of Art Under Hitler.* Cologne: DuMont, 1986.

Rosar, Wolfgang. *Deutsche Gemeinschaft: Seyss-Inquart und der Anschluss.* Vienna: Europa Verlag.

Rothfeder, Herbert. "A Study of Alfred Rosenberg's Organization for National Socialist Ideology." Ph.D. diss., University of Michigan, 1963.

Rousseau, Theodore. *Consolidated Interrogation Report No. 2: The Goering Collection.* Washington, DC: OSS, ALIU, 15 September 1945.

———. *Detailed Interrogation Report No. 1: Heinrich Hoffmann.* Washington, DC: OSS, ALIU, 1 July 1945.

———. *Detailed Interrogation Report No. 2: Ernst Buchner.* Washington, DC: OSS, ALIU, 31 July 1945.

———. *Detailed Interrogation Report No. 7: Gisela Limberger.* Washington, DC: OSS, ALIU, 15 September 1945.

———. *Detailed Interrogation Report No. 8: Kajetan Mühlmann.* Washington, DC: OSS, ALIU, 15 September 1945.

————. *Detailed Interrogation Report No. 9: Walter Andreas Hofer.* Washington, DC: OSS, ALIU, 15 September 1945.

————. *Detailed Interrogation Report No. 11: Walter Bornheim.* Washington, DC: OSS, ALIU, 15 September 1945.

————. *Detailed Interrogation Report No. 13: Karl Haberstock.* Washington, DC: OSS, ALIU, 1 May 1946.

Roxan, David, and Kenneth Wanstall. *The Rape of Art; the Story of Hitler's Plunder of the Great Masterpieces of Europe.* New York: McCann, 1965.

Ruhrberg, Karl. "Kein Platz für Arno Breker." In *Nazi-Kunst ins Museum?* edited by Klaus Staeck. Göttingen: Steidl Verlag, 1988.

Ryback, Timothy. "Letter from Salzburg." In *New Yorker* (30 December 1991).

Safrian, Hans. *Die Eichmann-Männer.* Vienna: Europa Verlag, 1993.

Sager, Peter. "Comeback der Nazi-Kunst?" *Zeitmagazin* 44 (24 October 1986), 58–73.

Sappok, Gerhard. *Krakau. Hauptstadt des deutschen Generalgouvernements.* Leipzig: S. Hirzel, 1944.

Schawe, Martin. "Vor 50 Jahre—Die Bayerischen Staatsgemäldesammlungen im Zweiten Weltkrieg." *Bayerische Staatsgemäldesammlungen Jahresbericht* (Munich: Bayerische Staatsgemäldesammlungen 1994), 1–28.

Schenk, Dietmar, and Gero Seelig. "Die deutsche Akademie in Rom: Felix Nussbaum und Arno Breker in der Villa Massimo 1932/33." "Die Kunst hat nie ein Mensch allein besessen." In *Akademie der Künste: Dreihundert Jahre, Hochschule der Künste*, edited by Monika Hingst et al. Berlin: Henschel Verlag, 1996.

Schenk, J. C. *Arno Breker.* Düsseldorf: Galerie Manfred Strake, 1961.

Schirach, Henrietta von. *Der Preis der Herrlichkeit.* Wiesbaden: Limes Verlag, 1956.

Schleuenes, Karl. *The Twisted Road to Auschwitz: Nazi Policy towards German Jews.* Urbana: University of Illinois Press, 1972.

Schmidt, Andrea. "Klaus Graf Von Baudissin: Kunsthistoriker zwischen Weimarer Republik und Dritten Reich." Masters thesis, Ruprecht-Karls-Universität Heidelberg, 1991.

Schmidt, Diether. *In Letzter Stunde: Künstlerschriften, 1933–1945.* Dresden: VEB Verlag der Kunst, 1964.

Schneider, Karl Ludwig. "Moral Twilight and Political Failure." *Vienna Library Bulletin* 1 (January 1949): 3.

Scholz, Robert. *Architektur und Bildende Kunst, 1933–1945.* Preussisch Oldendorf: K. W. Schütz, 1974.

————. "Die Bedeutung der Kunst Arno Brekers." *Deutsche Wochen-Zeitung* 22/42 (17 October 1980).

————. "Bewahrungszeit der Kunst." *Kunst im Deutschen Reich* 8 (1944), 156–75.

————. "Die Botschaft der deutschen Plastik: Zu einer Ausstellung neuer

Werke von Arno Breker." *Völksicher Beobachter* 130 (10 May 1942).
———. "Der Bildhauer des Monumentalen: Professor Josef Thorak 50 Jahre." *Völkischer Beobachter* 38 (7 February 1939).
———. "Deutsche Kunst in Grosser Zeit." *Völkischer Beobachter* 209 (27 July 1940).
———. "Emigrierter Kunstbolschewismus." *Völkischer Beobachter* 179 (27 June 1936).
———. "Gegen den modernistischen Ungeist." *Deutsche Wochen-Zeitung* 7/6 (5 February 1965).
———. "Kunstraub unter Napoleon: Aus ganz Europa wanderte das Beutegut nach Paris." *Die Klüter-Blätter* 30/2 (February 1979), 13.
———. "Kunstschwindel von London." *Völkischer Beobachter* 213 (1 August 1938).
———. "Neuordnung im Kronprinzen-Palais." in *Der Steglitzer Anzeiger* (15 February 1933).
———. "Das Problem Franz Marc." *Völkischer Beobachter* 135 (14 May 1936).
———. "Sieghaftes Bekenntnis der Kunst." *Völkischer Beobachter* 178 (27 June 1943), 3–4.
———. "Speer Gegen Speer: Verrat an seiner eigenen Architektur." *Die Klüter-Blätter* 30/4 (April 1979), 12–15.
———. "Der VB zum Geburtstag seines Kampfzeichner Hans Schweitzer-Mjölnir." *Völkischer Beobachter* 205 (24 July 1941).
———. "Verfälschte Kunstgeschichte: Kunst fand offenkundig zwischen 1933 and 1945 in Deutschland nicht statt." *Deutsche Wochen-Zeitung* 22/6 (8 February 1980).
———. "Vorschau auf Paris: Die Botschaft der deutschen Plastik." *Völkischer Beobachter* 130 (10 May 1942).
———. "Die Welle künstlerischer Dekadenz Verebbt." *Deutsche Wochen-Zeitung* 4/40 (6 October 1962).
———. "Wiedergeburt des Nationaltheaters." *Deutsche Wochen-Zeitung* 48 (30 November 1963).
———. "Wilhelm Peterson—ein Maler Poet: Zum 80. Geburtstag des Malers aus dem deutschen Norde." *Deutsche Wochen-Zeitung* 22/32 (8 August 1980).
———. "Zerstörung des Menschenbildes." *Deutsche Wochen-Zeitung* 6/25 (18 June 1965).
Schrick, Kirsten. *München als Kunststadt*. Vienna: Holzhausens, 1994.
Schumann, Karl. "Münchens Pinakotheksdirektor im Kreuzfeuer." *Mannheimer Morgen Post* 301 (29 December 1956).
Schumann, Klaus. "Beim dritten Schlag zersprang der Hammer." *Süddeutsche Zeitung* 238 (15/16 October 1983).
Schuster, Peter-Klaus. "Bode als Problem." In *Wilhelm von Bode als Zeitgenosse der Kunst. Zum 150. Geburtstag*, edited by Angelika Wesenberg. Berlin: Staatlichen Museen zu Berlin, 1995.

Schuster, Peter-Klaus, ed. *Nationalsozialismus und "Entartete Kunst": die "Kunst-stadt" München 1937*. Munich: Prestel, 1988.

"Schweitzer gestorben," *Das Freie Forum: Mitteilungsblatt der Gesellschaft für Freie Publizistik* 4 (October-December 1980).

"Le 'Sculpteur' oeuvre les perspectives." *La Gerbe* (28 May 1942).

Seidlmayr, Hans. *Verlust der Mitte: die bildende Kunst des 19. und 20. Jahrhunderts als Symptom und Symbol der Zeit*. Salzburg: Otto Müller, 1948.

Seidlmayr, Hans. *Streifzuge durch altbayerisches Brauchtum*. Berlin: Nordland Verlag, 1938.

Showalter, Dennis. *Little Man, What Now? "Der Stürmer" in the Weimar Republic*. New York: Greenwood Press, 1986.

Simon, Matila. *The Battle of the Louvre: The Struggle to Save French Art in World War II*. New York: Hawthorn, 1971.

Simpson, Christopher. *Blowback: America's Recruitment of Nazis and Its Effects on the Cold War.* New York: Weidenfeld & Nicolson, 1988.

Simpson, Elizabeth, ed. *The Spoils of War: World War II and Its Aftermath: The Loss, Reappearance, and Recovery of Cultural Property.* New York: Harry Abrams, 1997.

Slany, William. *U.S. and Allied Efforts to Recover and Restore Gold and Other Assets Stolen or Hidden by Germany During World War II*. Washington, DC: United States Department of State, 1997.

Sluga, Hans. *Heidegger's Crisis: Philosophy and Politics in Nazi Germany*. Cambridge, MA: Harvard University Press, 1993.

Sommer, Johannes. *Arno Breker*. Bonn: Ludwig Röhrscheid Verlag.

Spaulding, Mark. "Economic Influences on the Constructions of German Identity." In *A User's Guide to German Cultural Studies*, edited by Scott Denham, Irene Kacandes, and Jonathan Petropoulos. Ann Arbor: University of Michigan Press, 1997.

Speer, Albert. *Inside the Third Reich*. New York: Avon, 1970.

Sperber, Harry. "German Justice: 1949." In *Congress Weekly* (7 March 1949).

Spielvogel, Jackson. *Hitler and Nazi Germany: A History*. 3rd. ed. Upper Saddle River, NJ: Prentice Hall, 1996.

"Der Staatsakt in Dresden für Dr. Hans Posse." *Völkischer Beobachter* 346 (12 December 1942).

Stabenow, Herbert. *Arno Breker*. Stuttgart: Galerie am Hauptbahnhof Günter Galetzki, 1965.

Städtische Kunstsammlungen Augsburg. *Gemälde der Stiftung Karl und Magdalena Haberstock*. Augsburg: Städtische Kunstsammlungen Augsburg, 1960.

———. *Mythos und Bürgerliche Welt: Gemälde und Zeichnungen der Haberstock Stiftung*. Munich: Klinkhardt & Biermann, 1991.

Staeck, Klaus, ed. *Nazi-Kunst ins Museum?* Göttingen: Steidl Verlag, 1988.

Stavis, Barrie. "Hitler's Art Dictator Talks." *New Masses* (7 September 1937): 4.

Steele, Frank. "Die Verwaltung der bildenden Künste im 'New Deal' und 'Dritten Reich.'" In *Die Dekoration der Gewalt: Kunst und Medien im Faschismus*, edited by Berthold Hinz and Hans Mittig. Giessen: Anabas, 1979.

Steinberg, Michael. *The Meaning of the Salzburg Festival: Austria as Theater and Ideology 1890–1938*. Ithaca: Cornell University Press, 1990.

Steinweis, Alan. *Art, Ideology, and Economics in Nazi Germany: The Reich Chambers of Music, Theater, and the Visual Arts*. Chapel Hill: University of North Carolina Press, 1992.

Steiner, George. *In Bluebeard's Castle*. New Haven: Yale University Press, 1971.

Stepan, Peter. *Die deutschen Museen*. Braunschweig: Westermann, 1983.

Stern, Fritz. *Dreams and Delusions: The Drama of German History*. New York: Alfred Knopf, 1984.

Stiefel, Dieter. *Entnazifizierung in Österreich*. Vienna: Europaverlag, 1981.

Stiftung Karl und Magdalena Haberstock. *Hundert Bilder aus der Galerie Haberstock Berlin: Zur Erinnerung*. Munich: Satz und Druck Privatdruck, 1967.

Stockhorst, Erich. *Fünftausend Köpfe: Wer war was im Dritten Reich*. Wiesbaden: VMA Verlag, 1987.

Stone, Marla. *The Patron State: Culture and Politics in Fascist Italy*. Princeton: Princeton University Press, 1998.

Tabor, Jan. "Die Gaben der Ostmark: Österreichische Kunst und Künstler in der NS-Zeit. In *Im Reich der Kunst. Die Wiener Akademie der bildenden Künste und die faschistische Kunstpolitik*, edited by Hans Seiger, Michael Lunardi and Peter Josef Populorum. Vienna: Verlag für Gesellschaftskritik, 1990.

Talos, Emmerich, Ernst Hanish, and Wolfgang Neugebauer, eds. *NS-Herrschaft in Österreich, 1938–1945*. Vienna: Verlag für Gesellschaftskritik, 1988.

Tannenbaum, Edward. *The Fascist Experience: Italian Society and Culture, 1922–1945*. New York: Basic Books, 1972.

Taper, Bernard. "Investigating Art Looting for the MFA & A." In *The Spoils of War*, edited by Elizabeth Simpson. New York: Harry Abrams, 1997.

Taylor, Brandon, and Wilfried van der Will, eds. *The Nazification of Art: Art, Design, Music, Architecture, and Film in the Third Reich*. Winchester: Winchester Press, 1990.

Teachout, Terry. "Understanding Biography as the Heir to the Novel." *Baltimore Sun* (3 May 1998).

Thomae, Otto. *Die Propaganda-Maschinerie: Bildende Kunst und Öffentlichkeitsarbeit im Dritten Reich*. Berlin: Gebrüder Mann, 1978.

Tuchman, Barbara. *Practicing History*. New York: Alfred Knopf, 1981.

"Um den staatlichen Galeriedirektor." *Süddeutsche Zeitung* 64 (18 March 1953).

Valland, Rose. *Le Front de l'Art*. Paris: Plon, 1961.

Van der Vat, Dan. *The Good Nazi: The Life and Times of Albert Speer*. London: Weidenfeld & Nicolson, 1997.

Van Dyke, James. "Franz Radziwill, 'Die Gemeinschaft' und die nationalsozial-istische 'Revolution' in der Kunst." *Georges-Bloch-Jahrbuch des Kunst-geschichtlichen Seminars der Universität Zürich* 4 (1997): 135–63.

———. "'Neue Deutsche Romantik' zwischen Modernität, Kulturkritik und Kunstpolitik, 1929–1937." In *Adolf Dietrich und die Neue Sachlichkeit in Deutschland*, edited by Dieter Schwarz. Winthertur: Kunstmuseum Winterthur, 1994.

Venclova, Tomas. "State of Snitch." *New York Times Book Review* 12 October 1997, 15. Review of Timorthy Garton Ash, *The File: A Personal History.*

"Die Verhafteten in Werl übergeben." *Frankfurter Allgemeine Zeitung* (2 April 1953).

Vital-Durand, Brigitte. *Domaine Privé.* Paris: Éditions Générales First, 1996.

Vogt, Timothy. "Denazification in the Soviet Occupation Zone of Germany: Brandenburg, 1945–1948." Ph.D. diss., University of California at Davis, 1998.

Vollnhals, Clemens, ed. *Entnazifizierung: Politische Säuberung und Rehabili-tierung in den vier Besatzungszonen 1945–1949.* Munich: Deutscher Taschenbuch Verlag, 1991.

Vlug, Jean. *Report on Objects Removed to Germany from Holland, Belgium, and France during the German Occupation in the Countries.* Amsterdam: Report of Stichting Nederlands Kunstbesit, 25 December 1945.

War Department, Strategic Services Unit. *Art Looting Investigation Unit Final Report.* Washington, DC: OSS ALIU, 1 May 1946.

Watson, Peter. *The Caravaggio Conspiracy.* New York: Doubleday, 1984.

———. *From Manet to Manhattan: The Rise of the Modern Market.* New York: Random House, 1992.

———. *Nazi Loot: Plunder of the Arts During the Second World War.* London: Hutchinson, 1994.

———. *Sotheby's: The Inside Story.* New York: Random House, 1997.

Weigert, Hans. *Geschichte der deutschen Kunst.* Frankfurt: Umschau Verlag, 1963.

Weinreich, Max. *Hitler's Professors: The Part of Scholarship in Germany's Crimes Against the Jewish People.* New York: Yiddish Scientific Institute (YIVO), 1946.

Wendland, Ulrike. "Verfolgung und Vertreibung deutschsprachiger Kunsthis-toriker/innen im Nationalsozialismus: Ein biographisches Handbuch." Ph.D. diss.: Hamburg University, 1995.

Werckmeister, O. K. "Hitler the Artist." *Critical Inquiry* 23 (winter 1997): 270–97.

Werner, Wolfram. *Findbücher zu Bestanden des Bundesarchivs, Bd. 31: Reichs-kulturkammer und Einzelkammer.* Koblenz: Bundesarchiv, 1987.

Westheim, Paul. "Museumskreig." *Die Weltbühne* 4 (1938), 8.

Whitford, Frank. "The Reich and Wrong of Twentieth Century Art." *Sunday Times*, 8 October 1995.

Wien, Gauleitung, and Hauptstelle Bildende Kunst in der DBFU, *Fritz Klimsch: Kollektiv Ausstellung*. Vienna: DBFU, 1941.

Wiese, Stephan von. "Der Kunsthändler als Überzeugungstäter: Daniel-Henry Kahnweiler und Alfred Flechtheim." In *Alfred Flechtheim: Sammler, Kunsthändler, Verleger*, edited by Kunstmuseum Düsseldorf. Düsseldorf: Kunstmuseum Düsseldorf, 1987.

Wilcox, Larry. "The Nazi Press Before the Third Reich: *Völkische Presse, Kampfblätter, Gauzeitungen*." In *Germany in the Era of the Two World Wars: Essays in Honor of Oron J. Hale*. Charlottesville, VA: University of Virginia, 1986.

Williams, Maurice. "Captain Josef Leopold: Austro-Nazi and Austro-Nationalist?" In *Conquering the Past: Austrian Nazism Yesterday and Today*, edited by F. Parkinson. Detroit: Wayne State University, 1989.

Willrich, Wolfgang. *Des Edlen Ewiges Reich*. Berlin: Verlag Grenze & Ausland, 1939.

———. *Des Reiches Soldaten*. Berlin: Verlag Grenze & Ausland, 1943.

———. *Die Säuberung des Kunsttempels: Eine Kunstpolitische Kampfschrift zur Gesundung deutscher Kunst im Geiste nordischer Art*. Munich: J. F. Lehmann. 1937.

Willrich, Wolfgang, and Oskar Just, *Nordisches Bludtserbe im Süddeutsche Bauerntum*, introduced by Richard Walther Darré. Munich: F. Bruckmann, 1938.

Wirth, Irmgard. *Berliner Malerei im 19. Jahrhundert*. Berlin: W. J. Siedler, 1991.

Wistrich, Robert. *The Third Reich: Politics and Propaganda*. London: Routledge, 1993.

———. *Who's Who in Nazi Germany*. New York: Bonanza Books, 1982.

Witek, Hans. "Arisierungen in Wien: Aspekte nationalsozialistischer Entignungspolitik." In Emmerich Talos, Ernst Hanisch, and Wolfgang Neugebauer, eds., *NS-Herrschaft in Österreich, 1938–1945*. Vienna: Verlag für Gesellschaftskritik, 1988.

With, Christopher. *The Prussian Landeskunstkommission, 1862–1911: A Study in State Subvention of the Arts*. Berlin: Gebrüder Mann, 1986.

Witter, Ben. "Arno Brekers Kunstschaffen geht weiter." *Die Zeit* 26 (20 June 1980).

Wolbert, Klaus. *Die Nackten und die Toten des "dritten Reiches."* Giessen: Anabas-Verlag, 1982.

Wulf, Joesph. *Die bildenden Künste im Dritten Reich: Eine Dokumentation*. Frankfurt: Ullstein Verlag, 1963.

Zacharias, Thomas, ed. *(Art) Reine Kunst: die Münchener Akademie um 1937*. Munich: Akademie der bildenden Künste, 1987.

Zentner, Christian, and Friedemann Bedürftig, eds. *The Encyclopedia of the Third Reich*. New York: Macmillian, 1991.

Zernatto, Guido. *Die Wahrheit über Österreich*. New York: Longmans, Green, 1938.

Zuschlag, Christoph. *"Entartete Kunst": Ausstellungsstrategien in Nazi-Deutschland*. Worms: Wernersche Verlagsgesellschaft, 1996.

Zweite, Armin. "Franz Hofmann und die Städtische Galerie 1937." In *Nationalsozialismus und "Entartete Kunst": Die "Kunststadt" München 1937*, edited by Peter-Klaus Schuster. Munich: Prestel, 1987.

Index

Page numbers in *italic* indicate illustrations.